Nicolas Poussin 1594–1665

Nicolas Poussin
1594–1665

Richard Verdi

with an essay by Pierre Rosenberg

Zwemmer
in association with the
Royal Academy of Arts, London

First published on the occasion of the exhibition
'Nicolas Poussin 1594–1665'

Galeries nationales du Grand Palais, Paris
27 September 1994 – 2 January 1995

Royal Academy of Arts, London
19 January – 9 April 1995

The exhibition was organised by the Réunion des Musées Nationaux in
Paris and the Royal Academy of Arts in London

Supported by

 National Westminster Bank

Additional support has kindly been given by The Swan Trust

The Royal Academy of Arts is grateful to Her Majesty's Government for
its help in agreeing to indemnify the exhibition under the National
Heritage Act 1980 and to the Museums and Galleries Commission for
their help in arranging this indemnity.

Catalogue published in association with
Zwemmer
an imprint of
Philip Wilson Publishers Ltd
26 Litchfield Street
London WC2H 9NJ

Distributed in the USA and Canada by
Antique Collectors' Club
Market Street Industrial Park
Wappinger's Falls, New York 12590

ISBN 0-302-00647-8

Catalogue design by Harold Bartram

Typeset by Lasertext Ltd, Manchester
Typeset in Garamond

Printed by Snoeck-Ducaju & Zoon, NV, Ghent, Belgium

Contents

Steering Committee
Sir Denis Mahon
Neil MacGregor
Jane Martineau
Pierre Rosenberg
Norman Rosenthal
Richard Verdi

Exhibition Organisers
Annette Bradshaw
Charlotte Stirling

Editorial Coordinator
Jane Martineau

Photographic Coordinator
Miranda Bennion

Translation from the French
Caroline Beamish

Acknowledgements
We would like to extend our thanks to the advisors, lenders, directors and curators, and also to the following people who have contributed to the organisation of the exhibition and the preparation of the catalogue in many different ways:

Joseph Baillio
Ariane Bankes
G. John Brooks
Malcolm Bull
Catherine Chagneau
Desmond Costa
Hélène Flon
Griselda Grimond
Norman and Jacqueline Hampson
Benjamin Harvey
David Hemsoll
Jo Hollis
Anne Luckhurst
Elizabeth McGrath
Jennifer Montagu
Judith Nesbitt
Jacqueline Oliver
Mary Osborne
Keith Thompson
Anne Verdi
Giles Waterfield
John Whenham

President's Foreword

It is fitting that the four hundredth anniversary of Nicolas Poussin's birth should be celebrated by an exhibition in the British Isles, as well as in his native France, because, in the centuries after his death, it was in these two places that his work was most avidly collected and most highly prized. Approximately a quarter of the paintings in this exhibition are in British and Irish collections. The first set of Sacraments was bought in the 18th century by the ancestor of their present owner on the advice of Sir Joshua Reynolds; they were first exhibited at the Royal Academy in 1786. We are delighted that they have been able to return after three hundred years.

Poussin was the father of French painting, and the hero of some of the greatest painters who followed in his footsteps, from Jacques-Louis David and Ingres to Cézanne and Picasso, as well as of many artists working today. He is revered above all for two qualities: for his subtle and utterly original interpretations of subject-matter, whether drawn from biblical, historical or mythological sources; and for his mastery of composition.

Our aim from the start was to mount an exhibition of 'Poussin without Problems'. In this endeavour we were guided by our two *commissaires*, Pierre Rosenberg, Director of the Musée du Louvre, and Neil MacGregor, Director of the National Gallery. For their tireless work and endless patience we are deeply grateful. Pierre Rosenberg is the doyen of French Poussin scholars, and his masterly interpretation of the work has added profoundly to our understanding of it. The exhibition was shown in its first form at the Grand Palais in Paris last autumn; we are indebted to the staff of the Réunion des musées nationaux for their goodwill and cooperation over the years in which the exhibition was in preparation.

In London we relied on a small group of scholars to guide us to a final selection of works. Sir Denis Mahon has been for many years the most passionate advocate of Poussin as a supreme painter and has added inestimably to our appreciation and understanding of him. Richard Verdi has singlehandedly undertaken the difficult task of interpreting this complex and cerebral artist to an Anglo-Saxon audience in the catalogue, as well as working tirelessly on the preparation of the exhibition itself.

We are grateful to the National Westminster Bank for its support of the exhibition. But our greatest thanks are due to the lenders to this exhibition, who have selflessly agreed to live without their paintings while they are shown in London. Our thanks go in particular to the Musée du Louvre and to the National Gallery in London; to the Dukes of Sutherland and Rutland, and the National Gallery of Scotland in Edinburgh, who have enabled us to show both sets of Sacraments in Paris and London; and to the many other private individuals and institutions who have made this exhibition possible.

Sir Philip Dowson CBE
President, Royal Academy of Arts

Lenders to the Exhibition

AUSTRIA
Kunsthistorisches Museum, Vienna, 36

CANADA
National Gallery of Canada, Ottawa/Musée des Beaux-Arts du Canada, Ottawa, 11

DENMARK
Den Kongelige Maleri- og Skulptursamling, Statens Museum for Kunst,
Copenhagen, 58

FRANCE
Musee des Beaux-Arts, Caen, 4
Musée du Louvre, Département des Peintures, Paris, 15, 18, 27, 32, 34, 35, 37, 38, 59,
62, 64, 65, 70, 71, 76, 88, 89, 90, 91
Musée des Beaux-Arts, Rouen, 74

GERMANY
Staatliche Museen zu Berlin, Gemäldegalerie, 46, 63
Staatliche Kunstsammlungen, Gemäldegalerie, Dresden, 20
Städelsches Kunstinstitut, Frankfurt am Main, 75
Niedersächsisches Landesmuseum, Hanover, 14

IRELAND
The National Gallery of Ireland, Dublin, 6, 61, 82

ITALY
Musei Vaticani, Città del Vaticano, Rome, 10

RUSSIA
Pushkin Museum of Fine Arts, Moscow, 3, 45, 86
The Hermitage Museum, St Petersburg, 2, 21, 80

SPAIN
Museo del Prado, Madrid, 17, 22, 72

EDITORIAL NOTE

The catalogue entries are arranged in chronological order, and the colour plates follow that order with a few exceptions.

Dimensions are given in centimetres to the nearest 0.5 cm; height precedes width. All works are in oil on canvas.

The following abbreviations are used throughout the catalogue:

Blunt	Anthony Blunt, *The Paintings of Poussin, A Critical Catalogue*, London, 1966
CR	Walter Friedlaender and Anthony Blunt, *The Drawings of Poussin, Catalogue Raisonné*, London, 1939–74
Correspondance	*Correspondance de Nicolas Poussin* (Archives de l'art français, V), ed. C. Jouanny, Paris, 1911
Mérot	Alain Mérot, *Nicolas Poussin*, London, 1990
Oberhuber	Konrad Oberhuber, *Poussin: The Early Years in Rome. The Origins of French Classicism*, Oxford, 1988
Thuillier	Jacques Thuillier, *Tout l'oeuvre peint de Poussin*, Paris, 1974
Wild	Doris Wild, *Nicolas Poussin, Leben, Werk, Exkurse, Katalog der Werke*, 2 vols, Zurich, 1980
Wright	Christopher Wright, *Poussin, Paintings, A Catalogue Raisonné*, London, 1985

Nicolas Poussin 1594–1665

Nicolas Poussin was born in June 1594 in or near the town of Les Andelys in Normandy, the son of a nobleman whose fortunes had been ruined in the Wars of Religion. His early education included a grounding in Latin and letters, but he soon showed an inclination for art which was fostered by the itinerant painter Quentin Varin, who visited Les Andelys in 1611–12 and became Poussin's first master. Encouraged by Varin, Poussin departed for Paris in 1612, where he studied anatomy, perspective and architecture and worked under a variety of masters. Soon after, he was introduced to engravings after Raphael and Giulio Romano. According to Bellori, one of the artist's early biographers, these fired him with such enthusiasm that he could already be described as 'of the school of Raphael' at this early stage of his career.[1] Poussin's veneration for the masters of the Italian Renaissance also led him to make two unsuccessful attempts to reach Rome in the years before 1622.

During his apprenticeship in Paris, Poussin executed a number of major commissions, none of which survives. In 1622 he completed six large tempera paintings for the Jesuits, reputedly in only six days. In the same year, he was employed to work at the Luxembourg; and, in 1623, he received an important commission for a painting of the *Death of the Virgin* for a chapel in Notre-Dame. The paintings for the Jesuits brought Poussin to the attention of the Italian poet Giovanni Battista Marino (1569–1625), who had resided in Paris since 1615. Marino became Poussin's early protector and subsequently commissioned from him a series of drawings based on Ovidian mythology. The so-called Marino drawings (cf. fig. 30, 37), now at Windsor Castle, are the most important surviving works of Poussin's Paris years.

In the spring of 1623 Marino departed for Italy, and sometime in the autumn of that year Poussin followed him, spending several months in Venice before arriving in Rome in March 1624.

Poussin was not alone among the aspiring young artists of this time in journeying to Italy. With the exception of Rembrandt and Frans Hals, virtually every other great master of the early 17th century spent a period of study in the artistic centres of Italy, above all Rome. Rubens was there for eight years, between 1600 and 1608, arriving as a fledgling painter and departing as a mature master, having absorbed the lessons of antiquity, the Renaissance and the Italian artists of his own day. The most revolutionary of these, Caravaggio, also exerted a profound influence upon a group of Dutch artists who arrived in Rome between 1610 and 1620 and subsequently came to be known as the Utrecht Caravaggisti. The most important of them, Gerrit van Honthorst and Hendrick Terbrugghen, were to transport Caravaggio's dramatic new style north of the Alps, where it had a lasting effect upon the art of the young Rembrandt. Between 1621 and 1627 Van Dyck followed them, spending a productive period in Italy working mainly as portraitist to the Genoese aristocracy. In 1625 Claude Lorrain departed for Rome, where he was soon recorded living in a quarter of the city inhabited by many foreign artists, and later by Poussin himself. Even that most

innovative genius of the 17th century, Velázquez, paid two visits to Italy, first in 1629–30 and then in 1649–51, when his remarkably lifelike portrait style astonished artists in Rome. Where Poussin differs from all these masters except Claude, however, is that he would choose to remain in Rome for virtually the whole of his career.

Poussin's early years in Rome were marked by hardship and misfortune. Soon after his arrival, Marino presented him to the wealthy amateur, Marcello Sacchetti, who introduced him to Cardinal Francesco Barberini, nephew of Pope Urban VIII; but neither of these men showed any immediate interest in the young artist's work. Within two months, Marino himself departed for Naples, where he died in 1625. To earn his living, Poussin executed a large number of biblical and mythological paintings, in the hope of finding buyers. He studied anatomy, geometry and perspective, and drew from the live model in the studio of two of the leading classical masters of the day, Domenichino (1581–1641) and, after 1631, Andrea Sacchi (1599–1661). He also measured and copied examples of antique sculpture and studied the great works of Italian Renaissance art to be seen in Rome.

Around 1627, Poussin became acquainted with the scholar, antiquarian and collector, Cassiano dal Pozzo (1588–1657), secretary to Cardinal Barberini, who became his chief Italian patron and one of his closest friends. In addition to owning an important collection of paintings, Pozzo had a wide range of other interests, including the natural sciences and the art and life of the ancients. To further these pursuits, he commissioned a large quantity of drawings of natural specimens and ancient artefacts, which formed a type of 'paper museum'. By Poussin's own admission, he became 'a pupil in his art of the house and museum of the Cavaliere dal Pozzo'.[2] Together with his early friendship with Marino, this had a decisive impact upon the young artist's intellectual development. As early as 1627–8, Mancini described Poussin as being so well versed in history, mythology and poetry that he struck his contemporaries as having exceptional erudition for a painter of his time.[3]

In 1626 Poussin received a commission from Cardinal Barberini for the *Death of Germanicus* (cat. 9) and in 1628 he was commissioned to paint the *Martyrdom of St Erasmus* (cat. 10) for an altar in St Peter's. This was poorly received and proved to be the artist's only public commission for Rome. Thereafter, Poussin specialised in easel paintings for discerning private patrons, first in Italy and then in France, who appreciated the intellectual rigour and refinement of his art.

Poussin spent his early years in Rome in the company of artists from Northern Europe, among them Claude, who remained a friend for the rest of his life and, together with Poussin, was to become one of the greatest landscape painters in 17th-century Italy. Around 1629, the artist suffered a bout of serious illness, probably as the result of a venereal infection. The effects of this may be seen in a remarkably candid self-portrait drawing of this period (fig. 1),[4] which also reveals the fiery temperament and uncouth appearance of the youthful Poussin, who was involved in at least one brawl during his early years in Rome and was described by Marino as a young man who had 'the fury of a devil'.[5] Poussin was nursed through his illness by the family of Jacques Dughet, a cook from Paris, and in September 1630 he married Dughet's daughter Anne-Marie, who was nineteen years his junior and died one year before him, in 1664. In a letter of that year Poussin suggests that his wife was caring and dependable; otherwise, nothing is known of his marriage, which remained childless. Dughet's son Gaspard (1615–75) received instruction from Poussin between 1631 and 1635

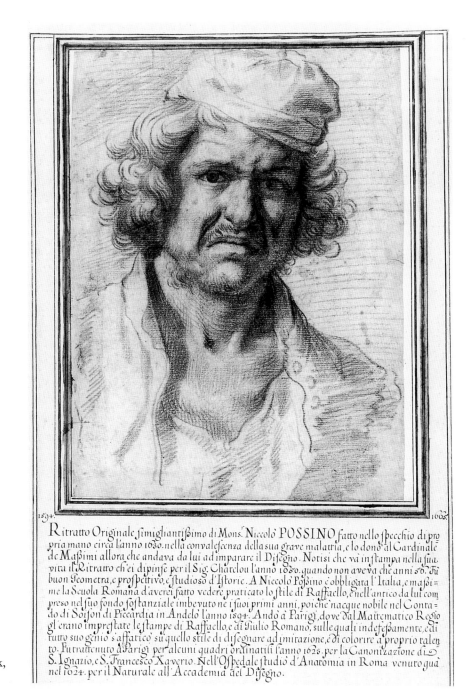

Fig. 1 Nicolas Poussin, *Self-Portrait*. Red chalk, 37.5 × 25 cm, *c.* 1630. The Trustees of the British Museum, London

and, under the name of Gaspard Poussin, became one of the leading landscape painters of the century.

By the beginning of the 1630s Poussin had established himself as an artist. In 1630–1 he completed the *Plague at Ashdod* (fig. 26) and *Kingdom of Flora* (cat. 20) for Valguarnera; by 1632 he had been elected a member of the Academy of St Luke in Rome; and, in the following year, he signed and dated the large *Adoration of the Magi* (fig. 67). Thereafter, important commissions proliferated, culminating in a series of bacchanals of 1635–6 for Cardinal Richelieu (cf. cat. 29–30) and a set of Seven Sacraments for Cassiano dal Pozzo, completed between *c.* 1638 and 1642 (cat. 39–44 and fig. 101). In 1638–9 Poussin also painted one of his most ambitious history paintings, the *Israelites Gathering the Manna* (cat. 37), for Paul Fréart de Chantelou (1609–94), who was to become his most important French patron and his most loyal and trusted friend. Around the

mid-1630s the artist also began to turn his attention seriously to landscape painting, which became a major preoccupation of his art in later years.

In January 1639 Poussin received an invitation to journey to Paris and work for Louis XIII. Reluctant to be uprooted, he confessed to Chantelou in the same year that he did not wish to risk his health by travelling and that he had married and hoped to die in Rome. 'One who is content does not move', observed the artist.[6] After repeated pressure from Richelieu, however, Poussin was forced to relent; and, in May 1640, Chantelou and his brother travelled to Rome to fetch the artist. The three arrived back in the French capital in December 1640, accompanied by Poussin's brother-in-law, Jean Dughet.

The next year and a half were among the unhappiest of Poussin's career. Soon after his arrival in Paris, he was named First Painter to the King and entrusted with all works of painting and decoration connected with the royal residences. These included executing designs for the Long Gallery of the Louvre, altarpieces for the king and members of his court, and title-page illustrations – many of them carried out with the aid of a team of assistants, a method of working with which Poussin was never at ease. As an artist of fierce integrity and creative independence, Poussin found the range and diversity of the king's commands uncongenial to his temperament and eventually secured permission to return to Rome in 1642, ostensibly to fetch his wife. With the death of Richelieu in December of that year and of the king himself four months later, the artist was effectively absolved of any obligation to return to the French court.

In 1642 Poussin also began to complain of a shakiness in his hand – an affliction that was to plague him for the rest of his life. This may have been a symptom of Parkinson's disease, a condition that can result from the illness the artist had suffered around 1630.

The second half of Poussin's career was dominated by commissions from French patrons. In 1644 he embarked on a second set of Seven Sacraments, this time for Chantelou, which he completed in 1648 (cat. 49–55). These remain one of the cornerstones of the artist's career and cost him much effort. 'In contrast to others', confessed Poussin in a letter to his patron of 1644, 'the older I get the more I feel inflamed with a great desire to do well'.[7]

This desire is nowhere more apparent than in the outstanding series of pictures Poussin produced in 1648–51, arguably the high-point of his career. Among these are his two painted self-portraits (cat. 63–4) and his great group of classical landscape compositions. Also from these years are some of his most rarefied figure paintings, including *Eliezer and Rebecca* (cat. 59) and the *Holy Family on the Steps* (cat. 60) of 1648 and the *Judgement of Solomon* (cat. 62) of the following year – works of a harmony and nobility that make it easy to see why Poussin was described as the 'Raphael of our century' by 1650.[8]

In marked contrast to the excesses of his youth, the mature Poussin led a modest and regulated existence, disdaining immoderation of any kind. Of his religious beliefs, little is known. He was certainly not in sympathy with the ecstatic Catholicism of his day, which he frequently mocks in his letters. But he apparently accepted the basic teachings of Christianity, especially when these conformed with the doctrines and morality of ancient Stoic philosophy, which was the dominant influence on his life and thought in his maturity. In this respect, Poussin has been described as 'a pure example of the Christian Stoic'.[9] Like Germanicus or Phocion – two of his favourite ancient heroes – Poussin followed a life guided by reason and virtue, and eventually attained a state of inner wisdom that made it possible for him to confront the vicissitudes of life

with apparent equanimity. As he himself admitted, 'peace and tranquillity of mind [are] possessions which have no equal'.[10]

Poussin's painting methods afford clear evidence of the rationality and discipline he exercised over all aspects of his life, even the act of creation. Having chosen the subject of a picture, he proceeded to consult the appropriate text and to make notes on it. He then worked out his ideas for the composition through a series of preparatory drawings, often using wax models to assist him in devising the design. According to Bellori, Poussin also drew from the live model at this stage in the planning. Finally, he transferred the design to canvas by means of a squared drawing or cartoon and proceeded to paint, his colours methodically arranged on his palette. He employed no assistants or collaborators and normally admitted no one into his studio while he was working. Unlike many of his greatest contemporaries, Poussin preferred to take complete responsibility for the conception and execution of his pictures. Upon completion, he affixed a price to the back of each canvas and allegedly never deviated from it. Questioned later in life on how he had attained such perfection in painting, Poussin replied simply: 'I have neglected nothing'.[11]

Poussin's patrons of these years were all members of the bourgeosie, the majority of them merchants, bankers and civil servants. Chief among these was Chantelou, who served as secretary to his cousin, Sublet de Noyers, adviser on art to Cardinal Richelieu until the latter's death in 1642. Chantelou owned the greatest collection of Poussin's paintings to be seen in Paris and later served as steward to the young Louis XIV. In 1665, he was appointed to escort the great Roman sculptor and architect Bernini around the French capital; and the result was an extensive diary by Chantelou of Bernini's visit. Another of Poussin's most important patrons was Jean Pointel, a merchant and banker from Lyons who had settled in Paris and eventually owned an even larger – if less distinguished – group of the artist's works. Other notable collectors included Michel Passart, *maître des comptes* and artistic adviser to the Prince de Condé, and Jacques Cérisier, a silk merchant from Lyons who resided in Paris. One fellow-painter also regularly commissioned works from Poussin: namely, Jacques Stella, who was likewise from Lyons and became one of the artist's closest friends. Prominently absent from this list, however, are members of the court or aristocracy. Instead, Poussin's most loyal patrons were solid and industrious citizens of the middle class. They were also men of taste and learning, capable of appreciating the works of an artist who distinguished himself in later life through his 'fine mind and wide reading'.[12]

Although Poussin was increasingly ill during the last years of his career, he continued to paint between three and four pictures a year throughout the 1650s, a significant number of them devoted to the theme of the Holy Family, a subject ideally suited to his contemplative style of this period. In 1651, he ceased painting landscapes altogether for a period of six years. When he resumed these, in 1657, they became the dominant theme of his late works. Poussin also enjoyed his highest reputation and greatest financial success during the 1650s, and in 1657 was named head of the Academy of St Luke in Rome – an honour he declined.

The chief occupation of Poussin's final years was the set of landscapes depicting the Four Seasons (cat. 88–91), executed for the Duc de Richelieu, nephew of Cardinal Richelieu, between 1660 and 1664. An unfinished *Apollo and Daphne* (fig.19) of these same years was given to Cardinal Massimi by the artist when he realised he could not complete it.

Poussin died on 19 November 1665 and was buried in the church of San

Lorenzo in Lucina, Rome. In accordance with his own wishes the ceremony was conducted 'without any pomp'.[13] Equally modest were the contents of his studio at his death.[14] These included nineteen books and manuscripts on painting plus two pictures by the artist – nothing to indicate the stature and achievements of a man who, only three years before, had been proclaimed 'the most accomplished and the most perfect painter of all the moderns'.[15]

Poussin's surviving works consist of around 220 paintings and 400 drawings. The majority of these treat themes from the Bible, ancient history or mythology and reflect the artist's belief that the noblest art should concern itself with the most elevated themes. Within his own lifetime this facet of Poussin's achievement earned the admiration of the French Academicians, who proceeded to codify his art into a series of precepts which they believed would guarantee excellence in painting. In this form, the 'learned' and 'philosophical' Poussin came to be known as 'the painter for people of intelligence', and was venerated by the Neoclassical painters of the late 18th and early 19th centuries, among them David and Ingres. More recent generations have also come to regard Poussin as one of the supreme masters of formal design in Western art; and in this respect, he exerted an important influence upon Seurat, Cézanne and even Picasso.

These complementary aspects of Poussin's genius – intellectual depth and formal mastery – account for the remarkable completeness of his art and for the satisfaction it affords to both the mind and eye. They also explain his undisputed position as the father of French painting – as the one artist who unites in his works many of those qualities that appear separately throughout the rest of the French school. 'As long as our school follows in your footsteps', confessed one critic, 'addressing' Poussin in 1812, 'it will be esteemed in spite of its faults; when it ceases to appreciate you, art will fall into decline'.[15]

1. Bellori, 1672, p. 409.

2. Filippo Baldinucci, *Notizie de'professori del disegno da Cimabue in quà*, Florence, 1681–1728, IV, p. 480.

3. Giulio Mancini, *Considerazioni sulla pittura*, ed. Adriana Marucchi and Luigi Salerno, Rome, 1956–7, I, p. 261. (Reprinted in *Actes*, 1960, II, p. 52.).

4. Further to this drawing, see CR V, pp. 57–8, no. 379, and Oxford 1990–1, no. 24. The drawing is elaborately inscribed in a 17th-century hand, though not that of the artist himself. The inscription records that the drawing was made by Poussin around 1630, when he was recovering from a serious illness, and subsequently given to Cardinal Massimi, his friend and patron of later years. Despite this evidence, the authenticity of the drawing has been questioned by Pierre Rosenberg ('Oxford, Poussin drawings from British collections', *The Burlington Magazine*, CXXXIII, 1056, March 1991, pp. 210–13.) – a view that has not found wide acceptance. Until the publication of Rosenberg's forthcoming *catalogue raisonné* of Poussin's drawings, it is impossible to assess the persuasiveness of his arguments, though it is very hard to believe that the drawing does not depict Poussin; and, on these grounds at least, it warrants inclusion here.

5. Roger de Piles, *Abrégé de la vie des peintres...et un Traité du Peintre parfait...*, Paris, 1699, p. 740.

6. *Correspondance*, p. 9.

7. *Ibid*, p. 289.

8. Roland Fréart de Chambray in *Actes*, 1960, II, p. 86.

9. Blunt, 1967, text. vol., p. 213.

10. *Correspondance*, p. 201.

11. Bonaventure d'Argonne(?) in *Actes*, 1960, II, p. 237.

12. Bellori, 1672, p. 436.

13. *Correspondance*, p. 469.

14. Ferdinand Boyer, 'Les inventaires après décès de Nicolas Poussin et de Claude Lorraine,' *Bulletin de la Société de l'Histoire de l'Art français*, 1928, pp. 143–52.

15. Roland Fréart de Chambray, *Idée de la perfection de la peinture...*, Paris, 1662, p. 121. (Reprinted in *Actes*, 1960, II, pp. 110–14.).

16. T. B. Eméric-David, *Vies des artistes anciens et modernes*, Paris, 1853, p. 345 (from a discourse delivered in October 1812).

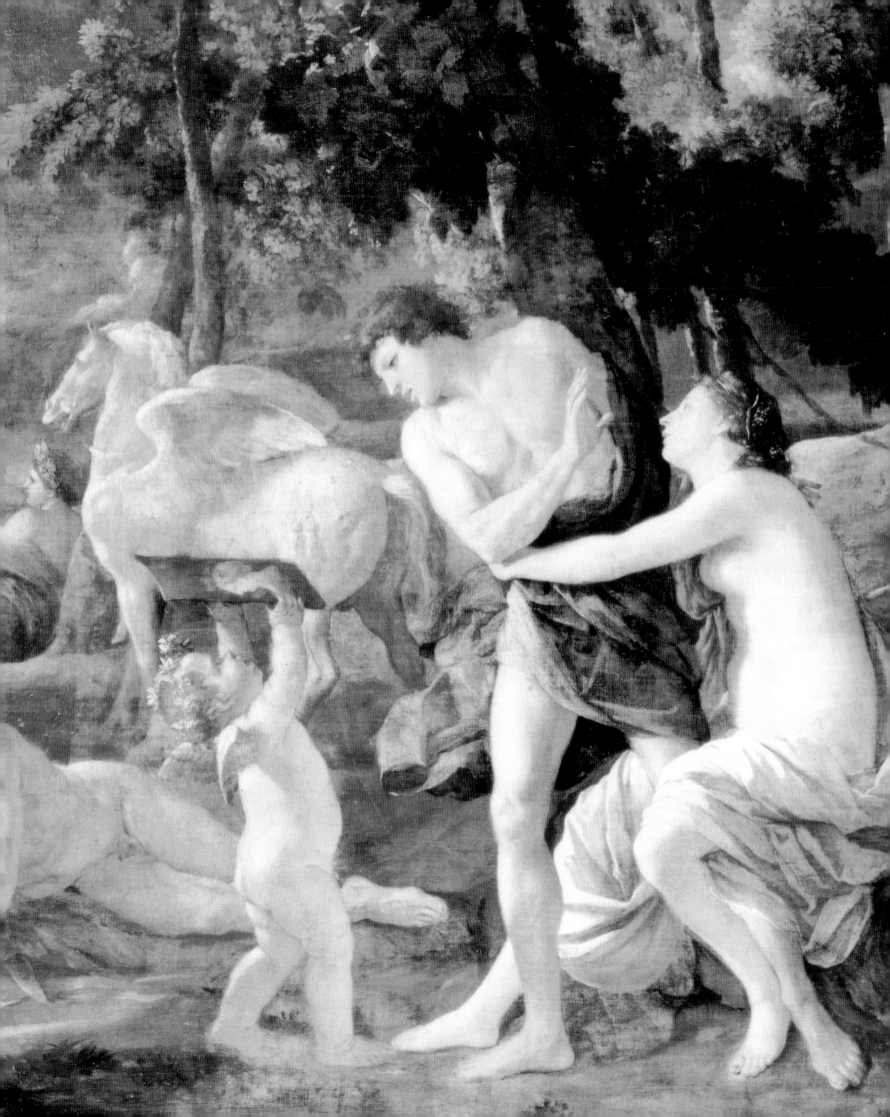

Poussin's subject-matter: Themes as types

Anyone coming to Poussin's art for the first time will immediately be struck by his novel choice of themes. The Inspiration of the Poet, the Kingdom of Flora, obscure episodes from the lives of Germanicus, Pyrrhus, Phocion and Eudamidas – all of these were entirely new to painting and testify to Poussin's creative independence and originality. They also remind us that he was the first great history painter in the Western tradition to enjoy considerable freedom in his choice of subjects. The reasons for this are easily explained. As a foreign artist working in Rome, Poussin never secured the important public commissions that were regularly bestowed upon his Italian contemporaries. After the lukewarm reception accorded to the *St Erasmus* altarpiece for St Peter's (cat. 10), he failed to gain any further papal commissions. Nor did he succeed in attracting numerous royal or princely patrons, like his friend and countryman, Claude. As a result, Poussin was seldom required to paint 'on command'. The principal exception to this was the brief and unhappy period he spent in Paris working for Louis XIII in 1640–2, when he was forced to turn his attentions to subjects and projects that were uncongenial to him, and the results are among his least inspired creations.

Instead, Poussin worked throughout his career for a discerning group of private patrons, who were increasingly willing to accept any canvas by his hand, regardless of the theme. At most, they restricted the genre of a commission, stipulating that it should depict a scene from religion or mythology, and left the rest to the artist's own devising. As we know from Poussin's early biographers, this is the way he preferred it, 'saying that the painter should himself choose the exact subject to be represented and avoid those that contained nothing'.[1] This made it possible for the artist to express his own personality through his choice of themes and is in marked contrast to the demands made upon such other major figure painters of the day as Caravaggio, Rubens, Van Dyck or Velázquez. Instead, Poussin's position has more in common with that of Rembrandt, whose history paintings were rarely commissioned and arose instead from the artist's inner need. In Rembrandt's case it has frequently been noted that his choice of subjects often reflects the emotional vicissitudes of his own life. And in the case of Poussin? Though traditionally regarded as a supremely impersonal painter, Poussin likewise reveals a preoccupation with certain favoured themes. These may be grouped together into larger categories as types of morality or human destiny. Although their exact motivation will never be known, many of these subjects afford a deeper insight into Poussin's emotional and spiritual development and his prevailingly stoical outlook upon life. At times, they even reflect the events of his own career.

During his early years in Rome, still seeking to find favour as a painter, Poussin executed a number of works on conventional religious or mythological themes – Holy Families (cf. fig. 2), Lamentations and bacchic revels – that were the stock-in-trade of Italian Baroque artists and may well have been demanded of him. Even at this formative stage of his career, however, he chose to portray a number of subjects so atypical of his time as to suggest that they were self-chosen

Fig. 2 Nicolas Poussin, *The Holy Family with St John Holding the Cross.* Oil on canvas, 101 × 75.5 cm, *c.* 1629–30. Staatliche Kunsthalle, Karlsruhe

– and chosen, moreover, to give visual expression to certain of his abiding concerns.

The most easily identifiable of these is the theme of the apotheosis of the arts and (by implication) the creative artist. This forms the subject of the two versions of the *Inspiration of the Poet* (cat. 14, 18), the *Parnassus* (cat. 22) and a small canvas depicting Venus and Mercury as protectors of the arts of poetry, painting and music (cf. fig. 3).[2] Though the circumstances surrounding the origin of all of these works are unknown, the theme of the nature and importance of creative inspiration is hardly surprising in a young artist steeped in humanism whose talents had been nurtured by the Italian poet Marino, and who had early been befriended and patronised by Cardinal Francesco Barberini, nephew of Pope Urban VIII, who himself had literary ambitions. In theme and spirit, all of Poussin's works in this vein derive from Raphael's great homage to poetry, the *Parnassus* fresco in the Vatican (fig. 62), the model for Poussin's canvas of this theme. Raphael's masterpiece also exerted a profound impact upon another of the young artist's most classicising contemporaries, the Roman painter Andrea Sacchi, with whom Poussin is recorded as working during the late 1620s.[3] But none of these influences fully accounts for the significance that Poussin himself attached to this theme, which reappears in his later years in the frontispieces he designed for editions of Virgil (fig. 57) and Horace in 1641–2[4] and even in the famous *Self-Portrait* in the Louvre (cat. 64).

The grandeur and nobility of Poussin's allegories of the arts attest to the fact that they were intended to extol the value and importance of the creative act and its dependence upon divine inspiration.[5] This is an idea to which the artist also refers in his letters,[6] but one which acquires an ironic twist when one considers that his principal works on this theme were executed during a phase of his career when he was finding it difficult to make his livelihood as an artist. Equally ironic is the fact that these pictures should have found their inspiration in the canonical art of Raphael, prince of painters; for Poussin's own circumstances could hardly

Fig. 3 F. Chiari (*after* Nicolas Poussin), *Venus and Mercury.* Etching, 28.3 × 38.2 cm, 1636. Private Collection

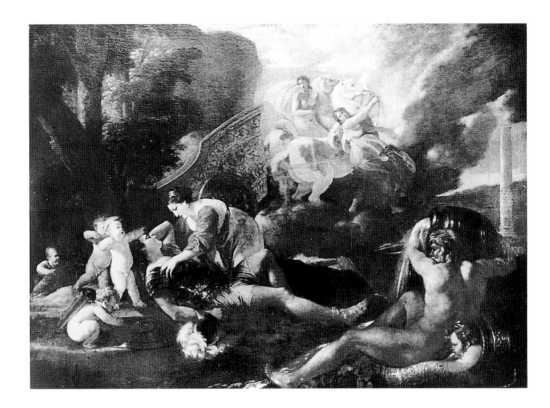

Fig. 4 Nicolas Poussin, *Rinaldo and Armida.*
Oil on canvas, 95 × 133 cm, *c.* 1627.
The Pushkin Museum of Fine Arts, Moscow

have been more different from those of his great Renaissance predecessor at the time that he painted them. Witness his letter of *c.* 1626–9 to Cassiano dal Pozzo, in which he enlists the latter's financial assistance and pleads: 'I am ill most of the time and have no other means of survival but the work of my hands.'[7] When one considers Poussin's precarious position in the Roman art world during these years, such works as the *Inspiration of the Epic Poet* and the *Parnassus* may have been intended to gain him – and the art of painting itself – greater recognition. They may even be regarded as a kind of creative wish-fulfilment.

It is noteworthy that Poussin chooses to couch this theme as a homage to poetry rather than painting. In this he differs from his follower Pietro Testa[8] and from any number of his greatest contemporaries, including Velázquez and Vermeer, whose *Las Meninas* and *Artist in his Studio* rank among the supreme affirmations of the nobility of the art of painting. Poussin's approach probably owes much to his early friendship with the poet Marino, tentatively identified by Panofsky as the figure kneeling before Apollo in the *Parnassus*. But it undoubtedly also springs from the humanist bias of his own art and, ultimately, from the teachings of the ancients, who regarded poetry as the highest form of creative expression and painting itself as mute poetry. In his letters Poussin repeatedly refers to himself as following a profession of 'things mute';[9] and, in his allegories of the arts, he may have thought that his own mute skills were themselves ennobled by reference to the sister art of poetry. Only when he had achieved lasting recognition as an artist was Poussin moved to commemorate the importance of painting itself in this way. This is in the *Self-Portrait* of 1649–50, where the female figure in the background personifies the art of painting and serves to celebrate the value of Poussin's profession while also doubling as his creative muse – a sure sign that the artist had arrived on Parnassus.

If Poussin's allegories of the arts reflect his professional aspirations during these years, an even more pervasive preoccupation of his art of this period may have its origins in the emotional upheavals of his early life. This is the theme of unrequited or ill-fated love, which forms the subject of the vast majority of the

artist's early paintings drawn from mythology or romance. Included among these are four versions of the story of Venus and Adonis and no fewer than ten additional canvases devoted to the themes of Acis and Galatea, Apollo and Daphne, Cephalus and Aurora, Diana and Endymion, Echo and Narcissus, Rinaldo and Armida, and Tancred and Erminia, the last two subjects portraying episodes from Tasso rather than Ovid. That this constitutes an undeniable obsession on Poussin's part becomes clear when one considers that the only scene of unimperilled love to be found among his early works is the *Mars and Venus* (cat. 7). While it would be idle to speculate too closely on the reasons for Poussin's attraction to this theme, the bout of syphilis that he suffered around 1630 attests to the romantic liaisons of his early years; and the pictures themselves suggest the extent to which the young artist may have felt himself enslaved by the power of woman. In the majority – including *Venus with the Dead Adonis* (cat. 4), *Diana and Endymion* (cat. 19), and both versions of *Rinaldo and Armida* (cat. 8, fig. 4) and *Tancred and Erminia* (cat. 21, 26) – a male figure is shown kneeling or recumbent and presided over by a dominant female figure who holds fate or future in her sway. As we shall see, this is a scheme that will be dramatically reversed in Poussin's later years.

One other characteristic of these early romantic pictures is worth noting. This is their prevailing mood of languor and melancholy and their preoccupation with the themes of love and death, which forms the tragic outcome of the stories of Venus and Adonis, Apollo and Daphne, Echo and Narcissus, Acis and Galatea and even Cephalus and Aurora, where the former's rejection of the goddess's advances ultimately results in the death of his wife, Procris.[10] Avoiding those mythological love stories that end happily – Bacchus and Ariadne, Pygmalion and Galatea, Venus and Anchises, or the many loves of Jupiter – the youthful Poussin preferred themes in which the unrequited love of a goddess for a mortal resulted in tragedy. These provide a classic example of what was to become one of the central concerns of his art: the unpredictable nature of human destiny.

This is also the theme of Poussin's first great history painting, the *Death of Germanicus* (cat. 9). According to Bellori, the artist himself chose the subject of this picture;[11] and there is every reason to believe this, since the story had never been treated before. Its source is the *Annals* of Tacitus, which tells of the tragic and untimely death of the great Roman general Germanicus, who was poisoned by his political enemies in the city on orders from the Emperor Tiberius. Poussin treats the theme in the manner of an antique bas-relief, showing the hero on his deathbed surrounded by his soldiers, who vow to avenge his death. The whole forms a kind of classical lamentation scene and, in both theme and style, reveals the degree to which Poussin was immersed in the art and writings of the ancients, even at this early stage of his career.

No less interesting than the source of the picture is Poussin's choice of theme. Tacitus describes Germanicus as a kind, modest and able leader whose life resembled that of Alexander the Great and whose cruel and untimely death could only be explained in one way: he was a hostage to fortune. In his letters, Poussin repeatedly refers to the inconstancy of fortune and to the need for the wise and virtuous to guard against its wayward blows.[12] This idea is in accordance with his stoical philosophy of life and was to become a key theme in his art of the 1640s and '50s. Seen in this way, Germanicus' death becomes an exemplar of the tragic fate that may befall even the noblest of beings and a grim reminder of the mutability of life itself – one which is also reflected in the lines that preface Poussin's will: 'nothing is more certain than death, and nothing

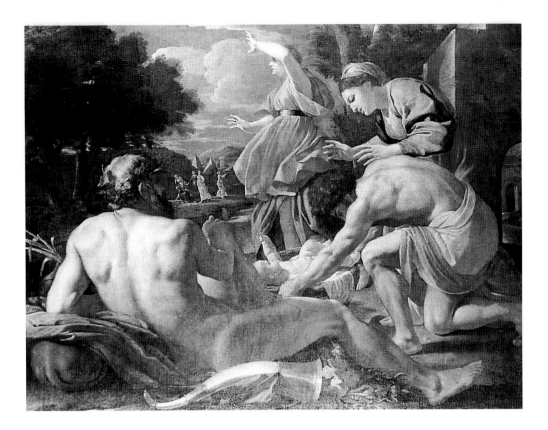

Fig 5 Nicolas Poussin, *The Exposition of Moses.*
Oil on canvas, 144 × 196 cm, *c.* 1627. Staatliche
Kunstsammlungen, Gemäldegalerie, Dresden

more uncertain than its moment'.[13]

In addition to the broad moral import of the theme, Poussin may have had
another reason for portraying the death of Germanicus at this stage of his career.
In 1628, the year the picture was completed, the artist was 34 – exactly the age of
Germanicus himself when he died. Though there is no reason to suppose that
Poussin felt his own life threatened at this time, there is every reason to imagine
that he regarded himself as unjustly treated by fortune. For he had been the
victim of a conspiracy of circumstances upon his arrival in Rome which left him
in the desperate financial state described in the aforementioned letter to Pozzo.
These included the death of his protector, Marino, one year after his arrival in the
city; the failure of Marcello Sacchetti, patron and amateur of the arts, to
commission anything from him; and the absence of Cardinal Barberini on a
diplomatic mission abroad. As a result, Poussin found himself without a
champion during his early years in Rome.

The unpredictability of life also forms the underlying subject of a series of
works spanning Poussin's entire career which revolve around the birth and
nurturing of a future hero. This is one of the dominant themes of the artist's
oeuvre and includes five canvases of the Exposition or Finding of Moses (cat. 35,
66, 77; fig. 5, 150), four of the Birth or Nurture of Bacchus (cf. cat. 83),[14] two of
the Nurture of Jupiter (cat. 31, fig. 87) and the *Saving of the Infant Pyrrhus*
(cat. 27). All of these are concerned with the imperilled early life of a future
leader: Moses being exposed on the Nile by his true parents and rescued and
raised in the house of Pharoah; Bacchus and Jupiter being taken from their
parents and raised by nymphs; and the young Pyrrhus, future king of Epirus,
being rescued by servants when his life is endangered, floated across a river, and
eventually raised at the court of King Glaucias. Nor are these events unique to
these individuals. As Otto Rank demonstrated in his classic study, *The Myth of
the Birth of the Hero*, hero-myths often take a similar form in widely differing
cultures[15] and may be summarised as follows. A prophecy announcing the birth

of a future hero warns that his life will be threatened at an early age. To protect him, his parents either hide him or expose him to the elements (e.g. Moses or Pyrrhus on the waters) from whence he is rescued and raised by a foster family who adopt him as their own and recognise his future greatness. Only after he has fulfilled his destiny in these surroundings does he return to his native land, where his valour and leadership are accorded belated recognition. In this form, the story becomes a type for the struggles and perils that may befall even the most exalted of beings – in short, an exemplar of the unpredictability of fate.

It is impossible to say whether Poussin was aware of the links between these religious and mythological tales, though given his fascination with other religions – and with the parallels between Christianity and mythology – it would be surprising if he were not. But what is uncanny is that Poussin's early life itself followed a course very similar to that of his favourite heroes and often conformed to the pattern of events that comprise the 'average' myth.

Poussin was the only child of his mother's second marriage, Marie Delaisement having already had a daughter, also named Marie, by her previous husband, Claude Lemoine. Though the young Nicolas was technically not an orphan, he may well have felt himself estranged from his half-sister, who was twelve years older and who married in 1604, when Poussin was only ten. Moreover, there is considerable evidence that he eventually became estranged from his entire family, visiting them only once after his move to Paris in 1612 and presumably losing touch with them altogether after his arrival in Rome, since his mother, at least, could neither read nor write.

Once in Paris, Poussin was 'raised' by a series of protectors: Alexandre Courtois, *valet de chambre* to Maria de' Medici, who introduced him to engravings after the great masters of the Renaissance;[16] an unnamed gentleman who commissioned him to decorate his château at Poitou; and (most important of all) the Italian poet Marino, who exerted a formative influence upon his artistic and intellectual development and eventually convinced the young artist to

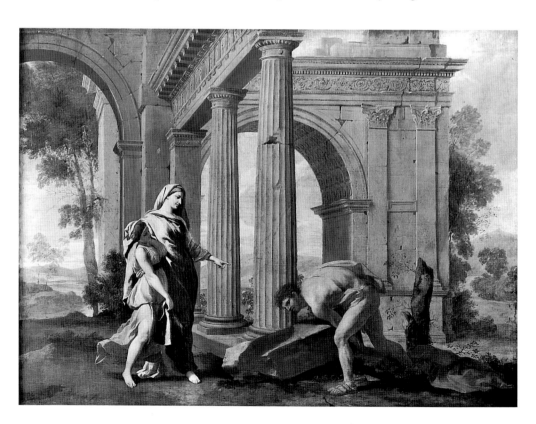

Fig. 6 Nicolas Poussin, *Theseus Finding his Father's Arms.* Oil on canvas, 98 × 134 cm, *c.* 1636–7. Musée Condé, Chantilly

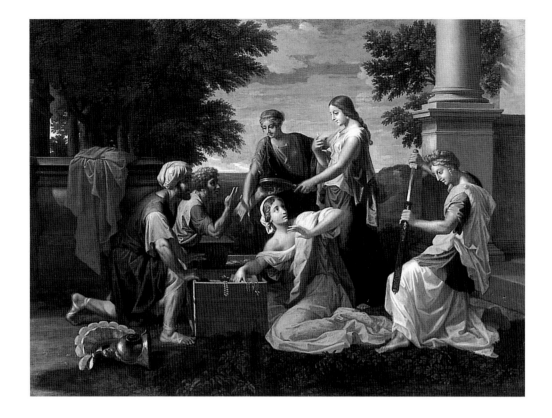

journey to Rome. Upon his arrival in the Eternal City, Poussin suffered much hardship and illness and sought refuge with the family of Jacques Dughet, who took him in around 1630 and nursed him back to health. This family included three children who were themselves much younger than Poussin; and, in different ways, the artist fostered all three of these members of his newly adopted family, marrying Dughet's daughter in 1630, instructing her brother Gaspard in the art of painting and eventually making the younger son Jean his personal secretary. In this respect, as Thuillier observed, the Dughet family 'became his true family'.[17] Further completing the coincidences between Poussin's life and the hero myths of antiquity is the fact that only after achieving genuine success as a painter in Rome was he called back to Paris by Louis XIII and accorded belated recognition in his native land.

Although the intriguing parallels noted here are best left to the Freudian psychologist, the student of Poussin cannot fail to notice that any number of the artist's other favourite themes involve the figures of foster children. Among these are Aeneas, Theseus, Achilles and the unnamed child of Queen Zenobia. Did Poussin – abandoning his family and uprooted from his homeland – feel himself even more tested by fortune to prove his worth in a foreign land? And might this have led, subconsciously at least, to a close identification with these foster heroes? All that we know for certain is that he regarded it as the greatest injustice to die outside one's native land[18] and seems to have harboured an anxiety about such displacement that may account for his predisposition towards such themes.

Scarcely less prominent in Poussin's oeuvre than the theme of the infancy of the future hero are the number of works devoted to the vocation of such figures. In classical mythology this theme typically takes the following form. The hero is hidden in the custody of his foster family when suddenly he is 'discovered' by someone aware of his true parentage, and his future destiny is revealed to him in the form of the weapons of warfare with which he will triumph over his adversaries. This is the theme of three separate subjects painted by Poussin,

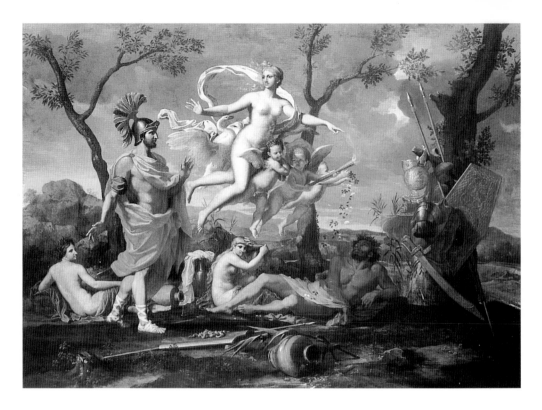

Theseus Finding his Father's Arms (fig.6),[19] *Venus Bringing Arms to Aeneas* (fig. 8)[20] and *Achilles among the Daughters of Lycomedes* (cat. 79, fig. 7), the last two of which the artist treated twice. In the first of these Theseus's mother, Aethra, reveals to him the sword and sandals that his father had hidden under a rock in order to test his strength. Equipped with these, Theseus sets out for Athens, slaying any number of foes along the way, and eventually succeeds in uniting the inhabitants of the city through his valour and leadership. In Venus and Aeneas, the orphaned Aeneas is conducted by his mother Venus to the weapons made for him by Vulcan, which depict his future glories and triumphs in founding the city of Rome. And in the Achilles story, the hero is disguised as a young maiden at the court of King Lycomedes but reveals his true identity when presented by Ulysses with a chest of jewels that also contains a sword and shield. Whereas the king's daughters are tempted by the jewels, the young Achilles seizes the weapons and, throwing off his disguise, proceeds to join the Greeks in the siege of Troy. Closely related to these themes is the biblical subject of *Moses Trampling on Pharoah's Crown*, which Poussin painted twice in the 1640s (cat. 56, fig. 129) and is likewise concerned with the moment when a predestined youth suddenly reveals his future greatness. All these subjects may be seen as examples of heroes who fulfil their destiny in spite of inauspicious beginnings. Moreover, they are all concerned with a single moment that alters the course of human history and provide a classic instance of the fickleness of fate.

With the exception of the two paintings of *Achilles among the Daughters of Lycomedes*, all Poussin's treatments of this theme date from the 1630s and '40s, a time when the artist's own success in his chosen vocation was at last assured. During these years Poussin also painted a series of allegorical compositions devoted to certain of the central issues of human existence, as though seeking to codify his own philosophy of life as he approached middle age.

One of these, the *Choice of Hercules* (cat. 33), again relates to the theme of the vocation of the hero discussed above and portrays the legendary Greek hero at the crossroads, choosing between Vice and Virtue. The former is personified by

a loosely clad woman wearing flowers in her hair, who points towards an idyllic stretch of land and the latter by a woman dressed in white, who points towards an arduous mountain range. Pondering his decision, the young Hercules turns away from the entreaties of Vice towards the challenges posed by Virtue. There can be no doubt as to what the outcome will be.

The other three allegories are *Time Rescuing Truth from Envy and Discord*, the *Dance to the Music of Time* (fig. 9) and the *Arcadian Shepherds* (cat. 38). According to Bellori, the first two of these were commissioned by Cardinal Giulio Rospigliosi, who also chose the themes.[21] At this stage of Poussin's career, however, it is hard to imagine him agreeing to paint any subject for which he did not feel a certain affinity, even for so distinguished a patron. The first of these pictures reminds us that truth will eventually triumph over all its adversaries and enjoy eternal life.[22] In the second, four figures symbolic of Pleasure (wearing roses), Labour (with a plain headdress), Wealth (pearls) and Poverty (a youth with a laurel wreath) dance to the music of Time, flanked by a Janus-headed statue and a putto with an hour-glass.[23] Above, Apollo drives his chariot across the sky surrounded by the signs of the zodiac and led by Aurora, sprinkling the rose petals of dawn. The message is as clear as it is eloquent: whatever one's station in life, we are all subject to the inexorable rule of time, symbolised by the cycles of night and day. Finally, in the *Arcadian Shepherds*, Poussin returns to a theme that he had already treated about ten years earlier in a more romantic vein (cat. 13). In both pictures, a group of shepherds and a shepherdess pause before a tomb bearing the inscription *Et in Arcadia ego* – 'Even in Arcadia [there] am I' – words 'spoken' either by Death itself or by the inhabitant of the tomb as a reminder of the omnipresence of death, even in the midst of ineffable happiness.

The triumph of virtue over vice, the enduring nature of truth, and the subjection of all human life to the passage of time – all these themes were central to Poussin's life and art and have their origins in the Stoic philosophers of

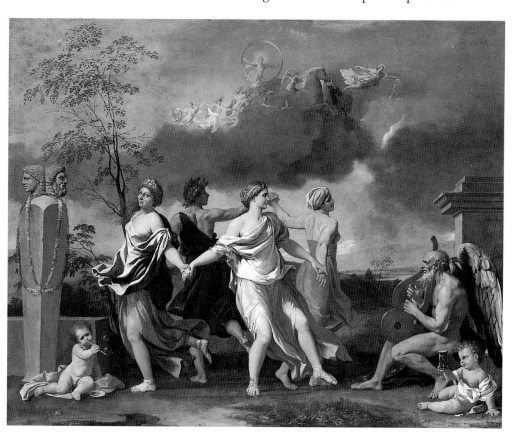

Fig. 9 Nicolas Poussin, *A Dance to the Music of Time.* Oil on canvas, 85 × 105 cm, *c.* 1639. The Wallace Collection, London

antiquity and of the 16th and 17th centuries, whose teachings were to inspire many of the artist's greatest paintings. Given the importance of these ideas for Poussin's own mode of living and his choice of pictorial themes, it would be well to consider briefly the basic tenets of Stoicism.

For the ancient Stoics the highest achievement of man was the attainment of virtue or wisdom which, in the words of Seneca, 'is the human mind's good brought to perfection'.[24] This can only be attained by freeing oneself from the world and from one's passions and feelings and living according to reason, which Cicero regarded as 'the supreme gift'.[25] To live in accordance with reason for the Stoic is to live in accordance with nature, which rules all things and itself reflects the divine will (or 'logos') of the creator. Therefore, he who attains such a state will live in harmony with nature and differ from God only in that he is mortal.

Virtue was divisible for the Stoics into four main parts: moderation, courage, prudence and justice. Moderation required the individual to lead a disciplined, modest and self-controlled existence; courage required him to be enduring, industrious and high-minded; prudence necessitated that he be contemplative, sensible and careful in all things; and justice that he be honest, pious and equitable. In pursuing these goals, the Stoics recognised that the individual must possess a strong desire for self-improvement and realise that virtue could only be attained by stages. 'This is enough for me', observed Seneca, 'to take away daily something from my faults and daily to reject my errors.'[26] The ultimate goal was the attainment of a state of moral rectitude that would grant man the ability to rise above the accidents and misfortunes of life. For although the Stoics acknowledged that nature was the source of all reason, they also accepted that goodness itself could not exist without its opposite, evil. Hence, human life would forever remain subject to nature's weal and woe.

In his maturity, Poussin followed many of the precepts of the Stoic philosophers and acknowledged that reason was the surest means of attaining virtue, of living in harmony with nature and even of correctly judging works of art.[27] 'We must not judge by our senses alone but by reason', he noted to Chantelou, when the latter expressed disappointment over a picture the artist had sent him.[28] Moreover, Poussin also regarded reason and virtue as one's greatest protection against 'the assaults of mad, blind fortune'.[29] In the end, however, the creator of the *Germanicus* conceded that even these might prove powerless against the randomness of fate.[30]

From what we know of Poussin's personal life it is clear that he also resorted to another means of protection against the inconstancy of fortune – namely, isolation and independence from those forces that might seize control of his destiny. Particularly after his unhappy years in Paris working for Louis XIII, Poussin adopted the contemplative life. According to Bellori, he followed an orderly daily routine, divided into periods for exercise, painting and conversation.[31] In his personal affairs, he avoided conflict or confrontation and remained a detached observer of events around him. Reacting to the widespread political upheavals of 1649 – the Masaniello revolt in Naples, the revolt of the Cossacks and the execution of Charles I – he confessed to Chantelou: 'It is a great pleasure to live in a century in which such great events take place, provided one can take shelter in some little corner and watch the play in comfort'.[32] That 'little corner' was Poussin's protection against the fickleness of the mob, so often the undoing of the rulers of his day, or of those in his paintings. In it, Poussin sought to order and control all aspects of his existence – life and art – as he admitted in one of his most revealing statements: 'My nature compels me to seek and love

things that are well ordered, fleeing confusion, which is as contrary and inimical to me as is day to the deepest night'.[33] And, for him – as for the Stoics – order was a manifestation of reason and reflected the order and harmony of nature itself.

* * *

Poussin also attached great value to other human qualities, among them humility, loyalty to one's friends and relations and the desire to improve oneself, the last of which led him to set himself even greater challenges as an artist. These themes also occupy an important place in Poussin's art, often in the form of subjects so obscure that they must surely be of his own devising and may even be regarded as a visual embodiment of his chosen moral code. Prominent among these are the themes of virtue and vice, which occupy a central place in Poussin's art throughout his career. A classic instance of the latter is the theme of greed, which forms the subject of no fewer than four canvases of Midas bathing in the River Pactolus (cat. 12; fig. 10, 50) to wash away the gift requested by him of Bacchus that all he touched should turn to gold. Though Poussin's predecessors and contemporaries treated other episodes from the legend of Midas, his are the first (and only?) works to deal with this exact theme – itself a paradigm of the vanity of earthly possessions and of the baseness of human nature; for, as Cicero observed, 'nothing is more the mark of a mean and petty spirit than to love riches'.[34]

Another unusual subject painted by Poussin is that of Phaeton and Apollo,[35] which treats the theme of human pride and depicts Phaeton begging to drive the chariot of Apollo, an ambition that results in his own death when he flies too close to the sun and is consumed by its flames. Idolatry forms the subject of two versions of the *Adoration of the Golden Calf* (fig. 69)[36] and the celebrated canvas of the *Plague at Ashdod* (fig. 26),[37] the latter being (as so often with Poussin) a

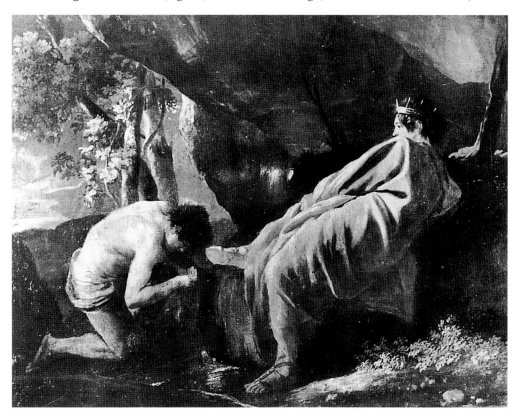

Fig. 10 Nicolas Poussin, *Midas at the Source of the Pactolus.* Oil on canvas, 51 × 67 cm, *c.* 1629–30. Musée Fesch, Ajaccio, Corsica

unique treatment of this theme. Greed and deceit are combined in another unprecedented canvas, the *Death of Sapphira* (fig. 161);[38] and deceit alone is the subject of the obscure theme of Camillus and the Schoolmaster of Falerii, which Poussin painted twice in the late 1630s (fig. 12).[39] The source is Plutarch's *Life of Camillus*, which tells the tale of a schoolmaster who offers his pupils to Camillus as conscripts when the latter is besieging Falerii. Camillus refuses them and orders the schoolmaster to be beaten, noting: 'A good general should rely on his own virtue and not on other men's vices'[40] – an idea that we can be sure earned Poussin's endorsement.

If the punishments of vice find a central place in the artist's oeuvre, so do the benefits of virtue, and often with reference to precisely those heroes whom the Stoics held in highest regard. Two of these were Cato the Younger and Scipio Africanus the Elder. The magnanimity of the latter is celebrated in a canvas of 1640 (cat. 45) showing him returning to her fiancé a beautiful young girl whom he had captured in his victory at New Carthage, a gesture that reveals both his generosity and his control over his own passions.[41] The suicide of Cato, who took his own life rather than live under the tyrant Caesar, has always been seen as an exemplar of virtue and self-sacrifice and forms the subject of a deeply moving drawing by Poussin (c. 1640; fig.11).[42] Not surprisingly, the virtue of both of these men led Seneca to recommend them as protectors and exemplars for the aspiring Stoic.[43]

Another Stoic hero, Diogenes, forms the subject of one of Poussin's greatest landscapes (cat. 70). This shows the famous Cynic philosopher, who had reduced all his worldly possessions to a cloak and a drinking bowl, abandoning the latter at the sight of a youth drinking from his hands alone. Once more, Poussin would appear to have been the first artist to treat this theme, and it is hard to imagine one closer to the heart of a man who prided himself on his own simple manner of living. This facet of Poussin's character is immortalised in a famous incident involving Cardinal Massimi. Poussin is once reputed to have shown the latter to the door of his house, carrying a candle to light the way. When the cardinal expressed pity that the artist had no servants to perform such tasks, Poussin retorted: 'And I pity your Eminence for having so many'.[44]

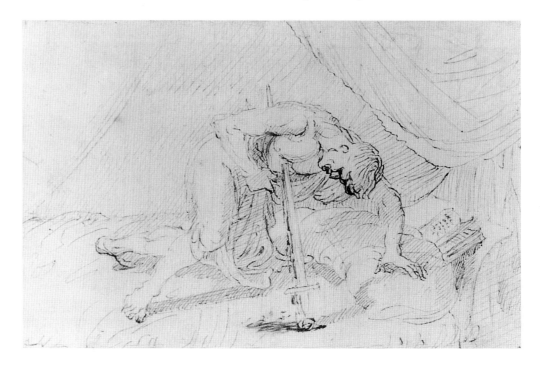

Fig. 11 Nicolas Poussin, *The Death of Cato.* Pen and brown ink, 9.6 × 14.9 cm. The Royal Collection

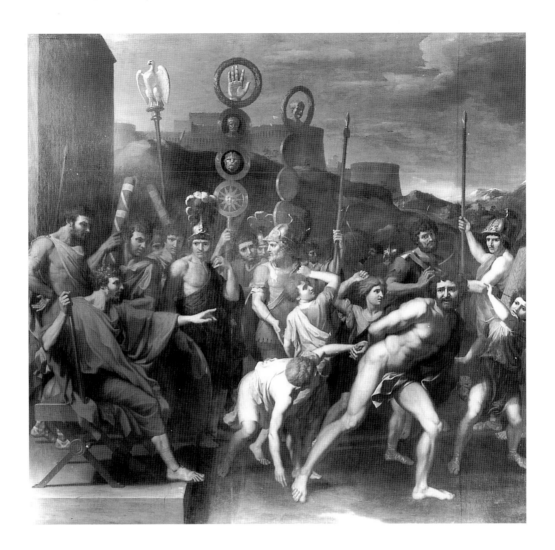

Fig. 12 Nicolas Poussin, *Camillus and the Schoolmaster of Falerii.* Oil on canvas, 252 × 268 cm, 1637. Musée du Louvre, Département des Peintures, Paris

In the late 1640s, Poussin also treated the theme of human charity using two Old Testament subjects, Eliezer and Rebecca (cat. 59) and Moses and the Daughters of Jethro (fig. 17).[45] In the former, one of three treatments of the subject by the artist (cf. cat. 5, 87), Rebecca provides water for Eliezer and his camels and, in so doing, is revealed to be the wife divinely selected for Isaac. The male counterpart to this tale is the story of Moses protecting the daughters of Jethro at the well from a group of intruding shepherds and, in return for his valour and kindness, gaining the hand of one of them in marriage. Thus, both are concerned with the blessings and benefits to be gained from performing acts of charity.

Finally, three of the most obscure subjects of Poussin's career appear in works of his middle years and exemplify the elevated moral tone that characterises his art of this period. One of these depicts the Roman general Coriolanus (fig. 13), who, despite his victory over the Volscians, was banished from his homeland through the inconstancy of the people and forced to take refuge with the enemy.[46] Appointed by them to lead an invasion against Rome, he is met at the outskirts of the city by his mother, wife and children, who implore him not to take up arms against his native land. Yielding to their entreaties, Coriolanus returns to the Volscian camp, where he is denounced as a traitor and executed. Though Poussin's choice of this subject in the years around 1650 may have been prompted by the outbreak of the Fronde in Paris, the theme of loyalty to one's fatherland and family recurs frequently in his art.

These virtues also form the respective themes of two wholly unprecedented

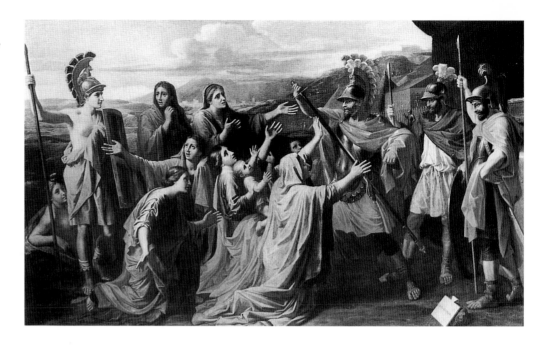

subjects to which Poussin turned at this time. The first is the moving tale of Queen Zenobia, wife of Rhadamistus, King of Armenia (fig. 14).[47] Escaping with her husband from Artaxta during an insurrection, she is suddenly seized with the pains of childbirth and begs her husband to kill her rather than allow her to fall into the hands of the enemy – an obvious parallel with the suicide of Cato. After stabbing her several times, the king abandons her in the river Araxes, where she is found by shepherds, rescued and revived. She is then transported back to her native city, where she is received by the enemy with kindness and accorded royal honours.

Self-abnegation also forms the underlying theme of a second work of these years. This is the *Testament of Eudamidas* (cat. 58), which depicts the poor but virtuous citizen of Corinth dictating his will on his deathbed, in which he entrusts the care of his mother and daughter to the custody of his two closest friends. When Eudamidas's will is read, it is greeted with merriment and derision by the people, who accuse him of wishing to spend his friends' money from the grave. But his friends themselves accept this honour and responsibility; and, when one of them dies five days later, the other continues to care for Eudamidas's mother and provides his daughter with a dowry for her wedding.

As a model of devotion to one's family and friends, and of modesty and humility in one's own mode of living, the story of Eudamidas epitomises the ideals of the Stoics – and of Poussin himself. Witness Cicero's declaration on friendship: 'Nothing else in the whole world is so completely in harmony with nature',[48] that is, with virtue and reason. And compare Eudamidas's loyalty to his friends and family with the following passage from a letter by Poussin, written a year before his death, when his health was seriously declining, to his own closest friend, Chantelou:

> Seeing myself in this condition, which cannot last long, I have wished to prepare for my departure. To this end I have made a small will by which I am leaving more than 10,000 crowns to my poor relations living in Andelys, who are simple, common people and who, coming into such a sum after my death, will have great need for help and succour from some honest and charitable person. I thus come to beg you to offer them a helping hand, to counsel them and to protect them so that they will not be cheated or robbed. They will come to you and humbly ask you this service.[49]

Here, as elsewhere in his art, Poussin practised what he painted.

The Christian counterpart in Poussin's oeuvre to these ancient and Old Testament themes of virtue and morality is the two series of Seven Sacraments, which trace the pathway through life to be followed by the devout Christian, from the initiation into the Church with the sacrament of Baptism to the anointing with oil of Extreme Unction. Unlike many of the works just discussed, however, Poussin's decision to paint this theme was probably not his own. Instead, it may have originated with the patron of the first series, Cassiano dal Pozzo, whose interest in the rites of the early Christian Church and in ancient religions generally is well-documented. Nevertheless, the manner in which Poussin treats these themes is clearly intended to be morally edifying and differs from the purely symbolic portrayal of them often encountered in earlier art. One has only to explore the subtle range of emotion and wide variety of narrative interest in the Chantelou *Confirmation* or *Baptism* (cat. 50–1) to realise that the artist is treating each theme as one of revelation, initiation and, ultimately, of human salvation. Moreover, in a letter to Chantelou of June 1648, written shortly after completing the second set of Sacraments, Poussin implies that he conceived it as a series of moral lessons intended to equip the believer with protection against the wayward workings of fortune.[50]

Poussin continues by noting that he would now like to treat the theme of the 'tricks of Fortune' in another series of pictures comparable to the Sacraments. These, he observes, might lead one to consider the wisdom and virtue that it is necessary to possess in order to stand firm against the blind folly of fortune. The artist then proceeds to divide humanity into three categories: those of extreme wisdom or stupidity, who remain impervious to fortune's blows – the one group above them and the other below – and those in the middle, who are constantly subject to its harshness. This idea originates with Virgil and is repeated in the writings of such neo-Stoic philosophers of Poussin's own time as Montaigne and

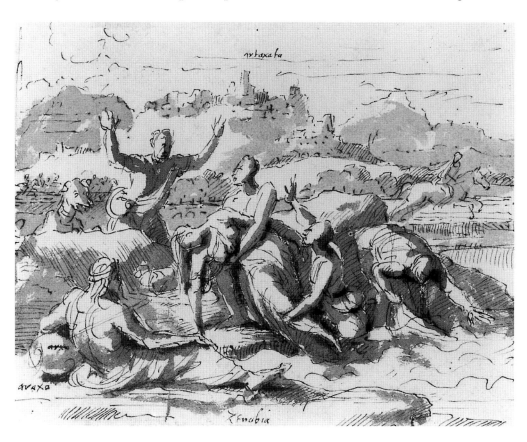

Fig. 14 Nicolas Poussin, *The Finding of Queen Zenobia*. Pen and brown ink and wash, 15.7 × 20 cm. The Royal Collection

33

Pierre Charron, whom Poussin paraphrases in his letter to Chantelou.[51]

Although Poussin never realised his ambition to paint a group of interrelated canvases devoted to this theme, the idea underlies many of the magnificent series of landscapes he embarked upon in 1648, the year the Chantelou Sacraments were completed. In these, human tragedies are set against a background of inanimate nature, which itself provides a pointed reminder of those unpredictable forces that shape men's lives.

Two of the greatest of these depict the death of Phocion (cat. 67–8), the noble Athenian leader and statesman who became a favourite hero of the Stoics, compared both to Socrates and Cato. References to Phocion also repeatedly occur in the writings of Montaigne and Charron; but, if the great Greek hero had frequently been celebrated in print before Poussin, he had never been celebrated in paint. Indeed, Poussin's two canvases of this subject are unique in the history of art, with even the artist's closest followers never treating this theme, probably because they regarded Poussin's solution as inimitable.

It is not difficult to see why Poussin was attracted to the story of Phocion, for the virtuous Athenian possessed many personal traits with which the artist himself would readily have identified. Among these were his emotional self-control, his modesty and frugality, and his brevity of speech, which led him 'to communicate the maximum of meaning within the smallest possible compass',[52] an ability he shared with the painter of the Louvre *Arcadian Shepherds* and the *Eudamidas*. Moreover, like Eudamidas and Poussin himself, Phocion also attached great importance to friendship, caring for the family of his close friend Chabrias after the latter's death, despite his vexation with the dead man's son.[53] Yet Phocion himself met with a cruel end. After a lifetime of serving his people, he was condemned to death by his enemies and forced to take hemlock. As a further injustice, he was denied burial in Athens and his corpse was cremated on the outskirts of Megara, a fate reminiscent of that of Coriolanus, and one with which the exiled Poussin also might readily have identified.

The closest parallels with Phocion's life may be found in that of Germanicus, the subject of Poussin's first painting on a Stoical theme (cat. 9); for both provide an example of a noble and righteous leader who met with an untimely end – a classic instance of virtue tested by fate. Both were men dedicated to public service, who chose to follow an active life, subject to the whims of the people, whose stupidity and inconstancy Poussin repeatedly reviles in his letters.[54] As such, they belonged to Charron's middle category of humanity rather than to the higher contemplative and philosophical type. And, as Charron remarked of the lives of Phocion, Socrates, Camillus and Scipio, among others:

> If a man shall call to mind the history of all antiquity, he shall find, that all they that have lived, and have carried themselves worthily and virtuously, have ended their course, either by exile, or prison, or some other violent death.[55]

It was precisely such injustices as these that would appear to have attracted Poussin to such subjects; for the fate of all these heroes epitomised the uncertain nature of human destiny. Nor can one fail to notice that the artist explores this broad theme in two opposing directions throughout his career. If the stories of the young Moses, Bacchus or Pyrrhus proceed from adversity to triumph, those of Germanicus, Coriolanus or Phocion progress from glory to misfortune. As Poussin often remarked, fortune repeatedly mixes the good with the bad in order to keep us on our guard, and a stoical acceptance of this fact is our surest protection against her. 'Whatever happens to me, I am resolved to accept the

Fig. 15 Nicolas Poussin, *Landscape with Two Nymphs and a Snake.* Oil on canvas, 118 × 179 cm, 1659. Musée Condé, Chantilly

good and bear the evil', observed the artist to Chantelou in 1643, 'miseries and disasters are things so common with men that I am surprised that men of sense should get angry with them, and that they do not laugh at them rather than sigh over them. We have nothing that is really our own; we hold everything as a loan.'[56] A paraphrase of a statement of Seneca,[57] this last sentence might serve as an epitaph for both Germanicus and Phocion.

Another painting of 1648, the *Landscape with a Man Killed by a Snake* (cat. 69) also concerns the wayward workings of fate and belongs to a group of pictures by the artist featuring serpents as agents of evil or death. In this, a youth who has approached the water's edge either to drink or to bathe is suddenly strangled by a serpent, striking fear and terror into the onlookers. An earlier landscape depicts a man being pursued by a serpent (fig. 152); and a late canvas shows two nymphs watching a serpent devour a large bird (fig. 15). Finally, the theme recurs in mythological and biblical works of these years. Eurydice's sudden death by snakebite forms the subject of two paintings of 1649-50 (cat. 71, fig. 154); and the biblical serpent appears in *Winter* (or the *Deluge*) from the Four Seasons (cat. 91). With the exception of the last work, all of these portray a tranquil and idyllic landscape in which (to quote Virgil) 'there's a . . . snake lurking in the grass'.[58] Like the tomb in Arcadia, the serpent serves as a reminder of the omnipresence of death, even in the midst of peaceable nature, and provides an archetypal instance of the unpredictability of fate. In addition, it may be seen as the natural counterpart to the mob in the stories of Germanicus and Phocion in that it represents a blind and malevolent force that can suddenly undo men's lives.

Nature's wrath takes a different form in the *Landscape with Pyramus and Thisbe* (cat. 75) and *Landscape with a Storm* (cat. 74), both of 1651. In the former, the tragic deaths of Pyramus and Thisbe are set in the midst of a violent storm, despite the fact that Ovid himself sets this scene on a moonlit night. In the latter, the devastating effects of a raging storm upon a group of anonymous travellers forms the subject of Poussin's picture. Though such meteorological disasters may seem far removed from the theme of human destiny, the Stoics repeatedly

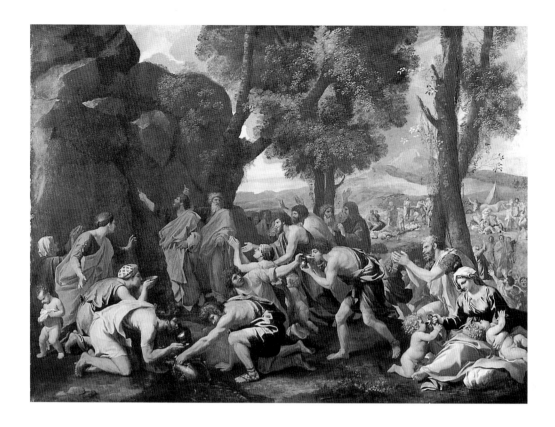

characterised the workings of fortune as bringing meteors and tempests into one's life and Poussin himself refers more than once in his letters to the terrible havoc that stormy weather can wreak upon both man and nature.[59]

The pictures just discussed serve to introduce us to the greatest of all Poussin's preoccupations where the natural world is concerned. This is the element of water. In more than four dozen of the artist's works – or nearly a quarter of his surviving *œuvre* – water plays a central role in themes as diverse as the Exposition or Finding of Moses, the Crossing of the Red Sea, Moses Striking the Rock (cf. fig. 16), the Return of the Holy Family from Egypt, the Baptism of Christ or of the People, the Birth of Bacchus, Midas bathing, and the landscapes with Diogenes, Pyramus and Thisbe and the Man killed by a Snake.[60] In many of these, it serves as a symbol of salvation and ritual purification, in accordance with the teachings of the early Christian Church. This applies not only to the themes of Baptism and Deluge, but to the many scenes focused around a well in Poussin's art: three paintings of Eliezer and Rebecca, two of Christ and the Woman of Samaria (fig. 35, 175) and another of Moses and the Daughters of Jethro (fig. 17). But in the majority of such works, a journey to or across the waters symbolises the initiation to a new and higher life – a natural boundary which marks a point of moral, spiritual or physical regeneration, as in the stories of Moses, Pyrrhus, Diogenes and Queen Zenobia. Sometimes, too, it can function as the transition to the after-life, as in the tales of Echo and Narcissus, Pan and Syrinx[61] or the man killed by a snake. Whatever its meanings in Poussin's art, the artist alone knew why he accorded it such an omnipresent role in his paintings. Two suggestions only may be offered here. Water is a universal symbol of the flowing course of life itself and therefore appropriate to an art pre-eminently concerned with the theme of human destiny. On a more subconscious level, however, one is naturally led to wonder if the illness that Poussin suffered around 1630 scarred him not only physically but psychologically as well, leading him to feel tainted and unclean.

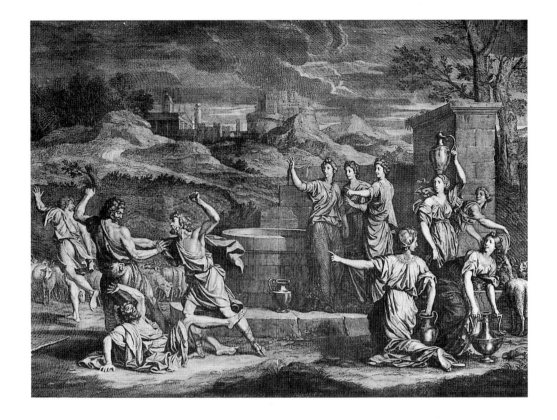

Poussin's venereal infection may also explain one of the chief human preoccupations of his art, especially in his later years. This is the theme of babies and especially of those who are either nurtured or imperilled – two conditions which, as we have seen, frequently come together in his art. The former provides the subject of any number of depictions of the infancy of Christ, Moses, Bacchus, Jupiter, and Pyrrhus; while the latter appears in the themes of the Massacre of the Innocents (fig. 24), the Judgement of Solomon (cat. 62) and Medea killing her children.[62] Moreover, in the years between 1648 and 1657, Poussin painted a dozen depictions of the Holy Family, a number of which show putti or young children attending the Christ child (cat. 61, 80, fig. 18). Though such scenes clearly conform to the type of the nurturing of the future hero discussed earlier, it should not be overlooked that Poussin's own marriage was childless and that, as Hibbard suggested,[63] such works may have their origins in the artist's 'frustrated fatherhood'. This may also explain the inordinate lengths to which he went to provide for his half-sister's grandchildren in his will, as also for the descendants of the Dughet family. In further support of this theory is the fact that childbirth itself becomes an important subject in Poussin's later years, in works such as the *Annunciation* (cat. 81), the *Birth of Bacchus* (cat. 83), the *Finding of Queen Zenobia* (fig. 14) and *Hagar and the Angel*.[64]

The other striking human concern of Poussin's final years is the relationship between the sexes; and in this alone may be seen his altered outlook upon life. In his youth, the artist often portrayed themes of unrequited love in which a mortal man appears subject to the powers of a goddess, princess or sorceress – a theme which, in a post-Freudian age, may be seen as an archetypal male fantasy. In old age, this relationship is reversed in a whole series of images in which a male figure of authority presides over a submissive member of the opposite sex. Included among these are the meeting between Ruth and Boaz (cat. 89), Esther and Ahasuerus,[65] Christ and the Adulterous Woman (cat. 76), Christ appearing to the Magdalene,[66] the Death of Sapphira (fig. 161), Coriolanus (fig. 13), the Finding of

Queen Zenobia and the Sacrifice of Virginia or Polyxena.[67] When taken together with the romantic mythologies, these works complement the early paintings and testify to the artist's comprehensive outlook upon the human condition, in much the same way as do his complementary treatments of the rise or fall of the hero. Beyond this, it is impossible to offer a precise explanation for this theme of his later years, except for the obvious one. If Poussin subscribed to the stereotyped notion that women are instinctual beings and men rational ones, then their relative position and importance at the beginning and end of his career may be seen to reflect his own changed vantage-point upon life and art, which itself evolved from passion to reason.

Fittingly, Poussin concluded his career immersed in the most all-embracing of themes: that of the parallels between the course of human life and the cycles of nature. To be sure, this had been a central concern of his art from his earliest years. It underlies many of the poetical mythologies with which he began his career, in which the theme of death and rebirth in nature is set against a landscape background suffused with a sense of transience. During the 1630s, it is treated allegorically in works such as the *Kingdom of Flora* (cat. 20) and the *Dance to the Music of Time* (fig. 9). In the two sets of Sacraments, however, the artist concerns himself largely with the progress of human life, though the glimpses of landscape that appear in certain of these works – virginal nature in the Chantelou *Baptism* (cat. 51) or cultivated terrain in the *Ordination* (cat. 53) from the same series – also serve as a counterpoint to the main theme. But it is only with the great series of landscapes begun in 1648 that Poussin begins to explore the ways in which nature may be employed to reflect the character or mood of a given literary theme: heroic in the Phocion pictures, lush and umbrageous in the *Diogenes*, or stormy and tragic in *Pyramus and Thisbe*.

Poussin's profoundest explorations of this theme are such very late works as the *Birth of Bacchus* (cat. 83), *Apollo and Daphne* (fig. 19) and, above all, the Four Seasons (cat. 88–91). In these, the cycles of human life are charted with

reference to the parallel phenomena in nature, from birth to death and from death to rebirth in another form. Thus, in both the *Birth of Bacchus* and *Apollo and Daphne*, the artist introduces figures alien to the myth into the picture, which convert it into an elaborate allegory of the cycles and balance of nature.[68] In the Four Seasons he portrays four different stages of human life against a setting of the cyclical progress of nature: innocence in *Spring*, maturity in *Summer*, fruitfulness in *Autumn* and death in *Winter*. The resulting canvases are rightly seen as among Poussin's most pantheistic creations. But it must not be overlooked that they are also among his most genuinely stoical ones; for at their heart rests a central tenet of Stoicism – namely, that man's life is itself a reflection of the order of nature. This idea may be found in the writings of Poussin's favourite ancient author, Ovid, who in *Metamorphoses* (Book XV, 199–213) recounts the parallels and similarities between the four seasons and the four stages of human life:

> . . . do you not see the year assuming four aspects, in imitation of our own lifetime? For in early spring it is tender and full of fresh life, just like a little child; at that time the herbage is young, swelling with life, but as yet without strength and solidity, and fills the farmers with joyful expectation. Then all things are in bloom and the fertile fields run riot with their bright-coloured flowers; but as yet there is no strength in the green foliage. After spring has passed, the year, grown more sturdy, passes into summer and becomes like a strong young man. For there is no hardier time than this, none more abounding in rich, warm life. Then autumn comes, with its first flush of youth gone, but ripe and mellow, midway in time between youth and age, with sprinkled grey showing on the temples. And then comes aged winter, with faltering step and shivering, its locks all gone or hoary.

Poussin's acceptance of this essential law of human existence is nowhere more evident than in the fact that he should have chosen to devote the last years of his life to an exploration of this theme in the two realms of imagery that had formed the wellsprings of his art, religion and mythology. Moreover, it is also apparent from what we may glean of his emotional life through his letters of these years.

Poussin was increasingly lonely towards the end of his life. In 1657, two of his closest friends died, the painter Jacques Stella and Cassiano dal Pozzo, the artist's greatest Italian patron and protector. These were followed three years later by the death of another of his most important patrons, Jean Pointel. Such losses must have come as a severe blow to the artist, who was now left only with his closest friend of all, Chantelou. The latter was in Paris, not in Rome, and had recently married. Yet Poussin's devotion to him and his wife is evident throughout the artist's correspondence and in the fact that he painted two major canvases for Madame Chantelou during these years. 'I am not fickle or changing in my affection once I have given it to a person', Poussin assured Chantelou in a letter of 1647;[69] and, in his last letters to this patron, he repeatedly expressed his gratitude for the close and enduring friendship they had enjoyed for more than 25 years.[70]

In October 1664, Poussin's wife died, leaving him old and ill, 'a foreigner and without friends' in Rome.[71] Shortly after this, he is recorded as living with two nieces and his younger brother-in-law, descendants of his adopted family in the city. According to one source, all that he did during the last months of his life was to enjoy an occasional glass of wine with his neighbour, Claude.[72]

Poussin was also obsessed with thoughts of death during these years and frequently refers in his letters to 'the end' or 'my end'. In 1657, the year of the *Birth of Bacchus*, he wrote poignantly to Chantelou: 'they say a swan always

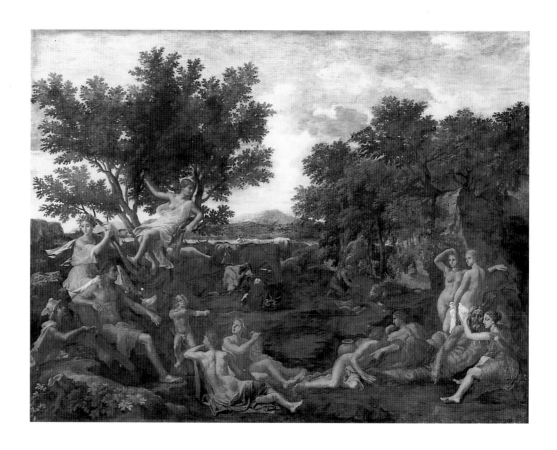

sings more sweetly when it is close to death'[73] – as though aware that he had
embarked upon the culminating phase of his career and that the creations which
were to follow would constitute his artistic testament. A year later he laments the
fact that man appears destined to do his best work as he approaches the end of
his life.[74] And, in the summer of 1660, he confessed to Chantelou: 'I pass no day
without sorrow, and the trembling of my limbs increases with the years'.[75]
Suffering from paralysis, stomach complaints, colds and weariness during these
years, the artist sensed that his end was near.

During the next four years, he completed the valedictory canvases of the Four
Seasons and began the *Apollo and Daphne*, which he was forced to leave
unfinished because of his poor state of health. In January 1665, he confessed to
Félibien that he had abandoned his brushes forever and now thought only of
death.[76] Such circumspection and self-control in superintending the course of his
own life are wholly characteristic of Poussin and may be contrasted with the
more impulsive behaviour of Rembrandt, who continued to wield his brushes
to the very end. Two months later, Poussin took up his pen to write his
observations on painting. This he defined as 'an imitation in lines and colours on
any surface of all that is to be found under the sun'.[77] Encompassing both human
and natural life with this definition, Poussin's own life's work was done. As he
admitted in one of his last letters, death was now the only remedy for the ills that
afflicted him.[78]

Poussin had obviously expected his wife to outlive him and to administer his
estate. When she died one year before him, however, he hastily drew up the will
cited earlier, and – like Eudamidas before him – entrusted the care of his relations
in France to his friend Chantelou. No sooner had he done this than he was
visited in Rome by a great-nephew, attempting to lay claim to his estate. This
affair ended acrimoniously when Poussin banished the 'miserable rustic' and, in
his final will, named his brother instead as the principal beneficiary.[79] However,

the latter died in 1672 and, one year later, the same fate befell his only son.[80] As a result, Poussin's legacy reverted to the descendant who had visited him in Rome. He in turn died prematurely in December 1673, leaving as his sole beneficiary a three-year-old son, also named Nicolas. An unexpected twist of events, perhaps, but one which would not have surprised the painter of the early lives of Moses or Bacchus, whose fate had ultimately come to rest, too, with a helpless infant . . .

1. Bellori, 1672, p. 438.

2. Blunt, no. 184; Mérot, no. 163 A and B. Further to this picture, see Dulwich 1986–7 and the literature cited there.

3. For Sacchi's principal work on this theme – the *Divina Sapienza* fresco of 1629–31 in the Palazzo Barberini – see Ann Sutherland Harris, *Andrea Sacchi*, Oxford, 1977, pp. 5–13, 57–9, no. 17.

4. Wildenstein, 1957, pp. 226–8, nos. 171–2.

5. Further to this theme in Poussin's art, see Paris 1989 and the bibliography cited there.

6. Cf. *Correspondance*, pp. 98–9, 106, 129, 134–5.

7. *Ibid.*, p. 2.

8. Cf. Elizabeth Cropper, *Pietro Testa 1612–1650, Prints and Drawings*, Aldershot, 1988, pp. 151–5, no. 73, and pp. 224–6, no. 102.

9. *Correspondance*, pp. 16 and 54.

10. Poussin's single-minded concern with these themes in his early mythological paintings may be contrasted with the more diverse range of subjects from Ovid treated in his early drawings for Marino, which were almost certainly chosen by the poet himself and reveal no comparable bias. (Cf. CR III, pp. 9–13, nos. 154–64)

11. Bellori, 1672, p. 413.

12. *Correspondance*, pp. 278, 299, 366, and 384.

13. *Ibid.*, p. 194.

14. Blunt, nos. 133–4 and Mérot, nos. 123–5, for Poussin's paintings of the *Nurture of Bacchus*.

15. Otto Rank, *The Myth of the Birth of the Hero*, New York. 1914.

16. On the importance of Courtois for Poussin, see Passeri, 1772, p. 345.

17. Thuillier, 1988, p. 136.

18. *Correspondance*, pp. 309 and 459.

19. Blunt, no. 182; Mérot, no. 190.

20. Blunt, nos. 190–1; Mérot, nos. 164–5.

21. Bellori, 1672, pp. 447–8.

22. Blunt, no. 123; Mérot, no. 201. Cf. Blunt, no. 122 and Mérot, no. 202 for a ceiling painting of the same theme by Poussin, executed for Cardinal Richelieu in 1641.

23. Blunt, no. 121; Mérot, no. 200. Cf. Blunt, 1976, pp. 844–8.

24. Seneca, *Epistulae Morales*, LXXXIX, 4–5.

25. Cicero, *De Natura Deorum,* II, 133.

26. Seneca, *De Vita Beata*, XVII, 3–4.

27. *Correspondance*, pp. 145 and 260.

28. *Ibid*, p. 372.

29. *Ibid*, p. 384.

30. *Ibid.*, p. 348.

31. Bellori, 1672, pp. 435–6.

32. *Correspondance*, p. 395.

33. *Ibid.*, pp. 134–5.

34. Cicero, *De Officiis*, I, 68.

35. Blunt, no. 172; Mérot, no. 120. The subject is from Ovid, *Metamorphoses*, II, 1–330.

36. Blunt, nos. 26–7; Mérot, nos. 21 and 23. The subject is taken from Exodus, XXXII, 1–35.

37. Blunt, no. 32; Mérot, no. 28. The subject is from I Samuel V, 1–6.

38. Blunt, no. 85; Mérot, no. 97. The subject is from Acts V, 1–10.

39. Blunt, nos. 142–3; Mérot, nos. 180–1.

40. Plutarch, *Life of Camillus*, X, 1–4.

41. Blunt, no. 181; Mérot, no. 189. The story is told by Livy, *Annals*, XXVI, 50.

42. CR II, p. 13, no. 124. The theme is from Plutarch, *Life of Cato the Younger*, LVIII–LXX.

43. Seneca, *Epistulae Morales*, XI, 8–10; XXV, 5–6.

44. Félibien (ed. 1725), IV, pp. 76–7.

45. For Poussin's lost painting of *Moses and the Daughters of Jethro*, see Blunt, no. 17, Mérot, no. 14 and CR I, pp. 8–9, nos. 10–12 and A 3. The subject is recounted in Exodus II, 16–21.

46. Blunt, no. 147: Mérot, no. 182. The theme is from Plutarch, *Life of Coriolanus*, XXXIV–XXXVI.

47. The story is told in Tacitus, *Annals*, XII, 51. For drawings of this subject by (or connected with) Poussin, see CR II, pp. 15–17, nos. 131–3 and A 34–6; CR V, pp. 96–7, no. 422. They may be dated from the late 1630s to the early 1650s. Cf. Blunt, no. L 28 and Mérot, no. 191, for an unfinished painting of this theme in the Hermitage which is attributed to Poussin and datable to the late 1630s (see also Paris, 1994–5, no. 79).

48. Cicero, *Laelius: On Friendship*, IV, 16.

49. *Correspondance*, p. 459.

50. *Ibid.*, pp. 383–4.

51. On the sources and applications of this idea in Poussin's art, see Verdi 1982 and McTighe 1989.

52. Plutarch, *Life of Phocion*, V.

53. *Ibid.*, VII.

54. *Correspondance*, pp. 398–9, 405–6.

55. Peter Charron, *Of Wisdome. . . .*, trns. S. Lennard, London, 1670, p. 495.

56. *Correspondance*, p. 197.

57. Seneca, *De Consolatione ad Helviam*, V, 1–5.

58. Virgil, *Eclogues,* III, 92–3.

59. *Correspondance*, pp. 120, 263.

60. Blunt, nos. 22–3; Mérot, nos. 19–20 (for Poussin's two paintings of *Moses Striking the Rock*). Blunt, no. 68; Mérot, nos. 66–7 (for the *Return of the Holy Family from Egypt*).

61. The subject of a painting of *c.* 1637 at Dresden (cf. Blunt, no. 171 and Mérot, no. 155). The story is recounted in Ovid, *Metamorphoses* (I, 689–713).

62. Cf. CR III, pp. 39–40, nos. 223 and A 64, for two drawings by or after Poussin of this subject, which is recounted by many ancient writers, among them Euripides, *Medea*, 1237–78.

63. Hibbard, 1974, p. 42.

64. The theme of Hagar and the Angel forms the subject of a very late landscape by Poussin of *c.* 1664, for which see Mérot, no. 210. The story is told in Genesis XXI, 9–21.

65. Blunt, no. 36 and Mérot, no. 32, for a canvas of this theme of *c.* 1655 in the Hermitage. The textual source is Esther V, 1–5.

66. The subject of a painting of 1653 which Félibien (ed. 1725, IV, p. 63) notes was painted for Pointel. It is now in the Prado (cf. Mérot, no. 84). The biblical source is John XX, 14–18.

67. Cf. CR II, p. 5, no. 107; pp. 11–12, no. 122, for two drawings by Poussin of these themes, which date from the 1640s.

68. For the complex iconography of the *Apollo and Daphne*, see especially Blunt, 1967, text vol., pp. 336–53.

69. *Correspondance*, p. 372.

70. *Ibid.*, pp. 455–6, 459–60.

71. *Ibid.*, p. 459.

72. Abraham Breughel, 1665, in *Actes*, 1960, II, p. 122.

73. *Correspondance*, p. 445.

74. *Ibid.*, p. 447.

75. *Ibid.*, p. 450.

76. *Ibid.*, p. 460.

77. *Ibid.*, p. 462.

78. *Ibid.*, pp. 460–1.

79. *Ibid.*, pp. 465–78.

80. For the genealogy of Poussin's relations in France and Italy, see Thuillier, 1988, pp. 285–6.

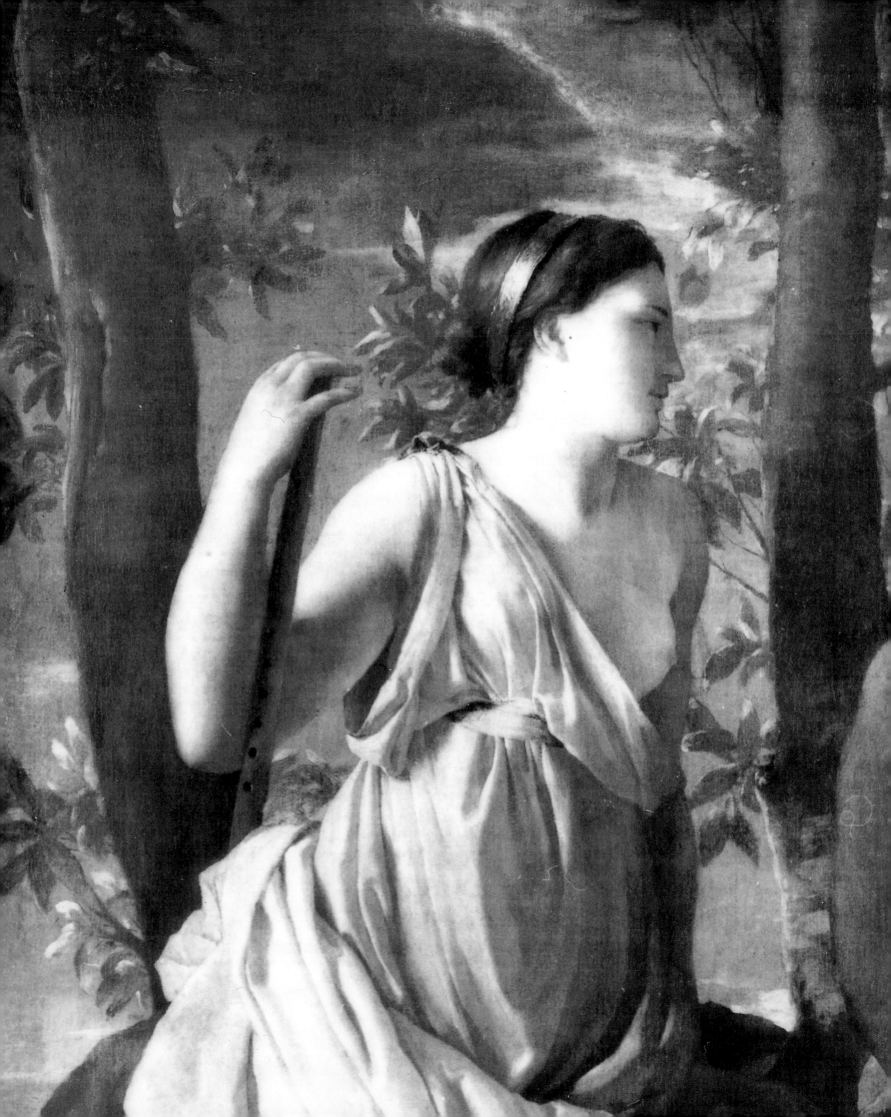

Poussin at the Louvre[1]

Pierre Rosenberg

That the Louvre has the world's greatest collection of paintings by Poussin has never been disputed. This statement does not, however, imply that there has been any real attempt to study, with any degree of objectivity, the delicate relationship between the French – collectors and art lovers, artists and art historians – and their greatest painter.

The majority of the paintings by Poussin now in the Louvre – 30 out of the total of 38 – belonged to Louis XIV. He acquired them between 1665, when he was less than 30 years old (and had only reigned for four years), and 1693. The King was eager to obtain the most important works by the artist available, whether in France or in Italy. Thanks to various more or less recent publications[2] and the research of Antoine Schnapper,[3] we now possess detailed information about the various royal acquisitions, including the names of the vendors (or donors), the price paid for each picture, as well as the reason the King wished to assemble such an exceptional collection of Poussin's work.

The majority of the paintings were acquired through the normal channels, via painter-dealers, although some were presented to the King. *St John Baptising the People* (cat. 32), *The Finding of Moses* of 1638 (cat. 35)[4] and *Christ and the Woman taken in Adultery* (cat. 76) were given to the King in 1693 by the famous gardener André Le Nôtre. Louis XIV's greatest coup, however, was the acquisition of 25 paintings from the collection of the Duc de Richelieu, 13 of which were by Poussin.

The Duke, nephew of the great statesman Cardinal Richelieu, was born in 1629, nine years before the King (they both died in 1715). He seems to have been even more infatuated by Poussin than his famous uncle. The Cardinal, wishing to add to his collection of celebrated paintings by Andrea Mantegna, Lorenzo Costa and Pietro Perugino from the *Studiolo* of Isabella d'Este (they belonged to Charles I of England before entering the Cardinal's collection), had acquired Poussin's *Bacchanals* in Rome; they are now divided between the Kansas City Museum and the National Gallery in London (see cat. 28, 29). In my opinion the *Triumph of Silenus* in the National Gallery, though in a ravaged condition, should also be attributed to Poussin.

The Duke had obtained Poussin's *Seasons* (cat. 88–91) directly from the artist, although nothing is known about the part he played in their commission. How did he come into contact with Poussin? What exactly did he want from the elderly artist? Who suggested to Poussin that he should paint such apparently banal subjects, which the artist treated in a completely novel manner? How much was paid for the *Seasons*? None of these questions can be answered. When the four paintings were unpacked from their crates in Paris in the autumn of 1664 they caused a sensation, and were the object of heated debate among the artists summoned to admire them. The Duke had little time to enjoy his paintings: a year later he lost them playing real tennis against the King. Nothing is known of the King's tennis-playing habits, but it seems clear that Louis XIV coveted the Duke's collection of paintings, and that the game of tennis was simply an elegant

Detail from *The Inspiration of the Epic Poet*,
cat. 18

means, in tune with the spirit of the age, of obtaining what he wanted. In compensation, on 26 December 1665 he paid the Duke 50,000 *livres*, a considerable sum at the time and one that approximated to the value of the twenty-five works. The date of the game of tennis – a game to which the curators of the Louvre owe an eternal debt of gratitude – is not known, but it cannot have been long before Poussin's death, on 19 November 1665. A few weeks earlier, on 13 October, during his stay in Paris, Gianlorenzo Bernini was taken to see the paintings in the Duc de Richelieu's collection. Chantelou, who was acting as his guide to the monuments and the great collections of Paris, made a daily note of the remarks made by the celebrated architect and sculptor. A certain severity might have been expected from Bernini, so divergent were his aesthetic ideals from those of Poussin. But this was not the case: Bernini's admiration for Poussin and the pride with which he recollected helping him during his difficult early years in Rome, in particular by engineering the commission to paint the *Martyrdom of St Erasmus* (cat. 10) for St Peter's, Rome, prove that he was fully aware of the painter's genius. As in the case of Picasso and Matisse, Bernini was not unaware that Poussin was his only true rival. So it is disappointing to find, at the point when the paths of these two geniuses crossed, that Bernini paid little attention to the *Seasons*.

Few paintings by Poussin were added to the Royal Collection in the Louvre after 1693. *Time saving Truth from Envy and Discord,* painted during Poussin's unhappy stay in Paris in 1640–2 for the Palais-Cardinal (now the Palais-Royal), was left by Richelieu on his death to Louis XIII. In 1763, when the Jesuit order was suppressed, the Louvre acquired *The Miracle of St Francis Xavier,* painted for the church of the Jesuit novitiate (now destroyed) in Paris.[5] And during the Revolution a fragment then belonging to the Duc de Penthièvre of the *Venus and Mercury* now in Dulwich, and the second version of *Camillus and the Schoolmaster of Falerii* from the Galerie La Vrillière, as well as the *Coriolanus* confiscated from Simon Charles Boutin and deposited at Les Andelys, Poussin's home town, entered the national collections.[6] As if by a miracle, a major painting arrived during this period: this was the *Self-Portrait* (1649–50; cat. 64) painted by Poussin for Chantelou; it had remained with the latter's descendants for many years. In 1797 a picture dealer named Lerouge exchanged it for a *Noli me Tangere* by Adriaen van der Werff which, like many of the best Dutch paintings in the Louvre, had been acquired by Louis XVI. Two further felicitous additions were still to be made: in 1869 the wonderful *Apollo and Daphne* was bought; it had been offered in its unfinished state to the future Cardinal Massimi by Poussin just before he died. From Massimi's heirs the painting entered the collection of the painter Guillaume Guillon-Lethière (1760–1832), director of the French Academy in Rome. Another miracle occurred in 1911 when the Louvre was able to buy, in England, the *Inspiration of the Poet* that had once belonged to Cardinal Mazarin.

All in all, however, these successful acquisitions cannot make up for the 'failures', over which I hope I may be forgiven for skating lightly. The Louvre's version of the *Landscape with the Body of Phocion Carried out of Athens,* acquired in 1921, is only a copy of the painting in Cardiff (cat. 67). The *Triumph of Pan* from the Paul Jamot collection is no match for the version in London, which is certainly the original (cat. 29). *Marsyas and Olympus,* acquired in 1968, was returned to its owners, who quickly got rid of it (it is now in Switzerland). Finally, the *Holy Family on the Steps* (cat. 60) will only be in the Louvre for a few more years before it takes up permanent residence in the galleries of the Cleveland Museum.

Missed opportunities abound. The paintings by Poussin in the Louvre were 'incomparable', people liked to repeat smugly each time an opportunity to buy another of his works presented itself, and there were plenty. Think of *Orion*, bought by the Metropolitan Museum, New York (cat. 84), or *Pyramus and Thisbe*, now in Frankfurt (cat. 75), not to mention the great gaps in the national collections. The record of the *musées territoriaux* (the new name for provincial museums) is even less satisfactory, although two disputed and badly damaged paintings should be mentioned: *The Massacre of the Innocents* in the Petit Palais and *Mercury, Herse and Aglaurus* in the Ecole des Beaux-Arts. In addition there is the *Coriolanus* in Les Andelys (fig. 13) and the worn *Venus with the Dead Adonis* in Caen (cat. 4), which comes from the collection of Louis XIV. The paintings in Ajaccio (*Midas;* fig. 10), Cherbourg (*Pietà*; its pendant, a *Virgin and Child*, identified by Christopher Wright, belongs to the Brighton Museum), and Montpellier (*Venus and Adonis* and *Landscape with a Sleeping Nymph and Satyr*) were all gifts from the great collectors of the age of Napoleon (Cardinal Fesch, Napoleon's uncle; the painter François-Xavier Fabre, the lover of the Countess of Albany) or the beginning of the 19th century (Thomas Henry).

There are, however, two pleasant exceptions. First, the museum at Rouen was astute enough to acquire *Venus Bringing Arms to Aeneas* (fig. 8) in 1866, and a century later, in 1975, *Landscape with a Storm* (cat. 74), sadly in only mediocre condition, pendant to the wonderful *Landscape with a Calm* in Sudeley Castle (cat. 73). The second is the Musée Condé in Chantilly. The Duc d'Aumale (1822–97), who spent 22 years in exile in England, managed to return to France with various admirable paintings by Poussin, including the *Youth of Bacchus* and *The Massacre of the Innocents* (fig. 24), once the property of Lucien Bonaparte. By subsequently acquiring the collection of Frédéric Reiset (1815–91), the Duc d'Aumale was able to establish at Chantilly the second most important collection of drawings by Poussin in France. Apart from the holdings of the Louvre, of the Ecole des Beaux-Arts, of Chantilly and Bayonne, the museums of France have few drawings by Poussin.[7] There are sheets in Bergues and Besançon, Orléans, Rouen, Lille, Lyon and Montpellier; but few of them were bought – most having arrived in museums by chance – and for years they remained unpublished and wrongly attributed.

All this leaves a bitter taste. Does it mean that French collectors did not like Poussin? To assume so would be to insult the memory of such men as Chantelou, Pointel, Stella, Passart, Serisier and the many admirers in Lyon or Paris whose names are listed by Félibien, all of whom competed furiously to own paintings by Poussin while he was still alive. The recently published posthumous inventories confirm that they had a real passion for the artist's work.[8] It was in the 18th century, particularly in the second half, that many of the paintings that had arrived in France from Italy during the preceding century left for England and Russia. Acting on Diderot's advice,[9] Catherine the Great, Empress of Russia, was able to acquire several major paintings by Poussin, including the *Landscape with Hercules and Cacus*, now in Moscow (cat. 86), and the *Landscape with Polyphemus* in the Hermitage (fig. 173). Above all, it was the loss during the Revolution of the Orléans collection, which included Poussin's second set of Sacraments painted for Chantelou among other paintings by the master, which irreparably impoverished the French patrimony. Poussin's first set of Sacraments, painted for Cassiano dal Pozzo, had never come to France. They remained in Rome in the possession of their patron's descendants and were on the market, as everybody knew. It was also common knowledge that the Pope would try to stop

their export. But times had changed, and Louis XV declined to buy them for reasons of economy, arguing that the acquisition was not essential because Chantelou's set was then still in France in the Orléans collection. Both sets were imported to England within the space of a few years, and are today unquestionably among the greatest treasures to be found in British collections.

Collectors in 19th-century France do not seem to have paid much attention to Poussin. The fashion was for the great Flemish masters, Dutch *petits maîtres*, 18th-century French artists, English painters and Italian primitives (and also, of course, for contemporary art). Poussin was omitted from the great collections then being assembled, as he has been during the present century. Poussin, it was endlessly reiterated, in a pejorative sense, was 'a painter for museums'. It was museums, chiefly those in the United States, that bought most of the works by Poussin that came on the market.

Unlike the collectors, French artists have, almost without exception, perpetrated a veritable cult for Poussin. This is not the place to investigate the reasons for this unconditional admiration (which is not confined to France). The enthusiasm of the two great rivals of the 19th century, Ingres and Delacroix, stands as a perfect example: in singing the praises of Poussin, they were, for once, in absolute agreement, although for very different reasons. Each generation of artists, each artistic revolution, with the exception of the Impressionists (and obviously setting Degas, Seurat and Cézanne apart), seems to have considered Poussin to be the model which justified and sustained their efforts. Times have not changed: nowadays, once again, artists young and old troop through the Poussin galleries in the Louvre.

French writers have seldom been able to resist responding to the celebrated challenge: 'Poetry is painting in words, painting is silent poetry'. Lists of prize-winners are invariably absurd, as incomplete as they are arbitrary. For the enjoyment of English readers, I will restrict myself to quoting the few lines devoted by Chateaubriand to Poussin's *Deluge* (*Winter*) in the Louvre (cat. 91): 'This painting reminds us of the abandonment of age, the hand of an old man: oh, the admirable trembling of time. Geniuses have frequently anticipated their end with great masterpieces: it marks the departure of the soul'.[10]

It would be wrong to conclude without mentioning the position occupied by French art historians in the annals of Poussin research. Although German academics (Otto Grautoff, Walter Friedlaender), and later English scholars, the latter with exemplary thoroughness (it is impossible not to mention Anthony Blunt), seem to have established themselves as the Poussin specialists (to the extent that it was said of this French painter established in Rome that he had been 'naturalised English'), it would be sad to neglect the works of Emile Magne, Charles Jouanny, Paul Jamot, Louis Hourticq, Paul Alfassa, Charles Sterling and Pierre du Colombier, to name but a few of the specialists who have died more or less recently. Each has brought a building block, often a well-hewn block, to the edifice of research. The international nature of the research has often meant that French scholarship, preoccupied with national concerns, has not been taken into account. Fortunately, since the Poussin exhibition held at the Louvre in 1960, this is no longer the case. Happily, it will be endorsed in this glorious *année Poussin*.

1. The title of this short contribution has been exercising my mind for a long time. 'Poussin, French painter' was, of course, rejected out of hand because it would still shock so many of our British friends (for whom 'Picasso, Spanish painter' would seem entirely natural). In the end 'Poussin at the Louvre' was chosen in preference to 'Poussin and the Louvre', in spite of the fact that the question of the decoration of the Grande Galerie of the Louvre, entrusted to Poussin in 1640 during his stay in Paris, is not discussed.

2. Most recently, Arnauld Brejon de Lavergnée, *L'inventaire Le Brun de 1683. La collection de tableaux de Louis XIV*, Paris, 1987.

3. Antoine Schnapper, 'The King of France as Collector in the Seventeenth Century', *Journal of Interdisciplinary History*, XXVII, 1986, pp. 185–202 and note 47.

4. Known as the *Little Moses* to distinguish it from the other painting of the same subject, also now in the Louvre, painted less than ten years later for Pointel, who, with Chantelou, was the artist's principal French patron.

5. Poussin painted this in competition with larger canvases by Stella (now at Les Andelys) and Vouet (lost during the last war).

6. The *Institution of the Eucharist* adorning the chapel of the royal Château de Saint-Germain-en-Laye also reached the Louvre, while the *Death of the Virgin*, painted for Nôtre-Dame before Poussin's departure for Italy in 1624, was sent to Belgium. The whereabouts of this painting are no longer known. In my opinion it must be hidden in a religious house in Belgium. If it were to be discovered, it might solve one of the questions most often asked by Poussin specialists: what was the extent of Poussin's education, what quality and type of training had he received (in other words, what did he know) before he settled permanently in Rome? It must be remembered that by that time he was already 30 years old.

7. One can consult the new catalogue raisonné of Poussin's drawings: Pierre Rosenberg and Louis-Antoine Prat, *Nicolas Poussin 1594–1665. Catalogue raisonné des dessins*, Milan, 1994, 2 vol. Pierre Rosenberg and Louis-Antoine Prat, catalogue of the exhibition held at the Musée Condé, Chantilly, 1994–5, *Nicolas Poussin. La collection du musée Condé à Chantilly*. Pierre Rosenberg and Louis-Antoine Prat, catalogue of the exhibition held at the Musée Bonnat, Bayonne, 1994–5, *Nicolas Poussin. La collection du musée Bonnat à Bayonne*.

8. At the time of writing the second volume of Antoine Schnapper's *Curieux du Grand Siècle*, devoted to the collectors of paintings, has not yet appeared.

9. *Nicolas Poussin 1594–1665*, catalogue of the exhibition held at the Grand Palais, Paris, 1994–5.

10. 'Ce tableau rappelle quelque chose de l'âge délaissé et de la main du vieillard: admirable tremblement du temps! Souvent les hommes de génie ont annoncé leur fin par des chefs-d'œuvre: c'est leur âme qui s'envole'. René de Chateaubriand, *Vie de Rancé*, ed. 1991, p. 104.

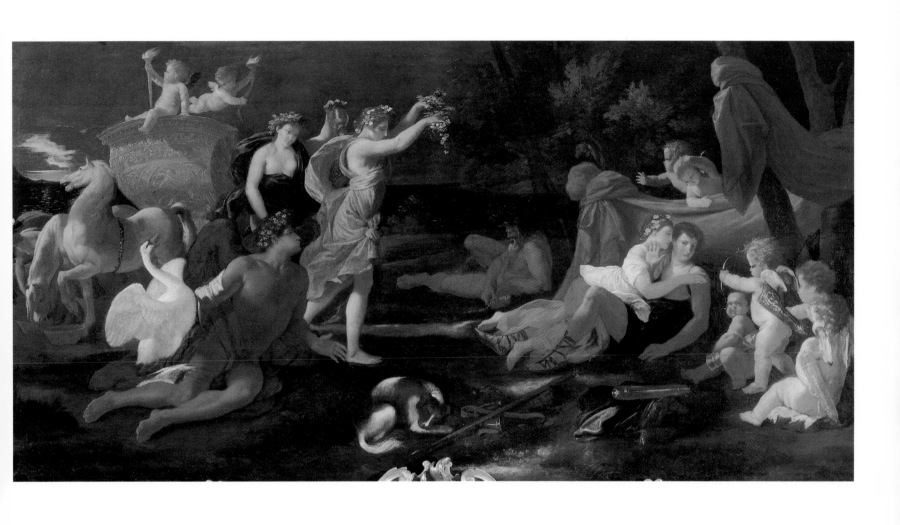

1 *Cephalus and Aurora*, c. 1624-5
Private Collection

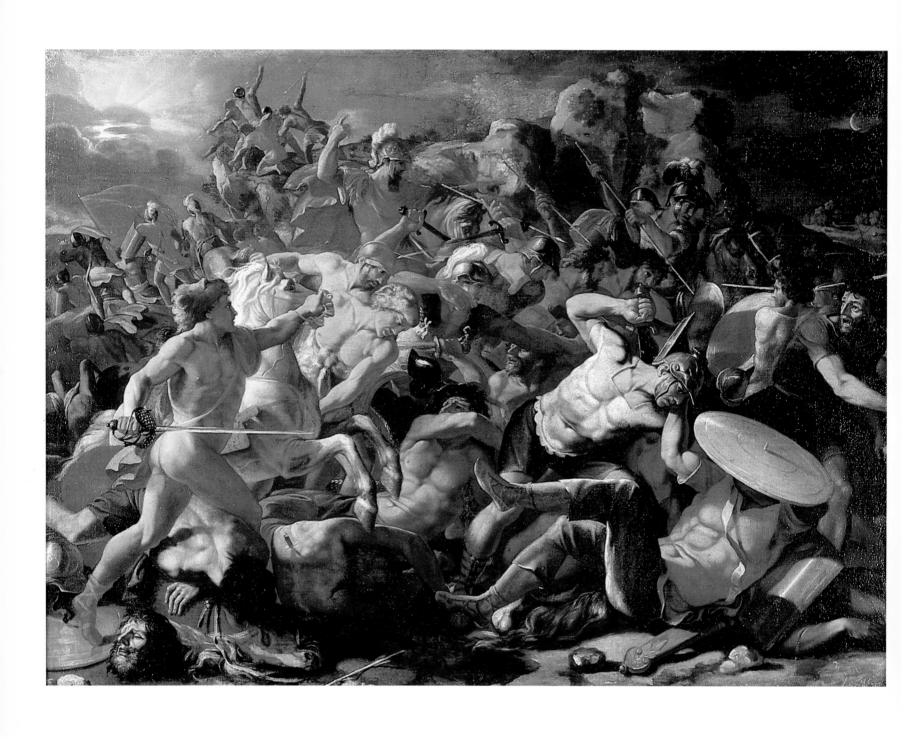

3 *The Victory of Joshua over the Amorites*, 1625-6
The Pushkin Museum of Fine Arts, Moscow

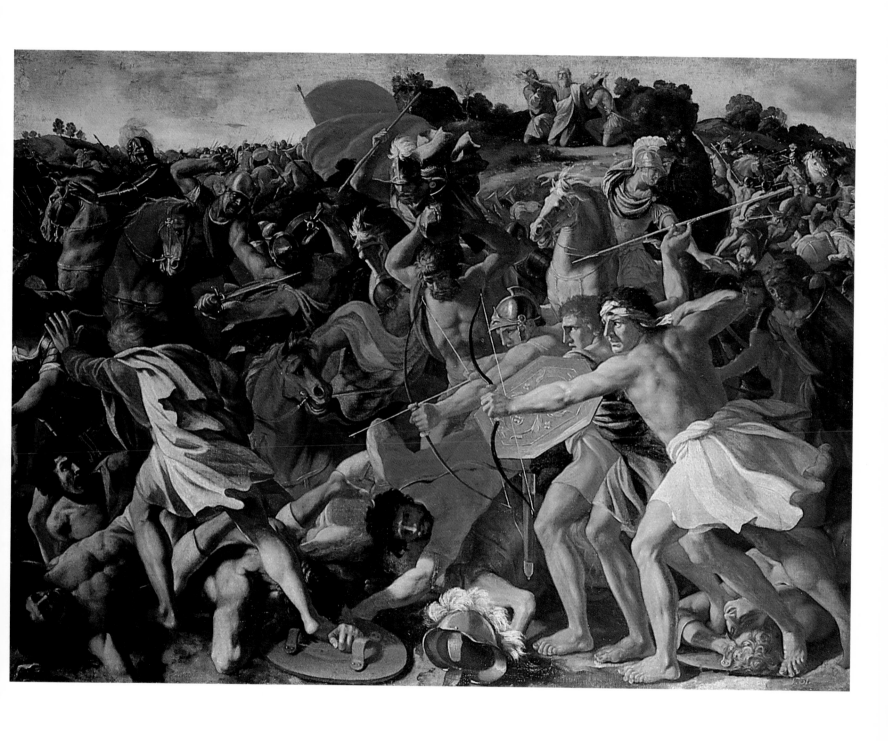

2 The Victory of Joshua over the Amalekites, 1625-6
The Hermitage Museum, St Petersburg

4 Venus with the Dead Adonis, c. 1626-7
Musée des Beaux-Arts, Caen

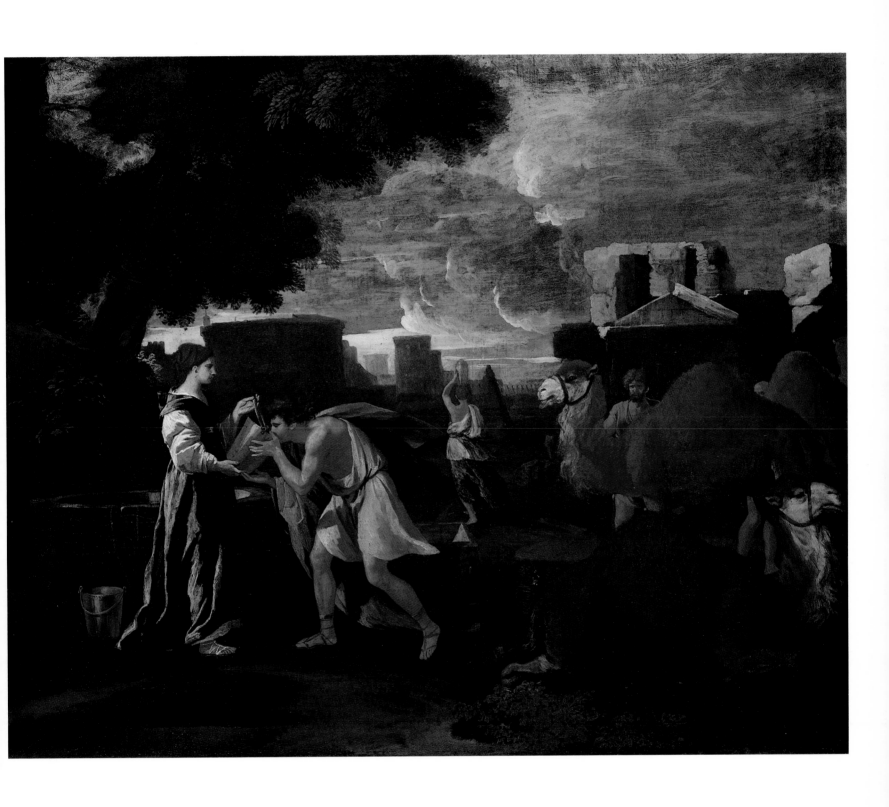

5 *Eliezer and Rebecca, c.* 1627
Private Collection

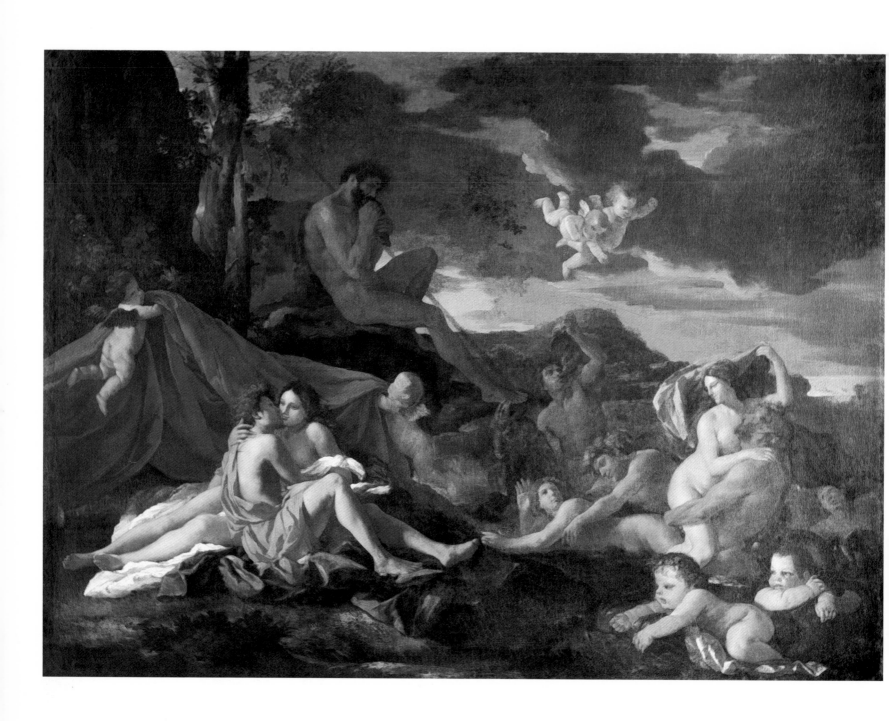

6 *Acis and Galatea, c.* 1627-8
The National Gallery of Ireland, Dublin

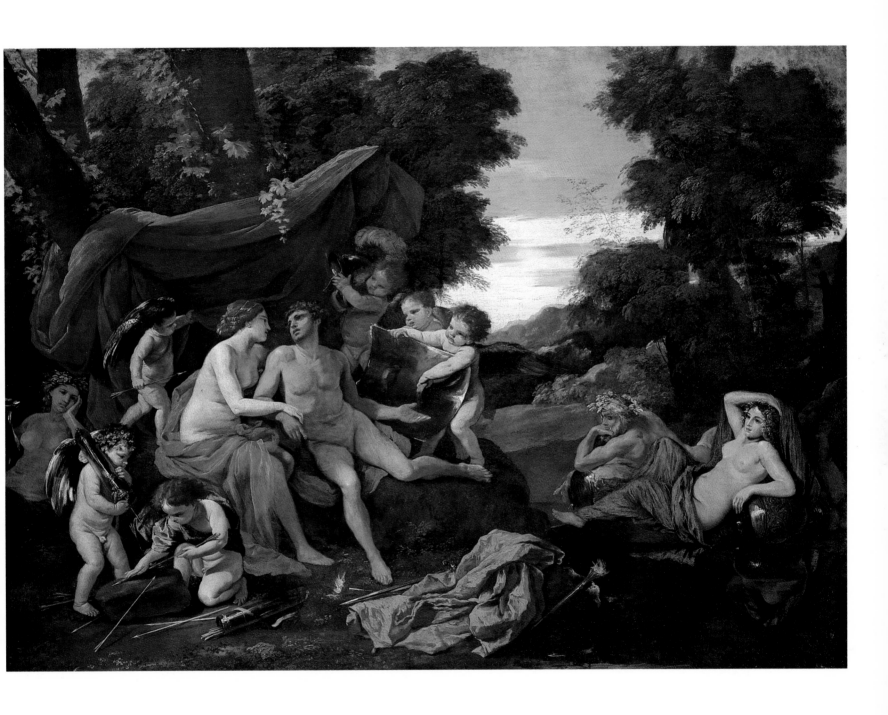

7 Mars and Venus, c. 1627-8
Museum of Fine Arts, Boston
Augustus Hemenway Fund and Arthur William Wheelwright Fund, 40/89

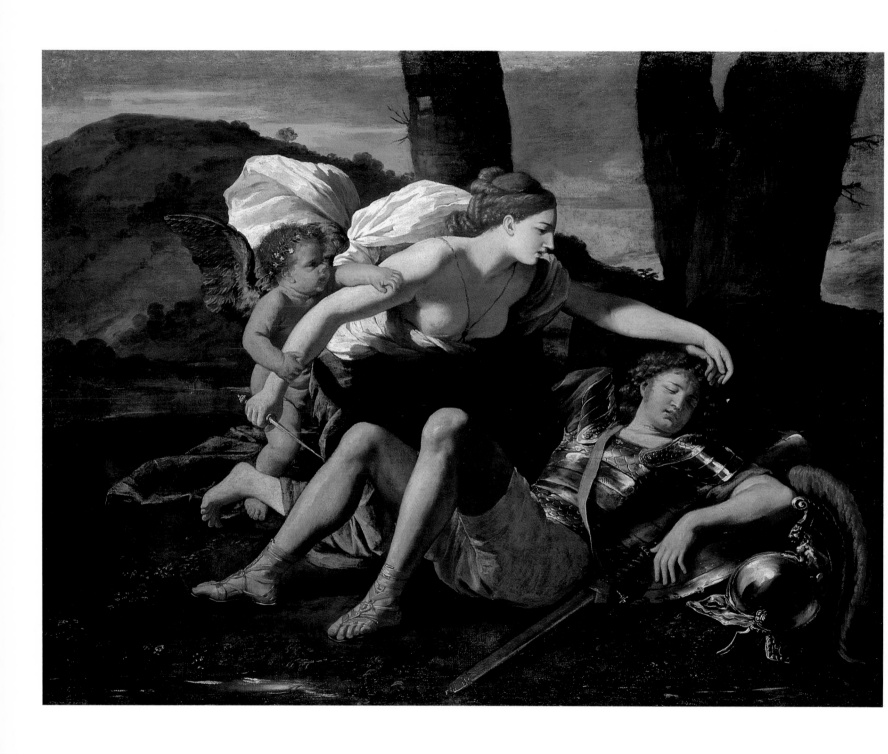

8 *Rinaldo and Armida*, c. 1628
Dulwich Picture Gallery, London

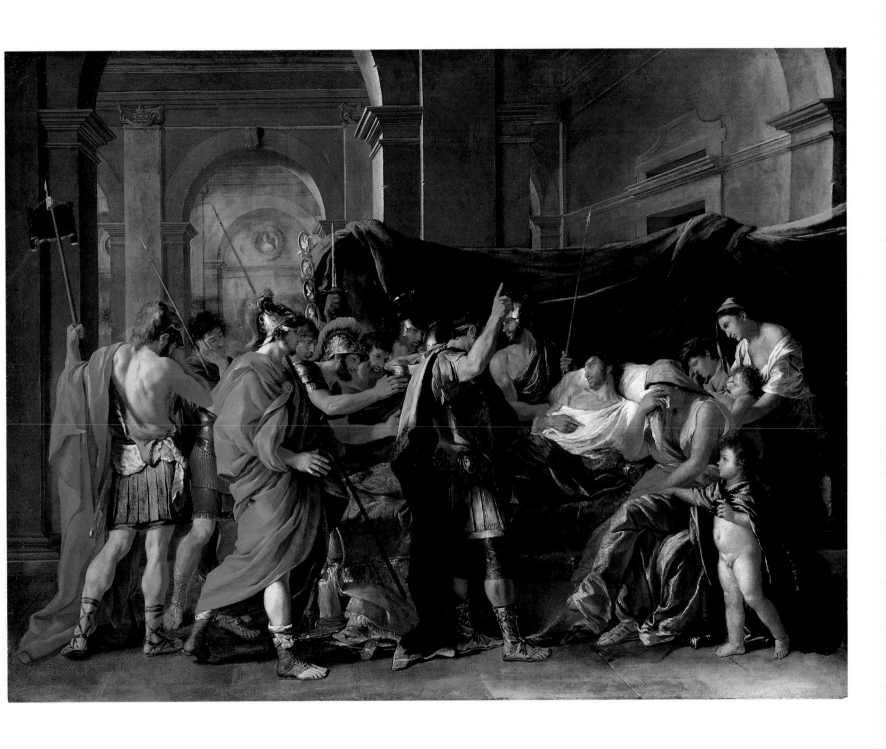

9 *The Death of Germanicus*, 1626-8
The Minneapolis Institute of Arts
The William Hood Dunwoody Fund

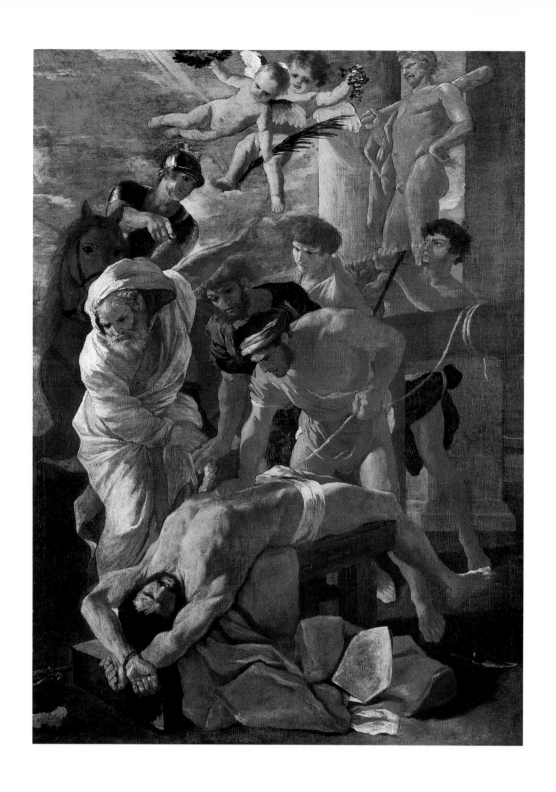

11 *The Martyrdom of St Erasmus*, 1628-9
The National Gallery of Canada, Ottawa

10 *The Martyrdom of St Erasmus*, 1628-9
Musei Vaticani, Città del Vaticano, Rome

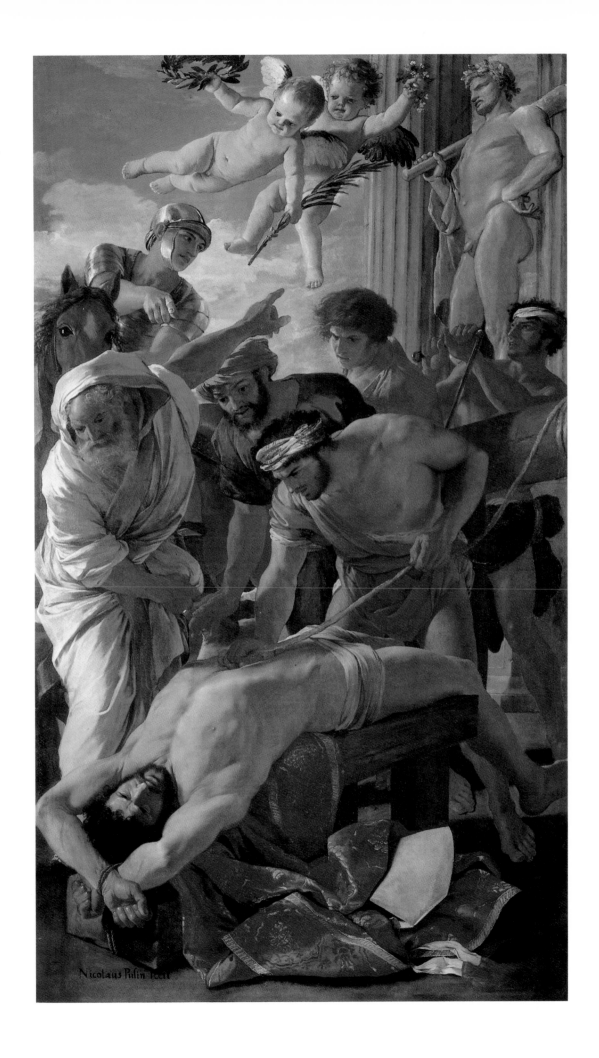

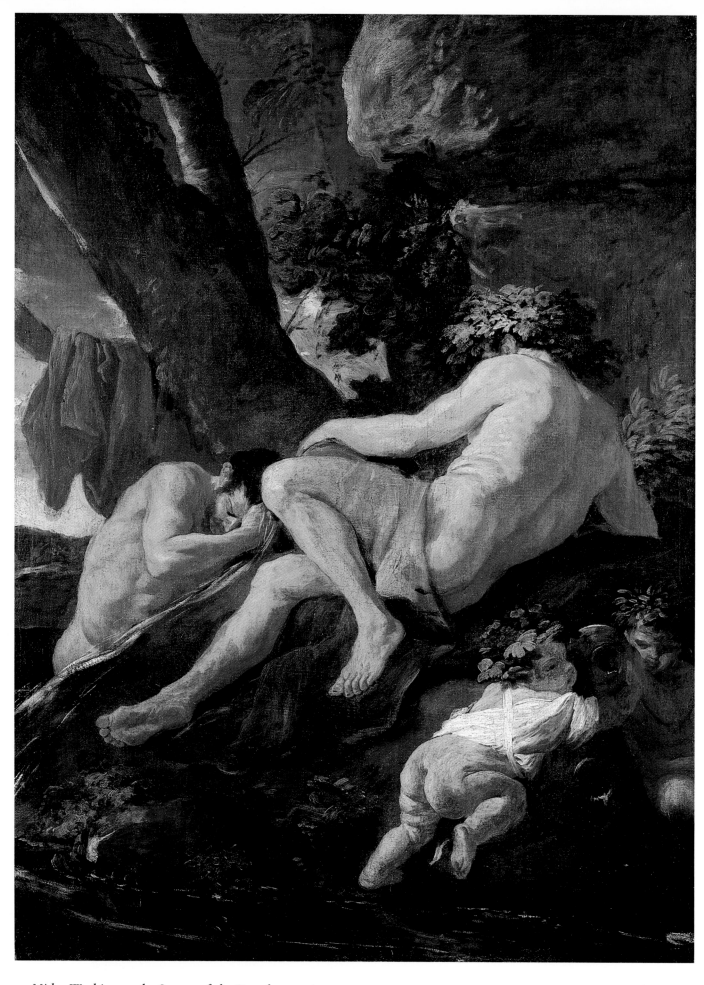

12 *Midas Washing at the Source of the Pactolus, c.* 1627-9
Lent by The Metropolitan Museum of Art, New York. Purchase, 1871

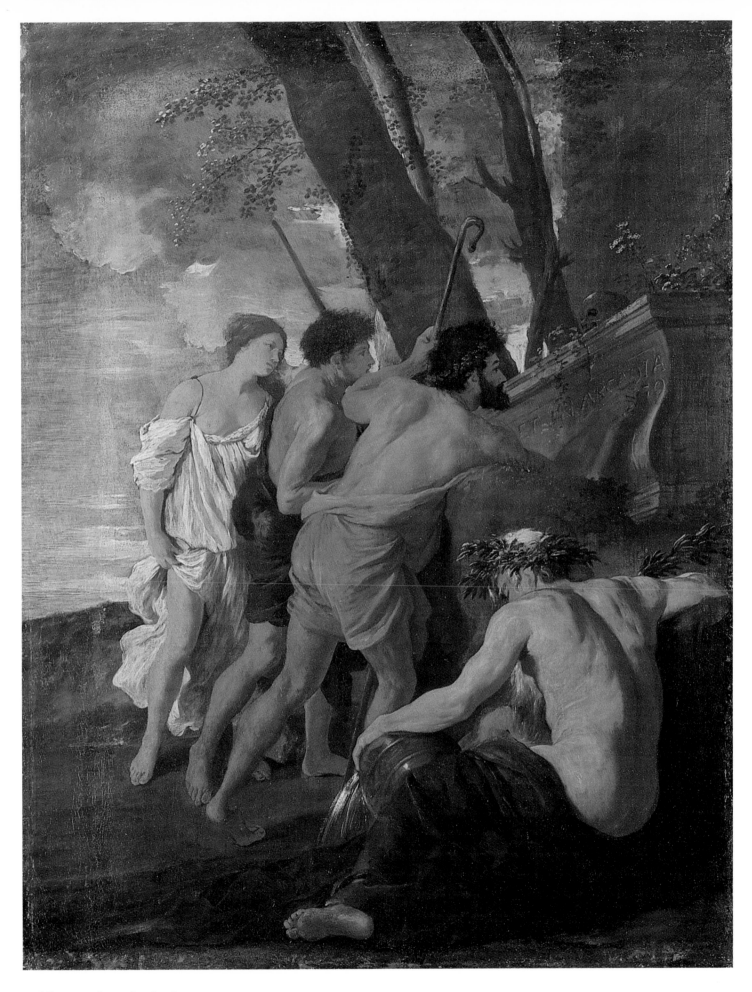

13 *The Arcadian Shepherds, c. 1628-9*
The Duke of Devonshire and the Chatsworth Settlement Trustees

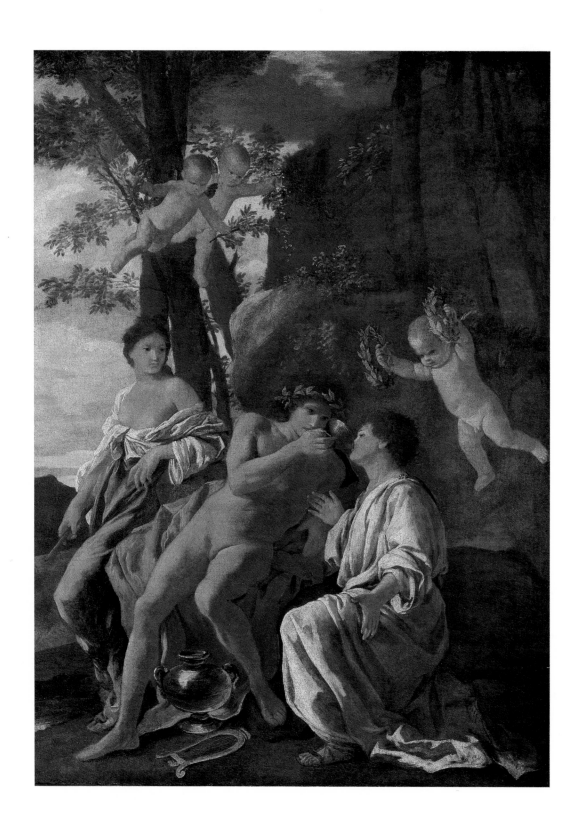

14 *The Inspiration of the Lyric Poet, c.* 1628-9
Niedersächsisches Landesmuseum, Hanover

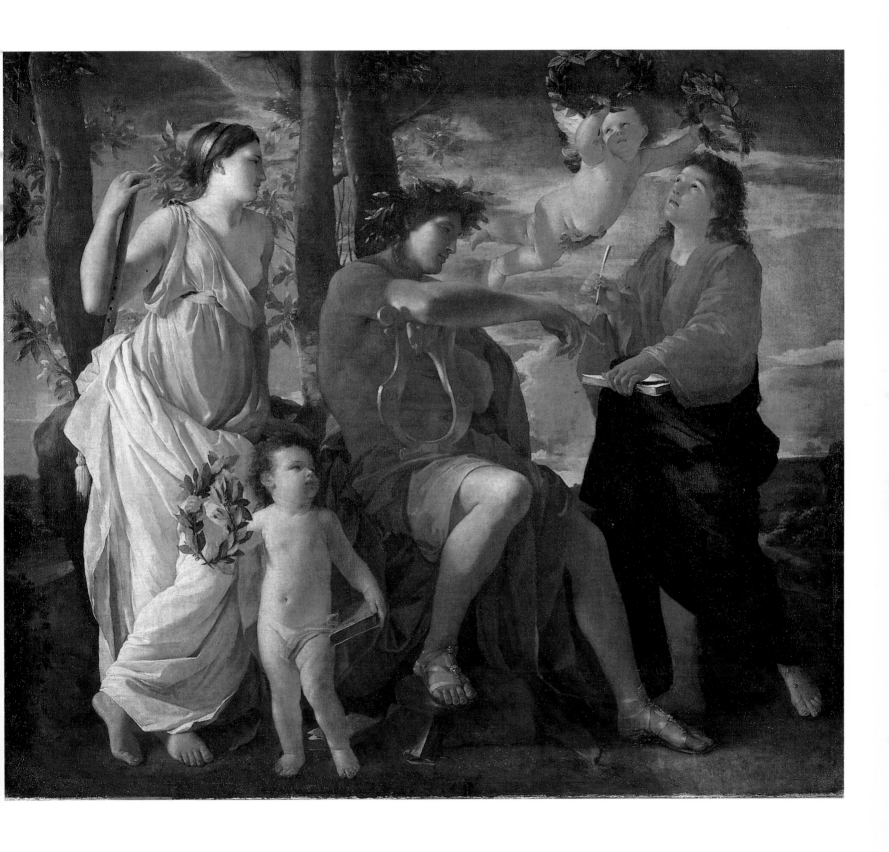

18 *The Inspiration of the Epic Poet*, c. 1630
Musée du Louvre, Département des Peintures, Paris

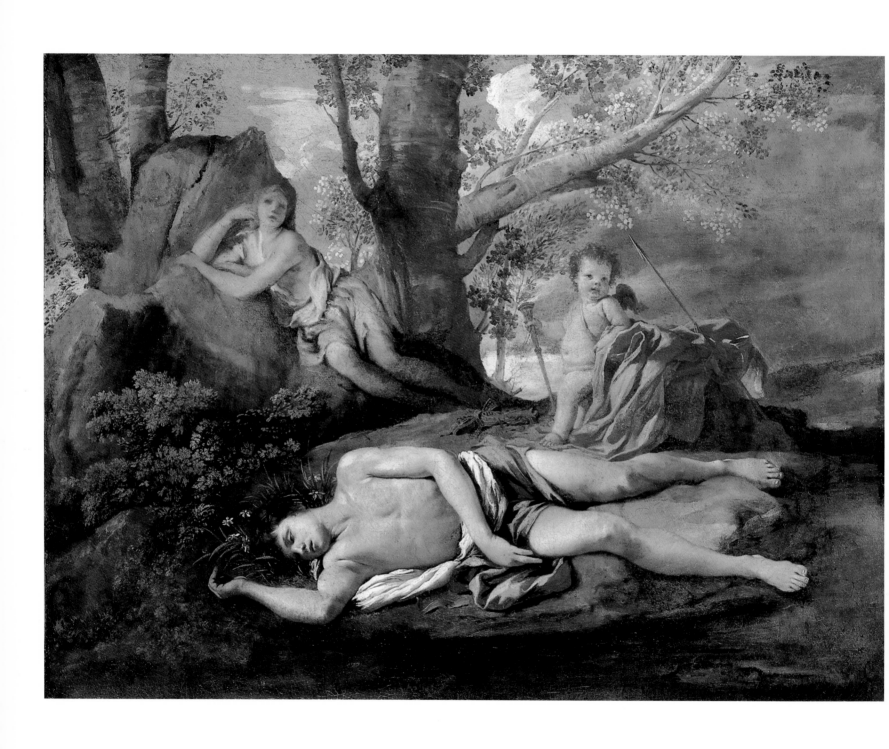

15 *Echo and Narcissus, c.* 1629-30
Musée du Louvre, Département des Peintures, Paris

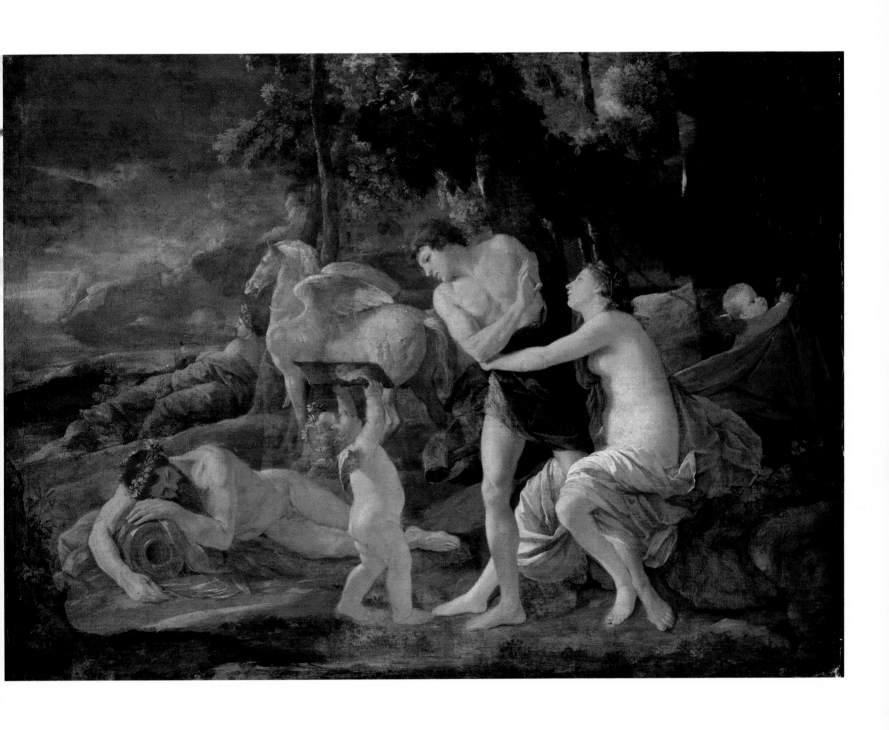

16 Cephalus and Aurora, c. 1629-30
The Trustees of the National Gallery, London

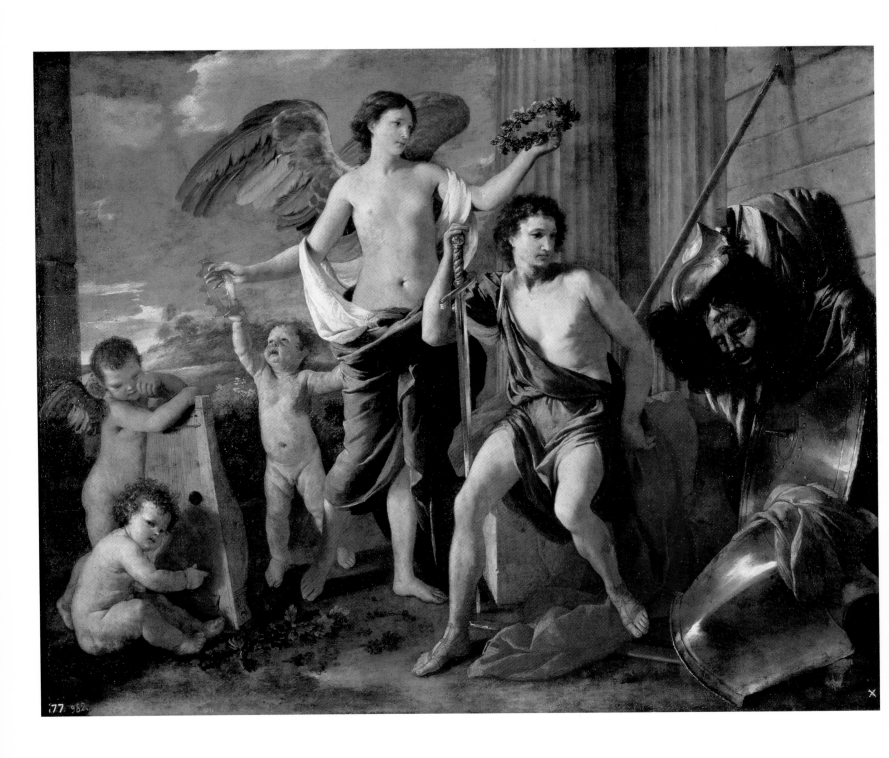

17 *The Triumph of David, c.* 1629-30
Museo del Prado, Madrid

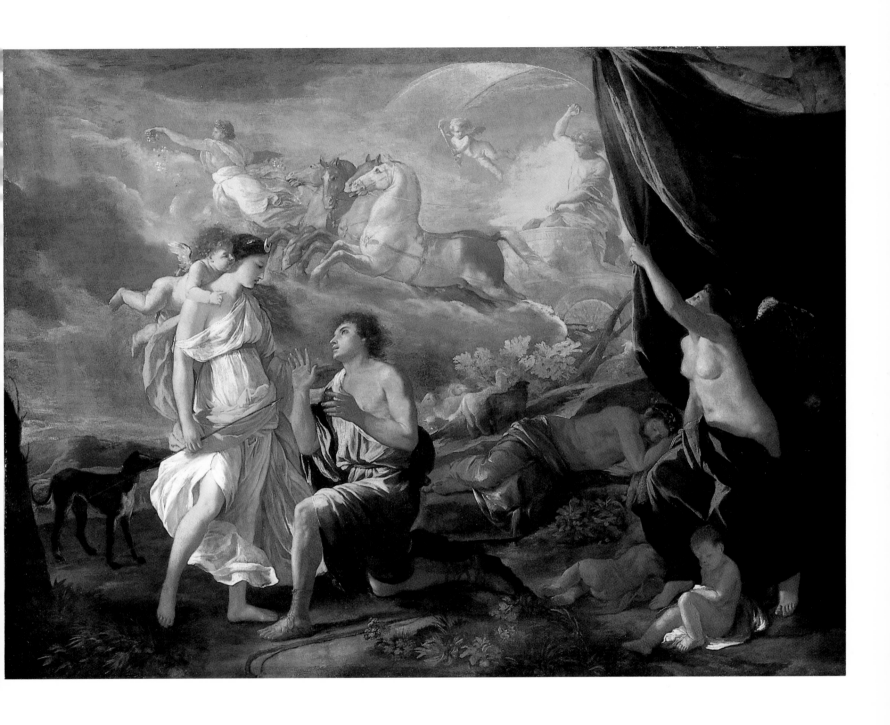

19 *Diana and Endymion, c.* 1630
The Detroit Institute of Arts
Founders Society Purchase, Membership and Donations Fund

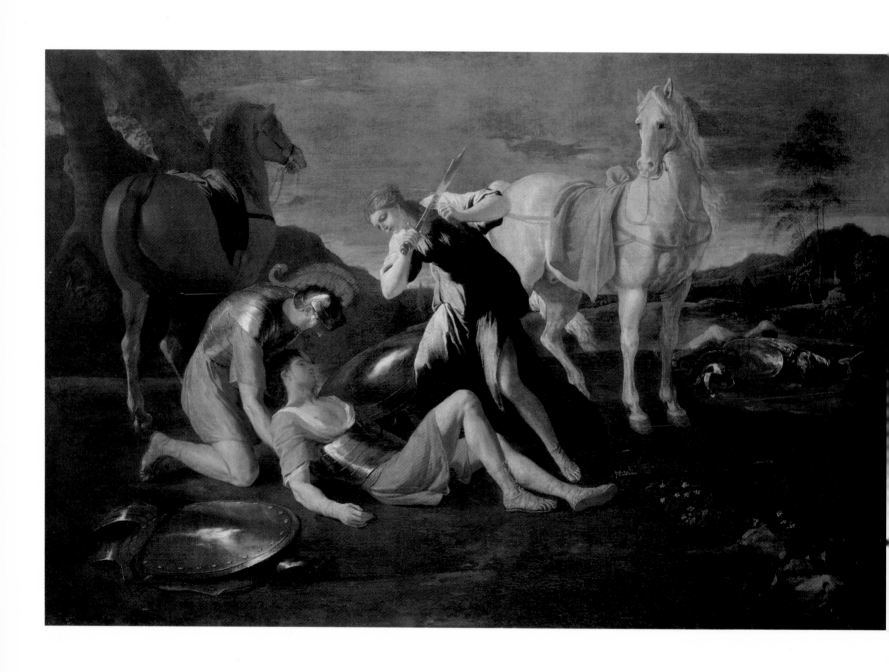

21 *Tancred and Erminia, c.* 1631
The Hermitage Museum, St Petersburg

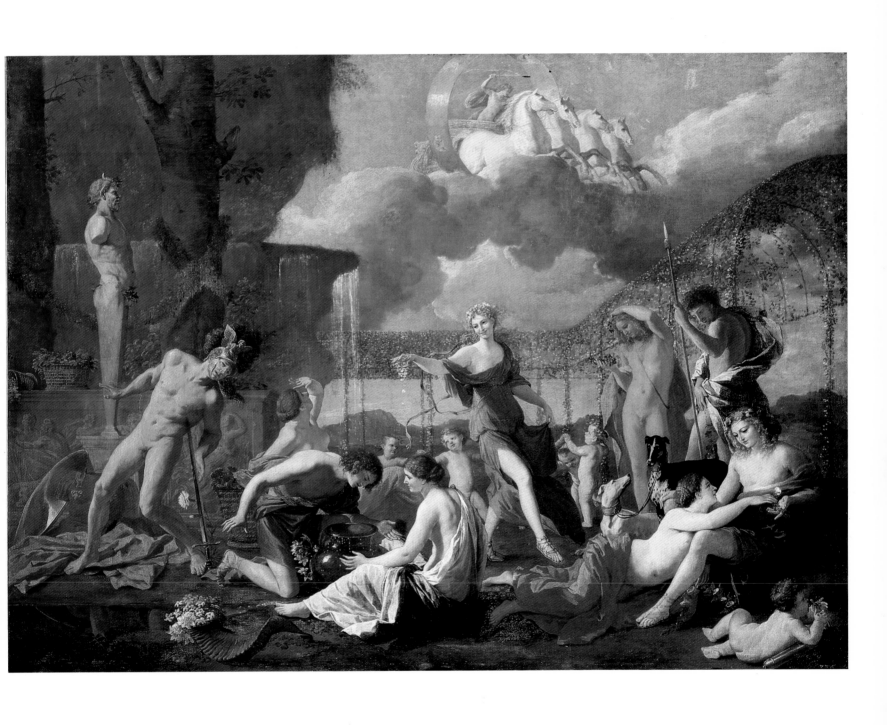

20 *The Kingdom of Flora*, 1631
Staatliche Kunstsammlungen, Gemäldegalerie, Dresden

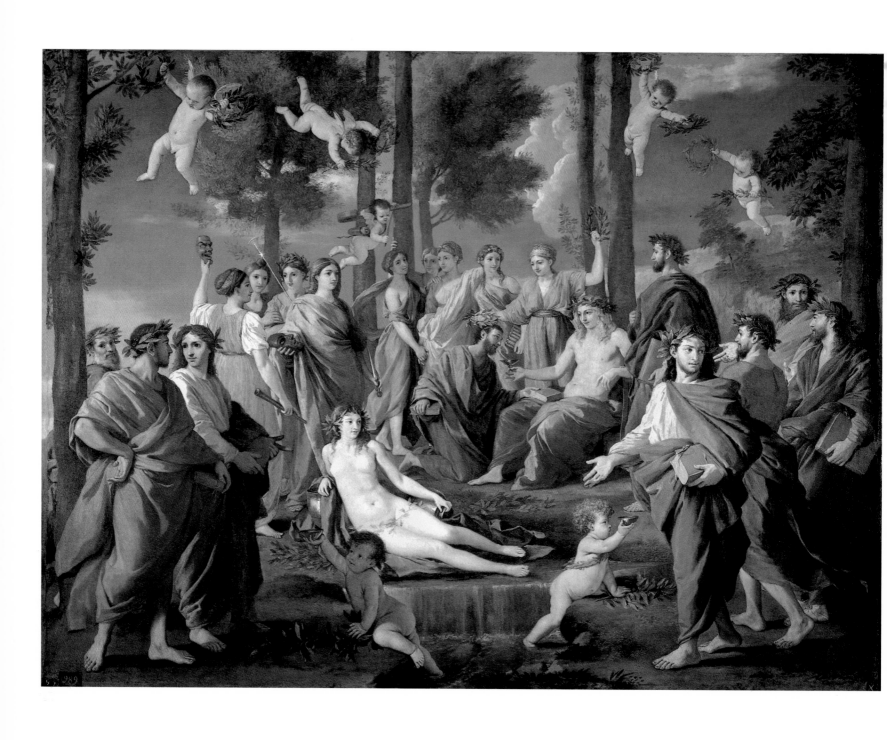

22 *Apollo and the Muses on Parnassus, c.* 1630-2
Museo del Prado, Madrid

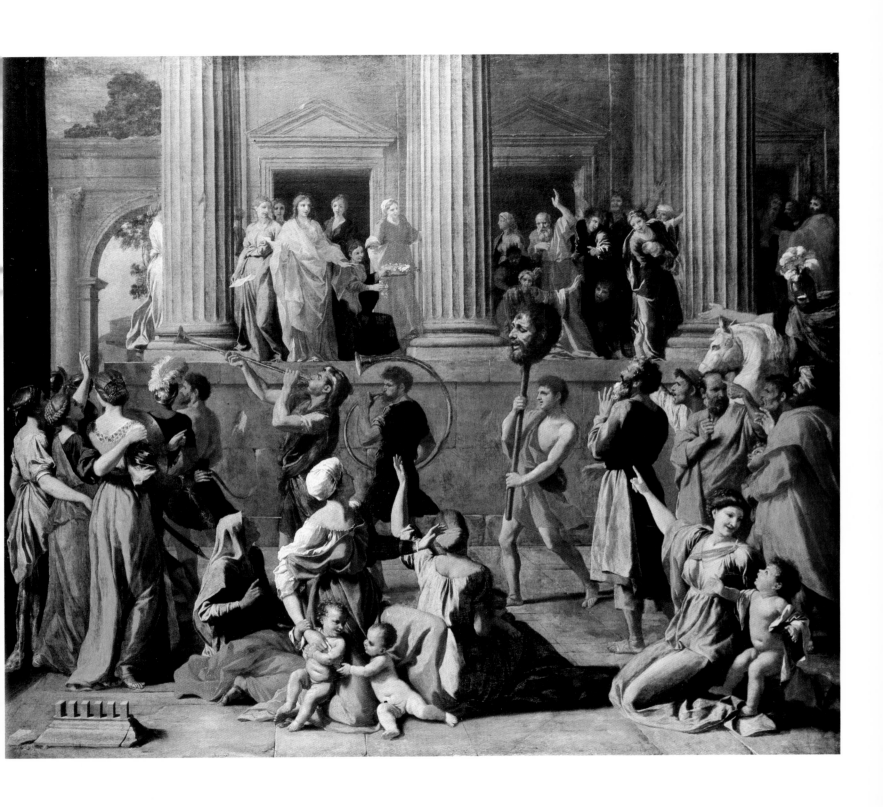

24 *The Triumph of David*, c. 1632
Dulwich Picture Gallery, London

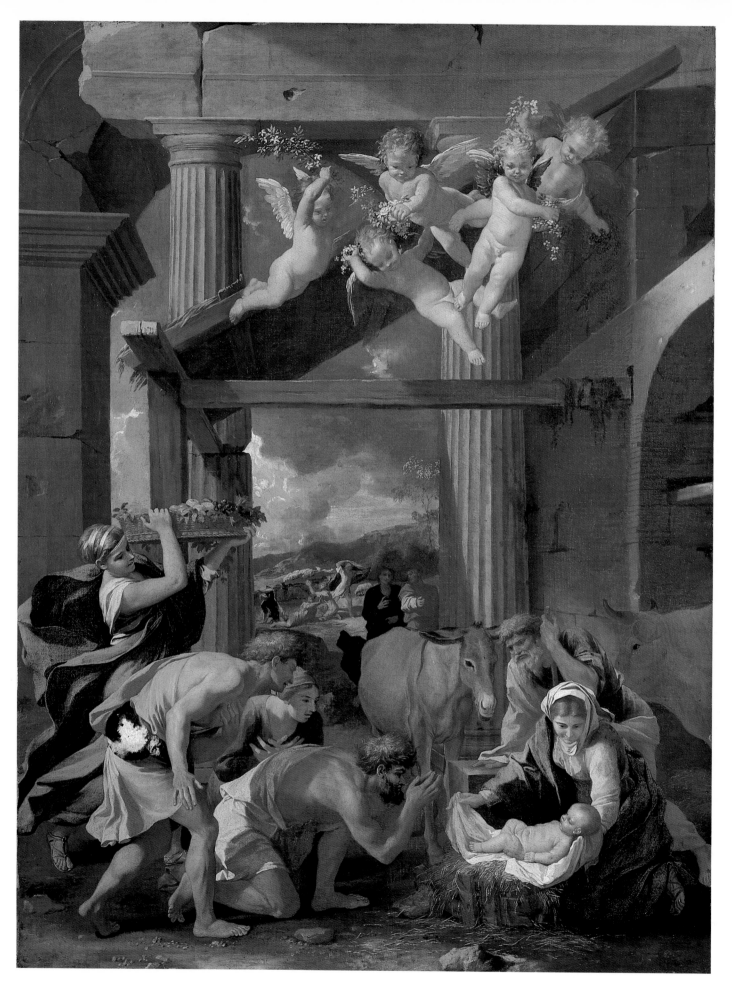

25 *The Adoration of the Shepherds*, c. 1633-4
The Trustees of the National Gallery, London
(Purchased with a Special Grant and a Contribution from the National Art Collections Fund)

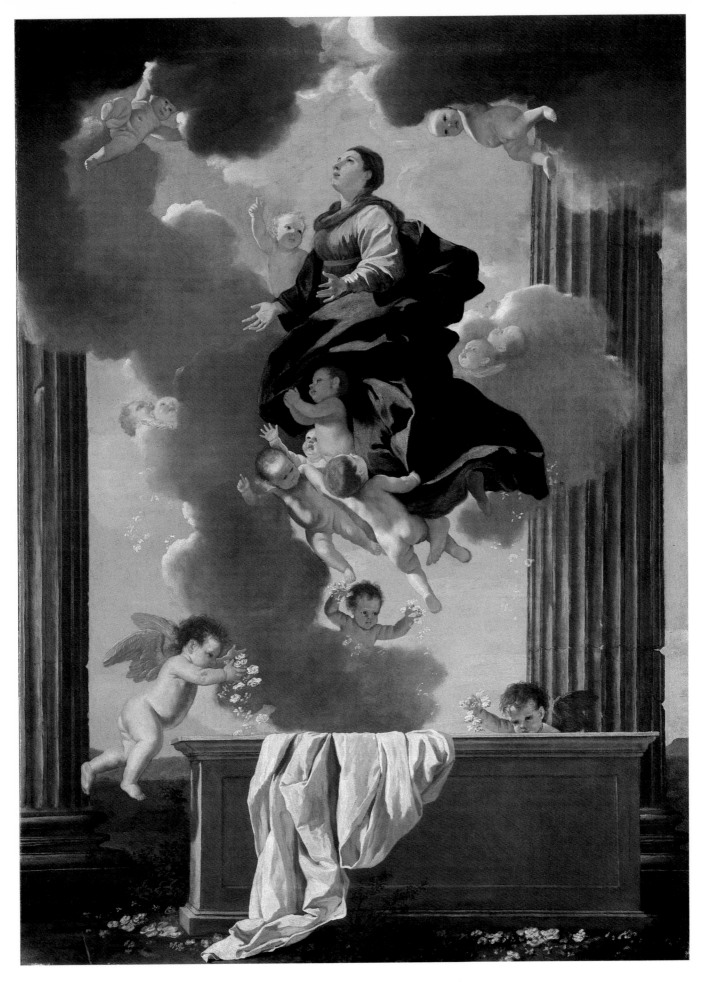

23 The Assumption of the Virgin, c. 1631-2
The National Gallery of Art, Washington
Ailsa Mellon Bruce Fund, 1963.5.1

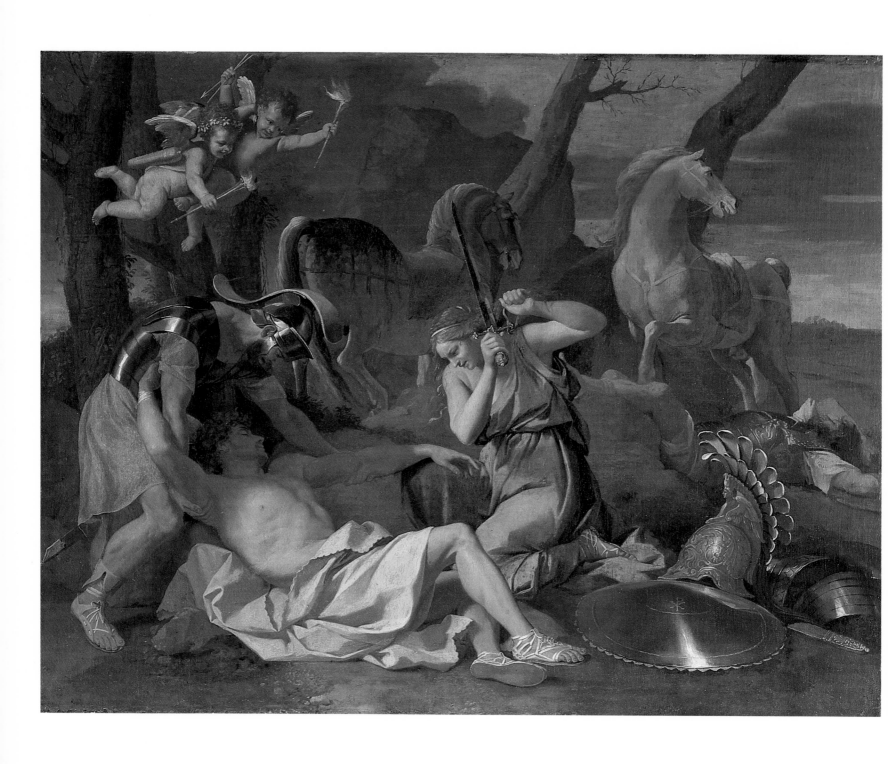

26 *Tancred and Erminia*, c. 1633-4
The Barber Institute of Fine Arts, The University of Birmingham

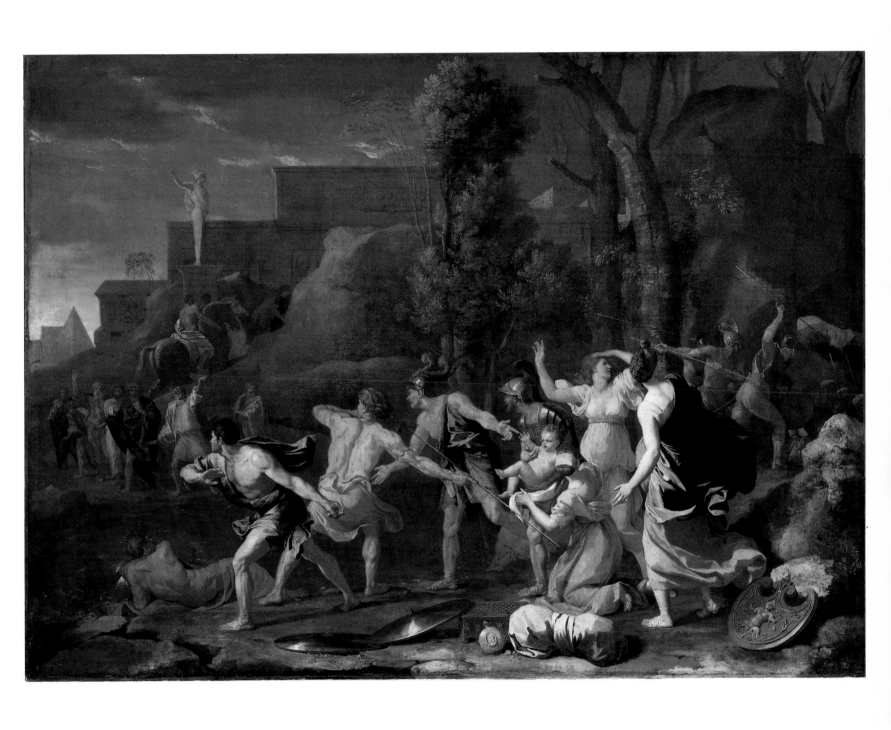

27 The Saving of the Infant Pyrrhus, 1634
Musée du Louvre, Département des Peintures, Paris

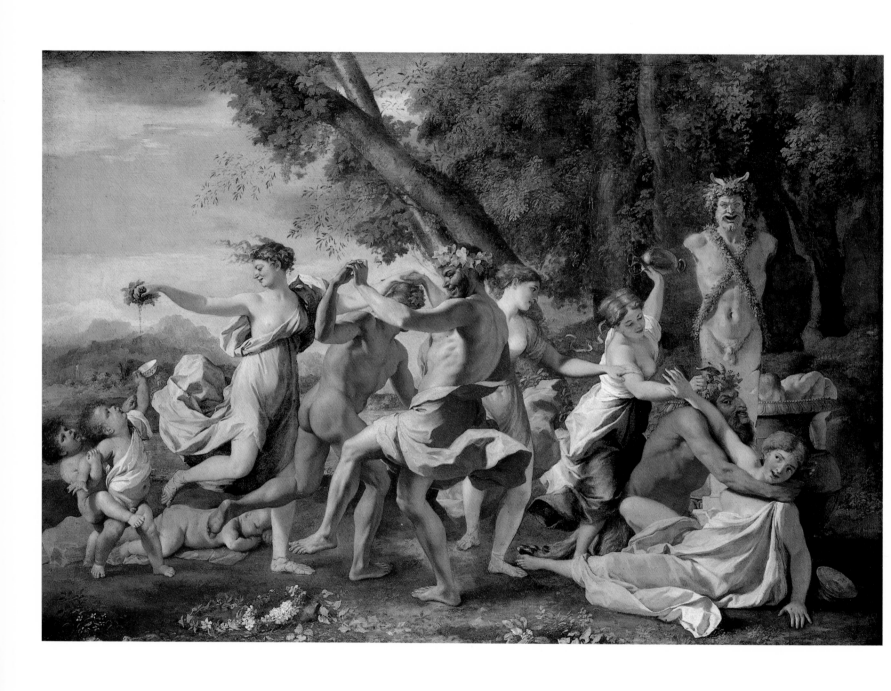

28 Bacchanal before a Herm, c. 1634
The Trustees of the National Gallery, London

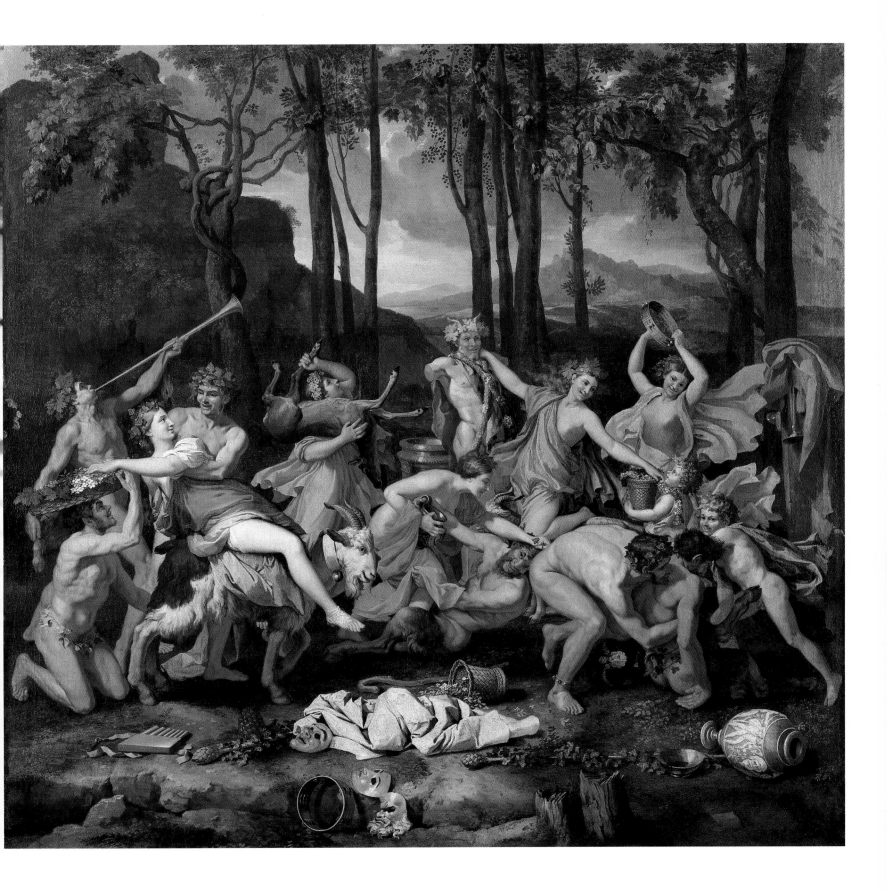

29 *The Triumph of Pan*, 1635-6
The Trustees of the National Gallery, London
(Purchased with Contributions from the National Heritage Memorial Fund
and the National Art Collections Fund)

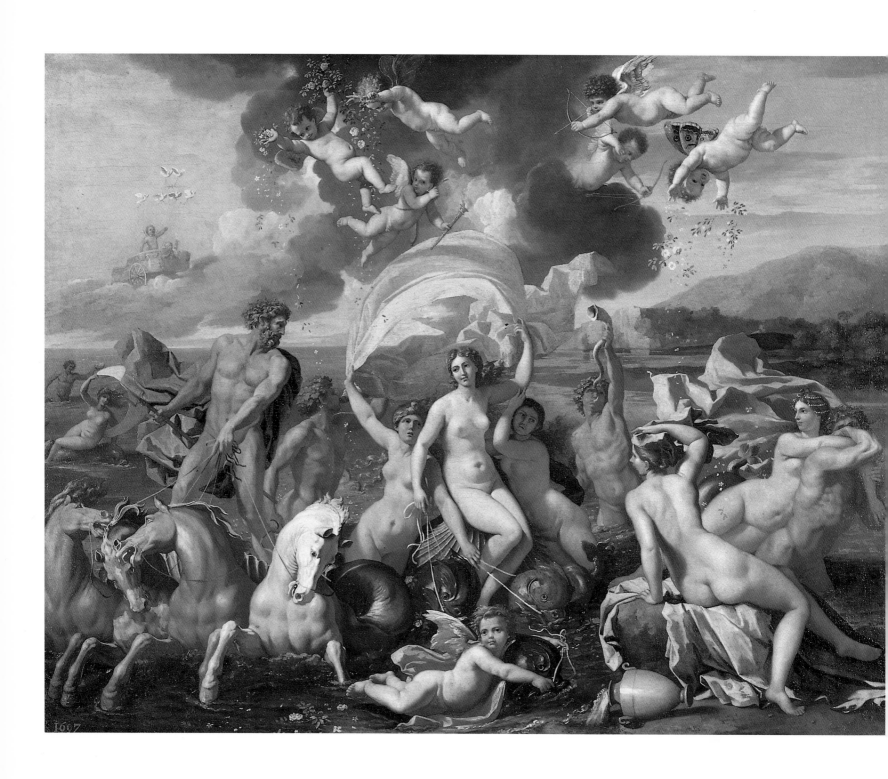

30 *The Triumph of Neptune, c.* 1635-6
The Philadelphia Museum of Art
The George W. Elkins Collection

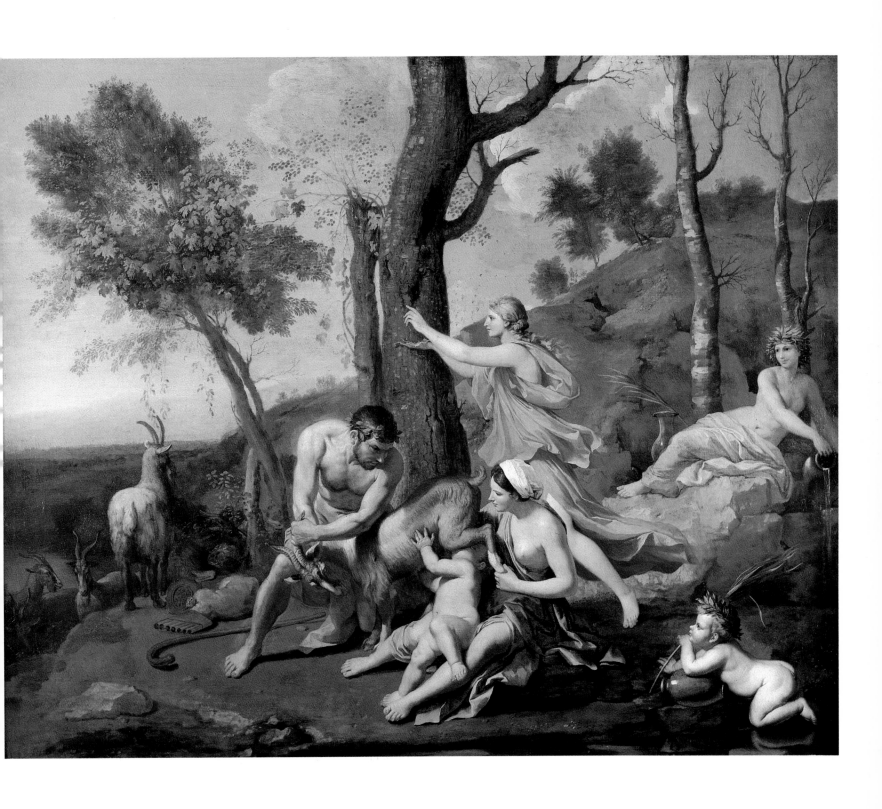

31 *The Nurture of Jupiter*, 1636-7
Dulwich Picture Gallery, London

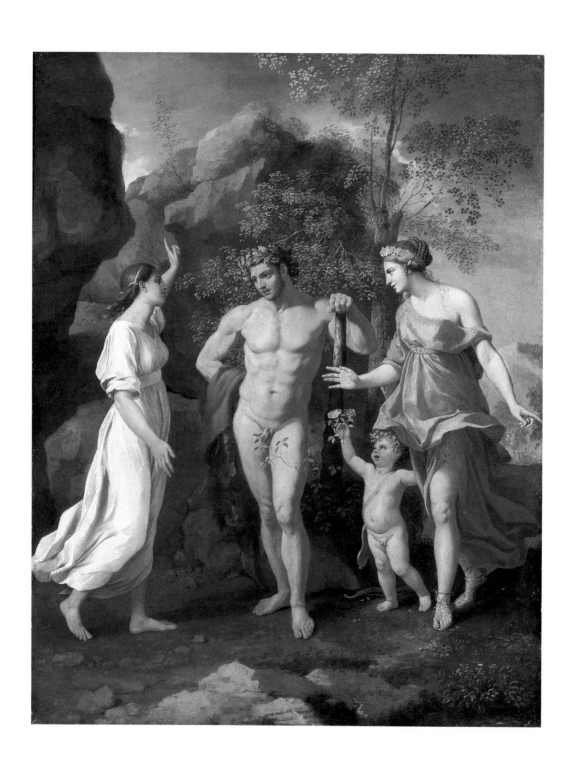

33 *The Choice of Hercules, c.* 1636-7
Stourhead, The Hoare Collection (The National Trust)

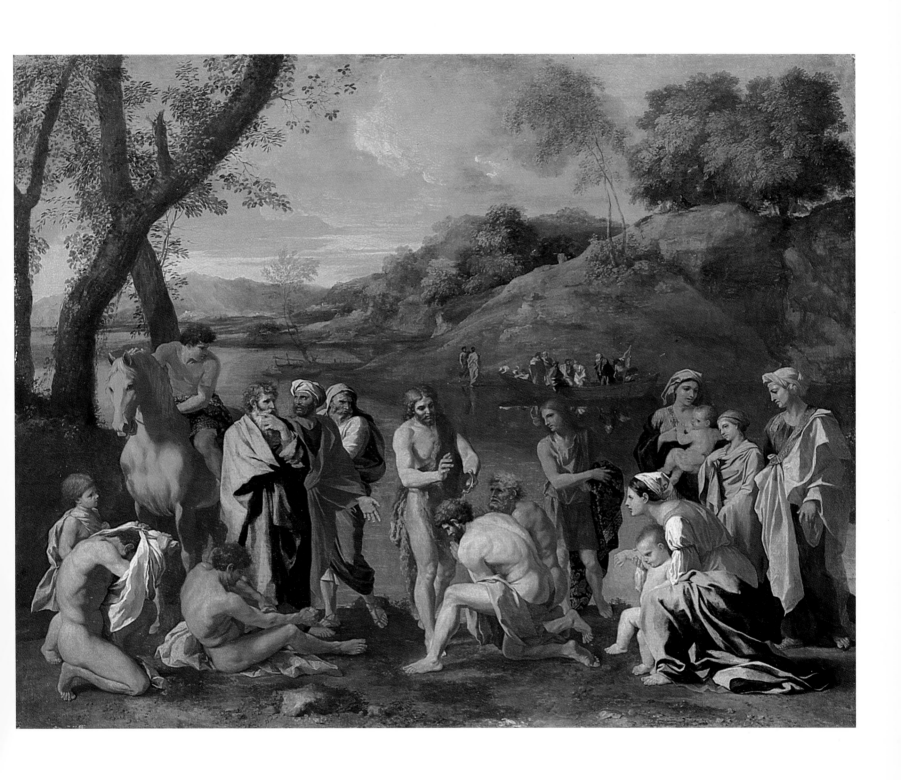

32 *St John Baptising the People*, c. 1636-7
Musée du Louvre, Département des Peintures, Paris

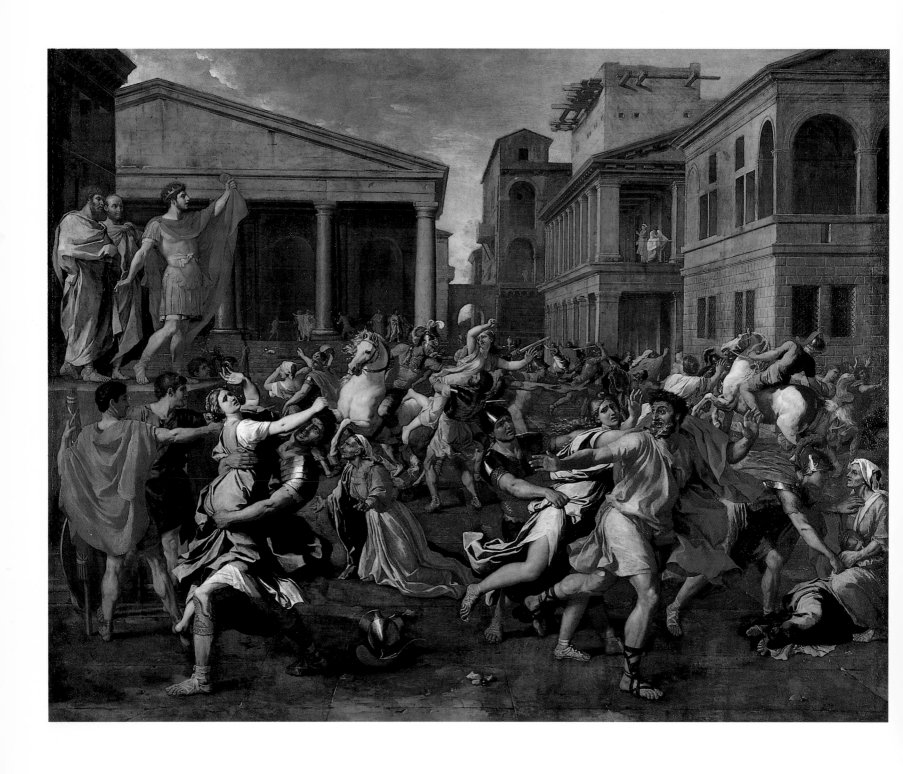

34 *The Rape of the Sabines, c.* 1637
Musée du Louvre, Département des Peintures, Paris

36 The Capture of Jerusalem by Titus, 1638
Kunsthistorisches Museum, Gemäldegalerie, Vienna

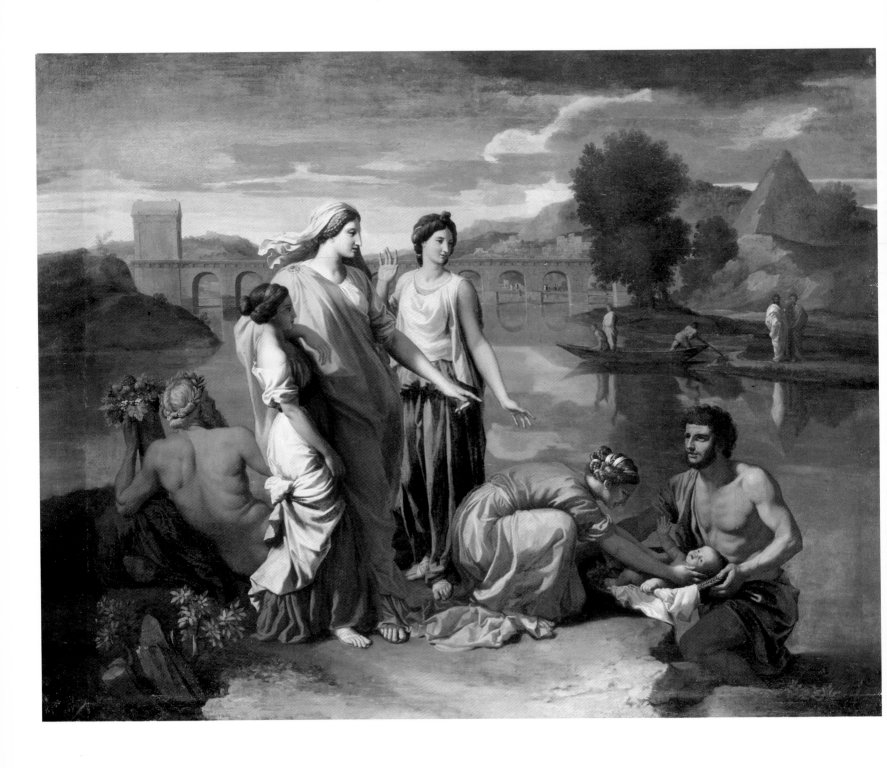

35 *The Finding of Moses*, 1638
Musée du Louvre, Département des Peintures, Paris

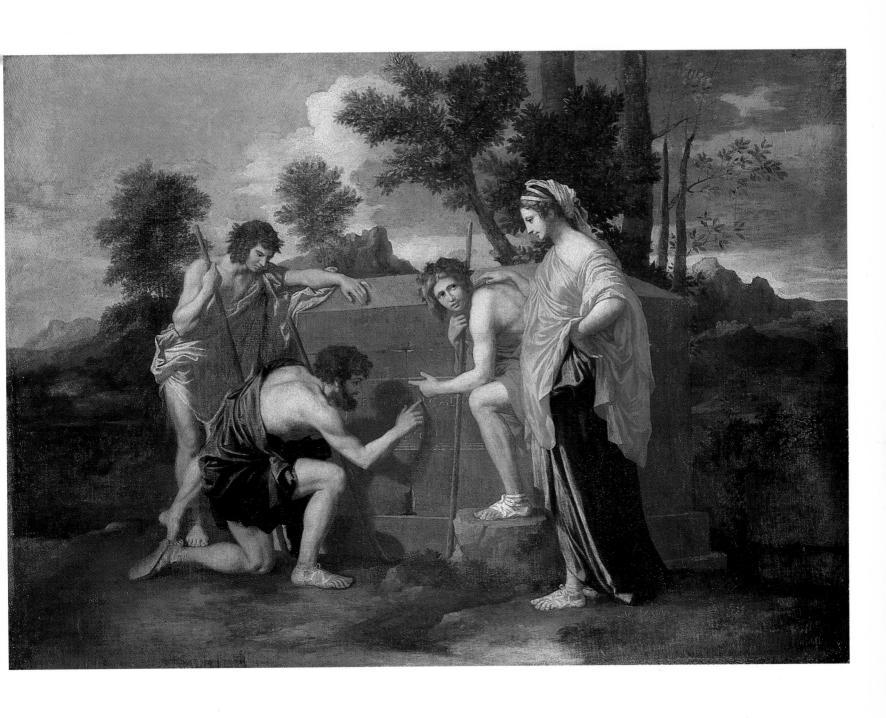

38 The Arcadian Shepherds, 1638-40
Musée du Louvre, Département des Peintures, Paris

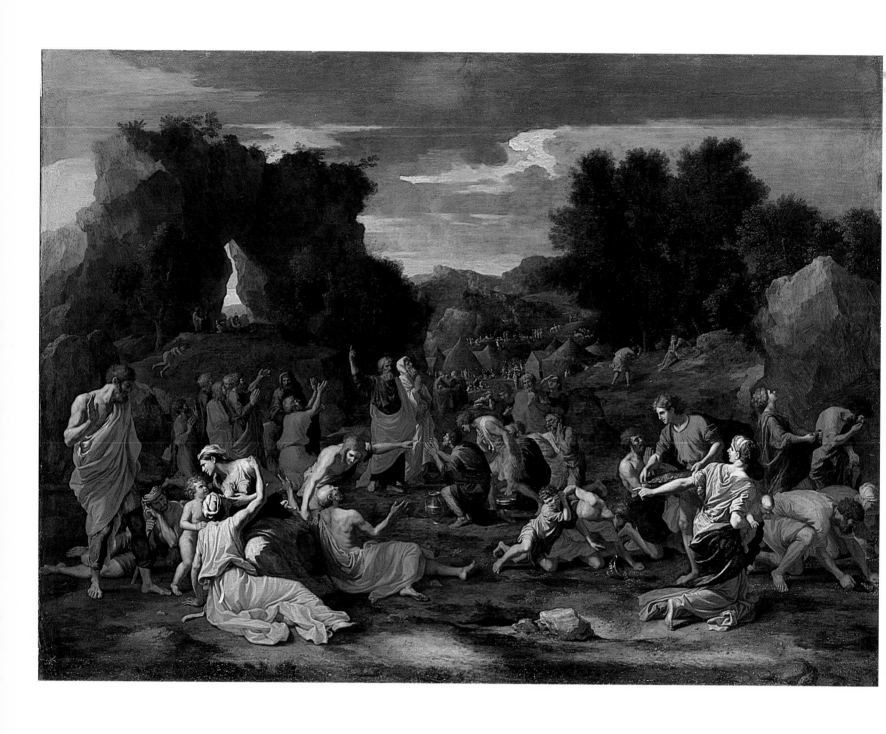

37 The Israelites Gathering the Manna, 1637-9
Musée du Louvre, Département des Peintures, Paris

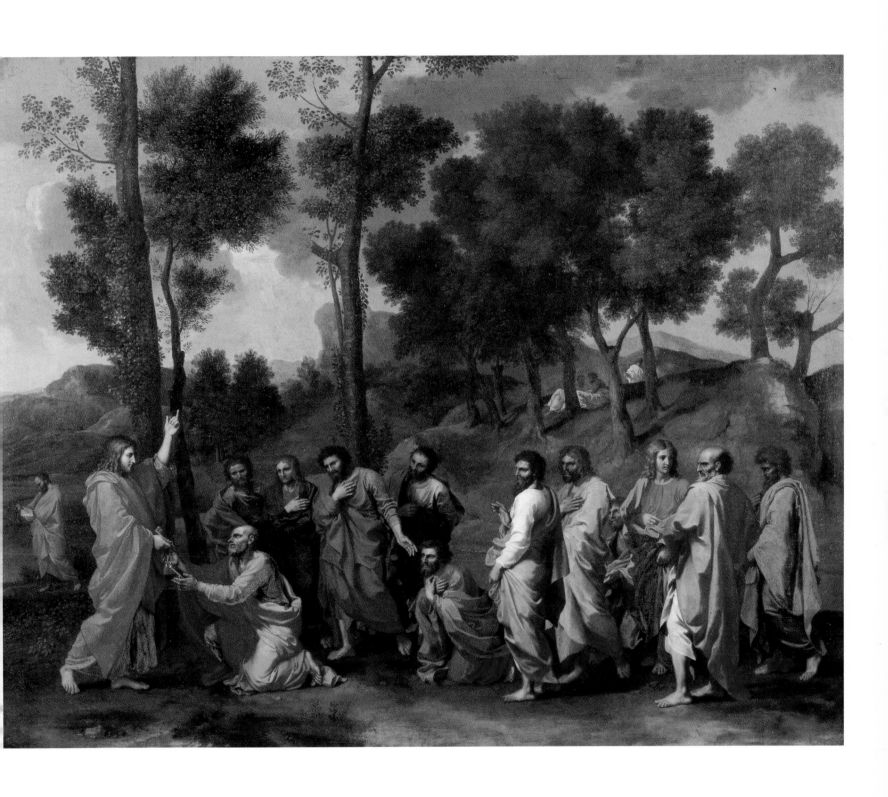

39 *Ordination, c.* 1638-40
His Grace the Duke of Rutland

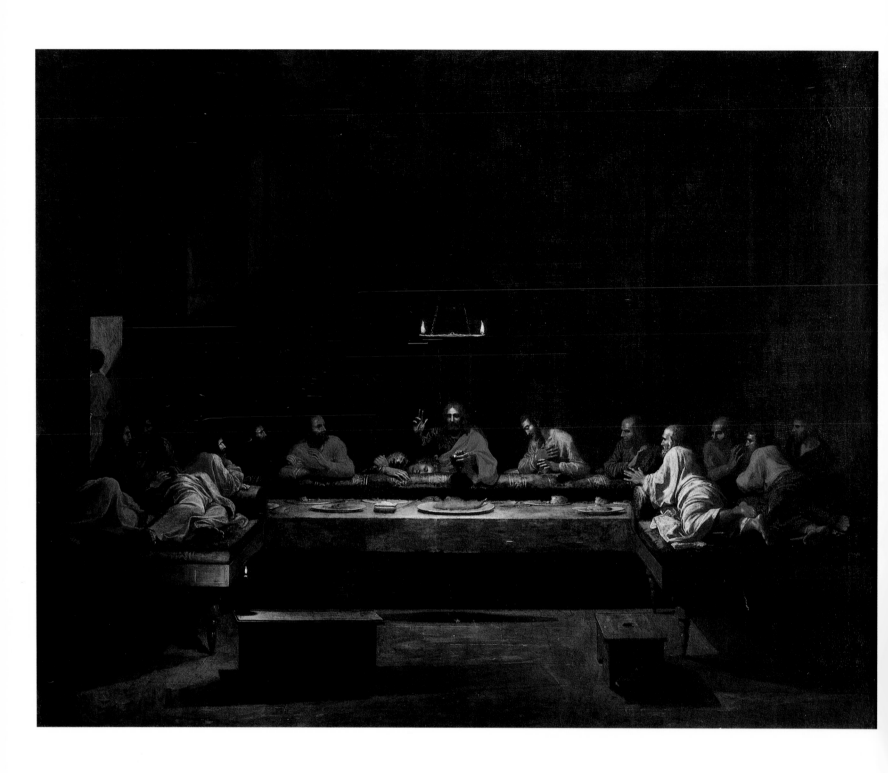

40 Eucharist, c. 1638-40
His Grace the Duke of Rutland

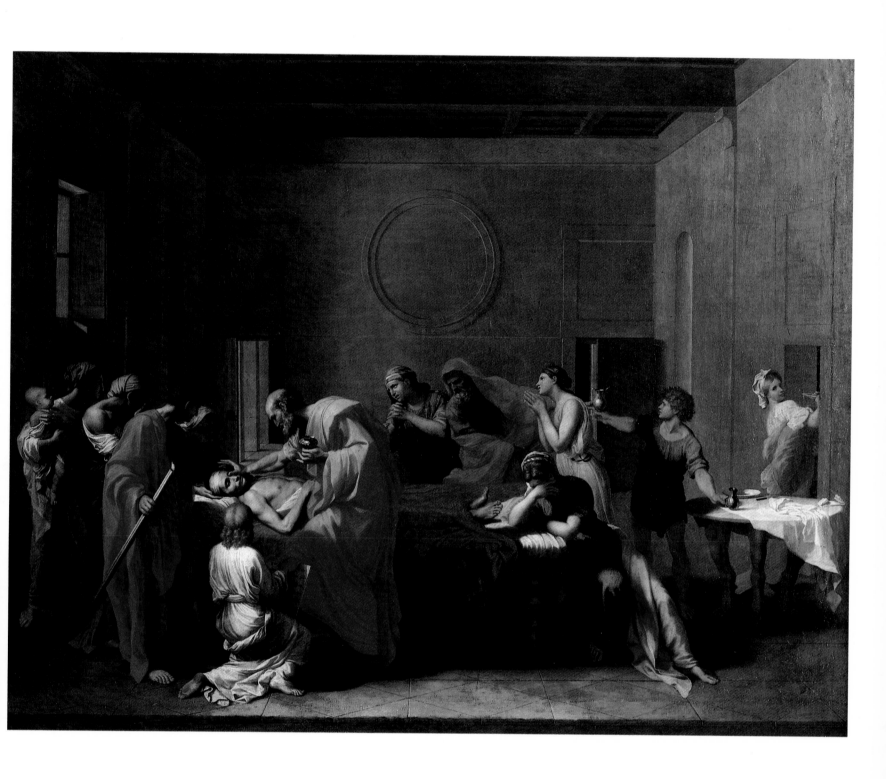

41 *Extreme Unction, c.* 1638-40
His Grace the Duke of Rutland

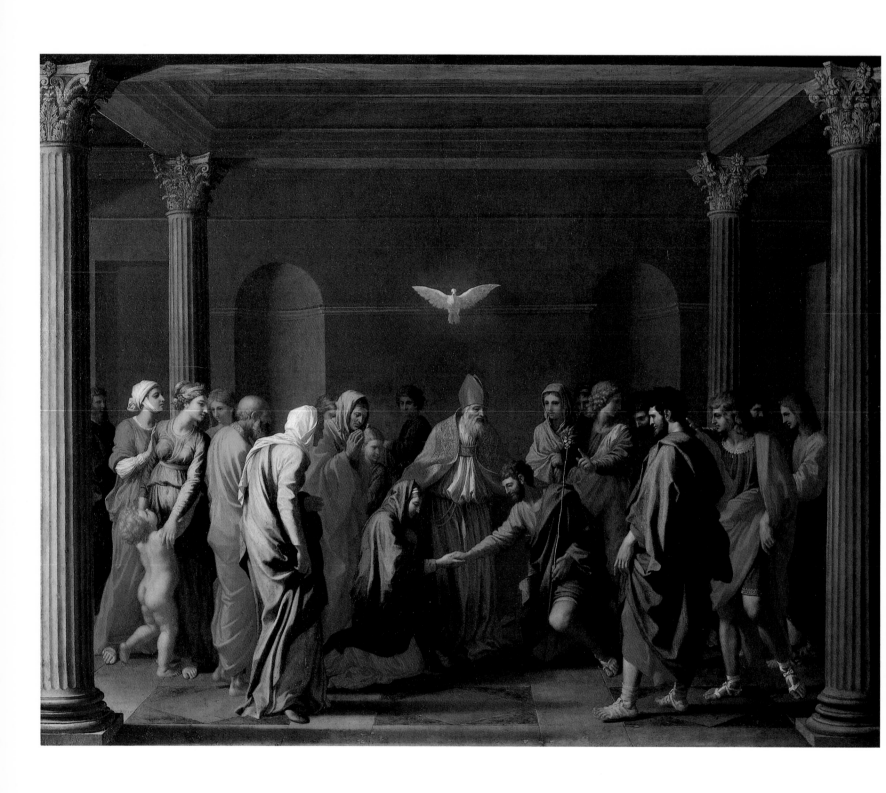

42 *Marriage, c.* 1638-40
His Grace the Duke of Rutland

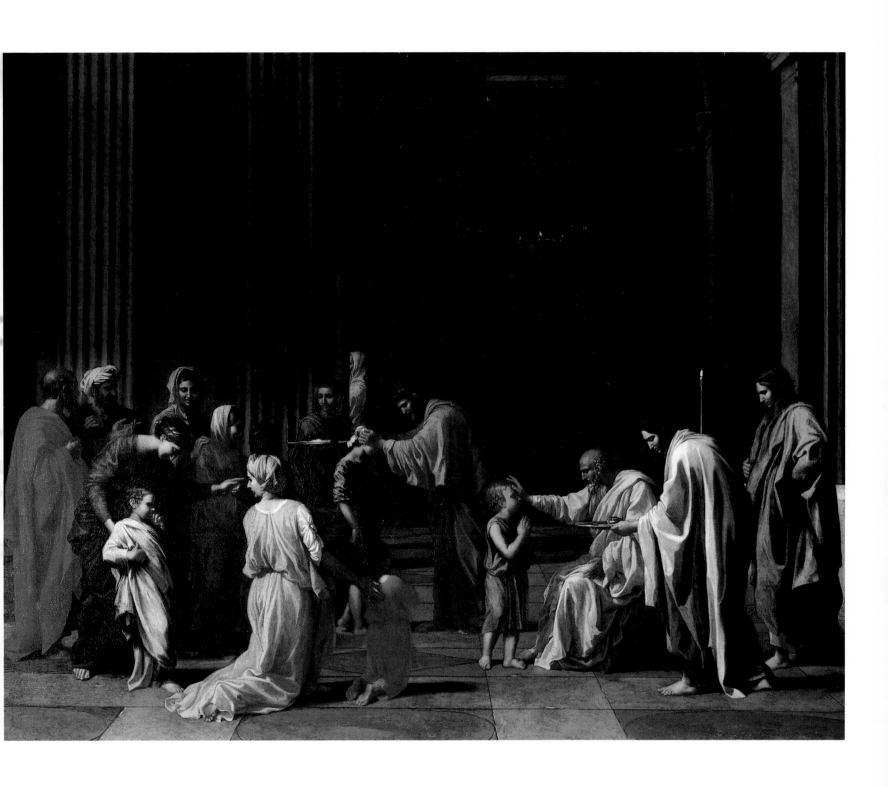

43 *Confirmation, c.* 1638-40
His Grace the Duke of Rutland

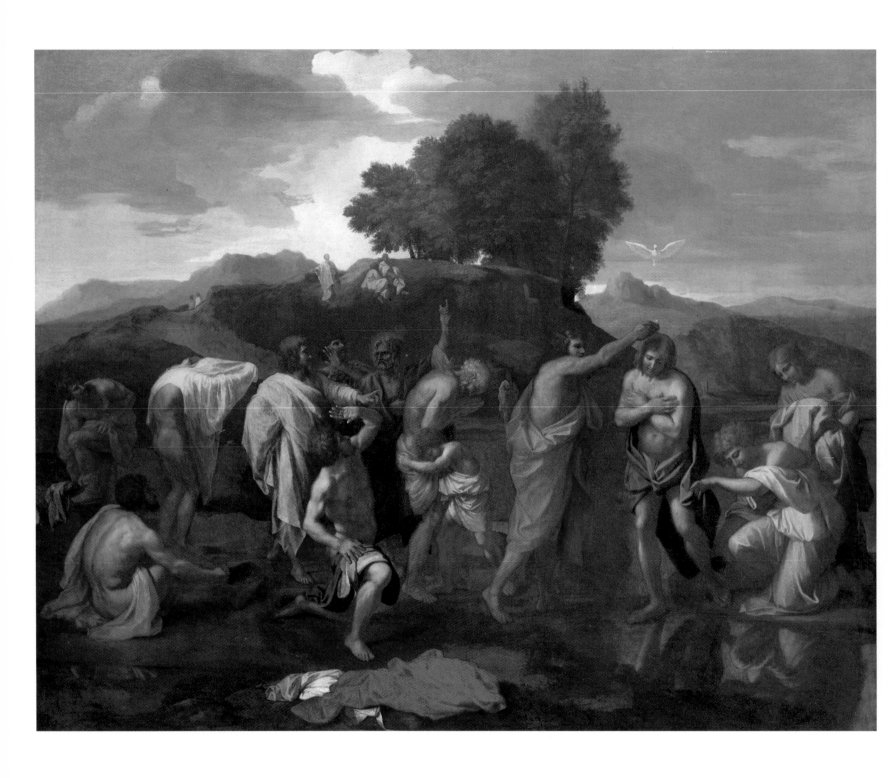

44 *Baptism*, 1640-42
National Gallery of Art, Washington
Samuel H. Kress Collection, 1946.7.14

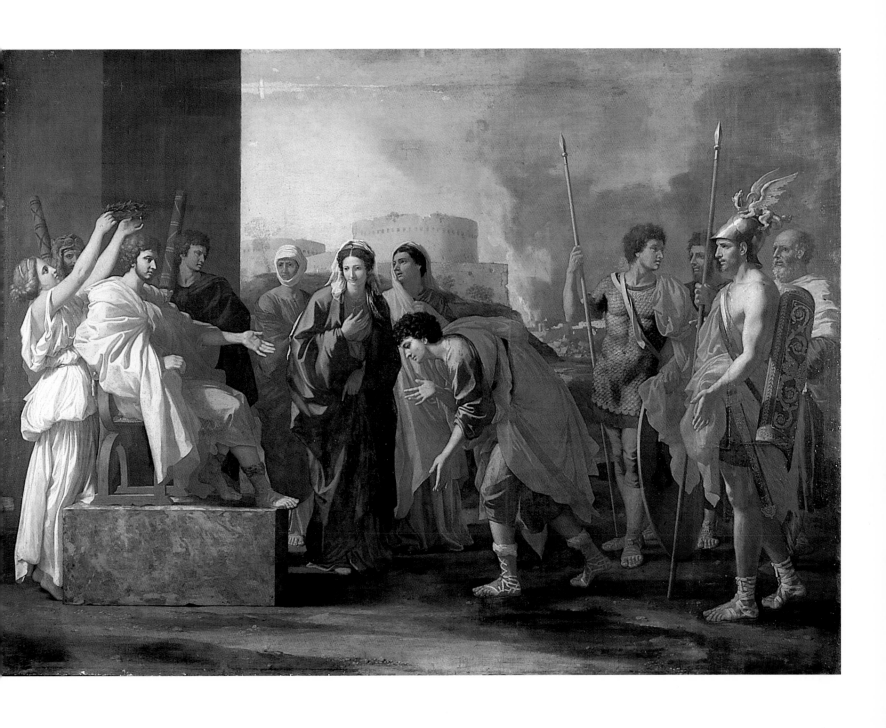

45 The Continence of Scipio, 1640
The Pushkin Museum of Fine Arts, Moscow

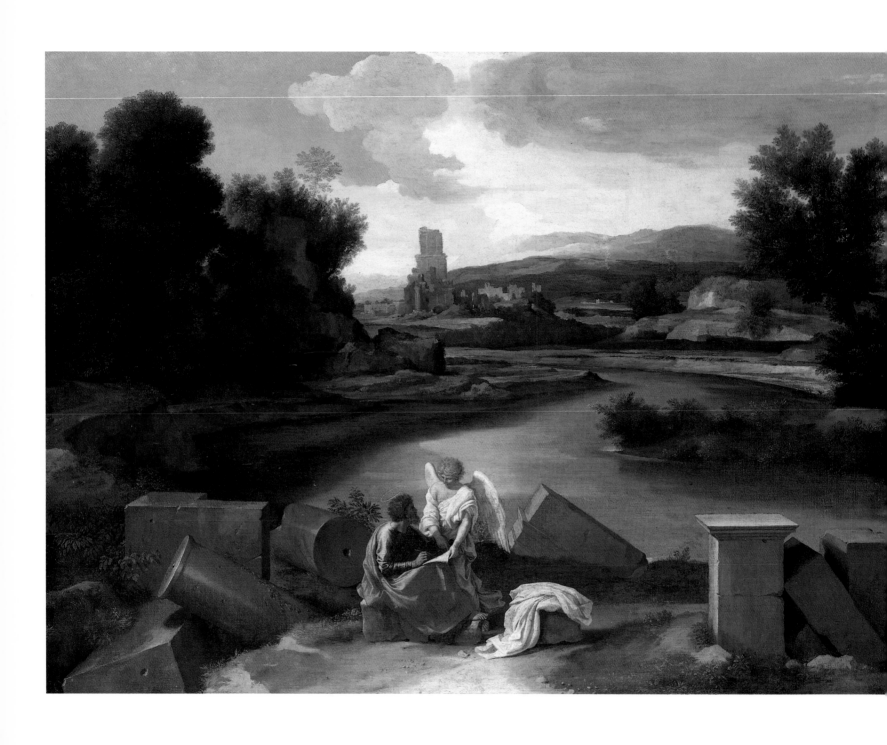

46 *Landscape with St Matthew,* 1640
Staatliche Museen zu Berlin, Preußischer Kulturbesitz, Gemäldegalerie

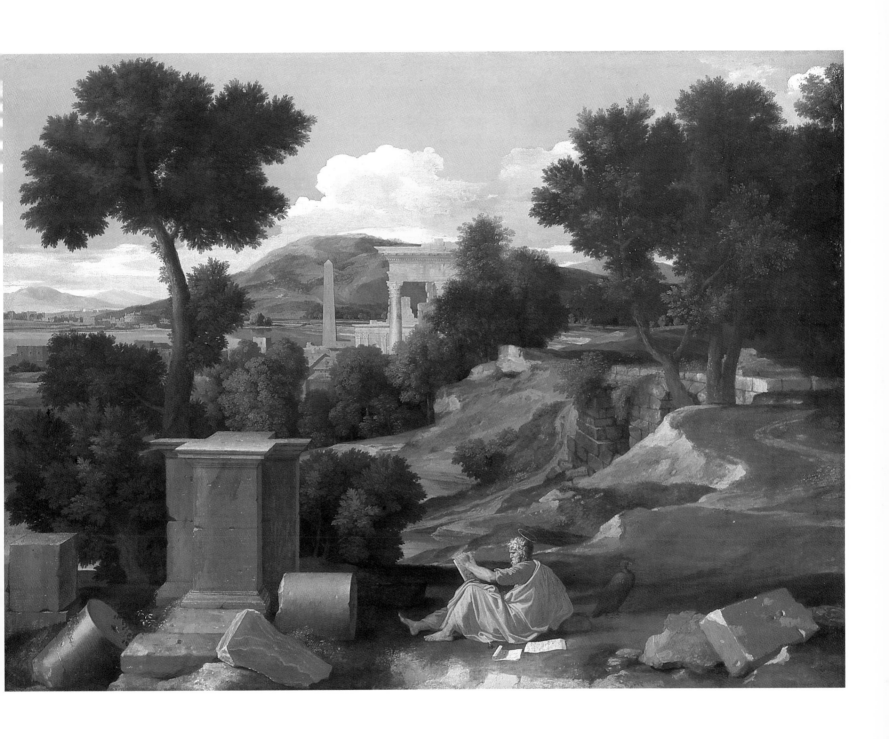

47 Landscape with St John on Patmos, 1640
The Art Institute of Chicago
A. A. Munger Collection

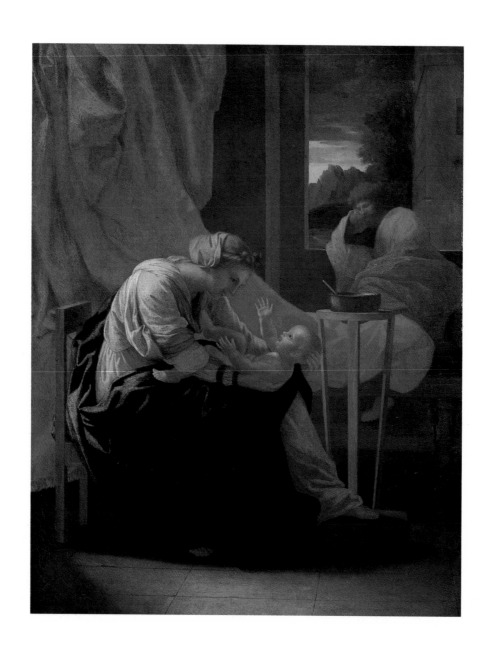

48 *The Holy Family*, 1641-2
The Detroit Institute of Arts
Gift of Mr and Mrs A. D. Wilkinson

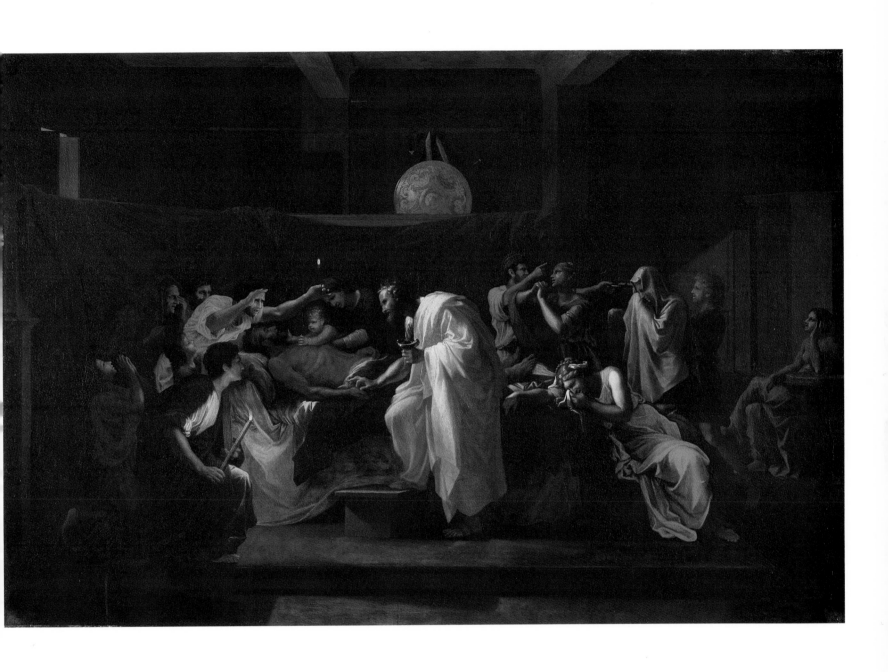

49 *Extreme Unction*, 1644
His Grace the Duke of Sutherland
(On loan to the National Gallery of Scotland, Edinburgh)

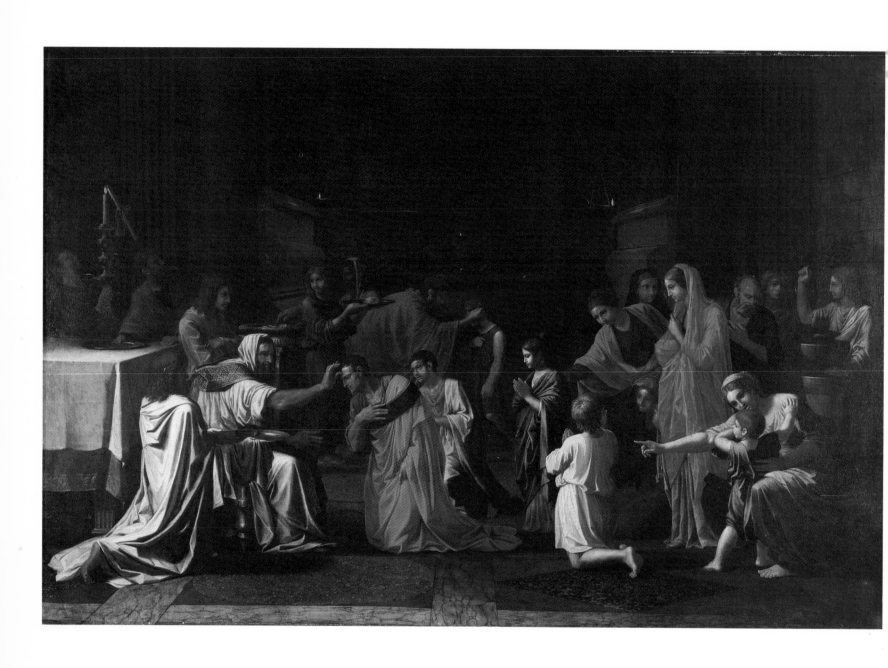

50 Confirmation, 1645
His Grace the Duke of Sutherland
(On loan to the National Gallery of Scotland, Edinburgh)

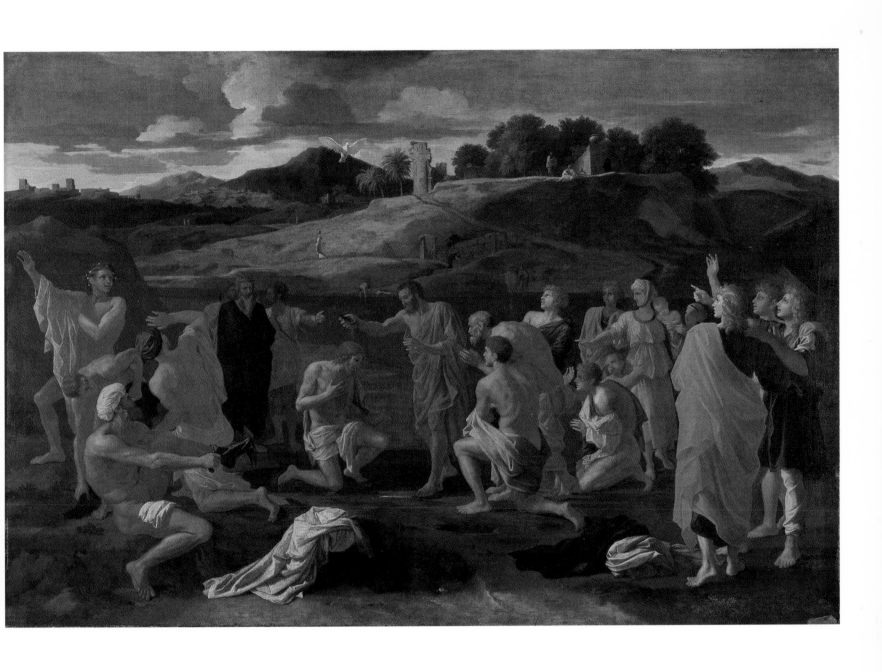

51 *Baptism*, 1646
His Grace the Duke of Sutherland
(On loan to the National Gallery of Scotland, Edinburgh)

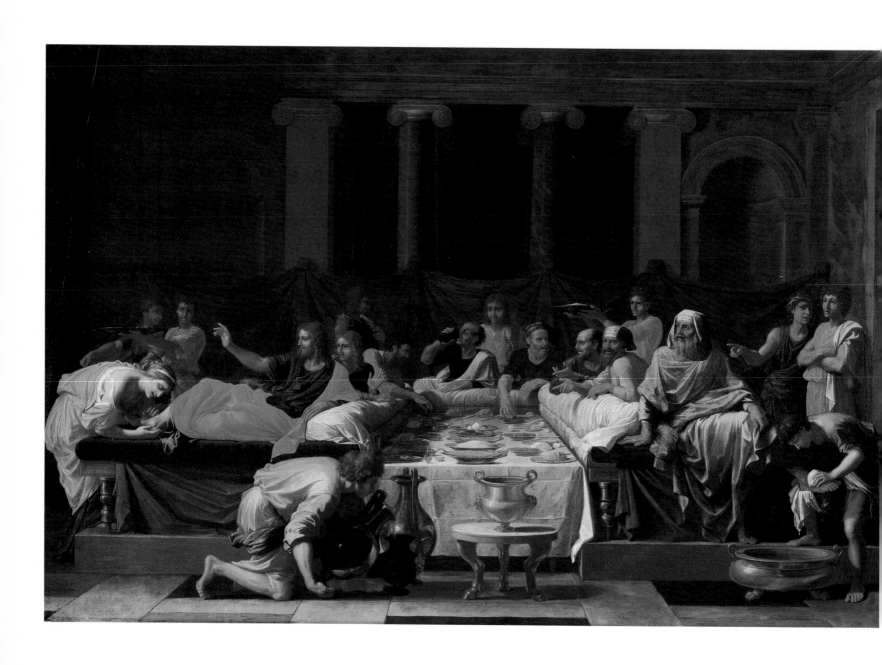

52 *Penance*, 1647
His Grace the Duke of Sutherland
(On loan to the National Gallery of Scotland, Edinburgh)

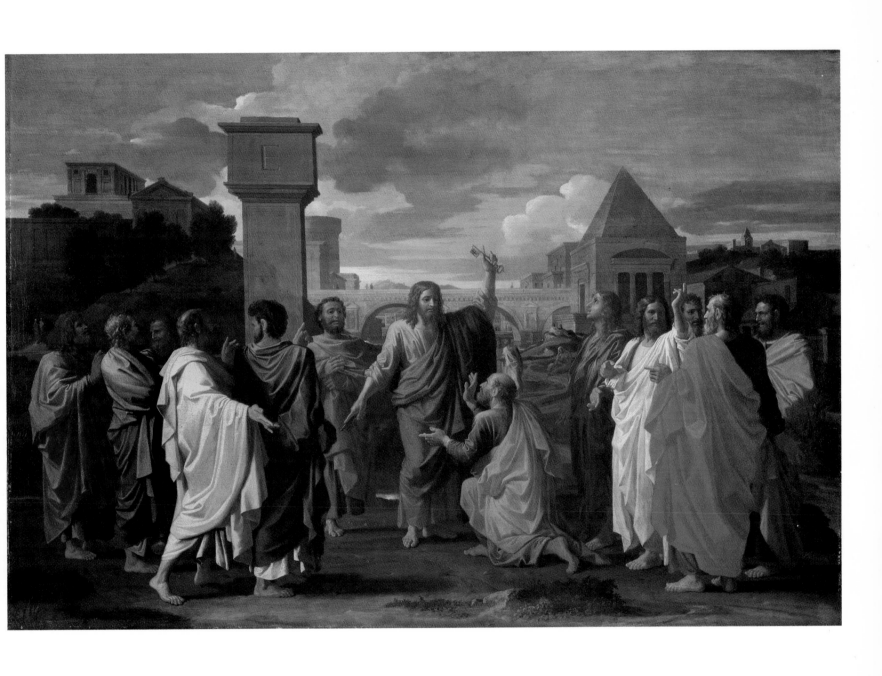

53 *Ordination*, 1647
His Grace the Duke of Sutherland
(On loan to the National Gallery of Scotland, Edinburgh)

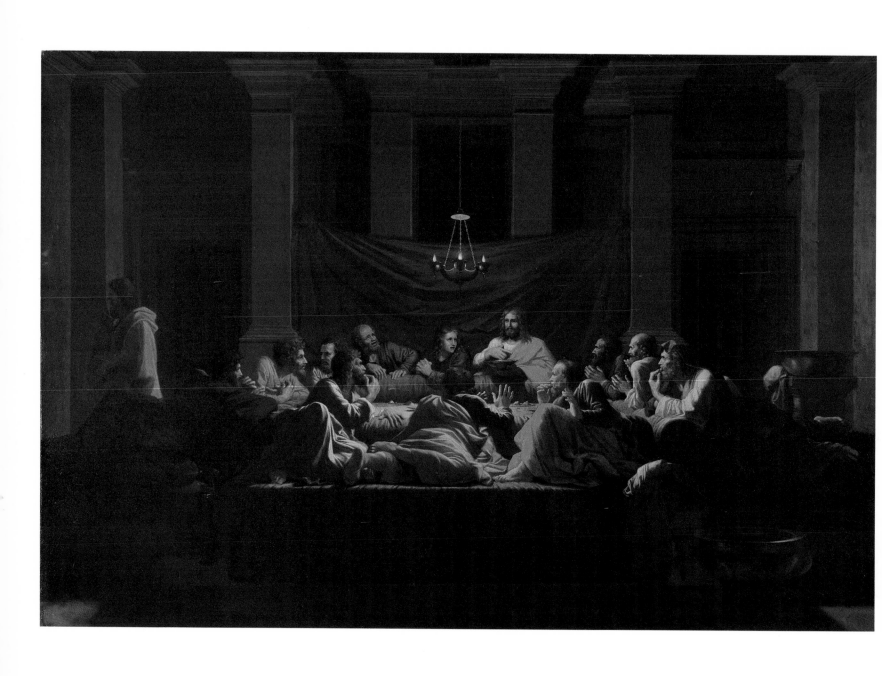

54 *Eucharist*, 1647
His Grace the Duke of Sutherland
(On loan to the National Gallery of Scotland, Edinburgh)

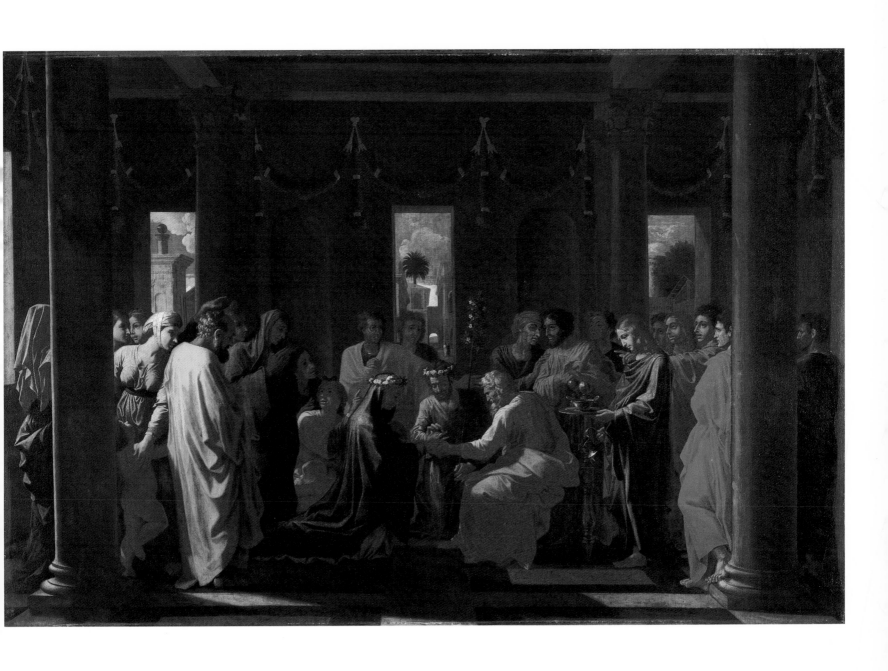

55 *Marriage*, 1647-8
His Grace the Duke of Sutherland
(On loan to the National Gallery of Scotland, Edinburgh)

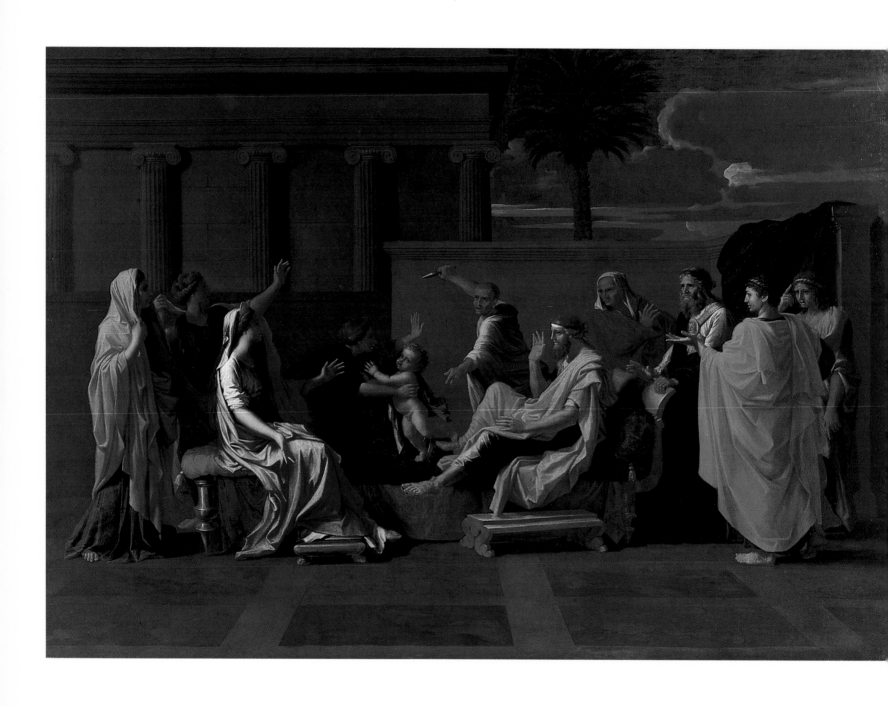

56 Moses Trampling on Pharoah's Crown, c. 1645
The Marquess of Tavistock and the Trustees of the Bedford Estate

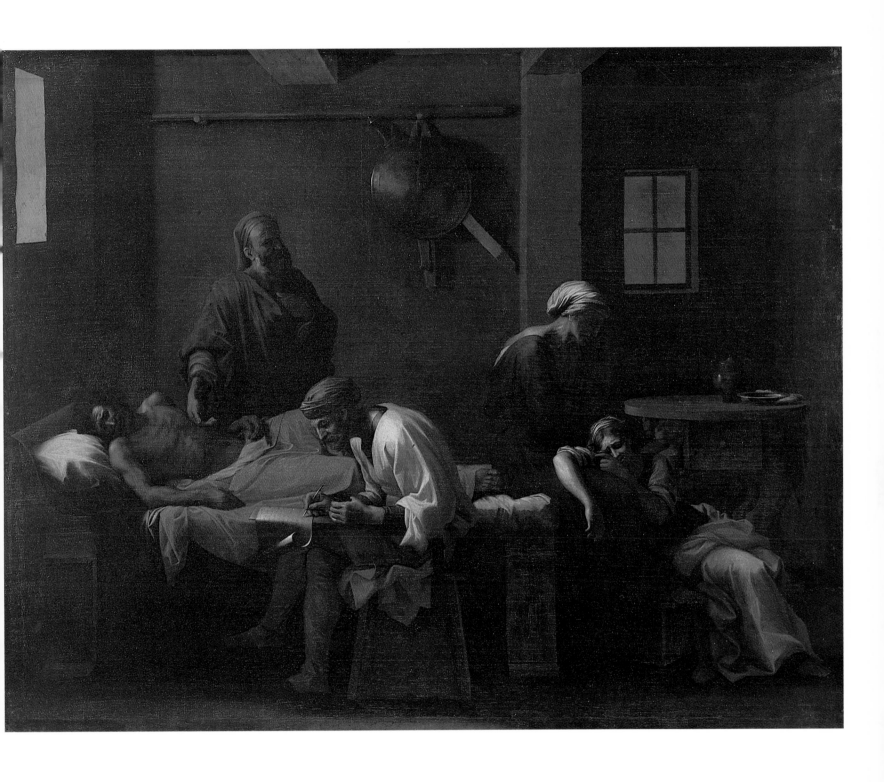

58 The Testament of Eudamidas, c. 1645-50
Den Kongelige Maleri- og Skulptursamling, Statens Museum for Kunst, Copenhagen

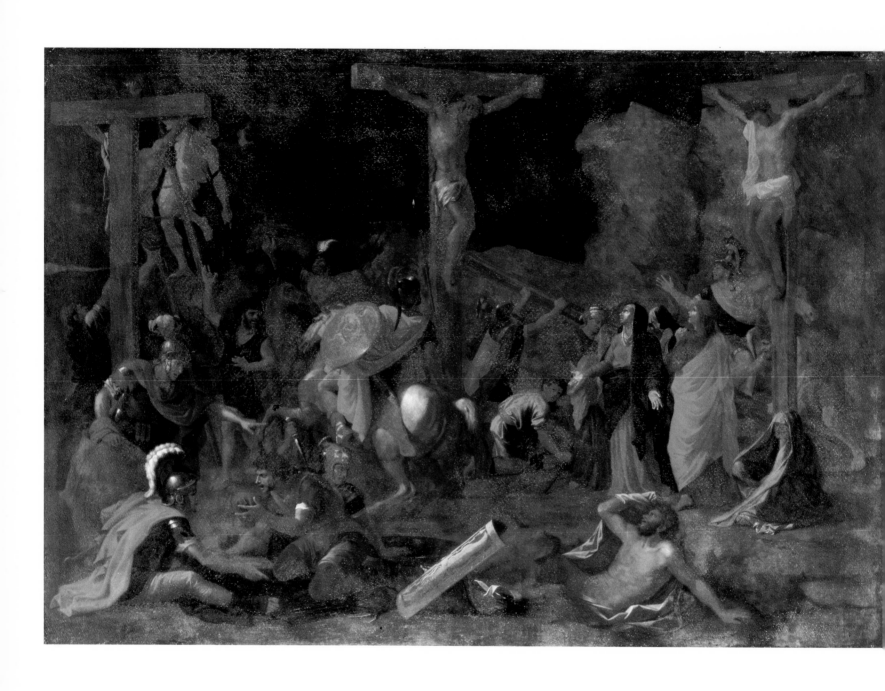

57 *The Crucifixion,* c. 1645-6
Wadsworth Atheneum, Hartford, Connecticut
The Ella Gallup Sumner and Mary Catlin Sumner Collection Fund

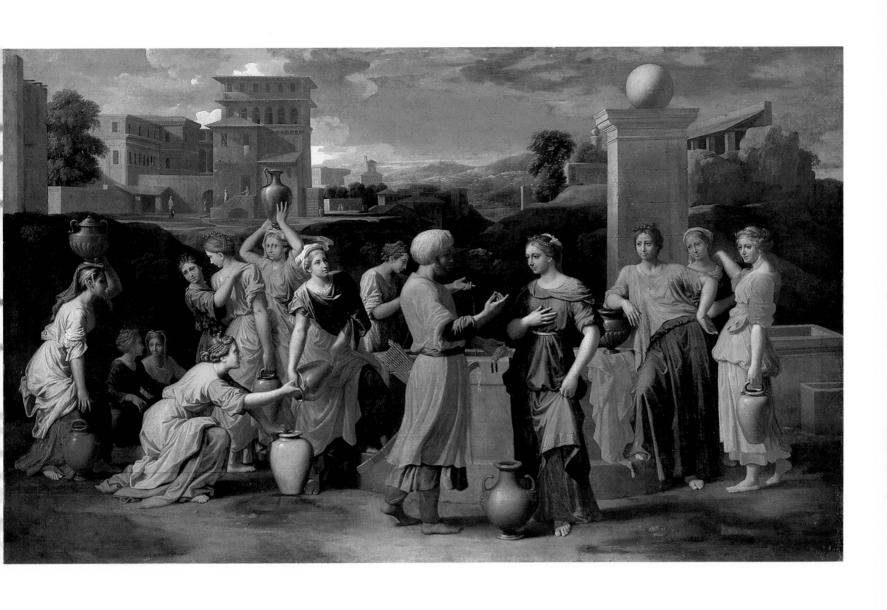

59 *Eliezer and Rebecca*, 1648
Musée du Louvre, Département des Peintures, Paris

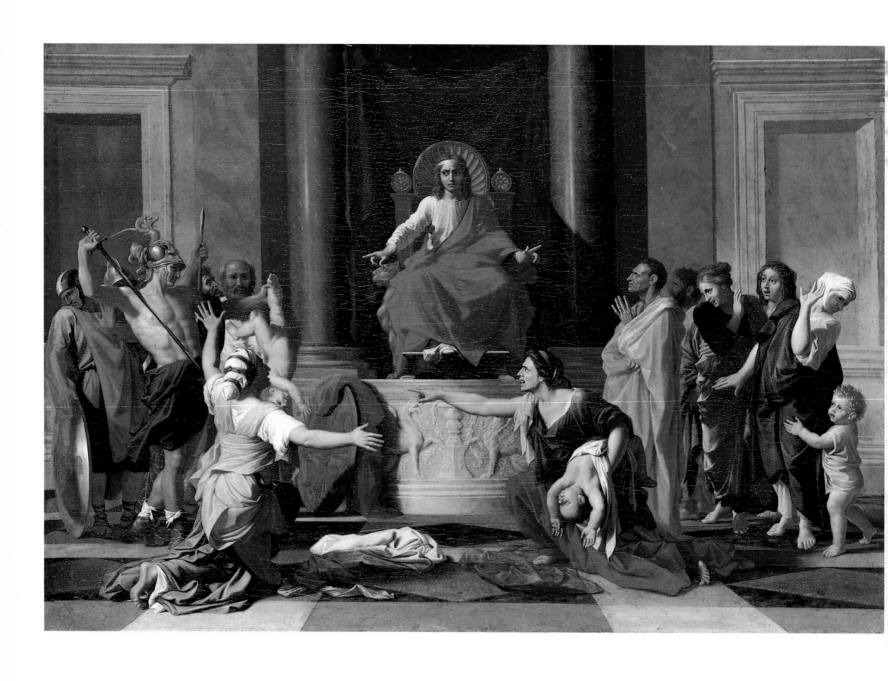

62 The Judgement of Solomon, 1649
Musée du Louvre, Département des Peintures, Paris

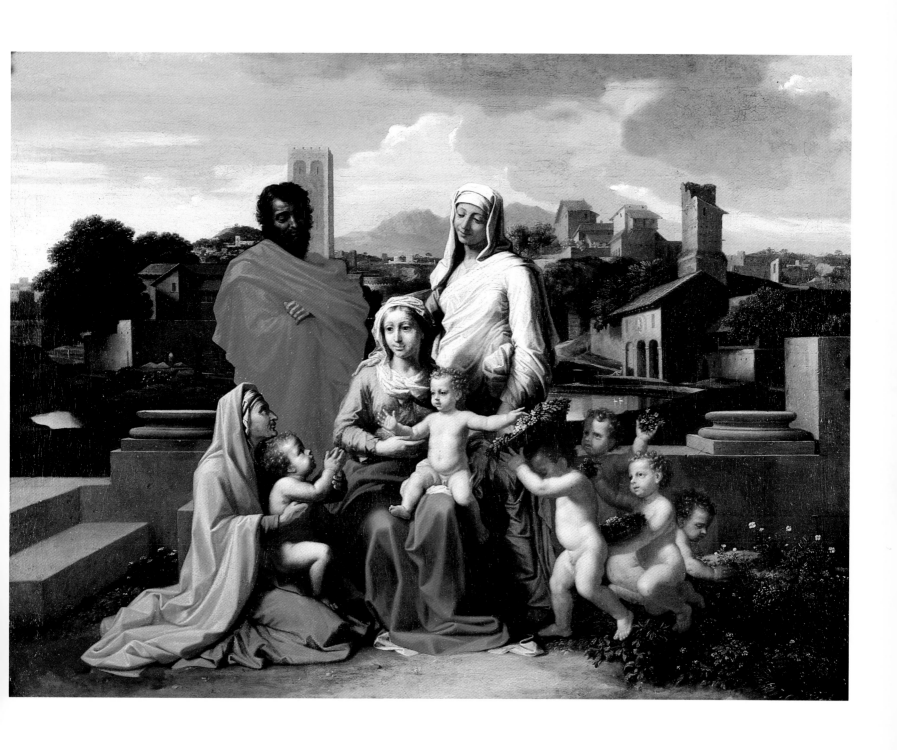

61 *The Holy Family with Ten Figures*, 1649
The National Gallery of Ireland, Dublin

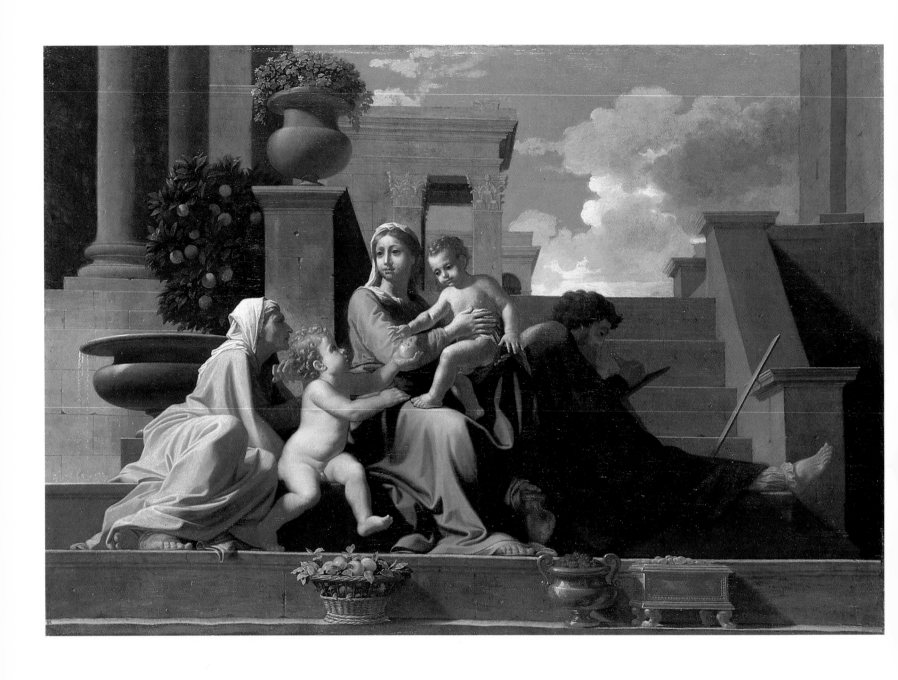

60 *The Holy Family on the Steps*, 1648
The Cleveland Museum of Art, Leonard C. Hanna Jr., Fund

65 *The Ecstasy of St Paul*, 1649-50
Musée du Louvre, Département des Peintures, Paris

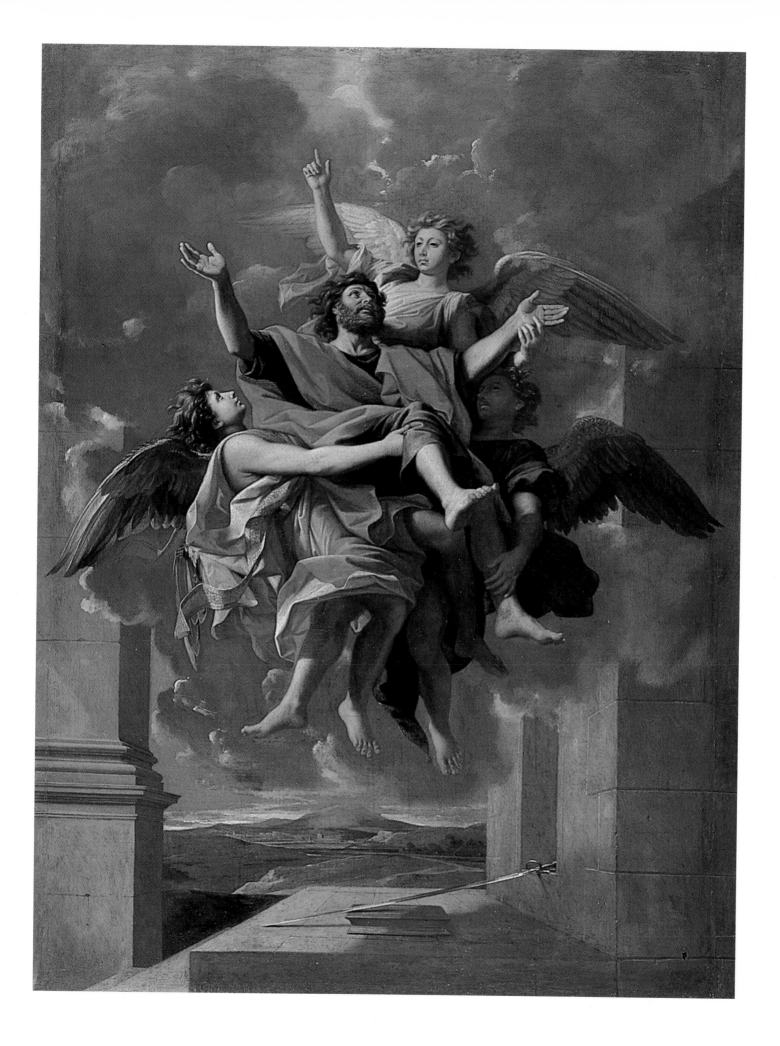

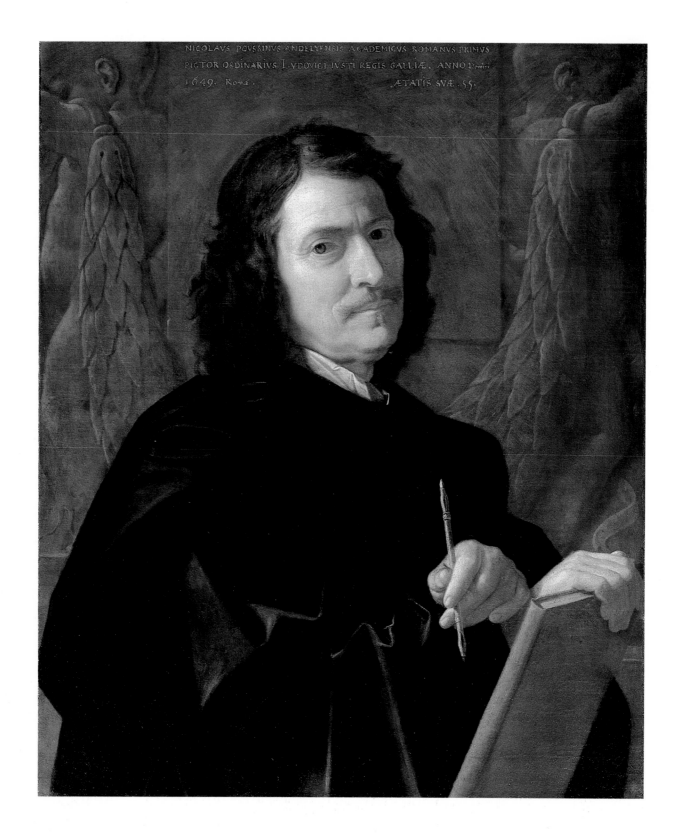

NICOLAVS POVSSINVS ANDELYENSIS ACADEMICVS ROMANVS PRIMVS
PICTOR ORDINARIVS LVDOVICI IVSTI REGIS GALLIÆ, ANNO Domini
1649. Roma. ÆTATIS SVÆ 55.

63 *Self-Portrait,* 1649
Staatliche Museen zu Berlin, Preußischer Kulturbesitz, Gemäldegalerie

64 *Self-Portrait,* 1649-50
Musée du Louvre, Département des Peintures, Paris

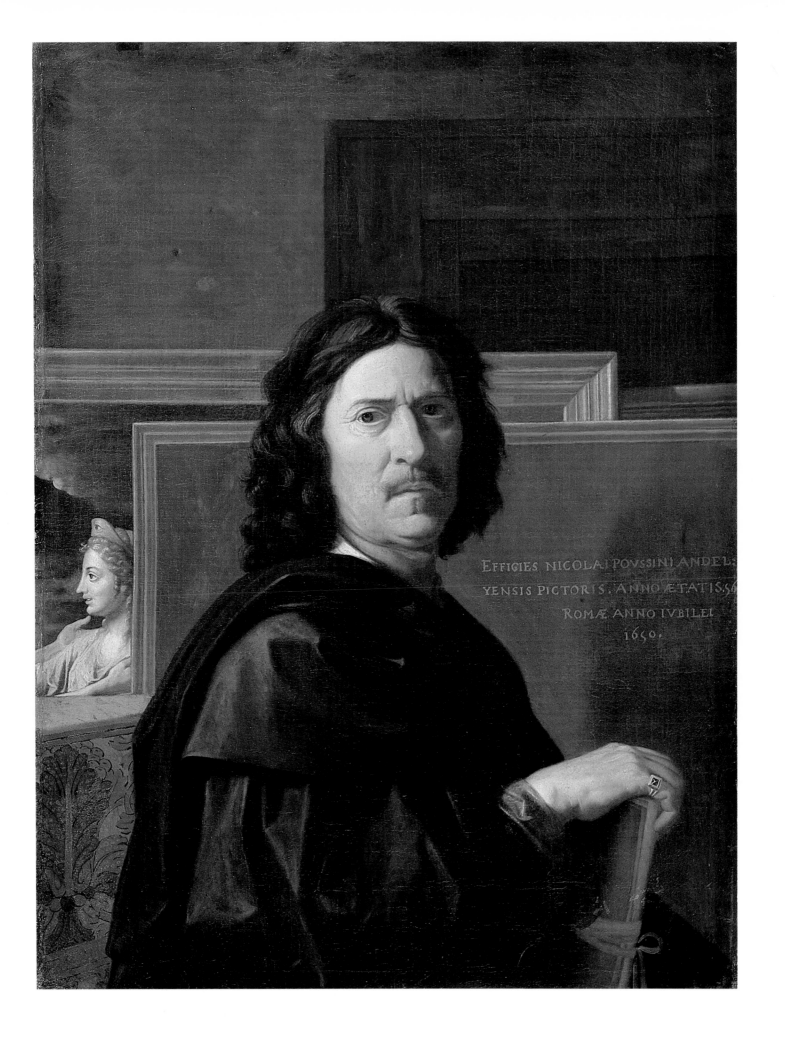

EFFIGIES NICOLAI POVSSINI ANDEL:
YENSIS PICTORIS. ANNO ÆTATIS 56
ROMÆ ANNO IVBILEI
1650.

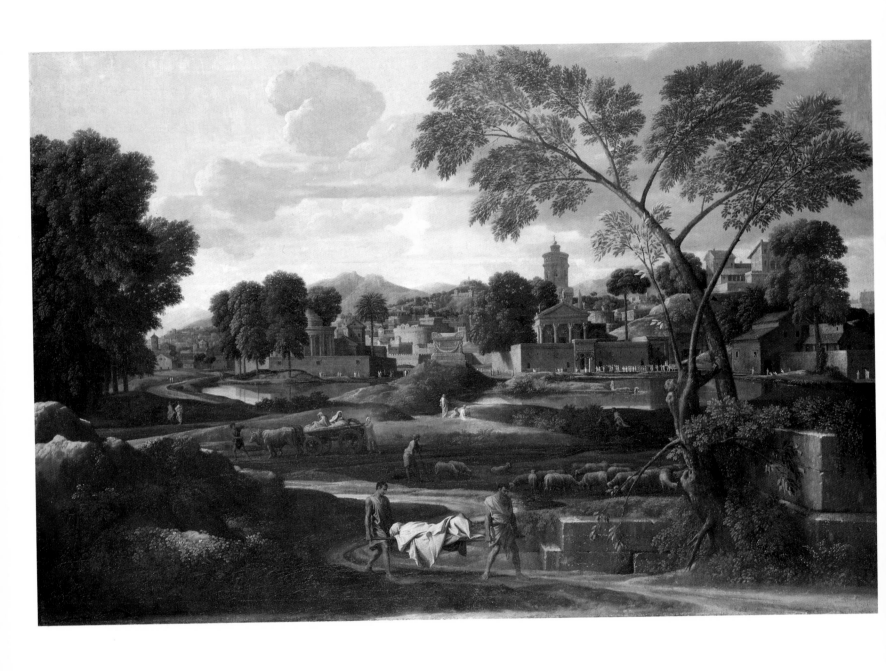

67 Landscape with the Body of Phocion Carried out of Athens, 1648
The Earl of Plymouth (on loan to the National Museum of Wales, Cardiff)

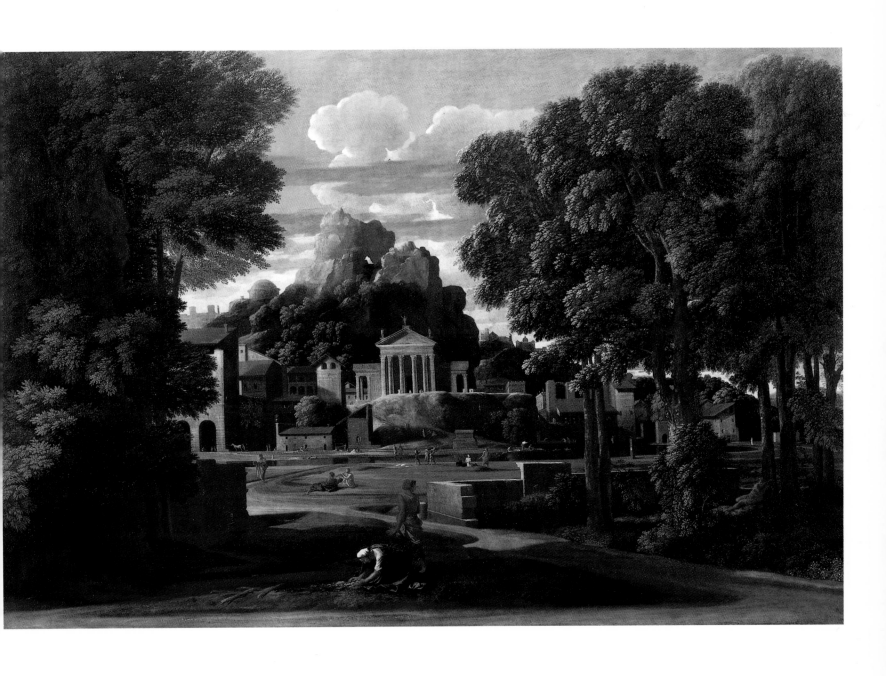

68 Landscape with the Ashes of Phocion Collected by his Widow, 1648
Trustees of the National Museums and Galleries on Merseyside
(Walker Art Gallery, Liverpool)

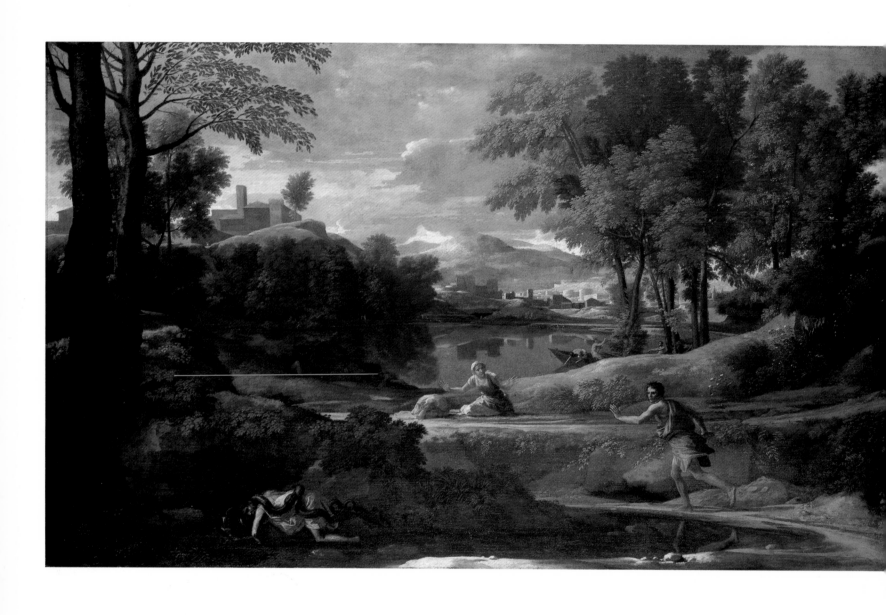

69 Landscape with a Man Killed by a Snake, 1648
The Trustees of the National Gallery, London

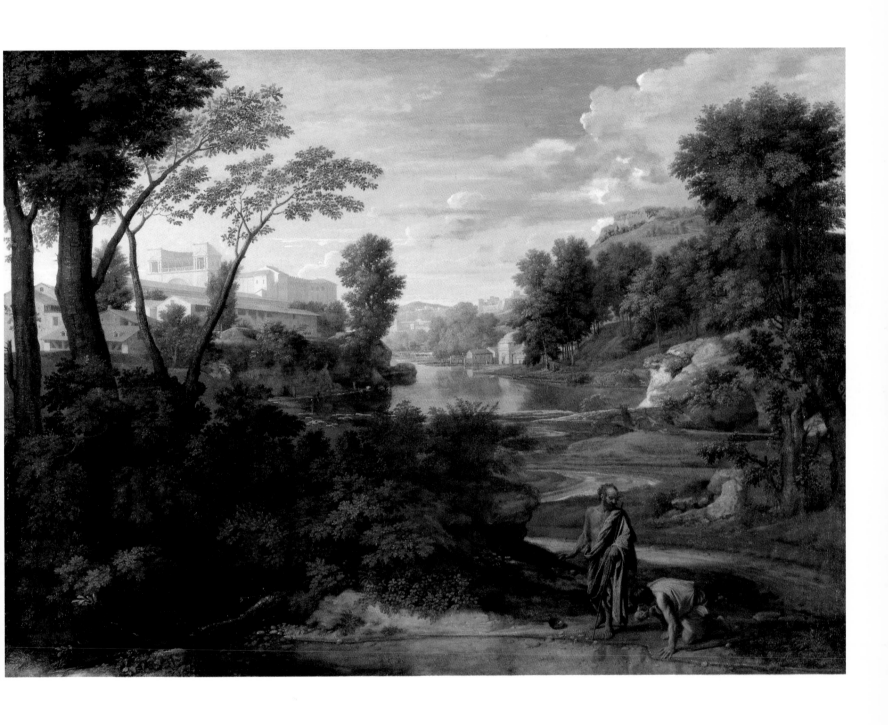

70 *Landscape with Diogenes,* 1648
Musée du Louvre, Département des Peintures, Paris

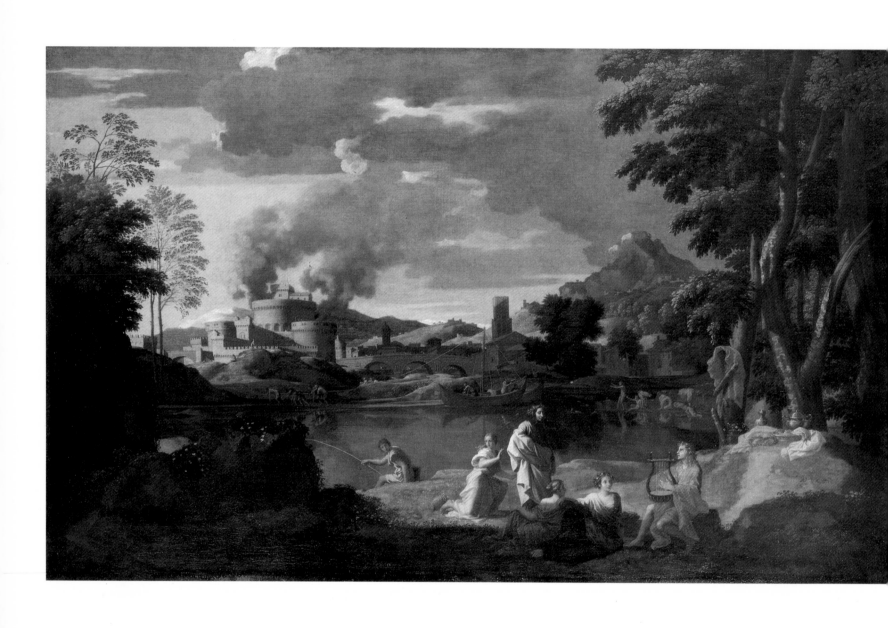

71 Landscape with Orpheus and Eurydice, c. 1650
Musée du Louvre, Département des Peintures, Paris

72 Landscape with Buildings, c. 1650-1
Museo del Prado, Madrid

73 Landscape with a Calm, 1651
Sudeley Castle Trustees

74 Landscape with a Storm, 1651
Musée des Beaux-Arts, Rouen

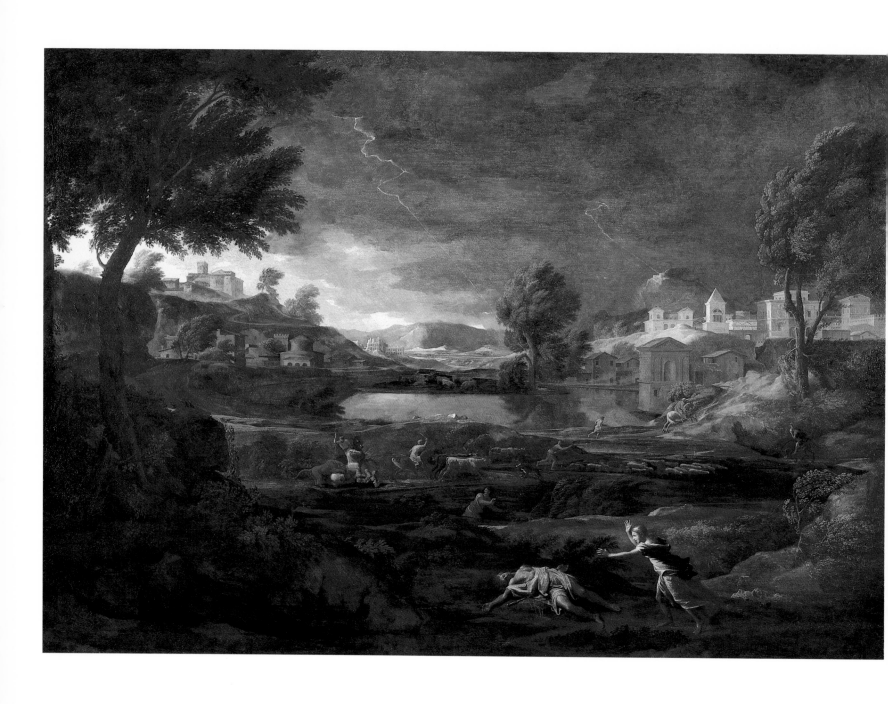

75 Landscape with Pyramus and Thisbe, 1651
Städelsches Kunstinstitut, Frankfurt am Main

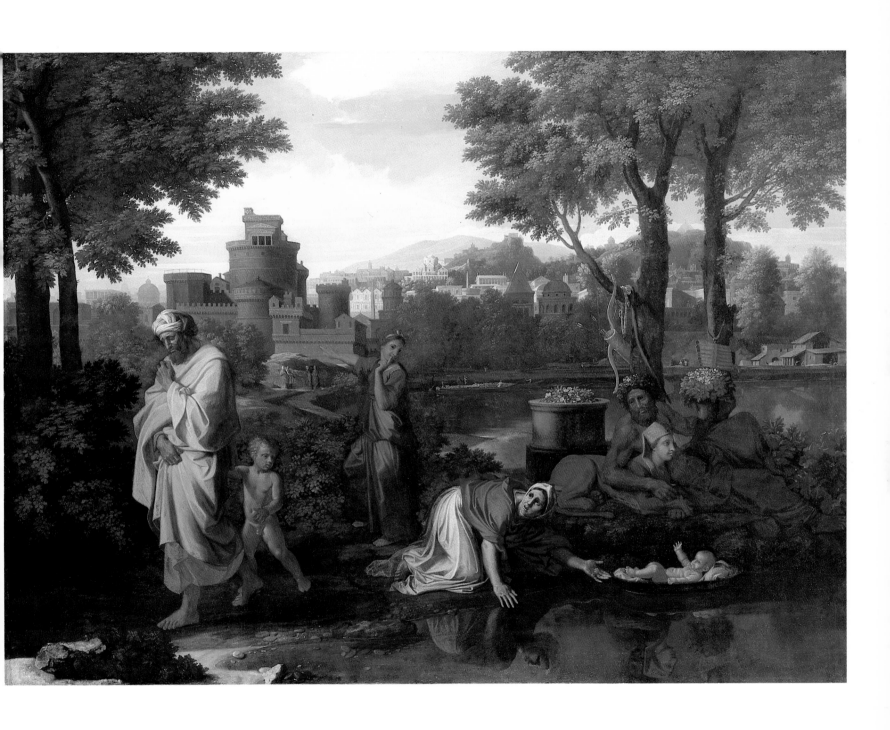

77 The Exposition of Moses, 1654
The Visitors of the Ashmolean Museum, Oxford

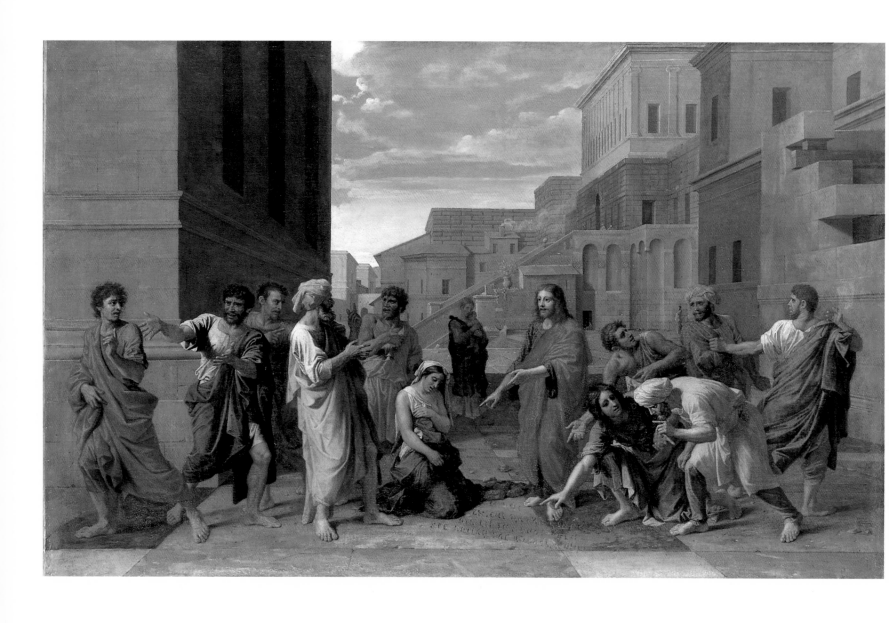

76 Christ and the Woman taken in Adultery, 1653
Musée du Louvre, Département des Peintures, Paris

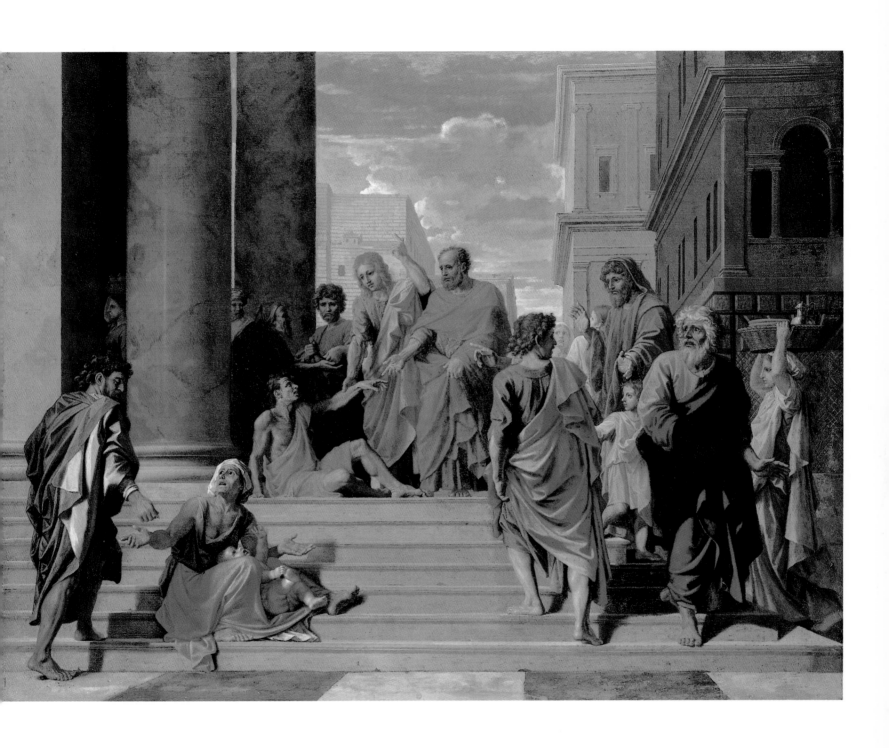

78 St Peter and St John Healing the Lame Man, 1655
Lent by The Metropolitan Museum of Art, New York
Purchase, Marquand Fund, 1924

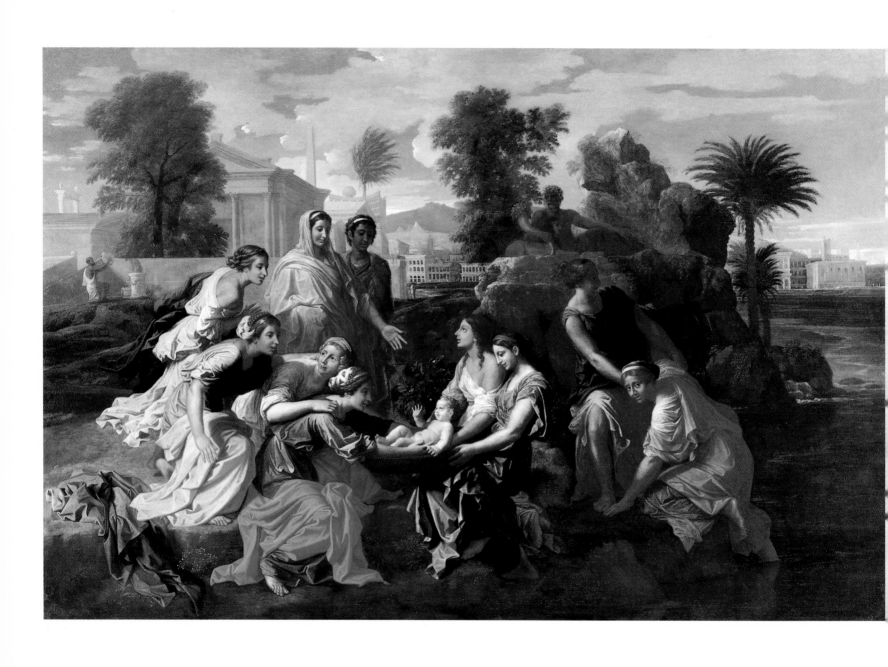

66 The Finding of Moses, 1651
The Trustees of the National Gallery, London, and the National Museum of Wales, Cardiff
(purchased with a Contribution from the National Art Collections Fund)

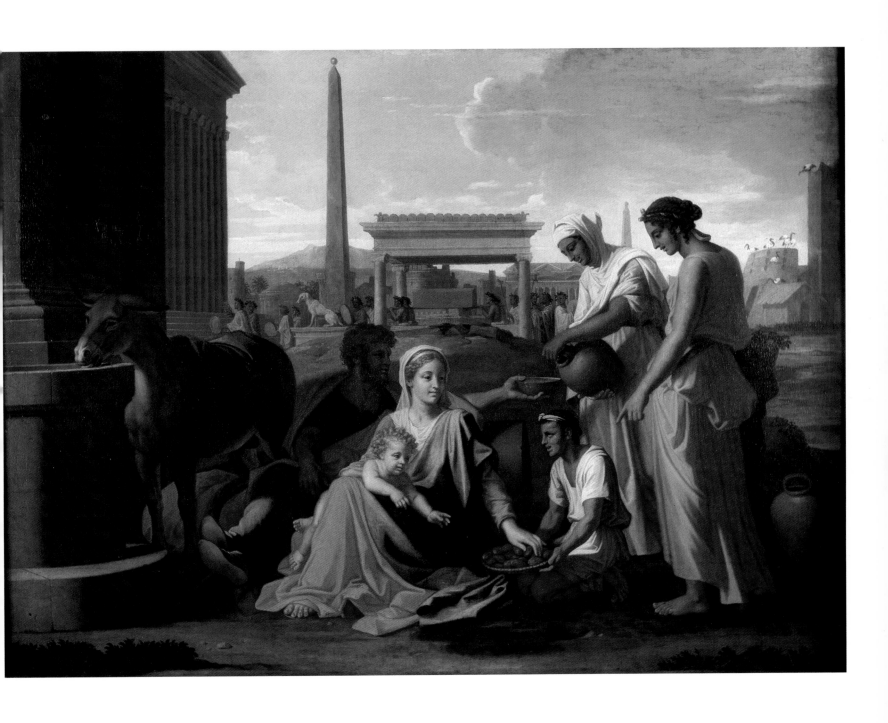

80 *The Holy Family in Egypt*, 1655-7
The Hermitage Museum, St Petersburg

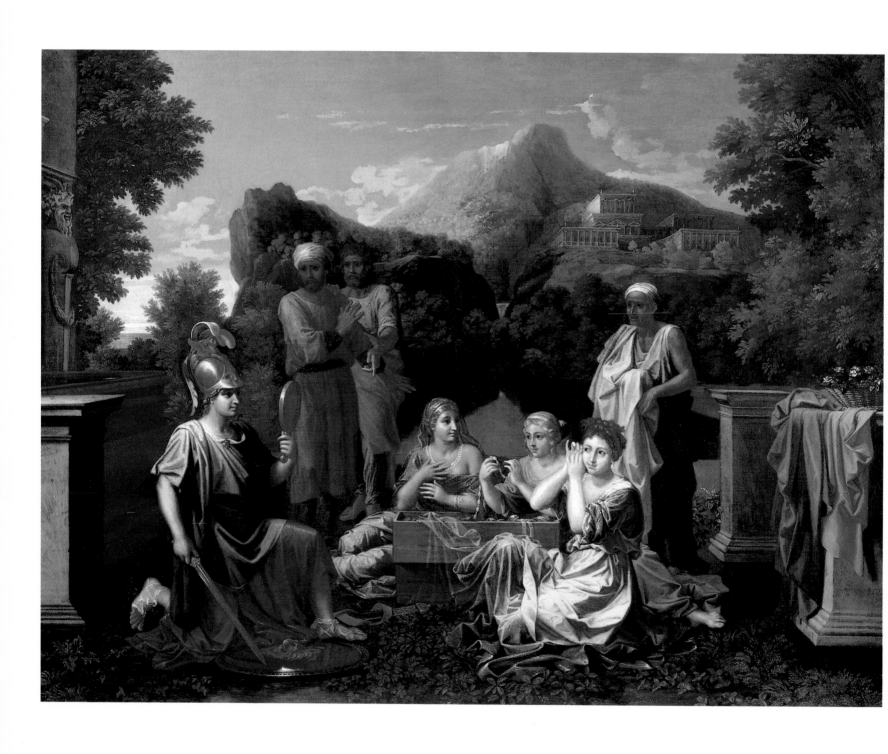

79 *Achilles among the Daughters of Lycomedes,* 1656
Virginia Museum of Fine Arts, Richmond
The Arthur and Margaret Glasgow Fund

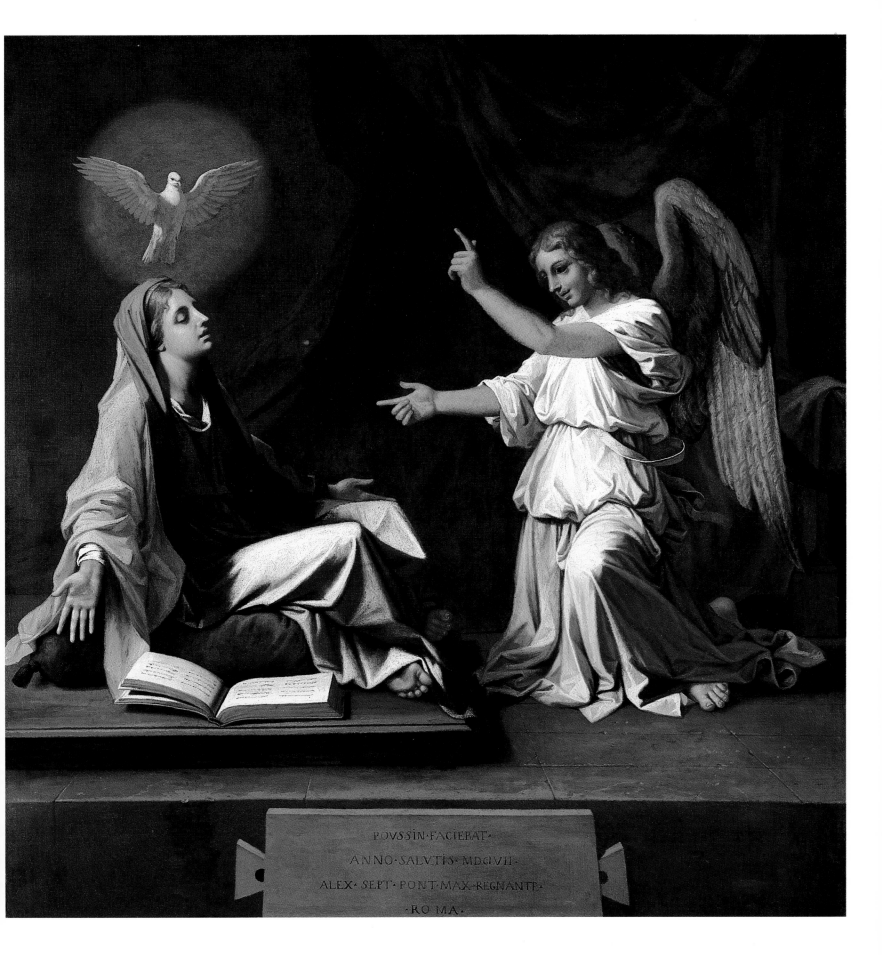

POVSSIN·FACIEBAT·
ANNO·SALVTIS·MDCLVII·
ALEX·SEPT·PONT·MAX·REGNANTE·
·RO MA·

81 *The Annunciation,* 1657
The Trustees of the National Gallery, London

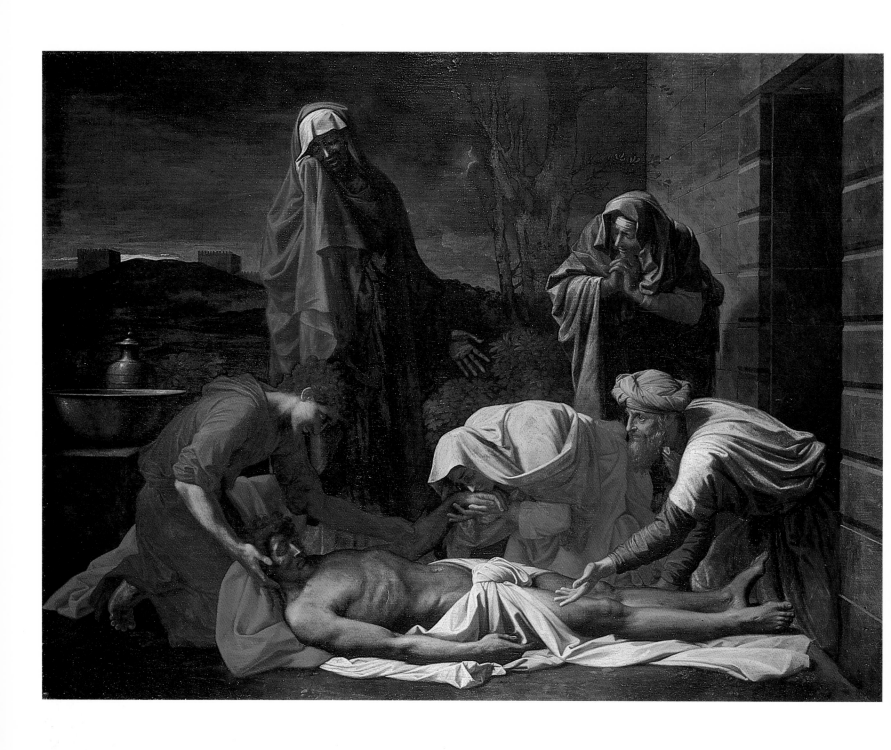

82 *The Lamentation over the Dead Christ, c.* 1656-8
The National Gallery of Ireland, Dublin

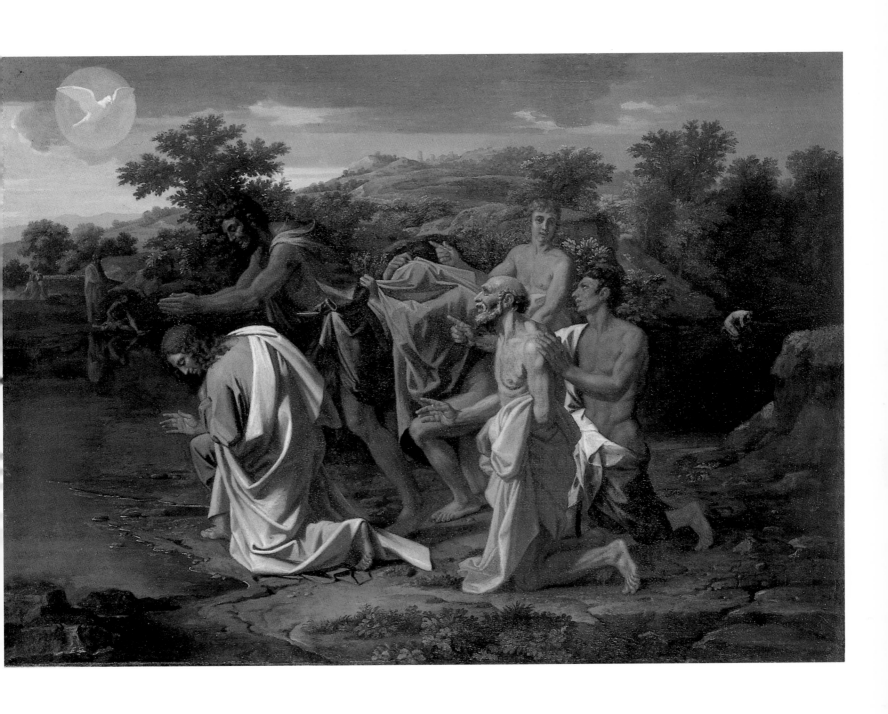

85 *The Baptism of Christ, c.* 1658
The Philadelphia Museum of Art
The John G. Johnson Collection

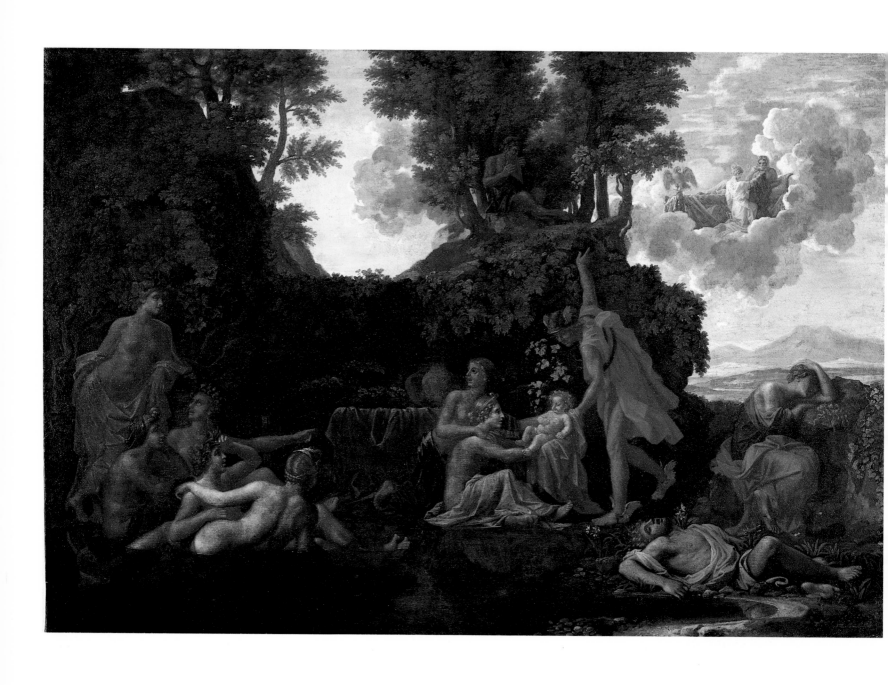

83 *The Birth of Bacchus, 1657*
Fogg Art Museum, Harvard University Art Museums, Cambridge, Massachusetts
Gift of Mrs Samuel Sachs in memory of her husband

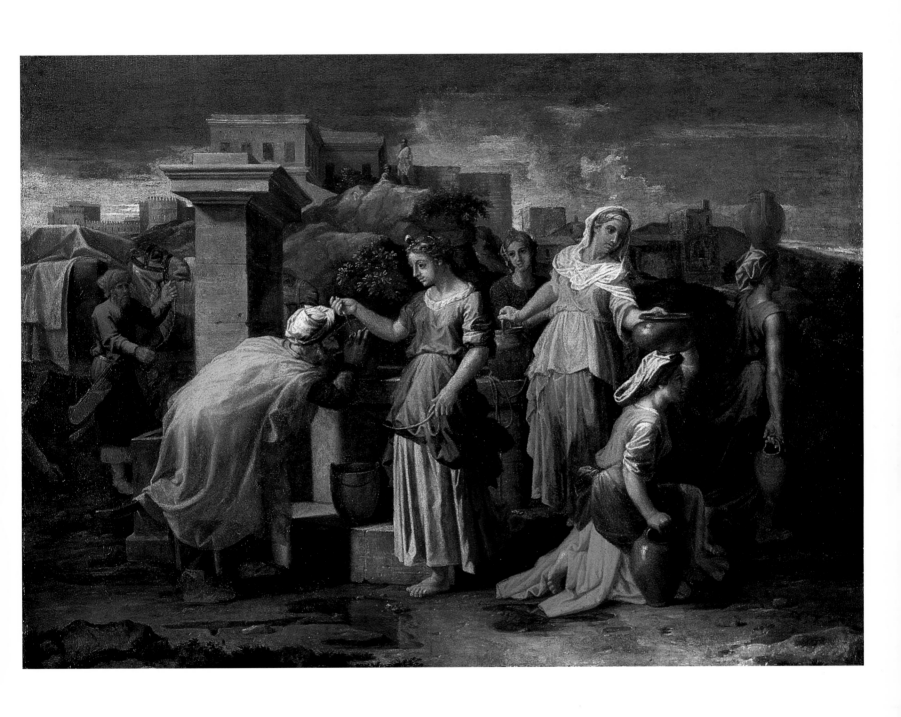

87 Eliezer and Rebecca, c. 1660-2
Lent by the Syndics of the Fitzwilliam Museum, Cambridge

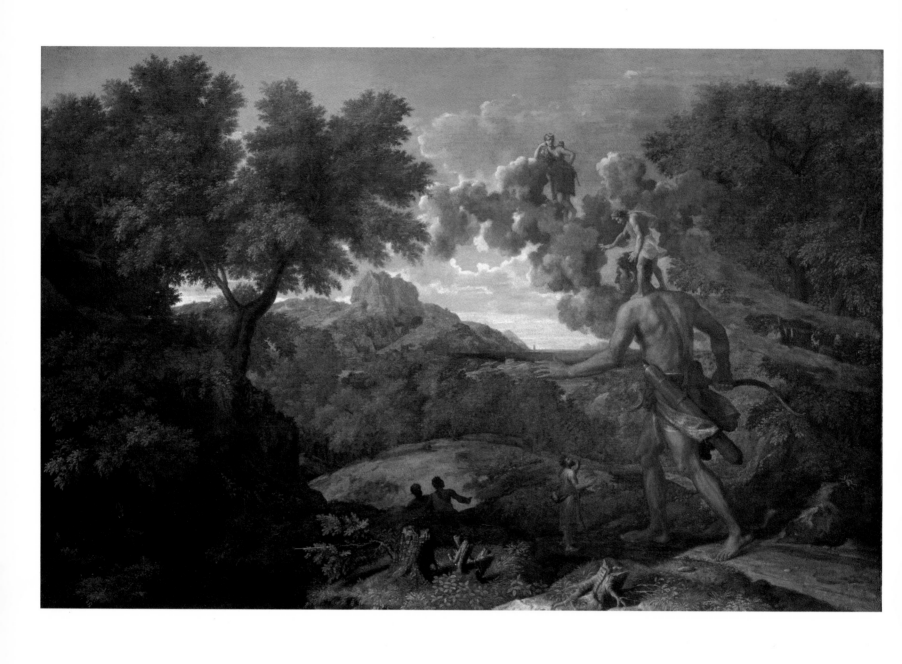

84 *Landscape with Orion,* 1658
Lent by The Metropolitan Museum of Art, New York
Fletcher Fund, 1924

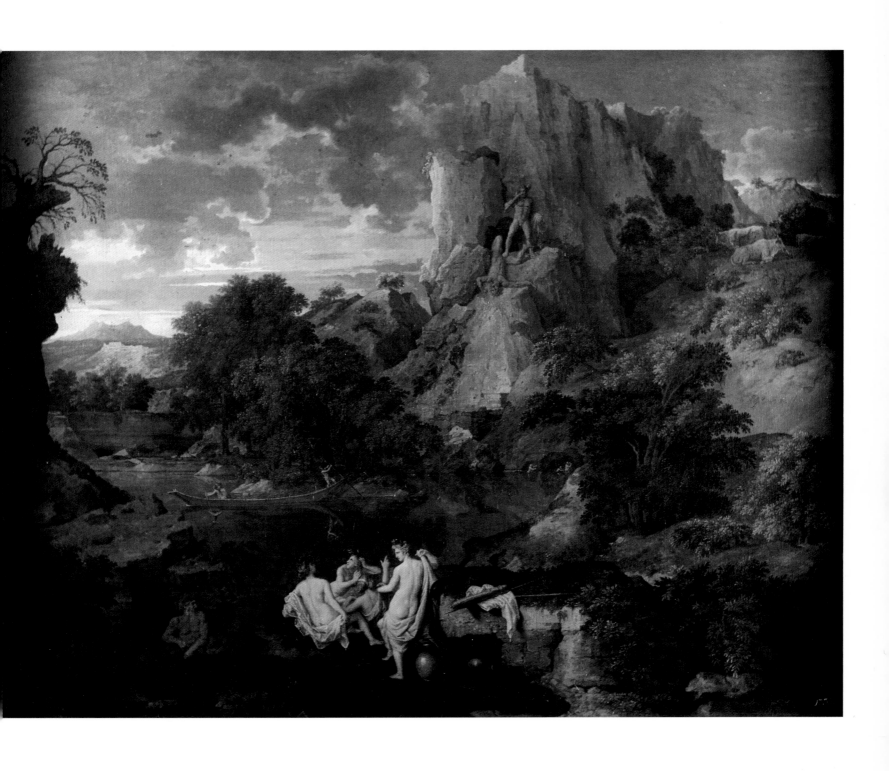

86 *Landscape with Hercules and Cacus, c.* 1660
The Pushkin Museum of Fine Arts, Moscow

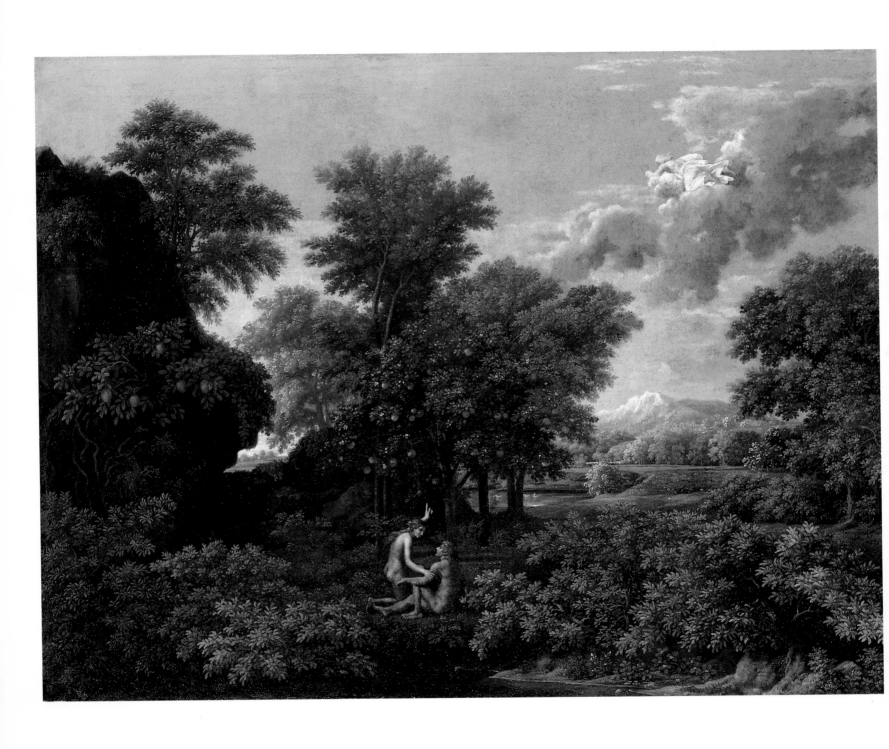

88 Spring, or the Earthly Paradise, 1660-4
Musée du Louvre, Département des Peintures, Paris

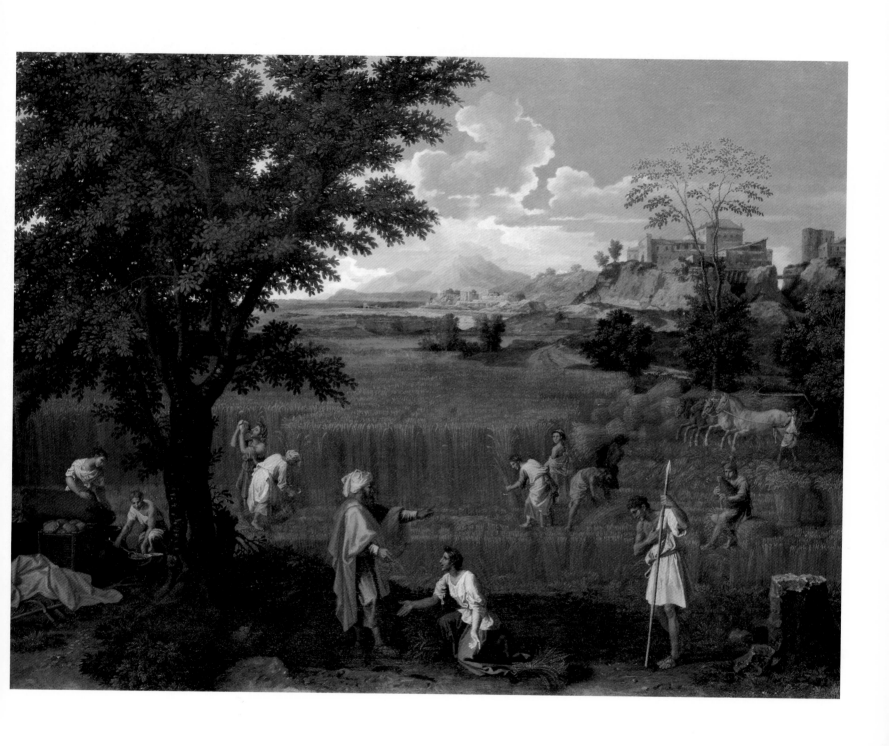

89 *Summer, or Ruth and Boaz*, 1660-4
Musée du Louvre, Département des Peintures, Paris

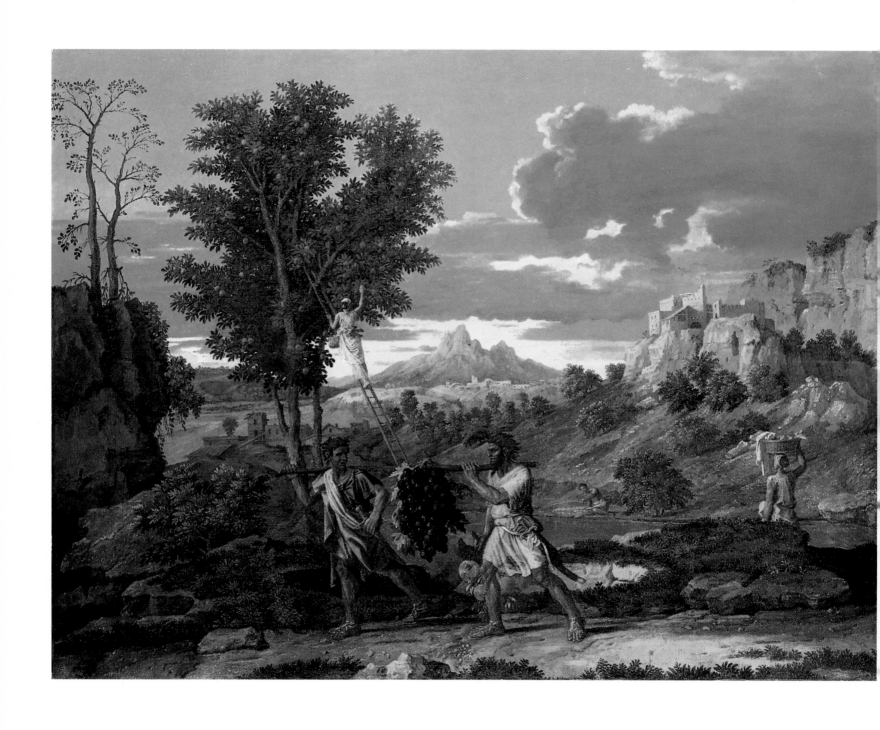

90 *Autumn, or The Spies with the Grapes from the Promised Land,* 1660-4
Musée du Louvre, Département des Peintures, Paris

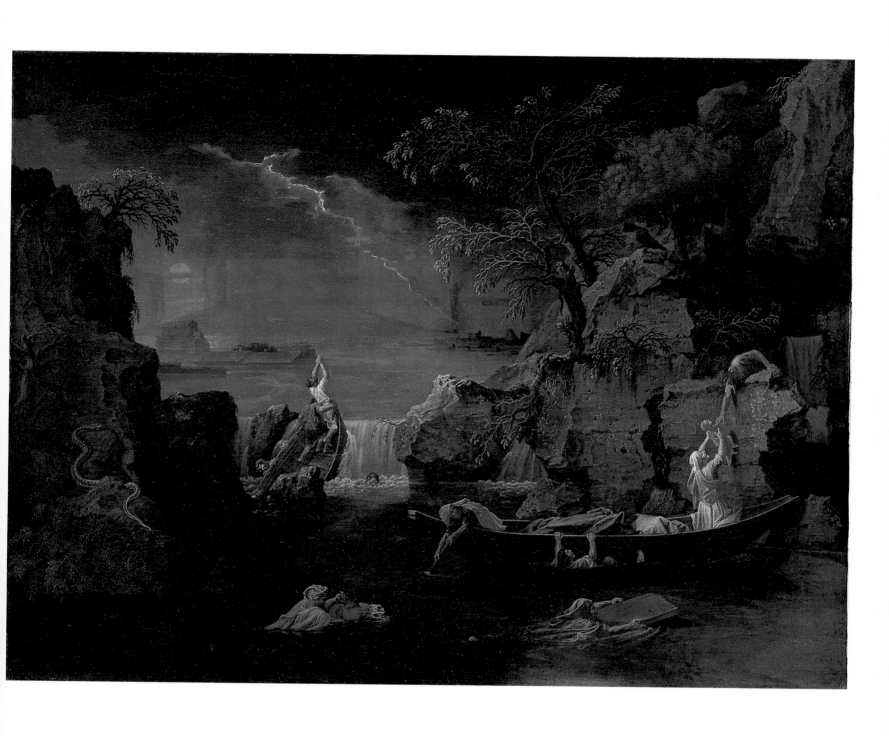

91 *Winter, or The Deluge*, 1660-4
Musée du Louvre, Département des Peintures, Paris

The Early Years: *c.* 1624–32

When Poussin arrived in Rome in March 1624, he was nearly thirty years old and still very inexperienced as an artist. Unlike Bernini, Velázquez or Van Dyck, he had not been a teenage prodigy; rather, he was a late developer. Though the drawings executed for Marino in 1622–3 reveal an innate dramatic gift, they are conceived in a variety of styles of scant originality based on the artistic sources available to Poussin in Paris. In some (fig. 37), the artist employs the familiar Mannerist device of contrasting a large foreground figure with a smaller group in the distance; in others, the composition is arranged in a shallow, frieze-like manner which recalls the art of Raphael and his school. Though the battle scenes (fig. 30) employ a mixture of styles, their preference for counterbalancing diagonals and parallel poses is also fundamentally classical in character and confirms Bellori's assertion that it was the art of Raphael and Giulio Romano that made the deepest impression upon the young Poussin.

Once in Rome, Poussin must initially have been overwhelmed by the range of styles and sources available to him. In addition to the art of antiquity and the Renaissance, there was the newly emerging style of the Baroque which, under the pontificate of Urban VIII (1623–44), would be employed to reaffirm the power and supremacy of the Counter-Reformation Church in an unprecedented number of building and decorative commissions throughout the city. In the year of Poussin's arrival, the chief exponent of this style, Bernini, began work on that triumphant symbol of resurgent Catholicism, the Baldacchino in St Peter's. During Poussin's forty years in Rome, he would witness Bernini's transformation of many of the city's churches and palaces into marvels of Baroque illusionism and theatricality (cf. fig. 168) that were the antithesis of his own art.

Roman painting of these years must have struck Poussin as bewilderingly diverse in style. Caravaggio's trenchant realism lived on in the works of a small group of artists, among them Poussin's countrymen Valentin de Boullogne (fig. 46) and Simon Vouet. Opposed to this manner was the bold and forthright classicism of Annibale Carracci (fig. 88) and his school, represented by his pupil Domenichino (fig. 66, 106) and by Andrea Sacchi, both of whom practised a style of sobriety and restraint which took as its models Raphael and the antique. But the dominant mode of painting when Poussin arrived in Rome was one which accorded more closely with the vigorously dramatic art of Bernini. This was exemplified by the daring illusionism of Giovanni Lanfranco and the vehement and extrovert art of Pietro da Cortona (fig. 90), whose masterpiece of 1633–9 – the ceiling of the Grand Salon of the Palazzo Barberini – was later to earn Poussin's disapproval.[1]

The chronology of Poussin's paintings between *c.* 1624 and 1632 is difficult to establish and has remained a notorious source of controversy among scholars. Before setting forth my own views on the matter, it would be well to review the facts. The documented canvases of these years are as follows: 1625–6, the *Victory of Joshua over the Amalekites* (cat. 2) and the *Victory of Joshua over the Amorites* (cat. 3); 1625–7, the *Virgin and Child* (Art Gallery and Museums, Brighton) and

Detail from *The Triumph of David*, cat. 17

its pendant, the *Pietà* (Musée Thomas Henry, Cherbourg), painted in collaboration with Daniel Seghers;[2] 1626–8, the *Death of Germanicus* (cat. 9); 1628–9, the *Martyrdom of St Erasmus* (cat. 10); 1629–30, the *Virgin Appearing to St James* (fig. 64); 1630–1, the *Plague at Ashdod* (fig. 26) and the *Kingdom of Flora* (cat. 20). In addition, one version of *Midas at the Source of the Pactolus* (fig. 10) is recorded as having been painted by 1631. Around this core of dated pictures, some sixty other works by the artist must be arranged.

Two factors emerge from the 'random' group of canvases listed above, one concerning the themes of Poussin's pictures and the other his choice of pictorial styles. No fewer than four of the works mentioned – the *Germanicus*, *Plague*, *Flora* and *Midas* – treat themes entirely new to painting and attest to Poussin's innovative approach to pictorial subject-matter, even at this formative stage of his career. This is a characteristic of his art throughout his life, and constitutes one of his greatest claims for consideration as a profoundly original and intellectual painter. As discussed elsewhere,[3] however, its origins may be not only in the meditative nature of his artistic temperament but in the fundamental preoccupations of his life.

Viewed stylistically, the selection of canvases listed above inevitably leads one to a very different conclusion. Before finding a style that was recognisably his own, Poussin was a restless experimenter, constantly given to assimilating ideas from a wide range of sources and to varying his style accordingly. Nor does his early development necessarily follow a logical progression. Thus, he paints two full-blooded Baroque altarpieces, the *St Erasmus* and *St James*, after the *Germanicus*, a composition manifestly inspired by ancient relief sculpture. These in turn are followed by a rhetorical history painting, the *Plague*, modelled on Raphael, and a mythological canvas, the *Flora*, that has its roots in Poussin's early interest in Venetian art but is conceived in a more classicising spirit. In the face of such stylistic shifts, probably the soundest basis for constructing a chronology of his early years is not on changing styles alone but on increasing degrees of *skill*, in draughtsmanship, modelling, composition and colour. The chronological sequence of the early works proposed in the present catalogue is based on this assumption.

Fig. 20 Titian, *The Andrians*. Oil on canvas, 175 × 193 cm, *c.* 1518–19. Museo del Prado, Madrid

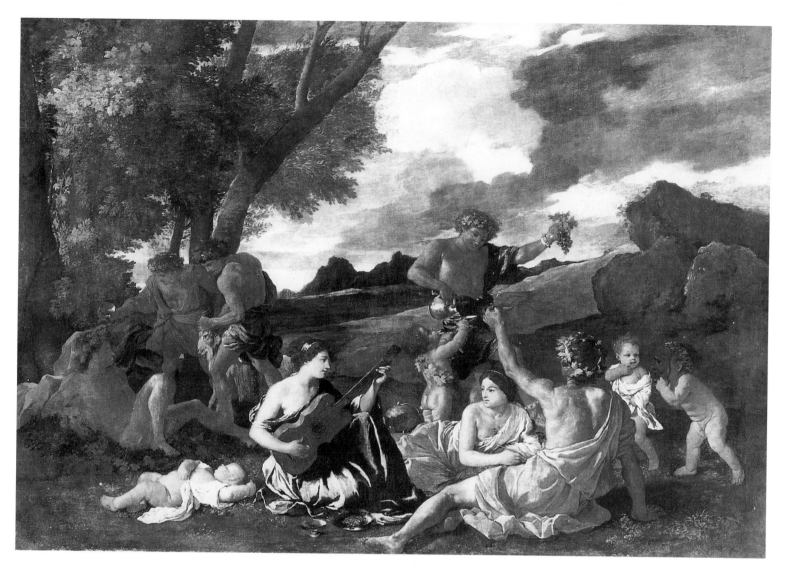

Fig. 21 Nicolas Poussin, *Bacchanal: The Andrians.* Oil on canvas, 121 × 175 cm, *c.* 1627. Musée du Louvre, Département des Peintures, Paris

Poussin began his painting career in Rome by translating the style of the Marino drawings into colour. This is the method adopted in the first version of *Cephalus and Aurora* (cat. 1) and the two battle-pieces from Russia (cat. 2–3). All of these include a multitude of figures piled into a shallow space and are painted in a limited range of hues. As such, they still rely largely upon those artistic sources Poussin had been exposed to in Paris and must date from his earliest Roman years, *c.* 1624–6.

The next group of canvases documents Poussin's first encounter with a master who was to exert a profound impact upon art throughout his early years: Titian. According to Bellori, Poussin repeatedly studied the great series of bacchanals by Bellini and Titian in the Aldobrandini and Ludovisi collections during his early years in Rome.[4] These included Bellini's *Feast of the Gods* (National Gallery of Art, Washington) and Titian's *Feast of Venus, Andrians* (fig. 20; both in the Prado, Madrid) and *Bacchus and Ariadne* (National Gallery, London). Proof of this is the existence of two small putto bacchanals by Poussin (Galleria Nazionale, Rome),[5] clearly indebted to the *Feast of Venus*, which probably date from *c.* 1626, and a canvas of *c.* 1627 of the *Andrians* (fig. 21), modelled on Titian's bacchanal of the same theme.

With their sensuous colour and lighting and erotically charged themes, these Venetian masterpieces made a deep impression upon the ardent young artist, encouraging him to adopt a more fluid and painterly manner of handling and to

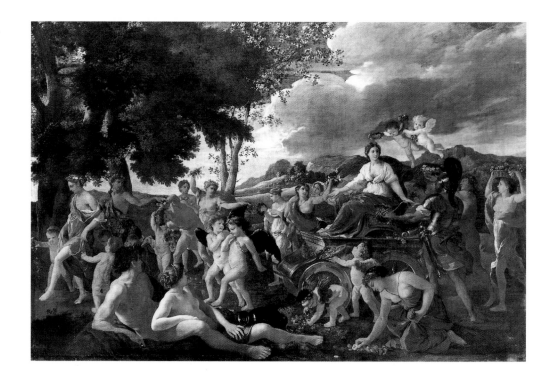

Fig. 22 Nicolas Poussin, *The Triumph of Flora.* Oil on canvas, 165 × 241 cm, *c.* 1627. Musée du Louvre, Département des Peintures, Paris

explore richer colouristic and atmospheric effects in his own canvases. The first stage of this development may be seen in a group of works of *c.* 1626–8, including *Venus with the Dead Adonis* (cat. 4), *Eliezer and Rebecca* (cat. 5) and *Acis and Galatea* (cat. 6). The masterpiece of this phase of the artist's career is the *Triumph of Flora* (*c.* 1627; fig. 22), Poussin's most ambitious attempt to revive the pagan splendour of Titian's bacchanals on a grand scale.

The importance of the colouristic art of Titian and his followers is evident in a succession of later canvases by Poussin, which progress from the robust to the refined and culminate in such exquisitely wrought works as *Diana and Endymion* (cat. 19) and *Tancred and Erminia* (cat. 21) of *c.* 1630–1. In addition to emulating the painterly style and lyrical themes of the Venetian masters, Poussin also adopted their pictorial practices in these pictures. Few drawings

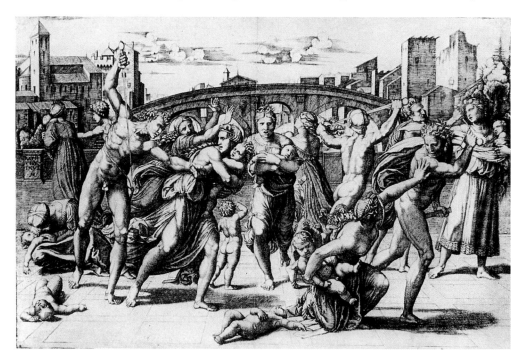

Fig. 23 Marcantonio Raimondi (*after* Raphael), *The Massacre of the Innocents.* Engraving, 28.3 × 43.4 cm. The Trustees of the British Museum, London

146

survive for any of them, and a number include prominent pentimenti. This suggests that the artist worked out the designs directly on the canvas, following the spontaneous methods of execution favoured by his Venetian predecessors.

At the same time as Poussin was exploring the naturalism of Venetian art, he was also attracted to the more cerebral style of Raphael, the antique and the classicising masters of his own day, above all Domenichino. During his first years in Rome he is recorded as admiring Domenichino's fresco of the *Flagellation of St Andrew* (fig. 66), while the majority of his contemporaries preferred a rival composition by the more decorative master, Guido Reni.[6] In 1627, he based the *Death of Germanicus* (cat. 9) upon the study of antique sculpture; and around the same time, he painted his earliest canvas in homage to Raphael. This is the stark and chilling *Massacre of the Innocents* (fig. 24) of *c.* 1627–8, which derives from an engraving of the same theme (fig. 23) after a design by Raphael. In contrast to the Venetian-inspired mythologies of these years, both works were preceded by a series of preparatory drawings, which reveal the artist gradually refining the composition, i.e. exactly the method of Raphael and his school. Thus, Poussin served his apprenticeship in Rome by assimilating the styles of the two great and opposed traditions of Renaissance art: the sensuous and intuitive manner of Titian and the classical and rational style of Raphael and his followers. Moreover, the subjects that he chose to treat in these two styles were themselves very different, with those in the Venetian mode being romantic in character and those in the classical style, stern and severe. On two occasions, however, he set himself the challenge of treating the same theme in both styles. These were the *Triumph of David* (cat. 17, 24) and the *Inspiration of the Poet* (cat. 14, 18); and the results in each case were either lyric or epic.

The commission for the two large altarpieces of these years (cat. 10, fig. 64)

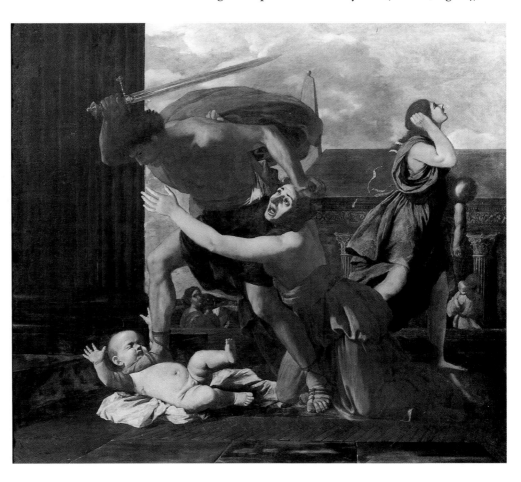

Fig. 24 Nicolas Poussin, *The Massacre of the Innocents.* Oil on canvas, 148 × 174.5 cm, *c.* 1627–8. Musée Condé, Chantilly

also encouraged Poussin to emulate the more vigorous and exuberant style of Roman Baroque art of this period, with its dynamic compositional schemes and daring foreshortenings. Though this approach had little lasting impact upon his art, it may also be seen in a number of his easel paintings of this period, such as the *Arcadian Shepherds* (cat. 13) and the *Holy Family with St John Holding the Cross* (fig. 2).

Around 1630, Poussin's art underwent a perceptible shift towards the classical style of Raphael, while still retaining certain Venetian elements. This development is apparent in a key transitional work of this period, the *Inspiration of the Epic Poet* (cat. 18), in which a group of self-consciously noble and idealised figures still appears bathed in the glowing light and colour of Titian. Much more unequivocal in style is the *Plague at Ashdod* (fig. 26) of 1630, which contains a quotation from Raphael's *Plague of the Phyrigians* (fig. 25) and marks a turning-point in Poussin's career. In its dramatically pointed narrative action and strikingly diversified figures, the *Plague* is the first great canvas of the artist's career to aspire to the ideals of Raphael's most rhetorical history paintings. This tendency becomes even more marked in a series of works of the immediately following years that are effectively paraphrases of compositions by Raphael or his school, among them *Apollo and the Muses on Parnassus* (cat. 22), the Dulwich *Triumph of David* (cat. 24) and the *Adoration of the Magi* (fig. 67) of 1633. In all of these Poussin portrays a large ensemble of figures in a chaste and severe style that forgoes the attractions of his early Venetian-inspired canvases. Instead, the artist now favours pure, unbroken colours, incisive outlines, solid modelling and an evenly diffused light. These elements add a new note of authority and high seriousness to his pictures which anticipates the heroic history paintings of his maturity.

The deliberate manner in which this stylistic change takes place suggests that it was a conscious decision on Poussin's part – a repudiation of the more seductive

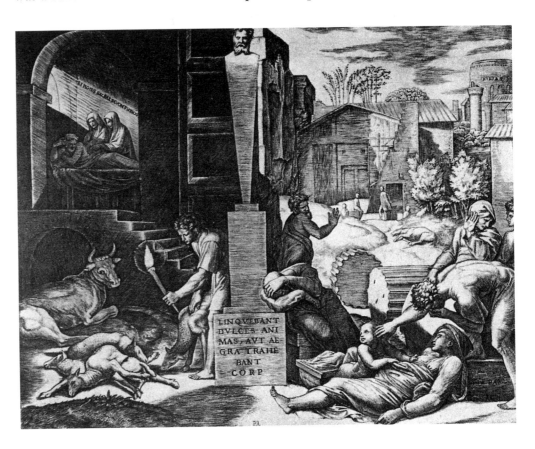

Fig. 25 Marcantonio Raimondi (*after* Raphael), *The Plague of the Phrygians.* Engraving, 19.4 × 25 cm. The Trustees of the British Museum, London

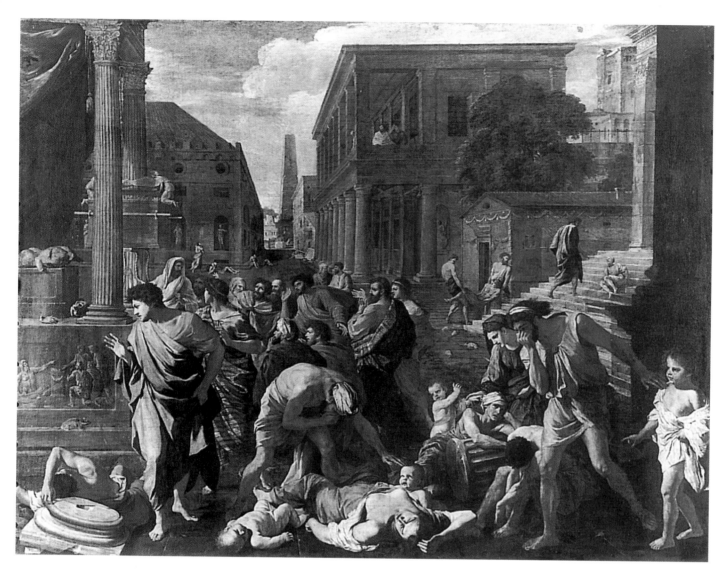

Fig. 26 Nicolas Poussin, *The Plague at Ashdod.* Oil on canvas, 148 × 198 cm, 1630–1. Musée du Louvre, Département des Peintures, Paris

qualities of Venetian art in favour of the loftier style of Raphael. Nor can one fail to notice that this new and more self-disciplined manner of painting comes into being at a key juncture in the artist's career, one which coincides with his marriage, his election to the Roman Academy of Painting and his growing reputation and success as an artist. The years of uncertainty were over.

1. Beal, 1984, pp. 142, 144.
2. Mérot, nos. 34 and 80; Birmingham, 1992–3, nos. 1 and 2 (with further bibliography).
3. *Supra*, pp. 19–41.
4. Bellori, 1672, p. 412.
5. Blunt, nos. 192 and 193; Mérot, nos. 174 and 175 (with further bibliography).
6. Bellori, 1672, pp. 412–3.

I

Cephalus and Aurora

c. 1624–5

79 × 152 cm

Private Collection

The subject is from Ovid (*Metamorphoses*, VII, 700–14). Aurora, goddess of the dawn, attempts to seduce the hunter Cephalus, who rejects her advances in order to remain faithful to his wife, Procris. The story ends tragically when Cephalus inadvertently kills Procris with a magic javelin that the latter had received from the goddess Diana – a reminder of the power of the gods over mortal man.

Bellori provides a full description of this picture,[1] which identifies the additional figures in the composition, none of whom appear in Ovid's tale. To the left are the Hours, summoning Aurora to the duties of the dawn, one pouring dew-drops from a vase and the other scattering fragrant flowers. Behind them is the goddess's chariot, led by two white horses, one of which bends to drink ambrosia fed to him by another of the Hours. Seated on the chariot are two putti with torches, anxious to depart; while, at the extreme right, additional putti armed with quivers and arrows greet the break of day or shoot arrows at it, as if to delay it. At the lower left sits the winged Zephyr, embracing the swan which he had incited to sing. According to Bellori, Zephyr is included not because he is a morning wind but as a representative of spring, the season of love.[2] Though Bellori makes no mention of the reclining figure in the background centre of the composition, this is presumably the aged Tithonus, husband of Aurora, or represents Oceanus, the site of the original loves of Aurora and Tithonus.

In its shallow, frieze-like design and flat and attenuated figures, the picture is close in style to the Marino drawings Poussin executed in Paris in 1622–3 and would appear to be the artist's earliest surviving painting, datable to his first years in Rome, *c.* 1624–5. Further evidence of its immaturity is the awkward composition, which is split into two distinct scenes, one occupied by the Ovidian couple and the other by their entourage. The colour also shows evident signs of insecurity; though warm and rich, it is sparing in its accents and patchily distributed. This does little to strengthen the overall coherence of the composition and is further exaggerated by the darkened

state of the picture, in which much of the ground colour shows through.

Two drawings related to the composition are in the British Museum.[3] One (fig. 27), drawn in a loose and summary manner, shows the design in reverse and differs from the painting in omitting Aurora's horses and chariot and including in the background right the figure of Apollo, driving his chariot across the sky. The second drawing (fig. 28) is executed in a more meticulous style and is identical in design to the finished canvas. This has led some critics to believe that it is Poussin's final preparatory study for the picture and others to maintain that it was made after the painting, as a record of the composition. In either case, the drawing also indicates that the canvas exhibited here has been cut by about 15 cm at the top – a fact which is confirmed by existing copies of the composition.

The picture is often identified with a painting of the same

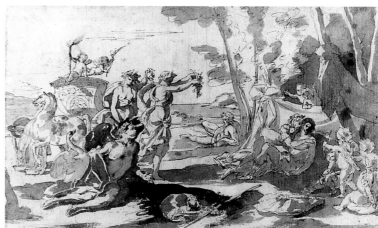

Fig. 27 Nicolas Poussin, *Cephalus and Aurora*. Pen and bistre wash with a little red chalk, 14.5 × 17.3 cm. The Trustees of the British Museum, London

Fig. 28 Nicolas Poussin, *Cephalus and Aurora*. Pen and bistre wash, 19.8 × 34.5 cm. The Trustees of the British Museum, London

theme inventoried in the collection of a nephew of Cassiano dal Pozzo in 1695, though the dimensions do not agree.[4] It is worth noting, however, that such early inventories are not always precise in recording measurements.

A connection with the learned literary circle associated with Pozzo becomes even more likely when one considers the complex iconography and symbolism of the present picture – one for which no literary text apparently exists. With the inclusion of the goddess of the dawn, the hours of the day, the season of spring, and a figure who may represent the oceans, the picture acquires an allegorical dimension which treats the unrequited love of Cephalus and Aurora against a background of the continuing cycles of nature. Seen in this way, it becomes the earliest example in Poussin's career of a theme that was to preoccupy him to the end of his life: namely, that of human life and love under the threat of time. When compared to the compositional weaknesses in the present picture, so sophisticated a programme reminds one of the extent to which the young Poussin's intellectual and imaginative powers outstripped his purely artistic skills.

For a later canvas of the same theme see cat. 16.

1. Bellori, 1672, pp. 444–5.
2. Two other connections between Zephyr and the theme of the present painting are worth mentioning, though they are not cited by Bellori. The first is that, according to Hesiod (*Theogony*, 378), Zephyr was the son of Aurora by Astraeus. In addition, Ovid's account of the myth of Cephalus and Aurora notes that Procris mistakenly believes that her husband is in love with a nymph named Zephyr at the end of the tale and, spying on him in the bushes, is mortally wounded by Cephalus, who mistakes her for a wild beast. As his wife lies dying, Cephalus confesses that the Zephyr he calls to each day is not a nymph but the cool wind from the valleys that soothes him while hunting. Thus, the inclusion of Zephyr in the present painting may also allude to the tragic outcome of the tale.
3. CR III, pp. 34–5, nos. A 56, A 57. The status of these drawings has been much discussed. For a summary of the arguments on this question, see Oxford, 1990–1, nos. 7, 8.
4. Brejon de Lavergnée, 1973, p. 87.

PROVENANCE
In the collection of William Worsley by 1770; by descent to the present owner

EXHIBITIONS
Edinburgh, 1981, no. 1

ŒUVRE CATALOGUES
Blunt, no. 145, Thuillier, no. 15, Wild, no. 5, Wright, no. 6, Oberhuber, no. 4, Mérot, no. 135

REFERENCES
Bellori, 1672, pp. 444–5; Blunt, 1947³, pp. 269–70

2

The Victory of Joshua over the Amalekites

1625–6

97.5 × 134 cm

The Hermitage Museum, St Petersburg

Bellori notes that, during his early years in Rome, Poussin painted two battle pieces which he was forced to sell for only seven *scudi* each[1] This occurred during the absence of Cardinal Francesco Barberini on a papal legation abroad (i.e. between March 1625 and October 1626) and provides an instance of the hardships the young artist endured before finding a patron and champion in Rome. The works in question are almost certainly the present canvas and the *Victory of Joshua over the Amorites* (cat. 3), both of which treat themes from the Old Testament.

The subject is from Exodus XVII, 8–13, and depicts the victory of the Israelites, led by Joshua, over the Amalekites. On a hill at the upper right kneels Moses, his hands raised towards heaven, supported by Aaron and Hur:

And it came to pass, when Moses held up his hand, that Israel prevailed: and when he let down his hand, Amalek prevailed.

But Moses's hands were heavy: and they took a stone, and put it under him, and he sat thereon, and Aaron and Hur stayed up his hands, the one on the one side, and the other on the other side; and his hands were steady until the going down of the sun.

Immediately below this group appears the helmeted figure of Joshua, riding a white charger and valiantly exhorting his troops to rise up against the enemy. The outcome of the struggle is made vividly apparent in the vigorous stances of three archers at the lower right, posed in unison, as if to indicate the Israelites' superior might and discipline. As has often been noted, this motif is adapted from a celebrated work by Polidoro da Caravaggio (c. 1500–43) depicting *Perseus and Phineas* (fig. 29).

Though the Russian battle-pieces are among Poussin's earliest surviving canvases, the artist had tackled this subject before in

the drawings executed for Marino in Paris, which include four battle scenes from ancient history (fig. 30).[2] Like the present picture, these appear cluttered and confused in composition, with the figures arranged in low relief and piled high on to the picture plane, and the setting barely indicated. In their claustrophobic construction, all of these works owe much to the battle paintings of Giulio Romano (fig. 31), engravings of which would already have been available to Poussin in Paris.[3] Even more chaotic in composition are two engravings of the *Battle of the Israelites against the Amalekites* by the prolific printmaker Antonio Tempesta (1555–1630), which adopt the same shallow space and high horizon that Poussin favours in his battle pieces.[4]

Like the early *Cephalus and Aurora* (cat. 1), the Russian battle pictures resemble painted versions of the Marino drawings and betray the artist's evident timidity in the handling of colour, which in the present picture appears pale and devitalised. To a greater extent than the mythological canvas, however, the battle paintings reveal a growing concern with both anatomy and modelling that doubtless derives from Poussin's study of antique sculpture (fig. 32) during his early years in Rome.

Despite the low price fetched by his two battle-pieces,

Poussin seems to have found some favour as a painter of such scenes during this period. On a brief visit to Rome in December 1625, Cardinal Barberini commissioned from him a *Capture of Jerusalem by Titus*, for which a payment of 61 *scudi* is recorded in February of the following year. This canvas is now lost, though its design may survive in an engraving (fig. 93).

1. Bellori, 1672, p. 411.
2. CR II, pp. 7–8, nos. 110–13.
3. The man hurling a stone in the centre of the present picture may also be related to a similar figure in Giulio's altarpiece of the *Stoning of St Stephen* in San Stefano, Genoa.
4. *The Illustrated Bartsch*, ed. Walter L. Strauss, 35 (formerly vol. 17, part 2), New York, 1984, p. 60, no. 234, and p. 70, no. 244.

PROVENANCE
Duc de Noailles by 1685; bought by Catherine the Great before 1774

EXHIBITIONS
Paris, 1960, no. 2; New York, Chicago, 1990, no. 2; Paris, 1994–5, no. 7

ŒUVRE CATALOGUES
Blunt, no. 29, Thuillier, no. 11, Wild, no. 16, Wright, no. 3, Oberhuber, no. 1, Mérot, no. 25

REFERENCES
NP/SM, pp. 45–7

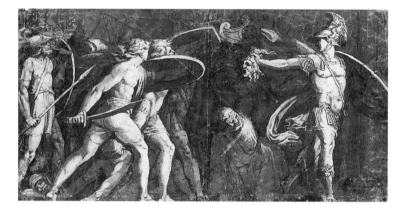

Fig. 29 Polidoro da Caravaggio, *Perseus and Phineas.* Musée du Louvre, Cabinet des Dessins, Paris

Fig. 30 Nicolas Poussin, *Battle Scene.* Pen and bistre with grey wash, 19 × 32.3 cm. The Royal Collection

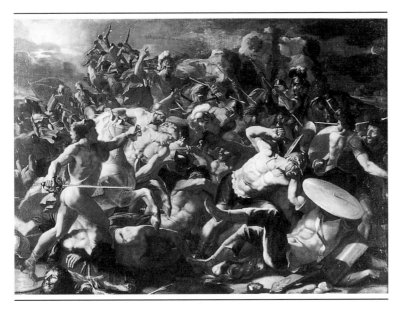

3
The Victory of Joshua over the Amorites

1625–6

98 × 134 cm

The Pushkin Museum of Fine Arts, Moscow

The pendant to the previous picture, *The Victory of Joshua over the Amorites* takes its theme from Joshua X, 7–14. Guided by the Lord, Joshua and the Israelite army defeat the Amorites at Gibeon. In the foreground are the hailstones cast down from heaven to aid them in their victory; while, at the upper left and right, appear the sun and moon. ('And the sun stood still, and the moon stayed, until the people had avenged themselves upon their enemies.') This miraculous occurrence provided Poussin with the opportunity to explore dramatic chiaroscuro effects and, in the right-hand portion of the picture, to create what is effectively a battle scene by moonlight.

Like the *Victory of Joshua over the Amalekites* (cat. 2), the composition is filled with figures and pervaded by a series of conflicting diagonals which vividly convey the discords of battle. To a greater extent than the previous canvas, however, these appear subordinated to a dominant triangular grouping which rises from the lower corners of the picture to culminate in the figure of Joshua, riding in profile at the left centre of the composition, his right hand raised in command. This pose recalls that of the Emperor Constantine in Giulio Romano's *Battle of Constantine* of 1523–4 in the Vatican (fig. 31) – one of the most celebrated of all Renaissance battle pieces and a work that Poussin much admired. According to Bellori, the artist was particularly attracted by the tumultuous action and apparent confusion of Giulio's epic fresco, noting that 'this harshness was not inconsistent with the ferocity of a great battle and with the impetuosity and fury of the combating soldiers'.[1] This remark suggests that the hectic designs Poussin devised for his own battle pictures were deliberately intended to unsettle the viewer. In the present picture, this effect is intensified by the dynamic play of light and shade over the scene, which adds to the turbulent impression.

If Giulio Romano's fresco is the most ambitious precedent in painting for Poussin's early battle pieces, the artist may have been drawn to this particular Old Testament subject by the fact that Giulio's teacher, Raphael, had treated the identical theme in the Loggia of the Vatican. Another follower of Raphael, Polidoro da Caravaggio, provided the source for the striking figure of a nude warrior striding on at the extreme left of the picture (fig. 29), though the severed head resting at his feet is a gruesome invention of Poussin's own and one that anticipates his treatment of similar motifs in the Vienna *Capture of Jerusalem by Titus* (cat. 36). Finally, the shallow relief of the composition, together with the emphatic contouring and modelling of the figures, reminds one of the importance of ancient sculpture for the young Poussin – and not least of the battle scenes to be seen on Roman sarcophagi or on monuments such as the Arch of Constantine (fig. 32).

A preparatory drawing for this painting is in the Fitzwilliam Museum and is inscribed, perhaps in a 19th-century hand, *G. Romano* – a misleading, though not entirely inappropriate attribution, given Poussin's own indebtedness to this master.[2] A later drawing (*c.* 1630) of what appears to be the same subject was recently discovered in Berlin.[3]

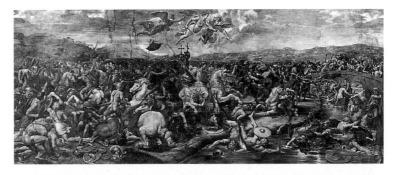

Fig. 31 Giulio Romano and Assistants, *Battle of Constantine.* Fresco, 1523–4. Sala di Constantino, Vatican, Rome

Fig. 32 Roman Sculpture, *Battle Scene.* Trajanic relief. Arch of Constantine, Rome

These two battle-pieces are not the only paintings of this type to survive from Poussin's early years. A third canvas, identical in size and illustrating the *Victory of Gideon over the Midianites*, was discovered in the Vatican and first published in 1960.[4] It is also datable to 1625–6 and differs from the Russian pictures in that it is a nocturnal battle scene, dramatically lit by torchlight.[5] Like the pictures exhibited here, it reveals an obvious debt to the battle compositions of Raphael and his school and presupposes no awareness of the one artist who was soon to make such a deep impression upon the young Poussin's colour and brushwork: namely, Titian.

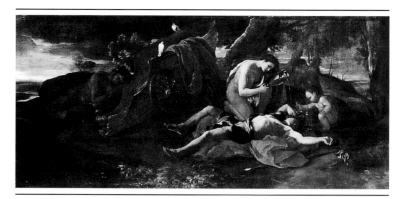

1. G. P. Bellori, *Descrizzione delle imagini dipinte da Raffaelle d'Urbino*, Rome, 1695, pp. 59–60.
2. CR V, p. 68, no. 388.
3. CR V, p. 69, no. 389.
4. Thuillier in *Actes* 1960, II, p. 264, no. 2; Mérot, no. 27 (with further bibliography).
5. Cf. CR V, p. 68, no. 387, for a drawing of these same years at Windsor that depicts the *Victory of the Israelites over the Midianites*.

PROVENANCE
Duc de Noailles by 1685; bought by Catherine the Great before 1774; 1927, transferred from the Hermitage to the Pushkin Museum

EXHIBITIONS
Paris, 1960, no. 3; Düsseldorf, 1978, no. 0; Paris, 1983–4, no. 200; New York, Chicago, 1990, no. 1; Paris, 1994–5, no. 6

ŒUVRE CATALOGUES
Blunt, no. 30, Thuillier, no. 12, Wild, no. 17, Wright, no. 4, Oberhuber, no. 2, Mérot, no. 26

REFERENCES
NP/SM, pp. 60–1

4

Venus with the Dead Adonis

c. 1626–7

57 × 128 cm

Musée des Beaux-Arts, Caen

In Book X of the *Metamorphoses*, Ovid recounts the tale of Venus's love for the huntsman Adonis. This ends tragically when the latter is killed by a boar in the course of the chase. Venus then mourns him and, sprinkling nectar over his blood, transforms it into the anemone. Poussin portrayed the love of Venus and Adonis three times in his early career, treating the theme in an unusually explicit manner (fig. 33).[1] However, this painting is his only depiction of the tragic conclusion to the tale.

As has often been noted, the abject figure of Venus mourning the dead Adonis recalls traditional depictions of the Magdalene mourning the dead Christ, among them one by Poussin of these same years (fig. 170). This would appear to reflect the artist's keen interest in the parallels between pagan religions and Christianity, and reminds us that both Adonis and Christ may be seen as symbols of death and resurrection and that both are

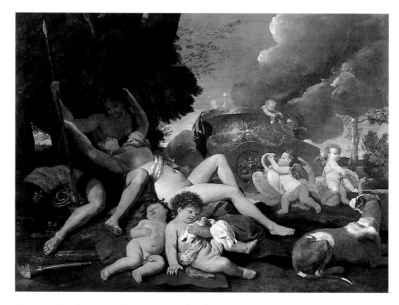

Fig. 33 Nicolas Poussin, *Venus and Adonis.* Oil on canvas, 98.5 × 134.6 cm, *c.* 1627. Kimbell Art Museum, Fort Worth, Texas

associated with the season of spring, a time of renewal in nature.[2] Thus, the date of the annual resurrection of Adonis coincides with the Christian feast of Easter; while, according to St Jerome, the cave in which Christ was born was identical with that in which Venus had mourned the dead Adonis.[3]

Poussin portrays the theme of death and resurrection in this picture by showing tiny blossoms sprouting around the head of Adonis. He also alludes to the cycles and rhythms of the natural world through two other devices in the picture. The scene is set against a dark sky which moves from sunset at the left, behind the slumbering river god, to daylight at the right, behind the youthful putti. Thus, the ages of man and the changing course of human life are contrasted with the continuing cycles of nature.

Though previously dated *c.* 1630, this would appear to be one of Poussin's earliest surviving works, *c.* 1626–7. Its oblong format recalls that of many of the mythological drawings made for Marino, the early *Cephalus and Aurora* (cat. 1) and the *Venus and Adonis* (Musée Fabre, Montpellier); and, like the other two canvases, this suggests that it may have been intended to hang over a door. Its style, too, appears to mark a transitional phase in the artist's development. The composition exhibits none of the congestion of the early battle-pieces (cat. 2–3) and depicts only a handful of figures, deployed more convincingly in space. Yet its summary treatment of form and jarring contrasts of colour still show signs of immaturity and link it most closely with Poussin's *Deposition* of *c.* 1626–7 (fig. 34). It also reveals a new-found concern with the broad and fluid application of paint – especially evident in the treatment of the draperies and sky – which appears indebted to the artist's initial encounters with the art of Titian.

The schematic technique of the picture notwithstanding, it remains one of Poussin's most affecting early works, both for its mood of languid melancholy and for its poetical rendering of the deeper symbolism of the theme. In these it anticipates such later Ovidian canvases as *Echo and Narcissus* (cat. 15), which is likewise a kind of mythological *pietà* combining the themes of death and rebirth in nature.[4]

PROVENANCE
(?) Cardinal Angelo Giori; *c.* 1683, in the French Royal Collection; 1804, deposited at Caen

EXHIBITIONS
Paris, 1960, no. 25; Rome, 1977–8, no. 14; Düsseldorf, 1978, no. 14; Birmingham, 1992–3, no. 4; Paris, 1994–5, no. 17

ŒUVRE CATALOGUES
Blunt, no. 186, Thuillier, no. 19, Wild, no. 7, Wright, no. 13, Oberhuber, no. 33, Mérot, no. 161

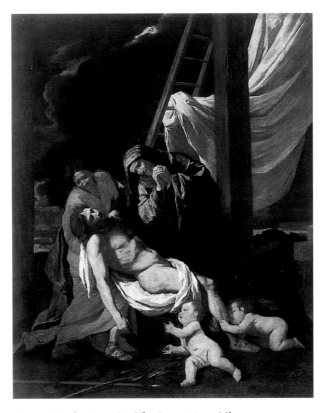

Fig. 34 Nicolas Poussin, *The Deposition.* Oil on canvas, 120 × 98 cm, *c.* 1626–7. The Hermitage Museum, St Petersburg

1. Blunt, no. 185 and Mérot, nos. 159, 160, 221 (with further bibliography).
2. For a fuller discussion of these parallels, see Blunt 1967, text vol. pp. 114–15.
3. Joseph Campbell, *The Masks of God, Occidental Mythology*, New York, 1991 (orig. 1964), p. 138; Hugo Rahner, *Greek Myths and Christian Mystery*, London, 1963, p. 149.
4. *Venus with the Dead Adonis* and *Echo and Narcissus* have recently been connected with two paintings by Poussin of these subjects inventoried in the collection of Cardinal Angelo Giori in 1669 (Brejon de Lavergnée 1987, pp. 396–7, nos. 401–2). This identification is perfectly plausible and provides an intriguing link between an early patron of Poussin who was also an avid collector of Claude's paintings and a close acquaintance of Bernini. But it does not necessarily follow that the two works date from the same moment of Poussin's early career; and, on grounds of style, this is unlikely.

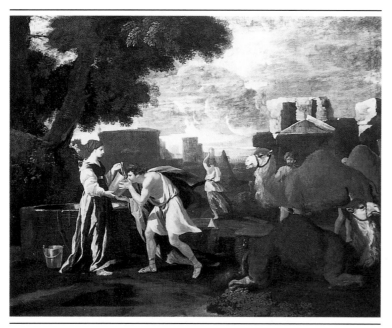

5
Eliezer and Rebecca

c. 1627

93.3 × 117.5 cm

Private Collection

This picture is first recorded in the collection of Cassiano dal Pozzo and was originally one of a pair. Its pendant was a *Christ and the Woman of Samaria* (fig. 35) last recorded on the London art market in 1926.[1] Both works were almost certainly commissioned by Pozzo – and their subjects dictated to the artist – since the well that figures prominently in both of them is a pun on the family name, *pozzo* meaning 'well' in Italian.

The theme of the present picture is from Genesis XXIV, 42–6. Eliezer, the servant and messenger of Abraham, has been sent to find a wife for Abraham's son, Isaac. In quenching Eliezer's thirst and providing water for his camels, Rebecca reveals herself to be the chosen one. Poussin treated the theme again in a very late canvas (cat. 87); while the well-known picture of 1648 (cat. 59) portrays a slightly later moment in the story and shows Eliezer presenting Rebecca with precious jewels as a reward for her charity.

The ceremonial nature of the subject elicits from the artist one of his most carefully designed early works. In a frieze-like grouping at the left appear Rebecca and Eliezer, the former standing erect, as if to indicate her strength and nobility, and the latter expressing his gratitude through his eagerly bending pose. To the right are Eliezer's camels and attendants, one of whom appears annoyed at the preference being shown to his master, while the camel registers delight and approval. In the centre, an elegant young woman bearing a pitcher of water on her head departs for the distant town. She is presumably included to remind us of those who draw water only for themselves and, unlike Rebecca, will not be divinely selected. Finally, even the treatment of the sky may allude to the vicissitudes of Eliezer's

journey, the dramatic cloudburst at the right suggesting its perils and hardships and the sunlight at the left its benevolent outcome.

Poussin based the poses of the principal figures in this picture on an engraving of the same subject after Primaticcio (fig. 36), which also includes the figure of the woman with a pitcher and a comparably youthful Eliezer, an idea that the artist abandoned in his later depictions of this theme.

The formality of the composition suggests a date around 1627, immediately before the even more rigorously designed *Death of Germanicus* (cat. 9). This may be seen in the balanced arrangement of the figures, the central placement of the woman bearing water, and the bold accents of primary colour that stress the key actors in the drama. Moreover, the use of all three primaries plus white to signal the all-important figures of Eliezer and Rebecca is a recurring device of Poussin, which here appears for one of the first times in his career. Though the picture has darkened, the best preserved passages (e.g. the draperies of the protagonists) reveal the increased precision and refinement of Poussin's brushwork and contrast with the loose and flowing manner of *Venus with the Dead Adonis* (cat. 4).

The picture was first discovered in 1960 and published five years later.[2] Until that time, the *Eliezer and Rebecca* inventoried in Pozzo's collection was assumed to be the canvas in the Fitzwilliam Museum (cat. 87), despite the fact that the latter was almost certainly painted after Pozzo's death, which occurred in 1657. This confusion was compounded by the fact that an inscription on the back of the original canvas identifies the painting as a portrayal of Rachel at the well – a misidentification that persists in many of the later Pozzo inventories and one which is readily understandable when one recalls that, with the exception of the camels, the two stories are virtually interchangeable.[3]

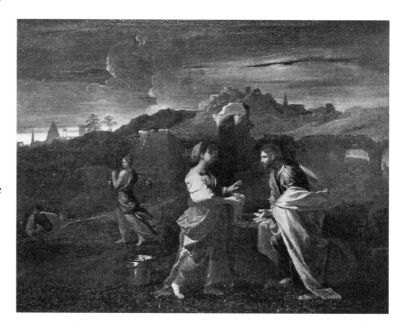

Fig. 35 Nicolas Poussin, *Christ and the Woman of Samaria*. Oil on canvas, presumably 93.3 × 117.5 cm, *c.* 1627. Present whereabouts unknown

Eliezer and Rebecca documents an important encounter in Poussin's early career – the emergence of Cassiano dal Pozzo, his first great patron and benefactor – and was obviously intended to win his approval. Not only would the camels have appealed to the latter's fascination with exotic beasts, but its townscape may be intended to represent the outskirts of Rome, home of both Poussin and Pozzo. Moreover, as Denis Mahon

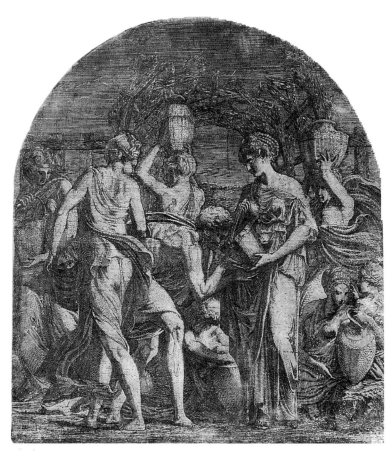

Fig. 36 Monogrammist LD (*after* Primaticcio), *Eliezer and Rebecca*. Engraving, 29.5 × 27 cm. The Trustees of the British Museum, London

has suggested, the choice of this subject can be seen to commemorate both the Pozzo family name and the artist's sudden change of fortune upon finding this benevolent champion:

> Poussin had an insatiable thirst for Rome and for antiquity. It was a struggle to get to Rome, and it was a struggle when he got there. More than any other patron it was Cassiano dal Pozzo who gave him a helping hand at this crucial juncture . . . Is it too fanciful to speculate that Eliezer may in some sense also be symbolical of the master himself and of his relationship to the patron to whom he was thus indebted, and for whom the picture was painted? What we see is a youngish man, fatigued by his travels and exertions in the heat of a Mediterranean summer's day, at length attaining his goal and receiving solace and refreshment from the well (*pozzo*) at the hands of a dignified and statuesque figure worthy of typifying the eternal city – in a setting which indeed evokes the environs of Rome.[4]

1. Last recorded in 1926 with the Sackville Gallery, London (cf. *The Burlington Magazine*, XLVIII, 274, 1926, xxiii).
2. Mahon, 1965[1], pp. 196–205.
3. In addition to all the other reasons that have been advanced for identifying this picture, rather than the Fitzwilliam canvas, as the painting that belonged to Pozzo, one other deserves to be mentioned. If Poussin intended the *Eliezer and Rebecca* and the *Samaritan Woman* to hang in the order in which these events occur in the Bible – as he surely would have, given his eminently logical turn of mind – then the present work is a more suitable left-hand composition than the Fitzwilliam version, in which Rebecca is turning her back on the space that would have been occupied by the pendant. Moreover, it is worth noting that the missing painting of the *Samaritan* (fig. 35) was designed to complement the present picture, with Christ framing the scene at the right.
Oberhuber has drawn attention to the fact that Breenbergh treated these same subjects in two pendant landscapes (one dated 1625) in the Colonna Collection, Rome (cf. Salerno, 1977–8, I, 41.7, 41.8). Poussin may have been familiar with these works through his close association with Northern artists in Rome during his early years.
4. Mahon, 1965[1], pp. 202–3.

PROVENANCE
Cassiano dal Pozzo; by inheritance to his heirs; 1779; purchased from them by Gavin Hamilton; 1795, almost certainly in the sale of Charles-Alexandre de Calonne, London; private collections in England until 1977, when purchased by the present owner

EXHIBITIONS
Fort Worth, 1988, no. 42

ŒUVRE CATALOGUES
Thuillier, no. B18, Wright, no. 32, Oberhuber, no. 42, Mérot, no. 4

REFERENCES
Mahon, 1965[1]

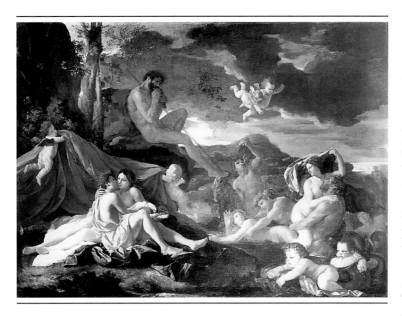

6
Acis and Galatea

c. 1627–8

98 × 137 cm

The National Gallery of Ireland, Dublin

The ill-fated love of Acis and Galatea was one of Poussin's favourite stories from Ovid (*Metamorphoses*, XIII, 748–897). Galatea, a sea nymph, is in love with the handsome youth Acis. She in turn is desired by the monster Polyphemus, who spies upon the lovers at the edge of the sea, serenades Galatea with his pan-pipes and, in a fit of jealousy, hurls a rock at Acis, killing him. Galatea then transforms her beloved into a river 'whose waters retain his original name'.

Poussin treated the climax of this tragic tale in one of his early drawings for Marino (fig. 37), which shows the one-eyed giant Polyphemus about to hurl a huge rock at the embracing couple. Another of these works portrays the transformation of Acis;[1] while a drawing at Chantilly (fig. 38) of *c.* 1629–30 depicts the same moment as the present canvas, but is not related directly to it.[2] In the centre, Acis and Galatea embrace; while on a rock at the left sits Polyphemus with his pipes. At the right appears Apollo, driving his chariot across the sky – a detail not mentioned by Ovid that adds to the symbolic meaning of the theme, which is one of change and transformation in nature. Finally, in a late landscape of 1649 (fig. 173), Poussin returned to this subject to portray the solitary figure of Polyphemus playing his pipes on top of a mountain.

This canvas is the most exuberant of all Poussin's treatments of the theme and calls to mind the celebrated frescoes of the same subject by Raphael (fig. 84) and Annibale Carracci. At the upper left appears Polyphemus serenading Galatea, who embraces her lover below, sheltered from the monster's gaze both by the rock mentioned by Ovid and by a screen of red drapery held up by two putti. On the right Poussin depicts a

kind of marine bacchanal. A group of tritons and nereids, accompanied by *amorini*, disport themselves on the waves in a state of consummated love that contrasts poignantly with the illicit embrace of Acis and Galatea and the unrequited love of Polyphemus. In the gently rocking motion of the right-hand group, the artist evokes a buoyant and uninhibited mood which subtly underscores the tensions implicit at the left of the picture, with its isolated figures and fiery colours. Adding to the highly charged atmosphere are the ominous storm clouds that gather overhead and anticipate the tragic outcome of the tale.[3]

The sensuous colour and lighting of the Dublin canvas owe much to Poussin's early immersion in the art of Titian and particularly to the great series of bacchanals by the latter that were then on view in Rome. Indeed, the style of *Acis and Galatea* is especially close to that of Poussin's *Andrians* (fig. 21), a work that derives not only its style but its theme from the Titian bacchanal of the same subject (fig. 20). Both pictures would appear to date from *c.* 1627–8. Characteristic of them are the abrupt tonal contrasts, isolated areas of intense colour and schematically drawn figures one associates with Poussin's early mythologies. Coupled with these features, however, are passages of exquisite delicacy which anticipate the Ovidian mythologies of the years around 1630. In the Dublin canvas this is especially evident in the subtle delineation of the relationship between Acis and Galatea and in the elegant refinement of their contours. These contrast with the more robust forms of the marine deities, as if to emphasise the tenderness and fragility of their love.

The most magical feature of the picture is the haunting separation of the figure groups and the mysterious spatial elisions the artist introduces between them. These endow the scene with a dreamlike quality which transcends Ovid's narrative and succeeds in encapsulating all moments in the story. The carefree existence of Galatea as a sea nymph before the start of the tale, the secret love of Acis and Galatea, the loneliness and menace of Polyphemus, and the tragic conclusion of the story – all of these are subsumed by Poussin into a single phantasmagoric image set against the waning light of day.

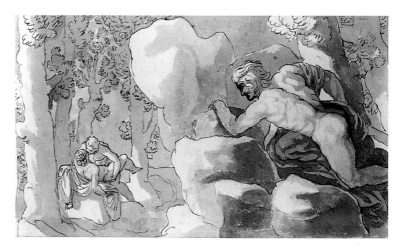

Fig. 37. Nicolas Poussin, *Galatea, Acis and Polyphemus.* Pen and grey brown wash with traces of pencil, 18.6 × 32.5 cm. The Royal Collection

Until recently, *Acis and Galatea* was wrongly identified as portraying the wedding of Peleus and Thetis – a theme that nowhere fits the present painting. Under this title it inspired the third stanza of W. B. Yeats's poem 'News for the Delphic Oracle', of 1938–9:

> Slim adolescence that a nymph has stripped,
> Peleus on Thetis stares.
> Her limbs are delicate as an eyelid,
> Love has blinded him with tears;
> But Thetis' belly listens.
> Down the mountain walls
> From where Pan's cavern is
> Intolerable music falls.
> Foul goat-head, brutal arm appear,
> Belly, shoulder, bum,
> Flash fishlike; nymphs and satyrs
> Copulate in the foam.[4]

1. CR III, p. 11, no. 158.
2. Cf. CR III, p. 37, no. A62, for a drawing which is closely related to the Dublin painting and in the same museum. Executed in pen and watercolour, it is too weak to be by Poussin but may be a copy of a lost original.
3. Even with the naked eye, it is evident that the artist reworked the area of the picture to the immediate right of Polyphemus.
4. *The Collected Poems of W. B. Yeats*, London, 1950 (2nd ed.), pp. 376–7.

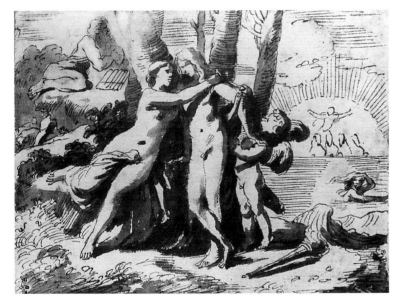

Fig. 38 Nicolas Poussin, *Acis and Galatea*. Pen and brown wash over black chalk, 13 × 18 cm. Musée Condé, Chantilly

PROVENANCE
Uncertain before 1831, when it belonged to Earl Spencer; 1856, sold to Sir John Leslie; bought from his descendants by Sir Hugh Lane, who bequeathed it to the Gallery in 1918

EXHIBITIONS
Rome, 1977–8, no. 19; Düsseldorf, 1978, no. 17; Edinburgh, 1981, no. 7; Dublin, 1985, no. 34; Fort Worth, 1988, no. 58; Paris, 1994–5, no. 22

ŒUVRE CATALOGUES
Blunt, no. 128, Thuillier, no. 46, Wild, no. 37, Wright, no. 46, Oberhuber, no. 58, Mérot, no. 116

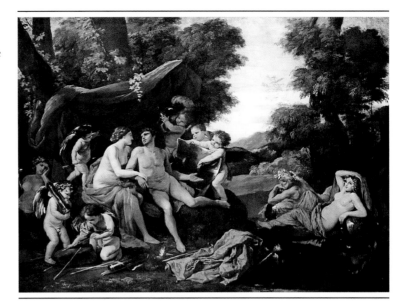

7
Mars and Venus

c. 1627–8
155 × 213.5 cm

Museum of Fine Arts, Boston
Augustus Hemenway Fund and Arthur William Wheelwright Fund, 40/89

The love of Venus and Mars is recounted by Virgil and Lucretius (among others) and, from the Renaissance onwards, acquired an important allegorical meaning. When the goddess of love subdued the god of war, peace reigned.[1] This subject was celebrated in marital portraits and marriage *cassoni*, such as Botticelli's *Mars and Venus* (National Gallery, London). Poussin's only painting of the theme follows this tradition and derives its inspiration from Lucretius's description of the encounter between the couple:

> Mars potent in arms, rules the savage works of war, yet often casts himself back into your lap, vanquished by the every-living wound of love, and thus hanging with rounded neck bent back and open-mouth he feeds his eager eyes with love, and as he lies back his breath hangs upon your lips. There, as he reclines, goddess, upon your sacred body, bend down around him from above and pour from your lips sweet coaxings, and for your Romans seek quiet peace.[2]

Mars reclines and gazes longingly into Venus's eyes 'with rounded neck bent back and open-mouth'. To the right, putti remove his armour; and, in the left hand corner, others are engaged in emptying his quiver and sharpening his arrows, thereby converting the weapons of war into those which will now inflict the wounds of love. Gazing on at the main group are a river god and voluptuous water nymph; while another nymph reclines in the shade of a grove at the left.

A drawing (fig. 39), which may be a preparatory study for the painting, shows the same arrangement of the embracing couple, but they are accompanied by a blindfolded cupid and another

putto mounting a wolf. The latter is presumably a reference to the wolf that nurtured Mars's twin sons, Romulus and Remus, legendary founders of Rome, and follows Lucretius's account of Venus's love for Mars as bringing peace to the Roman people.

The Louvre drawing was etched in reverse by Fabrizio Chiari in 1635; and one year later Chiari issued a pendant to this print (fig. 3), which is based upon a now dismembered painting by Poussin of *Venus and Mercury*, divided between Dulwich and the Louvre.[3] Though there is no reason to believe that Poussin conceived these pictures as pendants, the mirroring poses of Mars in the present picture and Venus in the canvas at Dulwich do relate the two works. Moreover, their themes are also interconnected. *Venus and Mercury* includes the figure of the winged Anteros, born of the union of Venus and Mars, and traditionally associated with celestial or spiritual love and specifically with the arts. He is shown defeating Eros – or earthly love – accompanied by the attributes of poetry, music and painting. When taken together with *Mars and Venus*, the underlying theme of the two works becomes clear. The goddess of love conquers the god of war and from their union is born a cultivation of the arts, which further civilises mankind.

The large scale of this picture is unusual in Poussin's early mythologies and may be explained by the fact that it was painted for Poussin's most important early patron, Cassiano dal Pozzo.[4] The style of the work suggests a date of 1627–8, closely contemporary with the *Education of Bacchus* (Chantilly) and the *Triumph of Flora* (fig. 22). In all three canvases, the application of paint appears vigorous, rather than delicate, and the figure types lack the precision and elegance one associates with the mythologies of the years around 1630, appearing somewhat inflated in their proportions.

The landscape of this picture is also unusual for Poussin's early mythologies, which typically portray dawn or dusk. In contrast, *Mars and Venus* depicts a genial setting illuminated by a steady and diffused noonday light. The reasons for this difference may lie in the artist's choice of theme. Whereas the vast majority of Poussin's early Ovidian pictures treat themes of unrequited love, the subject of the present painting is reciprocated love. Rather than setting it in a landscape suffused with an atmosphere of transience, therefore, Poussin painted it in one which reflects the peace and contentment of Venus's union with Mars.

1. Cf. Edgar Wind, *Pagan Mysteries in the Renaissance*, London 1967 (2nd ed.), p. 89–96.
2. Lucretius, *De rerum natura*, I, 32–40.
3. Further to this picture, see Dulwich 1986–7, pp. 5–18. The relationship between the Boston and Dulwich/Louvre pictures has recently been examined in depth by Dempsey 1992.
4. Standring, 1988.

PROVENANCE
Cassiano dal Pozzo; his heirs until 1729–30; 1758, Henry Furness sale, London; bought by the first Earl Harcourt; by descent until 1940, when acquired by the Museum

EXHIBITIONS
Paris, New York, Chicago, 1982, no. 86; Fort Worth, 1988, no. 80; Paris, 1994–5, no. 23

ŒUVRE CATALOGUES
Blunt, no. 183, Thuillier, no. 45, Wild, no. R17, Wright, no. 44, Oberhuber, no. 80, Mérot, no. 148

REFERENCES
Cunningham, 1940, pp. 55–8; Friedländer, 1942, pp. 22–6; Dempsey, 1992, pp. 435–62

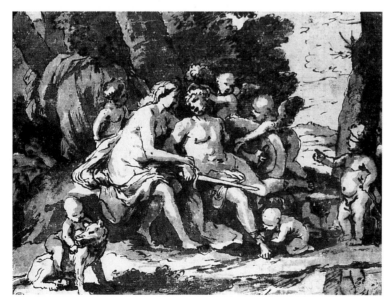

Fig. 39 Nicolas Poussin, *Venus and Mars.* Pen and bistre wash, 19.6 × 26.1 cm. Musée du Louvre, Cabinet des Dessins, Paris

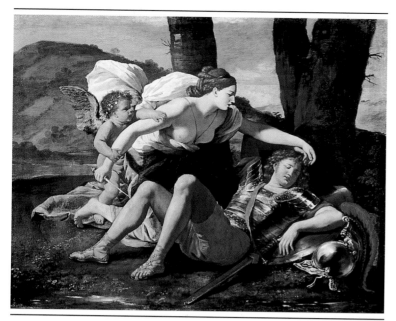

8

Rinaldo and Armida

c. 1628

82.2 × 109.2 cm

Dulwich Picture Gallery

Like the two versions of *Tancred and Erminia* (cat. 21, 26), this picture draws its subject from Torquato Tasso's epic poem on the First Crusade, *Gerusalemme Liberata* (1581) and depicts the most popular of the romantic tales included in that work (Canto XIV, 59–67). Rinaldo, a Christian warrior, has been lulled to sleep by Armida, a Saracen sorceress. Preparing to kill him, Armida is suddenly captivated by his beauty and overwhelmed by love. Lacking the words that are the poet's natural means of expression, Poussin enlists the help of a winged putto, not mentioned by Tasso, to indicate this dramatic turn of events and to stay Armida's hand and blow.

Poussin treated the next moments of the story in two other paintings. In a canvas of *c.* 1627 (fig. 4), he portrays Armida embracing Rinaldo.[1] Behind the couple appears the golden chariot with which she will transport the knight back to her enchanted garden on the Fortunate Isles. A later painting of *c.* 1637 (fig. 40), which may be either a damaged original or a good copy, depicts the heroine bearing Rinaldo to her magic domain.[2] Two further works portray the outcome of the tale. In a canvas of *c.* 1631–2 Poussin shows Rinaldo's companions, Carlo and Ubaldo, encountering a dragon on their journey to rescue the captured knight (Canto XV, 45–9).[3] Finally, in a drawing of 1645–8 (fig. 41), Carlo and Ubaldo lead Rinaldo away from Armida's enchanted realm, while the heroine herself collapses in a faint.[4]

Rinaldo and Armida is among the best preserved and most brilliantly painted of Poussin's early works and would appear to date from *c.* 1628. In its forceful gestures, robust modelling and sculptural figures, it is particularly close in style to the *Massacre*

of the Innocents (fig. 24), which is also dated to these years, and shares something of the present work's arbitrary treatment of space. In their boldness and vigour, both works anticipate the style of Poussin's major commission of this period, the *Martyrdom of Erasmus* (1628–9; cat. 10).

The picture is remarkable both for the richness and intensity of its colour and for its poetical rendering of the theme. Armida's power and treachery are conveyed by her severe profile, sweeping gestures and billowing draperies. With her right arm poised with the dagger and her left hand caressing its would-be victim, Poussin indicates her dominion over him while also signalling her sudden change of mind. Reinforcing the passion of the theme is the sumptuous colouring. In the gleaming highlights on Rinaldo's armour and the fiery orange hues of his breeches, Poussin reveals a delight in the sensuous application of paint that prompts one to wonder if he was attempting to evoke lust through lustre.

Poussin's attraction to the story of Rinaldo and Armida may be explained by the symbolic significance that Tasso attached to the events in his poem. These were intended to be read allegorically and thereby to instruct – rather than merely delight – the reader. Seen in this way, Rinaldo symbolises the war-like instincts in man, which are beneficial if directed by the intellect but evil if they succumb to concupiscence, or sexual desire.

The subject of the present picture may be related to that of *Venus with the Dead Adonis* (cat. 4), *Cephalus and Aurora* (cat. 1, 16) and *Tancred and Erminia* (cat. 21, 26). In all these the artist portrays a psychologically charged theme, which mixes love or lust with a contending emotion – be it grief, enmity or fear. In his choice of such a moment in *Rinaldo and Armida*, Poussin differs from the vast majority of artists who treated this theme, including Annibale Carracci, Domenichino,

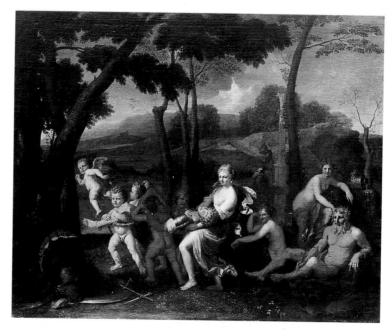

Fig. 40 Nicolas Poussin, *Rinaldo and Armida*. Oil on canvas, 122 × 155 cm, *c.* 1637. Staatliche Museen zu Berlin, Preußischer Kulturbesitz, Gemäldegalerie

Van Dyck and Giambattista Tiepolo. Whereas the latter concerned themselves solely with Armida's sudden infatuation with the handsome warrior, Poussin explores instead her deep and divided emotions.

X-rays reveal another composition beneath the present picture, which may depict the same or a similar scene: a young man, lying asleep or dying, is supported by a putto, while at the right a woman stretches out a hand towards him. Traces of this lower layer of paint may be seen above and below Armida's blue draperies at the left.

1. Blunt, no. 203; Mérot, no. 192; NP/SM, pp. 90–1.
2. Blunt, no. 204; Mérot, no. 194.
3. Blunt, no. 205; Mérot, no. 195.
4. CR II, p. 23, no. 146; Paris, 1994–5, no. 177.

PROVENANCE
1788, anonymous sale, Christie's, London; by 1804, Noël Desenfans; bequeathed at his death in 1807 to Sir Francis Bourgeois and by him to Dulwich College in 1811

EXHIBITIONS
Paris, 1960, no. 14; Edinburgh, 1981, no. 8; Forth Worth, 1988, no. 81; Birmingham, 1992–3, no. 5; Paris, 1994–5, no. 25

ŒUVRE CATALOGUES
Blunt, no. 202, Thuillier, no. 24, Wild, no. M 43, Wright, no. 64, Oberhuber, no. 81, Mérot, no. 193

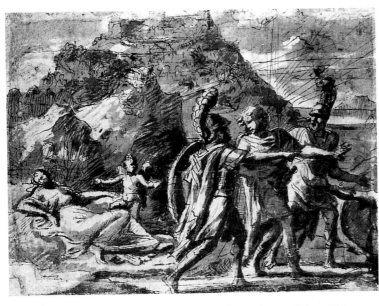

Fig. 41 Nicolas Poussin, *Armida Abandoned*. Pen, brown ink and bistre wash over traces of black chalk, 18.9 × 25.2 cm. Musée du Louvre, Cabinet des Dessins, Paris

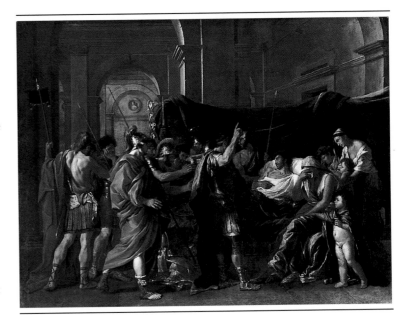

9
The Death of Germanicus

1626–8
148 × 198 cm

The Minneapolis Institute of Arts
The William Hood Dunwoody Fund

'None of the designs of Poussin has been more universally admired, than that of Germanicus', declared Henry Fuseli in 1798, 'and if he had never painted another picture he would have gained immortal honour by that alone'.[1]

Commissioned by Cardinal Francesco Barberini in 1626, and completed by January 1628, the *Death of Germanicus* is the supreme achievement of Poussin's early Roman years and one of the most original works of his entire career. Epic in theme and classical in design, it introduced a new subject into Western art – that of the hero on his deathbed. Though Poussin was to paint three more such scenes later in his career (cat. 41, 49, 58), none of these enjoyed the fame of the present picture, which remained in Italy until 1958 and became one of the talismans of the Neo-classical movement of the late-18th century.

The theme had never been painted before and, according to Bellori, was chosen by Poussin himself.[2] Its source is the *Annals* of Tacitus (II, 71–2). The Roman general Germanicus (15 BC–AD 19), adopted son of the emperor Tiberius, was renowned for his victories against the Germanic tribes (hence his name) and commanded the universal affection of his soldiers. Jealous of his success, Tiberius ordered him secretly poisoned by Piso. On Germanicus' deathbed, 'his friends touched the dying man's right hand, and swore to perish rather than leave him unavenged'. The hero then turned to his wife and children and, begging them to submit to cruel fortune, bade them farewell.

Poussin depicts the moment immediately before the touching of Germanicus' right hand, which is prominently positioned on his chest, pointing towards his family. The dying hero is surrounded by his loyal soldiers who react to the tragedy in a

variety of ways, from deep grief and gentle resignation at the left of the canvas to adoration and stoical resolve in the centre. In his delineation of Germanicus' family, Poussin likewise distinguishes a subtle range of reactions, from the curiosity of the youngest children, as yet unfamiliar with death, to the plangent sorrow of the nurse and the inexpressible grief of the dying man's wife, Agrippina, who conceals her face. This motif derives from a masterpiece of antique art, the *Sacrifice of Iphigenia* by Timanthes (fig. 42), in which the heroine's father is also shown hiding his face in unutterable grief. Pliny notes that the Greek painter chose this pose because the profoundest sorrow could only be suggested and never depicted,[3] and Poussin's Agrippina is obviously intended to convey the same ineffable depths of feeling.

Though the vibrant colours and fluid handling of the paint betray Poussin's continuing fascination with the art of Titian, the composition is consciously antique, with its frieze-like arrangement of figures and severe architectural setting. Poussin probably derived these from ancient sarcophagi depicting a hero such as Meleager on his deathbed (fig. 43). As Rosenberg ingeniously suggested, however, a more recent precedent is Rubens's *Death of Constantine*, which was one of a series of tapestries offered by Louis XIII to Cardinal Francesco Barberini in September 1625, the oil sketch for which is reproduced here (fig. 44).[4]

X-rays reveal that Poussin originally painted an archway at the upper left of the picture, showing two figures ascending a flight of stairs against a background of open sky. This motif also appears in a preparatory drawing for the painting in the British Museum,[5] and was presumably rejected by the artist because it distracted attention from the main figure group. Two other drawings may also be connected with the composition. Though long assumed to be preparatory studies for the painting, they have recently been dated to the 1630s on stylistic grounds.[6]

Numerous copies and variants of the design were made by artists as eminent as Greuze, David, Géricault, Delacroix and Gustave Moreau. The composition was also frequently translated back into sculpture, as if in acknowledgement of its antique origins. Among British artists who found inspiration in it were Reynolds, Fuseli and Gavin Hamilton, whose *Andromache Mourning the Death of Hector* of c. 1761 (fig. 45) is unthinkable without Poussin's *Germanicus* and signals the start of the Neo-classical preoccupation with heroic deathbed scenes.

The subject of the present picture, an *exemplum virtutis*, also

Fig. 43 *The Death of Meleager.* Ancient Sarcophagus. Relief. The Earl of Pembroke, Wilton House, Salisbury

enjoyed much favour during the Neo-classical period and may be related to that of certain other works by Poussin himself, including the two landscapes depicting the story of Phocion (cat. 67–8) and the *Coriolanus* (fig. 13). The reasons for Poussin's attraction to this theme in 1627 remain unclear, though several suggestions are put forward elsewhere in this catalogue[7] and another may be offered here. Tacitus describes Germanicus as a man devoid of arrogance or jealousy, who possessed great self-control and 'was kind to his friends' and 'modest in his pleasures'. Such a description closely fits that of

Fig. 42 *Copy after* Timanthes, *The Sacrifice of Iphigenia.* Fresco. Museo Nazionale (Capodimonte), Naples

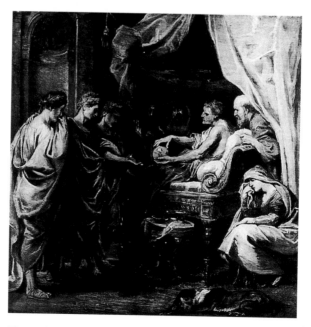

Fig. 44 Peter Paul Rubens, *The Death of Constantine.* Oil on panel, 33.3 × 33.7 cm, 1622. Private Collection

the mature Poussin and, even in 1627, may have struck him as a condition towards which he might aspire.

1. Rev. Matthew Pilkington, *The Gentlemen's and Connoisseur's Dictionary of Painters...*, London, 1798, p. 523.
2. Bellori, 1672, p. 413.
3. Pliny, *Historia Naturalis*, xxxv, 73.
4. Paris, 1973, pp. 9–10.
5. CR II, pp. 15–16, no. 129; Oxford, 1990–1, no. 16; Paris, 1994–5, no. 19.
6. CR II, pp. 15–16, no. 130; Blunt, 1974, pp. 239. Cf. Chantilly, 1994–5, pp. 114–5, no. 26, where both these drawings are dated to the years between 1632 and 1640. Whatever date may be assigned to them on grounds of style, they represent a regression on Poussin's part in his treatment of the theme, for if the soldiers in the present canvas are cast in a range of subtly differentiated poses, those in the two drawings are reduced to a chorus of onlookers waving their arms in unison as they vow to avenge Germanicus' death. So repetitive a scheme is hard to imagine from Poussin *after* the more inventive solution of the painting, as is the archway at the upper left of the Chantilly drawing, a detail overpainted in the finished picture.
7. *Supra*, pp. 22–3.

PROVENANCE
Painted for Cardinal Francesco Barberini between 1626–8; by descent in the Barberini collections, eventually to Prince Corsini; 1958, acquired by the Institute from Wildenstein.

EXHIBITIONS
Paris, 1973, no. 1; Rome, 1977–8, no. 13; Düsseldorf, 1978, no. 15; Paris, New York, Chicago, 1982, no. 85; Fort Worth, 1988, no. 49; Paris, 1994–5, no. 18

ŒUVRE CATALOGUES
Blunt, no. 156, Thuillier, no. 43, Wild, no. 15, Wright, no. 26, Oberhuber, no. 49, Mérot, no. 184

REFERENCES
Bellori, 1672, p. 413; Félibien (ed. 1725), IV, pp. 18, 21, 82; Hunter, 1959

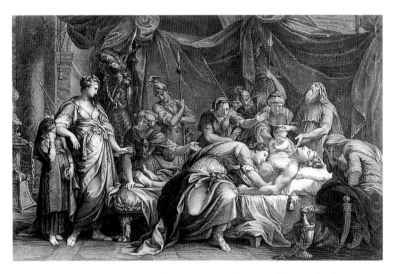

Fig. 45 Domenico Cunego (*after* Gavin Hamilton), *The Death of Hector*. Engraving, 1764 (after a painting of 1761). The Trustees of the British Museum, London

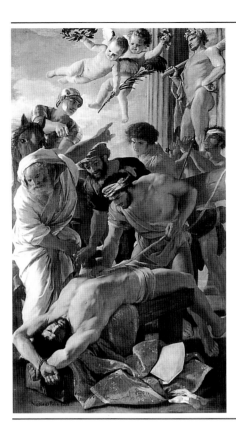

10

The Martyrdom of St Erasmus

1628–9

Signed: *Nicolaus Pusin fecit*

320 × 186 cm

Musei Vaticani, Città del Vaticano, Rome

The *Martyrdom of St Erasmus* is one of four monumental altarpieces by Poussin and the only public commission he ever received from his adopted city of Rome. It was painted for an altar in St Peter's in 1628–9 and provides evidence of his growing reputation in papal circles during these years.

The history of the commission is complicated and involved two of the most important Italian Baroque painters of the day, Guido Reni and Pietro da Cortona. In May 1627, the former was commissioned to paint a large altarpiece for St Peter's and Cortona a smaller one. Early in 1628, however, Reni left Rome and his commission was allocated to Cortona. Poussin was then called in to execute the altarpiece originally requested of the latter, which was to decorate a chapel in the right transept of the church. Concurrently, another French painter, Valentin de Boullogne, was commissioned to paint a *Martyrdom of SS. Processus and Martinianus* (fig. 46) for an adjacent chapel. According to Félibien, Poussin was recommended for this commission by Cassiano dal Pozzo,[1] but Bernini later claimed that he was responsible for this;[2] and it is perfectly possible that both men were. The picture was executed between February 1628 and September 1629 and a payment to the artist of 400 *scudi* completed in November of that year.

The subject is one of those exceptionally gruesome

martyrdoms much favoured by the Counter-Reformation Church and intended to remind the beholder of the extremes of pain or death that the early Christian martyrs suffered for their faith. Erasmus was a 3rd-century saint who, according to a late medieval tradition, was put to death by having his intestines wound around a windlass. Poussin paints this moment in all its horror and brutality. The saint is shown bound and laid out on a stone slab at the bottom of the picture as the executioners perform their task. At the left a high priest points to a brazen statue of Hercules, as though to remind Erasmus of the pagan gods to whom he should have directed his faith. Above, two putti descend bearing flowers, a martyr's palm and two laurel wreaths, symbols of eternal life.

Although the theme was rarely painted in Italy before the 17th century, it is common in northern Renaissance art and, in at least one instance (fig. 47), takes a form curiously similar to the present picture.[3] Poussin may have been aware of this tradition; but instead of portraying the uncoordinated action of the drawing reproduced here, he aligns all the principal figures in the composition parallel with one another and depicts the saint at the height of his suffering. This solution intensifies the dynamism and violence of the action while also resulting in a design which is more compact and essentially classical. The scene is bathed in a cool and even light and painted with remarkable breadth and assurance. Particularly notable is the brilliant handling of the rich brocade that lies beneath the saint, revealing the force and vigour of Poussin's brushwork at this moment of his career.

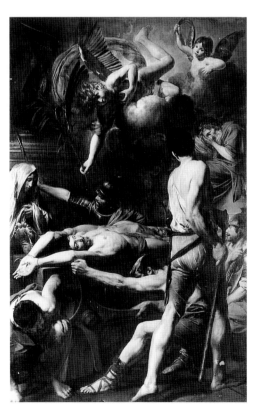

Fig. 46 Valentin de Boullogne, *The Martyrdom of St Processus and St Martianus*. Oil on canvas, 302 × 192 cm, 1629. Musei Vaticani, Città del Vaticano, Rome

Surprisingly, this masterpiece met with a mixed reception from the artist's contemporaries, some of whom compared it unfavourably with the rival altarpiece by Valentin. According to the German writer Sandrart, who was then in Rome and knew both artists, Poussin's picture was deemed superior in invention and expression and Valentin's preferable in naturalism, strength and richness and harmony of colour.[4] Nor can it be denied that the Caravaggesque Valentin employs a degree of surface realism in his picture that Poussin's chaste art studiously avoids. This verdict may account for the latter's failure to win any further public commissions in Rome; though, shortly after completing the *St Erasmus*, he succeeded in gaining a commission to paint another major altarpiece. This was the *Virgin appearing to St James* (fig. 64), painted for a church in Valenciennes in 1629–30 and arguably the most unashamedly Baroque work of the artist's career.

Despite the lukewarm reception accorded to the *St Erasmus*, it inspired numerous copies and derivations, among them several by Poussin's close follower, Pietro Testa (1612–50).[5] But its greatest accolade came from the supreme genius of Roman Baroque art, Gianlorenzo Bernini, who, in conversation with Chantelou in Paris in 1665, observed that when Guido Reni had criticised Poussin's altarpiece, Bernini himself had retorted: 'If I were a painter I should be mortified by that picture'.[6]

1. Félibien (ed. 1725) IV, p. 19.
2. Chantelou (ed. 1985), p. 181.
3. Wolfgang Wegner (ed.), *Kataloge der Staatlichen Graphischen Sammlung, München, Bd. I—Die niederländischen Handzeichnungen des 15.–18. Jahrhunderts*, Munich, 1973, p. 39, no. 189.
4. Sandrart, p. 257.
5. Cf. H. Brigstocke, 'Some further thoughts on Pietro Testa', *Münchner Jahrbuch der bildenden Kunst*, XXIX, 1978, pp. 118–19; E. Cropper, *Pietro Testa 1612–50, Prints and Drawings*, Aldershot, 1988, pp. 9–12, no. 6.
6. Chantelou (ed. 1985), p. 80.

PROVENANCE
Painted for an altar in St Peter's, Rome, in 1628–9; removed to the Quirinal before 1763 and replaced by a mosaic; 1797, taken to Paris, returned to Rome after 1815

EXHIBITIONS
Paris, 1994–5, no. 26

ŒUVRE CATALOGUES
Blunt, no. 97, Thuillier, no. 54, Wild, no. 22, Wright, no. 28, Oberhuber, no. 67, Mérot, no. 91

REFERENCES
Bellori, 1672, pp. 413–14; Briganti, 1960, pp. 16–20; Costello, 1975

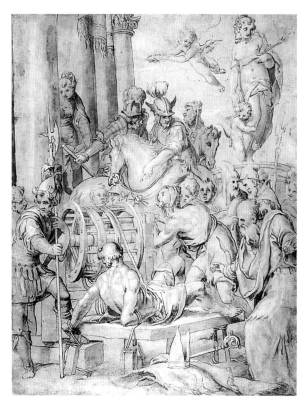

Fig 47 Anonymous 16th Century Netherlandish Artist, *The Martyrdom of St Erasmus.* Pen, brown ink and wash, heightened with white, 48.7 × 38.3 cm. Staatliche Graphische Sammlung, Munich

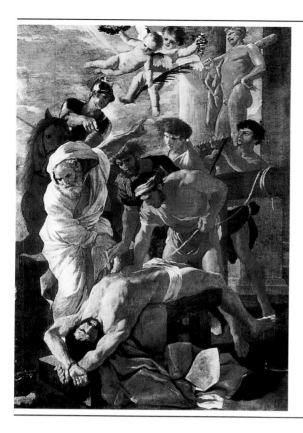

II

The Martyrdom of St Erasmus

1628–9

100 × 74 cm

The National Gallery of Canada, Ottawa

This is the *modello* for Poussin's altarpiece for St Peter's of 1628–9 (cat. 10) and was presumably submitted to the church authorities before work on the larger canvas was begun. It is first recorded in 1630 in the collection of Cardinal Francesco Barberini, nephew of Urban VIII, and is the only painted *modello* by Poussin to survive.

The Ottawa picture differs from the finished altarpiece in format, suggesting that the artist may have painted it before he became aware of the narrow dimensions of the site intended for this work. Otherwise it follows closely the design of the completed picture, with minor differences. In the *modello* the columns in the foreground are rounded rather than fluted, and both the man to the right of the high priest and the executioner working the windlass are bareheaded. In the final altarpiece, however, the former wears a turban and the latter a bandeau. Since St Erasmus was bishop of Antioch, the turban may have been added to symbolise the world of oriental paganism. In addition, the drapery beneath the saint is plain in the Ottawa canvas and richly brocaded in the Vatican picture. All of these changes add greater variety and colouristic richness to the scene and serve to emphasise the figures.

The *modello* also includes a stone and blood-stained knife on the ground to either side of the saint. Both of these instruments of torture are omitted from the final picture, presumably

because of its narrower format.

Two compositional drawings also exist for the Vatican picture,[1] both of them predating the Ottawa *modello*. The earlier of these (fig. 48) shows the saint with his head aligned to the right. Immediately above him appear the executioner, about to disembowel him, the high priest and a man pointing to the left. Behind these are the horseman, a figure exiting with the saint's garments and a group of women and children. At the right is a fluted column, behind which stands the portico of a temple.

The confusion and congestion of this drawing, with its centrifugal arrangement and unfocused action, appear radically revised in a second preparatory study (fig. 49). Like the preceding work, this is executed with a reed pen and reveals the remarkable vigour of Poussin's draughtsmanship at the most Baroque phase of his career. The design is much closer to the final canvas, with both the saint and the high priest shifted to the left and the executioner to the centre right. The group of onlookers has been reduced to three figures, and a pagan statue added at the upper right, though it does not yet appear to represent Hercules. This serves to explain the pointing gesture of the high priest, which had no real meaning in the first drawing. The drawing also depicts the horseman carrying a spear and the corner of a classical building at the left, two motifs that are omitted from the final work. Moreover, with the exception of the saint and the horseman, all the figures' heads appear at roughly the same level, rather than in the livelier and more lucid arrangement of the finished altarpiece, with its tiered

Fig. 48 Nicolas Poussin, *The Martyrdom of St Erasmus*. Reed pen in brown, slight black chalk underdrawing, 20.0 × 12.3 cm. Biblioteca Ambrosiana, Milan

construction and tightly interlocking figures.

The style of the *modello* is freer than that of the final altarpiece and is especially notable for its brilliant light accents and luminous draperies. It also shows traces of reworking, especially around the left arm of the saint.

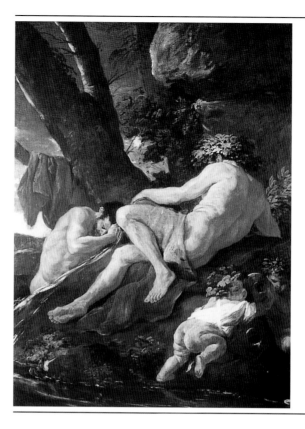

1. CR I, p. 39, no. 73; V, pp. 85–6, no. 409a. (Cf. Blunt, 1979, p. 194, n. 6 and Oberhuber, 1988, p. 341, no. D157).

PROVENANCE
Cardinal Francesco Barberini; his heirs; bought from them by Fairfax Murray before 1914; Ugo Ojetti, Florence; 1972, purchased by the Gallery

EXHIBITIONS
Fort Worth, 1988, no. 66; Paris, 1994–5, no. 27

ŒUVRE CATALOGUES
Blunt, no. 98, Thuillier, no. 53, Wild, no. 22a, Wright, no. 27, Oberhuber, no. 66, Mérot, no. 90

REFERENCES
Costello, 1975

Fig. 49 Nicolas Poussin, *The Martyrdom of St Erasmus.* Reed pen in brown, 20.4 × 13.2 cm. Gabinetto Disegni e Stampe degli Uffizi, Florence

12

Midas Washing at the Source of the Pactolus

c. 1627–9

97.5 × 72.5 cm

Lent by the Metropolitan Museum of Art, New York
Purchase, 1871

The pendant to the *Arcadian Shepherds* (cat. 13), this picture is first recorded with it in the collection of Poussin's friend and patron, Cardinal Camillo Massimi (1620–77), who also owned works by Claude and Velázquez and was one of the most discriminating collectors of his day. Though Massimi cannot have commissioned the pair, which were painted when he was still a boy, their obscure, moralising themes would undoubtedly have appealed to his learned tastes.

The subject of the present picture appears to have originated with Poussin himself and was certainly close to his heart; for no less than four canvases were devoted to it during his early Roman years. In *Metamorphoses*, (XI, 100–45) Ovid recounts the tale of King Midas, who served Bacchus by protecting his foster-father Silenus when the latter was seized by the king's subjects. In return, Bacchus offered the king any gift that he wished. Midas requested that all he touched should turn to gold; but, when he realised that even his food turned to gold, he returned to Bacchus and begged to be relieved of this gift. Bacchus then instructed him to bathe at the source of the River Pactolus, where he would be restored to his former state. Ovid concludes: 'The King went to the spring as he was bidden: his power to change things into gold passed from his person into the stream, and coloured its waters'.

This is the moment depicted in the New York painting, which shows Midas bathing, accompanied by the reclining god of the River Pactolus and two putti bearing urns. In a larger and more ambitious canvas of 1630–1 (fig. 50), Poussin combines two moments in the story, showing Midas kneeling before Bacchus in the foreground and the episode at the River Pactolus behind. Also in these years, Poussin painted a later moment in the story – one not recounted by Ovid – portraying the disillusioned King Midas reclining on the riverbank while a naked youth fishes for gold from the waters (fig. 10). In inventing this theme, Poussin gives an additional moral twist to the tale and suggests that human folly is never-ending. Finally, an unfinished replica of the New York picture in a private collection[1] appears to predate the present work, and differs from it primarily in showing a single putto clasping an overturned cornucopia at the lower right, a motif which may be intended to complement the main theme of the painting: the vanity of riches.

Curiously, Poussin was never moved to portray the most often depicted episode from the life of Midas – his foolish judgement of the musical contest between Apollo and Pan, for which Apollo awarded him asses' ears. This is probably because the incident contains little of moral significance. His preference instead for the theme of Midas and Bacchus is readily understandable; for not only was Poussin an iconographical innovator, deliberately seeking new subjects for his art from his earliest years, but he was also a highly didactic artist, even at the most lyrical and romantic phase of his career. The theme of Midas and Bacchus is one of vanity and greed and – as Poussin concludes in the painting in Ajaccio – of human nature itself. Poussin's own contempt for material possessions is well documented and finds expression in his art both in his four unprecedented canvases of this theme and in the *Testament of Eudamidas* (cat. 58) and *Landscape with Diogenes* (cat. 70).

Though the composition of this picture complements the *Arcadian Shepherds*, with its criss-crossing diagonal accents and reclining river god, the style of the work suggests a slightly earlier date, *c.* 1627–9. This is apparent in the broad and flowing handling, more muted palette and sombre lighting of the canvas. Although the two works were certainly intended as a pair, it is possible that Poussin painted both versions of the *Midas* before he decided to provide the more successful New York painting with its pendant, the *Arcadian Shepherds*. The river gods in both works provide evidence of such a time-lapse; for, whereas that in the *Midas* is summarily drawn and modelled, his counterpart in the *Shepherds* is more sensitively delineated. During the year or two which probably separate the two pictures, Poussin's art acquired an additional stylistic feature – finesse.

1. Blunt 1981, pp. 226–8.

PROVENANCE
Cardinal Camillo Massimi; bequeathed to his brother at his death in 1677; French private collections; 1836, bought from Solirène by J. Smith; 1871, acquired by the museum

EXHIBITIONS
Fort Worth, 1988, no. 51; Paris, 1994–5, no. 10

ŒUVRE CATALOGUES
Blunt, no. 165, Thuillier, no. 35, Wild, no. R25, Wright, no. 11, Oberhuber, no. 51, Mérot, no. 152

REFERENCES
Blunt, 1938; Friedländer, 1943, pp. 21–6

Fig. 50 Nicolas Poussin, *Midas and Bacchus*. Oil on canvas, 98.5 × 139 cm, *c.* 1630–1. Bayerische Staatsgemäldesammlungen, Munich

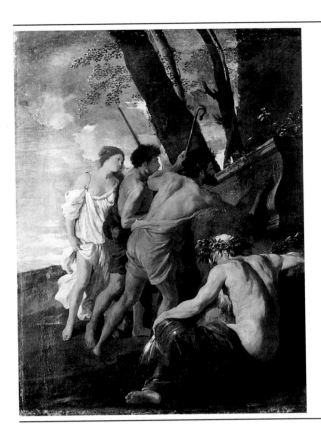

13
The Arcadian Shepherds

c. 1628–9

101 × 82 cm

The Duke of Devonshire and the Chatsworth Settlement Trustees

This picture is the companion to *Midas Washing at the Source of the Pactolus* (cat. 12). Both works are moral allegories, the latter concerning the vanity of riches and *The Arcadian Shepherds* the futility of life itself. But whereas the *Midas* is based on a well-known mythological theme, the present work is inspired by an *idée fixe* of Western culture that has no specific source. Instead, it has a complex genealogy in literature and art both before and after Poussin. More than any other subject painted by the master, however, it has come to be indelibly associated with him.

The motif of a tomb in Arcadia originates in Virgil's fifth *Eclogue* , where a group of mourners prepare a memorial for the shepherd Daphnis and inscribe it with an epitaph, lamenting his absence from the idyllic countryside in which he had once tended his flock.[1] This idea re-emerges in the Renaissance in Jacopo Sannazaro's *Arcadia* (1502); and, thereafter, it became a poetical commonplace, enjoying particular popularity during the 18th and early 19th centuries. Its earliest appearance in painting, however, is in a canvas by Guercino of *c.* 1618 (fig. 51), which depicts two shepherds contemplating a tomb surmounted by a skull and inscribed *Et in Arcadia ego* – 'Even in Arcadia, [there] am I'. These words are 'spoken' by the skull and intended as a grim reminder of the omnipresence of death,

even in the midst of ineffable happiness.

Guercino's picture is the first work to include this famous inscription and was presumably known to Poussin when he painted the present canvas. Like Guercino, Poussin depicts a group of shepherds coming upon a tomb bearing the identical words and surmounted by a skull. But he introduces a number of elements into his composition that intensify the meaning of the theme and convert the contemplative mood of the earlier painting into an active confrontation with death. The most obvious of these are the animated poses of his shepherds, who appear suddenly startled by the discovery of the tomb in the course of their journey. In addition, while Guercino's inscription faces the viewer, rather than the shepherds, Poussin's figures are actively engaged in deciphering it. (This direct involvement with Death's message may also explain the lesser importance of the skull in the Chatsworth painting.) The poignancy of this confrontation is enhanced by the figure of a river god at the lower right, whose flowing urn and drowsing pose call to mind the fleeting nature of earthly life and the final sleep of death. Poussin also departs from Guercino's prototype by including a shepherdess in his painting, dressed in a daring *décolletage* which suggests the amorous delights of the shepherds before they stumbled upon the tomb. Poetically speaking at least, this redoubles the force of the tomb's inscription, which here signals the end both of life and love.

The present picture is datable to 1628–9 and reveals Poussin's Titianesque manner at its most refined. Crisp, clear contours bound the forms and ensure the overall rhythmic flow of the design, with the elegant tree trunks at the top of the composition mirroring the extended legs of the shepherds below. Adding to the delicacy of the whole is the colour – greyish creams, mossy greens, muted golds and blues – which is

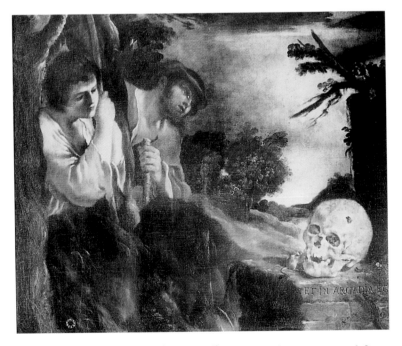

Fig. 51 Guercino, *Et in Arcadia Ego*. Oil on canvas, 82 × 91 cm, *c.* 1618. Galleria Nazionale d'Arte Antica, Palazzo Corsini, Rome

applied with a rapid and fluid touch that is in places of an almost caressing lightness and, in others, a bold impasto. But the principal unifying feature of the work is the dappled sunlight playing over the figures and foliage. This adds a palpable atmosphere to the picture that in itself reflects the transience of the theme.

Pentimenti are evident in the shoulder of the river god and the drapery of the right-hand shepherd. The picture has also been enlarged at the top and left through the addition of two strips of canvas that detract from the immediacy of the composition and presumably date from a time when it was no longer in the same collection as its pendant.

For a later version of the same theme, see cat. 38.

1. The history of this theme in literature and art since antiquity is fully explored in the classic essay by Panofsky of 1955.

PROVENANCE
Cardinal Camillo Massimi; bequeathed to his brother on his death in 1677; by 1761, Duke of Devonshire; thereafter by descent until the creation of the Chatsworth Settlement

EXHIBITIONS
Paris, 1960, no. 19; Edinburgh, 1981, no. 5; Fort Worth, 1988, no. 50; Paris, 1994–5, no. 11

ŒUVRE CATALOGUES
Blunt, no. 119, Thuillier, no. 55, Wild, no. 13, Wright, no. 54, Oberhuber, no. 50, Mérot, no. 198

REFERENCES
Weisbach, 1930; Klein, 1937; Weisbach, 1937; Blunt, 1938; Panofsky, 1938; *idem* (ed. 1955)

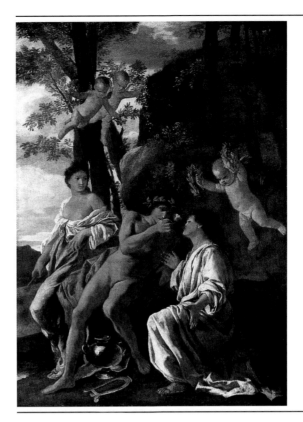

14

The Inspiration of the Lyric Poet

c. 1628–9

94 × 69.5 cm

Niedersächsisches Landesmuseum, Hanover

This belongs to a small group of early works by Poussin devoted to the theme of poetical inspiration. Though traditionally known as the *Inspiration of Anacreon*, there is no basis for this identification. Instead, the principal figure is more likely to represent an anonymous lyric poet. He is shown kneeling and drinking from a cup held up by Apollo. At the left stands Euterpe, Muse of Lyric Poetry, holding her attribute, a flute. Above, putti descend bearing laurel wreaths and the myrtle of Venus, the latter alluding to the lyric poetry of love. Although the laurel crown and lyre associated with Apollo are included in the picture, the wine jar at his feet is unusual. This motif led Panofsky to identify the god in the present picture as a composite deity, who combines the attributes of Bacchus and Apollo.[1] According to a tradition that originated with the ancients and survived into the Renaissance, Bacchus – as well as Apollo – was a leader of the Muses, and the wine associated with him was an influence upon the creative imagination. At the lower left of the picture is the Castalian spring, which flowed through Mount Helicon and was the legendary source of poetical inspiration.

Datable to 1628–9, the painting is close in style to the Chatsworth *Arcadian Shepherds* (cat. 13) and the *Holy Family with St John Holding the Cross* (fig. 2). All three works employ the diagonally aligned poses, asymmetrical figure groupings and

delicate, frosty hues of the present picture. They also reveal the increasing refinement of Poussin's draughtsmanship during these years. This is especially evident here in the eloquent figure of the poet and the adroit pose of Apollo – one which Poussin re-employed a year or two later for the figure of Ajax in the *Kingdom of Flora* (cat. 20).

Though nothing is known of the early history of this picture, it is conceivable that it owes its inspiration to Poussin's early friendship with the poet Marino, who died in 1625. As Panofsky suggested, another of Poussin's allegories of the arts, the *Parnassus* (cat. 22), may even have been intended by the artist as a posthumous tribute to his early patron and protector.

The enraptured pose of the poet in the present picture also suggests that this theme had deep personal significance for Poussin himself. This aspect of the work led André Gide to praise it as a masterpiece of mysticism among the artist's early canvases:

> ... it is in his *Inspiration of Anacreon* ... that I find unexpectedly revealed the mysticism that Poussin carried within himself. Pagan mysticism, it goes without saying, but so intense and sincere that one could not imagine its being expressed differently if Anacreon was quenching his thirst not with the cup of poetic inspiration that the god is handing him, but with the cup of the Eucharist. He has the gesture of self-surrender, the ecstatic gaze of the communicant. Nothing is more revealing that this admirable work which moves us, no doubt, by its extraordinary beauty but also as a confession.[2]

That 'confession' is almost certainly the importance that Poussin himself placed upon creative inspiration.

For a complementary canvas depicting the Inspiration of the Epic Poet, see cat. 18.

1. Panofsky 1960, pp. 45–7. This identification is refuted by Jane Costello, 'Erwin Panofsky, *A Mythological Painting by Poussin in the Nationalmuseum Stockholm*' (Review), *Art Bulletin*, XLIV, 1962, pp. 138–9.
2. Gide, 1945, n.p. (p. 11 of introduction).

PROVENANCE
The Electors of Hanover, probably by 1679; sent to England in 1803 and presumably returned to Hanover by 1837

EXHIBITIONS
Paris, 1960, no. 18; Paris, 1989, no. 2

ŒUVRE CATALOGUES
Blunt, no. 125, Thuillier, no. 56, Wild, no. 14, Wright, no. 55, Oberhuber, no. 35, Mérot, no. 203

REFERENCES
Panofsky, 1960, pp. 45–7 and *passim*

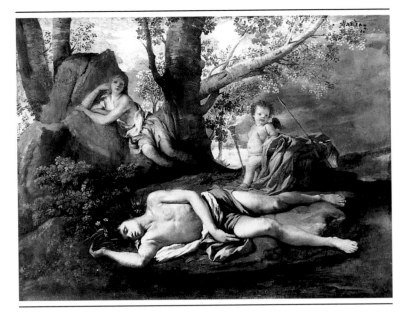

15
Echo and Narcissus

c. 1629–30

74 × 100 cm

Musée du Louvre, Département des Peintures, Paris

In this work, Poussin returns to the favourite theme of his early Ovidian pictures – unrequited or ill-fated love. As in *Venus with the Dead Adonis* (cat. 4), the composition takes the form of a lamentation scene. In the foreground the dying Narcissus lies beside the pool in which he had admired his own reflection (*Metamorphoses* III, 407–510). Sprouting around him are the narcissus blossoms that will eventually bear his name. Behind, Echo, the nymph who loved him unrequitedly, withers away, her bones turning to stone and only her voice, or 'echo', remaining. Poussin alludes to this element in the story by setting the nymph against a large rock and painting her so faintly that she appears to be dissolving into it. At the right, a mournful putto bearing a torch holds a silent vigil over the dying couple. Though unmentioned by Ovid, he is included here to symbolise the thwarted nature of their love.

With its smouldering evening sky and gradually waning light, the picture breathes the very atmosphere of romantic loss. But it is not only the restive nature of the landscape that conveys this sense of longing. It is also the dreamlike suspension of the figures and the languid nature of their poses. With the inconsolable figure of Echo at the upper left of the picture and Narcissus at the centre and right, Poussin creates a deliberate cleft in the design which intensifies its pathos. Contributing to this mood is the lifeless pose of Narcissus, which is borrowed from a representation of the dead Christ by the 16th-century Venetian master Paris Bordone (fig. 52), and serves further to give the picture the character of a Christian lamentation.[1] In the splayed legs of this figure, set adrift in the landscape and mirrored by the outstretched branch of a tree, Poussin adds a

poignant note of futility to the scene. As so often in the artist's early mythologies, a mood of trance-like reverie prevails between figures who inhabit the same physical space and yet appear emotionally distant.

The style of the picture is particularly close to the London *Cephalus and Aurora* (cat. 16) and the Prado *Triumph of David* (cat. 17). In all three works, a handful of large-scale figures is set against an intensely atmospheric background. The drawing and modelling of these figures is of exquisite refinement, and the colour almost sulphurous in its warmth and glow. With their self-absorbed figures and suspended actions, all three pictures possess a haunting and elegiac poetry which makes them among the most beautiful of the artist's Venetian-inspired canvases and suggests a date of 1629–30.

X-rays reveal that Poussin painted this picture over the remains of two earlier paintings.[2] The first portrayed a seated woman with a child and was probably an *Adoration of the Christ Child* or a *Rest on the Flight into Egypt*. The other showed a life-sized woman with her arm raised above her head, presumably a fragment of the larger composition that the artist cut down to paint the present picture. Also evident beneath the surface of the painting at the lower left is a seated figure resting its head in its hand. This appears to be an initial pose for the figure of Narcissus and accords with traditional renderings of the story, which often depict him kneeling and admiring his reflection in a pool.

Poussin incorporated the theme of Echo and Narcissus into two later mythological paintings, the *Kingdom of Flora* (1631; cat. 20) and the *Birth of Bacchus* (1657; cat. 83).

Recently the present picture has been identified with a painting of the same theme inventoried in 1669 in the collection of Cardinal Angelo Giori, who probably also owned the *Venus with the Dead Adonis* at Caen.[3] Among the many later admirers of the present work was Matisse, who made a copy of it during his student days, between 1892 and 1896.[4]

1. An alternative source for this figure in a fresco by Perino del Vaga has been proposed by Stein, 1952, pp. 6–8.
2. Hours, 1960, p. 6.
3. Brejon de Lavergnée, 1987, p. 396, no. 401.
4. Alfred H. Barr Jr., *Matisse: His Art and his Public*, New York, 1951, p. 33.

PROVENANCE
(?) Cardinal Angelo Giori; 1682, purchased by Louis XIV

EXHIBITIONS
Paris, 1960, no. 22; Rouen, 1961, no. 75; Bologna, 1962, no. 56; Rome, 1977–8, no. 16; Düsseldorf, 1978, no. 19; Paris, 1994–5, no. 38

ŒUVRE CATALOGUES
Blunt, no. 151, Thuillier, no. 49, Wild, no. 19, Wright, no. 53, Oberhuber, no. 71, Mérot, no. 138

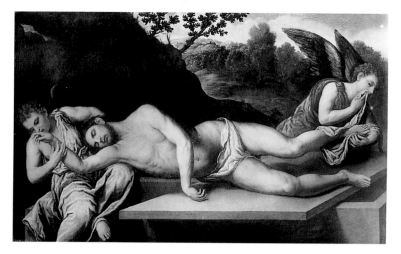

Fig. 52 Paris Bordone, *Pietà*. Fresco. Formerly Palazzo Ducale, Venice

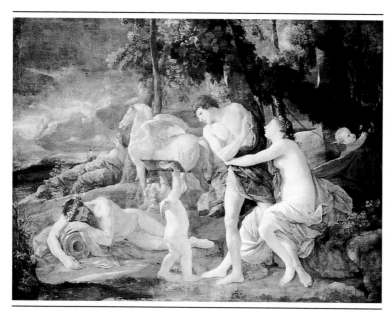

16

Cephalus and Aurora

c. 1629–30

96.5 × 130.5 cm

The Trustees of the National Gallery, London

Poussin's second version of *Cephalus and Aurora* depicts the same moment as his earlier canvas of this subject (cat. 1), but in a more original manner. The huntsman Cephalus rejects the amorous entreaties of Aurora, goddess of the dawn, and contemplates a portrait of his wife Procris, to whom he will shortly return and eventually mortally wound, in a tragic accident willed by the gods (*Metamorphoses* VII, 700–862).[1] Nearby waits the winged Pegasus, often referred to as Aurora's horse; while reclining at the left is Oceanus, personifying the site of the first love of Aurora and her husband Tithonus. Behind him is an earth goddess, gazing at the figure of Apollo, who drives his chariot across the sky to hasten the break of day.

Poussin may have derived the slumbering figure of Oceanus in the present picture from the pose of Tithonus in Annibale Carracci's fresco of this subject in the Palazzo Farnese (fig. 53). Yet nothing could be further removed from Annibale's vigorously dramatic portrayal of Aurora abducting Cephalus than the tender poetry of Poussin's picture. As in the artist's first version of this theme, the protagonists of the tale are combined with additional figures, unspecified by Ovid, to give an allegorical dimension to the myth. The inclusion of Apollo and Aurora alludes to the changing cycles of night and day. When seen together with the river god and earth goddess, however, these figures may also refer to the Four Elements, with Apollo representing air and Aurora the fiery light of dawn. Thus, Poussin sets Ovid's tragic love story in a cosmic context, in the manner of his earlier canvas of this subject.

In his treatment of the Ovidian lovers, Poussin reveals his deepened insight into the theme. In the first version Cephalus

rejects Aurora's advances with a gesture that resembles a slap on the face and the scene contains no reference to his undying love for Procris. In the London canvas, this somewhat gauche gesture is replaced by a pose of greater grace and eloquence, which seems at once to move forward and to dally behind and may owe its inspiration to the pose of Bacchus in Titian's *Bacchus and Ariadne* (National Gallery, London). Cephalus now strains to release himself from the goddess's embrace, urged on by the sight of Procris's portrait, held up by a winged putto. This enchanting motif, which is nowhere mentioned by Ovid, calls to mind Tamino's portrait aria in *The Magic Flute*. A precedent for it is Rubens's beguiling scene of *Henry IV contemplating the Portrait of Maria de'Medici* (fig. 54), which was installed in the Luxembourg Palace in May 1623 – an event the young Poussin may well have witnessed.

Enhancing the poignancy of the moment in the present painting is its instability. With Aurora's arm extended to its limits, and its imploring curve continued in the drapery behind, it is clear that this is the turning-point of the action and that the next moment will find the couple separated. The transience of this encounter is further reflected in the glowing hues of the sky, which charge the scene with a sense of kindled passion, but of a passion destined never to be fully flamed.

Cephalus and Aurora probably dates from 1629–30 and is comparable to the *Echo and Narcissus* (cat. 15) in its elegiac mood and pictorial subtlety. Like the latter canvas, it also appears to have undergone a complex gestation. Though no drawings survive for the picture, X-rays reveal extensive changes on the canvas itself, including the presence of a chariot (presumably Aurora's) where the earth goddess now appears. Even to the naked eye it is evident that Poussin also lowered the drapery around Aurora's waist to increase her allure.

Cephalus and Aurora was one of the first pictures by Poussin to enter the National Gallery and inspired many 19th-century British critics, among them William Hazlitt and his friend, the painter and engraver John Landseer, who preferred Poussin's mythologies to his biblical compositions because the former 'left his *will* more *free* than the sterner truths of religion'.[2] But it was left to C. R. Leslie, the friend and biographer of Constable, to remind us that Poussin's greatest

Fig. 53 Annibale Carracci, *Cephalus and Aurora*. Fresco, c. 1597–1600. Palazzo Farnese, Rome

strength in such pictures lay not in the power of his imagination but in his ability to give his ideas appropriate pictorial form:

> In the *Cephalus and Aurora*, of Nicolo Poussin in our National Gallery, the substitution of Apollo for the rising sun . . . is in the highest degree poetic. But the thought alone is a mere imitation of the poets, which might have occurred to the most prosaic mind. It is entirely therefore to the technical treatment – to the colour, and to the manner in which the forms of the chariot and horses melt into the shapes of the clouds, in fact to the chiaroscuro, that the incident . . . owes its poetry.[3]

1. For an unconvincing attempt to connect the subject of this picture with a poem by Ronsard, see Sohm, 1986, pp. 25–61.
2. J. Landseer, *A Descriptive, Explanatory, and Critical Catalogue of fifty of the earliest pictures contained in the National Gallery of Great Britain*, London, 1834, pp. 281–99.
3. C. R. Leslie, *A Hand-book for Young Painters*, London, 1855, p. 24.

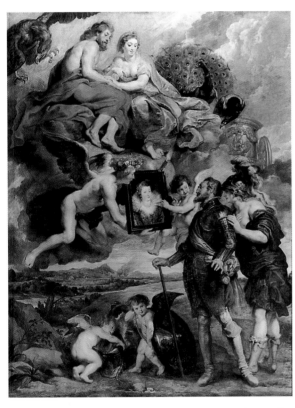

Fig. 54 Peter Paul Rubens, *Henry IV Contemplating the Portrait of Maria de' Medici.* Oil on canvas, 394 × 295 cm, 1621–3. Musée du Louvre, Département des Peintures, Paris

PROVENANCE
1750, Madame d'Hariague sale, Paris; 1789, Edward Knight; bought from his descendants in 1821 by G. J. Cholmondeley and bequeathed to the Gallery by him in 1831

EXHIBITIONS
Edinburgh, 1981, no. 12

ŒUVRE CATALOGUES
Blunt, no. 144, Thuillier, no. 30, Wild, no. 8, Wright, no. 24, Oberhuber, no. 61, Mérot, no. 136

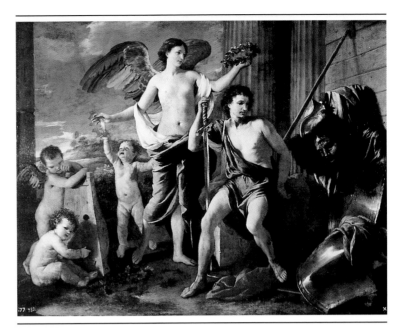

17
The Triumph of David

c. 1629–30

100 × 130 cm

Museo del Prado, Madrid

From his earliest years Poussin was fond of treating the same theme twice. Sometimes his second versions of a subject appear intended as 'improvements' on their predecessors and reveal the artist at his most self-critical. This is certainly true of the two sets of Seven Sacraments (cat. 39–44, 49–55) and may also be the case with the early versions of *Cephalus and Aurora* (cat. 1, 16), the second of which depicts the same moment in the story in a radically revised manner. In other instances, however, he painted two complementary canvases, which reveal the subject in a wholly different light, much as a composer might devise contrasting variations upon a single theme. This is the case with the two versions of the *Triumph of David*, which were painted within two or three years of one another and yet appear diametrically opposed, the present canvas being tender and lyrical in character and its successor (cat. 24) grippingly dramatic.

This painting depicts David being crowned by a winged figure of Victory after his triumph over Goliath, whose severed head and armour are seen at the right. According to Bellori, who provides an elaborate description of the picture, the laurel crown above him symbolises his triumph over the giant, and the crown of gold at the left alludes to his future reign.[1] Accompanying these figures are three putti, two of whom serenade the hero, while a third hands Victory the golden crown.

No biblical source exists for this subject, which would appear to be wholly imaginary, though it relates to traditional depictions of the triumph or apotheosis of a military hero. Where it differs from such pictures, however, is in its

175

meditative and melancholy air. This is reminiscent of Poussin's paintings of the apotheosis of the creative artist of these same years (cat. 14, 18) and imbues the picture with an intensely poetical quality. The youthful David, gracefully posed, gazes introspectively across at the head of his opponent; but, rather than contemplating his great victory, he appears to turn his thoughts to the fragility of life itself. Reflecting this mood are the pensive figure of Victory and the sorrowful countenances of the putti, one of whom wipes his tears at the solemn strains of the harp. In the distance silvery clouds part to reveal the dying rays of the sun – a motif that enhances the transience of the whole. The result is a kind of *poesie* around an Old Testament subject, which portrays three stages of human existence – youth, maturity and death – against a background of the inexorable passage of time.

The elegant draughtsmanship and warm, muted colouring of this painting link it with Poussin's mythological canvases of 1629–30 (cat. 15, 16) and reveal his continuing fascination with the art of Titian. Unique to Poussin, however, is the air of languor and passivity that pervades the picture, in which the figures appear suspended as in a dream.

Traces of an architectural setting, with a series of repeated arches, are visible beneath the surface of the picture and suggest that the artist may have painted it over an earlier work.

As may be seen from the provenance below, the *Triumph of David* has a distinguished history and was in the collections of a prelate and a notable Italian painter before entering that of the Spanish king.

1. Bellori, 1672, pp. 451–2.

PROVENANCE
By 1664, Monsignor Girolamo Casanate; Carlo Maratta; acquired from his heirs by Philip V of Spain in 1722

EXHIBITIONS
Rouen, 1961, no. 74; Edinburgh, 1981, no. 11; Paris, 1994–5, no. 36

ŒUVRE CATALOGUES
Blunt, no. 34, Thuillier, no. 66, Wild, no. 20, Wright, no. 61, Oberhuber, no. 72, Mérot, no. 29

REFERENCES
Bellori, 1672, pp. 451–25

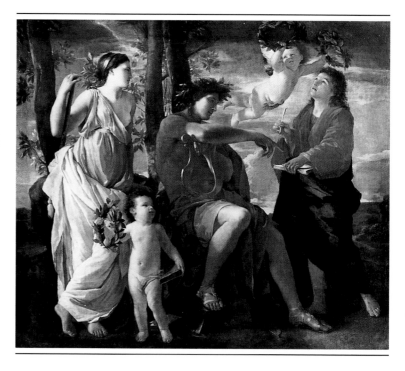

18
The Inspiration of the Epic Poet

c. 1630
182.5 × 213 cm

Musée du Louvre, Département des Peintures, Paris

Surprisingly, this masterpiece is not mentioned by any of Poussin's early biographers. It is first recorded in the collection of Cardinal Mazarin in 1653 along with another of the artist's most haunting creations, *Diana and Endymion* (cat. 19). Bernini saw it in the Cardinal's collection in Paris in August 1665 and remarked: 'This is a beautiful picture'.[1] When reminded by Chantelou that it was a work of Poussin's early years, he replied: 'That doesn't matter, it is painted and coloured in the manner of Titian'. Though this observation is true, it does not account for the unique position of the *Inspiration of the Epic Poet* in the artist's early career. If the style of the picture owes much to Titian, its majestic design calls to mind the art of Raphael. The result is a compelling fusion of those two opposing tendencies that had dominated the art of Poussin's early years: the sensuous and the ideal.

Although grander in scale and more elevated in theme, the picture complements the *Inspiration of the Lyric Poet* of *c.* 1628–9 (cat. 14). Like the latter, the *Venus and Mercury* (cf. fig. 3) and the *Parnassus* (cat. 22), it is an allegory celebrating the divine nature of creative inspiration. In the centre is Apollo, seated and resting his arm on his lyre. With a commanding gesture of his right hand, he imparts inspiration to an anonymous epic poet, whose enraptured gaze is directed upwards towards a putto bearing laurel wreaths, symbols of poetic inspiration. At the left stands Calliope, the Muse of Epic Poetry. At Apollo's feet are the *Odyssey, Iliad* and *Aeneid,* all masterpieces of the epic mode. As befits the most exalted genre

of poetry, the figures are monumental in scale and statuesque in pose and the design recalls that of a classical relief. Though numerous prototypes for the composition have been proposed in the art of antiquity (cf. fig. 55) and of Raphael himself (cf. fig. 56), Poussin does not appear to have borrowed directly from any of these sources. Rather, it is the lofty tone and elevated simplicity of the classical art of the past that he emulates in this remarkable canvas.

A comparison with the *Lyric Poet* reveals Poussin's ability to evoke two different genres of poetry in his conception of each scene. In the earlier painting, the figure group appears informally arranged and the poet literally imbibes his inspiration from a cup held up to him by Apollo. In contrast, the composition of the present picture possesses a hieratic symmetry and the poet appears divinely inspired, as he gazes heavenwards. In keeping with the nobler theme of the *Epic Poet*, the Muse no longer wears the daring *décolletage* of her counterpart in the earlier canvas but is more decorously clad. Through all of these devices, Poussin varies his treatment in accordance with the theme, a phenomenon also apparent in his two contrasting versions of the *Triumph of David* (cat. 17, 24).

The date of the picture has given rise to much discussion, certain critics preferring to place it around 1629–30 and others a year or two later. The physiognomy of the poet, with his broadly aligned features and fervent expression, recalls that of certain of the figures in the *Virgin Appearing to St James* of *c.* 1629–30 (fig. 64). The caressing light and molten colouring of the picture are likewise comparable to those of a group of mythological canvases datable to *c.* 1630, among them *Diana*

and Endymion. This would seem to be the most plausible date for the present picture. Since Mazarin is recorded in Rome in 1632–3, it is conceivable that he purchased both paintings directly from the artist's studio on this visit. This would explain the silence of the early sources on them, and might also account for the fact that they were never engraved.

No drawings survive for this painting, but X-rays reveal a number of changes made on the canvas itself.[2] The poet originally wore short hair, like his counterpart in the *Inspiration of the Lyric Poet,* and a putto was positioned to the immediate right of Calliope, rather than standing by her side. In addition, the Muse wore drapery over her left breast and right arm, a fussy and confusing arrangement that was altered by Poussin in favour of the languid and dignified treatment of this figure in the finished painting.

Poussin returned to the theme of poetic inspiration in two engraved frontispieces for editions of Virgil and Horace, executed in Paris in 1641–2.[3] The former (fig. 57) recalls the design of the present work in its statuesque figure group and planar composition. In keeping with the evolution of his own art during the 1630s, however, Poussin transforms the mood of ardent inspiration of the *Epic Poet* into one of greater gravity and solemnity in the engraved frontispiece. The figures now bear an air of Olympian detachment, Apollo himself crowning the poet while a putto descends with a tablet inscribed with the title of the work.

The *Inspiration of the Epic Poet* is recorded in private collections in England from 1772 to 1910. In 1911 it was acquired by the Louvre, the most recent purchase of a painting

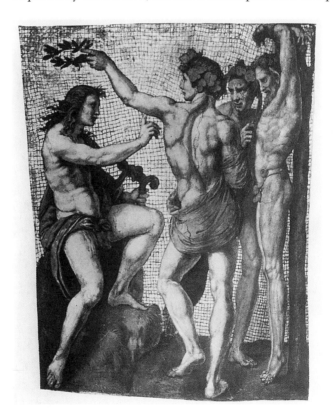

Fig. 55 Roman Sculpture, *Hercules and the Hesperides.* Relief. Villa Albani, Rome

Fig. 56 Raphael, *Apollo and Marsyas.* Fresco, 120 × 105 cm, 1508. Stanza della Segnatura, Vatican, Rome

by Poussin for the French national collection. Though its acquisition caused controversy in the French press, a number of enlightened critics arose in its defence. Coinciding with the most classical phase of Cubism and the radiant interiors of Matisse of these same years, the purchase was perfectly timed. As one critic observed in 1912, between the *Inspiration of the Epic Poet* and the creations of early 20th-century painting 'there is a tie which, although unconfessed, is no less strong'.[4]

The canvas has been slightly enlarged on all four sides; the largest addition is a strip of 9–10 cm at the top.

1. Chantelou (ed. 1985), p. 147.
2. Hours, 1960, pp. 17–22.
3. Wildenstein, 1957, pp. 226–8, nos. 171–2.
4. Jacques Rivière, 'Poussin et la peinture contemporaine', *L'art decoratif*, XXVII, March 1912, p. 148.

PROVENANCE
In the collection of Cardinal Mazarin by 1653; still recorded with his descendants in 1714; Marquis de Lassay; 1757, Hôtel de Lassay; 1772, Comte de Lauraguais sale, London; acquired by the 5th Earl of Carlisle; 1798, sale, Bryan, Cox, Burrell and Foster; 1824, Thomas Hope collection; his descendants until 1910; 1911, purchased by the Louvre

EXHIBITIONS
Paris, 1960, no. 8; Paris, 1989, no. 1; Paris, 1994–5, no. 30

ŒUVRE CATALOGUES
Blunt, no. 124, Thuillier, no. 61, Wild, no. 18, Wright, no. 56, Oberhuber, no. 54, Mérot, no. 204

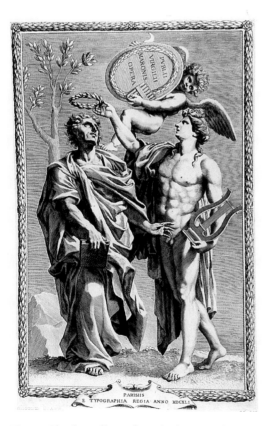

Fig. 57 Claude Mellan (*after* Nicolas Poussin), Engraving for the Frontispiece of Virgil. 36.3 × 23.8 cm, 1641. The British Library, London

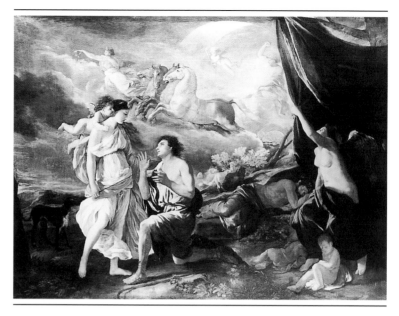

19
Diana and Endymion

c. 1630
121 × 168 cm

The Detroit Institute of Arts, Founders Society Purchase, Membership and Donations Fund

The legend of Diana and Endymion has a complex genealogy in ancient fable.[1] According to some sources, the goddess of the moon fell in love with the beautiful shepherd Endymion while he was sleeping and paid nightly visits to him, departing at the break of day. Others add that Zeus granted Endymion a wish, and the latter chose everlasting sleep rather than age or death. It is uncertain whether Zeus's gift was inspired by Endymion's beauty or Diana's love of him – a love that could now gaze upon his youth forever. In this form, the story was often depicted on antique sarcophagi, where it symbolised the eternal sleep of death. No version of the tale corresponds with the exact moment depicted in the present picture, however, which is widely regarded as one of the most beautiful and mysterious of Poussin's early works.

The time of day is dawn. Aurora sprinkles rose petals across the sky; she is followed by Apollo in his chariot. At the right, the winged figure of Night draws the curtain of darkness around her. At her feet are two putti representing Sleep and Death, while behind this group appears the reclining figure of Somnus, or Sleep. To the left, Endymion kneels before Diana, who wears a crescent-shaped moon on her head and holds an arrow. These attributes symbolise her dual role as goddess of the moon and the hunt. She appears to be departing for the chase, urged on by a putto and accompanied by a waiting hound.

Though the moment depicted seems to portray the lovers at the end of one of their nocturnal trysts, this does not account for the allegorical figures included in the picture or for the

awake and kneeling figure of Endymion. Certain of these features do occur, however, in a print by Crispin de Passe the Younger (fig. 58), made to illustrate Jean Gombauld's novel, *L'Endimion*, of 1624, a work which Poussin might easily have known.[2] This shows both the kneeling Endymion before Diana and a chariot drawn across the sky.

Even if this routine engraving provided the spur to Poussin's imagination, it can never account for the painting's haunting poetry. Rather, this appears directly related to the artist's non-specific treatment of the myth, together with the picture's delicate colour and melting light and its captivating delineation of the relationship between goddess and mortal. The imperious Diana, her draperies fluttering in the wind, bids farewell to the young shepherd, who kneels before her enraptured by her beauty and submissive to her power, in a pose that seems at once to adore and implore her. The emotional complexity of the moment is heightened by Endymion's facial expression, which combines ardour with obeisance, as though to suggest the goddess's contending claims over him. Adding to the atmosphere of romantic yearning is the pale and tender colouring of the picture, which looks as if it was painted with the rosy hues of dawn.

With its chiselled contours and pastel colour harmonies, the picture appears close in style to the Prado *Triumph of David* (cat. 17) and the London *Cephalus and Aurora* (cat. 16) and dates from *c*. 1630. Also linking these three canvases is the striking originality of Poussin's idea in each case, one that reveals the reflective young artist transforming a traditional tale

from the Bible or Ovid into a wholly imaginary conception that is steeped in poetry.

Nowhere is this more apparent than in the range and variety of allegorical figures included in the present picture. As so often in Poussin, these serve to set the myth against a background of the continuing cycles of nature and, thereby, of time. This adds poignancy to the ardent relationship between the lovers, especially when one contrasts them with the sleeping figures at the right of the design. Taken together, these comprise a group depicting the three ages of man and three stages of human love, in a manner so allusive that it may even have been unconscious to Poussin. The infant putti sleep, their passion not yet awakened, while the aged Somnus slumbers, his passion already spent. Only the mature couple at the left appear awake and in the full flush of love – though of a love which is itself imperilled by time.

Like another of Poussin's most ravishing early works, the *Inspiration of the Epic Poet* (cat. 18), this picture is first recorded in the collection of Cardinal Mazarin, who may have purchased it directly from the artist in Rome in 1632–3.

1. This has been studied most recently by Timothy Ganz, *Early Greek Myth, A Guide to Literary and Artistic Sources*, Baltimore and London, 1993, pp. 35–6.
2. Colton, 1967, pp. 426–31.

PROVENANCE
Cardinal Mazarin inventories of 1653 and 1661; perhaps Cardinal Fesch (cat. 1841) and Fesch sale, Rome, 1845; purchased from an English private collection by Cassirer, Berlin; 1922, sold to Julius Haas; Mrs Trent McMalt (*née* Haas); 1936, purchased by the Institute

EXHIBITIONS
Paris, 1960, no. 26; Bologna, 1962, no. 59; Rome, 1977–8, no. 20; Düsseldorf, 1978, no. 18; Paris, New York, Chicago, 1982, no. 87; Fort Worth, 1988, no. 62; Paris, 1994–5, no. 37

ŒUVRE CATALOGUES
Blunt, no. 149, Thuillier, no. 42, Wild, no. R57, Wright, no. 51, Oberhuber, no. 62, Mérot, no. 137

REFERENCES
Friedländer, 1943, pp. 26–30; Colton, 1967; Dowley, 1973

Fig. 58 Crispin de Passe the Younger, *Diana and Endymion*. Engraving from J. O. Gombauld, *L'Endimion*, 1624. The Trustees of the British Museum, London

20

The Kingdom of Flora

1631

131 × 181 cm

Staatliche Gemäldegalerie, Dresden

The *Kingdom of Flora* is the culmination of Poussin's early mythologies and has one of the most intriguing histories of any of his works. It was commissioned in 1630 by the Sicilian nobleman Fabrizio Valguarnera, who paid for the picture with the proceeds of a theft of diamonds, a crime for which he was arrested and put on trial in the following year.[1] Poussin himself was called to testify at this trial, where he stated that he had painted both the *Plague at Ashdod* (fig. 26) and the present picture for Valguarnera. Whatever may be said about the latter's morals, there can be no denying the standards of his taste. He also owned major works by a number of Poussin's greatest Italian contemporaries, some of them paid for in diamonds and others in cash. The undisputed masterpieces of his collection, however, were Poussin's *Plague at Ashdod* and *Kingdom of Flora*, two of the key pictures of the artist's early years.

This painting was referred to as a 'Primavera' in Valguarnera's trial, though Poussin himself called it a 'garden of flowers', and both descriptions are essentially correct. The picture portrays an allegorical gathering of all of those characters in Ovid's *Metamorphoses* who were transformed into flowers. Presiding over them are three deities associated with spring. In the centre dances Flora, goddess of the flowers, dressed in green, the colour of spring.[2] Above, Apollo drives the chariot of the sun across the sky; and, at the left, stands a herm of Priapus, god of gardens.

The remaining figures are all mortals. At the left is Ajax, running himself through with his sword after losing his claim to the arms of the dead Achilles (*Metamorphoses*, XIII, 380–98). From his blood will spring the hyacinth. In the centre foreground, Narcissus gazes at his reflection in an urn

accompanied by a water nymph, who may represent Echo (cf. cat. 15). Next to him grow the flowers that will bear his name (III, 344–510). Behind him, Clytie – who loved Apollo unrequitedly – gazes up at the sun god. She will become a heliotrope, or sunflower, destined always to turn towards the sun (IV, 256–70). At the foreground right are Crocus and Smilax, whose overzealous love led to their transformation into the plants of the same name (IV, 283). Behind them stand Adonis and Hyacinthus. The former is accompanied by his hunting dogs and shown touching the wound that led to his untimely death, from which sprang the anemone (X, 708–39; cf. cat. 4). Hyacinthus, who was accidentally killed by a discus thrown by Apollo, gazes instead at the blossom that will bear his name (X, 181–213). The scene is completed by a group of putti dancing around Flora and another reclining in the right corner. At the foreground left rests a cornucopia of flowers – an obvious reference to the ever-renewing powers of nature. The setting is a rustic grotto bounded by a delicate pergola, which Poussin borrowed from an engraving by Leon Davent after Primaticcio.[3]

Many of the figures in this picture also appear in Poussin's *Triumph of Flora* (fig. 22) of 1626–7, which is likewise a celebration of those mythological beings associated with the season of spring. But whereas the earlier canvas takes the conventional form of a triumphal procession in honour of the seasons, the present picture is entirely original in both theme and design. Though countless attempts have been made to uncover a literary source for the painting – especially in the poetry of Poussin's early friend and patron, Marino – none of these is wholly convincing; and it is more likely that the artist relied largely on Ovid and on the moralising commentaries on the *Metamorphoses* often included in early editions of this work. These frequently stressed the vanity of the pride and passions of the figures depicted in this picture and the tragic consequence of their vainglory: transformation into a flower,

Fig. 59 Nicolas Poussin, *The Kingdom of Flora*. Pen and bistre wash over some red chalk on rough paper, 21.3 × 29.3 cm. The Royal Collection

the most fragile and short-lived of beings.

Though the theme of human *vanitas* would no doubt have appealed to Poussin, who returned to it throughout his career, the picture is also concerned with another of the artist's favourite subjects: that of the cyclical progress of nature. If the former theme is implicit in the languid and melancholic poses of many of the figures in the present canvas, the latter is suggested by the lilting dance of Flora, the arrangement of the figures around her and by the picture's enchanting lightness of tone and colour.

The composition unfurls like a flower in a sequence of overlapping curves around the central figure of Flora. This movement is then inverted in the arc of clouds in the sky, giving the picture a grace and elegance that enhance its delicacy. Assisting in this is its exquisite draughtsmanship which, in the figures of Ajax and Smilax especially, reaches a pitch of refinement and stylisation worthy of Ingres. Scarcely less appealing are the colour harmonies: soft greens, light blues, dusky reds and muted golds – in themselves, the hues of springtime.

Four drawings may be connected with the picture,[4] two of which are for the entire composition. The earlier of these (fig. 59) dates from the late 1620s and may be the sketch Poussin showed to Valguarnera which led him to commission the painting. It shows the figure group largely as it appears in the final canvas, though with Flora posed in profile and Ajax bending at the knees as he falls on his sword. In the painting, he performs this action with a grace and eloquence that mirrors the pose of Flora herself and appears fully in harmony with the rarefied beauty of the entire ensemble. Minor adjustments to the figures occur in a later studio drawing (fig. 60), presumably made after a lost original. But both of these works appear crudely designed when compared with the final painting. One need only contrast the bent and stooping pose of Narcisuss in the drawings with his enraptured counterpart in the finished

canvas to witness a transformation almost worthy of Ovid. As the artist progressed from drawing to painting, raw nature became pure poetry.

1. Costello, 1950, pp. 237–84.
2. As many commentators have observed, this figure combines the characteristics of Flora and Spring and may be seen as a composite deity. This 'confusion' is reflected in the early sources; for, if Bellori refers to her as Flora, Valguarnera himself called her Spring, and she closely resembles the figure of Spring in Poussin's *Phaeton Begging the Chariot of Apollo* (c. 1628–9; Gemäldegalerie, Berlin).
3. *The Illustrated Bartsch*, ed. Walter L. Strauss, 33 (formerly vol. 16, part 2), New York, 1979, p. 195, no. 43-II(322).
4. CR III, pp. 35–6, nos. 214 and A 58; V, p. 111, nos. 440–1.

PROVENANCE
Painted for Fabrizio Valguarnera in 1630–1; by 1715 in the collection of the electors of Saxony

EXHIBITIONS
Paris 1960, no. 20; Paris, 1994–5, no. 44

ŒUVRE CATALOGUES
Blunt, no. 155, Thuillier, no. 67, Wild, no. 32, Wright, no. 62, Oberhuber, no. 85, Mérot, no. 141

REFERENCES
Bellori, 1672, p. 441; Félibien (ed. 1725), IV, p. 85; Costello, 1950; Spear, 1965; Simon, 1978; Worthen, 1979; Thomas, 1986

Fig. 60 *Studio of* Nicolas Poussin, *The Kingdom of Flora*. Pen and brown wash over black chalk, 34.9 × 47.6 cm. The Royal Collection

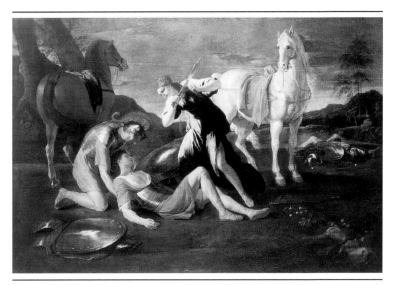

21

Tancred and Erminia

c. 1631

98 × 147 cm

The Hermitage Museum, St Petersburg

Though Poussin drew the majority of his subjects from the Bible, ancient history and mythology, he also devoted six canvases and a number of drawings to themes from Torquato Tasso's epic poem, *Gerusalemme Liberata*, which was first published in 1581 and rapidly became one of the most popular and widely translated works of Renaissance literature. The subject of the poem is the siege and capture of Jerusalem from the Saracens during the First Crusade (1096–9). Interwoven with this, however, are three romantic tales which provide relief from the military exploits of the crusaders and were destined to inspire a host of later artists, poets and musicians.

The present picture illustrates one such episode (Canto XIX, 104–14) from Tasso's poem. Erminia, a Saracen princess, has been captured from her father's camp by the Christian warrior Tancred, with whom she has fallen secretly in love. At the same time, Tancred has accepted a challenge to do battle with the Saracen giant, Argantes, whom he eventually slays. Seriously wounded from this struggle, Tancred collapses on the battlefield and is discovered by Erminia. She is accompanied by his squire Vafrino who has escaped from the enemy in search of him. Coming upon the body of the wounded knight, both initially think him dead; but when a spark of life is detected on his lips, Erminia cuts off her hair to staunch his wounds and the two transport him back to the crusaders' camp.

Poussin depicts the turning-point of the action. Vafrino supports the body of the injured knight while Erminia cuts off her hair. Behind appear the corpse of the pagan giant and the horses of Erminia and Vafrino. The scene is set at dusk, as described by Tasso; and the inclusion of an obelisk in the distance, immediately below Erminia's right arm, locates the action in the Holy Land.

Though the picture portrays a specific incident from Tasso's epic, Poussin alludes to other moments in the drama. The presence of Argantes provides a reminder of the immediate past; while the benevolent expression of Erminia's white horse appears to foretell a happy outcome to the story. Few animals in art have been gifted with greater intelligence and insight than this noble steed, who appears at once so alert and so ethereal. But perhaps the subtlest feature of the work is the pose and expression of Erminia, who gazes adoringly at Tancred, while impulsively cutting off her hair, as though momentarily caught between love and fear. This aspect of the work led the 19th-century critic C. P. Landon to acclaim the picture as an example of how painting 'as well as poetry may arouse in the soul several sentiments at the same time'.[1] Heightening the ardour and immediacy of the action are the glorious hues of the sunset which pervade the picture and charge the scene with tension.

This is one of the earliest depictions of the subject in art, though it was preceded by a canvas by Guercino of 1618–19 (fig. 61),[2] which shows Erminia coming upon the body of the wounded knight and, unlike Poussin's picture, is more concerned with the heroine's emotional response to this discovery than with her ensuing action. Both works take their inspiration from the traditional theme of the Lamentation over the dead Christ, with Vafrino substituted for the Evangelist and Erminia for the Magdelene or the Virgin. Poussin also alludes here to the theme of one of his early mythological paintings, *Venus with the Dead Adonis* (cat. 4), which itself may be related to a Christian lamentation. At the lower right of the present picture, flowers bloom on an otherwise bare patch of land. These may be related to the anemones that blossom around the dead Adonis and remind us that the subject of Tancred and Erminia may also be regarded as one of 'death' and resurrection.

The painting is datable to *c.* 1631, the period of the *Kingdom*

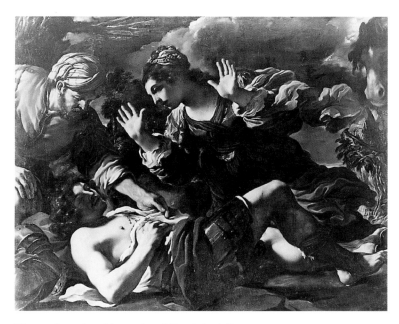

Fig. 61 Guercino, *Tancred and Erminia.* Oil on canvas, 145 × 187 cm, *c.* 1618–9. Galleria Doria-Pamphili, Rome

of *Flora* (cat. 20), and is closely comparable with that picture in its delicately proportioned figures and exquisite draughtsmanship. Both works also reveal a fondness for exploring the graceful linear rhythms between elements in the composition, evident in the present picture in the interweaving positions of the legs and draperies of Tancred and Erminia.

Poussin returned to this subject from Tasso two or three years later to paint an even more dramatic version of the theme (cat. 26).

1. C. P. Landon, *Annales du musée et de l'école moderne des beaux-arts*, XXVI, Paris, 1821, no. 20.
2. Cf. Birmingham, 1992–3, for the relationship of Poussin's two canvases of this subject to works by his predecessors and contemporaries (with further bibliography).

PROVENANCE
1766, purchased by the Empress Catherine II of Russia from the painter J.-A.-J. Aved

EXHIBITIONS
Paris, 1960, no. 42; Düsseldorf, 1978, no. 19a; New York, Chicago, 1990, no. 3; Birmingham, 1992–3, no. 6; Paris, 1994–5, no. 35

ŒUVRE CATALOGUES
Blunt, no. 206, Thuillier, no. 68, Wild, no. 55 (follower of Poussin), Wright, no. 65, Mérot, no. 196

REFERENCES
NP/SM, pp. 80–4

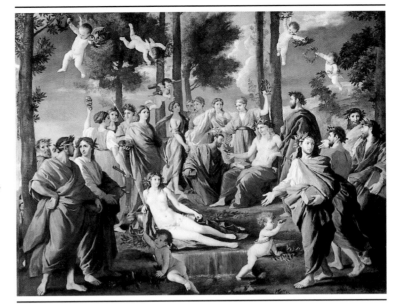

22

Apollo and the Muses on Parnassus

c. 1630–2

145 × 197 cm

Museo del Prado, Madrid

Closely modelled on Raphael's fresco of the same theme (fig. 62), the Prado *Parnassus* appears as an act of homage on Poussin's part to the Italian master who exerted such a profound influence upon his style throughout his middle years. The scene depicts Apollo and the nine Muses on Parnassus. They are accompanied by nine poets, one of whom kneels before the god, as if being initiated into their company. Below these figures is the reclining nymph of the Castalian spring – legendary source of poetic inspiration – from which two putti draw water. Hovering over the group are five additional putti bearing palms and laurel wreaths, attributes of both poetry and fame. Though these figures do not appear in Raphael's fresco, they are included in Marcantonio Raimondi's engraving after it, which Poussin follows more closely.

Four of the Muses bear attributes in Poussin's picture, making it possible to identify them. At the far left is Thalia (Muse of Comedy), holding a comic mask and flute. To her right appears Urania (Muse of Astronomy), holding a trumpet with a star, and Melpomene (Muse of Tragedy) with a dagger and tragic mask. Nearer to Apollo is Terpsichore (Muse of the Dance) and Euterpe, the Muse of Lyric Poetry, holding a pan-pipe. The statuesque figure crowning the poet in the centre is presumably Calliope, the Muse of Epic Poetry. Though the poets bear no identifying features, the group at the left may depict Homer, Virgil and Tasso. More intriguing is the identity of the poet being crowned, whom Panofsky has suggested may represent Poussin's early patron and protector, the Italian poet Giovanni Battista Marino.[1] Though the latter had died in March 1625, within months of Poussin's arrival in Rome, he enjoyed an enormous posthumous reputation as the equal of the ancient

poets. This was founded largely on his two epic poems, the *Adone* (1623) and the *Strage degli Innocenti* (1632) which – if this identification is accepted – would be the two books he holds here. Seen in this way, the *Parnassus* becomes a double act of homage to Poussin's early benefactor and to the Renaissance master upon whom he was to model his mature style.

Poussin's interest in Raphael's fresco appears to date from the late 1620s, when he made two drawings based on it. One of these is a faithful copy of the central group in Raphael's composition, which is one of Poussin's rare copies after any Old Master.[2] The second is a preliminary study for the Prado painting (fig. 63), which shows Poussin gradually transforming the static and self-absorbed figures of Raphael's design into ones involved in a more concerted action. Seated at the left is Apollo playing a viol, in a pose obviously inspired by the Vatican fresco. He is surrounded by the Muses, one of whom crowns two poets in the centre of the composition, while another leads on a third poet at the foreground left. Though the Castalian spring is already depicted here, the nymph that personifies it is lacking. According to Panofsky, the poets being crowned are Homer and Virgil and the one entering the scene is Tasso. Only after making this drawing did Poussin apparently conceive of the idea of a single poet kneeling before Apollo, which gives the design a clearer focus and a more centralised composition.

With its cool and even light and pale colouring, this picture appears painted in emulation of fresco and is unashamedly Raphaelesque in style. This is especially evident in the self-consciously noble attitudes of the Muses and the emphatically gesticulating figures of the poets. The elongated proportions of the water nymph, on the other hand, appear somewhat Mannerist and, as has often been noted, recall the School of Fontainebleau. These discrepancies, together with the somewhat stilted nature of the composition, led Blunt to date the picture very early in Poussin's career, *c.* 1626–7. More recent critics agree, however, that it is most probably a work of the early 1630s and cite as evidence of this the close resemblance between the figure of Apollo in the present picture and that of Crocus in

the *Kingdom of Flora* (cat. 20) of 1631. Any shortcomings in the Prado picture may best be explained by the fact that it is one of Poussin's first attempts at an ambitiously classicising composition and that the theme itself is essentially static. Moreover, as the style of the work suggests, it may have been intended to look consciously archaic, in deliberate emulation of Raphael's fresco.

Another unusual feature of the painting is its colour balance. With the exception of the group of poets at the right, virtually all the figures in the picture are clad in blue, gold or white, or some combination of these colours. The poets at the right, however, wear a bold range of contrasting hues – reds, greens, violet and blue. These figures are also the most incisively drawn and impressively modelled in the picture and prompt one to wonder if this canvas was executed in two distinct stages, one in the late 1620s and the other around 1632.

With the two paintings of the *Inspiration of the Poet* (cat. 14, 18) and the *Venus and Mercury* (cf. fig. 3), the *Parnassus* belongs to a small but significant group of early works by Poussin commemorating the theme of the creative artist, one that reflects the Humanist bias of his art and may even have been intended to extol the status of his chosen profession.[3]

1. Panofsky, 1960, pp. 51–6 (for all the identifications given here).
2. Blunt, 1974, pp. 239–40, pl. 3.
3. *Supra*, p. 20–1.

Fig. 63 Nicolas Poussin, *Parnassus*. Pen and bistre wash, 17.8 × 24.6 cm. The Collection of the J. Paul Getty Museum, Malibu, California

PROVENANCE
Apparently seen by Félibien in Rome in 1647; 1684, possibly sold in London (Banqueting House, Whitehall, anon. sale); by 1746, Spanish Royal Collection
EXHIBITIONS
Paris, 1960, no. 6 bis; Paris, 1983–4, no. 201; Paris, 1994–5, no. 45
ŒUVRE CATALOGUES
Blunt, no. 129, Thuillier, no. 69, Wild, no. 26, Wright, no. 67, Mérot, no. 121
REFERENCES
Panofsky, 1960, pp. 51–6 and *passim*

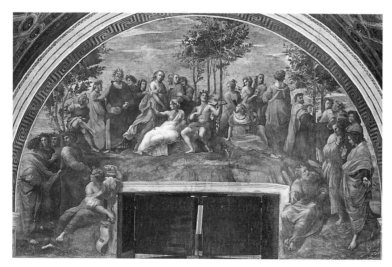

Fig. 62 Raphael, *Parnassus.* Fresco, 1511. Stanza della Segnatura, Vatican, Rome

23
The Assumption of the Virgin

c. 1631–2
134.5 × 98 cm

National Gallery of Art, Washington
Ailsa Mellon Bruce Fund, 1963.5.1

Poussin was seldom moved to paint the horrifying martyrdoms
and heavenly miracles that formed the stock-in-trade of
Counter-Reformation art and were repeatedly treated by many
of his contemporaries. When he did, however, he showed a
surprising aptitude for such subjects. This is certainly true of
the two great altarpieces of his early Roman years, the
Martyrdom of St Erasmus (cat. 10) and the *Virgin Appearing to
St James* (fig. 64), in which the dynamism of the compositions
and the vigour of the colour and handling reveal the artist fully
in sympathy with the aims of the Baroque and with the ecstatic
and visionary Catholicism of his day.

The same may be said for the present picture, which, judging
from its modest size and simple theme, was probably intended
for private devotion. The Virgin is borne heavenwards on a
bank of cloud accompanied by putti, who celebrate her ascent
by strewing flowers in her tomb. She is shown in profile, her
eyes gazing rapturously at a break in the clouds above, which
will soon part to receive her. Unusually, Poussin does not depict
the Apostles around the tomb, acting as eye-witnesses to the
miracle. In this he departs from the account of the event in the
Golden Legend, which was followed by Titian, Annibale
Carracci and Rubens, among others, in their altarpieces of this
subject.

The theme and design of *The Assumption*, with its animated
diagonals and billowing draperies, may be related to the
Virgin Appearing to St James, which depicts the miraculous
appearance of the Virgin, borne on a pillar and cloud, to
St James at Saragossa. But the style of the two works is
markedly different and suggests that the present canvas was
painted a year or two later, *c.* 1631–2. In the Louvre altarpiece,
dynamic accents of light, warm, glowing colour and flowing
brushwork combine in a bold and stirring manner to match the
drama of the theme. Here, however, the light is cooler and more
evenly diffused, the forms more finely drawn and proportioned,
and the diagonal accents of the figure group are stabilised by the
firm framing elements of the tomb, fluted columns and clouds.
This more classical approach to composition anticipates
Poussin's use of similar architectural devices in the *Adoration of
the Shepherds* (*c.* 1634; cat. 25). Most noticeable of all, however,
is the lighter colouring of the Washington picture, with its pink,
blue, silvery grey and cream tones. These may be related to
those in the *Kingdom of Flora* (cat. 20) or the Dulwich *Triumph
of David* (cat. 24) and indicate a date in the early 1630s.[1]

The delicacy of the colour harmonies in this picture have led
Thuillier and Wild to reject the picture as too sweet for Poussin
and to attribute it instead to his lesser-known contemporary,
Claude Mellin (1597?–1649). However, the latter's documented
works possess none of the unity and vivacity of the present
canvas, and reveal neither its concern with the careful
integration of figures and architectural elements nor its crisp,
staccato rhythms. The high level of quality of this painting

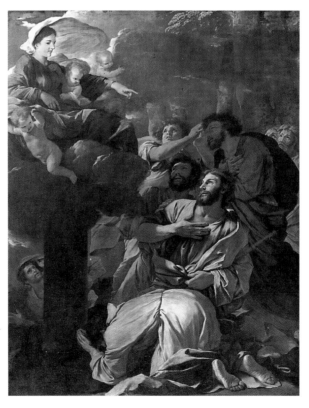

Fig. 64 Nicolas Poussin, *The Virgin Appearing to St James.* Oil on canvas,
301 × 242 cm, 1629–30. Musée du Louvre, Département des Peintures,
Paris

likewise eludes them, and is unthinkable from anyone but Poussin.

A more likely explanation for the enchanting freshness of the present picture may be found in the nature of the commission, which was one meant for private meditation on a joyous and traditional theme. Poussin met this challenge with a work that is as sincere and straightforward as it is seductive. The result is perhaps the loveliest picture of his career and one that anticipates the grace and charm of the Rococo.

1. Cf. CR V, p. 82, no. 406, for a drawing of the *Assumption of the Virgin* by Poussin, which is unrelated to the present canvas but datable to these same years.

PROVENANCE
Probably the picture mentioned in the inventory of the Marchese Vincenzo Giustiniani in 1638; 1750, Count Niccolò Soderini; by 1794, acquired by the 9th Earl of Exeter; 1962, sold by the 6th Marquess of Exeter; 1963, purchased by the Gallery

EXHIBITIONS
Paris, 1960, no. 7; Paris, 1982, no. 88; Fort Worth, 1988, no. 68

ŒUVRE CATALOGUES
Blunt, no. 92, Thuillier, no. B28, Wild, no. M27, Wright, no. 72, Oberhuber, no. 68, Mérot, no. 86

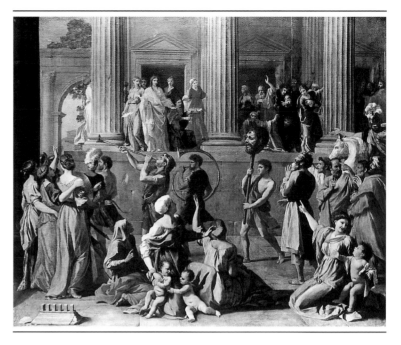

24
The Triumph of David

c. 1632
118.4 × 148.3 cm

Dulwich Picture Gallery, London

The Dulwich *Triumph of David* could hardly be more different from Poussin's first version of this subject (cat. 17). Whereas the latter is a poetical evocation of David's victory over the giant Goliath, which has no textual source, the present picture is a dramatic re-enactment of the event as it is recounted in the Bible (I Samuel XVII, 54; XVIII, 6–9). David bears the head of Goliath through the streets of Jerusalem in a triumphal procession accompanied by the people of Israel 'singing and dancing . . . with tabrets, with joy, and with instruments of musick'.

The picture is one of Poussin's earliest attempts at a type of composition that is indelibly associated with his name – that of an heroic subject, involving a complex and diverse group of figures, who act out the narrative through a variety of gestures and expressions which are intended to be 'read' by the viewer. Since the aim of such works is to edify and instruct the beholder, Poussin includes here figures of all ages and of both sexes, all of them expressing joy or admiration in a manner appropriate to their condition. The result is a depiction of the significance of David's victory for a cross-section of humanity. Young maidens sing, throw flowers or raise their arms in decorous expressions of rejoicing or salutation. Aged figures act with greater restraint and express wisdom or wonder with tense, moderated gestures in which their hands now seem to speak rather than sing. Thus, at the right an elderly man points to his forehead, indicating the spot at which David felled the giant. Children, on the other hand, remain characteristically indifferent to the momentous events that surround them. In the centre foreground, all these ideas are combined in a group

186

representative of the three ages of man, which contains the germ of much of the rest of the picture.

Although the date of the Dulwich picture is much disputed, the clarity and rationality of its invention and composition indicate that it was painted in the early 1630s, at a time when Poussin was forsaking the Venetian ideals of his earliest works and turning instead to an art modelled on that of Raphael and his school. This new and more rhetorical style of painting – with its cold, pure colours and emphatic gestures and expressions – is evident in the *Parnassus* (cat. 22) and the *Adoration of the Magi* (1633; fig. 67), both of which are based on designs by Raphael. *The Triumph of David*, on the other hand, was apparently inspired by a work by one of Raphael's disciples, Giulio Romano's *Mocking of the Prisoners* (c. 1533; fig. 65), from which Poussin derived both the figure group and the architectural setting of the present canvas. The planar construction and spartan simplicity of the picture also owe much to Domenichino's fresco of the *Flagellation of St Andrew* (1608–9; fig. 66), a work Poussin is known to have admired.

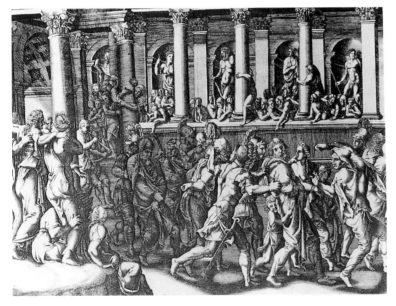

Fig. 65 Giorgio Ghisi (*after* Giulio Romano), *Mocking of the Prisoners*. Engraving, 43.2 × 56.7 cm, c. 1533. The Trustees of the British Museum, London

Where he surpasses both of these sources, however, is in the rhythmic deployment of his figures throughout the composition, in that lucid interplay between solid and void that assists at once in articulating the narrative and in engaging the eye.

X-rays reveal substantial changes in the course of composition, especially in the portico of the temple, which originally contained an arcade rather than the present double row of fluted columns. The remains of arches or blind niches may still be seen beneath the paint surface in this area. Numerous changes were also made to the figures standing in the portico, some of which were painted at the same time as the architecture while others were added after the completion of the columns, which now show through. The group of women in the left foreground was originally painted much further to the right and was moved to open up a space in front of the trumpeter. This transfer was carried out with the aid of a pricked cartoon, parts of which survive on the *verso* of a drawing at Chantilly.[1]

This is one of Poussin's first great masterpieces and a remarkable demonstration of his powers of invention and pictorial composition. Without disturbing the harmony of the whole, David is subtly singled out by the spaces opened up to either side of him, by the cold slate-blues that frame him, and by being the only figure in the main group who is not significantly overlapped by another. Nor can one fail to notice the ironic contrast Poussin creates here between David's profile and that of the vanquished Goliath, the one so proud and the other so pained. Interest is sustained throughout by an answering sequence of limbs, poses and colours which both rivets the attention and ensures the seamless coherence of the design. In the centre of the canvas a curved trumpet sets the pattern for the disposition of the main figure group, which itself revolves around this motif in an ever-widening circle. And, in the lower left corner, a fragment of an up-ended pediment frames the scene and repeats in miniature the main axes and rhythms of the temple in the background. Such a passion for exactitude, and for a total integration of the picture space and surface, reveals Poussin's increasing concern with the principles of abstract design in his pictures and heralds a new phase of his art.

1. CR I, p. 14, no. 29. *Ibid.*, no. 30 for another compositional study for this same group at Windsor.

PROVENANCE
Pierre Lebrun, Paris; before 1771, B. Vandergucht, London; by 1776, 2nd Lord Carysfort; c. 1787, C. A. de Calonne; his sale, Skinner and Dyke, London, 26 March 1795 (92); 1811, bought by Desenfans; Bourgeois Bequest

EXHIBITIONS
Paris, 1960, no. 9; Edinburgh, 1981, no. 13

ŒUVRE CATALOGUES
Blunt, no. 33, Thuillier, no. B26, Wild, no. 4, Wright, no. 68, Mérot, no. 30

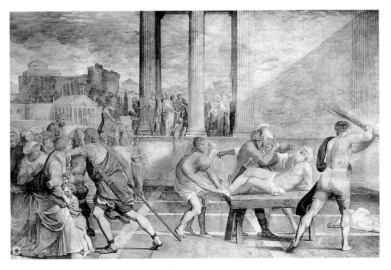

Fig. 66 Domenichino, *The Flagellation of St Andrew*. Fresco, 1608–9. S. Gregorio Magno, Rome

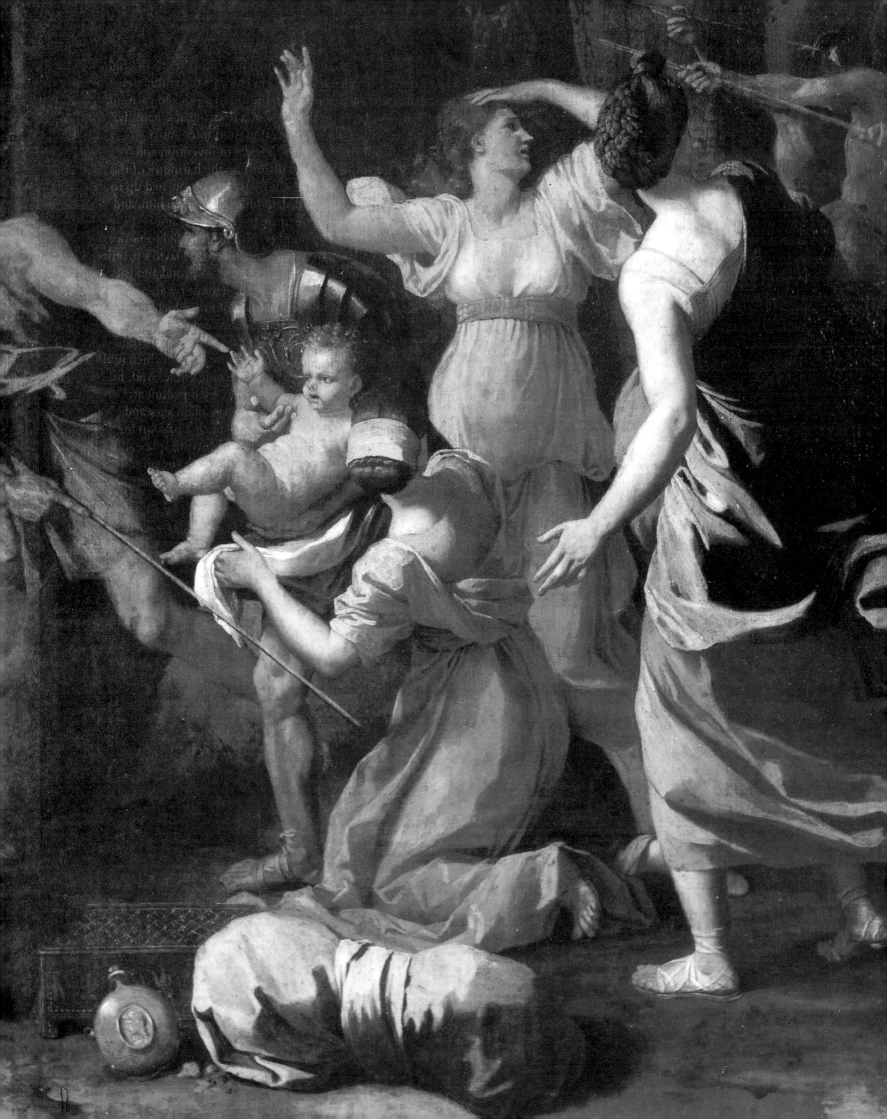

The Middle Years: 1633–51

After the stylistic indecision of his early years, Poussin followed a remarkably consistent development during the middle phase of his career. The dominant influence on his art of this period is openly declared in a large and doctrinaire canvas of 1633, the *Adoration of the Magi* (fig. 67), which (unusually for Poussin) is elaborately signed and dated and unashamedly based on Raphael's fresco of the same subject in the Loggia of the Vatican (fig. 68). Classical in style and traditional in theme, this picture was obviously conceived as an act of homage to the great Renaissance master and may even have been intended as a manifesto on Poussin's part – as a rejection of the Venetian mode of painting of his earliest years in favour of the nobler art of Raphael and his school.

During the years that followed, Poussin consolidated this allegiance in a succession of major works that invite comparison with central Italian art of the Renaissance. In 1634 he painted the pendant pictures of the *Crossing of the Red Sea* (National Gallery of Victoria, Melbourne) and the *Adoration of the Golden Calf* (fig. 69)[1] under the spell of Raphael's portrayals of these subjects, also in the Vatican Loggia. In the same year, he completed one of two versions of the *Rape of the Sabines* (fig. 70),[2] basing certain of the figure groups in this picture on Giambologna's celebrated sculpture of the same theme. One year later, he embarked upon the series of bacchanals for Cardinal Richelieu (cat. 29–30), with

Opposite: detail from *The Saving of the Infant Pyrrhus*, cat. 27

Fig. 67 Nicolas Poussin, *The Adoration of the Magi.* Oil on canvas, 161 × 182 cm, 1633. Staatliche Kunstsammlungen, Gemäldegalerie, Dresden

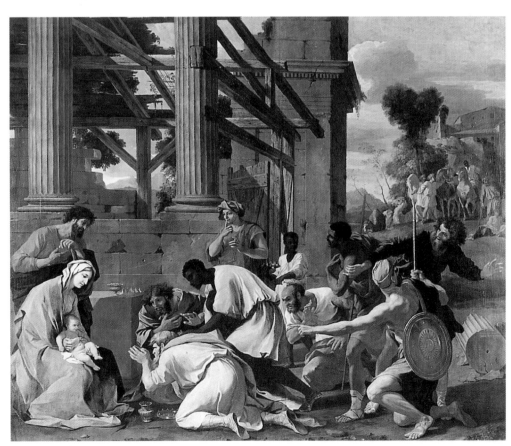

Fig. 68 Raphael, *The Adoration of the Magi.*
Fresco, 1518–9. Logge, Vatican, Rome

their distinct echoes of designs by Raphael and Giulio Romano (fig. 81, 84). All these are large-scale works containing a wealth of animated figures' and remain among Poussin's most elaborate creations. As such, they strike one as a conscious attempt to rival and revive the grand style of history painting of the Renaissance. Perhaps it is no coincidence that the bacchanals for Richelieu were intended to hang alongside masterpieces of Italian Renaissance art that epitomised this style. Did the French minister turn to Poussin for these pictures because the latter already enjoyed a reputation as the 'Raphael of our century' at this comparatively early stage of his career?

Poussin's increased fame as a painter also accounts for the existence of dates, documents and commentaries on the majority of his works from the mid-1630s onwards, all of which greatly facilitate the charting of his development. Chief among these sources are the artist's own letters, more than 200 of which survive from the period between 1637 and Poussin's death in 1665. Of the greatest masters of the 17th century, only Rubens has bequeathed to us so extensive a correspondence, albeit one which affords fewer insights into his creative aims.

Certain of Poussin's letters of the late 1630s reveal two of his key artistic objectives of these years. One of these was a desire to vary the style of a picture in accordance with the chosen theme. This concern first emerges in a letter of c. 1637[3] and is apparent in the different style, colour and composition of such canvases as the *Finding of Moses* (cat. 35) and *Capture of Jerusalem by Titus* (cat. 36), both of 1638. Though there is no reason to believe that Poussin codified this doctrine into a system, as Seurat and Kandinsky were later to do, the surprising diversity of his canvases at any one moment of his career suggests that, intuitively at least, Poussin adapted his style to his subject in order to reflect the prevailing mood of the theme. This practice testifies to his rational approach to all aspects of painting and may be seen as a logical development of the Renaissance doctrine of decorum in art, which recommended that everything included in a composition be suitable to the action depicted and the chosen location. Whereas Renaissance theorists concerned themselves largely with the *content* of a work of

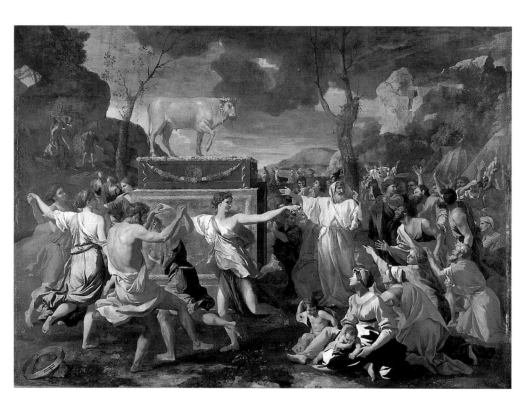

Fig. 69 Nicolas Poussin, *The Adoration of the Golden Calf.* Oil on canvas, 154 × 206 cm, 1634. The National Gallery, London

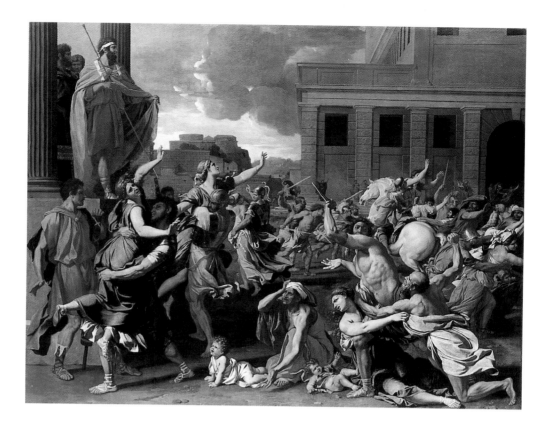

Fig. 70 Nicolas Poussin, *The Rape of the Sabines.* Oil on canvas, 154.6 × 210 cm, 1634. The Metropolitan Museum of Art, New York, Harris Brisbane Dick Fund, 1946

art, however, Poussin extended this doctrine to encompass its *style*. In this respect, his use of colour and composition to mirror the underlying emotion of his subjects appears as one of the most revolutionary features of his art and anticipates the practices of the abstract artists of our own century.

Poussin's other great concern of these years was that of compressing a complex narrative action into a single, static image that encapsulates all moments in the story and provides a comprehensive account of the theme. This desire is outlined most fully in the series of letters concerning the *Israelites Gathering the Manna* of 1638–9 (cat. 37), the most ambitious history painting of the artist's career. But it is already apparent in such earlier works as the *Plague at Ashdod* (fig. 26), the *Adoration of the Golden Calf* (fig. 69) and *Moses Striking the Rock* of c. 1637 (fig. 16), which may be regarded as a kind of 'trial run' for the more elaborate *Manna*. In all of these, the artist combines successive stages in the action, placing the principal figures in the middle distance and reserving the foreground for a group of anonymous actors representative of 'ordinary' humanity, whose reactions to the event are intended to appeal directly to the viewer. Their purpose is to edify the mind and move the soul and, above all, to underline the universality of the drama. Though this approach has clear antecedents in Renaissance art – most notably, in the theories of Alberti and the paintings of Raphael – the care and deliberation that Poussin devoted to this aspect of painting led him to surpass all of his predecessors in the intricacy and precision of his narrative painting style – one which (by the artist's own admission) was intended to be 'read' by the viewer.

One other striking feature of Poussin's creative personality was his lifelong desire to improve upon himself. The most obvious evidence of this is the existence of a wide range of subjects treated more than once in the artist's career. Though this phenomenon spans all phases of Poussin's development, it is particularly noticeable in the 1630s, when he repeated nearly a dozen such themes, in an apparent attempt to give them definitive expression. Few would dispute that he succeeded in this in the second *Arcadian Shepherds* (cat. 38) or

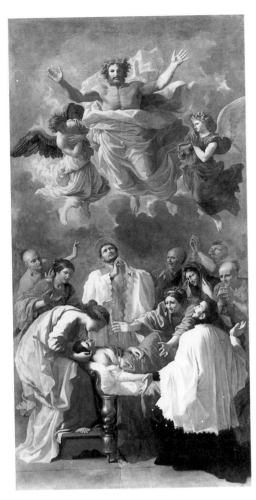

Fig. 71 Nicolas Poussin, *The Miracle of St Francis Xavier.* Oil on canvas, 444 × 234 cm, 1641. Musée du Louvre, Département des Peintures, Paris

Nurture of Jupiter (fig. 87). But the greatest of all such 'revisions' was the second set of Seven Sacraments (cat. 49–55) of the mid-1640s, which was certainly intended by the artist to improve upon the first.

By the mid-1630s Poussin had also established the broad physical characteristics that would distinguish his paintings for the rest of his career. Almost invariably, he chose medium-sized rectangular canvases a metre or more high and up to two metres across, a format that the 18th century dubbed 'Poussin size'. Typically, the figures occupy one half of the canvas and are arranged parallel to the picture plane, with the remainder devoted to a natural or architectural background, which grew increasingly diversified as the artist's career progressed. This approach is exemplified by the two sets of Sacraments and ideally suited Poussin's declamatory style of narrative painting – one in which the picture space functions as a theatre stage on which a group of figures act out the drama for the viewer.

Poussin's discomfort with any other type of format may be seen by the pictures he painted in Paris in 1641–2. These include two upright altarpieces – among them the *Miracle of St Francis Xavier* (fig. 71) – and two decorative paintings of a circular or oval format. The narrowness of these works discouraged the artist from devising the design in depth and instead led him to think vertically, piling the figures into a shallow space in a stilted and somewhat academic manner that permits little interaction between them and is dramatically unconvincing.

In retrospect, it is clear that the dissatisfaction Poussin experienced in Paris, working for Louis XIII, had a wholly beneficial effect upon his art. Realising that he was not cut out to be a virtuoso, capable of turning his hand to any commission that came his way, Poussin consolidated his approach to painting in the years after 1642 and embarked on the most austere and monumental phase of his career. Evidence of this is apparent even in his choice of subjects. As far as we know, the artist painted no mythological canvases between 1640 and 1649 and chose instead to draw his themes from the more elevated realms of religion or ancient history.

Poussin's style also remained unusually consistent during the mid-1640s, probably as a result of his desire to ensure that the second set of Sacraments of 1644–8 appeared visually unified. Characteristic of his art of these years is a preference for painting on a reddish-brown ground and an overriding emphasis upon the three primary colours plus white in the depiction of draperies. Though the dark ground-tone has often become more pronounced with age, leading to a distortion of the original colour balance of his pictures, Poussin seems to have adopted this method in an attempt to make his works appear more convincingly antique. The restricted palette may likewise be inspired by a desire to rival the legendary masters of antiquity, who were renowned for attaining the most remarkable effects with the most limited means.

In spite of its prevailing uniformity, Poussin's art also exhibits subtle variations during these years. These may best be approached through the celebrated letter on the modes that the artist wrote to Chantelou in November 1647, which had been anticipated by that of *c.* 1637, mentioned above. The letter was prompted by Chantelou's accusation that Poussin had painted the *Finding of Moses* for Pointel in this year (fig. 150) with 'greater love' than the *Ordination* for his own set of Sacraments (cat. 53). Poussin replied that 'it is the nature of the subject which has produced this result and your state of mind' and reminded his patron 'that the subjects that I am depicting for you require a different treatment'.[4] He then proceeds to discuss the modes of the ancient Greeks, in which 'all the things that

pertained to the composition were put together in proportions that had the power to arouse the spectator to diverse emotions'. For example, the Dorian mode was grave and severe, the Lydian mode mournful, and the Ionic mode cheerful. Poussin based this account on a 16th-century treatise on music, the *Istitutioni Harmoniche* by Gioseffo Zarlino, first published in 1558, which discusses the modes of ancient Greek music as they formed the basis for those of the Renaissance.[5] Though the artist did not specify the qualities or characteristics of these modes when adapted to painting, he implies in his letter that the treatment and handling of a picture should be varied in response to the theme. This principle is also apparent in his paintings of these years and accounts, for instance, for the remarkable differences between *Eliezer and Rebecca* of 1648 (cat. 59) and the *Judgement of Solomon* of the following year (cat. 62). If the colour harmonies of the former appear sweet and seductive, those of the *Solomon* are strident and severe, in accordance with the nature of the subject. Similar disparities are also observable in Poussin's two painted self-portraits of these years (cat. 63–4), in which the artist explores the contrasting sides of his own character, one genial and the other austere.

The chief development in Poussin's art of the end of the 1640s is his sudden immersion in landscape. Though the artist had occasionally painted landscapes earlier in his career, they had hitherto comprised only a sideline of his art. In 1648, however, they entered the mainstream and eventually came to dominate the output of his final years. No single explanation may be offered for this sudden change of direction, but it is worth mentioning that two of the artist's closest associates – Gaspard Dughet and Claude Lorrain – were acknowledged masters of landscape. In addition, Poussin's preoccupation with the order and harmony of nature accords with the philosophy of the ancient Stoics, from which he derived so much inspiration in the mature years of his career. It is also clear that Poussin thrived on setting himself new and ever greater challenges as an artist, a phenomenon which resulted in his astonishing stylistic and spiritual evolution over little more than forty years.

The majority of Poussin's landscapes of 1648–51 derive their inspiration from

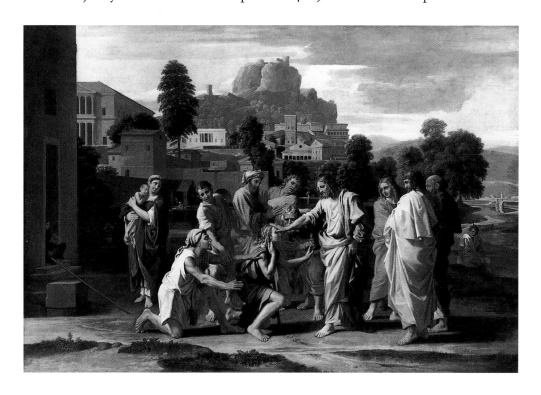

Fig. 72 Nicolas Poussin, *Christ Healing the Blind Men.* Oil on canvas, 119 × 176 cm, 1650. Musée du Louvre, Département des Peintures, Paris

the formal principles that governed the artist's figure paintings of these years: an emphasis upon the central axis of the composition, a planar disposition of objects back into space and firm framing elements to either side of the design. Characteristically, too, they portray landscape as a setting for the activities of man and, in this regard, may be seen as a logical extension of his concerns as a history painter. Only in the very last years of Poussin's life is the natural world seen on its own terms and man introduced into the artist's landscapes as a personification of the forces of nature.

Like the landscapes with the story of Phocion (cat. 67–8), Diogenes (cat. 70) or Orpheus and Eurydice (cat. 71), Poussin's figure paintings of these years possess an unparalleled splendour and authority and remain among the grandest achievements of the artist's career. In certain of them, such as the *Holy Family on the Steps* (cat. 60) or the *Judgement of Solomon* (cat. 62), Poussin models the composition closely on a comparable work by Raphael (fig. 138, 142). Even when no obvious prototype by the Renaissance master exists, he invites comparison with the heroic history paintings of Raphael's maturity. In *Eliezer and Rebecca* (cat. 59) of 1648 or *Christ Healing the Blind Men* (fig. 72) of 1650, Poussin succeeds in emulating the monumentality and nobility of Raphael's tapestry cartoons for the Sistine Chapel (fig. 102, 162–3), which appear to have inspired so many of his greatest figure paintings of the 1640s and '50s. Like Raphael's masterpieces, these works portray a group of highly idealised figures against an austere architectural setting. Where Poussin surpasses Raphael, however, is in his concern to attain the highest possible formal integration between the figures and their surroundings. This desire often leads him to achieve a miraculous unity of all elements of the composition and to create a compelling tension between the spatial illusionism of the picture and the flat surface design.

A concern for the abstract harmony of the composition is also apparent in Poussin's determination to reduce the myriad forms of the visible world to pure, geometric shapes. This objective of his art is vouchsafed to us in a drawing of the 1640s which is reproduced here from a fair copy (fig. 73) that is more legible than the original.[6] The drawing depicts four youths at work in an imaginary artist's studio, one of whom is seated at the left and measuring with a set of dividers. On

Fig. 73 *Copy after* Nicolas Poussin, *An Artist's Studio.* Pen and bistre wash. The Hermitage Museum, St Petersburg

a platform in front of him sit a sphere, cone and cylinder – the solid, perfect forms of the artist's own canvases of these years. This aspect of Poussin's art anticipates the even more abstract approach to pictorial composition of Seurat and Cézanne, both of whom acknowledged their debt to the 17th-century master.

The purity and finality of Poussin's paintings of the late 1640s also posed a potential threat for the artist's creative development. When you have distilled your art to so rarefied a form of expression as the *Holy Family on the Steps*, where do you go from there? Poussin avoided this crisis by turning for inspiration to that other great concern of his art during these years: landscape. In the figure paintings of the early 1650s – the *Holy Family with Six Putti* (fig. 18) or the *Finding of Moses* (cat. 66) – the poses suddenly appear more mobile and unstable, draperies flutter and the figures are arranged in a relaxed and uncalculated manner. The artist had dropped his guard. Intellect alone no longer dominated his creative thinking. Instead, the vagaries of nature were gradually being readmitted into his art.

1. Blunt, nos. 20 and 26; Mérot, nos. 17 and 21 (with further bibliography).
2. Cf. Blunt, nos. 179–80 and Mérot, nos. 187–8 for Poussin's two versions of this theme.
3. *Correspondance*, p. 4.
4. *Ibid.*, pp. 370–5.
5. Alfassa, 1933.
6. CR V. p. 55, nos. 369 and A 157.

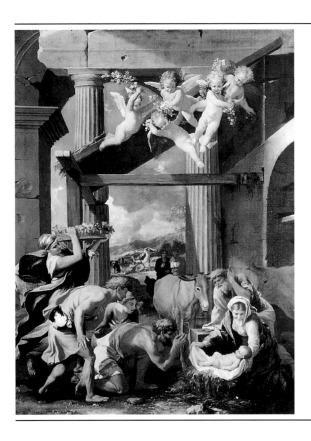

25

The Adoration of the Shepherds

c. 1633–4
Inscribed *N. Pusin. fe.*
96.5 × 73.5 cm

The Trustees of the National Gallery, London
(Purchased with a Special Grant and a contribution from the
National Art Collections Fund)

During his early years in Rome, Poussin painted a number of
Holy Family pictures in a richly Venetian style. The majority of
these are small in scale and reflective in mood and were
presumably intended for private devotion. In the ensuing
decade he returned to this theme and executed a handful of
more ambitious works, containing a larger number of figures
and a greater degree of narrative interest, in keeping with his
more historical approach to subject matter during these years.
Chief among these is the *Adoration of the Magi* (fig. 67) of
1633, a work on an epic scale which includes a wealth of figures
and reveals the extent to which Poussin could instil action and
variety into an essentially undramatic subject. Closely related to
this work is the present picture, which treats the more modest
theme of the Adoration of the Shepherds and, accordingly, is
smaller in size and more lyrical in mood.

The subject is from Luke II, 7–17, and combines the
adoration of the shepherds with the annunciation of Christ's
birth to them, which takes place in the middle distance. Linking
the two events – as though to establish the continuity of the
action – are the figures of two men beside the column at the

right, who point towards the main scene. The treatment of the
theme is traditional, though the basket of fruit being presented
to the Holy Family and the putti strewing flowers from above
lend to it an unusually festive air.

The picture is datable to 1633–4 and is close in style to the
Birmingham *Tancred and Erminia* (cat. 26) and the *Saving of
the Infant Pyrrhus* (cat. 27), which is documented to 1634. In all
three works, Poussin shows a preference for a copper-coloured
ground tone against which are set a range of cold and slightly
acid hues – pale pinks, lime greens and steel blues. Further
linking these pictures are their sharp outlines, harsh lighting and
emphatically posed figures. All of these features signal a new
note of high seriousness in Poussin's art, even when – as in the
present picture – he chooses to paint an undemanding theme.

The National Gallery canvas may also be compared to *The
Rest on the Flight into Egypt* (fig. 75) at Winterthur, which is
similar in size and subject and dates from these same years.
Here, too, Poussin adopts a more formal approach to the
theme. The Holy Family are shown at rest, attended by a group
of putti, who offer them fruit and flowers. But this charming
idyll is set against a background of framing columns, billowing
drapery and a distant landscape – all of which add an element of
grandeur to the scene. In this respect, the picture calls to mind
the devices employed in the London canvas to enhance the
dignity of the theme.

In the *Adoration of the Shepherds* Poussin frames the figure
group with an elaborate architectural setting. Its geometric
accents, with rhythmically interlocking horizontals, verticals
and diagonals, are in turn mirrored by the poses and actions of
the figures. The shepherds at the left are arranged in a
descending diagonal that is complemented below by the group
of the Holy Family and above by the lines of the building and
the arrangement of the putti. The result is a harmonious unity
between figures and setting and a more highly integrated surface

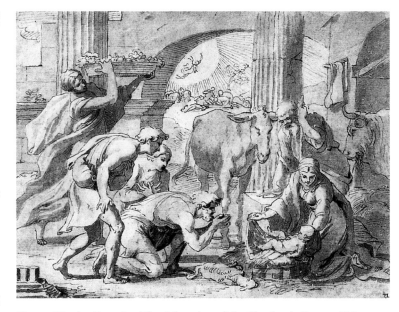

Fig. 74 Nicolas Poussin, *The Adoration of the Shepherds.* Pen and bistre
wash, 19 × 26 cm. The Trustees of the British Museum, London

design. These features – which were already apparent in the Dulwich *Triumph of David* (cat. 24) and the *Assumption of the Virgin* (cat. 23) – characterise Poussin's approach to pictorial composition throughout his mature years.

Two preparatory drawings exist for the London picture, both of them testifying to the premeditative effort that Poussin expended upon his works by this time. One shows the group of hovering putti in the arrangement adopted in the final canvas[1] although they are not yet aligned with the axes of the building and thus do not link these two planes in space. The other (fig. 74) depicts the principal figure group as it appears in the National Gallery picture with the addition of a bound lamb below the infant Christ and an upturned pediment at the left.[2] Only Poussin could account for the omission of these details from the finished picture, but two suggestions may be offered here. The pediment is a straight duplication from the same corner of the Dulwich *Triumph of David* and one unworthy of so inventive a master. The lamb, on the other hand, is a reference to the Passion, which Poussin may have deemed inappropriate to so joyous a scene.

This picture was in the collection of Reynolds in the 18th century and would appear to have been one of Poussin's most popular compositions. Numerous copies and variants of it exist, including some much larger than the original and at least one the size of an altarpiece (Church of St Pierre, Avignon).

1. CR I, p. 19, no. 35; Oxford, 1990–1, no. 26.
2. CR I, p. 19, no. A6; Oxford 1990–1, no. 25.

PROVENANCE
Possibly Le Nôtre; 1761, De Selle sale, Paris; bought by Thibauts; 1795, Sir Joshua Reynolds sale, London; Henry Walton; Sir Thomas Beauchamp-Proctor; by descent to Jocelyn Beauchamp; 1956, sold, London; 1957, purchased by the Gallery

EXHIBITIONS
Birmingham, 1992–3, no. 8; Paris, 1994–5, no. 46

ŒUVRE CATALOGUES
Blunt, no. 40, Thuillier, no. 72, Wild, no. 50, Wright, no. 74, Mérot, no. 56

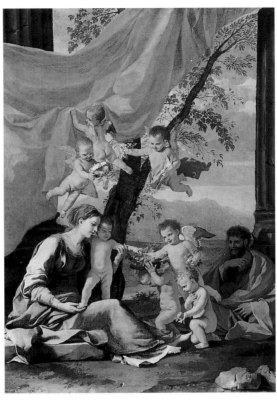

Fig. 75 Nicolas Poussin, *The Rest on the Flight into Egypt.* Oil on canvas, 87 × 66 cm, *c.* 1634. Sammlung Oskar Reinhart, Winterthur

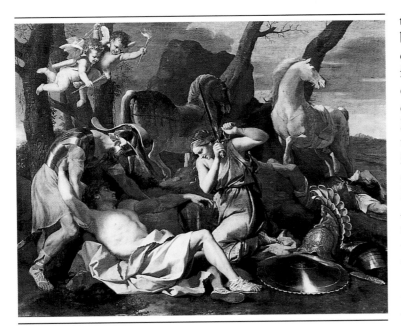

26

Tancred and Erminia

c. 1633–4

75.5 × 99.7 cm

The Trustees of the Barber Institute of Fine Arts,
The University of Birmingham

This illustrates the same episode from Tasso's *Gerusalemme Liberata* (XIX, 104–14) as the earlier painting in the Hermitage (cat. 21). The Saracen princess, Erminia, discovers the body of the wounded knight, Tancred, on the battlefield and, in a desperate attempt to save his life, cuts off her hair to bind his wounds. She is accompanied by Tancred's squire, Vafrino. At the right appears the body of the giant, Argantes, slain by Tancred after a fierce struggle. At the upper left are two putti presumably included by Poussin to symbolise Erminia's unrequited love for Tancred or even to provide a happy ending to the tale, a point on which Tasso is curiously silent.

Like the two versions of *Cephalus and Aurora* (cat. 1, 16), Poussin's paintings of Tancred and Erminia are a classic example of the artist reviving a theme he had treated earlier in his career in accordance with his altered style and creative aims. Though only two or three years separate the two versions, these years witnessed a fundamental change in Poussin's art – one which brought it increasingly under the power of his intellect. This is reflected in both the greater narrative clarity and compositional coherence of the present picture.

In the Hermitage canvas Tancred is depicted wearing the protective armour of battle, whereas in the present version he is shown as a semi-nude figure of heroic proportions. This change more accurately follows Tasso's account, which notes that Erminia and Vafrino remove his armour in order to inspect his wounds, while also serving to emphasise Tancred's valour and nobility. In addition, his shield now bears the monogram of Christ, a detail omitted from the earlier painting, to indicate

that he is a Christian warrior; and the inclusion of two putti bearing torches and arrows provides an unequivocal reminder of Erminia's love for the wounded knight. The presence of these figures also makes it possible for Poussin to recast the pose and expression of the heroine. Erminia no longer has the rapt and distracted appearance of the earlier version, but has fallen to her knees and cuts off her hair with a vehemence and desperation that speak of the most sublime self-sacrifice. Finally, Poussin introduces one further change in the later version that serves to clarify the theme. This is the motif of Tancred's raised left arm, held up by Vafrino – one that recalls Michelangelo's *Creation of Adam* and reminds us of Tancred's eventual revival. Reinforcing this idea of 'death' and resurrection is the background sky, which moves from sunset at the left to daylight at the right, in the manner of the early *Venus with the Dead Adonis* (cat. 4).

Many of these changes also underscore the parallels with a Christian lamentation which are implicit in both of Poussin's versions of this subject. In the present canvas these are evident in the heroic figure of Tancred covered with a loincloth, recalling the dead Christ, and in the benevolent pose of Vafrino, clad in red, who takes the place of the Evangelist in such scenes. Indeed, a comparable figure, supporting Christ's left arm, reappears in Poussin's own *Lamentation* of 1656–8 (cat. 82). Similarly, the anguished expression of Erminia is reminiscent of traditional depictions of the distraught Magdalene, mourning the dead Christ, and reminds us of one further parallel between the two themes. Just as the repentant Magdalene had once served Christ by anointing his feet with oil and drying them with her hair (Luke VII, 36–50), so Erminia here prepares to bind Tancred's wounds with her own hair.

The greater rigour and precision with which Poussin treats the theme is matched by an equally uncompromising formal

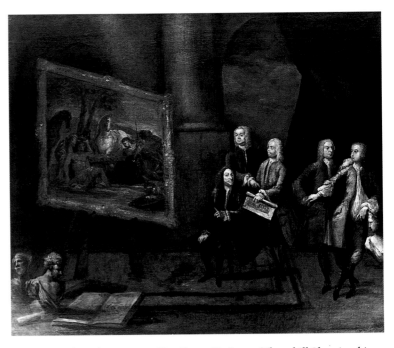

Fig. 76 Attributed to Gawen Hamilton, *Sir James Thornhill Showing his Poussin to his Friends.* Oil on canvas, 62.9 × 75.6 cm, *c.* 1728–32. Beaverbrook Art Gallery, Fredericton, New Brunswick

design. Whereas the earlier version appears loosely composed and arranged in depth, with light and colour serving as the principal unifying agents of the scene, the present canvas is more compact and concentrated in construction. This is apparent in the repeated accents of pure colour which link the foreground and background of the picture: the intense blue of Erminia's garments and the distant sky, or the coppery flesh-tones of the figures and the surrounding rocks. But it is most strikingly evident in a sequence of interweaving linear rhythms which bind all elements of the composition – horses, hills, helmets and heroine – to the flat surface of the canvas, thereby denying the illusionism of the scene. This more rational and abstract approach to pictorial design finds obvious parallels in the *Adoration of the Shepherds* (cat. 25) of the same date, *c.* 1633–4.

Tancred and Erminia was purchased by Sir James Thornhill in Paris in 1717 and was the first painting by Poussin to enter a British collection. Soon after, it inspired a small conversation piece depicting Thornhill showing his Poussin to a group of connoisseurs (fig. 76), one of whom may be Jonathan Richardson Senior, who devoted an extensive essay to the picture in 1719.[1] This is undoubtedly the most important account of Poussin's art to appear in English before Reynolds, and still repays reading. In its sensitive analysis of the challenges Poussin faced in treating Tasso's tale, it justifies Richardson's claim that 'the painter hath made a finer story than the poet'.

1. *The Works of Jonathan Richardson*, London, 1773, pp. 192–200 (reprinted in Birmingham 1992–3, pp. 35–43).

PROVENANCE
1717, bought by Sir James Thornhill in Paris; his sale, 1734; bought W. Lock; sold by his son to Earl Poullett, from whose descendant it was purchased by the Institute in 1938

EXHIBITIONS
Paris, 1960, no. 53; Edinburgh, 1981, no. 14; Birmingham, 1992–3, no. 7; Paris, 1994–5, no. 49

ŒUVRE CATALOGUES
Blunt, no. 207, Thuillier, no. 99, Wild, no. 55, Wright, no. 66, Mérot, no. 197

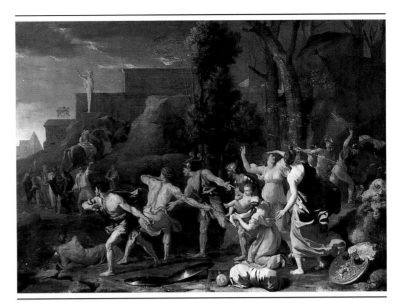

27

The Saving of the Infant Pyrrhus

1634
116 × 160 cm

Musée de Louvre, Département des Peintures, Paris

Poussin was repeatedly drawn to the theme of an endangered infant who is forced to flee his homeland and is rescued and nurtured by a foster family. This is the subject of his numerous versions of the Exposition or Finding of Moses (cat. 35, 66, 77; fig. 5, 150) and of the Nurture of Jupiter (cat. 31, fig. 87) or Bacchus (cat. 83). It is also the theme of the present picture, which derives from Plutarch's *Life of Pyrrhus* (II) and had apparently never been painted before.

Pyrrhus was the son of Aeacides, King of Epirus, who had been defeated by the Molossians. To protect the infant from his father's captors, Pyrrhus was rescued by two loyal soldiers and eventually entrusted to the care of three men, who were instructed to carry him to Megara. Arriving on the outskirts of the city, with the enemy still in pursuit, they found the river which bordered it impassable. They then attached messages requesting help to a stone and a javelin, which were hurled across the waters. When the people on the other side read these, they built a raft to transport the infant to safety and eventually took him to Glaucias, King of the Illyrians, whose family raised him.

Characteristically, Poussin depicts the turning-point of the action, the moment when the young Pyrrhus's fate hangs in the balance. At the far right, a group of soldiers advance upon the enemy, whose approach arouses alarm in three women in the foreground, one of whom distractedly hands the infant to a soldier, as though fearful for its safety. To the left are three men, one calling out for help across the river and the other two hurling the javelin and stone, which has attached to it a piece of paper inscribed 'PYR'. In their vigorous actions and tautly synchronised poses these figures convey the urgency and desperation of the rescue attempt. On the opposite bank appear

the inhabitants of Megara, gesticulating wildly because they cannot hear the cries of the group. The scene is set at dusk, as described by Plutarch, and bounded by a group of buildings which depict the outskirts of the city.

The picture is an outstanding example of Poussin's ability to compress a complex – and even confusing – theme into an unbroken sequence of figures which, when read from right to left, encapsulate all moments in the tale. Further clarifying key points in the drama are the rhythmically disposed colours of the picture, which is exceptionally well preserved. Particularly noteworthy are the steel blues that appear at regular intervals across the foreground of the picture – like cadences punctuating the action – and the three primary colours that converge upon the infant Pyrrhus. Small wonder that Félibien lavished praise on the remarkable unity of this picture,[1] and that later painters were reluctant to tackle the theme again, presumably because they regarded Poussin's treatment as definitive.

The painting was traditionally dated 1636–7 until the recent discovery of a document revealing that it was acquired in 1634 by the abbot Gian Maria Roscioli, a protégé of the Barberini family, who eventually owned three other paintings by Poussin (cat. 45–7).[2] This discovery affords important evidence of the rapid stylistic advances made by the artist during the early 1630s and has led to a substantial revision of the chronology of his works during these years. Both the *Adoration of the Shepherds* (cat. 25) and the Birmingham *Tancred and Erminia* (cat. 26) were also once dated to the later 1630s. Yet, in their coppery ground tones and chiselled contours they bear obvious similarities to the *Pyrrhus* and must therefore be dated earlier.

During the mid-1630s Poussin was also engaged in making a series of illustrations to Leonardo da Vinci's *Treatise on Painting*, which was eventually published in Paris in 1651.[3] Included among these is one showing two figures throwing a stone and a spear (CR 253), made to illustrate Leonardo's theories of motion, which bears a close relation to the

comparable figures in this painting. A preparatory drawing for the latter also exists at Windsor.[4] Excellently preserved, it contains studies for the picture on either side of the sheet. On the *verso* is a pen sketch for the group at the right, which was not adopted in the finished picture. Much closer to the latter is the brilliant pen-and-sepia drawing for the composition on the *recto* (fig. 77), in which rhythmic passages of wash vigorously applied convey in a near-abstract manner the frenzied activity of the group. To Poussin's self-critical eye, however, there were still changes to be made before tackling the final canvas. In this, the river god at the left appears parallel to the picture plane, the soldiers' arms are more strictly aligned, standing and crouching figures are omitted and the episodes of the startled women and the approaching enemy introduced for the first time.

Poussin's *Pyrrhus* inspired a drawing by G. B. Castiglione (1610?–1663/5; fig. 78). In this, the groups of the women and child, the soldiers and the rescuers appear as isolated episodes across the sheet and lack the dramatic thrust of Poussin's arrangement, which moves from danger to safety in a single inevitable curve.

1. Félibien (ed. 1725), IV, pp. 82–5.
2. Barroero, 1979, pp. 69–74.
3. CR IV, pp. 26–33, nos. 251–69, A 125–36 (with further bibliography).
4. CR II, p. 6, nos. 108–9; Oxford, 1990–1, no. 27.

PROVENANCE
1634, Gian Maria Roscioli; Duc de Richelieu; bought with his whole collection by Louis XIV in 1665

EXHIBITIONS
Paris, 1960, no. 54; Rouen, 1961, no. 79; Bologna, 1962, no. 63; Rome, 1977–8, no. 24; Düsseldorf, 1978, no. 23; Paris, 1994–5, no. 51

ŒUVRE CATALOGUES
Blunt, no. 178, Thuillier, no. 94, Wild, no. 47, Wright, no. 85, Mérot, no. 186

REFERENCES
Félibien (ed. 1725), IV, pp. 82–5

Fig. 77 Nicolas Poussin, *The Saving of the Infant Pyrrhus.* Pen and brown ink and wash over red chalk, 21.5 × 34.3 cm. The Royal Collection

Fig. 78 G. B. Castiglione, *The Saving of the Infant Pyrrhus.* Drawn in brown oil paint, 26.3 × 38 cm, *c.* 1637–40. The Royal Collection

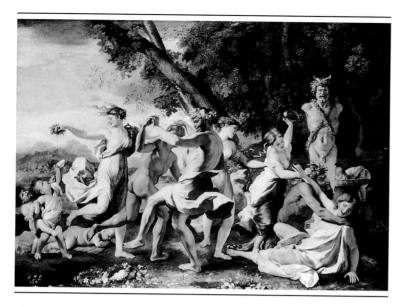

28

Bacchanal before a Herm

c. 1634

100 × 143 cm

The Trustees of the National Gallery, London

Several factors have conspired to make this modest canvas one of the best-loved of all Poussin's works, especially with British critics. Among these are its excellent state of preservation, its early entry into the National Gallery, its infectious high spirits and its delectable and undemanding theme. Fuseli, Etty, Farington, Hazlitt and Ruskin were all moved to praise it as one of the artist's most engaging and accessible creations. Indeed, in 1807, when more than one-third of Poussin's entire output was to be found in Britain, the National Gallery canvas was still deemed by one writer 'the finest Nicholas Poussin in the country'.[1]

'A jocund group of rural powers have assembled, and are dancing with wild delight, as if thoroughly sensible that enjoyment was obedience to the will of the gods', wrote the painter and engraver John Landseer in 1834:[2]

> The dancers consist of four Wood-nymphs, or Bacchantes; two Bacchanals, or perhaps Fauns . . . and three or four chubby sylvan boys. The composition abounds in picturesque and poetic incident. One of the Wood-nymphs . . . although engaged in the dance, contrives, in passing, to squeeze grapes into the wine-cup of a little thirsty soul who eagerly reaches for it, while another less favoured little curly-pated rogue would share the boon: a third boy has fallen down, having already had too much of the delicious beverage; and a fourth, having climbed the side of a large sculptured vase, is stooping his head . . . in order to partake without stint or measure of the exhilarating contents of the mighty bowl . . .
>
> The principal male figure of the group is a sort of Faun, slightly habited in yellow drapery: His head bound with ivy, and his rubicund face and figure, replete with 'tipsy dance and jollity', is almost beaming with mirthful enjoyment. In threading the mazes of the dance, this figure passes under the uplifted arms of the sprightly and rosy nymph, and of a naked swain . . . who has 'knit hands' on

the other side, with a second Bacchante, and is painted with masterly ability . . .

> But the most prominent, if not the most poetic, incident, in the whole composition, is, that an intrusive Satyr has rushed in a wild freak from some neighbouring thicket or circumjacent grove, and, dashing with dissonance the harmony of the meeting, has interrupted the regularity of the dance, by clasping a fallen nymph who has just been tripped down – perhaps by his unceremonious rudeness, and who . . . is half averting, half inviting, a kiss. Meanwhile another nymph would, with her brass vase, batter the Satyr's head, for the naughty trick; and a third would perhaps also obtain a Satyrical kiss for preventing this assault and battery: but all in sport, of course – the whole is no more than the wild joke of a moment.

This 'moment' has been frozen in an image of such unity that it redoubles the picture's appeal. The figures are arranged parallel to the picture plane in the manner of an antique frieze, with Poussin establishing a seamless progression across the canvas through the interweaving positions of their limbs. Like the figures themselves, these unfold from right to left with the ease and naturalness of a ribbon unfurling in the wind. The sequence begins with the left arm of the fallen bacchante at the right and progresses through a series of threaded and interlocking positions to the raised arm of the nymph squeezing grapes, who appears to conduct and discharge the accumulated energies of the rest of the group into the surrounding atmosphere.

Reinforcing the harmony of the composition is the relationship between the figures and their setting. Immediately behind them, a grove of trees follows the principal lines of the dancers, beginning vertically at the right, behind the standing herm, and becoming more diagonal and expansive at the left, in keeping with the livelier poses of the figures in this portion of the picture. Similarly, the billowing blue drapery of the nymph squeezing grapes is echoed in the shapes and colours of the distant hills, establishing a clear link between the foreground and background of the scene. Holding all of this energy in check, however, is the covert symmetry of the picture. At its centre is the ruddy faun clad in yellow, whose solidly modelled draperies and firmly planted leg provide a fulcrum for the composition. Radiating out from him, like the spokes of a wheel, are the extended legs of his companions, whose draperies or skin tones appear in an orderly sequence of coppery red, blue and white as one moves to either side of the picture. Through such devices as these, Poussin endows a scene brimming with motion – and the momentary – with a semblance of the timeless and eternal.

The origins of the figure group are in a drawing of the late 1620s at Windsor.[3] When he came to paint the present canvas of *c.* 1634, however, Poussin worked from a squared preparatory drawing (British Museum, London) which shows only minor differences from the final composition.[4]

The identical group of dancers appears, in reverse, in one of the artist's most ambitious biblical pictures of this period, the *Adoration of the Golden Calf* (1634; fig. 69).

1. Joseph Farington, *The Farington Diary, 1793–1821*, ed. James Greig, London, 1922–8, IV, p. 107. (Further to the reputation of this picture in the 19th century, see Verdi 1976, pp. 307–11.)

2. John Landseer, *A Descriptive, Explanatory and Critical Catalogue of fifty of the earliest pictures contained in the National Gallery of Great Britain*, London, 1834, pp. 311–2.

3. CR III, p. 27, no. 196.

4. CR III, p. 27, no. 198; Oxford 1990–1, no. 37.

PROVENANCE

1777, Randon de Boisset sale, Paris; 1787, Vaudreuil sale, Paris; 1795, Calonne sale, London; 1795, Bryan's Gallery; Rev. Frederick Hamilton; 1807, William Troward sale; 1813, Lord Kinnaird sale; Delahante; Thomas Hamlet by 1816 (when exhibited at the British Institution); 1826, sold to the Gallery

EXHIBITIONS

Paris, 1960, no. 50; Edinburgh, 1981, no. 15; Paris, 1994–5, no. 47

ŒUVRE CATALOGUES

Blunt, no. 141, Thuillier, no. 71, Wild, no. 49, Wright, no. 79, Mérot, no. 133

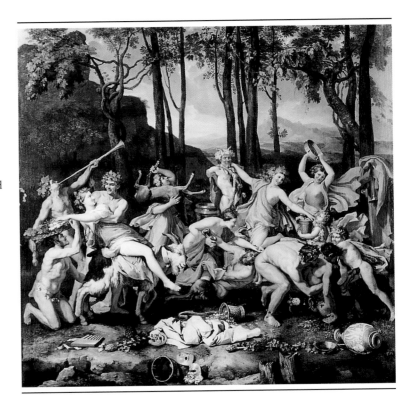

29

The Triumph of Pan

1635–6

134 × 145 cm

The Trustees of the National Gallery, London
(Purchased with Contributions from the National Heritage Memorial Fund and the National Art Collections Fund)

Around 1635 Poussin was commissioned to paint two bacchanals for Cardinal Richelieu, the French prime minister and the most important French collector of his day. These were to hang in his château at Poitou, outside Paris, with a group of mythological canvases by Mantegna, Perugino and Lorenzo Costa that Richelieu acquired from the Gonzaga collection in the early 1630s (now in the Louvre, Paris). Poussin's contributions to this decorative scheme were the present picture and the *Triumph of Bacchus* (Nelson Atkins Gallery, Kansas City), both of which were dispatched from Rome in May 1636. A third bacchanal, the *Triumph of Silenus*, apparently followed soon afterwards. This picture is now lost and known only through copies, the finest of which is in the National Gallery, London.

Few works by Poussin are more highly wrought than the *Triumph of Pan*. The design centres upon the rouged and garlanded herm of Pan, god of the pastures and their flocks and lover of the maenads during their drunken orgies.[1] Surrounding him, in a brilliantly choreographed sequence of poses, are a group of bacchic revellers who pay homage to the god, dancing, making music or offering him flowers or animal sacrifices. At the left, a bacchante seated on a goat is locked in an embrace with an amorous faun. To the centre, another bacchante pulls

the hair of a satyr who is shamelessly assaulting her; and, at the right, two figures struggle to lift a drunken satyr. In the foreground is a group of still-life objects, including pan-pipes and a bent stick; the thyrsi (staves wrapped in vine leaves and crowned with pine cones) traditionally associated with Bacchus and his votaries; a tambourine and wine jar; and tragic, comic and satirical masks, which allude to the bacchic origins of drama.

No literary source exists for this painting, which was entirely of Poussin's own invention and one of the most intricate figure compositions he had ever undertaken. This combination of factors may explain the difficulties he experienced in devising it. No less than eleven preparatory drawings exist for the *Triumph of Pan*[2] – more than for any other painting of the artist's career.

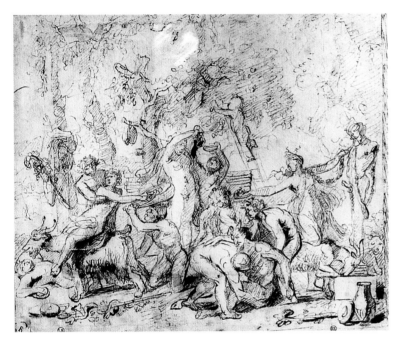

Fig. 79 Nicolas Poussin, *The Triumph of Pan.* Pen and bistre wash, 17.4 × 21.3 cm. Musée Bonnat, Bayonne

These show Poussin gradually forging the remarkable unity of the final canvas by a process of trial and error. Though at times almost painful to witness, such struggles attest to the artist's tenacious quest for perfection in his finished paintings.

In the earliest drawings, the herm is located at the right of the composition, in the manner of the *Bacchanal before a Herm* (cat. 28) and the central axis is occupied by a large altar. The most advanced of these (fig. 79) already shows the artist having alighted upon the motifs of the drunken satyrs, the bacchante on the goat and the female figure decorating the herm. Competing with this figure, however, is that of a youth squeezing grapes into a bowl in the centre of the composition. In two later studies, drawn on the same sheet, Poussin experiments by giving the herm a more central position within the design. The earlier of these (fig. 80) retains the figure of the youth and introduces at the right the motif of the brawling nymph and satyr. What it lacks, however, is any clear

compositional links between these separate groups.

Turning the sheet upside down, Poussin made another study in which the herm is at last positioned in the centre and all the actors converge upon it. Included among them is the figure of the nymph with the sacrificial faun and the corybant blowing a trumpet. The latter motif derives from an engraving of the *Sacrifice of Priapus* (fig. 81) after Giulio Romano, from which Poussin also derived the central position of the herm and the nymph garlanding it with flowers. Though this drawing possesses a greater degree of compositional coherence than any that had preceded it, this has been achieved by omitting the episodes of the drunken satyr and the nymph and goat and by replacing them with five figures making music. Greater unity has thus been attained, but only at the expense of narrative variety.

In his final compositional study for the painting (fig. 82), Poussin solves this problem by the ingenious means of multiplying the actions but duplicating the poses through the use of mirroring limb or head positions. Though the figures are engaged in a variety of dynamic actions, they now appear welded together through a sequence of interlocking poses and reciprocal gestures, like the parts of a well-oiled machine.

This is the scheme adopted in the finished canvas, where Poussin also adds the foreground still-life and replaces the trellis of vines in the background of the final drawing with a landscape of rocks and hills, whose ascending lines echo the vigorous sequence of diagonal thrusts and counter-thrusts that animate – and integrate – the figure group. Adding to the unity and vitality of the whole are the evenly distributed colour accents of red, blue and peach-pink that adorn the figures and are repeated in the distant landscape.

The picture is remarkable both for its highly formalised design and its equally uncompromising style. The composition

Fig. 80 Nicolas Poussin, *The Triumph of Pan.* Pen and bistre wash, 19.5 × 29.1 cm. The Royal Collection

is conceived in low relief and executed with a hard-edged and almost brittle linearism. When taken together with the shrill colouring and absence of strong chiaroscuro, these features suggest that Poussin may have consciously modelled it on the 'archaic' style of late 15th-century Italian art, so that it might harmonise with the canvases with which it was to hang in Richelieu's château. Further evidence of this is the screen of trees in the middle distance, which derives from Bellini's *Feast of the Gods* of 1514 (National Gallery of Art, Washington), then in the Aldobrandini collection in Rome.

'an exercise, a self-discipline'.[4] Since they were created during the liberation of Paris in August 1944, they may also have been conceived in a more celebratory vein.

1. This figure is sometimes referred to as Priapus, god of gardens and fertility, who also had a red face and is the subject of the engraving after Giulio Romano (fig. 81) upon which Poussin based the composition of the present picture. Since none of the early sources refers to the latter by name, however, this confusion may never be resolved.
2. CR III, pp. 23–6, nos. 186–93; V, p. 107, nos. 437a, 438.
3. Chantelou (ed. 1985), p. 78.
4. Alfred H. Barr Jr., *Picasso: Fifty Years of his Art*, New York, 1946, p. 243.

PROVENANCE
Cardinal Richelieu; by descent to his great-nephew; 1741–2, bought by Peter Delmé; 1790, his sale, London; bought by Lord Ashburnham; 1850, his sale; bought for James Morrison; by descent until purchased by the Gallery in 1982

EXHIBITIONS
Paris, 1960, no. 45; Edinburgh, 1981, no. 18; Copenhagen, 1992, no. 17

ŒUVRE CATALOGUES
Blunt, no. 136, Thuillier, no. 90b, Wild, no. 67, Wright, no. 82, Mérot, no. 128

REFERENCES
Adelson, 1975

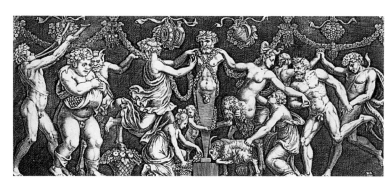

Fig. 81 Master of the Die (*after* Giulio Romano), *Sacrifice to Priapus.* Engraving, 15.7 × 28.4 cm. The Trustees of the British Museum, London

The inventiveness and demonic intensity of the *Triumph of Pan* have won it many admirers, including two great artists. Upon seeing a copy of this picture in Paris in 1665, Bernini exclaimed: 'Truly this man was a great painter of history and fable'.[3] Nearly three centuries later, Picasso made two variations on Poussin's picture (fig. 83), a challenge which he described as

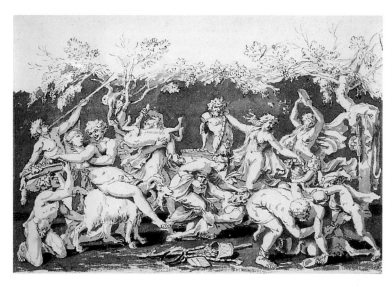

Fig. 82 Nicolas Poussin, *The Triumph of Pan.* Pen and dark bistre wash, 22.8 × 33.5 cm. The Royal Collection

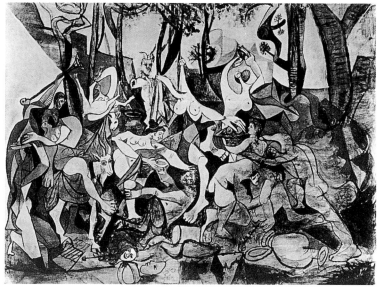

Fig. 83 Pablo Picasso (*after* Nicolas Poussin), *Bacchanal.* Watercolour and gouache, 31.1 × 41.3 cm, 1944. Present whereabouts unknown

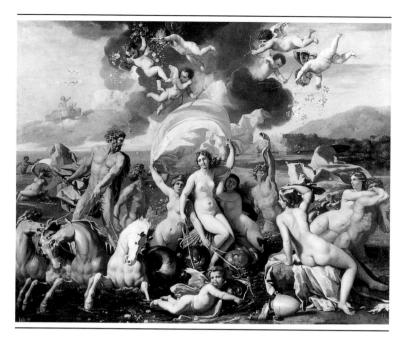

30

The Triumph of Neptune

c. 1635–6

114.5 × 146.5 cm

Philadelphia Museum of Art;
Purchased: The George W. Elkins Collection

Like the *Triumph of Pan* (cat. 29), this picture was painted for
Cardinal Richelieu in 1635–6. However, it does not appear to
have formed part of Richelieu's original commission for a series
of bacchanals by Poussin to hang alongside the canvases by
Mantegna, Perugino and Lorenzo Costa that the cardinal had
acquired by 1636. Nor was it intended for the same room, but
was displayed separately and differs from all the above-
mentioned works in that it is a marine bacchanal. It has
plausibly been suggested that the choice of theme was intended
to commemorate Richelieu's decisive role in re-establishing the
French navy during these years.

The subject of the painting is uncertain and has given rise to
much controversy.[1] Both Bellori and Félibien describe it as a
Triumph of Neptune; and this is certainly the correct
identification of the figure bearing a trident at the left of the
composition. More problematic is the identity of the female
figure in the centre of the picture. As early as 1653, she is
referred to as Amphitrite,[2] a sea nymph who was loved by
Neptune and, in order to escape him, fled to the furthest limits
of the sea. This would appear to be the true subject of Poussin's
picture; for Amphitrite was eventually persuaded to marry
Neptune by a dolphin, which is presumably the creature in the
centre foreground of the composition. However, this figure has
also been identified as Venus rising from the sea, despite the fact
that the ancients make no mention of Neptune's love for Venus;
and the iconography of the present picture is closely related to
that of Vasari's fresco of the *Birth of Venus* of 1556–9 in the
Palazzo Vecchio, Florence.[3]

Further complicating the issue is the fact that Poussin based
elements of the painting on a work celebrating a third marine
goddess – Raphael's *Triumph of Galatea* (fig. 84) – and that,
during the years he completed this painting, he made drawings
for all three themes (cf. fig. 85).[4] The most likely solution is that
the picture is intended to portray Neptune and Amphitrite and
that the artist combined with this echoes of the themes of the
Birth of Venus and the Triumph of Galatea, upon which he was
also working at this time.[5]

Poussin's indebtedness to Raphael's fresco in the Farnesina is
apparent in the symmetry of the present picture and in the air-
borne putti, the tritons blowing trumpets and, especially, the
putto riding a dolphin. The nereid at the right, seen from
behind, is borrowed from another work by Raphael, the
Marriage of Cupid and Psyche of 1517–18, also in the Farnesina.
This close dependence upon an earlier Italian master may have
been intended to make the work harmonise with the
Renaissance canvases that formed the centrepiece of Richelieu's
decorative scheme at Poitou – a practice Poussin also adopted in
his other bacchanals for the cardinal.

The light colours and bright tonality of the picture also call to
mind Raphael's fresco and remind us that both artists may be
alluding to a legendary masterpiece of antique art, Apelles' lost
painting of Venus rising from the sea. But, whereas Raphael's
design appears self-consciously noble, Poussin's picture is
animated and embellished through the introduction of
additional figures and accessories – billowing draperies,
scattered rose petals, ruffled waters – and by a more intricate
alignment of poses. The composition of both works takes the

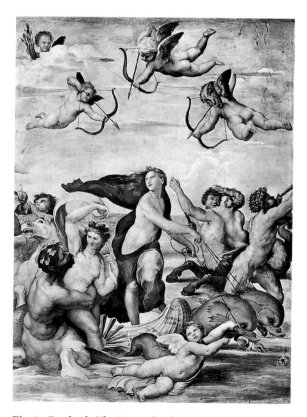

Fig. 84 Raphael, *The Triumph of Galatea*. Fresco, 1512. Villa Farnesina,
Rome

form of a large W, with the figure of Galatea/Amphitrite at the centre. In Raphael's fresco, all the figures conform to this arrangement. But, in Poussin's canvas, the contrasting diagonals of Neptune and the nereid at the right enliven this scheme by creating a visual counterpoint across the foreground of the picture. This intensifies the painting's exuberant mood and is further enhanced by the frolicking horses and dolphins and the playful antics of the putti. One of these brandishes a torch and gazes cheekily out of the picture. Others bear the arrows and quivers of love or sprinkle flowers from the heavens, in an unashamedly celebratory manner. In the background left, another putto propels Venus's chariot across the sky, preparing to unite the couple.

The painting is excellently preserved and remains one of Poussin's most radiant creations, with its enchanting colour harmonies of blue, pink, peach and saffron. This combination of hues is rare in the master's art of any phase, where the dominant colour accents tend to be the assertive primaries plus white. In the *Triumph of Neptune*, however, Poussin fashioned the scene out of the pale and aqueous hues of the water and sky, endowing it with a delicacy and charm that surpass both his predecessors in such subjects and his other bacchanals for Richelieu. If its harmony and equilibrium recall the art of Raphael and the antique, its slender, mobile figures and pastel colour harmonies look forward to that of Boucher and Fragonard. Gravity and lightheartedness exist here in equal measure – and in perfect balance.

1. The disputes concerning the picture's exact subject are set out in a series of articles listed under References below.
2. Thuillier, in *Actes* 1960, II, p. 95.
3. Dempsey 1965, pp. 338–43.
4. CR III, p. 29, nos. 202–4; p. 34, no. 213; p. 37, nos. 216–17.
5. It is worth noting that a comparable 'cross-fertilisation' of images occurs in the *Triumph of Pan*, where the principal figure group derives from an engraving after the *Triumph of Priapus* by Giulio Romano. In Poussin's picture, the central herm bears the attributes of both Pan and Priapus and becomes a mixed deity, in much the same way as the figure of Amphitrite/Venus in the present picture.

PROVENANCE
Cardinal Richelieu; By 1700, Froment de Brévannes; by 1755, Louis-Antoine Crozat, Baron de Thiers; 1771, sold by him to Catherine the Great of Russia; 1930, sold by the Russian government; 1932, acquired by the Museum

EXHIBITIONS
Paris, 1960, no. 47; Edinburgh, 1981, no. 27; Paris, New York, Chicago, 1982, no. 89; Paris, 1994–5, no. 54

ŒUVRE CATALOGUES
Blunt, no. 167, Thuillier, no. 93, Wild, no. 66, Wright, no. 80, Mérot, no. 131

REFERENCES
Bellori, 1672, p. 423; Félibien (ed. 1725), IV, p. 27; Sommer, 1961; Levey, 1963; Dempsey, 1965; Sommer, 1968; Simon, 1978, pp. 65–6

Fig. 85 Nicolas Poussin, *Triumph of Galatea*. Black chalk with bistre wash on yellow paper, 12 × 14 cm. Statens Konstmuseen, The National Swedish Art Museums

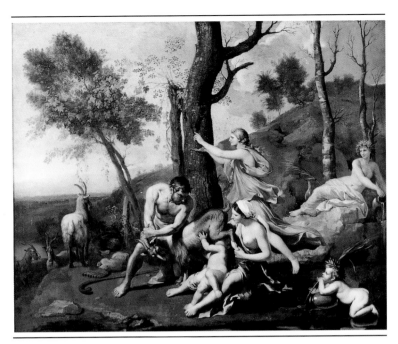

31
The Nurture of Jupiter

c. 1636–7
96.2 × 119.6 cm

Dulwich Picture Gallery, London

According to legend, Jupiter – the most powerful of the gods – was born of Rhea and Kronos (or Saturn). Warned that he would eventually be overthrown by one of his children, Kronos swallowed the first five of them as soon as they were born. When the sixth was about to arrive, Rhea devised a plan to save it. She substituted for the baby a stone wrapped in swaddling clothes, which Kronos duly swallowed, and had the infant Jupiter transported to Mount Ida in Crete, where he was hidden in a cave and tended by two nymphs, who nourished him on goat's milk and honey.[1] These nymphs are sometimes referred to as Melissa and Amalthea, though in certain versions of the myth the goat itself is given the latter name. Within a year, the infant Jupiter was strong enough to wage war against the Titans and to force his father to disgorge his swallowed children. Two of these, Neptune and Pluto, were given respectively the realms of the sea and the underworld to rule; while Jupiter himself reigned in the kingdom of heaven.

The nurture of Jupiter on Mount Ida forms the idyllic theme of this painting, which shows the infant god suckling from a goat's udder attended by a nymph and shepherd. Behind them, Melissa draws honey from a tree; and, looking on at the right, are a cheerful water nymph and putto. The scene is set against an atmospheric landscape background of hills, trees and distant mountains that evokes both safety and seclusion.

Poussin derived the main figure group of the Dulwich picture from an engraving by Bonasone after Giulio Romano (fig. 86). Yet nothing could be further removed from this fussy and ill-coordinated composition than the immaculate order wrought by Poussin, who arranges his figures in a single pyramidal grouping flanked by the legs of the shepherd and standing nymph. As so often in the master's finest inventions, all elements of the design come together in a seemingly inevitable manner. 'Nothing in his figure paintings . . . has been snatched from chaos or temporarily rescued from mystery,' observed John Berger of the present picture.[2] 'The wind blows in the right direction to furl the striding nymph's golden dress so that it becomes a precise extension of and variation on her movement. The reeds break, and point like arrows to the focal centre of the scene. The sitting nymph's foot forms a perfect ten-toed fan with the foot of the child . . . This is simply the world ordered beyond any previous imagining.'

This order is not confined to the figure group alone. The trunks and branches of the trees also echo the extended limbs of the figures in a eurhythmic manner that enhances the picture's poetry. Added to this is the limpid colour harmony of azure blue, crocus yellow, aquamarine and white, which unites the figures with the surrounding landscape and itself calls to mind the milk and honey of the theme.

The picture is datable to 1636–7, contemporary with the *Triumph of Neptune* (cat. 30) and *St John Baptising the People* (cat. 32). A preliminary drawing for the main figure group in the painting, executed in pen and wash over chalk, has recently been acquired by the Stanford University Museum of Art.[3]

Two or three years after painting this picture, Poussin executed another version of the subject (fig. 87). This is more highly formalised in theme and design and lacks the Dulwich picture's bucolic intimacy. As befits his future role as leader of the gods, Jupiter now drinks from a precious vessel held up to him by Amalthea, while the goat itself is milked by a faun. The figures are increased in size and pressed close to the foreground plane, with their extended limbs mirroring one another across the picture and relating them to other elements of the scene. At the upper right a tree resembling a piece of oriental driftwood spreads its branches across the sky in a manner that repeats, in reverse, the disposition of the figures. Immediately below this,

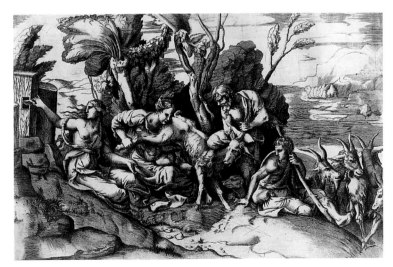

Fig. 86 Bonasone (*after* Giulio Romano), *The Education of Jupiter.* Engraving, 27 × 42.1 cm. The Trustees of the British Museum, London

the ears and horns of the goat appear silhouetted against the distant landscape in a pattern which echoes, in miniature, the sinuous and stylised curves of the entire design. The result possesses an abstract harmony and finality that are often characteristic of Poussin's later versions of a subject and testify to his increasingly rational approach to pictorial composition.

1. Hesiod, *Theogony*, 453–91; Callimachus, *Hymn to Zeus*, 49.
2. John Berger, 'Poussin at Dulwich', *New Statesman*, 4 April 1959, p. 472.
3. Dwight Miller, 'A Preparatory Study for Poussin's *Nurture of Jupiter* at Dulwich', *The Stanford Museum*, XVI–XVII, 1986–7, pp. 3–8.

PROVENANCE
By 1757, Blondel de Gagny, Paris; 1776, his sale, Paris; 1778, Ogilvie sale, London; bought by Campbell; Desenfans by 1804; 1811, Bourgeois bequest to the Gallery

EXHIBITIONS
Paris, 1960, no. 48; Paris, 1994–5, no. 59

ŒUVRE CATALOGUES
Blunt, no. 161, Thuillier, no. 120, Wild, no. 58, Wright, no. 89, Mérot, no. 144

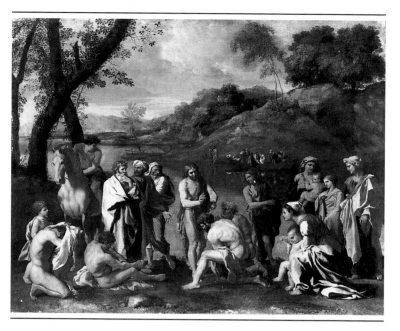

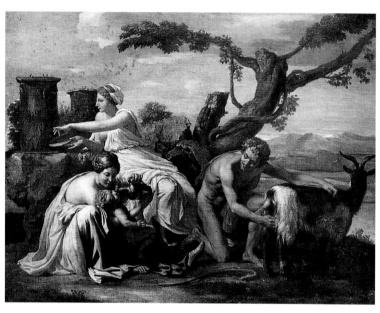

Fig. 87 Nicolas Poussin, *The Nurture of Jupiter*. Oil on canvas, 97 × 133 cm, c. 1639. Staatliche Museen zu Berlin, Preußischer Kulturbesitz, Gemäldegalerie

32
St John Baptising the People

c. 1636–7
94 × 120 cm

Musée de Louvre, Département des Peintures, Paris

In 1636–7 Poussin painted two closely related versions of *St John Baptising the People*. One of these (fig. 100) was painted for Cassiano dal Pozzo and may have been intended as a 'trial piece' for the set of Seven Sacraments (cat. 39–44) that Poussin was soon after to embark upon for the same patron; not only is it identical in size to these canvases but it is related to the *Baptism* (cat. 44) of the series in theme and, until 1958, was in the same collection.

The present painting is also virtually identical in size to these works and was painted for an unknown patron. In design and condition it is superior to the Pozzo canvas and, in certain features, anticipates Poussin's most heroic treatment of the theme, the *Baptism* of 1646 made for Chantelou (cat. 51).

The subject derives from Matthew III, 1–11, and shows St John baptising the people on the banks of the River Jordan immediately before the appearance of Christ, to whom he will also administer the sacrament. Surrounding the Baptist are four distinct groups of figures that outline the key elements in the story. At the right, a group of women and children await their turn to receive the sacrament. In the centre, three male figures, representative of youth, maturity and old age, are baptised by St John. Behind him, three Pharisees look on sceptically. One of them turns to question a youth on horseback, who is presumably an adherent of the new faith. Finally, at the far left, two men who have already been baptised dress themselves. One of these – the youth donning his stocking – is derived from Michelangelo's *Battle of Cascina* cartoon (fig. 108) and reappears in virtually the same position in the Baptism paintings of both sets of Sacraments.

The picture is notable both for its lucid exposition of the theme and for the beauty and serenity of its landscape, which portrays the receding river bank flanked by undulating hills and framed at the rear by a ridge of blue mountains. The scene is bathed in a melting light which touches the tips of the hills and trees and, in itself, suggests the dawn of a new dispensation. The style of the landscape, with its feathery foliage and trailing vines, is particularly close to that of the *Nurture of Jupiter* (cat. 31) and *Moses Striking the Rock* (c. 1637, fig. 16) and differs from the more simplified and schematic landscape backgrounds of the *Finding of Moses* (cat. 35) and the *Israelites Gathering the Manna* (cat. 37) of a year or so later.

No less refined is the colour scheme of the picture, with its mossy greens, salmon pinks and muted golds. Deprived of all of these accents, however, is the key figure of the Baptist, dressed in 'his raiment of camel's hair'. Yet he commands attention through his central position, his lightness of tone, and through the frosty blue garments worn by the kneeling mother at the right and the Pharisee on the opposite side. These vie for attention across the picture and, in so doing, emphasise him.

The meticulous care which Poussin lavished upon even so comparatively 'minor' a work as the present picture justifies the claims of André Gide, who observed of the artist in 1945:

> Recognise that it is thought that motivates and animates all his paintings. It is this which determines the grouping of the figures and their gestures, the movement of lines, the distribution of light, and the choice of colours. The very foliage of the trees in his vast landscapes seem an emanation of it, through their tranquil balance and the serenity which they breathe forth.[1]

1. Gide, 1945, n.p. (8 of introduction).

PROVENANCE
1685, André Le Nôtre; given by him to Louis XIV in 1693
EXHIBITIONS
Paris, 1960, no. 55; Rouen, 1961, no. 80; Bologna, 1962, no. 61; Edinburgh, 1981, no. 30; Paris, 1994-5, no. 53
ŒUVRE CATALOGUES
Blunt, no. 69, Thuillier, no. 78, Wild, no. 42, Wright, no. 96, Mérot, no. 69

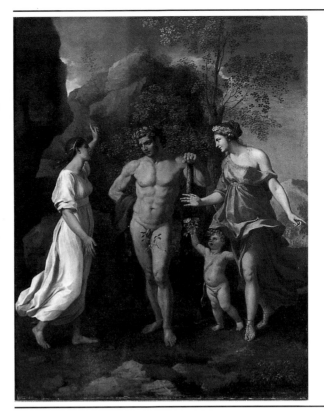

33
The Choice of Hercules
c. 1636–7
91 × 72 cm

Stourhead, The Hoare Collection (The National Trust)

The theme of this picture is derived from Xenophon (*Memorabilia* II, i, 21–33), who tells of the adolescent Hercules faced with a choice between Vice and Virtue. The latter appears as a woman of virgin purity, clad in white, who invites him to follow a life of toil and effort that will lead to both honour and glory. The former is personified by a more richly adorned woman who tempts him to pursue the path of pleasure and happiness. In pictorial representations of this theme, the two women are traditionally shown surrounded by two contrasting types of terrain: Vice by an undulating landscape of meadows and trees and Virtue by an arduous mountain range.

Poussin follows this practice by showing Virtue standing on a bare patch of ground and Vice upon verdant pasture. Moreover, while the tree behind the latter is in leaf, the sapling on top of the mountain at the left appears bare. Further reinforcing the allegorical meaning of the theme are the serpent, dimly visible halfway up the mountain, and the striking contrast between the sunburst on this side of the picture and the tranquil sky on the right. The former probably alludes to the serpents strangled by the infant Hercules – thereby indicating that he was predestined to follow the path of valour – while the dramatically lit sky suggests the vicissitudes of following an active life.

The picture is datable to 1636–7 and, in its highly keyed colouring and brittle handling, is close in style to the *Triumph*

of *Pan* (cat. 29) of a year or two earlier. It also has affinities with *St John Baptising the People* of 1636–7 (cat. 32), particularly in the treatment of the landscape, where delicate strokes of the brush capture the effect of sunlight tingeing the leaves of the trees. In addition, the theme of the present painting may be related to a series of allegorical compositions executed by Poussin during the second half of the 1630s in a highly didactic mode and style, clearly intended to edify. Among these are the *Arcadian Shepherds* (cat. 38), the *Dance to the Music of Time* (fig. 9) and a lost *Time Saving Truth from Envy and Discord*.[1] During these same years, Poussin also treated the theme of Hercules carrying off his wife Deianira in another lost painting, known through drawings.[2]

The present picture has been rejected by Thuillier for its hard and dry handling and 'the mediocrity of the inspiration' and is often treated condescendingly in the literature on the artist. To the present writer, however, it appears wholly characteristic of Poussin's style of the mid-1630s in its clarity of definition, crispness of handling and delicacy of colour. Moreover, it is arguably the most eloquent of all depictions of this somewhat stilted and unrewarding theme. For the subject necessitates only three figures engaged in a rhetorical – rather than a dramatic – confrontation and invites a static and symmetrical treatment, with Hercules confronted on either side by Vice and Virtue. This scheme is potentially so impoverished that even the very greatest artists have sought to avoid it.

The canonical treatment of this subject among Poussin's Roman predecessors is that by the arch-classicist Annibale Carracci (fig. 88). This follows the traditional compositional scheme for the theme and was certainly known to Poussin. Yet a comparison between the two works is an object lesson in the latter's superior powers of invention. In Annibale's canvas, the ponderous and inert figure of Hercules appears seated, his elbow touching that of Virtue, while the figure of Vice is seen

from behind and, pictorially speaking at least, already appears disadvantaged. The result is at once obvious and anticlimactic.

In contrast, Poussin portrays a true contest between equals in a design of emblematic clarity which reveals the essence of Hercules' dilemma with the minimum of pictorial distraction. As the hero contemplates the figure of Virtue, Vice advances towards him wearing a floral headdress and with one shoulder bared. She is assisted by a putto who attempts to bribe Hercules by offering him flowers. In contrast to these figures is the noble and idealised personification of Virtue, seen in shadow and strict profile, whose distance from Hercules poses a challenge rather than a temptation. In the rhythmic interplay of these figures may be seen the nature of Hercules' choice; for, if Vice invites him to follow her, Virtue beckons him to lead. The result is as lucid as it is expressive and, like the *Arcadian Shepherds* of the same years, reveals Poussin's ability to pare down his theme to essentials in order to enhance both its grandeur and gravity.

1. Blunt, no. 123; Mérot, no. 201 (with further bibliography).
2 CR III, pp. 38–9, nos. 218–20 and A63.

PROVENANCE
Possibly Richaumont and then his son-in-law François Blondel; 1747, Duke of Chandos sale, London; bought by Sir Richard Hoare; by descent to Sir Henry Hoare, who bequeathed Stourhead and its contents to the National Trust in 1947

EXHIBITIONS
Paris, 1960, no. 49; Bologna, 1962, no. 60; Birmingham, 1992–3, no. 9

ŒUVRE CATALOGUES
Blunt, no. 159, Thuillier, B 35, Wild, no. 70, Wright, no. 116, Mérot, no. 142

Fig. 88 Annibale Carracci, *The Choice of Hercules.* Oil on canvas, 167 × 237 cm, *c.* 1596. Pinacoteca del Museo Nazionale (Capodimonte), Naples

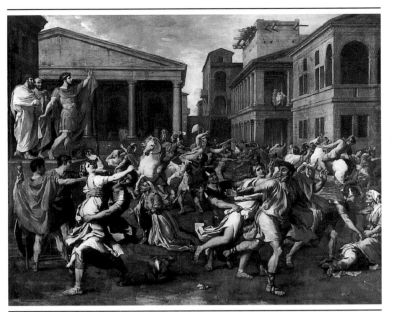

34
The Rape of the Sabines

c. 1637

157 × 203 cm

Musée de Louvre, Département des Peintures, Paris

In the mid-1630s, Poussin painted two versions of the *Rape of the Sabines*. One of these (fig. 70), was executed for the Duc de Créqui and dates from 1633–4, when he was French Ambassador to Rome. The present picture is first recorded in the collection of Cardinal Aluigi Omodei, who also owned Poussin's *Triumph of Flora* (*c.* 1627; fig. 22) and is widely though not unanimously dated to around 1637. It is fully described by Bellori and has recently been cleaned.

The subject is recounted by several ancient authors, among them Livy (I, 9). Poussin follows closely the account given by Plutarch (*Life of Romulus*, XIV). The Roman warriors led by Romulus, legendary founder of Rome, have invited the neighbouring Sabines to a sporting competition. At a given signal from Romulus, the Romans carry off the unmarried Sabine women. According to Plutarch 'they did not commit this rape wantonly, but with a design purely of forming alliance with their neighbours by the greatest and surest bonds'. Plutarch attributes to this the origin of the custom of carrying a bride over the threshold of her consort's house.

Poussin portrays Romulus standing on the portico of a temple at the upper left and giving the signal by raising his cloak, as described by Plutarch. Below him, the Roman soldiers seize the Sabine women, who attempt to flee. Kneeling before Romulus is an aged woman, mother of one of the Sabine maidens, who begs Romulus to desist. At the far right, another old woman attempts to shield her daughter from an attacking warrior. The violence and confusion of the moment are captured in the maelstrom of activity and in the figures' anguished expressions. Particularly striking is the man dressed in yellow at the right who flees, terrified. He is presumably the

father of one of the Sabine women, whom he has forsaken in an attempt to save himself.

The scene is set before a Doric temple and a receding row of buildings at the right, which recalls that of Poussin's *Plague at Ashdod* of 1630–1 (fig. 26). The severity of the background assists in stabilising the design, which is further unified by the repeated colours and rhyming poses of the figures, among them the kneeling older women, the two soldiers on horseback and the Roman warriors bearing maidens in the foreground left and centre middle distance.

Though the composition has certain affinities with Poussin's earlier version of this theme, the latter includes larger and fewer figures and is set in a relatively shallow space. Both of these devices permit the artist to stress the surface design of the picture and contrast with the more recessional and illusionistic treatment of the theme in the present painting, which relates to that of the *Capture of Jerusalem by Titus* (cat. 36) and the *Israelites Gathering the Manna* (cat. 37) of these same years.

Poussin made four drawings of this subject in the mid-1630s, among them two compositional studies (cf. fig. 89), neither of which is exactly comparable to either of his paintings of the theme.[1] Technical examination reveals that when he came to execute the present picture he relied on a series of incised lines, drawn into the coloured ground, which mark the geometrical divisions of the scene and converge upon the helmet of the mounted soldier at the centre left.[2]

The demonic intensity of both Poussin's versions of the *Rape of the Sabines* may instructively be compared with a canvas of the same theme of *c.* 1625 by Pietro da Cortona (fig. 90), supreme exponent of Baroque painting among Poussin's Roman contemporaries. In the latter, the balletic poses of the figures, the landscape background and the cascading draperies add a decorative element to the composition that Poussin rigorously eschews. Moreover, the melodramatic poses and expressions of

Fig. 89 Nicolas Poussin, *The Rape of the Sabines*. Pen, brown ink and wash, 16.4 × 22.4 cm. The Duke of Devonshire and the Chatsworth Settlement Trustees

the figures in Cortona's canvas appear more befitting to the world of opera than to that of ancient history.

The *Rape of the Sabines* has enjoyed an illustrious reputation with a number of French painters. David found inspiration for his *Oath of the Horatii* of 1784–5 (fig. 133) in the figure of the lictor, rigidly posed with his back to the viewer, at the extreme left of Poussin's painting. In 1799 David also painted an *Intervention of the Sabine Women* (Louvre, Paris), as a 'sequel' to the present picture, which he praised as 'moving' and 'severe'.

In the 1860s, Degas made a full-scale painted copy of the *Sabines* (Norton Simon Museum, Pasadena), which, with its leaping horses and animated figures, anticipates certain of his favourite themes. Rare among the Impressionists in his admiration for Poussin, Degas even sought to model his life on the example of the master, writing to Rouart in 1872, 'I am thirsting for order…I am dreaming of something well done (style Poussin and Corot's old age)'.[3] Degas's interest in Poussin, and particularly in the *Rape of the Sabines*, also forms the subject of an episode in Edouard Duranty's short story of 1881, *Le peintre Louis Martin*, in which a young artist secures permission to copy Poussin's *Sabines* in the Louvre.[4] Arriving there, he finds Degas already copying this work. When the youth proceeds to criticise the banality of its gestures, Degas retorts: 'purity of drawing, breadth of modelling, grandeur of disposition'. Since Duranty was a close friend of the Impressionists during these years, this remark may have some basis in fact.

1. CR II, pp. 8–10, nos. 114–17. *Ibid.,* pp. 10–11, nos. 118–19 for two drawings of the same theme of the 1640s.
2. Houston, Princeton 1983, pp. 21–32.
3. Edgar Degas, *Letters,* ed. Marcel Guerin, Oxford, 1947, p. 26.
4. Theodore Reff, 'New Light on Degas's Copies', *The Burlington Magazine,* CVI, 735, 1964, p. 255.

PROVENANCE
Painted for Cardinal Aluigi Omodei; his collection until *c.* 1664; 1685, acquired by Louis XIV

EXHIBITIONS
Paris, 1960, no. 41; Rouen, 1961, no. 78; Houston, Princeton, 1983; Paris, 1994–5, no. 72

ŒUVRE CATALOGUES
Blunt, no. 179, Thuillier, no. 114, Wild, no. 61, Wright, no. 101, Mérot, no. 188

REFERENCES
Bellori, 1672, p. 449

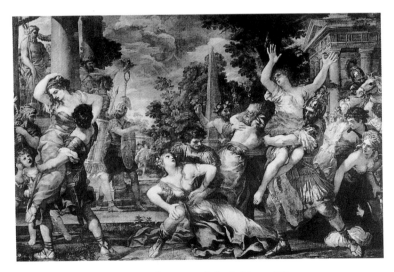

Fig. 90 Pietro da Cortona, *The Rape of the Sabines.* Oil on canvas, 275 × 423 cm, *c.* 1625. Museo Capitolino, Rome

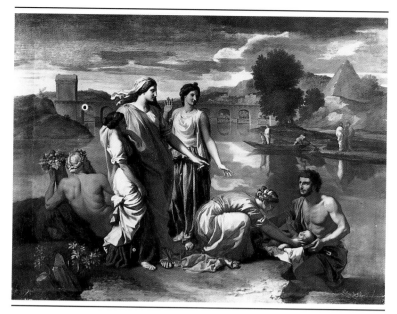

35
The Finding of Moses

1638

93 × 120 cm

Musée du Louvre, Département des Peintures, Paris

Poussin painted eighteen canvases illustrating episodes from the life of Moses, his favourite Old Testament hero. Among these are two pictures depicting the infant Moses's exposure on the Nile (cat. 77, fig. 5) and three portraying his rescue by Pharoah's daughter (cf. cat. 66, fig. 150). The present picture, which Félibien dates to 1638, is his earliest treatment of this theme and derives from Exodus II, 2–6. The daughter of Pharoah, accompanied by her maidservants, rescues the infant Moses from the waters of the Nile, personified by the reclining river god at the left. Though the Bible does not mention the male

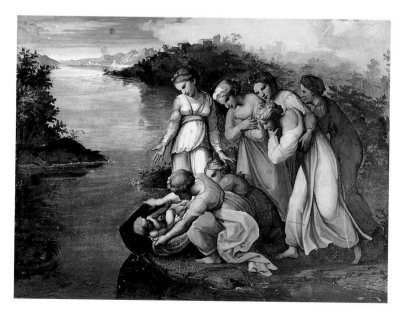

Fig. 91 Raphael, *The Finding of Moses*. Fresco, 1518–19. Logge, Vatican, Rome

servant stepping out of the water, this detail may derive from Josephus (*Antiquities* II, 10, 5), who notes that when Pharoah's daughter saw 'a cradle borne along by the current, she sent some that could swim, and bid them bring the cradle to her'.

The Louvre picture is one of the most exquisitely designed and coloured of all Poussin's works and possesses an artifice and elegance reminiscent of Greek vase painting. This is apparent in the tapered limbs and stylised curves that describe the figure of Pharoah's daughter, whose profile pose, flowing draperies and commanding gesture endow her with a regal authority. Swathed in golden yellow, she stands out from the delicate and silvery cast of the rest of the picture, where pinks, beiges, greys and blues predominate. To either side of the composition, the coppery flesh tones of the male figures frame the group and echo the prevailing hues of the landscape. Such suave and appealing colour harmonies were presumably chosen to mirror the joyous nature of the theme and may be contrasted with the clashing colours of another picture of 1638, the *Capture of Jerusalem by Titus* (cat. 36), which is likewise very different in theme.

Adding to the poise and serenity of this work is its atmospheric landscape, which sets the figures against the blues and greys of the water and sky and frames them with the receding banks of the Nile, marked to left and right by the fortifications of a bridge and a pyramid, locating the scene in Egypt.

Poussin may have derived inspiration for the general design from Raphael's fresco of the same theme in the Loggia of the Vatican (fig. 91), which also depicts the figure group against a background of the receding banks of the Nile. However, the motif of Pharoah's daughter leaning on her maidservant is derived from Poussin's *Theseus Finding his Father's Arms* (*c.* 1636–7, fig. 6), a work with which the present canvas also bears an underlying affinity of theme. Both pictures are concerned with the destiny of the future hero as it is presided over by a powerful yet benevolent female figure. This is one of the abiding themes of Poussin's career and finds expression in the late 1630s not only in the Louvre canvas but in two versions each of the *Nurture of Jupiter* (cat. 31, fig. 87) and *Venus bringing Arms to Aeneas* (cf. fig. 8).[1]

The purity and precision of Poussin's art in this excellently preserved painting attest to the increasingly rarefied nature of his inspiration in the late 1630s. How amusing to discover, therefore, that 19th-century artists and critics imagined him simply to have come upon the subject on one of his periodic outings along the banks of the Tiber. In a lost painting of 1855 by Léon Benouville, known through a watercolour copy of the following year (fig. 92), Poussin is shown alighting upon the idea for this picture at the sight of a group of washerwomen bathing an infant in the Tiber. Such an assumption – which was reiterated by at least one major critic of the day[2] – tells us more about the naturalistic concerns of 19th-century artists than about the more strenuous working methods of Poussin.

The Louvre picture has been enlarged by the addition of two strips of canvas at the top and left, possibly by the artist himself.

1. *Supra*, pp. 23–6.
2. Charles Blanc, *Grammaire des arts du dessin*, Paris, 1867, p. 10.

PROVENANCE
First recorded in the collection of André Le Nôtre; presented by him to Louis XIV in 1693

EXHIBITIONS
Paris, 1960, no. 57; Bologna, 1962, no. 66; Paris, 1994–5, no. 92

ŒUVRE CATALOGUES
Blunt, no. 12, Thuillier, no. 117, Wild, no. 81, Wright, no. 103, Mérot, no. 9

Fig. 92 Léon Benouville, *Poussin sur les bords du Tibre, trouvant la composition de son 'Moïse sauvé des Eaux'*. Watercolour, 22.7 × 39.5 cm, 1856. Amsterdams Historisch Museum, Fodor Collection

36
The Capture of Jerusalem by Titus
1638
Signed on the oval shield at the right: NI. PVSIN FEC.
148 × 199 cm

Kunsthistorisches Museum, Gemäldegalerie, Vienna

In 1626, Cardinal Francesco Barberini commissioned from Poussin a *Capture of Jerusalem by Titus*, which he presented to the French Ambassador, almost certainly as a present for Richelieu. This picture is now lost, though its appearance may be recorded in an engraving after a lost drawing (fig. 93). Twelve years later, in 1638, the Cardinal commissioned another painting of the same subject from the artist – the picture exhibited here. This was given to the Imperial Ambassador, Prince Eggenberg, and was presumably intended as a gift for the Emperor. Though Poussin was adept at painting battle pieces in the mid-1620s, when he executed at least three other such scenes (cf. cat. 2–3), the same may not be said for the years around 1638, when his art was entering its most contemplative and classical phase. The result is one of the most uncompromising – and visually discomforting – works of his entire career.

The subject of the picture is from Josephus (*Jewish War*, VI) and shows Titus and the Roman army besieging the city of Jerusalem in AD 70. Titus appears on horseback at the right, gazing up at the burning temple of Jerusalem, which he had attempted to save from destruction. Escaping from it are Roman soldiers, laden with plunder. The rest of the picture portrays the slaughter of the Jews by Titus's troops. 'Nor was there a commiseration of any age, or any reverence of gravity', notes Josephus of the massacre of the Jews by Titus's army, 'but children, and old men, and profane persons, and priests, were all slain in the same manner; so that this war went round all sorts of men, and brought them to destruction.' Accordingly, Poussin portrays a scene of brutal carnage which shows the slaughter of citizens of all ages.

Reinforcing the violence of the theme is the design and colour of the work. The composition is organised around an intricate meshwork of conflicting diagonals which in themselves evoke the discords of the action and create a visually unsettling impression. Compounding this effect is the cold, searing light of the picture and its astringent colour harmonies. The latter revolve around two combinations of hues that are calculated to disturb the eye: namely, those of red and yellow and red and green. Employed with relentless insistence both in the figures and their armour and weapons, these result in a kind of visual cacophony – in a strident and raucous effect that is wholly appropriate to the theme.

All of these devices demonstrate Poussin's determination to adapt his means of expression to his chosen subject, a desire that is further reflected in a fragment of a letter by the artist which dates from this period, *c.* 1637.[1] Poussin observes that whereas he had painted the seductive theme of Rinaldo and Armida in a 'soft' manner because the subject demanded it, he had treated the contrasting subject of *Camillus and the Schoolmaster of Falerii* (fig. 12) in a more severe style. This principle would eventually be more fully formulated by the artist in 1647 and has come to be known as the theory of the modes. But it may already be observed in Poussin's art of the preceding decade. One need only compare the attractive colour harmonies of the *Finding of Moses* (cat. 35) with the visual dissonances of the present picture, completed in the same year, to realise the truth of Poussin's confession to Chantelou in 1647: 'I am not one of those who when singing always assumes the same tone.'[2] To our eyes, the 'tone' of the *Moses* may be more agreeable, but it would never have suited the jarring theme of the Vienna picture.

The Capture of Jerusalem by Titus was the last work commissioned from Poussin by Cardinal Francesco Barberini, one of the key patrons of the artist's early years. Like the lost version of this subject of 1626 for Richelieu, it may have been intended by the cardinal as political propaganda at the Austrian Imperial Court. 'It would be interesting to know why he chose this particular subject as a theme for the paintings to be presented to the most powerful – and rival – figures in the European power struggle of the Thirty Years' War', observed Anthony Blunt:

> Was it to flatter them with the thought that Emperors – and even Ministers – can sometimes carry out God's will as Titus did in destroying Jerusalem as a punishment on the Jews for having caused the death of Christ? Or did he want to remind them that the Pope, his uncle, was the heir of the High Priests of the Temple, and that his authority was greater than theirs and was received directly from God?[3]

1. *Correspondance*, p. 4.
2. *Ibid.*, p. 352.
3. Anthony Blunt, 'Poussin at Rome and Düsseldorf', *The Burlington Magazine*, CXX, 1978, pp. 423–4.

PROVENANCE
Commissioned by Cardinal Francesco Barberini and given by him to Prince Eggenberg, Imperial Ambassador to Urban VIII, in 1638–9; 1718, Imperial Collection; Fürst Kaunitz; bought back from him by the Museum in 1820

EXHIBITIONS
Paris, 1960, no. 39; Rome, 1977–8, no. 25; Paris, 1994–5, no. 77

ŒUVRE CATALOGUES
Blunt, no. 37, Thuillier, no. 115, Wild, no. 84, Wright, no. 102, Mérot, no. 33

Fig. 93 Anonymous 17th-century Artist (*after* Nicolas Poussin), *The Capture of Jerusalem by Titus.* Engraving. The Courtauld Institute of Art, The University of London

37
The Israelites Gathering the Manna

1637–9

149 × 200 cm

Musée du Louvre, Département des Peintures, Paris

The Israelites Gathering the Manna was Poussin's first commission from Paul Fréart de Chantelou, who became one of the artist's greatest patrons and closest friends. As though conscious of the special relationship he was to enjoy with Chantelou, Poussin produced for him one of his most elevated and ambitious pictures, a work that was destined to become a cornerstone of the French classical tradition.

The subject is from Exodus XVI, 11–18, and depicts the miraculous fall of the manna to the Israelites in the wilderness. In the foreground figures gather the divine nourishment and, in the middle distance, Moses and Aaron give thanks to the Lord for this miracle.

No drawings survive for this canvas, though the complexity of the design and the clarity with which the narrative is unfolded indicate that it was among the most carefully planned of all the artist's works. Poussin himself hints at this in a letter of *c.* 1637 to his friend Jacques Stella:[1]

> I have found a certain distribution . . . and certain natural attitudes which show the misery and hunger to which the Jewish people had been reduced, and also the joy and happiness which came over them, the astonishment which had struck them, and the respect and veneration which they feel for their lawgiver, with a mixture of women, children, and men, of different ages and temperaments – things which will, I believe, not displease those who know how to read them.

Later, when sending the finished canvas to Chantelou, Poussin provided him with the following account of the scene:[2]

> If you will remember the first letter which I wrote you, about the movements that I proposed to give to the figures and, if at the same time, you will look at the painting, I think you will easily recognise those who are languishing from hunger, those who are struck with amazement, those who are taking pity on their companions and performing acts of charity . . . Read the story and the picture, so that you can judge whether everything is appropriate to the subject.

The picture is intended to be 'read' in three distinct stages, which progress across the foreground from left to right and come to rest in the centre middle distance. Viewed in this way it unfolds like a dramatic narrative, which encompasses all moments in the story and all types of humanity in a conscious attempt to give comprehensiveness to the theme.

At the left figures languish, as though before the appearance of the divine nourishment. Prominent among them is a group which comprises the three ages of man. A kneeling mother offers her breast to an aged female figure, who is presumably her own mother, while withholding it from her hungry child – a sublime act of charity which reminds us of the dependence of both youth and age upon maturity. Witnessing this moving scene is a standing man who raises his hand in wonder and admiration, as if seeking to elicit a similar response from the viewer. Immediately behind this group is a seated old man comforted by a youth who points to another youth at the right, hastening towards them with a basket of manna. Urging the latter on, in the foreground right, is a mother holding her infant, whose distracted pose and forceful gesture likewise give her the semblance of a figure of charity – one who has momentarily forsaken the needs of herself and her child for the greater needs of another.

In inventing these actions, Poussin provides an even more edifying account of the tale than the Bible, which notes that Moses instructed each of the Israelites to gather only as much manna as they could eat. As Poussin treats the story, however, the benevolence of the Lord results in the moral elevation of the Israelites themselves by prompting them to perform acts of charity.

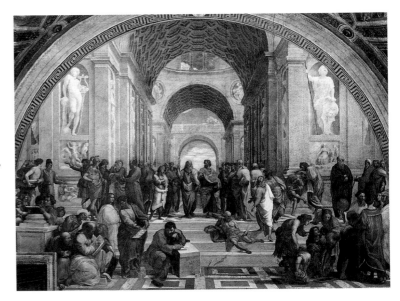

Fig. 94 Raphael, *The School of Athens*. Fresco, 1509–10. Stanza della Segnatura, Vatican, Rome

The remainder of the right-hand group consists of figures gathering the manna. These include two youths fighting over it and, in the process, knocking over the vessel they have been filling, spilling its precious contents. Nearby, an aged man kneels and prays, his withered frame and cadaverous flesh-tones suggesting that he alone gives thanks for the miracle before partaking of it. At the extreme right, a kneeling couple eagerly gather manna, while behind them an innocent maiden lifts up her skirt and gazes heavenwards, as though imagining that this is all she need do for it to come to her. Finally, at the far right, a bearded man feeds himself. He provides a perfect example of the economy and universality of Poussin's thinking in this picture. For, in a scene which centres around the theme of relieving one's hunger, he alone eats.

As the last act in the drama, Poussin depicts Moses and Aaron, surrounded by a chorus of Israelites, paying homage to the Lord.

The scene is set in an arid and rocky landscape which stresses the privations of the Israelites before the fall of the manna. In the far distance appear the tribe's tents, surrounded by diminutive figures who have yet to discover the miracle. Dominating the landscape at the left is a huge rock arch

Fig. 95 *Follower of* Pietro da Cortona, *Roman Landscape*. Fresco formerly in the Palazzo Barberini, Rome. Watercolour, 35.9 × 48 cm. The Royal Collection

through which the dawn light may be glimpsed. Poussin derived this fantastic structure from a Roman fresco formerly in the Palazzo Barberini, copies of which existed in the collection of Cassiano dal Pozzo (fig. 95).

The design is one of the most lucid and clearly articulated ever conceived by Poussin, and one of the most intricate. Never before had the artist assembled such a wealth of actors and incidents on a canvas and employed them so purposefully or imaginatively – a challenge which tested not only his powers of invention but also of pictorial composition. Yet the abstract harmony of the picture is as deeply satisfying as its narrative

content, with its incisively delineated figures, lucid formal groupings, and animated and reciprocal poses and gestures. Aiding in this are the selective accents of light, which emphasise key points in the drama, and the strategic choice of colours: red, white and blue for Moses and Aaron, and blue and yellow – the heavenly colours – for the charity groups in the foreground.

For all its originality, the picture appears steeped in the tradition of Italian Renaissance narrative painting and possesses a harmony of design and nobility of thought that call to mind Raphael's *School of Athens* (fig. 94). Whether or not Poussin's picture was conceived in emulation of this great fresco, with Moses and Aaron replacing Plato and Aristotle, *The Israelites Gathering the Manna* remains one of the handful of works since the 16th century to aspire to the lofty moral tone and elevated style of Raphael's masterpiece.

The picture has long been among Poussin's most admired and influential works. In 1667, it was made the subject of an extended lecture – or *conférence* – at the French Academy of Painting and Sculpture, delivered by Charles Lebrun, First Painter to Louis XIV.[3] Lebrun reserved especial praise for its variety of contrasting episodes and incidents, the expressiveness of its figures and the relationship between these and some of the greatest works of antique sculpture. As he was careful to point out, however, Poussin had not borrowed directly from such sources, but only given to his figures the harmony and proportions of their ancient prototypes. In this respect, the artist could be seen to emulate – rather than imitate – the art of the past. Later critics have also drawn attention to Poussin's practice of relegating the principal figures in such pictures – in this case, Moses and Aaron – to the middle distance and giving over the foreground to a group of anonymous actors who exemplify 'ordinary' humanity and thereby communicate more directly with the viewer. This is a technique which the artist regularly adopted and is also apparent in the *Plague at Ashdod* (fig. 26), the Dulwich *Triumph of David* (cat. 24) and the *Adoration of the Golden Calf* (fig. 69).

The present picture originally measured 130 by 231 cm. It has been cut by about 30 cm at the sides and enlarged at the top and bottom by approximately 19 cm.

1. *Correspondance*, pp. 4–5.
2. *Ibid..*, p. 21.
3. *Conférences*, 1667, pp. 76–107.

PROVENANCE
Commissioned by Paul Fréart de Chantelou in 1637–8 and delivered in 1639; Nicolas Fouquet; in the French Royal Collection by 1667

EXHIBITIONS
Paris, 1960, no. 56; Rouen, 1961, no. 81; Bologna, 1962, no. 67; Rome, 1977–8, no. 26; Düsseldorf, 1978, no. 25; Paris, 1994–5, no. 78

ŒUVRE CATALOGUES
Blunt, no. 21, Thuillier, no. 118, Wild, no. 85, Wright, no. 113, Mérot, no. 18

REFERENCES
Conférences, 1667, pp. 76–107; Félibien (ed. 1725), IV, pp. 26, 120–44

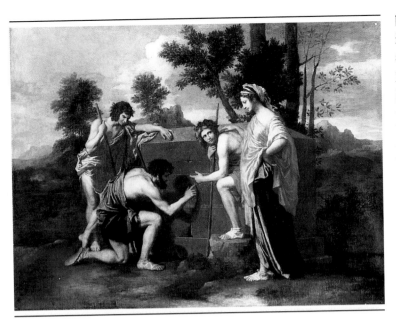

38
The Arcadian Shepherds

1638–40

85 × 121 cm

Musée du Louvre, Département des Peintures, Paris

Probably the best known of all Poussin's paintings, the *Arcadian Shepherds* depicts the same theme as the early Titianesque canvas at Chatsworth (cat. 13), but in a wholly different mood. Whereas the early picture portrayed the figures in a sudden and dramatic confrontation with death, the Louvre painting shows them solemnly meditating upon it. In keeping with this more philosophical approach to the theme, the skull included in the Chatsworth picture has been omitted and the inscription – *Et in Arcadia ego* or 'Even in Arcadia, [there] am I' – is literally allowed to speak for itself. As Panofsky notes in his classic study of this picture, the absence of the skull eventually led these words to be attributed not to death itself but to the inhabitant of the tomb, with the result that 'the Arcadians are not so much warned of an implacable future as they are immersed in mellow meditation of a beautiful past'.[1]

The scene is one from which virtually all movement has been eliminated. Three shepherds and a shepherdess appear welded into a single group which follows the contours of the tomb, as though already confined by its controlling law. As one figure kneels to decipher the inscription, his shadow falls prophetically upon the tomb. Another transmits the tomb's message to a shepherdess leaning on his shoulder; while the standing shepherd at the left contemplates the meaning of these words with an air of gentle resignation.

The composition is of the utmost simplicity, which may explain why the Louvre picture has long been regarded as the quintessence of Poussin's art. Poses are stilled, action is frozen and the scene is set in a timeless context which contains nothing to engage or divert the eye. The colour is pure, matt and largely confined to the primary hues; and the landscape is reduced to a

bare and arid terrain bounded by a mountain range and including only a few isolated trees. The sparseness of this setting is presumably intended to stress the purely symbolic presence of the landscape and to concentrate attention upon the picture's deeper meaning. To achieve this, Poussin appears to have lavished less care upon the execution of this canvas than upon many of his other works. It is as though he wished it to appeal to the mind rather than the eye and to impress the viewer more as a visual image than as a painted surface.

The stoical mood and remarkable economy of the present canvas led Blunt to date it after 1655 and to relate it to such other late works by the artist as the *Holy Family in Egypt* (cat. 80) and the Philadelphia *Baptism* (cat. 85). The majority of critics, however, prefer a date in the late 1630s and relate it to a group of allegorical compositions Poussin created during these years which were painted for Cardinal Giulio Rospigliosi, whom Bellori cites as the inspiration for the present painting[2] and who certainly commissioned two other works from the artist in these same years, the *Dance to the Music of Time* (fig. 9) and a lost *Time Saving Truth from Envy and Discord*.[3] The schematic treatment of the landscape would likewise suggest an earlier date and has obvious affinities with the *Finding of Moses* of 1638 (cat. 35). Further complicating the issue is the fact that X-ray examination of the picture in 1960 revealed it to be closer in technique to Poussin's paintings of the

Fig. 96 Paul Cézanne (*after* Nicolas Poussin), *Arcadian Shepherdess.* Pencil, 20.2 × 12.2 cm, 1887–90. Œffentliche Kunstsammlungen, Basel, Kupferstichkabinett

1650s and '60s.[4] It is hoped that its juxtaposition with other works by the artist in the present exhibition may help to resolve this problem.

The *Arcadian Shepherds* has always been among the most popular of Poussin's paintings and has inspired numerous imitations and variations, especially during the 18th and 19th centuries. These include not only other canvases of the subject but sculpted reliefs, snuffbox designs and, in one case, a long dramatic poem.[5] Given the poignancy of its theme and its indelible association with the master, it is perhaps inevitable that it also came to adorn Poussin's own tomb (fig. 97). This was erected in the church of S. Lorenzo in Lucina, Rome, between 1828 and 1832 and replaced one put there earlier by Bellori. Commissioned by Chateaubriand, who was then French Ambassador to Rome, it consists of a sculpted relief of the *Arcadian Shepherds* surmounted by a bust of the artist.

But the greatest 19th-century admirer of the present picture was Cézanne, who applied for permission to copy it in the Louvre in 1864 and, around 1890, made two partial copies of it, both of which explore the formal links between individual figures and other elements in the composition (fig. 96).[6] Sometime after 1893, too, Cézanne hung a reproduction of the *Arcadian Shepherds* in his studio. 'The beauty of the subject pleased him', we are told of Cézanne's devotion to this picture. Obsessed with thoughts of death during these years, Cézanne was surely aware that the 'beauty' of Poussin's allegorical theme comprised the essence of his own daily struggles – that of reconciling man's inescapable fate with the enduring life of nature.

1. Panofsky (ed. 1955), p. 313.
2. Bellori, 1672, p. 448.
3. Blunt, no. 123, Mérot, no. 201 (with further bibliography).
4. Hours, 1960, pp. 5, 34–7.
5. Further to the critical history of this picture, see Verdi, 1979.
6. On Cézanne's interest in the *Arcadian Shepherds*, see Edinburgh, 1990, p. 45, and the bibliography cited there.

PROVENANCE
Probably the Chevalier d'Avice; 1685, bought by Louis XIV from C. A. Hérault

EXHIBITIONS
Paris, 1960, no. 99; Paris, 1994–5, no. 93

ŒUVRE CATALOGUES
Blunt, no. 120, Thuillier, no. 116, Wild, no. 83, Wright, no. 104, Mérot, no. 199

REFERENCES
Bellori, 1672, p. 448; Félibien (ed. 1725), IV, p. 88; Weisbach, 1930; Klein, 1937; Weisbach, 1937; Blunt, 1938; Panofsky, 1938; Panofsky, 1955; Steefel, 1975; Verdi, 1979

Fig. 97 Vaudoyer, Lemoyne et Desprez, *Monument to Nicolas Poussin*. Marble. Erected by François-René de Chateaubriand, 1828–32. S. Lorenzo in Lucina, Rome

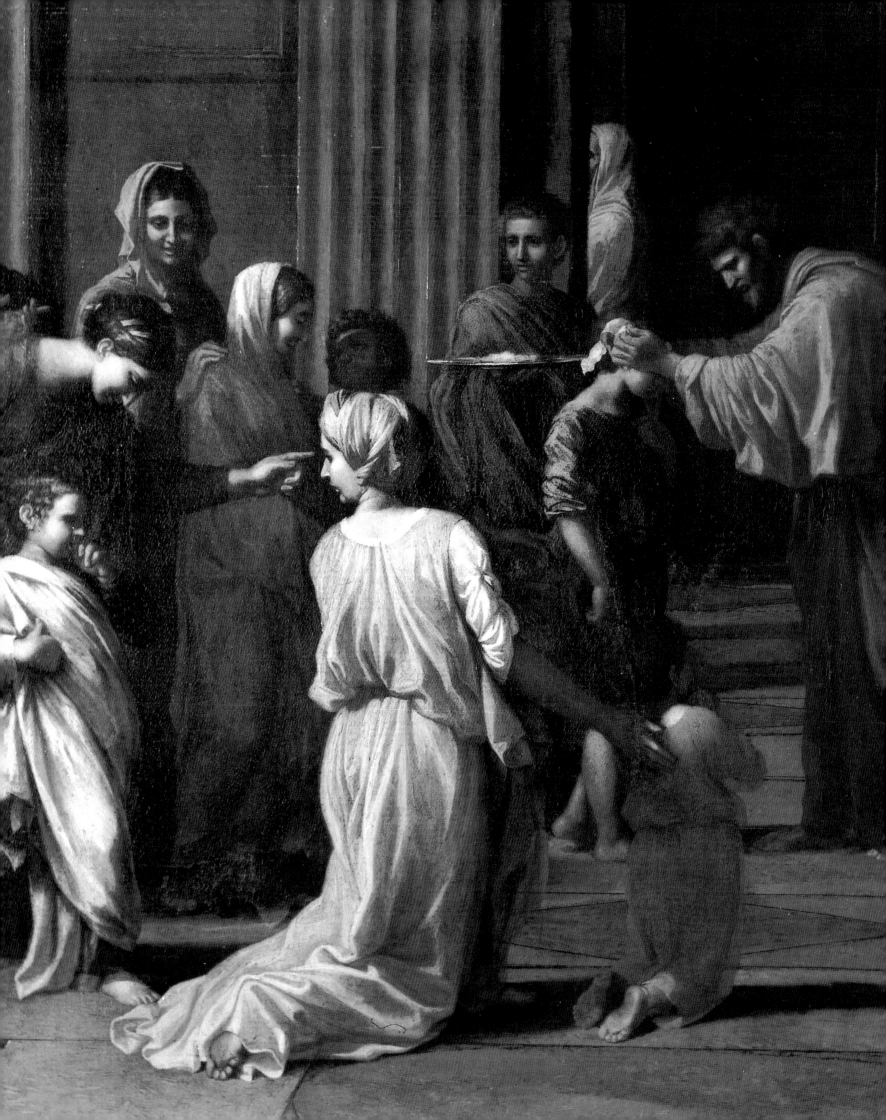

The First Set of Seven Sacraments

In the second half of the 1630s, Poussin embarked upon a set of Seven Sacraments for Cassiano dal Pozzo which was eventually completed in 1642. No documents survive concerning the origins of this commission, which was the most important so far undertaken by the artist, other than the fact that a drawing for the *Triumph of Pan* (cat. 29) of 1635–6 also contains a study for a figure in one of the Sacraments.[1] But this cannot be taken as conclusive evidence that the series was begun by this date; and most scholars are inclined to believe that it dates from around 1638, if only because of the large number of other commissions documented to the immediately preceding years. However, Bellori states that the Sacraments were painted 'at different times',[2] suggesting that Poussin may have worked intermittently on the series over a somewhat longer period. The order in which individual canvases were completed is also uncertain, with the exception of *Baptism* (cat. 44), which Poussin took with him unfinished to Paris in 1640 and dispatched to Pozzo in May 1642.

The subject of the Seven Sacraments is rare in art before Poussin and almost unprecedented in painting. Prior to the 17th century, it may occasionally be found in religious sculpture – especially on English fonts of the 15th and 16th centuries – and on Flemish tapestries and German and Flemish engravings. But it

Opposite: detail from *Confirmation*, cat. 43

Fig. 98 Rogier van der Weyden, *Seven Sacraments Triptych*. Centre panel 199.4 × 97 cm; each wing 119 × 63 cm, *c.* 1451–3. Koninklijk Museum, Antwerp

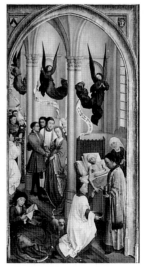

Fig. 99 Giuseppe Maria Crespi, *Sacrament of Confirmation.* Oil on canvas, 125 × 93 cm, *c.* 1712. Staatliche Kunstsammlungen, Gemäldegalerie, Dresden

was seldom a theme treated in painting, the most notable exception being Rogier van der Weyden's altarpiece in the Antwerp Museum (fig. 98), which portrays all seven sacraments on one triptych: Eucharist, in the form of the Crucifixion, in the centre panel, and the remaining six sacraments on the wings. Moreover, even after Poussin's celebrated series of Sacraments for Pozzo – and his even more ambitious set for Chantelou (cat. 49–55) – the theme remained rare in painting. Both Giuseppe Maria Crespi and Pietro Longhi depicted it in a series of seven interrelated canvases in the 18th century.[3] But their responses to the theme are as different to Poussin's as was van der Weyden's altarpiece. For, if the latter portrays the sacraments in a devotional context, set within a Flemish Gothic interior, both Crespi (fig. 99) and Longhi depict them in a series of religious genre paintings, showing contemporary figures receiving the sacraments in an unspecified setting. Poussin, however, eschews all references to the contemporary and the purely devotional in favour of a more archaeological approach to the theme. Both of his sets of Sacraments are instead true history paintings which portray the origin or administration of each sacrament in the practices of the early Christian Church.

This highly unorthodox approach to the theme was almost certainly suggested to the artist by Pozzo, whose learned and antiquarian interests are well documented and who was particularly attracted to the culture and customs of the early Church and to the parallels between pagan religions and Christianity. In keeping with these interests, Poussin chose to depict five of the sacraments with episodes from the Bible: *Baptism* with St John baptising Christ, *Penance* with the Magdalene washing Christ's feet, *Ordination* with Christ giving the keys to St Peter, *Marriage* with the marriage of the Virgin, and *Eucharist* with the Last Supper. For the remaining two sacraments, *Confirmation* and *Extreme Unction*, he chose no specific biblical incident but instead portrayed anonymous figures in classical dress receiving the sacrament in the manner of the ancients.

Fig. 100 Nicolas Poussin, *St John Baptising the People.* Oil on canvas, 94 × 120 cm, *c.* 1636–7. The Collection of the J. Paul Getty Museum, Malibu, California

Fig. 101 *Copy after* Nicolas Poussin, *Penance.* Oil on canvas, 120 × 94.3 cm. Collection Lew Sonn, New York

Though the decision to treat this theme in a series of monumental historical canvases was profoundly original, there were numerous precedents for the individual subjects included in the series, both in the art of the Renaissance and in that of Poussin himself. The most notable of the latter are the artist's two versions of *St John Baptising the People*, one of which was also commissioned by Pozzo during these same years. Since both these canvases are exactly the same size as the first set of Sacraments and the scale of their figures roughly similar, one is naturally led to wonder if they are not even more closely related to this commission. Stylistically, the Louvre picture (cat. 32) would appear to be the earlier of these two works; and it was certainly not painted for Pozzo. Did the sight of this painting, destined for another patron, prompt Pozzo to commission a version of the same theme for himself (fig. 100)? And might his satisfaction with that canvas in turn have led him to suggest to Poussin that he further develop his ideas on the early history of the sacraments in a series of works related to this theme? Circumstantial evidence for this exists in the form of the difficulties, and delays, the artist obviously experienced in painting the *Baptism* for the present series. This is radically different and, if anything, less successful than the *St John Baptising the People* that was already in Pozzo's collection and suggests that Poussin was aware that it should not imitate or compete with the earlier canvas.

Though the sequence in which individual canvases in the series were executed is unknown, stylistic variations among them are readily discernible, especially in the scale of the figures, which occupy much less than half of the canvas in *Ordination* and nearly two-thirds in *Baptism*. Further evidence of Poussin's growing confidence with these pictures is the noticeable progression from the shallow, frieze-like arrangement of the figures in the former canvas to the more intricate spatial organisation of, for instance, *Confirmation*. Such anomalies cannot have gone unnoticed by Poussin himself; and it is notable that he studiously avoided them in his second set of Sacraments for Chantelou.

223

Until the late 18th century, the first set of Sacraments were among the most important canvases by Poussin to be seen in Rome. There they aroused much admiration among both artists and collectors, beginning with Chantelou, whose even finer set of Sacraments had its origins in a desire for copies of the Pozzo series. In Pozzo's residence itself, they eventually gave their name to the principal room of the collection, which also contained other important paintings by the artist. Further evidence of their celebrity is the fact that sometime before 1745 they were sold to Sir Robert Walpole, although their export from Italy was forbidden. When they were offered to the Duke of Rutland in the 1780s, they were replaced – one by one – by copies, purporting to be the originals. And when the Sacraments finally arrived in London in 1786, they created such a stir that even King George III wanted to see them. This he did at the Royal Academy in 1787, in the company of Sir Joshua Reynolds.[4]

Five of the Seven Sacraments remain in the collection of the present Duke of Rutland. *Penance* was destroyed in a fire at Belvoir Castle in 1816 and is known through engravings and painted copies (cf. fig. 101), and *Baptism* was sold in about 1939 and is now in the National Gallery of Art, Washington.

1. CR III, p. 24, no. 188.
2. Bellori, 1672, pp. 418–19.
3. Cf. Mira Pajes Merriman, *Giuseppe Maria Crespi*, Milan, 1980, pp. 317–18, nos. 290–6; Vittorio Moschini, *Pietro Longhi*, Milan, 1956, pls. 123–9.
4. W. T. Whitley, *Artists and their Friends in England 1700–1799*, II, New York and London, 1928, pp. 75–8.

PROVENANCE
Cassiano dal Pozzo; by inheritance to Cosimo Antonio dal Pozzo, grandson of Cassiano's younger brother, Carlo Antonio, and then to Cosimo's daughter, Maria Laura, who married a member of the Boccapaduli family in 1727; 1785, bought by James Byres for the 4th Duke of Rutland; 1816, *Penance* destroyed by fire; *Baptism* sold *c.* 1939 and now in the National Gallery of Art, Washington; the remaining canvases by descent to the present owner

REFERENCES
Bellori, 1672, pp. 416–19

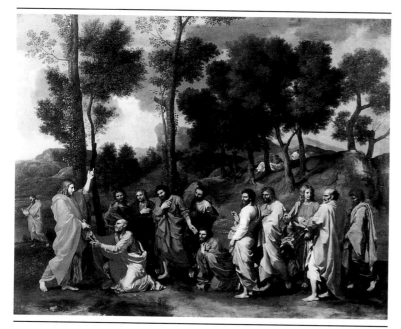

would also suggest that it was among the first of the Pozzo Sacraments to be completed.

Despite its comparative immaturity, *Ordination* appeals through its immaculate colour and handling, its excellent state of preservation and its airy landscape background. It also contains one iconographical subtlety which bears witness to Poussin's desire to introduce as much meaning into the scene as possible. Behind the group of Christ and his twelve Apostles are twelve trees. One of these, at the extreme right, is dead and stands immediately above the Apostle furthest from Christ, who lurks in the shadows. With his livid flesh tones and lime-green draperies, he is presumably Judas.

1. CR V, p. 89, nos. 413–14. Cf. Blunt 1979², p. 126 and pl. 6 for a sheet of studies of three heads in the present picture.

EXHIBITIONS
Edinburgh, 1981, no. 31; Paris, 1994–5, no. 67
ŒUVRE CATALOGUES
Blunt, no. 110, Thuillier, no. 111, Wild, no. 76, Wright, no. 109, Mérot, no. 102

39
Ordination

c. 1638–40

95.5 × 121 cm

His Grace the Duke of Rutland

The subject is from Matthew XVI, 16–20. Christ, accompanied by the Apostles, presents Peter with the keys of heaven and earth. In the background, figures recline and converse in the shade of a group of trees; and at the left, another exits reading. It has been suggested that these figures may represent the theme of the philosopher's grove and draw a parallel between the philosophy of classical antiquity and that of Christianity.

Poussin derived the composition from Raphael's tapestry cartoon, *Feed my Sheep* (fig. 102), which portrays Christ's appearance to his disciples after his death, and thereby omits Judas. But, rather than arranging the Apostles in one sculptural group, Poussin spreads them out across the foreground of the picture in a frieze-like manner and avoids the monotony inherent in such an arrangement by diversifying their poses and gestures and by portraying three figures kneeling at equal intervals across the picture. A preparatory study for the painting (fig. 103),[1] drawn on both sides of the sheet, reveals that the artist initially intended to include many more kneeling figures and only gradually evolved the arrangement adopted here. Unlike Raphael's prototype, this stresses the individuality of the Apostles and their diverse responses to the event.

With its diminutive figures and shallow spatial treatment, the picture would appear to be one of the earliest of the Pozzo Sacraments and may well date from before 1638. In its cool, pure colours and atmospheric landscape it has certain affinities with *St John Baptising the People* (cat. 32) and *Moses Striking the Rock* (c. 1637; fig. 16). Like the *Eucharist* (cat. 40) of the same series, its close dependence upon a Renaissance prototype

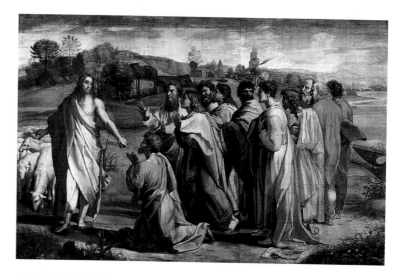

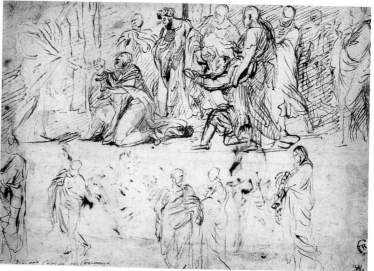

Fig. 102 Raphael, *Feed My Sheep.* Cartoon, 3.43 × 5.32 m, 1515–16. The Victoria and Albert Museum, London

Fig. 103 Nicolas Poussin, *Ordination.* Pen and bistre wash. Private Collection, New York

40

Eucharist

c. 1638–40

95.5 x 121 cm

His Grace the Duke of Rutland

Although all four Gospels contain an account of the Last Supper, this picture is based on John XIII, 21–25 and shows Christ blessing the chalice with the Evangelist asleep at his side. Surrounding him are the remaining Apostles, who are shown reclining on a Roman *triclinium* in the manner of the ancients. Poussin employed this archaeological detail in his versions of *Penance* and *Eucharist* in both sets of Sacraments and was evidently proud of it, since he refers to it in a letter to Chantelou of 1644 as 'something new'.[1] At the left, a servant exits through a half-opened door. Judas is probably the figure facing outwards at the far left, who is the only one of the disciples not turned towards Christ.

Though the general disposition of the figures contains echoes of Leonardo's *Last Supper*, the device of showing some of the Apostles further forward than Christ, with their backs to the viewer, is probably derived from Frans Pourbus the Younger's *Last Supper* of 1618 (fig. 104), a work which Poussin certainly knew from his youth in Paris and reputedly much admired. Elements of this picture may also be seen in the artist's second version of *Eucharist* (cat. 54) of 1647 for Chantelou.

As in *Ordination* (cat. 39), the small scale of the figures and the clear indebtedness of the artist to the works of previous masters suggests that this was one of the earliest of the first set of Sacraments to be completed. It is also one of the least well preserved of the series and is severely abraded in places.

The most striking feature of the picture is its complex play of light and shadow. Bellori observed of this:[2]

There are in this work three sources of artificial light; two come

from a lamp hanging up high with two wicks that illuminate the fronts of all the figures; the third light comes from a candle placed low upon a stool, and this means that there is a doubling and tripling of rays of light and shadows, which are spliced together at larger and smaller angles, and more or less clearly depending on the distances; this can be seen in the bench itself and in the feet of the bed where the Apostles rest facing the light.

Elizabeth Cropper has convincingly demonstrated that Poussin owed this complex effect of shadow projection to a manuscript by Matteo Zaccolini owned by Pozzo, which was in turn based on a lost treatise on light and shadow by Leonardo.[3] Since Poussin himself was also engaged in illustrating the writings of Leonardo during these years, the combined references to the latter's *Last Supper* and to his theories of optics in the present picture appear consistent, especially in a canvas destined for Pozzo.

1. *Correspondance*, p. 272. In fact, this device had occasionally been employed by artists from the late 16th century onwards, but never became general practice. (See A. Blunt, 'The triclinium in religious art since the Renaissance', *Journal of the Warburg Institute*, II, 1938–9, pp. 271–6 and Jacques Vanuxem in *Actes*, 1960, I, pp. 151–62.)
2. Bellori, 1672, p. 417.
3. Cropper, 1980, pp. 579–81.

EXHIBITIONS
Edinburgh, 1981, no. 34; Paris, 1994–5, no. 68

ŒUVRE CATALOGUES
Blunt, no. 107, Thuillier, no. 112, Wild, no. 89, Wright, no. 110, Mérot, no. 106

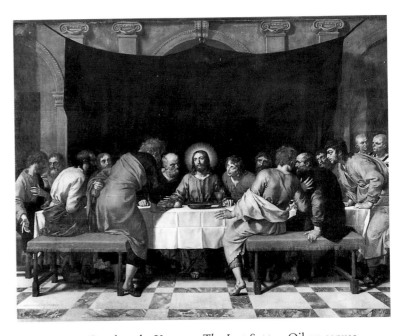

Fig. 104 Frans Pourbus the Younger, *The Last Supper.* Oil on canvas, 287 × 370 cm, 1618. Musée du Louvre, Département des Peintures, Paris

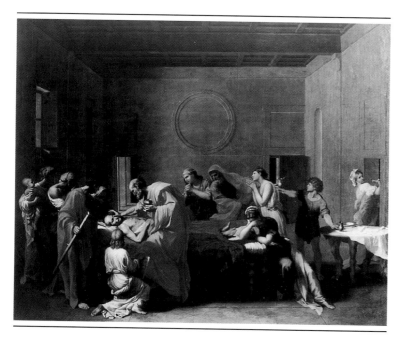

41
Extreme Unction

c. 1638–40

95.5 × 121 cm

His Grace the Duke of Rutland

Poussin chose to represent the sacrament of Extreme unction by portraying a dying man being anointed with oil in accordance with the practices of the ancient Roman Church. The scene is based on no textual source but is derived instead from one of the great masterpieces of the artist's early years, the *Death of Germanicus* (cat. 9) of 1626–8. As in that picture, the composition is arranged like an antique relief, with the deathbed aligned parallel to the picture plane and surrounded by a group of mourners. But, whereas the figures in the earlier work are deployed in a crowded and overlapping manner, in this picture they appear rhythmically distributed across the canvas – each contributing a clearly articulated action or emotion to the communal grief of the whole.

According to Bellori, many of the figures in the present canvas bear an identifiable relationship to the dying man.[1] Behind him is his mother, holding his head while the priest anoints his eyes. Accompanying the latter are two acolytes, one holding a candle and the other kneeling. At the foot of the bed is the dying man's wife, covering her face in an expression of inconsolable grief – a device that Poussin had also employed in the *Death of Germanicus*. Behind her is their daughter, her hands joined in silent prayer for her father. Next to her is an elderly man – presumably a doctor or apothecary – who distractedly hands a flagon to a youth at the right while directing his gaze towards the dying man. At the centre, another woman wrings her hands in anguish; while, at the far right, a servant exits from the scene. Poussin employs such departing figures in five of the Pozzo Sacraments, where they add to the naturalism and animation of the proceedings.

The action is set in a spacious interior lit by a window at the left and two doors at the rear. These illuminate the pure, cool colours of the figures with a clarity and precision that enhances the picture's appeal. Adding to the cohesiveness of the composition are the geometric accents of the architecture and the lucid arrangement of the figures in a sequence of diagonals which rise and fall across the picture and reveal the artist's growing concern with the principles of abstract design. These may be compared with the more arbitrary relationship between the figures and their setting in *Ordination* (cat. 39) and suggest that the present picture is later in date. In its colour, compositional devices and architectural setting, it appears particularly close in style to *Marriage* (cat. 42) from the same series.

A drawing for one of the mourning women at the left appears on a sheet of studies for the *Triumph of Pan* at Windsor.[2]

According to Wildenstein,[3] a copy of *Extreme Unction* was in the collection of M. Briand de Varras at Lyons in the 18th century. There it was admired by such pioneers of Neo-classicism as Drouais, Ménageot and Jacques-Louis David, whose indebtedness to Poussin's heroic deathbed scenes is among the central features of his art of the 1770s and '80s.

1. Bellori, 1672, p. 418.
2. CR III, p. 24, no. 188.
3. Wildenstein, 1957, p. 148.

EXHIBITIONS
Bologna, 1962, no. 68; Edinburgh, 1981, no. 33; Paris, 1994–5, no. 64

ŒUVRE CATALOGUES
Blunt, no. 109, Thuillier, no. 109, Wild, no. 44, Wright, no. 107, Mérot, no. 105

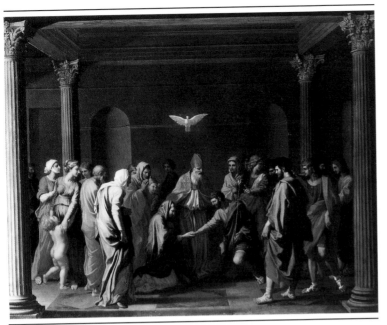

42

Marriage

c. 1638–40

95.5 × 121 cm

His Grace the Duke of Rutland

The subject is the Marriage of the Virgin. Mary and Joseph kneel before an officiating priest, their right hands clasped. In his left hand Joseph holds a flowering rod, which is pointed out by a youth behind him. This is an allusion to Aaron's rod, which flowered again as a symbol of the birth of Christ. Above appears the dove of the Holy Spirit, and surrounding the kneeling couple is a crowd of onlookers. Prominently positioned behind the Virgin are her parents, Joachim and Anna, the former in yellow and the latter in red. The ceremony takes place in a classical atrium decorated with fluted Corinthian columns, blind niches and an elaborately tiled floor. All of these elements enhance the festive nature of the theme and anticipate the even greater use Poussin would make of such architectural elements in his second set of Sacraments. Somewhat anachronistically, the priest is dressed as a bishop, with a cope and mitre, rather than in Jewish vestments. Poussin presumably did this to emphasise the fact that the ceremony taking place was a Christian marriage.

As befits the subject, the picture is one of the most attractive of the Pozzo Sacraments and also one of the best preserved. Though the action itself is essentially static, Poussin enlivens the scene by the criss-crossing diagonals of the figure group, the rhythmically positioned feet of the onlookers and the limpid colouring. Especially notable is the wide range of greens, golds and blues which create such an animated and uplifting impression. No less animated are the stances of the figures. Feet shuffle, necks crane, figures arrive or depart, all of them introducing a note of calculated informality into the proceedings. Moreover, the proportions of the figures are now

tall and slender, in keeping with the surrounding columns – and in marked contrast to those of *Ordination* (cat. 39). These reach an extreme in the old woman in green at the left, who looks as if she has strayed out of a painting by Pontormo, with her willowy pose, tensely furrowed draperies and quizzical expression.

The style of the picture is especially close to that of *Extreme Unction* (cat. 41) in its figure type and compositional devices. Both works also employ the same wide gamut of colours and a deeply recessed architectural setting, which serves as a visual counterpoint to the rhythmic arrangement of the figures.

The strictly symmetrical composition of the present picture is unusual among the first set of Sacraments, though it becomes the rule in those for Chantelou. Poussin may have derived this from such celebrated Renaissance treatments of the theme as Raphael's *Marriage of the Virgin* in the Brera, Milan.

A preliminary study for the painting is at Windsor.[1] It shows the figure group essentially as it appears in the final canvas, but without the architectural setting or the dove.

1. CR I, p. 44, no. 90.

EXHIBITIONS
Edinburgh, 1981, no. 32; Paris, 1994–5, no. 63

ŒUVRE CATALOGUES
Blunt, no. 111, Thuillier, no. 108, Wild, no. 43, Wright, no. 106, Mérot, no. 104

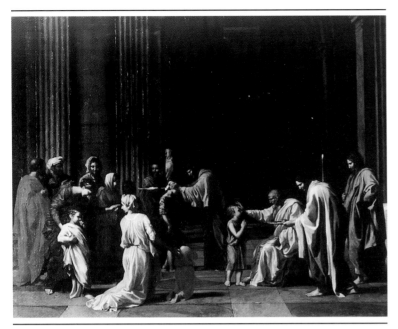

43
Confirmation

c. 1638–40
95.5 × 121 cm

His Grace the Duke of Rutland

There is no textual source for *Confirmation*, which depicts anonymous figures receiving the sacrament in accordance with the practices of the early Christian Church. At the right, a priest anoints the forehead of a young boy with the chrism, and in the centre middle distance another priest binds the head of a youth who has already received the sacrament with a fillet. The ceremony takes place on Easter Eve, as indicated by the lit Paschal candle at the right. This was the time designated by the early Church for the administration of both baptism and confirmation. The setting, however, is not antique but is based on the interior of the church of Sant'Atanasio dei Greci by Giacomo della Porta, which stood opposite Poussin's house in Rome. This anachronism would be corrected in the second version of *Confirmation* (cat. 50), which is set in the Roman catacombs.

The composition is the most intricate of all the Pozzo Sacraments and also one of the most successful. Self-contained figure groups appear carefully positioned on the geometrically patterned floor like pieces on a chessboard. Each of these serves to add narrative variety to the proceedings – the two priests administering the sacrament, the mothers and children patiently awaiting their turn, or the Pharisees at the extreme left, who appear to be doubting the validity of the ceremony. Yet all of these separate areas of interest are harmoniously interwoven with one another through a sequence of extended limbs and carefully directed glances which unify the whole. Even the mysterious figure exiting at the rear assists in tying together both halves of the composition by combining the white draperies of the figures at the right with the more animated

actions of those on the opposite side of the picture. Together with the solid, sculpturesque modelling of the figures, the compositional skills evident in *Confirmation* suggest that it was among the last of the Pozzo Sacraments to be completed.

As has often been noted, the group of the priests and two acolytes at the right would appear to be inspired by Domenichino's altarpiece of the *Last Communion of St Jerome* of 1614 (fig. 106), which, according to both Bellori and Félibien,[1] Poussin regarded as one of the three greatest pictures in Rome. (The other two were Raphael's *Transfiguration* of 1517–20 and Daniele da Volterra's *Deposition* of 1541–5 in SS. Trinità dei Monti.)

A compositional study for the painting (fig. 105) reveals that Poussin introduced a number of major alterations to the design as he went along.[2] In the drawing the heads of the figures appear more vertically spread out across the sheet and the artist shows two youths distractingly turned towards the altar at the right. In the painting this episode is omitted in favour of one which focuses into the scene and the more uniform line of heads adds further to the harmony of the composition. The drawing also shows the rustic figure of an old man leaning on a staff at the left and a rebellious infant next to him, wriggling in its mother's arms, as though fearful of the ceremony. Poussin presumably omitted these from the final canvas on grounds of decorum and historical accuracy; for here it is old age that has its doubts about the sacrament and youth that piously – or bashfully – partakes of it.

The picture is heavily painted and in a generally good state of preservation. Even to the naked eye it is apparent that Poussin indented the lines of the architecture and floor into the paint surface – evidence of the careful attention he devoted to all aspects of the final composition.

1. Bellori, 1672, p. 309; Félibien (ed. 1725), III, 477–8.
2. CR I, p. 43, no. 85.

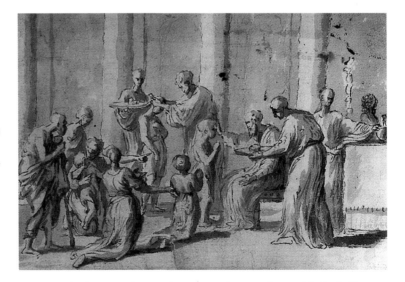

Fig. 105 Nicolas Poussin, *Confirmation*. Bistre wash over black chalk, 13.7 × 20.8 cm. The Royal Collection.

EXHIBITIONS
Paris, 1960, no. 61; Bologna, 1962, no. 69; Edinburgh, 1981, no. 35; Paris, 1994–5, no. 66
ŒUVRE CATALOGUES
Blunt, no. 106, Thuillier, no. 110, Wild, no. 87, Wright, no. 108, Mérot, no. 107

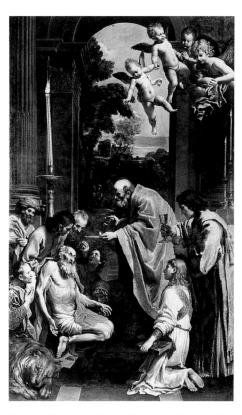

Fig. 106 Domenichino, *The Last Communion of St Jerome.* Oil on canvas, 419 × 256 cm, 1614. Musei Vaticani, Città del Vaticano, Rome

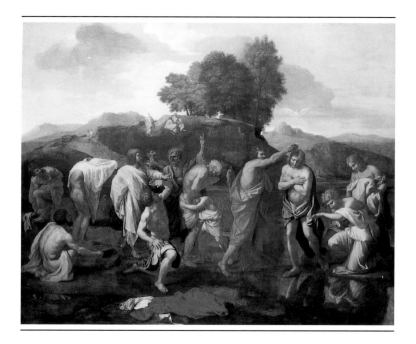

44
Baptism

1640–2
95.5 × 121 cm

National Gallery of Art, Washington
Samuel H. Kress Collection, 1946.7.14

Baptism was the last of the first set of Sacraments to be executed. Poussin took it with him unfinished to Paris in the autumn of 1640 and eventually sent the completed picture to Cassiano in May 1642. In his letters to this patron, the artist frequently apologises for the delays he is experiencing in finishing the picture as a result of the heavy demands made upon him by Louis XIII. He even confesses that he fears Cassiano will not find the work as agreeable as previous members of the series and blames this on the conditions under which it was painted.[1] Poussin was not unjustified in fearing this, for *Baptism* fits uneasily with the rest of the Pozzo Sacraments and bears clear evidence of the labours and distractions under which it was conceived.

 The picture portrays St John baptising Christ on the banks of the river Jordan, an event recounted in all four Gospels. Assisting him at the right are two figures referred to by Poussin in one of his letters as angels,[2] though they do not bear wings. Above Christ appears the dove of the Holy Spirit; to the left, an animated sequence of figures don their garments or disrobe, in preparation for baptism, while others react with fear or astonishment to the appearance of the dove. In the background, an imposing landscape of hills, mountains and trees reinforces the gravity of the theme.

 Several factors contribute to the discordant impression conveyed by this canvas, especially when it is seen in the company of the other Sacraments for Pozzo. One of these is the large scale of the figures, which exceeds that of any other member of the series. Yet another is the cold and waxen choice

of hues. This consists almost entirely of acidic reds, pinks, whites and blues and omits the greens, golds, ochres and paler colours that enhance the visual appeal of, for instance, *Ordination* or *Marriage* (cat. 39, 42). But the picture's most serious weaknesses are compositional and result from the combination of a range of strikingly diversified poses and declamatory gestures which appear only loosely coordinated with one another and lack the rhythmic liaisons between figures evident in *Extreme Unction* or *Confirmation* (cat. 41, 43). Whatever may be the reasons for this, Poussin has here violated one of the cardinal principles of his own art: namely, that of always subordinating the parts to the whole. Small wonder that he subjected his next *Baptism* (cat. 51), for Chantelou, to such a radical revision.

The present canvas is also notable for its large number of quotations from other works of art. The man putting on his stocking and the one pulling off his shirt both derive from Michelangelo's *Cascina* cartoon (fig.108). The angels attending Christ and the figure of the Baptist are loosely based on

Raphael's fresco of the same theme in the Loggia of the Vatican (fig. 107). In themselves, these borrowings may suggest the artist's momentarily flagging inspiration and add to the stilted and academic impression of the whole.

Two compositional drawings are related to the present picture.[3] One, at Chantilly, shows the figure group largely established, though the landscape is barely indicated and the angels still have wings. The second, in Paris, reverses the composition and includes the figure of a kneeling man to the right of the Baptist – an idea Poussin re-employed in the comparable canvas for Chantelou.

1. *Correspondance*, pp. 175–6.
2. *Ibid.*, p. 124.
3. CR I, pp. 40–1, nos. 75–6.

EXHIBITIONS
Edinburgh, 1981, no. 37; Paris, 1994–5, no. 69

ŒUVRE CATALOGUES
Blunt, no. 105, Thuillier, no. 113, Wild, no. 105, Wright, no. 111, Mérot, no. 108

Fig. 107 Raphael, *The Baptism of Christ.* Fresco, 1518–19. Logge, Vatican, Rome

Fig 108 Aristotile da Sangallo (*after* Michelangelo), *The Bathers (The Battle of Cascina).* Oil on panel, grisaille, 76.4 × 130.2 cm, 1542. The Earl of Leicester, Holkham Hall

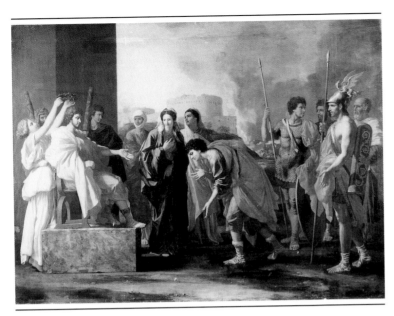

45
The Continence of Scipio

1640

114.5 × 163.5 cm

The Pushkin Museum of Fine Arts, Moscow

During his victory at New Carthage, the Roman general Scipio Africanus the Elder captured a beautiful young maiden who was betrothed to a Celtiberian youth named Allucius. Learning of their love, Scipio summoned the girl's parents and fiancé and restored her to them. As a reward, he requested only that Allucius be a friend to him and the Roman people. Overcome with humility and joy, the youth gave thanks to Scipio, who was then presented with a ransom of gold by the girl's parents. In a further act of generosity, Scipio bestowed these riches on the couple in turn 'as a nuptial gift'. Though this tale is told by Plutarch (*Moralia*, 196B) and Valerius Maximus (IV, 3, 1), the fullest account is in Livy (XXVI, 50), who was most probably Poussin's source.

The present painting shows Allucius paying homage to Scipio, who is seated at the left and being crowned by a young woman, a detail not mentioned by Livy. Between them stands the young man's fiancée, in a demure pose that has often been compared with that of a vestal virgin. At the right, a group of soldiers marvel at Scipio's magnanimity. In the background, the citadel of the town appears engulfed in flames. This motif reminds one of the devastation and brutality of the recently waged war and serves to throw the scene of clemency in the foreground into even sharper relief.

The theme of the present picture recalls the story of Camillus and the Schoolmaster of Falerii, which Poussin painted twice in the late 1630s.[1] In this, the Roman general Camillus punishes a schoolmaster who had offered his pupils as conscripts when the Romans besieged the Etruscan town of Falerii. Both subjects portray acts of generosity performed by noble and virtuous warriors towards their innocent captives. The composition of

the present work is particularly close to the version of *Camillus and the Schoolmaster of Falerii* (fig. 12), which Poussin painted for La Vrillière in 1637. In both, the hero is seated in profile at the left and the remaining figures are arranged in a shallow, frieze-like manner across the foreground of the picture. The architectural details and background landscape also appear very similar in each. Finally, the style of the two works is comparable, with its planar organisation, rhetorically gesturing figures and unadorned composition. It is conceivable that Poussin adopted this unusually plain and severe style in a deliberate attempt to make these subjects from ancient history appear more convincingly antique.

The *Continence of Scipio* was unanimously dated to the mid-1640s until the discovery of a document stating that it was in the collection of Gian Maria Roscioli, secretary and chamberlain to Urban VIII, in 1640.[2] Also inventoried in this collection in the same year were Poussin's landscapes with St Matthew and St John (cat. 46–7) – two works which were likewise traditionally dated to around 1643–5. The revised dating of these three pictures indicates that Poussin's mature classical style was already fully formed before his visit to Paris in 1640. It seems unlikely, however, that any of these works was executed much earlier than 1640, the date assigned to all three of them here. The two landscapes appear more advanced in conception than the first *Ordination* (cat. 39) and the style of the present canvas seems more accomplished than that of the first set of Sacraments. Not only are the figures more solid and statuesque but the design possesses a greater monumentality and, in this respect, anticipates the grander and more heroic style of the second set.

Though the story of the Continence of Scipio is a familiar one in 17th-century art, Poussin's interest in this great stoic hero exceeds that of any of his contemporaries. In addition to making at least two preparatory drawings for the present picture,[3] he made a fine study for the same subject (fig. 109), which is unrelated to the present canvas and datable to the late 1640s.[4] This shows Scipio seated in the centre, with Allucius kneeling before him and the latter's fiancée standing to the right. Behind the general, a winged figure of Fame or Victory crowns him.

Fig. 109 Nicolas Poussin, *The Continence of Scipio*. Pen, brown ink and brown wash, 17.6 × 32.7 cm. Musée Condé, Chantilly

Poussin also executed a number of drawings in the early 1640s on the even more obscure episode of Scipio Africanus and the Pirates[5], an incident recounted by Valerius Maximus (II, 10, 2). When Scipio retired to his villa at Linternum, he was visited by pirates. Thinking they were about to attack him, Scipio prepared to defend himself. But the pirates intended instead to pay homage to the great general and, when presented to him, kneeled down and kissed his hands. This is the moment portrayed in a large drawing from Poussin's studio (fig. 110), which is probably the work on this theme commissioned from the artist by Cardinal Barberini in 1642.[6] Nor is it difficult to see why Poussin was attracted to this episode from Scipio's life. If the theme of the present painting paid tribute to his great generosity, that of the drawings commemorates another of his supreme virtues: humility.

The *Continence of Scipio* was almost certainly the first of Poussin's designs to reach the New World. In 1728 the Scottish painter John Smibert took a copy he had made of this painting to Boston, where he settled until his death in 1751. There it served as one of the 'only teachers' among the Old Masters for aspiring artists in the American colonies.[7]

1. Blunt, nos. 142–3; Mérot, nos. 180–1 (with further bibliography).
2. Barroero, 1979, pp. 69–74.
3. CR V, pp. 94–5, nos. 420 and A 174.
4. CR II, pp. 13–14, no. 125
5. CR II, pp. 14–15, nos. 126–8 and A 32. For CR 127, see also Oxford, 1990–1, no. 44.
6. *Correspondance*, pp. 165f.
7. W. T. Whitley, *Artists and their Friends in England 1700–1799*, I, New York and London, 1928, p. 67.

PROVENANCE
1640, Gian Maria Roscioli; Comte de Morville; by 1741, Robert Walpole collection; purchased by Catherine the Great in 1779; transferred from the Hermitage to the Pushkin Museum in 1927

EXHIBITION
Paris, 1994–5, no. 96

OEUVRE CATALOGUES
Blunt, no. 181, Thuillier, no. 135, Wild, no. 109, Wright, no. 135, Mérot, no. 189

REFERENCES
NP/SM, pp. 128–9

Fig 110 *Studio of* Nicolas Poussin, *Scipio Africanus and the Pirates.* Pen and bistre wash over black chalk, 33.1 × 46.8 cm, 1642. The Royal Collection

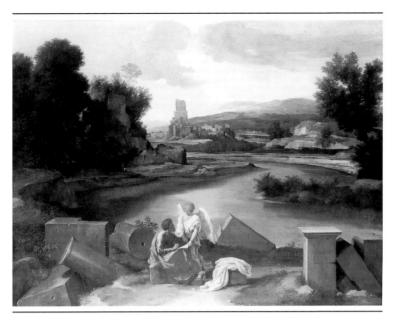

46
Landscape with St Matthew

1640

125 × 155.5 cm

Staatliche Museen zu Berlin, Gemäldegalerie

Landscape figures prominently in many of Poussin's early works, especially the mythologies. Only in the mid-1630s, however, did he turn his attentions to this subject in its own right, though he is recorded as making drawings from nature as early as *c.* 1629–30. Around 1635–6 he executed three small landscapes with anonymous figures travelling or resting in a rural setting of undulating hills and trees which recalls the countryside of the Roman Campagna (cf. fig. 152).[1] In 1637 he received an invitation from Philip IV, King of Spain, to contribute to a series of landscapes featuring anchorites in the wilderness for the Buen Retiro Palace in Madrid – a commission that also included Claude, Gaspard Dughet and others.[2] The resulting *Landscape with St Jerome* (fig. 111) is Poussin's first large-scale work in this form, and remains unique in his career in its detailed naturalism and its proto-Romantic mood of hermetic seclusion. However, its theme of a solitary saint in communion with nature anticipates that of the present picture and its pendant, depicting St John on Patmos, (cat. 47), both of which date from 1640.

The painting portrays St Matthew writing his gospel with the assistance of an angel, his traditional attribute, against a view of the Tiber Valley above the Milvian Bridge and alongside the Acqua Acetosa. In contrast to all of the artist's earlier landscapes, the picture presents a panoramic view, seen from above, and combines architectural forms with elements of the natural world. In this it recalls the *Finding of Moses* (cat. 35) of 1638 and signals a new development in Poussin's landscape art. In the majority of the artist's great series of landscapes of 1648–51 he would likewise choose to contrast the irregular forms of the organic world with the geometric shapes of man's

own devising to enhance the grandeur and austerity of the impression. More than any other feature of Poussin's landscape paintings, this combination of nature and architecture led his works in this form to be characterised as 'heroic'.

Poussin's conception of landscape here owes much to the pioneering achievements of Annibale Carracci, whose *Landscape with the Flight into Egypt* (c. 1604, fig. 112) may be regarded as the archetypal classical landscape painting. In this, Annibale reveals a comparable desire to create a lucid and highly structured landscape framed by trees and crowned by a fortified building in the centre which stabilises the composition and emphasises the group of the Holy Family immediately below it. Poussin employs a similar device in the present painting by aligning the imposing form of the Torre di Quinto in the background with the centrally placed figures which form the focus of the composition. But he departs from Annibale's more naturalistically conceived landscape by framing his figure group with an arbitrary assemblage of architectural remains, whose cubic and cylindrical forms mirror the arrangement of the trees in the middle distance while also adding to the gravity

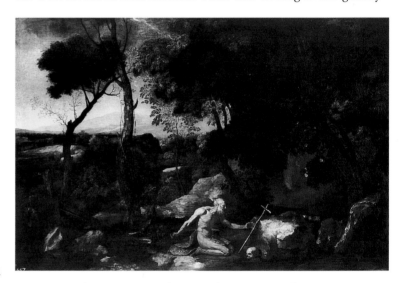

Fig. 111 Nicolas Poussin, *Landscape with St Jerome*. Oil on canvas, 155 × 234 cm, c. 1637. Museo del Prado, Madrid

of the whole. Indeed, so carefully calculated is Poussin's picture that the arrangement of the figures follows the broad course of the river behind them. This flows in a meandering curve from right to left, mirroring the positions of the angel and St Matthew, and exits at the lower right of the composition, echoing the contours of the discarded white drapery immediately below it. An even more covert connection between the figures and their setting is the white reflection on the river, immediately above the angel, which recalls the shape of the latter's wings, establishing a seamless transition between foreground and distance.

Together with its pendant the *St Matthew* is first recorded in October 1640 in the collection of Gian Maria Roscioli, chamberlain and secretary to Pope Urban VIII.[3] It is conceivable that the artist intended these pictures to form part of a series of all four Evangelists in landscape settings which was interrupted

by his visit to Paris in 1640–2 and by Roscioli's untimely death in September 1644.

According to a 19th-century tradition, Poussin was so fond of the stretch of the Tiber Valley depicted in the present picture that it subsequently became known as *La promenade de Poussin*. In this form, it was painted by Corot (fig. 113) in apparent homage to his great predecessor and countryman.[4]

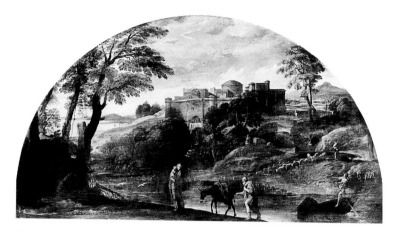

Fig. 112 Annibale Carracci, *The Flight into Egypt*. Oil on canvas, lunette, 122 × 230 cm, *c.* 1604. Galleria Doria-Pamphili, Rome

1. Blunt, nos. 213–15 and Mérot, nos. 233–5 (with further bibliography).
2. On this commission, see especially Blunt, 1959.
3. Barroero, 1979, pp. 69–74.
4. Cf. Alfred Robaut, *L'œuvre de Corot, catalogue raisonné et illustré*, Paris, II, no. 53 (cf. nos. 76, 95).

PROVENANCE
1640, Gian Maria Roscioli (payment 1641); 1671–1812, Barberini collection; Colonna di Sciarra collection; bought from there by the Museum in 1873

EXHIBITIONS
Paris, 1960, no. 66; Bologna, 1962, no. 72; Rome, 1977–8, no. 27; Düsseldorf, 1978, no. 26; Edinburgh, 1990, no. 5; Paris, 1994–5, no. 95

ŒUVRE CATALOGUES
Blunt, no. 87, Thuillier, no. 136, Wild, no. 115, Wright, no. 150, Mérot, no. 215

Fig. 113 J.-B. Camille Corot, *La promenade du Poussin*. Oil on paper, mounted on canvas, 33 × 51 cm, 1826–8. Musée du Louvre, Département des Peintures, Paris

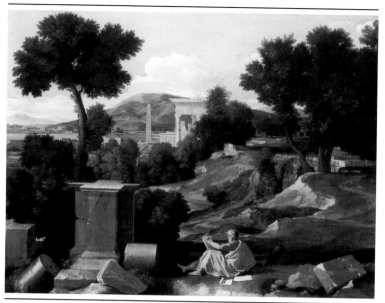

47
Landscape with St John on Patmos
1640
102 × 136 cm

The Art Institute of Chicago
A. A. Munger Collection

The pendant to the previous picture (cat. 46), this painting is first recorded with it in the collection of Gian Maria Roscioli in 1640. The latter also owned Poussin's *Saving of the Infant Pyrrhus* (cat. 27) and *Continence of Scipio* (cat. 45). But whereas he paid 70 *scudi* each for these, the pair of Evangelist landscapes cost him only 40 *scudi*, a revealing indication of the comparatively low esteem with which landscapes were regarded by Poussin's contemporaries. Even in such relatively early works as these, however, the artist imbues the landscape with an authority and nobility comparable to those of his finest history pictures.

The scene depicts St John writing his gospel on the island of Patmos, accompanied by an eagle.[1] The position of the saint indicates that this canvas was intended to hang on the right of the Berlin painting, and the landscape itself suggests that it was painted later. For whereas the *Landscape with St Matthew* portrays an identifiable site, the present work depicts a wholly imaginary setting and is more concentrated and rigorous in composition.

Framing the scene at the foreground left is a solitary tree, its tufted crown silhouetted against the sky. Complementing this at the right is a group of trees in the middle distance, flanking a winding pathway that originates in the centre foreground of the picture. In the distance, a temple and obelisk rise above the seated figure of the saint; and, beyond them, a view of water, mountains and buildings encloses the scene. Thus, the landscape appears bounded and finite in construction and logical in its spatial design, which is articulated through a rhythmically integrated arrangement of trees, buildings and terrain.

Adding further to the overall unity of the composition is the harmonious surface design. This is achieved by repetitions of colour and shape throughout the picture, most notably in the identical greens of the foliage and the geometric accents of the architecture. Even the irregular forms of trees, clouds and mountains are rendered as solid, compact shapes – in short, as natural objects aspiring to the condition of architecture. Characteristically, Poussin also avoids effects of atmospheric perspective in the landscape and preserves the clarity and distinctness of all elements in the picture regardless of their position in space. This serves further to strengthen the decorative unity of the composition and is nowhere more evident than in the rhyming shapes of the temple in the centre of the picture and the architectural remains in the left foreground. The latter in turn mirror the erect pose of the Evangelist, endowing the whole with an unshakeable stability.

The theme of a solitary saint in a landscape is a familiar one among Poussin's predecessors and contemporaries and was frequently treated by both Annibale Carracci and Domenichino, two of the artists he most admired. Yet a glance at the latter's *Landscape with St Jerome* (c. 1610; fig. 114) will immediately reveal the loftier nature of Poussin's ambitions in the present work. Like the French master, Domenichino sets his figure prominently in the foreground of the picture. But unlike Poussin, Domenichino places him before a loosely composed and labyrinthine landscape to which the saint bears no apparent relation. One could easily transpose such a figure to a totally different setting without it appearing to lesser advantage. But the same may not be said of Poussin's Evangelist, whose sweeping pose and pivotal position serve as a formal prelude to the entire composition.

1. Cf. CR V, pp. 58–9, nos. 381–2, for two drawings of eagles' heads attributed to Poussin which may relate to the present picture.

PROVENANCE
1640, Gian Maria Roscioli; 1801, Robit sale, Paris; bought Bryan; 1840, Sir Simon Clarke sale, London; bought Andrew Geddes; 1845, Geddes sale, London (bought in); 1861, Mrs Geddes; 1918, Max Rothschild; 1930, with Fleischmann, Munich; 1930, A. A. Munger, Chicago

EXHIBITIONS
Paris, 1960, no. 68; Rome, 1977–8, no. 28; Düsseldorf, 1978, no. 27; Paris, 1982, no. 91; Paris, 1994–5, no. 94

ŒUVRE CATALOGUES
Blunt, no. 86, Thuillier, no. 137, Wild, no. 114, Wright, no. 151, Mérot, no. 213

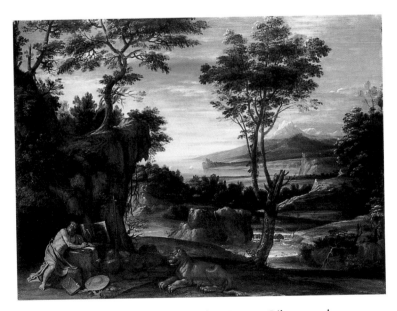

Fig. 114 Domenichino, *Landscape with St Jerome.* Oil on wood, 44 × 59.8 cm, *c.* 1610. Glasgow Museums: Art Gallery and Museum, Kelvingrove

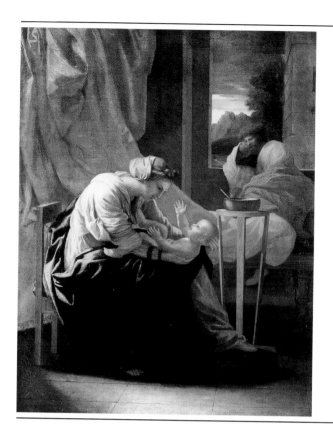

pictures. This permits him to place greater emphasis upon the setting and coincides with his interest in landscape painting during these years. Since the style of these works is itself intensely Raphaelesque, the result may be seen as a synthesis of the central Italian and Venetian traditions, one which combines the ideal figure types of Raphael with the Venetian love of landscape.

The present picture is a transitional work in this development which shows the Virgin and Child in an interior with Joseph asleep in the background, leaning against a window. The scene is conceived in low relief, with the figures aligned parallel to the picture plane, and is completed by the addition of an antique tripod at the right, at the base of which the Virgin rests her foot. Linking the figures is a swathe of peach-coloured drapery, a device reminiscent of certain of the artist's early works on this theme (fig. 75). In its order and economy, however, the composition is characteristic of Poussin's maturity and, in the intimate relationship of mother and child, reveals the increasingly psychological concerns of his later figure paintings.

The colour of the picture is of exceptional refinement, both in the figure group and the distant landscape, which echoes the pinks, blues and creams of the Virgin and Child and adds to the preciosity of the effect. Together with the purity of the design, this delicate colour harmony gives the picture the appearance of an ancient cameo.

Two drawings at Windsor may be related to the composition (cf. fig. 115).[1] Both show the Virgin and Child in the foreground,

48
The Holy Family

1641–2

71 × 55 cm

The Detroit Institute of Arts
Gift of Mr and Mrs A. D. Wilkinson

Due to the large number of commissions required of him by Louis XIII and members of his court, Poussin painted few pictures for private patrons during his stay in Paris in 1640–2. The two documented exceptions to this are the *Baptism* (cat.44) for Pozzo's set of Sacraments and the present painting, which was executed for the Roman art dealer Stefano Roccatagliata in 1641–2 and sent to Italy in May 1642. Though small in size and modest in theme, the present painting reveals Poussin's classicism of these years at its most distilled and uncompromising.

The subject of the Holy Family occupied Poussin throughout his career, though most of his works in this vein were painted in his early years and in the period between 1648 and 1657, when he executed about a dozen works around this theme. In his early Holy Families (cf. fig. 2), Poussin follows the great Venetians – especially Titian and Veronese – in his informal grouping of the figures and his vibrant colour and handling. But whereas the Venetian masters often portray this theme in a spacious natural or architectural setting, Poussin chooses to paint his early Holy Families in an upright format, one associated with the rival art of Raphael. Only at the end of the 1640s does he repeatedly adopt a landscape format for such

Fig. 115 Nicolas Poussin, *The Holy Family*. Pen and bistre wash, 14 × 10.1 cm. The Royal Collection

attended by the infant Baptist, with Joseph standing at the rear, a scheme reminiscent of certain of Raphael's late Holy Families, such as the *Madonna of Francis I* (1518, Louvre, Paris) or the *Madonna della Quercia* (Prado, Madrid) of around the same time. In the final picture, however, Poussin pares the design down to its essentials and omits the narrative 'distraction' of the Baptist in favour of a much more original treatment of the theme.

The immaculate order and handling of this picture acquires added significance – and poignancy – when one recalls that it was created during the most disrupted period of Poussin's life. Exasperated with the conflicting demands made upon his energies by the king and his court, the artist wrote to Cassiano dal Pozzo in May 1642: 'Nothing torments the spirit of men more than thinking of more than one thing at a time'.[2] Seen in this light, the Roccatagliata *Holy Family*, which was dispatched to Rome in this same month, appears to have been a brief and welcome respite for the artist during these unsettled years.

1. CR I, p. 24, nos. 40–1.
2. *Correspondance*, p. 150.

PROVENANCE
1641–2, painted for Stefano Roccatagliata; 1652, bequeathed by him to Carlo Antonio dal Pozzo; his heirs; 1759–61, Le Bailli de Breteuil, Rome; 1771, Robert Ansell sale, London; bought for Lord Melbourne; before 1925, Mr and Mrs Edgar Whitcomb, Detroit; by descent to Mr and Mrs A. D. Wilkinson; 1954, presented by them to the Institute

EXHIBITIONS
Paris, 1960, no. 65; Bologna, 1962, no. 71; Paris, 1994–5, no. 101

ŒUVRE CATALOGUES
Blunt, no. 46, Thuillier, no. 130, Wild, no. 106, Wright, no. 121, Mérot, no. 37

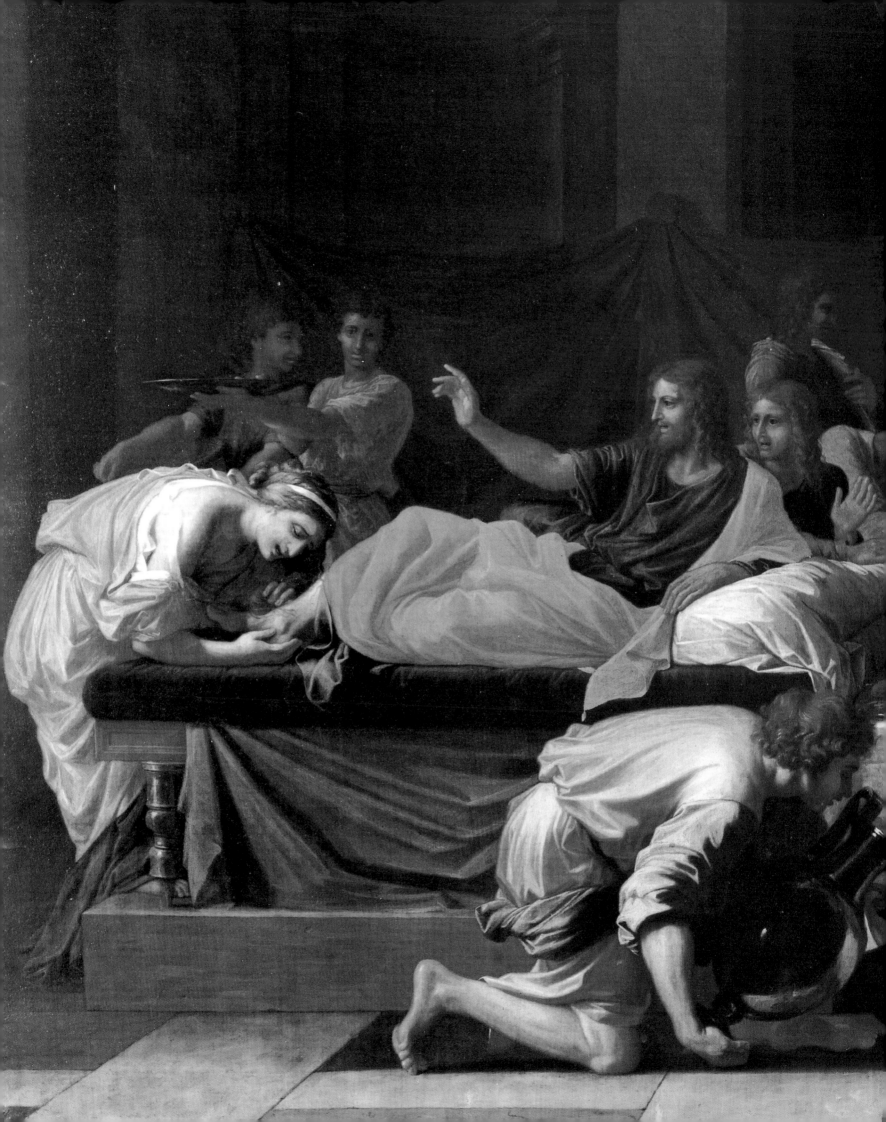

The Second Set of Seven Sacraments

Poussin's second set of Seven Sacraments is the best-documented commission of his career. Painted for Paul Fréart de Chantelou between 1644 and 1648, its history may be traced through the artist's extensive correspondence with his patron during these years. This records the order in which individual works in the series were painted and the length of time devoted to each. It also bears witness to the slow and painful gestation of these pictures, which were among the most demanding ever undertaken by the artist. Further evidence of this is the existence of more than two dozen preparatory drawings for the series. These make it possible to follow the complicated evolution of these pictures and provide a rare insight into the artist's creative methods in his maturity. 'They are my chief concern', confessed Poussin to Chantelou upon embarking on the series in April 1644, 'and into them I will put all my intellect and all the vigour of my talent, such as it is'.[1] True to his words, Poussin painted few other canvases during these years, with the result that – numerically speaking at least – the mid-1640s are among the least productive phases of his career. But the stature of the Chantelou Sacraments outweighs such considerations and qualifies these works to rank among the noblest of all the artist's creations. Painted exactly halfway through Poussin's career, they are both literally and figuratively the central achievement of his art.

The commission originated with Chantelou's desire for a series of copies of the first set of Sacraments made for Cassiano dal Pozzo (cat. 39–44), which he presumably saw when he visited Rome in 1640, to escort Poussin back to Paris. Initially, Pozzo refused this request and offered Chantelou coloured drawings after his pictures instead. Unhappy with this proposal, Chantelou requested Poussin to approach Pozzo again, and the latter apparently relented; for, soon after, Poussin was engaged in negotiations with a number of artists in Rome to make copies after these pictures. These plans came to nothing, however, as a result of Poussin's dissatisfaction with the poor quality of such copyists' work and with their exorbitant prices. In January 1644, the artist offered to make copies of these pictures himself 'or even to do them in another arrangement'. This, he assured Chantelou, 'would be worth more than copies, cost hardly more and take no longer to do'.[2] Since Poussin disliked copying his own works, there can be little doubt as to which proposal he wished Chantelou to take up.

Within two months, the latter had agreed to Poussin painting a wholly new set of Sacraments, an idea which the artist accepted with enthusiasm, promising to set aside his other works for Chantelou and to lavish all his attentions on this commission – 'to do my best'. Somewhat rashly, Poussin also promised his patron to paint two canvases of the series a year; though, in the event, he proceeded much more slowly. In 1644, he completed *Extreme Unction* and, in the following year, *Confirmation*. *Baptism* was painted in 1646, and sketches for *Penance* were also made in this same year. The latter was executed in 1647; thereafter the pace quickened, doubtless because of Chantelou's growing impatience with the artist's slow manner of working. *Ordination* and *Eucharist* were also painted in 1647; and

the series was completed with *Marriage*, which was begun in the winter of that year and finished by March 1648. The only other pictures by the artist datable to these years are the *Crucifixion* (cat. 57), the two versions of *Moses Trampling on Pharoah's Crown* (cat. 56, fig. 129), *Moses Turning Aaron's Rod into a Serpent*,[3] and the *Finding of Moses* (fig. 150) for Pointel.

The themes of the Chantelou Sacraments are identical to those of the earlier set for Pozzo, with Poussin choosing biblical episodes to illustrate five of the sacraments and portraying the other two – extreme unction and confirmation – showing anonymous figures receiving the sacrament in accordance with the practices of the early Christian Church. In all other respects, however, the later set represents a notable advance over the first series and demonstrates Poussin's propensity for revising and improving his ideas. Both the style and content of the Chantelou pictures endow them with a grandeur and unity exceeding those of the Pozzo Sacraments and reveal the artist at his most intensely self-critical. Pozzo himself apparently realised this; for, after he had seen the Chantelou *Exreme Unction* (cat. 49), Poussin wrote to the latter that Pozzo 'would clearly not like it if these pictures were to remain in Rome. But as they will be in your hands and far away from here, he will swallow the pill more cheerfully'.[4]

In keeping with his desire to create a more monumental impression in the second series, Poussin chose a significantly larger canvas size for these pictures. In addition, the figures dominate their surroundings in the later series, with the heads coming just over two-thirds up the picture, whereas the head levels in the Pozzo canvases vary from one scene to the next. Further enhancing the unity of the second set is the fact that all paintings in this series are designed symmetrically, with either the perspective lines of the architecture or the main figure group marking the central axis. Finally, whereas the colour harmonies in the first series differ noticeably from picture to picture, Poussin employs the same highly saturated primary hues to link individual works in the second set. The striking surface unity which results from all of these devices becomes even more remarkable when one recalls that the artist himself never saw the Chantelou series hung together, dispatching the individual canvases to Paris as soon as they were completed. The same may not be said of the set made for Pozzo, which the artist could easily have studied in Rome. Perhaps it was the somewhat disparate impression created by these works that spurred Poussin to attempt another series and to endow it with a superior degree of unity, both of colour and design.

To achieve this, however, Poussin had to make one crucial sacrifice. In the five years during which these pictures were painted he sought wilfully not to modify his style and, creatively speaking, stood still. No other comparable period of his career shows so imperceptible a change or development in the artist's creative aims. Small wonder that, upon completing the Chantelou Sacraments, Poussin suddenly moved forward into the realm of landscape painting, as though eager for a fresh challenge.

Chantelou displayed his set of Seven Sacraments in one room, hanging a curtain in front of each of them, so that they could be viewed separately – a scheme of which Poussin approved, noting that a simultaneous view of these works was 'too much for the eye to take in'.[5] Bernini saw them in Paris in 1665 and admired them deeply, observing to Chantelou: 'You must realise that in these pictures you possess a jewel that you must never part with'.[6] Later on this same visit he compared them favourably with the productions of the contemporary French school, noting that 'in the works of Signor Poussin, there is profundity, and much of antiquity, and of Raphael, of everything indeed that one could desire in painting'.[7]

The comparison with Raphael – so often apt in the case of Poussin – is unusually so here. For, in 1641, Poussin was commissioned by the French king to make a set of Old Testament tapestry designs as pendants to the tapestries of the Acts of the Apostles by Raphael. A year later, he was requested to make a series of drawings of the Seven Sacraments for a set of tapestries. Nothing apparently came of either of these schemes, until the Chantelou Sacraments. Repeatedly led to think of his own art in terms of that of his great predecessor, Poussin rose to this challenge and created works comparable in style and nobility to Raphael's Acts of the Apostles.

The Chantelou Sacraments are painted over a deep red-brown priming colour, a common feature of Poussin's mature pictures. Although the condition of these works is generally good, certain of the colours in them – white, blue, yellow and vermilion – appear exaggeratedly prominent against this dark background, while other, secondary hues merge into it. This is a familiar phenomenon in 17th-century pictures painted over a dark ground and accounts for the somewhat discordant colour balance apparent in these works.

1. *Correspondance*, p. 261.
2. *Ibid.*, p. 245.
3. Blunt, no. 19 and Mérot, no. 16 (with further bibliography).
4. *Correspondance*, p. 268.
5. *Ibid.*, p. 384.
6. Chantelou (ed. 1985), p. 80.
7. *Ibid.*, p. 181.

PROVENANCE
Pained for Paul Fréart de Chantelou between 1644 and 1648; his nephew Roland Fréart; the latter's nephews, the brothers Favry; by 1714, Jacques Meyers, Rotterdam; 1716, bought by the Duc d'Orléans; 1798, sale, Bryan's Gallery, London; reserved for the Duke of Bridgewater; by descent to the present owner; on loan to the National Gallery of Scotland since 1946

REFERENCES
The history and progress of the commission is recounted in detail in Poussin's *Correspondance*; for the relevant page references, see Blunt, pp. 76–9, nos. 112–18

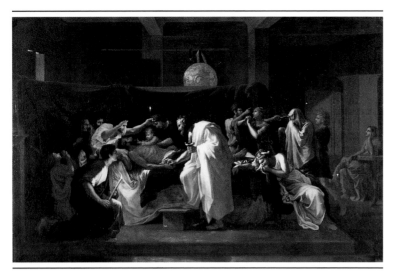

49
Extreme Unction

1644

117 × 178 cm

His Grace the Duke of Sutherland
(On loan to the National Gallery of Scotland, Edinburgh)

Poussin embarked upon his second set of Seven Sacraments with a representation of the last sacrament of the Church, extreme unction, which he began by April 1644 and completed by October of that year. This may be because he realised that the design of this picture would cause him the least trouble and that it was bound to make a favourable impression upon Chantelou. Not only is it similar to the comparable picture for Pozzo (cat. 41), but it is also reminiscent of one of the most celebrated canvases of Poussin's early years, the *Death of Germanicus* (cat. 9).

The scene portrays a dying Christian soldier receiving the sacrament, surrounded by mourners. In a letter to his patron of 25 April 1644, Poussin describes this subject as 'worthy of Apelles (for it pleased him much to represent scenes of death)'[1] – proof, if it were needed, that he was seeking to emulate the legendary masters of ancient art in these pictures. Poussin continues by observing that the canvas 'will contain figures of men, of women, of children young and old, some overcome with weeping, and others praying to God for the dying man.' From a description of the picture provided by Bellori, however, it is apparent that many of the figures are intended to bear a specific relationship to the dying man, in the manner of the earlier *Extreme Unction*.[2]

Standing in the shadows at the background left are the dying man's mother and father, the former wiping tears from her eyes in a moderated expression of deep grief. In front of them, dressed in red, is his brother, holding up a candle to assist the priest with a gesture that conveys his own vehement sorrow. Next to him, a young boy unaware of the meaning of death stands on tiptoes to catch sight of his father, as though more curious than concerned. Behind him, a daughter of the dying

man kneels and prays. Surrounding the hero are a kneeling acolyte holding a book and candle and the officiating priest, who anoints the dying man's palm. Behind appears his wife holding an infant, who reaches out to embrace its father. The scene is completed at the right by the figures of a doctor and his servant, two weeping women, and the hero's eldest daughter, mourning at the foot of the bed. Seated at the extreme right is the figure of a nurse, fatigued from the long vigil, with whom the scene fades away *pianissimo*.

Though many of these figures appear in the first *Extreme Unction*, they are strung out across the canvas of the early picture in a manner that lacks the gravity and concentration of the present work. Adding to the solemnity of the latter are the glowing colour accents and selective lighting, provided by two candles and an open door at the left. These serve to create an atmosphere both dramatic and funereal.

Poussin employs other devices to enhance the intensity and meaning of the Chantelou picture. One of these is the greater emotional engagement of the figures in the action. This may be seen if one compares the mourning figures at the foot of the bed in both canvases. Whereas the female figure in the Pozzo picture is posed in an expression of subdued sorrow, her counterpart in the present work has collapsed in an attitude of inconsolable grief. Similarly, the lively servant girl exiting at the right of the early picture has been replaced by the lamenting nurse; and the priest anoints the hand, rather than the eyes, of the dying man. This change permits the artist to introduce the moving episode of the dying man's wife and child and is in keeping with the greater humanity of the later version. Finally, a shield, inscribed with a monogram of Christ, replaces the blind niche of the Pozzo canvas. Although both devices mark the central axis of the picture, it is characteristic of the more meditative approach of Poussin in the Chantelou Sacraments that this motif now serves both a formal *and* an iconographical

Fig. 116 Nicolas Poussin, *Extreme Unction.* Pen and bistre wash, 21.7 × 33.1 cm. Musée du Louvre, Cabinet des Dessins, Paris

function, informing us that the protagonist was a Christian warrior.

Studies for the weeping woman at the right and the youth with a candle appear on a drawing in the Gabinetto Nazionale, Rome.[3] A compositional drawing for the whole picture is also in the Louvre (fig. 116).[4] Further drawings for the theme, unconnected with the present picture, were published by Blunt in 1979.[5]

Like Poussin's other heroic deathbed scenes, the *Germanicus*, first *Extreme Unction* and *Eudamidas* (cat. 58), the composition enjoyed great popularity with later artists, beginning with Jean Jouvenet, whose histrionic treatment of the same theme of 1685–90 (Louvre) contains unmistakable echoes of Poussin's design. Two copies of the picture by Degas also survive, both made from engravings.[6] Fittingly, the composition was also re-employed by François-Marius Granet in his *Death of Poussin* (fig. 117) of 1834, which recreates that fateful moment on 19 November 1665 when the artist himself received the last rites of the church, mourned by his friends and relations.

The most moving tribute to Poussin's picture was that of Bernini, when visiting Chantelou's collection in July 1665:

> He looked at it standing for a while, and then got onto his knees to see it better, changing his glasses from time to time and showing his amazement without saying anything. At last he got up and said that its effect on him was like that of a great sermon, to which one listens with the deepest attention and goes away in silence while enjoying the inner experience.[7]

1. *Correspondance*, p. 266. The reference to Apelles derives from Pliny, *Historia Naturalis*, XXXV, 90.
2. Bellori, 1672, pp. 432–5.
3. CR V, p. 90, no. 415.
4. CR I, p. 49, no. 103.
5. Blunt, 1979 (²), pp. 124–9; pls 4 and 5. Cf. CR I, p. 49, nos. 102 and A 22.
6. Theodore Reff, 'Degas's copies of older art', *The Burlington Magazine*, CV, 1963, p. 246.
7. Chantelou (ed. 1985), p. 79.

EXHIBITIONS
Paris, 1960, no. 69; Edinburgh, 1981, no. 40; Paris, 1994–5, no. 107

ŒUVRE CATALOGUES
Blunt, no. 116, Thuillier, no. 140, Wild, no. 121, Wright, no. 124, Mérot, no. 109

REFERENCES
Bellori, 1672, pp. 432–5; Félibien (ed. 1725), IV, pp. 53–4, 116–17, 146

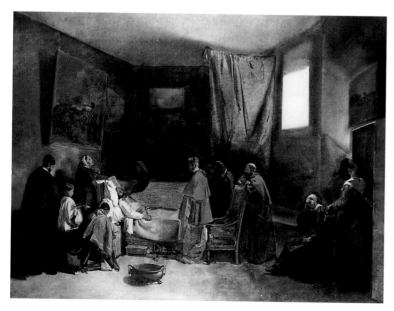

Fig. 117 François-Marius Granet, *The Death of Poussin*. Oil on canvas, 1834. Musée Granet, Palais de Malte, Aix-en-Provence

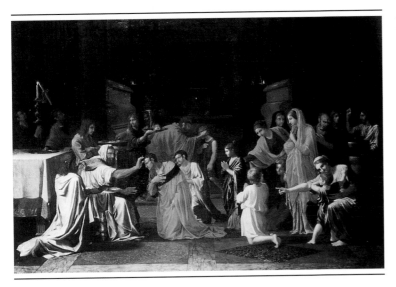

50
Confirmation

1645
117 × 178 cm

His Grace the Duke of Sutherland
(On loan to the National Gallery of Scotland, Edinburgh)

The second member of the Chantelou Sacraments to be completed was *Confirmation*, which was begun before April 1645 and finished in December of the same year. When compared with Poussin's first version of this theme (cat. 43), this is one of the most radically revised – and rigorously designed – of the entire series. No fewer than five preparatory drawings survive for the picture, tracing his progress from the solution of the Pozzo picture to that of the canvas for Chantelou. As a further testimony to the effort expended on this picture, Poussin wrote to his patron in August 1645:

> ...if I am able to finish your picture of Confirmation and send it to you by the end of the year, I shall think I have done well. It contains twenty-four complete figures, to say nothing of the architectural background, and is such that no less than five or six months will be needed to finish it properly; moreover, Sir, when you come to consider it, these are not things that one may do a-whistling, like your painters of Paris, who amuse themselves by dispatching a picture in twenty-four hours. If I complete a head in a day, and give it its proper effects, I feel I have done a good day's work.[1]

The scene is set in the Roman catacombs, the traditional place for administering baptism and confirmation in early Christian times. In the background centre is a large baptismal font; immediately above it, the body of a dead man appears laid out for burial. Further reflecting the practices of the early Christian Church, Poussin sets the scene on Easter Eve, signalled by the lighting of the Paschal candle at the left. On the far right, figures entering the room are sprinkled with hyssop, an ancient Hebrew custom taken over by the early Christians. Finally, as befits the origins of the sacrament itself, Poussin shows figures

of all ages being confirmed, though he tellingly indicates that belief increases with age. As one moves from the foreground right to the centre of the canvas, one goes from childhood to maturity – and from diffidence to devotion.

The solemn and measured procession of figures that converges upon the seated priest at the left of Poussin's picture possesses the clarity and intricacy of a three-part fugue by Bach. Intervals opened up in one group are filled by figures in another, until all three strands of figures are united in the centre in a triangular grouping that has its base in the foreground and its apex in the distance, where a priest binds the head of a youth who has just been confirmed with a fillet.

This seamless progression from onlookers to participants is not apparent in the Pozzo *Confirmation*, which is broadly divided into two groups, one consisting of the officiating priest and his assistants and the other of figures awaiting confirmation. Poussin also dispenses with other features of the early version in the present picture. Among these are the anachronistic architectural setting, the Pharisees disputing the sacrament and the inclusion of children alone preparing to be confirmed.

Fig. 118 Nicolas Poussin, *Confirmation*. Pen with light bistre wash, 18.2 × 25.6 cm. The Royal Collection

Fig. 119 Nicolas Poussin, *Confirmation*. Pen with bistre wash, 12.1 × 24.5 cm. Musée du Louvre, Cabinet des Dessins, Paris

The surviving drawings for this picture take as their starting point the scheme of the Pozzo *Confirmation*, though in reverse.[2] In the earliest of them (fig. 118), two groups of small-scale figures are placed in an architectural setting of columns and arches reminiscent of the earlier canvas, a motif that suggests Poussin had not yet decided upon the symmetrical arrangement of the architecture when he drew this sheet. To the left, figures administer and receive the sacrament and, at the right, others observe the scene. Separating them from the principal group is a gap which divides the composition rather awkwardly in two.

In two further studies in the Louvre (cf. fig. 119) this gap is filled by a diagonal alignment of figures which moves from the kneeling mother at the lower right to the youth being bound with a fillet in the centre background. Complementing this on the opposite side is a similar arrangement of figures which progresses from the kneeling server in the foreground through the seated priest to converge also upon the youth with the fillet.

This arrangement was apparently too static and symmetrical for Poussin, who proceeded to introduce figures that connected both halves of the composition. These appear in another drawing (fig. 120), which includes the additional figures of a kneeling young girl and boy in the centre, positioned between the two groups, as though moving from one to the next. Though these figures form part of the procession awaiting confirmation, they are linked with the onlookers through the extended arm of the girl's mother and the backward glance of the young boy. With his body facing in one direction and his head in the other, this figure serves as a lively counterpoint to the action, while also filling the space between the two groups present in all the previous drawings.

Poussin struggled so hard to invent this figure that it may seem impertinent to reveal that he had already invented it once before. The youth in the Chantelou picture performs the same function as the kneeling mother at the left of the Pozzo *Confirmation*, whose striking pose the artist had apparently 'forgotten' in his attempts to devise a new composition. In the end, however, even Poussin could not improve upon this idea.

Finally, a drawing at Windsor, which is squared for transfer, shows the figures arranged as in the painting and the architectural setting fully established.

1. *Correspondance*, p. 317.
2. CR I, pp. 43–4, nos. 86–9 and A 20, for all the drawings connected with this picture. A 20 is now accepted as an original. Further to CR 86 and A 20, see Oxford, 1990–1, nos. 46–7.

EXHIBITIONS
Paris, 1960, no. 70; Edinburgh, 1981, no. 41; Paris, 1994–5, no. 108

ŒUVRE CATALOGUES
Blunt, no. 113, Thuillier, no. 141, Wild, no. 125, Wright, no. 125, Mérot, no. 110

Fig. 120 Nicolas Poussin, *Confirmation.* Pen and heavy bistre wash, 9.5 × 25.3 cm. Musée du Louvre, Cabinet des Dessins, Paris

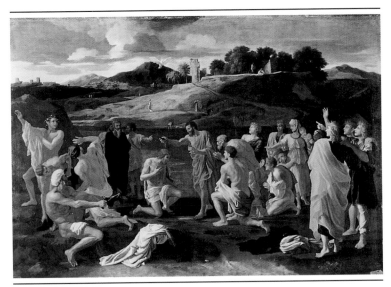

51
Baptism

1646
117 × 178 cm

His Grace the Duke of Sutherland
(On loan to the National Gallery of Scotland, Edinburgh)

The earliest of the Chantelou Sacraments to treat a biblical theme, *Baptism* is first mentioned by Poussin in a letter to his patron of 4 February 1646 and was finished by November 1646. Upon its arrival in Paris early the next year, it met with a mixed reception and was apparently considered too mild compared with its predecessors – a criticism that led Poussin to reply to Chantelou: 'I am not one of those who when singing always choose the same tune, I know how to vary it if I wish'.[1] Chantelou's disappointment with the picture may have been prompted by its idyllic landscape background, so different from the austere architectural settings of *Extreme Unction* and *Confirmation*. But Poussin was surely right not to have chosen 'the same tune', for the theme itself was very different.

Like the comparable canvas for Pozzo (cat. 44), the picture depicts St John baptising Christ on the banks of the River Jordan. To either side of the main figures appear two groups engaged in clearly defined reactions to the event. At the right foreground three youths register wonderment and delight at the appearance of the dove of the Holy Spirit directly above Christ. Behind them a group of figures of differing ages prepares to receive the sacrament. Prominent among these is the bowed form of a devout old man supported by two youths. To the immediate left of Christ a group of Pharisees ponder or argue over the proceedings; while, in the foreground left, four men who have already been baptised dress themselves. One of these, pulling on his stocking, derives from Michelangelo's *Cascina* cartoon (fig. 108) and appears in the same position in the *Baptism* for Pozzo.

The scene is set against a landscape of gently undulating hills which mirror the broad motions and divisions of the figure group. At the right it appears largely horizontal, like the row of heads below it, while at the left the criss-crossing diagonals of a range of hills surmounted by clouds echo the more animated poses of the male figures donning their garments. Further tying the figures to their setting are the shadows on the hills in the middle distance, which lead unobtrusively to Christ and the Baptist. Architectural elements on the distant riverbank likewise appear immediately above the Baptist and subtly draw attention to him.

The composition bears little in common with the Pozzo *Baptism*, which is asymmetrical in design and more weakly coordinated in construction. Poussin also omits the supernatural figures of the angels included in the earlier picture and now portrays Christ kneeling to receive the sacrament, an eloquent pose that stresses his humility while also avoiding the awkward, straining gesture of the Baptist in the earlier picture. Even more revealing is the transformation of the bent old man, who is depicted as fearful in the Pozzo canvas and reverential in the present work. Through such seemingly minor adjustments as these, Poussin enhances the solemnity and meaning of the

Fig. 121 Nicolas Poussin, *Baptism*. Pen and bistre wash, 16.4 × 25.5 cm. The Hermitage Museum, St Petersburg

Fig. 122 Nicolas Poussin, *Baptism*. Pen and bistre wash, 15.7 × 25.6 cm. Musée du Louvre, Cabinet des Dessins, Paris

second set of Sacraments.

If the present picture owes little to the earlier *Baptism*, it does recall the *St John Baptising the People* (cat. 32) of 1636–7 in its basic disposition, individual figure groups and prevailing harmony of narrative and design. The existence of eight preparatory drawings for the present picture indicates, however, that this can only have been a subconscious reminiscence on Poussin's part and that the lucid organisation of the Chantelou *Baptism* was the result of stringent effort.[2]

In the earliest drawing for the picture (fig. 121), the group is set before a landscape that towers distractingly over them. Though the disposition of the figures follows the basic arrangement of the finished picture, Christ and the Baptist are shown standing, the group of the old man with two youths appears at the left, and the man pulling on his stocking faces out of the composition – an almost perverse attempt on Poussin's part to avoid repeating the pose of the *St John Baptising the People* or the Pozzo *Baptism*.

In a later study in the Louvre (fig. 122), the group with the old man has been moved to the right and Christ is shown

Fig. 123 Nicolas Poussin, *Baptism.* Pen and heavy bistre wash over black chalk, 16.2 × 25.3 cm. Musée du Louvre, Cabinet des Dessins, Paris

partially kneeling, but the man with the stocking appears unchanged and the landscape still too dominant. Most surprising of all is the inclusion of the figure of a man at the right shaking his fists in the air at the appearance of the dove. Poussin retained this motif in two other drawings (CR 79 and 80) before suppressing it, a revealing indication of the passionate conviction with which he approached his subjects and of the effort of will he exercised to constrain it.

The final drawing for the painting (fig. 123) shows the man donning his stocking at last turned inwards, framing the scene, and the landscape reduced to a harmonious backdrop to the figures. Christ has now been brought fully to his knees and the scene appears pervaded by a ghostly silence that penetrates to the essence of the theme.

The bold and near-abstract play of light and shade in these

drawings, created by heavy areas of wash applied against the white of the paper, reveals the extent to which Poussin was seeking an overall unity of figures and setting in such works. This is evident in the final picture both in the compositional devices mentioned earlier and in the rhythmically arranged areas of strong local colour. Poussin's colour also serves a narrative purpose in the picture, one instance of which may be cited here. In contrast to the Pozzo *Baptism*, Christ is dressed in a white loincloth in the present canvas – a motif that probably alludes to his eventual sacrifice. To counterbalance this the artist includes a lively and brightly coloured passage of drapery in the centre foreground. This serves as a kind of naturalistic pedestal for Christ and immediately emphasises him.

The epic treatment accorded to this theme in the present picture may be compared with the more introspective and intensely spiritual mood of Poussin's last *Baptism* (cat. 85).

1. *Correspondance*, p. 352.
2. CR I, pp. 41–2, nos. 77–83; V, p. 88, no. 412 (for all of the drawings connected with the presenting painting).

EXHIBITIONS
Paris, 1960, no. 71; Edinburgh, 1981, no. 47; Paris, 1994–5, no. 109

ŒUVRE CATALOGUES
Blunt, no. 112, Thuillier, no. 142, Wild, no. 130, Wright, no. 126, Mérot, no. 111

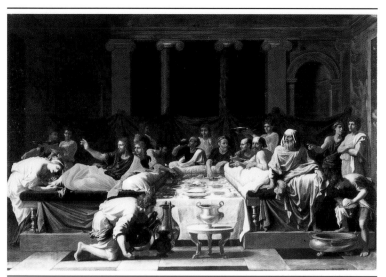

52

Penance

1647

117 × 178 cm

His Grace the Duke of Sutherland
(On loan to the National Gallery of Scotland, Edinburgh)

Poussin chose to illustrate the sacrament of penance with the story of Christ at the feast in the house of Simon (Luke VII, 36–50):

> And, behold, a woman in the city, which was a sinner, when she knew that Jesus sat at meat in the Pharisee's house, brought an alabaster box of ointment.
> And stood at his feet behind him weeping, and began to wash his feet with tears, and did wipe them with the hairs of her head, and kissed his feet, and anointed them with the ointment.

Rebuked by Simon for receiving this guest, Christ admonishes his host and blesses the woman, forgiving her sins. Though not named in the Bible, the repentant sinner is traditionally identified as Mary Magdalene.

Poussin portrays the dinner guests reclining on couches, in the ancient Roman manner, an archaeological detail he incorporated into his paintings of *Penance* and *Eucharist* in both sets of Sacraments. Before them rests a magnificent array of food and precious vessels – the most elaborate still-life ever devised by the artist. At the left Christ blesses the Magdalene, who is wiping his feet with her hair; while, at the right, Simon gazes incredulously on. The scene is completed by an animated gathering of servants and guests, some of whom react with wonder and astonishment at Christ's clemency while others remain oblivious to it.

The composition is one of the most festive of the Chantelou Sacraments, with its lively architectural background, decorative curtain and gesticulating figures. Although the setting is symmetrical, Poussin creates a more solemn and dignified impression behind Christ by darkening the niche at the left of the picture.

Poussin also introduces an unusual note of irony into the scene through the rhyming poses and actions of certain of the figures. Like Christ, Simon is also shown having his feet washed, but by a dutiful servant rather than a devoted and repentant sinner. In addition, the abject figure of the Magdalene is mirrored in a similarly posed serving boy in the foreground of the picture. The tense and furrowed folds of his yellow drapery echo those of the Magdalene herself and reveal Poussin's draughtsmanship at its most incisive. But the action of this youth contrasts strikingly with that of the penitent Magdalene. Engaged in pouring wine, he performs a purely menial task that could hardly be further removed from her love for Christ.

Though the *Penance* from the first set of Sacraments perished in a fire in 1816, the design of this picture survives through engravings and painted copies (cf. fig. 101). The composition of this work is similar to that of the present painting, though the event is set outdoors, in the manner of a feasting scene by Paolo Veronese. In addition, Simon merely reclines among the guests at the right of the design rather than actively confronting Christ and making possible the two contrasting scenes of foot-washing. In keeping with the less focused and dramatic nature of the scene, the earlier picture is enlivened by the comings and goings of a larger number of serving youths, whose domestic duties threaten to usurp attention from Christ. In the Chantelou picture, however, they discreetly stress the significance of his action through their poses or the direction of their gaze.

Although Poussin announced his intention of beginning this picture in a letter to Chantelou of 30 May 1644, he apparently abandoned this plan until early 1646, when he noted that he was at work on sketches for the composition. The canvas itself was begun by 4 February 1647 and completed five months later, by 3 July.

Four drawings survive for the picture,[1] among them a sheet of

Fig. 124 Nicolas Poussin, *Detail Studies for Eucharist and Penance.* Pen, 18.4 × 25.4 cm. Musée du Louvre, Cabinet des Dessins, Paris

studies for certain of the dinner guests (fig. 124), all of them expressively characterised and ranging from the guileful to the sinister. In addition, a magnificent compositional drawing for the whole picture exists at Montpellier (fig. 125). It shows the figures undraped, a practice often followed by artists of the Renaissance and subsequently employed by Poussin in a drawing for *Eucharist* (fig. 128).

The composition of the present picture enjoyed considerable popularity among Poussin's contemporaries and successors, perhaps because of its clear reminiscences of the great Venetian feasting scenes of the 16th century. Versions of the *Feast in the House of Simon* by Charles Le Brun (c. 1653; Accademia, Venice), Philippe de Champaigne (c. 1656; Louvre) and Pierre Subleyras (1737; Louvre) all contain distinct echoes of the Chantelou *Penance*.

1. CR I, p. 47, no. 99, and pp. 48–9, no. 101; V, p. 73, no. 391; and Blunt, 1974, p. 241, and pl. 8a.

EXHIBITIONS
Paris, 1960, no. 72; Edinburgh, 1981, no. 52; Paris, 1994–5, no. 110

ŒUVRE CATALOGUES
Blunt, no. 115, Thuillier, no. 143, Wild, no. 131, Wright, no. 127, Mérot, no. 112

Fig. 125 Nicolas Poussin, *Penance*. Pen and bistre wash, squared, 20.7 × 31.8 cm. Musée Fabre, Montpellier

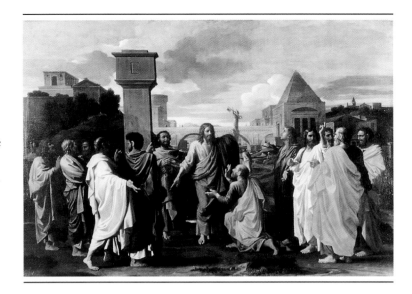

53
Ordination

1647

117 x 178 cm

His Grace the Duke of Sutherland
(On loan to the National Gallery of Scotland, Edinburgh)

The subject is the same as the *Ordination* for Pozzo (cat. 39). Christ presents Peter with the keys of heaven and earth, surrounded by the Apostles (Matthew XVI, 16–20). While the earlier version depicted this scene taking place in a rural landscape, the present picture portrays it before an architectural background, presumably intended to represent the walls and gates of the city of Jerusalem. This imposing setting appears to have been an afterthought on Poussin's part. Both the tower at the left and the buildings on the right are painted over the landscape, which now shows through them.

The mysterious letter E inscribed on the tower may stand for Ecclesia – a reference to the theme of the painting, the foundation of the Christian Church. As Blunt observed, however, it may also refer to the letter E that Plutarch describes above the sanctuary at Delphi.[1] This was perhaps intended to signify the Greek word ει, or 'thou art', which Plutarch assumed to be addressed to Apollo, who was worshipped at this shrine. These words also apply to the theme of the present painting – 'Thou art Peter . . . and upon this rock I will build my church' – and may have been introduced by Poussin to draw a parallel between the mysteries of Greek religion and those of Christianity.

The composition shows a notable advance over the first *Ordination*. Whereas the latter was heavily dependent upon Raphael's tapestry cartoon *Feed my Sheep* (fig. 102), the present picture is at once more original in conception and more profoundly evocative of the gravity and monumentality of Raphael's art. Christ and St Peter appear in the centre of the picture, flanked by two groups of Apostles, whose lively gestures and expressions replace the more passive and

devotional poses of the Pozzo *Ordination* and engage them actively in the event. In keeping with this more explicit approach to the subject, Christ now holds a key in each of his hands, one pointing to earth and the other to heaven. Blunt has noted that the symmetrical arrangement of these figures, seen before the city walls, conforms to that of a number of early Christian sarcophagi that depict Christ and his Apostles in front of the gates of Jerusalem, including one that was in the Borghese collection in Poussin's lifetime (fig. 126) and could readily have been known to him.[2]

The theme of the present picture placed unusual constraints upon Poussin. Unlike the previous four Sacraments, the subject involves only Christ and his disciples and does not allow for the introduction of women or children, nor even for much variety of pose. Moreover, the action itself is essentially static and lacks the drama of *Eucharist* (cat. 54), which includes the same cast of characters – and which the artist was to paint next. To overcome these limitations, Poussin introduces the striking architectural setting, which complements the rural landscape background of the *Baptism* (cat. 51) for Chantelou. Further enlivening the scene are the bold and diverse hues of the Apostles' garments, which span the gamut of Poussin's palette in his maturity and contrast with the more delicate and blended tints of the comparable picture for Pozzo. Together with the large-scale and emphatic gestures of the figures, these make the Chantelou *Ordination* among the most austere of the second set of Sacraments.

Five drawings survive for the present picture.[3] Two of these, in the Louvre, show Christ at the extreme right and his Apostles lining the foreground of the composition, in the manner of the Pozzo *Ordination*. In one of these, Christ hands Peter the keys and, in the other, a scroll. Both feature a background of buildings and hills and, together with a fragmentary drawing in Amsterdam (CR 97), would appear to mark a transitional stage between the first and second versions of this theme. In two later studies, at New York (fig. 127) and Windsor, the figure group follows that of the present picture, though the landscape is entirely different, with a spacious vista of mountains and hills and fewer buildings.

Ordination was begun by 3 June 1647 and completed, with unusual speed for Poussin, by 19 August 1647. On its arrival in Paris, it apparently failed to please Chantelou, who compared it unfavourably with the *Finding of Moses* (fig. 150) that Poussin painted in the same year for Pointel. This prompted the artist to write his famous letter on the modes in November 1647, in which he observed to Chantelou that, as the themes of the two works were very different, he had treated them accordingly. Though Poussin does not enumerate the differences in the case of these two paintings it is evident even in reproduction that the light-hearted theme of the *Moses*, with its prevailingly female cast of characters, elicited a softer and more seductive treatment from the artist than the present picture, with its stern and doctrinaire subject and exclusively male figures.

Seurat made two partial copies after an engraving of this picture in his apprenticeship, between 1875 and 1880.[4]

1. Blunt, 1967, text vol., pp. 195–205.
2. *Ibid.*, pp. 196–7. (Cf. pp. 204–5 for suggested sources for the architectural monuments that appear in the background of the present picture.)
3. CR I, pp. 45–7, nos. 95–8 and A 21.
4. C. M. de Hauke, *Seurat et son oeuvre*, II, Paris, 1961, nos. 224–5.

EXHIBITIONS
Paris, 1960, no. 73; Edinburgh, 1981, no. 53; Paris, 1994–5, no. 111.

ŒUVRE CATALOGUES
Blunt, no. 117, Thuillier, no. 144, Wild, no. 133, Wright, no. 128, Mérot, no. 113

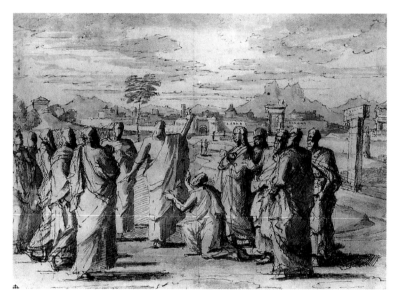

Fig. 127 Nicolas Poussin, *Ordination.* Pen and bistre wash, 18.7 × 25.5 cm. The Pierpont Morgan Library, New York

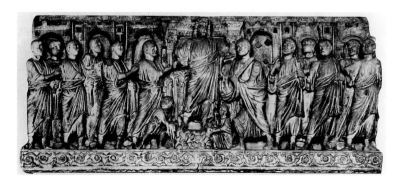

Fig. 126 *Christ and the Twelve Apostles.* Early Christian Sarcophagus. Musée du Louvre, Paris

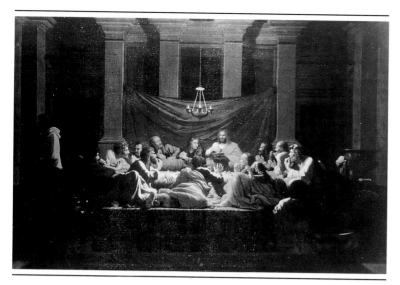

54
Eucharist

1647

117 × 178 cm

His Grace the Duke of Sutherland
(On loan to the National Gallery of Scotland, Edinburgh)

Eucharist is the most solemn and mysterious of the second set of Sacraments, and arguably the most moving. Poussin painted it even more quickly than *Ordination* (cat. 53), beginning the work by 1 September 1647 and completing it by 3 November of that year. After Chantelou's disappointment with the previous picture, the artist was relieved to discover that he approved of this member of the series and wrote to his patron on 12 January 1648 noting that his appreciation was a 'great consolation' to him.[1]

The theme is the Last Supper. Christ and his Apostles recline on couches against the most severe architectural background in the Chantelou set of Sacraments. Christ has just blessed the bread and placed it in the hands of his disciples, who proceed to eat. Blessing the chalice, he appears about to utter the words: 'This is my blood . . . which is shed for many for the remission of sins.' Poussin further encapsulates the theme by depicting both Peter and John recoiling to the left of Christ. In their expressions of horror and grief they appear to be reacting to Christ's announcement that he will be betrayed. At the far left, Judas exits carrying the sop that Christ had given him. In the foreground, a laver, pot and cloth recall Christ's washing of the disciples' feet immediately before the supper. The scene is lit by a candelabrum which casts a pool of light over the huddled figures and enhances the drama and intimacy of the moment.

Unlike all of the other Sacraments, *Eucharist* is not arranged for the benefit of the viewer, with the figures fanning out across the space to solicit our gaze. Instead, the artist turns the figure group in upon itself, in order to emphasise the private nature of the occasion. In addition, the figures occupy a smaller portion of the canvas than in any other member of the series. This intensifies the introspective mood and deep spirituality of the scene.

The most remarkable feature of the Chantelou *Eucharist* is its independence of Leonardo's *Last Supper* of 1495–7. As the canonical solution to the subject, Leonardo's fresco had haunted (and constrained) the imaginations of generations of artists portraying the Last Supper or the Supper at Emmaus, from Pontormo to Titian and Caravaggio to Rembrandt. Poussin himself adopted Leonardo's design in his earlier *Eucharist* (cat. 40) for Pozzo. But the present picture is much more original in invention, with its animated backviews of certain of the Apostles, its nervous gestures and impulsive actions, and its off-centre placement of Christ.

The painting also contains one further refinement on the first version of this theme. In five of Pozzo's set of Sacraments, Poussin included a figure leaving the scene, whose action adds a note of calculated informality to the proceedings. These figures have been omitted in all but one of the canvases for Chantelou, in keeping with their mood of high seriousness. The exception is the present picture, where Judas replaces the servant departing at the left in the early *Eucharist*. Like the sword and shield in the second *Extreme Unction* (cat. 49), this motif now serves to enrich both the formal and the iconographic meaning of the scene. Small wonder that, upon seeing the second set of Sacraments at Chantelou's residence in 1665, Bernini was led to exclaim: 'Today you have caused me great distress by showing me the talent of a man who makes me realise that I know nothing'.[2]

Two drawings survive for the picture, one of them on the same sheet that contains studies for certain of the heads in *Penance* (fig. 124).[3] Viewed upside-down, this reveals two rapid sketches for the figures reclining at the left of the present painting. The other is a poignant study for the whole composition (fig. 128), showing the figures unclothed and probably made with the aid of small wax models. It differs little from the painting save in the position of Peter, who here leans in towards the centre, and in the inclusion of an aureole around

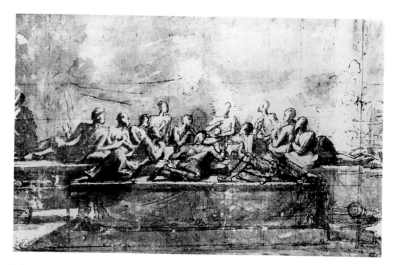

Fig. 128 Nicolas Poussin, *Eucharist*. Pen and heavy bistre wash; traces of squaring, 15.7 × 25.4 cm. Musée du Louvre, Cabinet des Dessins, Paris

Christ – a miraculous touch that the artist omitted from the finished picture. In its hushed atmosphere and intense fervour, however, this drawing rivals the painting, despite the mannequin-like figures.

Eucharist is the last of the four Chantelou Sacraments in which Christ appears; and, in each of these, Poussin varies his character and appearance to accord with the given theme. Thus, the Christ of *Baptism* (cat. 51) is a meek and delicate figure: the Christ of humility. In *Penance* (cat. 52), however, he appears as an expansive and benevolent being: the Christ of humanity and forgiveness. *Ordination* (cat. 53) reveals him instead as a firm and powerful figure: the Christ of authority, founder of the Church. Finally, in *Eucharist*, he appears as a stoical being of rock-like calm, his eyes tinged with sorrow as he submits to his fate: the Christ of suffering and sacrifice.

1. *Correspondance*, p. 378.
2. Chantelou (ed. 1985), p. 79.
3. CR I, pp. 48–9, nos. 100–1.

EXHIBITIONS
Paris, 1960, no. 74; Edinburgh, 1981, no. 54; Paris, 1994–5, no. 112

ŒUVRE CATALOGUES
Blunt, no. 114, Thuillier, no. 145, Wild, no. 134, Wright, no. 129, Mérot, no. 114

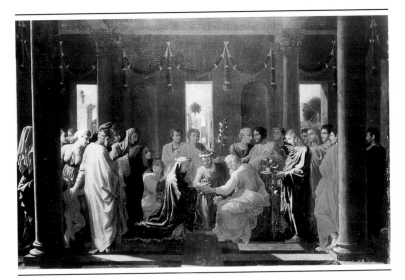

55
Marriage
1647–8
117 × 178 cm

His Grace the Duke of Sutherland
(On loan to the National Gallery of Scotland, Edinburgh)

The last of the Chantelou Sacraments to be completed, *Marriage* contains the largest number of figures of any member in the series and evidently caused Poussin considerable concern. Chantelou apparently disliked the earlier version of this theme (cat. 42), and the artist sought to improve upon it in the present painting, noting in a letter to his patron of 22 December 1647:

> I have the last picture under way; and this time I shall keep carefully in mind those works of mine in other hands which you seem to like so much; since this appears to be the only way of keeping in your graces and remaining, of all men, your most affectionate servant – for such in truth I am.[1]

The 'works of mine in other hands' to which Poussin refers in this letter is almost certainly a reference to the *Finding of Moses* (1647; fig. 150) for Pointel, which Chantelou had preferred to his own *Ordination* (cat. 53) when both had arrived in Paris earlier that year. Accordingly, Poussin introduced into the present picture a number of features of the Pointel picture: flowers, a wealth of young maidens and three enchanting landscape vistas.

Like the comparable canvas for Pozzo, the subject is the Marriage of the Virgin. Mary and Joseph kneel before a seated priest, who joins their hands. As in the earlier picture, Joseph holds a flowering rod – a reference to Aaron's rod, which flowered again at the birth of Christ. Surrounding the couple are a group of onlookers, including Joachim and Anna – the Virgin's parents – dressed in yellow and blue at the left. Kneeling beside the Virgin is a young woman pointing to Joseph's flowering rod and addressing her companion. These figures are taken directly from an identical group at the left of the Pointel *Finding of Moses*.

The scene is set in an ornate interior, decorated with a tiled floor, Corinthian columns, festive garlands and three windows which provide a glimpse outdoors. Though the subject itself permits little dramatic action, Poussin animates the scene through these decorative elements and through the lively and attentive gazes of the figures. Prominent among these is a veiled female figure, concealed behind a column at the left, who earned Bernini's praise for her 'nobility' and 'intentness'.[2] Scarcely less appealing is the wide spectrum of colour included in the picture. In addition to the assertive primary hues, this encompasses a range of greens, mauves and creamy whites that add to the celebratory mood of the whole.

Though the composition of the scene is similar to that of the earlier *Marriage*, the figures here appear less agitated in pose and more compactly grouped. They also adopt more rectilinear attitudes in the present picture, in harmony with the more elaborate architecture of the scene. Poussin also omits the dove of the earlier version and replaces it 'naturalistically' with a palm tree and sunburst visible in the centre background above the heads of the wedded couple. This modification is in keeping with his more historical approach to these themes in the second set of Sacraments.

The most striking development between the two pictures is a new concern with the abstract logic – and beauty – of the two-dimensional surface design. In the first *Marriage*, the architecture serves as an illusionistic setting for the figures and is clearly subordinate to them. In the present picture, however, it is treated as the visual equal of the figure group through the variety of decorative elements the artist introduces into the upper half of the picture. The result is a rhythmic articulation of the entire canvas surface that anticipates the style of *Eliezer and Rebecca* (cat. 59) and the *Holy Family on the Steps* (cat. 60) of this same year.

This subtle shift of emphasis – from illusionism to greater abstraction – also serves to distinguish the present picture from the earliest of the Chantelou Sacraments (cat. 49–50), where the setting still serves instead as a stage to contain the figures. This innovation constitutes one of the chief developments of Poussin's art during the five-year period when he was engaged in painting the second set of Sacraments. Another is the slightly altered proportions of the figures in the present canvas, whose heads appear enlarged and whose bodies are somewhat squatter than their counterparts in the earliest members of the series.

Poussin began painting *Marriage* by 24 November 1647 and completed it by 23 March of the following year. A preparatory study for the picture is in the Louvre.[3] It differs from the finished picture in showing a door instead of the central window and in the absence of the garlands above.

1. *Correspondance*, p. 376.
2. Chantelou (ed. 1985), p. 79.
3. CR I, p. 45, no. 91. (Nos. 92–4 are for an apparently unrelated composition of the same theme.)

EXHIBITIONS
Paris, 1960, no. 75; Edinburgh, 1981, no. 55; Paris, 1994–5, no. 113

ŒUVRE CATALOGUES
Blunt, no. 118, Thuillier, no. 146, Wild, no. 135, Wright, no. 130, Mérot, no. 115

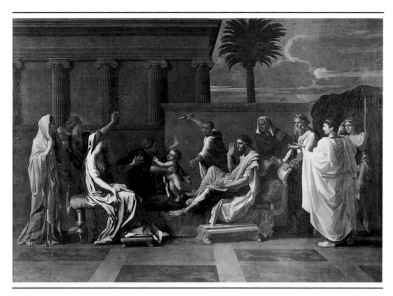

56
Moses Trampling on Pharoah's Crown

c. 1645

101 × 144 cm

The Marquess of Tavistock and the Trustees of the Bedford Estate

Painted for the Parisian merchant Pointel *c.* 1645, *Moses Trampling on Pharoah's Crown* is one of only a handful of canvases executed by Poussin during the years when he was occupied with the Seven Sacraments for Chantelou. Like those works, it possesses a nobility and severity hitherto unknown in Poussin's career and invites comparison less with the humanistic art of Raphael than with the more abstract and archaic style of 5th-century Greece.

The subject is not recorded in the Bible but derives instead from Josephus (*Antiquities*, II, 9, 7). Thermutis, daughter of Pharoah, has presented the infant Moses to her father, who places a diadem upon his head:

> ... but Moses threw it down to the ground ... and trod upon it with his feet; which seemed to bring along with it an evil presage concerning the kingdom of Egypt. But when the sacred scribe saw this ... he made a violent attempt to kill him: and crying out in a frightful manner, he said, 'This, O King!, this child is he of whom God foretold, that if we kill him we shall be in no danger; he himself affords an attestation to the prediction of the same thing, by his treading upon thy government, and treading upon thy diadem. Take him, therefore, out of the way, and deliver the Egyptians from the fear they are in about him.' But Thermutis prevented him, and snatched the child away. And the king was not hasty to slay him, God himself, whose providence protected Moses, inclining the king to spare him.

This event presages the triumph of the Hebrews over their oppressors and, on a purely symbolic level, was a favourite theme of Poussin's. Like comparable episodes from the early lives of Aeneas, Achilles, Pyrrhus and Theseus, it may be understood as a type for the future hero, overcoming the obstacles of his youth and revealing his predestination to greatness.[1]

Poussin portrays the action at its turning-point. As the young Moses tramples upon Pharoah's crown, the scribe prepares to kill him but is foiled by a maidservant, who snatches the infant to safety. At the left sits Thermutis, imploring her father, whose raised hand indicates his willingness to spare the child. To either side of the main group, figures react to the drama with a series of stylised gestures, some suggesting fear and others forgiveness. In their clipped, staccato movements and frozen poses, Poussin's actors seem intent upon enacting the story with the maximum force and clarity.

The scene is set before a temple which Blunt has identified as the Temple of Fortuna Virilis in Rome. Decorated with Ionic half-columns and flanked by a solitary palm, this motif adds to the almost forbidding austerity of the composition. So, too, does the disposition of the figures, who are arranged in a shallow frieze-like manner across the picture plane, rather than in the more recessional style of the Chantelou Sacraments. In itself this treatment serves to give the picture a more antique flavour than the canvases for Chantelou and locates the scene at an earlier moment of history. Enhancing this impression are the cold, unalloyed colours, which are applied with a smooth and impersonal touch that emulates the sheened surfaces of ancient painting.

The present canvas is one of two versions of this subject painted by Poussin in the mid-1640s. The other is a picture in the Louvre (fig. 129), commissioned by Cardinal Camillo Massimi in these same years as a pendant to *Moses Changing Aaron's Rod into a Serpent* in the same museum.[2] The Massimi version follows the arrangement of the figures in the Woburn painting, though the scene is now set indoors, a device that permits Poussin to explore dramatic effects of chiaroscuro to intensify the urgency of the action. It is uncertain which of the two pictures is earlier. Circumstantial evidence suggests that the

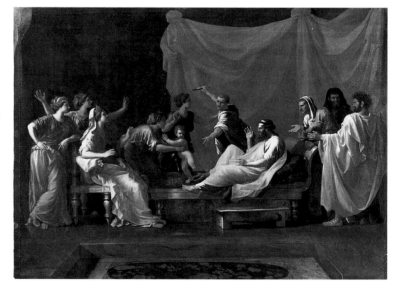

Fig. 129 Nicolas Poussin, *Moses Trampling on Pharoah's Crown*. Oil on canvas, 92 × 128 cm, *c.* 1647. Musée du Louvre, Département des Peintures, Paris

present canvas was executed in 1645; for Chantelou records that when the painter Charles Le Brun saw this picture in Paris in 1665, he noted that it had been painted 'twenty years ago'.[3] The more compact composition and monumental figure style of the Louvre canvas suggests that it dates from slightly later, *c.* 1646–7. In its unrelieved starkness and strident colouring, it makes even fewer concessions to the eye than the present painting and anticipates the *Judgement of Solomon* (cat. 62) of 1649, yet another of Poussin's many treatments of the theme of an imperilled infant.

Episodes from the life of Moses figure prominently in Poussin's art of the second half of the 1640s and may be seen as the Old Testament counterparts to the Sacraments upon which he was working for Chantelou. Like the New Testament themes of those pictures, the Moses subjects are also concerned with types of salvation. In addition to the pictures discussed here, the artist also executed a *Finding of Moses* (fig. 150) in 1647, *Moses Striking the Rock* in 1649,[4] and a lost *Moses Defending the Daughters of Jethro* (fig. 17) around 1647–8.

1. *Supra,* pp. 23–6.
2. Blunt, no. 19 and Mérot, no. 16.
3. Chantelou (ed. 1985), p. 289.
4. Blunt, no. 23; Mérot, no. 20; NP/SM, pp. 154–6.

PROVENANCE
Jean Pointel; bought at his sale in 1660 by Lomenie de Brienne; Cotteblanche in 1665; Jean-Baptiste Colbert; his descendants; before 1727, bought by Philippe, Duc d'Orléans; 1792, Orléans collection sale; 1792, Laborde de Méréville; 1798, Bryan; bought from him by the Duke of Bedford; by descent to the present owner

EXHIBITIONS
Paris, 1994–5, no. 145.

ŒUVRE CATALOGUES
Blunt, no. 16, Thuillier, no. 138, Wild, no. 124, Wright, no. 133, Mérot, no. 12

57
The Crucifixion

c. 1645–6
148.5 × 218.5 cm

Wadsworth Atheneum, Hartford, Connecticut
The Ella Gallup Sumner and Mary Catlin Sumner Collection Fund

Even in its present, much darkened state, the Hartford *Crucifixion* is among the most impressive achievements of Poussin's maturity, and also among the most deeply moving. In its tragic intensity and wealth of invention, it is equalled only by Rembrandt's etching of the *Three Crosses* among 17th-century depictions of this theme. But whereas Rembrandt infuses his print with a visionary quality that transcends the circumstances of the action, Poussin adheres closely to the account given in the Gospels. The result is a scene devoid of all hope.

Christ is shown crucified between the two thieves. At the base of the cross is the centurion, on horseback, bearing the spear with which he pierced Christ's side. To the right are the Virgin and Evangelist accompanied by the two Marys. At the left a soldier on a ladder hands down an iron bar with which he has just broken the legs of one of the thieves; while below, two seated soldiers cast lots for Christ's garments. All of these episodes accord with the account of the event given in John XIX, 16–34. However, the mysterious figure rising from his grave in the foreground derives from Matthew XXVII, 52. He is identifiable as Adam who, according to a tradition that originated in the Middle Ages, was believed to be buried on Golgotha. Gazing at him from the left is a helmeted soldier brandishing a dagger, who appears fearful of this apparition.

The scene is completed by additional figures who assist the executioners, some carrying ladders and others on horseback, issuing instructions. At the far right a helmeted soldier gazes up at Christ and raises his hand in wonderment, as though echoing the centurion's words: 'Truly this man was the Son of God'.

Most moving of all, however, is the seated figure of a woman at the lower right, whose slumped and shrouded pose epitomises the mood of utter despair.

The picture is held together by one of the most complex series of actions and reactions ever devised by the artist. Yet, rather than resolving these into an orderly progression across the canvas, in the manner of the *Israelites Gathering the Manna* (cat. 37) or the Chantelou *Confirmation* and *Baptism* (cat. 50–1), Poussin creates a deliberately disjunctive composition which reflects the chaos and confusion of the theme. Figures skelter, gestures collide, and the poses throughout appear taut and angular, endowing the whole with a gothic starkness that has often been compared with Mantegna's painting of the subject (Louvre, Paris). Adding to this effect is the shallow spatial setting and barren and rocky landscape background. The colour, too, creates a jarring impression, with its stabbing patches of red

seen against a sombre brown ground. Though this effect has doubtless been exacerbated by the deteriorated state of the painting, the picture can never have possessed the stable and harmonious colour balance of *Moses Trampling on Pharoah's Crown* (cat. 56) or certain members of the Chantelou Sacraments. If the resulting effect is unnerving, it is also undeniably expressive and led Uvedale Price to observe in 1810 that Poussin's harsh and discordant colours in this picture had been 'designedly introduced, from an idea . . . that they suited the terror of the subject'.[1]

Four drawings exist for this work.[2] The earliest of these reveal that the artist originally intended to include many more soldiers on horseback surrounding the dead Christ and only gradually evolved the more varied actions and incidents of the finished picture through the invention of the figure of Adam rising from his grave and the episode of the breaking of the legs of the thief. The final drawing (fig. 130), a magnificent sheet squared for transfer to the larger scale of the canvas, attests to the careful preparation Poussin lavished upon this composition.

The *Crucifixion* was painted for the Président de Thou in 1645–6 and was the artist's most ambitious undertaking of these years other than the Chantelou Sacraments. Sometime after this, the picture passed into the collection of Poussin's close friend and fellow artist, Jacques Stella (1596–1657), who requested a pendant to the composition depicting Christ bearing the cross. Poussin's ideas for this subject are preserved in a drawing (fig. 131), but the painting itself was never executed. The reasons the artist gave for this will surprise no one confronted with the present picture.[3] 'I no longer possess enough joy or good health to engage in such sad subjects', wrote Poussin to Stella:

> The Crucifixion made me ill, I took such pains over it, but the Carrying of the Cross would finish me off. I would not be able to withstand the deep and distressing thoughts with which it is necessary to fill one's mind and heart in order to paint such sad and gloomy subjects with any conviction. Do not insist, I beg you.

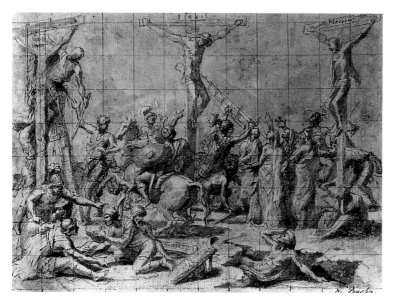

Fig. 130 Nicolas Poussin, *The Crucifixion.* Pen and bistre wash, squared, 17.9 × 24.8 cm. Museum der Bildenden Künste, Leipzig

Fig. 131 Nicolas Poussin, *Christ Carrying the Cross.* Bistre wash with traces of underdrawing in black chalk, 16.8 × 25.5 cm. Musée des Beaux-Arts, Dijon

1. Uvedale Price, *Essays on the Picturesque, as Compared with the Sublime and the Beautiful*, London, 1810, III, pp. 312–13.
2. CR I, p. 34, nos. 66–8; V, p. 79, no. 399. Blunt (1964, fig. 19) publishes a reconstruction of one of the drawings in the Louvre which exists in two fragments.
3. *Actes*, 1960, II, p. 219.

PROVENANCE
Commissioned by Président Jacques de Thou in 1644 and delivered in 1646; Jacques Stella; by descent to his relations; 1744, Blackwood sale, London; bought by Scott; 1751, Blackwood sale, London; 1794, Sir Lawrence Dundas sale, London; the Marquesses of Zetland; 1934, Zetland sale, London; bought Durlacher; 1935, purchased by the Wadsworth Atheneum

EXHIBITIONS
Rome, 1977–8, no. 29; Düsseldorf, 1978, no. 28; Paris, 1994–5, no. 146.

ŒUVRE CATALOGUES
Blunt, no. 79, Thuillier, no. 139, Wild, no. 128, Wright, no. 131, Mérot, no. 78

REFERENCES
Bellori, 1672, p. 453; Félibien (ed. 1725), IV, p. 54; Blunt, 1964

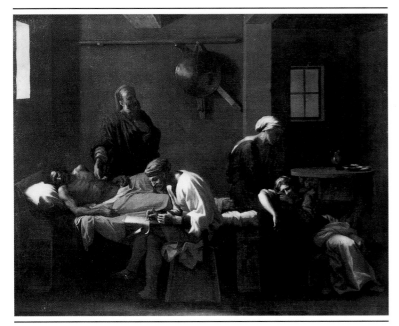

58
The Testament of Eudamidas

c. 1645–50

110.5 × 138.5 cm

Den Kongelige Maleri- og Skulptursamling, Statens Museum for Kunst, Copenhagen

The *Testament of Eudamidas* was Poussin's fourth and final deathbed picture and is his most economical in style and humble in theme. Unlike the *Death of Germanicus* (cat. 9) or the two versions of *Extreme Unction* (cat. 41, 49), it does not commemorate a great leader or warrior whose death was mourned by many, but a poor citizen of Corinth whose death was mourned by few.

The story is from Lucian's *Toxaris, or Friendship* (22–3). Eudamidas, an honourable man of lowly means, lies dying. On his deathbed, he dictates a will entrusting the care of his mother and daughter to his two closest friends, the wealthy Corinthians Aretaeus and Charixenus. When his will is read, it is greeted with laughter and derision by the people, who accuse him of wishing to spend his friends' money from the grave. But Aretaeus and Charixenus honour their obligations; and when the latter dies five days later, Aretaeus continues to care for Eudamidas's mother and provides his daughter with a handsome dowry for her marriage.

Though Poussin was probably familiar with Lucian's account of this tale, the story of Eudamidas is also told by Montaigne and Pierre Charron,[1] two more recent, French authors whom he certainly read. Moreover, its theme of the value of family and friendship over all other earthly possessions is one that would certainly have appealed to the artist, who constantly stresses in his letters the importance of such ties. In one of them, Poussin even follows the example of Eudamidas and entrusts the care of his own poor relations in Normandy to his closest friend,

Chantelou, begging the latter to guide and protect them after his death.[2]

The composition of the picture reflects the stoical abnegation of the theme and reveals Poussin's art at its most austere. Eudamidas lies dying in a humble interior attended by a doctor and a notary. At the foot of the bed are his mother and daughter, the former restrained in her grief and the latter inconsolable. On the wall behind hangs the dying man's sword and shield. The design is aligned strictly parallel to the picture plane, in the manner of a funerary relief, and the figures arranged with a Spartan simplicity. The men wear primary colours and are posed stiffly; the women wear secondary hues and are arranged in a sequence of overlapping curves. Linking the two groups is the reclining figure of Eudamidas, whose anguished expression intensifies the sombre mood. Finally, the arrangement of the weapons on the back wall follows the principal axes of the figures and repeats, in miniature, the design of the entire picture.

A drawing for the composition (fig. 132) shows many of these motifs already established.[3] Curiously, however, it depicts the hero's daughter as a young girl, seeking comfort from her grandmother, despite the fact that Lucian describes her as 'already marriageable'. The drawing also shows the doctor turning towards Eudamidas, whose legs are raised. All of these features add animation to the composition and were rejected in favour of the more sober and self-absorbed figures of the final canvas. Revealingly, the sword and shield are arranged differently in the drawing, where they direct attention solely to the male figures rather than leading to the female group. In this alteration alone may be seen the perfectionism of Poussin's approach to pictorial composition, which struggles with even the most 'trivial' elements of the design until it has finally crystallised.

The *Testament of Eudamidas* was painted for Michel Passart, *maître des comptes*, who eventually owned at least three other works by the artist, including the *Landscape with Orion*

Fig. 132 Nicolas Poussin, *The Testament of Eudamidas*. Pen and bistre wash, 12.8 × 19.3 cm. Kunsthalle, Hamburg

(cat. 84). The dating of the picture has caused much controversy, with some critics placing it around 1645 – just after the Chantelou *Extreme Unction* – and others in the early 1650s, or even later. On circumstantial grounds, it would fit most conveniently after the relevant member of the second set of Sacraments. But the style of the drawing, with its freely applied wash and somewhat tremulous line, suggests a slightly later date, *c.* 1650. Moreover, the severity of the design finds obvious counterparts in Poussin's very late figure paintings, especially the *Annunciation* (cat. 81) and *Lamentation* (cat. 82). In its present, much darkened state it is difficult to date the work on grounds of style, though it is hoped that its juxtaposition with other pictures by the artist in the present exhibition may serve to clarify this problem.

The picture enjoyed enormous popularity in the 18th century, especially among the pioneers of Neo-classicism – despite the fact that the original was already in Denmark and could only be known through copies and engravings.[4] In this form, it inspired copies and variants in painting, drawing and relief sculpture and, along with the *Arcadian Shepherds* (cat. 38), came to be regarded as the quintessential Poussin and as the master's most 'antique' painting. Both Diderot and Napoleon accorded it fulsome praise, the latter regarding the artistic achievements of his own time as feeble when compared with Poussin's *Eudamidas*. Ironically, one of the greatest of those achievements – David's *Oath of the Horatii* (1784–5; fig. 133) – probably owed much of its chilling starkness and simplicity to Poussin's emblematic design. Lauded both for the sublimity of its theme and the economy of its means, the *Eudamidas* earned the ultimate accolade when certain critics attempted to deny that it was a 17th-century picture. Instead, they preferred to imagine that it had been unearthed at Athens or Herculaneum.

1. 'Of Friendship', *The Complete Essays of Montaigne*, trans. Donald M. Frame, Stanford, 1965, pp. 141–2; Pierre Charron, 'De l'Amour, ou Amitié', *De La Sagesse*, III, vii, 9
2. *Supra*, pp. 32–3; *Correspondance*, p. 459
3. CR V, p. 92, no. 417b, and Blunt 1974, pp. 241–2 and pl. 8b.
4. Cf. Verdi 1971, for the later history of this picture.

PROVENANCE
Michel Passart; Froment de Veine before 1700; by 1757, Beauchamp, Paris; 1759, bought by Count Moltke; 1931, bought from his descendants by the Museum

EXHIBITIONS
Paris, 1960, no. 97; Copenhagen, 1992, no. 21; Paris, 1994–5, no. 139

ŒUVRE CATALOGUES
Blunt, no. 152, Thuillier, no. 187, Wild, no. 122, Wright, no. 177, Mérot, no. 183

REFERENCES
Bellori, 1672, p. 455; Verdi, 1971

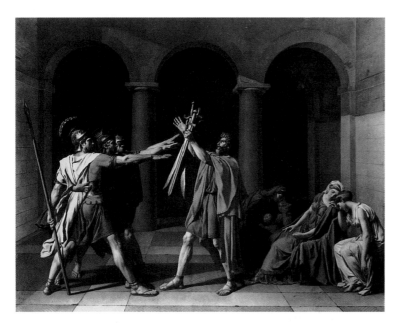

Fig. 133 Jacques-Louis David, *The Oath of the Horatii*. Oil on canvas, 265 × 375 cm, 1784–5. Musée du Louvre, Département des Peintures, Paris

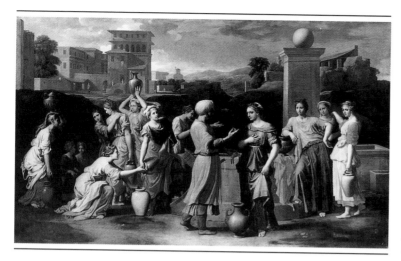

59
Eliezer and Rebecca

1648

118 × 197 cm

Musée du Louvre, Département des Peintures, Paris

Poussin's second version of *Eliezer and Rebecca* depicts a later moment in the story than his other two canvases on this theme (cat. 5, 87) both of which show Rebecca offering water to Eliezer, servant of Abraham, who has been sent on a journey to find a wife for the latter's son, Isaac. Rebecca then proceeds to draw water for Eliezer's camels and, in this double act of charity, reveals herself to be the chosen one. As a reward for her generosity, Eliezer presents her with a gold earring and two bracelets and announces that she has been divinely selected by the Lord as Isaac's future wife (Genesis XXIV, 22–7).

This is the action of the present picture, which was painted for Pointel in 1648 as the result of an unusual request. According to Félibien,[1] Pointel was attracted to a painting by

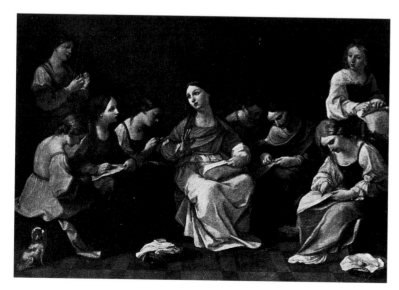

Fig. 134 Guido Reni, *The Sewing School.* Oil on canvas, 146 × 205.5 cm, *c.* 1635–40. The Hermitage Museum, St Petersburg

Guido Reni depicting the Virgin sewing with her companions (fig. 134), which he had seen in the collection of Cardinal Mazarin, and wrote to Poussin requesting a comparable canvas for himself, one that included a number of young maidens and depicted different types of female beauty. This may account for the grace and charm of the painting, the subject of which was apparently chosen by Poussin himself.

As Glen has demonstrated,[2] the theme complements that of Reni's canvas. In the latter, the Virgin holds a needle, symbol of the sword of sorrow that will later pierce her heart. In the Louvre canvas her Old Testament counterpart, Rebecca, is offered a ring, rather than an earring. This may be seen as a prefiguration of the Virgin's mystical marriage with God and an allusion to the Annunciation.

Poussin employs the story to explore a subtle range of responses to Rebecca's sudden elevation. At the right, a group of three women react with joy, curiosity or apparent jealousy. Even more inventive are the figures at the left, some of whom express dawning recognition of the significance of the meeting of Eliezer and Rebecca while others remain unaware of it. One of these, a woman in red and green, gazes distractedly at them while pouring water into the jug of her companion, who attempts to halt her action, presumably because the vessel is already full. And, at the far left, a woman bearing a jug of water on her head is about to lift another, a demonstration of skill and greed that contrasts strikingly with the charity of the heroine. Rebecca herself radiates both grace and goodness as she confronts the animated figure of Eliezer and places her hand upon her breast in a gesture of modesty. Revealingly, she is the only woman in the picture who is not handling her jug of water. Instead, it rests on the ground at her feet, as though indicating that it is intended for another.

Behind the group, Poussin portrays an elaborate architectural landscape. With its straight lines and cubic forms, this provides a foil for the organic curves of the figure group while also stressing the harmonious proportions of the figures themselves. This is especially true of the pillar surmounted by a sphere at the right, which repeats in its purest and most abstract form the columnar shapes and smoothly rounded heads of the figures. Mediating between the two are the rounded forms of the pitchers, which link the organic with the geometric – the natural with the ideal.

This intricate dialogue of shapes reminds one of the inspiration Poussin derived from the most elevated forms in nature and has often been related to a passage in a letter to Chantelou of 1642 in which the artist observes: 'The beautiful girls that you will have seen in Nîmes did not, I am sure, please you any less than the beautiful columns of the Maison Carrée, since the latter are only old copies of the former'.[3] In *Eliezer and Rebecca* Poussin gives visual expression to this idea by stressing the relations between the ideal world of architecture and that of perfected nature.

In its integration of figures and setting, the picture has obvious affinities with the Chantelou *Ordination* (cat. 53) and may be seen as the female counterpart to that picture. Rather

than employing the bold and authoritarian hues of the latter, however, the Louvre picture contains a delicate range of pinks, mauves, beiges and greens that mirror the joyous character of the theme.

Though no preparatory sketches survive for the composition, a drawing at Lyons which depicts Rebecca offering water to Eliezer may be connected with the commission for the present picture and appears to date from the late 1640s.[4]

Eliezer and Rebecca is elaborately discussed and praised by Félibien and has remained one of Poussin's most celebrated works. In 1668, it formed the subject of a *conférence* at the French Academy of Painting and Sculpture delivered by Philippe de Champaigne.[5] This included a notorious discussion of the artist's failure to include camels in the picture, which some regarded as taking undue liberties with the theme. Others explained this as arising from Poussin's laudable desire to avoid introducing anything bizarre into the composition, which might detract from its overall beauty.

Notwithstanding this criticism, the Louvre picture has continued to win admirers and imitators, even at times when Poussin's general reputation was far from high. In 1701, at the dawn of the Rococo era, Antoine Coypel based his own version of this theme (fig. 135) on Poussin's prototype, converting the harmony and nobility of the original into a more self-consciously sweet and seductive style, in keeping with the tastes of the time. Around 1805, Ingres painted a variant after a portion of Poussin's picture (fig. 136), which he deemed 'the most beautiful of his admirable paintings'.[6] And, in our own century, Picasso revived the harmony and grandeur of the Louvre canvas in certain of his most Neo-classical works (fig. 137), as though to reaffirm the enduring appeal of Poussin's ideal figure style.[7]

1. Félibien (ed. 1725), IV, pp. 99–115.
2. Glen, 1975, pp. 221–4.
3. *Correspondance*, p. 122.
4. CR I, p. 4, no. 2.
5. *Conférences* (ed. Jouin), pp. 87–99.
6. Henri Lapauze, 'Une vie de Poussin annotée par Ingres', *Revue de Paris*, LX, 1909, p. 873.
7. Cf. Paris 1993, pp. 181, 189–90, 192, for a selection of other works inspired by this picture, including one by Larry Rivers.

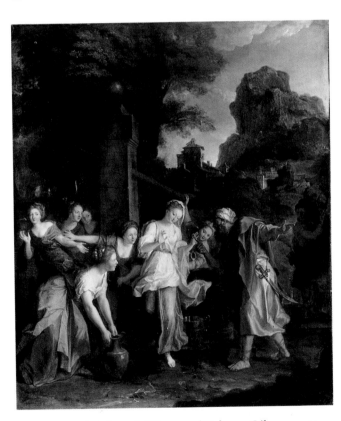

Fig. 135 Antoine Coypel, *Eliezer and Rebecca.* Oil on canvas, 125 × 106 cm, 1701. Musée du Louvre, Département des Peintures, Paris

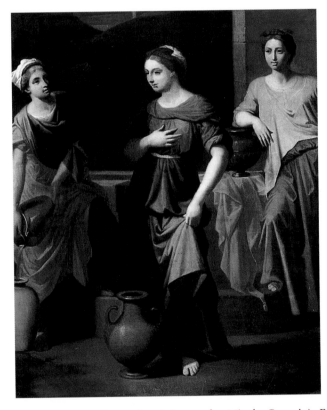

Fig. 136 J.-A.-D. Ingres (*partial copy after* Nicolas Poussin), *Eliezer and Rebecca* . Oil on canvas, 46 × 37 cm, *c.* 1805. Musée des Beaux-Arts, Marseille

PROVENANCE
Painted for Pointel in 1648; sold by the Duc de Richelieu to Louis XIV in 1665
EXHIBITIONS
Paris, 1960, no. 79; Bologna, 1962, no. 77; Rome, 1977–8, no. 31; Düsseldorf, 1978, no. 30; Paris, 1994–5, no. 166
ŒUVRE CATALOGUES
Bunt, no. 8, Thuillier, no. 154, Wild, no. 145, Wright, no. 138, Mérot, no. 5
REFERENCES
Bellori, 1672, p. 451; Félibien (ed. 1725), IV, pp. 59, 90–1, and 99–115; *Conférences* (ed. Jouin), pp. 87–99; Glen, 1975

60

The Holy Family on the Steps

1648

72.4 × 111.7 cm

The Cleveland Museum of Art
Leonard C. Hanna, Jr., Fund

In the late 1640s Poussin created a new type of Holy Family composition. Abandoning the upright format he had previously favoured for such pictures, he executed six major works on this theme between 1648 and 1657 on a landscape canvas that permitted him to depict the figure group against a strikingly diversified setting. In their calm and contemplative figures, all of these works recall the monumental Holy Family pictures of Raphael and his school. But in their architectural and landscape backgrounds, they invite comparison with Poussin's own landscapes of these years. Like those works, these pictures reveal a desire to attain the strictest possible integration between figures and setting – and none more so than the present painting, which was executed for Hennequin de Fresne, Master of the royal hunt, in 1648, and is universally acknowledged to be one of the supreme masterpieces of Poussin's career.

The picture depicts the Holy Family seated on the steps of a temple accompanied by St Elizabeth and the infant Baptist, who offers the Christ child an apple, a motif which alludes to the role of both Mary and Christ in the redemption of mankind. At the right, Joseph measures with a pair of compasses, while propped up against the stairs next to him is a T-square. These devices characterise him as a man of learning, and specifically of mathematical and architectural learning, which Poussin esteemed so highly and which could hardly be more appropriate to so finely calibrated a composition.

At the base of the picture are a basket of apples and two precious vessels. It has been plausibly suggested that they contain frankincense and myrrh, the gifts of the Magi. More intriguing is the architectural setting. This may be intended to represent the Temple of Jerusalem and is similar to that of

Fig. 137 Pablo Picasso, *Three Women at the Spring.* Oil on canvas, 203.9 × 174 cm, 1921. The Museum of Modern Art, New York. Gift of Mr and Mrs Allan D. Emil

St Peter and St John Healing the Lame Man (cat. 78) of 1655, which certainly represents this building. Further references to the Old Testament appear in the figures of Elizabeth, who resembles a prophetess, and Joseph, relegated to an area of shadow. Most striking of all, however, is the motif of the stairway, which Hibbard has identified as representing the *scala coelestis*, or stairway to heaven, a theological concept that sees Mary as both the means by which God descended to earth in the form of Jesus, and by which we in turn can ascend to heaven. As Hibbard observed, 'Poussin actually shows a

Fig. 138 Raphael, *Madonna of the Fish*. Oil on canvas, 215 × 158 cm, *c.* 1514. Museo del Prado, Madrid

stairway behind Mary, sharply foreshortened, leading directly up to the brilliant sky'.[1]

The poses of the Madonna and Child in the present picture appear closely indebted to Raphael's *Madonna of the Fish* (*c.* 1514; fig. 138) while the attitude of Joseph may be related to the comparable figure in Andrea del Sarto's *Madonna del Sacco* of 1525 and to the figure of Naason in Michelangelo's Sistine Ceiling.

Four drawings survive for the painting.[2] These show Poussin gradually forging the abstract harmony of the final composition from much more naturalistic beginnings. In the earliest of them, a group of putti engage the Christ Child against a receding architectural background. A later study (fig. 139) depicts the figure group of the painting, with an additional figure behind Elizabeth and with Joseph shown reading. More importantly, it includes a receding arcade at the left and a greater wealth of vegetation. Certain of these elements are retained in a final surviving study (fig. 140), which introduces the motif of the

steps and shows Poussin still undecided about the architectural setting. X-rays reveal that certain of these elements – most notably the arcade at the left – also appear in the underpainting of the present picture.[3] In the final canvas, however, the artist suppresses these features and reduces the amount of vegetation to achieve a taut and severe surface design that matches the regal authority of the figures.

One of the most arresting features of the composition is the intricate sequence of relationships it establishes between disparate elements. Hard and soft forms, rounded and rectilinear shapes, and sharp and swelling planes all appear bound together in a flawless unity. Directly above the pyramidal figure group rises the similarly shaped architectural setting. To the left of the Virgin a pier surmounted by an urn of flowers discreetly echoes the form of her own body and head, with the trailing foliage mirroring the soft, lapping curves of her veil. Carefully positioned above her head is an ornate Corinthian capital, which provides her with a naturalistic crown; while, above the Christ child, a rectangular patch of blue sky serves to give him a similarly naturalistic halo. At the upper right, the motion of the clouds in the sky complements the architecture on the opposite side of the picture and ensures the seamless integration of the whole. Further linking all elements of the composition are the rich, glowing colours and the subtle overlaps that undermine its seemingly rigid geometry. Thus, Joseph's head breaks the horizontal of the topmost stair; Elizabeth's draperies and the still-life objects interrupt the line of the lower stair; and the gifts of the Magi are disposed towards the right of the picture, counterbalancing the greater disposition of figures on the opposite side. Never was Poussin more logical and rational than this, and rarely was he more inspired. The result is an image of utter perfection – one in which logic and reason themselves acquire the fascination of the unattainable.

Fig. 139 Nicolas Poussin, *The Holy Family on the Steps*. Pen and bistre wash, 18.4 × 25.1 cm. Pierpont Morgan Library, New York

A recent technical examination of the Cleveland canvas confirmed the presence of incised lines in the paint layer, especially in the architecture at the upper right. In places these are just visible to the naked eye and converge upon a vanishing point at the bottom centre of the picture, which the artist marked with a pinpoint indentation.

Another version of the *Holy Family on the Steps* (National Gallery of Art, Washington) was widely regarded as the original until the re-emergence of the present picture in 1981. It is of very high quality and differs from this painting principally in showing a small area of drapery between the legs of the infant Baptist. When the two pictures were brought together in Washington in May 1994, it was unanimously agreed that the Cleveland picture alone was by Poussin and that the Washington version must be by a gifted follower, who has yet to be identified. Since the provenances of the two versions are likely to have become confused, only those collections that certainly contained the Cleveland picture are given below.

1. Hibbard, 1974, p. 90.
2. CR I, pp. 25–6, nos. 45–7; V, p. 73, no. 391.
3. Lurie, 1982, pp. 668–9.

PROVENANCE
1648, painted for Hennequin de Fresne; Lord Ashburton; 1908, sold London; bought by Quinto; Henry Lerolle; 1944, Mlle Thérèse Bertin-Mourot; 1981, purchased by the Museum

EXHIBITIONS
Paris, 1994–5, no. 173

ŒUVRE CATALOGUES
Blunt, no. 53 (Washington version); Thuillier, no. 152; Wild, no. 138; Wright, no. 140b; Mérot, no. 42

REFERENCES
Félibien (ed. 1725), IV, p. 59; Kauffmann, 1960, pp. 36–65; idem. in *Actes*, 1960, I, pp. 141–50; Hibbard, 1974; Lurie, 1982

Fig. 140 Nicolas Poussin, *The Holy Family on the Steps*. Pen and bistre wash over chalk, 18.2 × 24.6 cm. Musée du Louvre, Cabinet des Dessins, Paris

61

The Holy Family with Ten Figures
1649
79 × 106 cm

The National Gallery of Ireland, Dublin

The second of Poussin's Holy Family pictures of the late 1640s has never enjoyed the celebrity of the incomparable *Holy Family on the Steps* (cat. 60). Painted for Pointel in 1649, the Dublin canvas portrays an even more hieratic arrangement of figures than the Cleveland picture. The Virgin and Christ are seated in the centre flanked by Joseph and St Anne. At the left sits St Elizabeth holding the infant Baptist. Complementing this group on the opposite side are four putti, who offer flowers to the Christ Child. The design is rigorously symmetrical and possesses a chilling clarity which calls to mind the *Judgement of Solomon* (cat. 62), painted for Pointel in the same year. Reinforcing this impression is the architectural landscape which fills the background of the composition, its rigidly geometric accents mirroring the stilled and frozen poses of the figures.

Like the *Holy Family on the Steps*, the present painting reveals Poussin's art at its most abstract and irreducible. The composition is dominated by straight lines and sharp angles and the figures are aligned parallel with the picture plane in an arrangement which takes the form of a large X. This scheme is echoed in the diagonally receding lines of the architecture, which provides an internal frame for the figures. The colour also shows Poussin's art at its most impersonal and uncompromising. Confined almost entirely to the primary hues plus white, it appears pared down to essentials. In all of these respects, the picture possesses a starkness and purity that at once look back to Piero della Francesca and forward to Mondrian. Enhancing this effect are the aloof and timeless gazes of the figures, which seem petrified in their immobility. Even Poussin appears to have realised that he could distil his art no

further than this; and, in his ensuing Holy Families, he abandoned the absolutes of the present canvas in favour of more informal figure groupings and more naturalistic settings.

This may be seen in the *Holy Family with Six Putti* (c. 1651; fig. 18), which also depicts a group of putti presenting the Christ Child with flowers. With its animated figures and more spacious and diversified landscape setting, this canvas has a relaxed and engaging quality that is markedly different from the static and timeless effect of the Dublin picture. Since the years that separate it from the latter were marked by a succession of great landscape paintings, one is tempted to wonder if Poussin's sudden immersion in nature during this period accounts for the more fugitive and felicitous effects he sought in certain of his later Holy Family pictures. Adding to the genial character of the work is the nonchalant pose of Joseph and the momentarily distracted attitude of the Virgin, whose supple pose and flowing draperies reveal Poussin's deepening response to one of the most admired features of Raphael's art: grace.

No drawings survive for the present picture, but a magnificent sheet (fig. 141) may be related to it.[1] This shows the Holy Family posed in a similar manner and attended by putti, who offer them flowers. They are seen against an elaborate throne decorated with festive garlands, an archaic device that recalls the shallow and symmetrical spatial compositions favoured by 15th-century Italian masters.

Though the authenticity of this picture has occasionally been doubted, the existence of a prominent pentimento around the head of St Anne, together with the high quality of the painting itself, leaves little doubt that it is original.

Bernini expressed disapproval of this picture when he saw it in Paris in 1665, noting that he would never have believed that Poussin had painted such children.[2] Coming from the greatest exponent of the Italian Baroque, such criticism reveals the extent to which Poussin was here working against the taste of his time.

1. CR I, p. 27, no. 52.
2. Chantelou (ed. 1985), pp. 110–11.

PROVENANCE
1649, painted for Pointel; by 1665, Cérisier; by 1826, the Earls of Milltown; 1902, presented to the Gallery by Geraldine, Countess of Milltown, widow of the 6th Earl

EXHIBITIONS
Bologna, 1962, no. 78; Dublin, 1985, no. 35; Paris, 1994–5, no. 182

ŒUVRE CATALOGUES
Blunt, no. 59, Thuillier, no. 164 (copy), Wild, no. 150, Wright, no. 143, Mérot, no. 49

Fig. 141 Nicolas Poussin, *The Holy Family.* Pen and bistre wash, 15.7 × 19 cm. Statens Konstmuseen, The National Swedish Art Museums

62

The Judgement of Solomon

1649

101 × 150 cm

Musée du Louvre, Départment des Peintures, Paris

According to Bellori,[1] Poussin regarded this picture as his best work, and few would dispute that it is among his most orthodox. No other canvas by the artist is as intensely dramatic or morally edifying as this stark and chilling scene. Refusing to make any concessions to the senses, Poussin here summons all the devices of his art – composition, colour, gesture and expression – to convey the force and urgency of the theme.

The subject is from I Kings III, 16–28, and tells the tale of two harlots who have recently given birth. When the baby of one of them dies in the night, its mother steals the other woman's live child and substitutes for it her own dead baby. The two are then brought before King Solomon. Unable to tell which of them is the living infant's true mother, the king decrees that it be cut in two and shared between them. The rightful mother immediately renounces her claim to the child and begs Solomon to give it to her rival rather than having it slain. The king then restores the child to its true mother. 'And all Israel heard of the judgement which the king had judged; and they feared the king: for they saw that the wisdom of God was in him, to do judgement'.

Poussin portrays the moment when Solomon issues the command that the remaining child be slain. Kneeling before him at the left is the infant's mother, who implores the king to desist. At the right is the evil mother, angrily accusing her opponent. As has often been noted, Poussin errs in showing her bearing the corpse of the dead child, which should either be in the arms of the good mother or on the ground between the two women. But this was probably done deliberately to indicate that the dead baby is hers.

Surrounding these figures is a group of onlookers, who react to the king's decision with vehemently declamatory gestures. These range from horror and incredulity to dawning awareness

of his great wisdom. At the far right, a mother accompanied by her own young child shrinks from witnessing the murder of an innocent baby; while, closer to the centre, a sagacious old man raises his hand in sudden recognition of Solomon's strategy.

The composition is strictly symmetrical and set out like a scale of weights and measures, as befits a theme of judgement. Closer inspection of the design reveals, however, that Solomon is displaced slightly to the left – towards the side of the good mother – and that the verticals of the architecture likewise incline in this direction. But, if the composition of the picture reflects the righteousness of the king's judgement, the aggressive surface design and abrasive colouring of the work mirror the conflict of the theme and provide a classic demonstration of Poussin's theory of the modes.

Set against the grid-like division of the background, with its rigorously interlocking verticals and horizontals, is a series of conflicting diagonal accents – the stabbing gesture of Solomon, the outstretched arms of the two women and the lurching back and sword of the soldier about to slay the child. The tensions created by these seem calculated to unsettle the eye and are further intensified by one of the most astringent colour harmonies ever devised by the artist. In the centre of the composition sits Solomon, wearing vermilion and white and framed by a golden throne flanked by dark blue columns and purple drapery. This jarring colour scheme is then reiterated in the reds, golds and blues of the onlookers and in the contrasting hues of the female protagonists. The good mother is painted with creamy flesh tones and wears the compatible colour combination of yellow and blue. The bad mother is given livid green skin tones and clothed in the clashing, complementary hues of red and green. The distinction is akin to that between consonance and dissonance in music.

The centralised composition and vehement gestures of this work reflect those of Raphael's fresco of the same theme in the

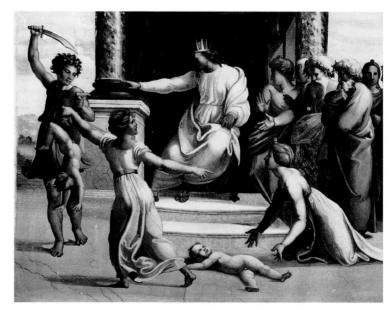

Fig. 142 Raphael, *The Judgement of Solomon*. Fresco, c. 1518–9. Logge, Vatican, Rome

Loggia of the Vatican (fig. 142) and, along with any number of Poussin's figure paintings of these years, confirm the extent to which he was consciously seeking to emulate his great predecessor at this most classical moment of his career.

The *Judgement of Solomon* was painted for Pointel in 1649. Three drawings survive for the picture,[2] including a remarkable compositional study in Paris (fig. 143). This shows the group set in a more elaborate interior and includes a second chorus of onlookers witnessing the drama from behind the king, like the audience in a theatre. The drawing also depicts Solomon as larger than life, a motif that recalls the devices employed by medieval or Byzantine artists to emphasise the omnipotence of a great religious figure. But perhaps the most astonishing feature of the drawing are the mask-like faces of the bad mother and certain of the onlookers, whose ghostly and grimacing expressions add a blood-curdling intensity to the scene. In the finished picture, these are replaced by the more vigorous, pantomime-like gestures of Poussin's actors, who appear even more unequivocal in their reactions to the drama.

Perhaps because of the great store that Poussin himself set upon this work, it inspired few imitations among later artists, who appear to have regarded it as a paradigm in the treatment of this theme. Ingres apparently was commissioned to make a copy of it during his early years in Rome and later owned another copy of the composition.[3] But the most famous variant of the picture is Benjamin Robert Haydon's *Judgement of Solomon* of 1812–14, an act of unashamed homage to the French master which heralded his growing reputation among British artists and critics in the first half of the 19th century.[4]

1. Bellori, 1672, p. 452.
2. CR I, pp. 15–16, nos. 31–3.
3. Henri Lapauze, *Ingres, sa vie et son oeuvre*, Paris, 1911, pp. 58, 60; Daniel Ternois, 'Livres de comptes de Madame Ingres', *Gazette des Beaux-Arts*, XLVIII, 1956, p. 174.
4. Frederick Cummings, 'Poussin, Haydon and *The Judgement of Solomon*', *The Burlington Magazine*, CIV, 1962, pp. 146–52.

PROVENANCE
1649, painted for Pointel; 1685, probably Nicolas du Plessis-Rambouillet; Achille III de Harlay; 1685, bought by Louis XIV from Charles-Antoine Hérault

EXHIBITIONS
Paris, 1960, no. 87; Rome, 1977–8, no. 33; Düsseldorf, 1978, no. 33; Paris, 1994–5, no. 183

ŒUVRE CATALOGUES
Blunt, no. 35, Thuillier, no. 162, Wild, no. 148, Wright, no. 142, Mérot, no. 31

REFERENCES
Bellori, 1672, p. 452; Félibien (ed. 1725), IV, pp. 59–60

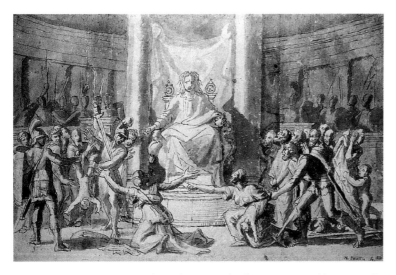

Fig. 143 Nicolas Poussin, *The Judgement of Solomon.* Pen and bistre wash on a foundation of chalk, 24.8 × 38.4 cm. École nationale supérieur des Beaux-Arts, Paris

63

Self-Portrait

1649

Inscribed: NICOLAVS POVSSINVS ANDELYENSIS ACADEMICVS
ROMANVS PRIMVS PICTOR ORDINARIVS LVDOVICI IVSTI REGIS
GALLIÆ. ANNO Domini 1649. Romæ. ÆTATIS SVÆ. 55

78 × 64.5 cm

Staatliche Museen zu Berlin, Gemäldegalerie

In 1649–50, Poussin painted two self-portraits, one for Pointel
and the other for Chantelou. The commission originated in
Chantelou's request for a portrait of the artist. Initially, Poussin
intended to have himself painted by a portraitist in Rome.
Dissatisfied with the standard of all of these, however, he
reluctantly undertook the commission himself, despite the fact
that – as he warned Chantelou in a letter of March 1650 – he
had not painted a portrait in 28 years.[1] Unhappy with his first
attempt (i.e. the present picture) he embarked on another,
promising to send Chantelou the better of the two. This turned
out to be the well-known canvas in the Louvre (cat. 64), which
Poussin sent to Chantelou in June 1650. At the same time, he
dispatched the present painting to the latter's rival, Pointel. His
memory still fresh from the accusations he faced over the
Finding of Moses and the *Ordination* (fig. 150, cat. 53), Poussin
assured Chantelou that this time he had no cause to be jealous
of Pointel; for, in the artist's estimation, the picture destined for
him was 'the better painting and the better likeness'.[2]

The present canvas portrays a half-length view of the artist
facing to the right and wearing a pensive and somewhat
melancholy expression. He clasps a chalk holder in one hand

and rests his other hand upon a book. Behind him is a sculpted
relief depicting two putti supporting a garland and flanking a
tablet which bears an inscription identifying the artist, the date
of the painting and the sitter's age. This motif resembles a
funerary monument and is closely comparable to several works
of this kind (fig. 144) executed by the Flemish sculptor François
Duquesnoy (1597–1643), with whom Poussin had shared a
house during his early years in Rome. The whole forms a kind
of *memento mori*, different in type but not in theme from the
vanitas self-portraits so often encountered in Dutch
17th-century art.

Reflecting this elegiac mood are the characterisation and
colouring of the painting, both of which differ markedly from
the self-portrait for Chantelou. In the gentle tilt of his head and
the wistful expression of his eyes, Poussin stresses here the
more lyrical and vulnerable aspects of his nature and, above all,
his warmth and humanity. This plaintive mood, faintly tinged
with sadness, is matched by the colour-scheme of the picture,
which is pervaded by sombre tones of black, brown and grey.
With its delicate gradations of tone and hue, this mono-
chromatic harmony evokes all that is most fleeting and elusive
in nature and reinforces the transience of the theme.

This depiction undoubtedly accords with one side of
Poussin's temperament – that which, in his letters, frequently
reveals a deep-seated resignation in the face of fate and
misfortune. 'We have nothing that is really our own', he
confessed to Chantelou in 1643, 'we hold everything as a loan'.[3]
But if such a sentiment accords with the prevailing mood of the
present picture, it is revealing that Poussin regarded this as an

Fig. 144 François Duquesnoy, *Funerary Monument to Ferdinand van der
Eynden.* Marble, 1630. S. Maria dell'Anima, Rome

inferior likeness of him when compared with the self-portrait for Chantelou, which is one not of resignation but of stoical resolve.

Comparison with an early engraving of this picture by Jean Pesne (fig. 145) reveals that the Berlin painting has been cut down on all four sides, with the greatest losses occurring at the top. The engraving also includes an inscription on the spine of the book held by the artist. This reads *De lumine et colore* and previously also existed on the picture itself. During a recent cleaning of the present canvas, this inscription was discovered to be a later addition and removed.[4] Since it appears on an engraving of *c.* 1660, however, it must have been added to the picture soon after its arrival in Paris and probably with the artist's knowledge. The authenticity of the inscription at the top is also doubtful, though it too appears on the engraving and – from the evidence of the second self-portrait – is likely to have replaced one by Poussin himself.

Bernini saw the Pointel *Self-Portrait* in Cérisier's collection when he visited Paris in 1665. Though concurring with the artist's own judgement that it was not as good a likeness as the painting for Chantelou, he 'studied it with great concentration'. 'A little later', Chantelou continues, 'when they tried a second time to take it away, he asked for it to be left there a little longer'.[5] Perhaps Bernini too was beguiled by this disarming image of Poussin at his most approachable.

1. *Correspondance*, p. 412. The identity of the portrait made 28 years before (i.e. in 1622) is impossible to establish, since no earlier works of this type by Poussin survive, with the exception of the self-portrait drawing of *c.* 1630 in the British Museum (fig. 1), which most scholars accept as authentic.

2. *Ibid.*, p. 416.

3. *Ibid.*, p. 197.

4. Much scholarly attention has been devoted to this inscription, which has been enlisted to explain Poussin's theories of light and shadow or even to announce a treatise that he one day intended to write. In the end, Blunt may have been nearer to the truth when he observed: 'No satisfactory solution has been offered for the fact that Poussin, a firm partisan of *disegno*, should have chosen to inscribe on the book he is holding the battle cry of his opponents, the supporters of *colore*.' (Blunt 1967, text vol., p. 265, n. 18). Whoever added the inscription, however, was admirably sensitive to the visual subtleties of the Berlin picture, which is one of the most finely nuanced of Poussin's paintings in both tone and hue.

5. Chantelou (ed. 1985), p. 110.

PROVENANCE
Painted for Pointel in 1649 and sent to Paris on 19 June 1650; by 1655, Cérisier; Solly Collection; 1821, purchased by the Museum

EXHIBITIONS
Paris, 1960, no. 89a; Paris, 1994–5, no. 189

ŒUVRE CATALOGUES
Blunt, no. 1, Thuillier, no. 163, Wild, no. 147, Wright, no. 144, Mérot, no. 1

REFERENCES
Félibien (ed. 1725), IV, p. 62; Dorival, 1947; Blunt, 1947², pp. 222–5 (on the version in the Gimpel collection); Winner, 1987

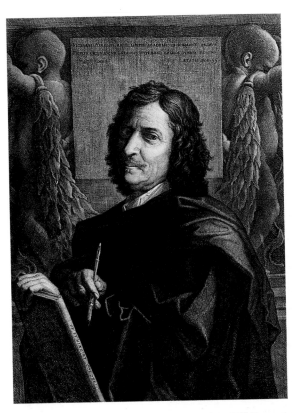

Fig 145 Jean Pesne (*after* Nicolas Poussin), *Self-Portrait* (Berlin version). Engraving, 35.85 × 24.6 cm, c. 1660. The Trustees of the British Museum, London

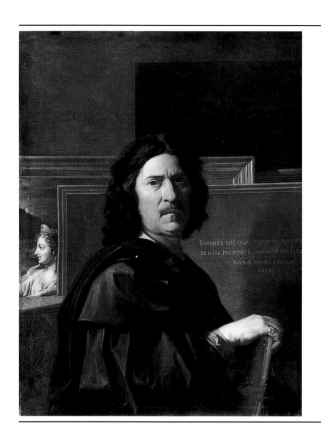

64
Self-Portrait

1649–50

Inscribed: EFFIGIES NICOLAI POVSSINI ANDELYENSIS PICTORIS.
ANNO ÆTATIS. 56. ROMÆ ANNO IVBILEI 1650.
98 × 74 cm

Musée du Louvre, Département des Peintures, Paris

This celebrated canvas has fixed Poussin's image for posterity.
Regarded by the artist himself as 'the better painting and the
better likeness' of his two painted self-portraits, it epitomises
those qualities one associates with the master: severity,
authority and unflinching determination. Though superficially
similar to the earlier *Self-Portrait* for Pointel (cat. 63), the
present picture is very different in theme. Whereas the former
commemorates Poussin's frailty and mortality, the latter
celebrates the most enduring facets of his character: his
devotion to his friend and patron Chantelou and to the art of
painting.

Like the Berlin *Self-Portrait,* the present canvas portrays a
half-length view of the artist facing to the right and wearing a
toga, in the manner of the ancients. Behind him appears a group
of framed canvases and a door, representing an abstract view of
the artist's studio. Plainly visible on a fragment of one of these
pictures is a female figure, embraced by two hands, who is
wearing a diadem with an eye in the middle. According to
Bellori,[1] this motif symbolises Painting embraced by the arms of
Friendship and is a reference to the artist's unswerving
dedication to the patron of the present picture, Chantelou.
Poussin rests his hand on a portfolio, as more than one critic

has observed, like Moses gripping the tablets of the law. On his
finger is a diamond ring cut into a four-sided pyramid. This is a
well-known stoical symbol of constancy and serves further to
clinch the theme.[2] At the right, an inscription records the
identity of the sitter and the date of the painting – 1650, the
year of the Pope's jubilee.

In contrast to the earlier *Self-Portrait*, Poussin here portrays
himself as a stern and formidable figure, one obviously not
given to compromise or deviation from his chosen path. This is
apparent in the erect pose of his head, the fixity of his gaze and
the mane-like treatment of his hair. Reinforcing this impression
is the geometric severity of the background and the clear and
decisive colouring of the work, which contrasts strikingly with
the monochromatic palette employed in the 'funereal' self-
portrait for Pointel. Pictorial rectitude here becomes an
expression of moral rectitude and reminds us of the discipline
and deliberation with which Poussin confronted the challenges
of both art and life.

The definitive status of this portrait has inevitably given rise
to much symbolic interpretation, especially where the female
figure in the background is concerned. Variously seen as
Thermutis, Hera, Providence, or even the artist's own wife, she
is more likely to represent the figure described by Bellori, who
assuredly based his interpretation on the artist himself. As a
personification of the art of painting, she may also be seen to
double as the artist's muse and takes the role traditionally
reserved for such figures in other portraits of creative artists,
among them Ingres's *Portrait of Cherubini* (1842; Louvre,
Paris).

The abstract surface design of this picture, with its prevailing
emphasis upon straight lines and right angles, is reminiscent of
the devices employed in *Eliezer and Rebecca* (cat. 59), the *Holy
Family on the Steps* (cat. 60) and the *Judgement of Solomon*
(cat. 62) of the immediately preceding years. All of these works

Fig. 146 J.-A.-D. Ingres, *The Apotheosis of Homer.* Oil on canvas,
386 × 512 cm, 1827. Musée du Louvre, Département des Peintures, Paris

271

reveal Poussin's art at its most austere and forward-looking. Not until the advent of Seurat and Mondrian does one encounter a comparable insistence upon mathematical order and certainty in painting.

The Louvre picture has won countless admirers and imitators, who have come to regard it as providing the key to Poussin's art and character. Ingres re-employed it in his *Apotheosis of Homer* (fig. 146) of 1827, in which the revered French master appears at the lower left, pointing to the enthroned figure of Homer and acting as an intermediary between the achievements of the ancients and those of the modern school. The picture was copied by numerous other artists – including Seurat (fig. 147) and Maurice Denis[3] – and was even subjected to at least two physiognomic analyses which aimed to uncover in the artist's bone-structure a confirmation of his wisdom, seriousness and apparent invulnerability.[4]

Few would dispute the existence of such qualities in the present canvas, but it is worth remembering that these are based on a single image of the master, painted at the height of his powers and at the most classical moment of his career. Unlike many of his greatest contemporaries – Rembrandt, Van Dyck, or even Rubens – Poussin has bequeathed to us no visual record of his changing emotional and spiritual evolution, upon which one might construct a more well-rounded view of his

personality. Instead, the two portraits explore the opposing sides of his character at the identical moment of his career: one tender and the other austere. What alternative image of the artist might we have had, one wonders, if Chantelou had requested a self-portrait of him in the year of the *Landscape with Orion* (cat. 84) or the *Deluge* (cat. 91)?

1. Bellori, 1672, p. 440.
2. Kauffmann, 1960, pp. 88–95.
3. Cf. Paris 1993, pp. 168 and 183.
4. François-Emmanuel Toulongéon, *Manuel du Muséum français . . .*, I, Paris, 1802, no. 79; Miel de Lacombe, 'Essai physiognomonique sur le Poussin', *Annales de la Société Libre des Beaux-Arts*, VII, 1837, pp. 72–84.

PROVENANCE
1649–50, painted for Chantelou; his heirs; offered by them to Louis XVI in 1778 but refused; 1797, acquired by the Louvre from the dealer Lerouge, by means of an exchange

EXHIBITIONS
Paris, 1960, no. 90; Paris, 1994–5, no. 190

ŒUVRE CATALOGUES
Blunt, no. 2, Thuillier, no. 170, Wild, no. 161, Wright, no. 167, Mérot, no. 2

REFERENCES
Bellori, 1672, p. 440; Félibien (ed. 1725), IV, p. 62; Blunt, 1947², pp. 219–25; Dorival, 1947; Tolnay, 1952; Kauffmann, 1960, pp. 82–98; Posner, 1967; Winner, 1983

Fig. 147 Georges Seurat, *Copy after a Detail in Poussin's Self-Portrait.* Drawing, 21.2 × 14.6 cm, *c.* 1875–7. The Metropolitan Museum of Art, New York. Gift of Mrs Alfred H. Barr, Jr., 1987

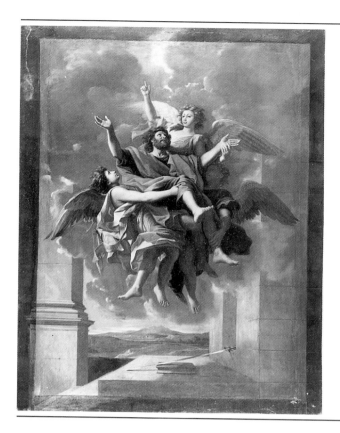

65
The Ecstasy of St Paul

1649–50

148 × 120 cm (originally 128 × 96 cm)

Musée du Louvre, Département des Peintures, Paris

In 1643, Poussin painted an *Ecstasy of St Paul* (fig. 148) for Chantelou as a pendant to a version of Raphael's *Vision of Ezekiel* (fig. 149) that Chantelou owned and believed to be the original. Daunted by the prospect of painting a work that might be compared with one by the Italian Renaissance master, Poussin requested his patron to employ the *St Paul* as a cover for Raphael's masterpiece or at least to exhibit them separately, so that his picture would not lose what little beauty it had.[1] Chantelou presumably dictated the subject of this commission, since it commemorated the saint after whom he was named.

Poussin's second version of the *Ecstasy of St Paul* was painted in 1649–50 for another patron who bore the saint's name, the satirical writer Paul Scarron (1610–60), who specialised in writing parodies of the ancients, which Poussin abhorred. The artist undertook this commission at the request of Chantelou, who was a friend of the poet, and initially planned to provide Scarron with a bacchic subject, which would have been much in keeping with the writer's tastes. In the event, however, he painted for him one of his most chaste and noble religious canvases. Though it is uncertain what led Poussin to change his mind about the subject of Scarron's commission, Alain Mérot has ingeniously noted of the Louvre canvas: 'St Paul is the patron saint of poets, and it is possible that in this work Poussin was making something of a point about poetic dignity to the

man who wrote *Virgile travesti*'.[2]

The theme of the present painting derives from II Corinthians XII and shows Paul borne heavenwards by three angels. Below rest his traditional attributes, the book and sword. The group is set against a luminous bank of cloud and flanked by a pilaster and wall, beyond which stretches an atmospheric landscape. In the upraised eyes and outstretched arms of the saint, Poussin eloquently indicates his ardour and eagerness to ascend aided by the angels, one of whom clasps his left hand and points imperiously towards the heavens.

Though Poussin was never entirely at home with the visions and ecstasies that were the common currency of so many of his Baroque contemporaries, he painted a handful of such works in his maturity, of which the present picture is arguably the finest. In this, he dispenses with the putti included in the earlier *Ecstasy of St Paul*, which were presumably intended to complement those in Raphael's *Ezekiel*, and limits the scene to adult figures, which lend it greater authority. Moreover, whereas the figure group in the earlier version is posed frontally and somewhat statically, in the Louvre canvas it is arranged diagonally and appears to be spiralling upwards. This more dynamic solution is aided by the swirling draperies and extended limbs of the figures, which radiate out from the group like the spokes of a wheel, suggesting greater momentum. Particularly noteworthy is the sequence of five legs silhouetted against the clouds and positioned at regular, rhythmic intervals with the precision and exactitude one has come to expect from this most fastidious of painters.

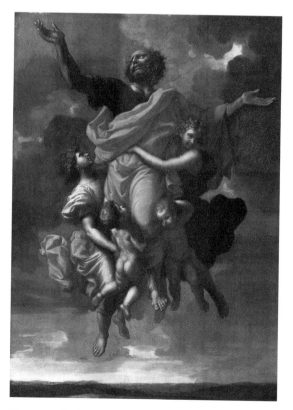

Fig. 148 Nicolas Poussin, *The Ecstasy of St Paul.* Oil on canvas, 41.5 × 30 cm, 1643. The John and Mable Ringling Museum of Art, Sarasota, Florida

Adding to the immaculate appeal of the picture are the elegant draughtsmanship and pure, intense colours, which are set against the silvery greys of the background to brilliant effect. No less striking is the still-life of the saint's attributes, carefully arranged so that the horizontal of the book and the diagonal of the sword echo the lines of the distant fields and hills. This motif recalls the similarly abstract treatment of still-life objects in *Eliezer and Rebecca* (cat. 59) or the *Holy Family on the Steps* (cat. 60) of these same years.

A preliminary drawing for the composition is in the Ecole des Beaux-Arts, Paris.[3]

The picture formed the subject of two *conférences* delivered in the French Academy by Jean Nocret (1670) and Charles Le Brun (1671).[4] A more unexpected admirer of this work was the Surrealist painter André Masson, who derived inspiration from it for his painting *Homme* of 1924–5.[5]

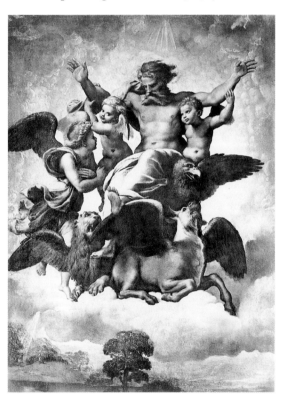

Fig. 149 Raphael, *The Vision of Ezekiel*. Oil on panel, 40 × 30 cm, *c.* 1518. The Palazzo Pitti, Florence

1. *Correspondance*, pp. 202 and 229.
2. Mérot, p. 133.
3. CR I, p. 37, no. 72.
4. Cf. *Conférences* (ed. Jouin), pp. 104–7; *Conférences* (ed. Fontaine), pp. 77–89.
5. Paris 1993, pp. 167–8.

PROVENANCE
1649–50, painted for Scarron; Jabach; Duc de Richelieu; 1665, bought from the latter by Louis XIV

EXHIBITIONS
Paris, 1960, no. 92; Rouen, 1961, no. 86; Bologna, 1962, no. 80; Paris, 1994–5, no. 192

ŒUVRE CATALOGUES
Blunt, no. 89, Thuillier, no. 169, Wild, no. 160, Wright, no. 170, Mérot, no. 95

REFERENCES
Félibien (ed. 1725), IV, p. 60; see n.4 above

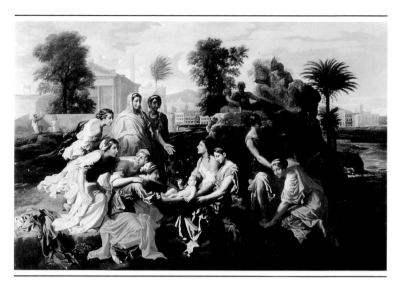

66
The Finding of Moses

1651
116 × 177.5 cm

The Trustees of the National Gallery, London, and the National Museum of Wales, Cardiff (Purchased with a contribution from the National Art Collections Fund)

This is Poussin's third and last treatment of the Finding of Moses. It was preceded by the canvas of 1638 (cat. 35) and by a version of 1647 (fig. 150), painted for Pointel. In both of these, the artist portrays the theme in a self-consciously stylised manner, evident in the Pointel canvas in the symmetrical grouping of the figures and the central position of Pharoah's daughter, who faces outwards, confronting the viewer, and appears scarcely involved in the action. Somewhat surprisingly, this uninspired composition aroused the envy of Chantelou, who accused Poussin of lavishing more attention on this commission for Pointel than upon the *Ordination* (cat. 53) for the second set of Sacraments. Fortunately for Poussin, Chantelou appears not to have known the present picture, which was painted for Bernardin Reynon, a silk merchant from Lyons, in 1651, and surpasses both its predecessors in beauty and inventiveness. In its brilliant colouring alone, it ranks among the most sumptuous and seductive of all the artist's works.

The subject is from Exodus II, 5–10, and shows Pharoah's daughter, dressed in yellow at the left, rescuing the infant Moses from the Nile, accompanied by her handmaidens. One of these, wearing loose hair and a white shift, may be Miriam, Moses' sister, who is being instructed by Pharoah's daughter to fetch a nurse to tend the infant – a role which was to be filled by Moses' true mother. The excitement created by the discovery of the child, who raises his hand to greet or bless the group, is vividly conveyed by the fluttering draperies and rapt gazes of the figures, who rush forward to adore the future leader of the Jews much as the shepherds would to greet the new-born Christ.

Mirroring the semicircular arrangement of the figures is the expansive landscape background, which opens to reveal a distant vista immediately above the figure of Moses. Seated on an outcrop of rock at the right is a personification of the Nile embracing a sphinx. Other elements in the landscape reveal Poussin's archaeological concern to recreate a setting for the action that is convincingly Egyptian. In the background left, a figure holding a tambourine kneels before an altar containing a cult statue of a dog, who may be Anubis or Isis. Immediately behind him is a group of buildings surrounded by a low wall, which is evidently intended to represent a reconstruction of an ancient Egyptian temple complex. Silhouetted against the sky at the extreme left is the Porta Sacra, a sacred gate surmounted by vases; while, to the immediate right of Pharoah's daughter is a tower with a concave roof and a large vase for catching dew, a motif that also appears in the *Holy Family in Egypt* (cat. 80) of 1655–7. All these details of ancient Egyptian life derive from the Palestrina mosaic and the wall paintings from the Columbarium Pamphili in Rome, which were excavated between 1644 and 1652 and were certainly familiar to Poussin.[1]

A recent cleaning of the picture has revealed both its intensity of colour and sharpness of focus. Particularly attractive are the audacious hues of the figures and the delicate blues and whites of the sky. These endow the scene with a pristine clarity and freshness akin to that of the *Holy Family with Six Putti* (fig. 18) or the *Calm* (cat. 73), also of 1651. In all three works, the setting glistens with light and colour, much as it would after a brief sunny shower.

A drawing for the picture, too faint to reproduce here, is in the Louvre.[2]

Three years after completing this picture, Poussin returned to the theme to paint the *Exposition of Moses* (cat. 77), the last work devoted to his favourite Old Testament hero. Thereafter, he explored the theme of the infancy of an elected leader in representations of both the Holy Family and the Adoration of the Shepherds, a subject which (as noted earlier) has obvious parallels with the subject of the present picture. No less striking are the evident similarities in the main figure group of the *Finding of Moses* and that of the *Birth of Bacchus* (cat. 83) of 1657, which is also concerned with the rescue and nurture of a predestined hero. In both, handmaidens or nymphs greet the infant with an eagerness and delight that signal his future greatness.

1. Dempsey, 1963, pp. 113–17.
2. CR I, p. 6, no. 6.

PROVENANCE
1651, painted for Reynon; Duc de Richelieu; Lomenie de Brienne before 1662; Marquis de Seignelay before 1685; Moreau by 1702; Nyert family sale, Paris, 1772; 1st Lord Clive; his descendants until purchased jointly by the present owners in 1988

EXHIBITIONS
Paris, 1960, no. 102; Paris, 1994–5, no. 211

ŒUVRE CATALOGUES
Blunt, no. 14, Thuillier, no. 178, Wild, no. 166, Wright, no. 176, Mérot, no. 11

REFERENCES
Blunt, 1950, pp. 39–40; Dempsey, 1963, pp. 113–17; *The National Gallery Report, January 1988–March 1989*, London, 1989, pp. 12–14

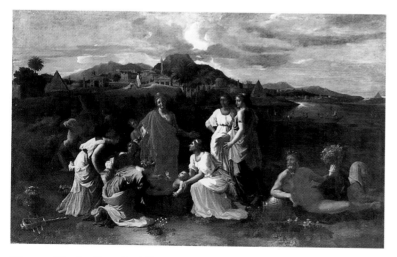

Fig. 150 Nicolas Poussin, *The Finding of Moses*. Oil on canvas, 121 × 195 cm, 1647. Musée du Louvre, Département des Peintures, Paris

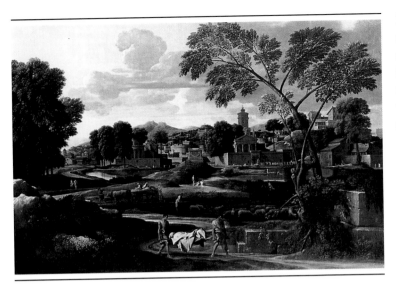

67

Landscape with the Body of Phocion Carried out of Athens

1648

117 × 178 cm

The Earl of Plymouth
(On loan to the National Museum of Wales, Cardiff)

Painted in 1648 for the Lyons merchant Cérisier, Poussin's two landscapes illustrating the story of Phocion have long been regarded as cornerstones of the classical landscape tradition and among the greatest achievements of the artist's maturity.

The theme is from Plutarch's *Life of Phocion* (XVIII). Phocion (402–318 BC), a noble Athenian general and leader of his people, was condemned to death by his enemies in the city and forced to take hemlock. As a further indignity, his body was refused burial within the city walls and carried to the outskirts of Megara, where it was cremated. His widow then secretly gathered his ashes and transported them back to Athens, where they were accorded an honourable burial once the tide of political opinion had changed. This episode forms the subject of the pendant picture (cat. 68).

Poussin's choice of theme, which had never before been treated in painting, reflects his staunch creative independence and profoundly stoical outlook upon life. The theme of the tragic fate which may befall even the most honourable of men had already formed the subject of one of the artist's early masterpieces, the *Death of Germanicus* (cat. 9) of 1626–8, and appears elsewhere in his art.[1] It is possible that the story of Phocion appealed to Poussin because of its close parallels with events in France in the late 1640s, where the civil unrest that was to lead to the outbreak of the Fronde in 1649 was already gaining momentum.[2] On a deeper level, Poussin himself must have identified closely with the character of Phocion, who possessed many of the traits which the artist valued most highly. Living a life of virtue, moderation and humility, the great Athenian prided himself on his prudence and frugality, and valued honour and friendship above all worldly possessions.

Like the master of the Louvre *Self-Portrait* (cat. 64), too, he struck his contemporaries through his 'stern and forbidding' appearance. In all of these respects, Phocion appears as a model for Poussin's own mode of living, with the important exception that whereas the painter chose a life of contemplation and withdrawal, the Greek general followed an active, public life, subject to the inconstancy of his people.

The landscape in which Poussin has set the burial of Phocion is one of unparalleled splendour, which at once seems to celebrate the virtues of his hero and to serve as an ironic foil to his unhappy fate. On a mound in the centre middle distance of the picture stands the tomb of a rich Athenian – one such as Phocion himself deserved, and one probably earned by material wealth rather than genuine virtue. This motif acquires added poignancy when one recalls an earlier incident from Phocion's life. Questioned by a rival on what good he had done for the city of Athens during his years as its general, the peace-loving Phocion retorted: 'Do you think it nothing, then, that our citizens are all buried at home in their own tombs?' If the elaborate tomb above Phocion's corpse commemorates this gift to his people, death itself was his cruel 'reward'.

At the upper right, a procession of figures approaches the Temple of Zeus, an annual event celebrated by the Athenians on 19 May, the day of Phocion's execution. According to Plutarch, 'all those who were still capable of humanity and whose better feelings had not been swept away by rage or jealousy felt that it was sacrilege not to postpone the execution for a single day and thus preserve the city from the pollution incurred by carrying out a public execution while a festival was being celebrated.' In keeping with this festive mood, the landscape is brimming with figures engaged in a variety of activities, all of them unaware of the tragic fate that has befallen Phocion.

In devising the setting, Poussin applied the rigorous principles of composition of his most Raphaelesque paintings of these years to the creation of a landscape. Like the *Baptism* (cat. 51) or *Ordination* (cat. 53) from the Chantelou Sacraments, the protagonists are centrally placed and the design contains firm framing elements and a parallel recession back into space. Adding to the clarity and coherence of the construction is the rhythmic disposition of buildings and trees in the distance and the carefully distributed accents of light. The result is a composition that is not only much more ambitious than the artist's two evangelist landscapes of eight years earlier (cat. 46–7), but also more logically ordered, one in which an intensely idealised vision of nature is made wholly believable.

This aspect of the picture may instructively be compared with the landscapes of Poussin's predecessors, especially Domenichino, whose *Landscape with the Flight into Egypt* (c. 1625; fig. 151) portrays an equally imposing and heroic view of nature. Unlike Poussin's *Phocion*, however, Domenichino's landscape consists of a somewhat disjunctive arrangement of elements which appear to have been conceived as separate units and brought together to form a larger whole. This impresses us more as an anthology of natural motifs than as a convincing scene. Moreover, Domenichino relegates the Holy Family to the

lower right-hand corner of his picture, where it may easily be overlooked amongst the welter of activity that surrounds it. In contrast, Poussin coordinates subject and setting in the Phocion pictures so that both form part of an indissoluble whole. This feature of Poussin's landscapes earned the admiration of Wordsworth, who praised them for their 'unity of design', their 'superintending mind' and (above all) their 'character of *wholeness*'.[3]

Certain of the buildings in the background of the present picture have been identified, the circular temple in the grove at the left with Palladio's reconstructions of the Temples of Vesta in Rome and Tivoli and the circular fortress to the right of it with the Castel Sant'Angelo, which Poussin also introduced into the background of his *Landscape with Orpheus and Eurydice* (cat. 70).

The picture has always been among the most celebrated of the artist's landscapes, both for its formal beauty and its tragic theme. Around 1695, it was made the focus of an imaginary dialogue between Poussin and the ancient Greek painter Parrhasius, which was written by Fénelon and was clearly intended to portray Poussin as the equal of the greatest masters of antiquity.[4] Thereafter, the picture earned the esteem of Delacroix who, in his great essay on Poussin of 1853, praised the solemn gravity of its mood. 'What could be more striking', wrote the French Romantic master, 'than this sombre vault of ancient trees under which advance the two poor slaves bearing the body of the virtuous Phocion, while the view proceeds in the distance towards the pleasant countryside around Athens, his ungrateful fatherland!'[5]

A recently discovered drawing for the principal figure group in the present picture is in the Louvre.[6]

1. *Supra*, pp. 22–3, 30–1, 34.
2. Cf. Blunt, 1944, p. 158–61.
3. *The Complete Works of William Hazlitt*, ed. P. P. Howe, London and Toronto, 1934, XI, p. 93.
4. Fénelon, 1730, pp. 173–85.
5. Delacroix (ed. 1966), p. 107.
6. Blunt, 1974, p. 241 and pl. 7.

PROVENANCE
1648, painted for Cérisier; by 1687, Pierre de Beauchamp; 1702, Denis Moreau; by descent to the Nyert family; by 1774, Lord Clive; by descent to the present owner

EXHIBITIONS
Paris, 1960, no. 80; Bologna, 1962, no. 75; Edinburgh, 1990, no. 18; Paris, 1994–5, no. 168

ŒUVRE CATALOGUES
Blunt, no. 173, Thuillier, no. 155, Wild, no. 175, Wright, no. 152, Mérot, no. 228

REFERENCES
Félibien (ed. 1725), IV, pp. 59 and 148; Fénelon, 1730, pp. 173–85; Blunt, 1944, pp. 157–64

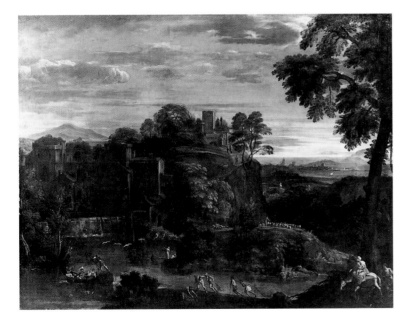

Fig. 151 Domenichino, *Landscape with the Flight into Egypt.* Oil on canvas, 165 × 212 cm, *c.* 1625. Musée du Louvre, Département des Peintures, Paris

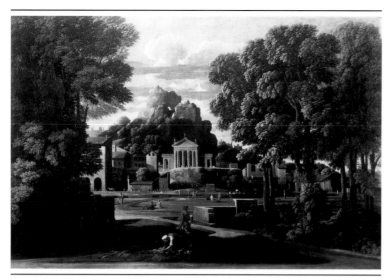

68

The Ashes of Phocion Collected by his Widow

1648

116.5 × 178.5 cm

Trustees of the National Museums and Galleries on Merseyside (Walker Art Gallery, Liverpool)

The second of the two Phocion landscapes differs in type, as in theme, from its pendant (cat. 67). In the latter, Poussin contrasts the heroic action of the slaves bearing Phocion's body out of Athens with the public ignominy that has resulted in his execution, symbolised by the monumental cityscape which forms the setting of the picture and at once recalls the hero's dignity and eventual disgrace.

In the present picture Poussin commemorates instead the private devotion of Phocion's widow and a maidservant as they gather his ashes on the outskirts of Megara, a clandestine act that is mirrored in the more enclosed and mysterious nature of the scene. Protected from the town by a grove of trees, whose dense shadows fall across the foreground of the picture, as though serving as an accomplice to the action, Phocion's widow performs her task in a manner that conveys both her trepidation and despair. Gazing warily on, as if fearful of detection, is her faithful maidservant; while, hidden in the shadows at the right is a youth, spying upon the women. His presence reinforces the surreptitious nature of the deed and serves to remind us of its attendant dangers. In the middle distance, Poussin includes a variety of figures engaged in everyday pursuits who seem oblivious to the momentous events that surround them. Bathing, reading or practising archery, they go about their daily lives indifferent to Phocion's fate. The world does not pause over the downfall of one man, suggests Poussin in this and other works of these years.

According to the early sources, ancient Megara was built upon two rocks. Poussin introduces these above the central temple, where they serve both to set the scene and to enhance the ominous mood of the picture. Even to the naked eye it is apparent that these rocks are painted over a layer of cloud and

were added at a late stage. The temple itself is derived from a reconstruction by Palladio of a temple at Trevi and adds to the convincingly antique character of the scene.

The style of the picture shows Poussin's art at its most immaculate, with its crisply chiselled forms, brilliant accents of light and colour and firmly blended handling. Most remarkable of all, however, is the striking surface design. This immediately arrests one's gaze through the framing of the distant townscape by the foreground trees, a relationship that appears to defy the sense of recession created by the buildings and figures in the middle distance. Reinforcing this are the numerous relations Poussin uncovers between disparate elements in the composition – between the clouds, rocks and flanking trees; the columns of the temple and the trunks of the trees; or the ascending line of the hills at the upper right and the pathway leading into the picture. In the last of these, a motif that lies parallel to the picture plane aligns itself with one that recedes diagonally into it, creating a tension between space and surface that is ultimately resolved by the abstract unity of the surface design.

Adding to the majesty of the whole is the equal emphasis accorded to both vertical and horizontal axes within the composition, rather than to the horizontals that normally prevail in landscape painting. This gives the picture an intricately faceted appearance and accounts for its remarkable concentration. The result is among the most rationally conceived of all Poussin's works and one of his greatest evocations of the order, diversity and nobility of the natural world. Small wonder that, upon seeing this picture in Paris in 1665, Bernini pointed to his forehead and exclaimed: 'Signor Poussin is an artist who works from here'.[1]

The geometric articulation of the picture surface in the present canvas is characteristic of a number of Poussin's paintings of 1648–50, including *Eliezer and Rebecca* (cat. 59), the *Holy Family on the Steps* (cat. 60) and the Chantelou *Self-Portrait* (cat. 64). In all of these, the artist contrasts the irregular forms of the natural world with the rounded or rectilinear shapes of man's own devising to achieve a tautly integrated surface design that recalls the abstract art of our own century. Poussin may have been led to adopt this severe method of pictorial composition by the prolonged experience of painting the Chantelou Sacraments, six of which include architectural backgrounds that provide a geometric setting for the actions of the figures. Conceived in a shallow, frieze-like manner, these works anticipate the austerity and finality of the composition of the present picture, which is arguably Poussin's finest landscape of these years and his supreme embodiment of the stoical belief that 'nothing is more finished, more nicely ordered than Nature'.[2]

1. Chantelou (ed. 1985), p. 111.
2. Cicero, *De Finibus* III, xxii, 74

PROVENANCE
1648, painted for Cérisier; still in his possession in 1665; between 1776 and 1782, acquired by the 12th Earl of Derby; thence by descent; 1983, acquired by the Walker Art Gallery

EXHIBITIONS
Paris, 1960, no. 81; Bologna, 1962, no. 76; Edinburgh, 1990, no. 19; Paris, 1994–5, no. 169

ŒUVRE CATALOGUES
Blunt, no. 174, Thuillier, no. 156, Wild, no. 176, Wright, no. 153, Mérot, no. 229

REFERENCES
Félibien (ed. 1725), IV, p. 59; Blunt, 1944, pp. 157–64; Walker Art Gallery, Liverpool, *Supplementary Foreign Catalogue*, Liverpool, 1984, pp. 15–18

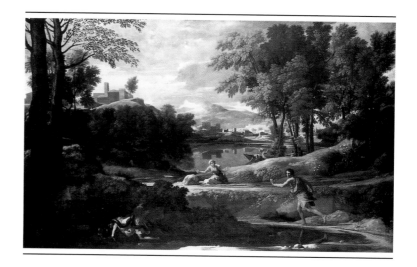

69

Landscape with a Man Killed by a Snake

1648

119.4 × 198.8 cm

The Trustees of the National Gallery, London

According to a lost letter by Poussin, the artist completed this painting for Pointel by 31 August 1648. Given its imposing size and unusual theme, one might assume it to be based on a specific literary source. However, there is no evidence for this; and the subject of the picture – which has given rise to much controversy – would appear to be of the artist's own invention.

Félibien's description of the present painting indicates that its purpose was to explore the effects of horror and fear as they reverberate through a landscape,[1] and this interpretation is borne out by other early accounts of the picture. In the foreground, an innocent youth, who has approached the water's edge either to drink or to bathe, lies strangled by a huge serpent. This incident is witnessed by a fleeing man, whose expression of fear elicits a more restrained reaction from a kneeling woman in the middle distance, unaware of the cause of his alarm. Further back at the left a group of figures recline at the edge of the lake. Though they are scarcely visible in the darkened canvas, an engraving of the composition shows one of these figures turned towards the foreground with an expression of mild curiosity while two others converse, unaware of the presence of the serpent and the dead youth. Like the background figures in the two Phocion landscapes (cat. 67–8), they remain oblivious to the tragic events that occur in their midst.

Though numerous attempts have been made to connect this incident with a precise mythological theme, none is wholly convincing. However, there is a tradition – recorded in both Baudet's engraving of the picture of 1701 and the Strange sale catalogue of *c.* 1773 – that Poussin based this theme on an incident that he had witnessed in the environs of Rome or near the ancient city of Terracina. On this evidence, Blunt posited a trip by Poussin to the snake-infested Lake of Fondi, outside Terracina, in 1647.[2] The theory has not met with general

acceptance and, even if it were true, is irrelevant to the picture's deeper meaning.

The theme of a serpent lurking in the grass to prey upon unsuspecting humanity occurs in a number of classical sources, including the *Iliad* (III, 32–4; XXII, 92–5) and *Aeneid* (II, 377–80). It also appears in Dante's *Inferno* (VII, 83–4), but finds its most memorable expression in Virgil's *Eclogues* (III, 92–3):

> You lads there, gathering flowers and strawberries from their earthy beds, take to your heels! There's a clammy snake lurking in the grass.

In all of these, it serves as a classical *topos* of the omnipresence of death in the midst of peaceable nature. In this form the

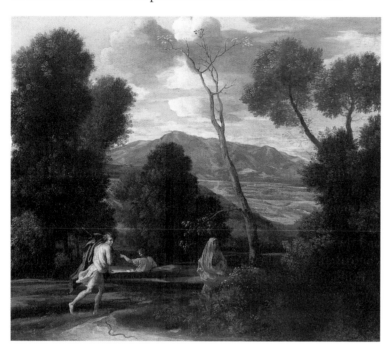

Fig. 152 Nicolas Poussin, *Landscape with a Man Pursued by a Snake.* Oil on canvas, 65 × 76 cm, *c.* 1635. Montreal Museum of Fine Arts

serpent reappears in Poussin's later landscapes with *Orpheus and Eurydice* (cat. 70) and *Two Nymphs and a Snake* (fig. 15). On a more fundamental level, the theme may also be related to the artist's two versions of the *Arcadian Shepherds* (cat. 13, 38) and serves as a reminder that death lurks where one least expects it.

Poussin had already treated a similar incident in a landscape now at Montreal (*c.* 1635; fig. 152) which shows a man pursued by a serpent, whose presence is undetected by a woman and fisherman nearby. Here, too, the artist appears to be exploring the sudden dangers that may befall hapless humanity – a favourite theme of his art which may be related to the teachings of the Stoics, who often referred to attacks from wild beasts as symbolic of the wayward workings of Fortune.[3] Yet they also teach that fear itself drives wisdom from the mind.[4] Seen in this way, the reactions of the figures in this painting would be regarded as reprehensible by the Stoics, who considered wisdom and strength to be the only weapons against what Poussin himself called the 'tricks of fortune'.[5]

Three drawings survive for the present painting,[6] among them a compositional study (fig. 153) which portrays a solitary figure in the landscape and suggests that the theme of this canvas only occurred to Poussin at an advanced stage in the planning. This may explain the apparent anomaly between the picture's tragic theme and the harmony and tranquillity of the setting, which contrasts with the more ominous landscapes Poussin devised for two comparable Ovidian subjects during these same years, *Orpheus and Eurydice* and *Pyramus and Thisbe* (cat. 75). It may equally be argued that the Virgilian symbolism of this picture necessitates a vision of benevolent nature.

Like the *Landscape with the Body of Phocion Carried out of Athens,* the London painting formed the subject of an imaginary dialogue by Fénelon of *c.* 1695. In this, Poussin discusses the work with Leonardo, who initially appears puzzled by its subject:[7]

> Leonardo: But what is the design? – is it history? I don't know it. It is rather a caprice.
>
> Poussin: It is a caprice.

Later, the dialogue continues:

> Leonardo: This picture, from what you tell me, appears less learned than that of Phocion.
>
> Poussin: There is less of the knowledge of architecture, it is true. Besides, it displays no acquaintance with the antique. But, on the other hand, the science of expressing the passions is considerable.

These ideas, which may derive from Poussin himself, suggest that the artist had another objective in the London canvas. This was to move the soul and emotions of the viewer through the reactions of his figures to a dramatic theme set in an ideal

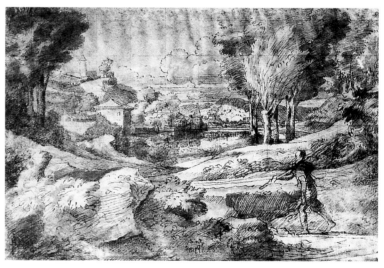

Fig. 153 Nicolas Poussin, *Study for the Snake Landscape.* Black chalk underdrawing, pen and bistre wash; pen and grey wash, black chalk squaring, 26 × 38.8 cm. Musée des Beaux-Arts, Dijon

landscape. Such a goal is wholly in keeping with the aims of Poussin's mature history paintings and serves to distinguish his landscapes from those of virtually all his contemporaries. For, in these works too, it is the idea that matters most.

1. Félibien (ed. 1725), IV, pp. 63, 150–1.
2. Blunt, 1967, text vol., pp. 286–91.
3. Cf. Cicero, *De Officiis*, II, 6, 19–20.
4. Cf. 'Of Fear', *The Complete Essays of Montaigne*, trans. Donald M. Frame, Stanford, 1965, pp. 52–3 (and the classical sources cited there).
5. Further to this theme in Poussin's landscapes of these years, see Verdi, 1982 and *supra*, pp. 33–5.
6. CR IV, pp. 46–7, nos. 281–3.
7. Fénelon, 1730, pp. 186–95

PROVENANCE
1648, painted for Pointel in 1648; Duplessis-Rambouillet; 1685, Denis Moreau; by descent to the Nyert family; bought from them *c.* 1773 by Robert Strange; Sir Watkin Williams-Wynn; 1947, purchased by the Gallery from his descendant

EXHIBITIONS
Paris, 1960, no. 83; Bologna, 1962, no. 74, Paris, 1994–5, no. 179

ŒUVRE CATALOGUES
Blunt, no. 209, Thuillier, no. 159, Wild, no. 140, Wright, no. 155, Mérot, no. 236

REFERENCES
Félibien (ed. 1725), IV, pp. 63, 150–1; Fénelon, 1730, p. 186–95; Waterhouse, 1939; Watson, 1949; Tervarent, 1952

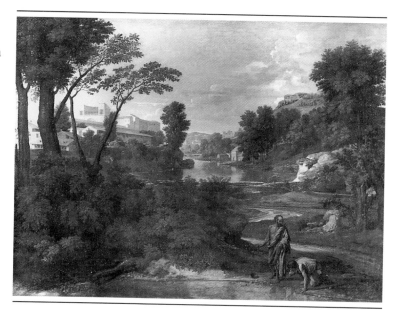

70

Landscape with Diogenes

1648

160 × 221 cm

Musée du Louvre, Département des Peintures, Paris

If Poussin's favourite ancient hero was not Phocion, it was most probably Diogenes, whose mordant wit and simple manner of living would automatically have endeared him to the artist.[1] Proof of this may be found in the theme of the present picture, which – like those of the two Phocion landscapes (cat. 67–8) – had never been painted before. This depicts an incident recorded by Diogenes Laertius (*Lives of Eminent Philosophers*, VI, 37). Diogenes (420–324 BC), the Cynic philosopher from Sinope, had reduced his worldly possessions to a cloak and a drinking bowl. He is here shown casting the latter aside at the sight of a youth drinking from his hands alone, whose action convinces him that this possession is unnecessary to his stoical manner of existence.

The idea of renouncing one's worldly possessions to return to a state of nature is mirrored in the surrounding landscape, which is one of the most spacious and luxuriant of the artist's career. Rather than the lucid and rigorous interplay of natural and architectural elements of the Phocion pictures, Poussin creates here a scene of verdant and untrammelled growth that befits the theme. To be sure, the artist includes a prominent group of buildings at the upper left, which contrasts with the dense outcrop of trees and undergrowth in the foreground of the scene. Prominent among these buildings is the Belvedere of the Vatican, which also forms the subject of a drawing by the artist of these same years.[2] But in this contrast alone Poussin seems to retrace Diogenes's progress from civilisation back to nature.

This theme is further reflected in the broad and textured handling of the picture and in the almost intoxicating range of greens that pervades it. Poussin even seems to allude to the

natural state of existence of his protagonists in the colours that clothe them. These are blue and yellow, which combine to make green, the dominant hue of the rest of the picture and of nature itself.

According to Félibien,[3] the present landscape was painted in 1648 for Lumague – almost certainly Marc-Antoine II Lumague, a Swiss banker frequently mentioned in Poussin's letters, who resided in both France and Italy, dying in Milan in 1655. Recent research by Marie-Félicie Pérez[4] has revealed that Lumague was an important benefactor of churches and charitable institutions in both of these countries, a role which would be appropriate to the theme of the present painting. So far as we know, Poussin executed no other works for this patron.

In 1961, Denis Mahon rejected Félibien's date for this picture on grounds of style and suggested that it was painted ten years later, c. 1658–60 (i.e. after Lumague's death in 1655). This view, which has not found general acceptance, was based on a reasoned analysis of Poussin's altered attitude towards nature in the Louvre canvas when compared with the Phocion pictures of 1648. Unlike them, the *Landscape with Diogenes* accords a less prominent role to architecture and is pervaded by a softer light and atmosphere and a more fluid application of paint – all of which make nature itself the true protagonist of the picture. Few would dispute the accuracy of these judgements; but they may be explained by the different nature of the picture's theme and by Poussin's remarkable stylistic versatility, even at the same moment of his career. A classic example of this is the *Plague at Ashdod* (fig. 26) and *Kingdom of Flora* (cat. 20), which were dated six years apart until documentary evidence proved otherwise. Until such evidence regarding the *Diogenes* emerges, it is likely that most critics will prefer to follow Félibien, who was in Rome between 1647 and 1649, and retain the date of 1648.

The Louvre picture has long been among the most celebrated of Poussin's landscapes, especially among 19th-century artists and critics, who were attracted by its subtlety of colour and lighting and its prevailing naturalism. One of these was J. M. W. Turner, who praised it as a 'charming and grand composition' with 'the foreground large as to parts and beautifully pencil'd and the figures happily introduced'.[6] With the exception of *Winter* from the Four Seasons (cat. 91), it was the most highly valued of all the artist's landscapes in the French national collection during the 19th century; and in 1851, it was the only painting by Poussin – indeed, the only French picture – to be hung in the Salon Carré of the Louvre, that pantheon traditionally reserved for the gems of the collection, including the *Mona Lisa*.

1. Further to the parallels between Diogenes and Poussin, see p. 30 above.
2. CR IV, p. 46, no. 200.
3. Félibien (ed. 1725), IV, p. 59.
4. M.-F. Pérez, 'Le Mécénat de la famille Lumague', *Mazarin et la France*, Grenoble, 1985, pp. 161–2.
5. Mahon, 1961, pp. 129–32 and *passim*. Blunt's arguments against this view are set out in his catalogue entry on this picture: Blunt, no. 150.
6. A. J. Finberg, *A Complete Inventory of the Drawings of the Turner Bequest*, London, 1909, I, p. 183.

PROVENANCE
1648, painted for Marc-Antoine II Lumague; Duc de Richelieu; 1665, purchased with his collection by Louis XIV

EXHIBITIONS
Paris, 1960, no. 82; Bologna, 1962, no. 85; Rome, 1977–8, no. 32; Düsseldorf, 1978, no. 31; Edinburgh, 1990, no. 22; Paris, 1994–5, no. 171

ŒUVRE CATALOGUES
Blunt, no. 150, Thuillier, no. 160, Wild, no. 139, Wright, no. 156, Mérot, no. 226

REFERENCES
Félibien (ed. 1725), IV, p. 59; Kimura, 1979, 1982, 1983

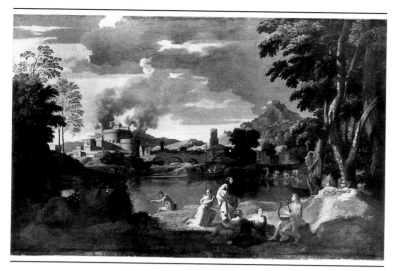

71

Landscape with Orpheus and Eurydice

c. 1650

124 × 200 cm

Musée du Louvre, Département des Peintures, Paris

Surprisingly, this important landscape is not mentioned by any of the early writers on Poussin until 1685, when it entered the collection of Louis XIV. Recent research has revealed, however, that it was painted for Jean Pointel, the Parisian merchant who was Poussin's chief French patron after Chantelou. Twenty-one paintings and eighty drawings by the artist were listed in the posthumous inventory of Pointel's collection, including the *Landscape with a Man Killed by a Snake* (cat. 69), the present canvas and the closely related landscapes with a *Calm* and *Storm* (cat. 73–4).[1]

The subject is from Ovid (*Metamorphoses*, X, 1–11). Orpheus summoned Hymen, god of marriage, to attend his wedding festivities with Eurydice. 'He did not bring good luck', notes Ovid:

His expression was gloomy, and he did not sing his accustomed refrain. Even the torch he carried sputtered and smoked, bringing tears to the eyes, and no amount of tossing could make it burn. The outcome was even worse than the omens foretold; for while the new bride was wandering in the meadows, with her band of naiads, a serpent bit her ankle, and she sank lifeless to the ground.

Orpheus then follows her to the underworld, where he laments the fact that 'we mortals and all that is ours are fated to fall to you, and after a little time, sooner or later, we hasten to this one abode'.

Like the Phocion landscapes (cat. 67–8) and the *Man Killed by a Snake*, the theme is one of the tragic fate that may befall even the most fortunate or innocent of beings. Poussin intensifies the poignancy of this idea in the present picture by dividing the figure group into two. At the right Orpheus is shown serenading the wedding party with his lyre, attended by two reclining female figures and the standing figure of Hymen. Behind the latter appears the frightened Eurydice, who has just

espied the serpent that will kill her. This tragic turn of events is witnessed only by a man fishing in the lake behind the group. As Maurice de Sausmarez has observed, however, 'one of the haunting things about this painting is the fact that you, the spectator, are the only person to share Eurydice's full horror – the fisherman does not yet realise the cause of her startled movement, the presence of the snake, and Orpheus and his enraptured friends are too deeply immersed in the beauty of his song'.[2]

The scene is pervaded by a mood of ominous tranquillity, evident in the contrast between the serenity of the background landscape and the leaden sky which rises above it. In the distance, at the left, thick smoke issues from a building resembling the Castel Sant'Angelo, as though to remind us of the ill-omened wedding ceremony, with its sputtering torch. Most disquieting of all, however, is the shadow that encroaches upon the foreground of the picture, symbolising those powers of darkness that will soon engulf the hapless lovers. As so often in his treatment of tragic themes, Poussin contrasts the fate of the individual with the continuing life of mankind – and of nature itself. In the middle distance figures are shown swimming in a lake, tugging a boat along the shore or simply relaxing at the water's edge, in all cases heedless of the terrible twist of fate that has befallen Eurydice.

The composition of the landscape – with its framing trees, centrally positioned lake and background of buildings and mountains – recalls that of the *Landscape with a Man Killed by a Snake* of 1648 and the *Calm* of 1651. Though the present picture is not exactly dated, a drawing of a blazing castle in the British Museum which may be related to it is executed on the back of a letter by Poussin of 1650,[3] a date that is consistent with the style of the Louvre canvas.

From the evidence of both Pointel's inventory and an early engraving, it is clear that the present picture has been cut by about 25 cm in height. In its original format, it contained much more of the dark grey sky and ominous foreground shadow.

Poussin treated the myth of Orpheus and Eurydice in two other works. One of these is among the mythological drawings for Marino executed in Paris in 1622–3 and depicts Orpheus serenading the gods of the underworld.[4] The other is a magnificent drawing (fig. 154),[5] which dates from 1649, just

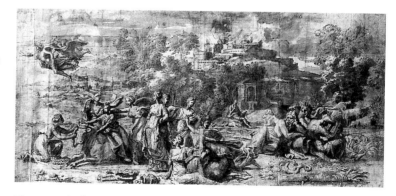

Fig. 154 Nicolas Poussin, *The Rape of Europa.* Pen with slight bistre wash, 26.3 × 57.2 cm. Statens Konstmuseen, The National Swedish Art Museums

before the present painting. The drawing portrays the theme of the rape of Europa at the left and the death of Eurydice on the opposite side and is a compositional study for a painting that now exists only in a much-damaged fragment.[6] Though the stories of Europa and Eurydice are unrelated in Ovid, Poussin combines them to symbolise the order and balance of nature, a theme that is frequently to be found among his very late works. Thus, the fertility of Europa, who is abducted to found a dynasty of kings on Crete, is contrasted with the unfruitful darkness of Eurydice in the underworld. This idea is also implicit in the *Landscape with Orpheus and Eurydice* through the contrast between Eurydice's sudden death and the teeming life of man and nature which surrounds it.

1. Thuillier-Mignot, 1978, pp. 39–58.
2. Sausmarez, 1969, p. 28.
3. CR IV, pp. 47–8, no. 284.
4. CR III, pp. 12–13, no. 161.
5. CR III, pp. 14–15, no. 166.
6. Blunt, no. 153, Mérot, no. 139 (with further bibliography).

PROVENANCE
Painted for Pointel *c.* 1650; 1685, purchased for Louis XIV by Branjon

EXHIBITIONS
Paris, 1960, no. 93; Bologna, 1962, no. 81; Paris, 1994–5, no. 180

ŒUVRE CATALOGUES
Blunt, no. 170, Thuillier, no. 173, Wild, no. 174, Wright, no. 161, Mérot, no. 219

REFERENCES
See n. 2 above

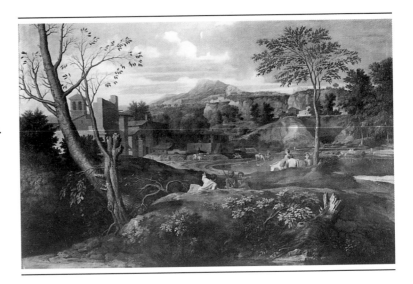

72
Landscape with Buildings

c. 1650–1
120 × 187 cm

Museo del Prado, Madrid

Unmentioned by any of the early writers on Poussin, the *Landscape with Buildings* – which has recently been beautifully cleaned – is unanimously accepted by all scholars on the artist and dated *c.* 1650–1. In its pristine handling and prevailing mood of meditative calm, it is particularly close in style to the *Calm* (cat. 73) that Poussin executed for Pointel in 1651.

The present picture depicts a rugged and uncultivated landscape showing the outskirts of a town at the edge of a lake and bounded by a distant range of mountains and hills. In the foreground, an outcrop of land encloses the composition and enhances its tranquil nature. Animating the landscape is a series of anonymous figures – horsemen, travellers, bathers and figures conversing – who reflect the mood of peace and contentment that pervades the scene. In the centre foreground, two travellers asking the way are redirected by a seated youth clad in blue and red. The outstretched arms of the youth and old man, pointing in opposite directions, provide both a focus for the eye and an inducement to the viewer to explore the broad terrain that stretches beyond them, so rich in human interest and natural variety.

Rarely in his landscape art does Poussin appear more engrossed in the peculiarities of individual forms in nature than in the present painting, with its blasted tree-stumps, dense undergrowth and bare and spindly trees. Yet these elements cannot conceal the equally methodical control the artist has devoted to the overall harmony of the composition. The design is symmetrical, with the foreground group of figures and the distant mountain peak crowned by clouds marking the exact centre of the composition. To either side, framing trees delimit the scene, progressing from the left foreground to the right middle distance and thence to the buildings and hills beyond, in an alternating sequence across the picture which both balances

the composition and charts the progression back into space. Assisting in this are the rhythmically distributed accents of light and colour, particularly the reds, blues and whites of the figures and horses, which appear in different combinations throughout the picture, linking foreground with distance while avoiding obvious repetitions.

In its rural seclusion and selective naturalism, the Prado picture calls to mind the more lyrical landscape art of Poussin's brother-in-law, Gaspard Dughet, who often portrays anonymous travellers resting or conversing in wooded and hilly surroundings (fig. 155). But even Dughet's most classically conceived works in this vein never contain the wealth of interest or the carefully stratified construction of the present picture, which may be seen as a rare incursion by Poussin himself into that realm of nature imagery – gentle and undemonstrative – chiefly associated with his brother-in-law.

It has long been assumed that Poussin did not base the figures in this picture upon any literary source. However, Charles Dempsey has recently suggested that the old man in the foreground is Diogenes departing from Sparta to Athens and has noted the obvious similarities between this figure and the depiction of Diogenes in the Louvre landscape (cat. 70).[1] While this suggestion deserves consideration, it also raises a number of important questions: why would the ever-inventive Poussin choose to devote two otherwise unrelated landscapes to the same ancient hero; and why would he choose to portray so trivial a moment from the philosopher's life – one which is hardly of great moral import and not even mentioned (but merely implied) in Diogenes Laertius's *Life of Diogenes* (*Lives of Eminent Philosophers*, VI, 59)? Moreover, if the subject of the present picture is Diogenes, it becomes all the more surprising that the work is not recorded in the early literature on the artist.[2]

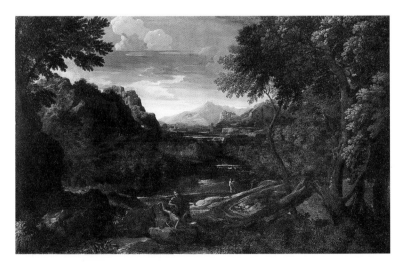

Fig. 155 Gaspard Dughet, *Ideal Landscape*. Oil on canvas, 96.2 × 153.6 cm, *c.* 1657. The Metropolitan Museum of Art, New York, Rogers Fund, 1908

1. Charles Dempsey, 'The Greek Style and the Prehistory of Neoclassicism' in Elizabeth Cropper, *Pietro Testa 1612–1650, Prints and Drawings*, Aldershot, 1988, lxiii, no. 21.
2. Even if this identification is accepted, it does not necessarily follow that the Prado picture may be connected with the *Diogenes* that Poussin painted for Lumague in 1648 and the Louvre *Diogenes* accordingly redated, as Denis Mahon has proposed (*supra*, p. 283). For Félibien specifically states that the painting for Lumague depicted Diogenes breaking his bowl – certainly not the theme of the present picture; and, since he was in Rome in 1648, he was clearly in a position to know.

PROVENANCE
Almost certainly Jacques Meyers sale, Rotterdam, 1714; 1746, inventoried in the collections of Philip V at La Granja

EXHIBITIONS
Rome, 1977–8, no. 36; Düsseldorf, 1978, no. 32; Edinburgh, 1990, no. 23; Paris, 1994–5, no. 181

ŒUVRE CATALOGUES
Blunt, no. 216, Thuillier, no. 180, Wild, no. 142, Wright, no. 154, Mérot, no. 237

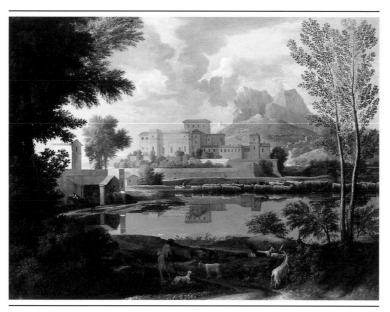

73

Landscape with a Calm

1651

97 × 131.5 cm

Sudeley Castle Trustees

Félibien records that Poussin painted two companion landscapes for Pointel in 1651 depicting a *Storm* and a *Calm*.[1] Though the former was engraved around 1680 (fig. 157), the original versions of both pictures were believed to be lost until the mid-1970s, when the present canvas was identified as the missing *Calm*, previously attributed to Poussin's brother-in-law, Gaspard Dughet.[2] Coincidentally, the original of the *Storm*, likewise attributed to Gaspard, emerged in the collection of a dealer in Rome. It has subsequently been assigned to Poussin himself and is exhibited here (cat. 74). The re-emergence of both of these pictures is the most important Poussin discovery of recent years and serves further to document his output as a landscape painter during its most prolific phase.

Poussin chose to illustrate no literary theme in these two works but simply to portray the contrasting effects upon mankind of benevolent and malevolent nature. The *Storm* depicts the terrified reactions of humanity to Nature's wrath, and the *Calm* is a scene of utter tranquillity, in which man exists in harmony with his surroundings. In the foreground, a peaceful goatherd tends his flock. Poussin derived this motif from the similar figure of a shepherd leaning on his staff in the centre middle distance of the *Landscape with the Body of Phocion Carried out of Athens* (cat. 67). Beyond him stretches a scene of limpid clarity, which centres upon a view of the Belvedere of the Vatican, also visible at the upper left of the *Landscape with Diogenes* (cat. 70). This is painted with a purity and intensity of colour and a sensitivity to the most delicate gradations of light that make the *Calm* appear one of Poussin's most naturalistically rendered scenes. Small wonder that 19th-century viewers believed it to depict an actual site, the Lake of Bolsena.[3]

The style of the painting is close to that of the *Landscape with Diogenes* and the *Landscape with Buildings* (cat. 72) and testifies to the versatility of Poussin's landscape art in the years between 1648 and 1651. With their sharply focused forms and pellucid light, all three of these works anticipate the *'plein air'* effects of the 19th century and differ from the artist's more schematically illuminated scenes of these years. Adding to the appeal of the present work is its excellent state of preservation. Unusually for Poussin, the picture is painted over a light ground, which enhances its vibrant luminosity.

No less remarkable than the colour and handling of the *Calm* are the poise and clarity of its design, which is as finely calibrated as any of Poussin's more ambitious landscapes of this period. The composition is carefully divided into alternating areas of land, water, buildings and sky. In the middle distance, a group of buildings appears wreathed by the intense blues of the motionless lake and billowing clouds – a rarefied effect that calls to mind the art of Claude Lorrain and justifies the description of this picture as 'Nicolas's *Enchanted Castle*'.[4] To either side, groups of trees discreetly frame the composition, the slender poplars at the right unfurling their lacy fronds against the sky to reflect the fragile beauty of the scene. The result is among Poussin's most idyllic and 'uneventful' landscapes and makes it easy to see why the picture bore an attribution to Gaspard Dughet before its recent cleaning.

The back of the original canvas of this picture is inscribed 'N. P. + F. R.' (Nicolas Poussin + Fecit Romae), the cross either indicating that Poussin painted it in the Holy Year of 1650 or that the inscription was added after the artist's death.

A drawing at Turin includes a group of buildings similar to those which appear at the left of the present picture.[5]

The lyricism and delicacy of the *Calm* inspired a number

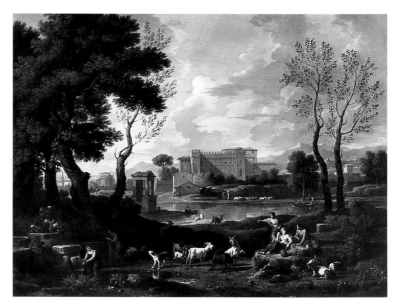

Fig. 156 Jan Frans van Bloemen, *Landscape with a View of the Belvedere*. Oil on canvas, 119.5 × 163 cm, 1738. Musées royaux des Beaux-Arts de Belgique

of landscapes by Jan Frans van Bloemen (known as Orizzonte) in the mid-18th century (fig. 156).[6] These attest to the picture's popularity with the more naturalistic landscape painters of later generations and reflect something of its bucolic tone, if not of its transfixing stillness or immaculate beauty. Corot alone would rival these in his early landscape paintings.

1. Félibien (ed. 1725), IV, p. 63.
2. Whitfield, 1977.
3. *Ibid.*, pp. 7–9.
4. *Ibid.*, p. 4 (a reference to Claude's *Landscape with Psyche outside the Palace of Cupid*, otherwise known as the *Enchanted Castle*, of 1664 in the National Gallery, London).
5. CR IV, p. 48, no. 285.
6. Andrea Busiri Vici, *Jan Frans van Bloemen, Orizzonte e l'origine del paesaggio romano settecentesco*, Rome, 1974, nos. 213 and 218 (and the version of the latter illustrated here).

PROVENANCE
1651, painted for Pointel ; by 1685, Louis Bay, Lyons; 1806, Lansdowne sale; 1823, Lord Radstock sale; by 1854, James Morrison; thence by descent

EXHIBITIONS
Rome, 1977, no. 35; Düsseldorf, 1978, no. 35; Frankfurt, 1988, no. P 7 (not exhibited); Edinburgh, 1990, no. 24; Paris, 1994–5, no. 201

ŒUVRE CATALOGUES
Wild, no. 172b, Wright, no. 164, Mérot, no. 239

REFERENCES
Félibien (ed. 1725), IV, p. 63; Whitfield, 1977; Thuillier-Mignot, 1978, pp. 50–1

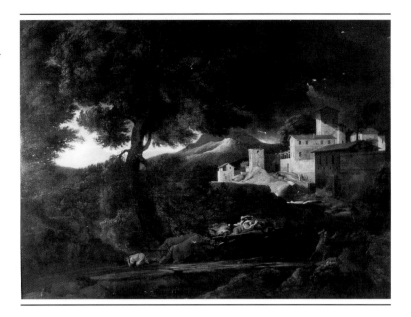

74
Landscape with a Storm
1651
99 × 132 cm

Musée des Beaux-Arts, Rouen

Like its pendant (cat. 73), this picture was painted for Pointel in 1651 and has only recently been discovered. In contrast to the *Calm*, however, the design of the *Storm* was recorded in an engraving by Chatillon (*c.* 1680; fig. 157). This was issued as one of a set of six landscape prints after Poussin which, inexplicably, omitted the pendant composition. When the present painting emerged on the Roman art market in the 1970s, it was initially regarded as a collaborative work, in which Poussin painted the figures and Gaspard Dughet the landscape.[1] More recent critics are unanimous in attributing the entire composition to Poussin himself and in relating it to his other great storm scene of 1651, the *Landscape with Pyramus and Thisbe* (cat. 75). Though the *Calm* is in pristine condition, the present painting has suffered badly and is severely abraded in places. For this reason the composition is more legible in the early engraving.

Like the *Calm*, the central motif of the *Storm* derives from one of the auxiliary incidents in the middle distance of the *Landscape with the Body of Phocion Carried out of Athens* (cat. 67): in this case, the ox-cart with figures. In the present work, they are shown caught in the midst of a raging storm which strikes fear and terror into humans and animals alike. Above the group, a large tree has been struck by lightning, splitting off two of its branches, which have fallen to the ground. Immediately below them, a crouching figure presses his hands to his head and two oxen have collapsed in fear. The group is completed by the cowering figures in the cart, who cover themselves with their cloaks as protection from the wind, and a standing youth at the right who recoils in horror at the violence of the storm. Beyond appears a group of buildings lit by a cold and eerie glare, as though from a bolt of lightning.

The picture inspired a long description by Félibien, who compares the impact of a sudden storm in which the air appears so turbulent 'that one can scarcely see either the sky or the land' with the effects observed in Poussin's painting.[2] Félibien concludes by relating the master's achievement in such works to that of the legendary Greek master Apelles, who (according to Pliny) 'painted the unpaintable, thunder, for example, lightning and thunderbolts'.[3] Thus, even in so proto-Romantic a canvas as the present picture, Poussin may well have been striving to emulate the art of the ancients.

Though the *Storm* and *Calm* were undoubtedly conceived as pendants, the order in which they were intended to be hung is unclear. In both Félibien's biography and Pointel's inventory, the *Storm* is listed first, though it is arguable that Poussin intended the two pictures to hang with the *Calm* at the left, so that the figure of the peaceable goatherd in the latter might be compared with that of the terrified youth at the right of the *Storm*.

Poussin's decision to portray two contrasting states of nature in the *Calm* and *Storm* may reflect his theory of the modes of 1647. This would account for the strikingly different effects of light, colour and design in the two pictures, which appear as a logical development from the artist's figure paintings of the immediately preceding years. If the latter explore the varied reactions of his human actors to a dramatic situation, the *Calm* and *Storm* portray the contrasting passions (or *affetti*) of the natural world and their corresponding effects upon the actions and emotions of man. When taken together, these two pictures also illustrate the order and balance of nature itself and reflect the Stoic belief that humanity is powerless in the face of her abruptly changing moods. Seneca provides an account of these that is particularly apposite to the themes of Poussin's *Calm* and *Storm*:

Let's not be taken aback by any of the things we're born to, things no one need complain at for the simple reason that they're the same for everybody … reversals, after all, are the means by which nature regulates this visible realm of hers; clear skies follow cloudy; after the calm comes the storm; the winds take turns to blow; day succeeds night; while part of the heavens is in the ascendant, another is sinking. It is by means of opposites that eternity endures.[4]

1. Blunt, 1975
2. Félibien (ed. 1725), III, pp. 52–5
3. Pliny, *Historia Naturalis*, XXXV, 96
4. Seneca, *Ad Lucilium Epistulae Morales*, CVII, 6–8

PROVENANCE
1651, painted for Pointel; by 1685, Louis Bay, Lyons; *c.* 1950, London art market; bought on the Roman art market in 1975 by the Musée des Beaux-Arts

EXHIBITIONS
Rome, 1977, no. 34; Düsseldorf, 1978, no. 34; Frankfurt, 1988, no. P 5; Paris, 1994–5, no. 200

ŒUVRE CATALOGUES
Blunt, no. 217 (lost), Thuillier, no. 181 (lost), Wild, no. 172a, Wright, no. 163, Mérot, no. 238

REFERENCES
Félibien (ed. 1725), III, pp. 52–5; IV, p. 63; Blunt, 1975; Thuillier, 1976; Whitfield, 1977; Thuillier-Mignot, 1978, pp. 50–1; McTighe, 1989

Fig. 157 Louis de Chatillon (*after* Nicolas Poussin), *Landscape with a Storm*. Engraving. Before 1680.

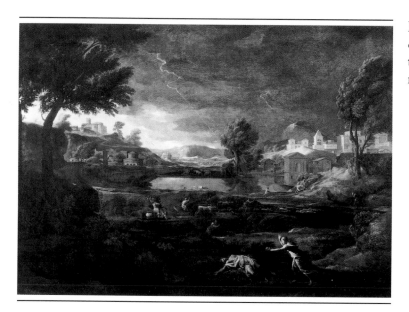

75

Landscape with Pyramus and Thisbe

1651

192.5 × 273.5 cm

Städelsches Kunstinstitut, Frankfurt am Main

Painted for Cassiano dal Pozzo in 1651, this picture is the largest landscape by Poussin and one of the most audacious works of his entire career. Its theme relates to that of the two landscapes illustrating the story of Phocion (cat. 67–8), the *Man Killed by a Snake* (cat. 69) and *Orpheus and Eurydice* (cat. 70), all of which revolve around a terrible twist of fate. In *Metamorphoses* (IV, 55–166) Ovid recounts the tale of the star-crossed lovers, Pyramus and Thisbe, who are forbidden from marrying by their parents. The two plan a nocturnal tryst outside the city walls by a mulberry tree and spring. Thisbe arrives first and is startled by a lioness, fresh from the kill, which has come to quench its thirst. Thisbe flees and, in her haste, drops a cloak, which the beast tears to shreds. When Pyramus arrives, he discovers the blood-stained garment and assumes Thisbe dead. Blaming himself for this, he plunges a sword into his side and dies, his spurting blood turning the mulberries into a deep red colour. When Thisbe returns and finds her lover dying, she falls upon his sword, and the hapless couple are reunited in death.

Though Ovid sets this scene on a moonlit night, Poussin portrays it in the midst of a raging storm. In this he follows Théophile de Viau's tragedy on this theme, *Les Amours tragiques de Pyrame et Thisbé*, first published in 1623, when Poussin was still in Paris, in which Thisbe's mother has a premonition of the couple's misfortune that includes a vision of a violent thunderstorm.[1]

Although Poussin was probably familiar with Viau's tragedy, there may be other reasons for his attraction to this theme. As in the *Storm* landscape of the same year (cat. 74), the subject is one of the terrible havoc that nature can wreak upon man and, as such, would have appealed to his stoical outlook upon life.

Moreover, in a letter of 1651, Poussin suggests that his principal objective in the present canvas was the depiction of a storm and that the mythological subject was only introduced at the last moment:

> I have tried to represent a land storm, imitating as well as I could the effect of a violent wind, of air filled with darkness, with rain, with lightning and with thunderbolts which fall here and there, not without producing disorder. All the figures to be seen play their part in relation to the weather: some flee through the dust, and go with the wind which carries them along; others … go against the wind and walk with difficulty, putting their hands before their eyes. On one side a shepherd runs away and leaves his flock, seeing a lion, which, having already thrown down some oxherds, is attacking others, some of whom run away while others prick on their cattle and try to make good their escape. In this confusion the dust rises in whirlwinds. A dog some way off barks, with his coat bristling, but without daring to come nearer. In the front of the picture you will see Pyramus, stretched out dead on the ground and beside him Thisbe, given over to her grief.[2]

In his portrayal of malevolent nature in *Pyramus and Thisbe* and the *Storm*, Poussin appears to have been inspired by Leonardo da Vinci's account of 'How to represent a Tempest',[3] which includes the clouds of sand, blasted trees and frightened figures introduced into the present picture. As has often been noted, both landscapes were conceived in the same year that saw the publication in Paris of an edition of Leonardo's *Treatise on Painting*, containing illustrations by Poussin.[4] It has also been observed that Leonardo's word for a tempest – *fortuna* – means 'both storm and tempest as well as good and bad luck, chance and fate'.[5] In this sense, the theme of Pyramus and Thisbe is appropriate to the natural catastrophe described in this picture.

X-rays reveal that Poussin began the painting with a very different landscape in mind and worked out the composition as he went along. Among the changes introduced were the suppression of a second framing tree and the alteration of the

Fig. 158 Nicolas Poussin, *Shepherds on Horseback Attacked by a Lion*. Pen and bistre wash over traces of black chalk, 15 × 25.2 cm. Musée Bonnat, Bayonne

contour of the hills at the left, the substitution of the lake for a group of buildings and the addition of all of the figures on top of the landscape. But the most dramatic change was the introduction of the ominous storm clouds over a layer of blue sky. This suggests that the artist began the landscape as a scene of calm.

The round temple at the edge of the lake at the left is based on Palladio's reconstruction of the Temple of Bacchus (later the church of S. Costanza, Rome); and the pyramidal tomb at the upper right is similar to those found outside Jerusalem and was presumably included to indicate an Eastern setting, since Ovid locates the story of Pyramus and Thisbe in Babylon.

Several drawings have been connected with the present picture, among them a sheet of studies of shepherds on horseback attacked by a lion (fig. 158) that is closely related to the comparable figure group in the finished painting.[6]

The *Landscape with Pyramus and Thisbe* is Poussin's last recorded commission for Cassiano dal Pozzo, though the *Annunciation* of 1657 (cat. 81) may have been painted by the artist for Pozzo's tomb. Along with the *Calm* and *Storm*, this picture is also the last landscape of Poussin's middle years. If its planar construction and balanced composition still relate to the classical landscapes of the artist's maturity, its irrational theme and sombre colouring anticipate certain of the artist's more pantheistic landscapes of the years after 1657, above all the *Deluge* (cat. 91).

The picture has had numerous admirers, beginning with Poussin's brother-in-law Gaspard Dughet, whose landscape on the same theme (*c.* 1655; fig. 159) reflects an awareness, if not a direct indebtedness, to the present painting. Turner studied the picture when it was in the Ashburnham collection and later acclaimed it as 'truly sublime'.[7] No less enthusiastic was Roger Fry, who praised its colour harmonies of inky blue and buff as '*modern* in feeling, as though interpreted directly from the artist's observation of such an effect in nature'.[8]

1. Bätschmann, 1990, pp. 100–4.
2. *Correspondance*, p. 424.
3. *The Literary Works of Leonardo da Vinci*, compiled by Jean Paul Richter, London, 1970 (3rd edition), I, p. 351.
4. Bialostocki, 1954.
5. Bätschmann, 1990, pp. 102–4.
6. CR III, no. 225; see also Paris, 1994–5, nos. 204–6.
7. Ziff, 1963, pp. 315–16.
8. Fry, 1923, p. 53.

PROVENANCE
1651, painted for Cassiano dal Pozzo; his heirs until 1730, Furnese collection; William Morice before 1750; 1786, bought from his heirs by Lord Ashburnham; 1850, Ashburnham sale; 1923, Max Rothschild, London; 1926, Asti, Paris; 1931, bought by the Museum from Julius Böhler

EXHIBITIONS
Frankfurt, 1988, no. P 1; Paris, 1994–5, no. 203

ŒUVRE CATALOGUES
Blunt, no. 177, Thuillier, no. 182, Wild, no. 173, Wright, no. 162, Mérot, no. 222

REFERENCES
Bellori, 1672, p. 455; Félibien (ed. 1725), IV, p. 160; Bialostocki, 1954; Bätschmann, 1987; Bätschmann, 1990, pp. 93–110

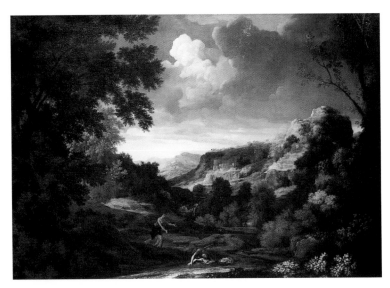

Fig. 159 Gaspard Dughet, *Landscape with Pyramus and Thisbe.* Oil on canvas, 100 × 145 cm, *c.* 1655. Board of Trustees of the National Museums and Galleries on Merseyside (Walker Art Gallery, Liverpool)

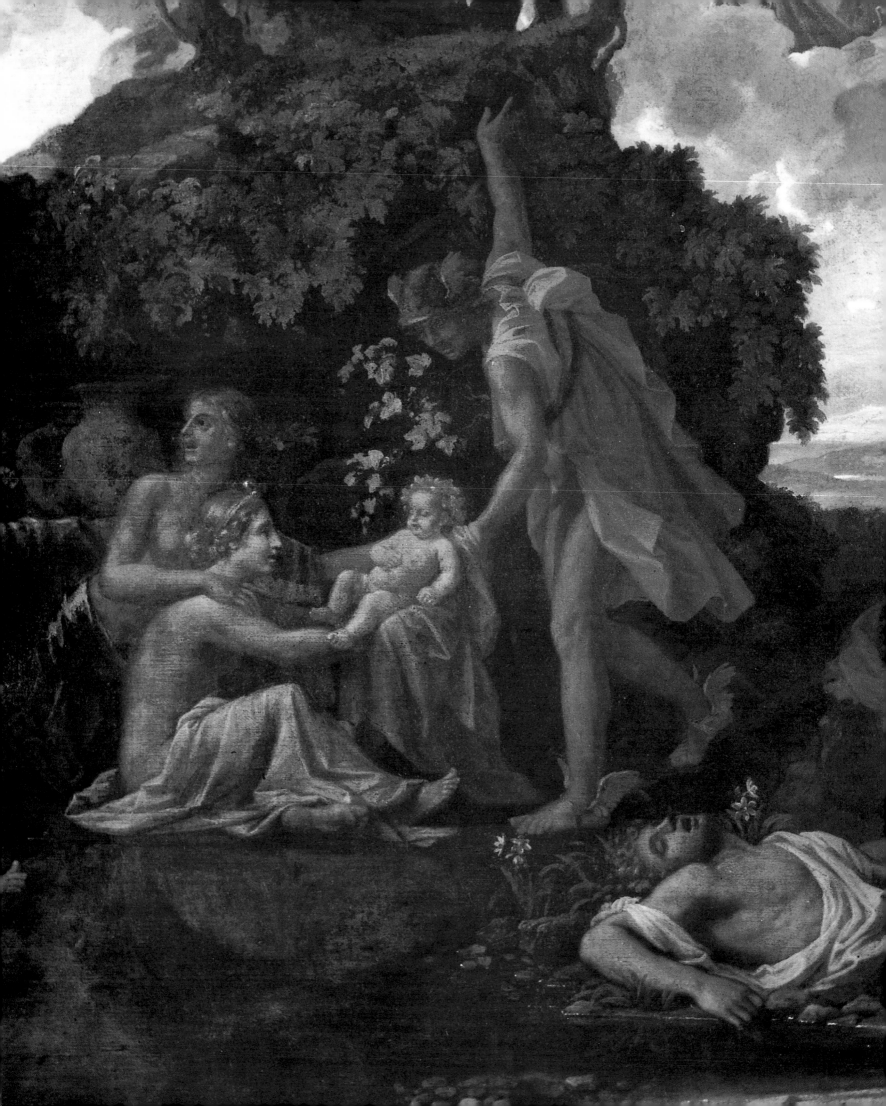

The Late Years: 1652–65

It is a remarkable and often discussed phenomenon that great artists develop in the last years of their lives a sublime style which differs symptomatically from the style of their youth and maturity. The works of the late or 'old age' style of Titian, Rubens, Rembrandt and others display a deepening and broadening of imagination in form and idea, that compensates for the natural uncertainty of vision caused by the decay of bodily forces. It seems that in their late works aged artists strive for totality of impression while they are less concerned with the delineation of detail. Frequently their works are filled with a new and moving lyricism, a revival from youth, but in a different, often elegiac tone which contrasts with the clear and vigorously expressed narration or action of their mature works.

Walter Friedlaender[1]

Written as the preface to an article on Poussin's old age, Friedlaender's words could scarcely be bettered as an introduction to the artist's late style, which inhabits a world so personal and poetic that it found few adherents among Poussin's contemporaries. Conditioned to regard the artist as the eminently rational master of the Chantelou Sacraments (cat. 49–55) or the *Judgement of Solomon* (cat. 62), such critics greeted the mysterious canvases of Poussin's last years with little more than qualified approval. Faced with even the most orthodox of these works, Bernini declared that the artist should have laid aside his brushes rather than continued painting. Only with the advent of Romanticism were such sublime late works as the *Landscape with Orion* (cat. 84) and the Four Seasons (cat. 88–91) acknowledged as among the supreme masterpieces of Poussin's career, precisely because they revealed a 'new and moving lyricism' that one would never have anticipated from the learned and intellectual canvases of the artist's middle years.

If the *Adoration of the Magi* (fig. 67) of 1633 marks a clear break between the early and middle phases of Poussin's career, announcing his conversion to Raphael and his repudiation of Venetian art, no single canvas by the master heralds the start of the last phase of his career. In 1651, Poussin completed the first great series of landscapes of his maturity (cat. 67–75), and no works by him may be firmly dated to the following year. These two factors make 1652 a convenient point at which to place a caesura in the artist's career.

Increased age and failing health led Poussin to paint fewer works than ever during the last years of his life, with less than three dozen canvases being documented to the period between 1652 and 1665. Like the vast majority of the pictures that had preceded them, these draw their inspiration from the Bible, ancient history and mythology. But they follow an unusual pattern that is encountered nowhere else in the artist's career. In the mid-1650s Poussin confined himself almost exclusively to religious themes and, so far as we know, painted no landscapes. In 1657, however, he turned to depicting a whole sequence of mythological subjects in landscape settings and his output of biblical canvases dropped markedly. During the final years of his career, all these concerns came together in a series of works, including the Four Seasons and *Apollo and Daphne*

Detail from *The Birth of Bacchus,* cat. 83

(fig. 19), in which religious and mythological themes are portrayed in a landscape. These distinct oscillations between religion and mythology, and the eventual synthesis of both in the realm of landscape, suggest that Poussin approached the paintings of his last years as a final formulation of his ideas – in short, as his artistic testament.

In theme and style, Poussin's figure paintings of the 1650s reflect his deepening response to Raphael's art. A significant number of these are Adorations or Holy Families, a theme indelibly associated with the Renaissance master; and, unusually for the mature Poussin, at least three of the Holy Families are painted on an upright canvas (cf. fig. 160), like the comparable works by Raphael and his followers. A second group of strikingly Raphaelesque canvases consists of the three monumental cityscapes representing *Christ and the Woman Taken in Adultery* (cat. 76), the *Death of Sapphira* (fig. 161) and *St Peter and St John Healing the Lame Man* (cat. 78). All of these draw their inspiration from Raphael's tapestry cartoons of the Acts of the Apostles (fig. 162–3). Painted in rapid succession between 1653 and 1655, these works are so close in theme to certain of Raphael's designs that they would seem to be a deliberate attempt to equal or excel the Renaissance master. In a very late group of figure paintings, however, Poussin departs from subjects and designs associated with Raphael to paint a series of devotional subjects – the *Annunciation* (cat. 81), the *Baptism of Christ* (cat. 85) and the *Lamentation* (cat. 82) – in a style so timeless and austere that it evokes comparison not with the humanistic art of the Renaissance but with the more monumental style of 5th-century Greece.

Characteristic of Poussin's late history paintings is a tendency towards extremism – a desire to be ever more explicit in his treatment of a given theme. This reveals the aged master at his most intractable, and has been seen by some critics as a form of 'hyper-classicism'. Typical of this are the heavily proportioned and somewhat overblown figures of the late history pictures, with their large heads and hands and ungainly limbs. In many of these works, the figures are posed hieratically and appear motionless and inert, as though petrified. In those subjects that require movement, however, Poussin portrays them in an exaggeratedly declamatory manner, with vehement, stabbing gestures, as in the *Adulterous Woman* or the *Sapphira*. The literalness of this approach also leads him to devise more appropriate settings for his figures in his last years. This tendency towards archaeological accuracy culminates in his detailed depiction of ancient Egypt in the *Holy Family in Egypt* (cat. 80) of 1655–7.

Certain other features of Poussin's late figure pictures contrast with this doctrinaire approach and pave the way for the landscape paintings of his final years. One of the most striking of these is the artist's preference for centrifugal and decentralised compositions, in which the figures migrate towards the extremities of the picture rather than the central axis. This is a feature of the *Exposition of Moses* (cat. 77) of 1654 and of the three cityscapes of these years that serves to distinguish Poussin's history paintings of the 1650s from those of the preceding decade, which typically portray figures entering rather than leaving the scene. In this development alone, Poussin evokes a less sealed and self-contained world.

The colour of these pictures also appears less dogmatic than that of the works of the 1640s. Rather than the pure, platonic hues of the Chantelou Sacraments or the *Holy Family on the Steps*, Poussin now favours a range of blended and variegated hues which culminate in the powdery, pastel tints of the *Eliezer and Rebecca* (c. 1660–2; cat. 87). Closely related to this development in his art is the

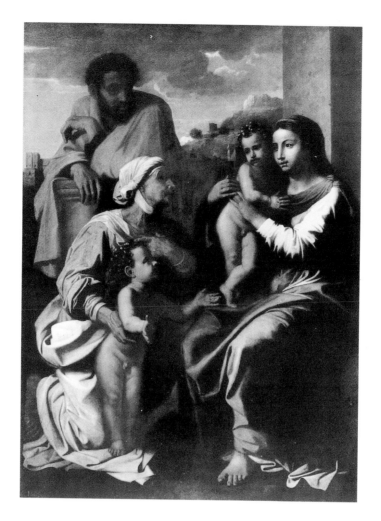

Fig. 160 Nicolas Poussin, *The Holy Family with St John and St Elizabeth.* Oil on canvas, 172 × 133.5 cm, 1655. The Hermitage Museum, St Petersburg

creation of a whole group of late 'figure' paintings in which landscape appears as an important protagonist in the scene. Among such hybrid compositions are the *Exposition of Moses, Achilles among the Daughters of Lycomedes* (cat. 79) and the *Baptism of Christ.* Both these changes in style reveal the artist's increasing immersion in the world of nature, with all its subtleties and uncertainties.

The landscapes of Poussin's final years also differ fundamentally from the artist's previous works in this vein. The most notable change is the less prominent role accorded to humanity or its artefacts and the correspondingly greater importance given to inanimate nature. The two Phocion paintings (cat. 67–8) or the *Landscape with a Man Killed by a Snake* (cat. 69) are replete with references to the habitation and activities of man. In the late landscapes, however, the scenes are less populous, with anonymous figures reduced to a minimum, if not entirely excluded, and architecture is rarely included in the composition. Also noticeably absent is that traditional symbol of civilisation, and of Poussin's earlier landscapes: the paved road.

In place of these features, Poussin's late landscape paintings evoke an earlier moment in the earth's history. The scenes appear more freely composed, as though not yet cultivated by the hand of man; and, in works like the *Orion* or the *Landscape with Hercules and Cacus* (cat. 86), they possess a primeval grandeur and wildness that is awe-inspiring. As Hazlitt was later to remark, all these landscapes have the 'unimpaired look of original nature, full, solid, large, luxuriant, teeming with life and power'.[2] Leafy trees burgeon with growth, foliage blankets the earth and mountains appear encircled by dense cloud formations, laden with moisture. The organic processes of the living world – rather than its

mere existence – become the true theme of these pictures.

Little is known of Poussin's creative methods in his last years, as fewer drawings survive from this period than from any other phase of his career. For the landscapes themselves, scarcely any compositional studies exist. Given the naturalism of these pictures, it is tempting to conclude that they were extemporised on the canvas itself. According to one source,[3] Poussin was regularly observed returning to his studio from his walks along the Tiber laden with pebbles, bits of moss, flowers and other natural specimens. These he proceeded to paint in his studio 'exactly according to nature'. To this detailed scrutiny of the microcosm of nature one may owe the profusion of plant life that fills the foreground of *Achilles among the Daughters of Lycomedes* or the fantastic rock formations of any number of the artist's other late landscapes.

The subjects that Poussin portrays in these pictures are themselves concerned with the phenomena of birth, death and transformation in nature. In the most straightforward, such as the *Landscape with Two Nymphs and a Snake* (fig. 15), a serpent is shown devouring a large bird and the theme is the elemental struggle for survival in nature. However, the majority of these pictures treat subjects from Ovid, 'a revival from youth, but in a different, often elegiac tone'. No longer concerned with the theme of thwarted love, as in his earlier Ovidian pictures, Poussin now employs these tales to personify the order and balance of nature. In the *Birth of Bacchus* (cat. 83), *Orion* and *Apollo and Daphne*, the artist combines unrelated episodes from one or more myth to symbolise the phenomena of the natural world. In devising the complex and often esoteric programmes of these pictures, Poussin relied on the writings of earlier mythographers, such as Natalis Comes and Tommaso Campanella, who interpreted the ancient myths as allegories of the physical truths of nature. This idea was in accordance with the doctrines of Stoic philosophy and aimed to discover a rational explanation for the mysteries of the universe in the world of ancient religion.

Poussin's last completed works, the cycle of Four Seasons, are also concerned with this theme and, like the mythological landscapes, rank among his most pantheistic creations. In the Seasons, the artist employs biblical episodes to personify the progress of human life against a background of the changing cycles of nature. The visionary quality of these pictures – especially the *Deluge* – makes them a fitting conclusion to the artist's career. Like Poussin's last letters, they reveal a mood of philosophical resignation in the face of the ineluctable course of human destiny. Viewed in the context of the artist's entire output, however, they also provide a conclusive formulation of his thoughts on the human condition.

The prevailing theme of Poussin's early paintings is the fate of the individual, in life, love and death. In the middle years of his career, he turns instead to exploring the progress of humanity in civilisation, as epitomised by the two sets of Sacraments. The last works of his life explore an even more transcendent and universal theme – that of the destiny of mankind in the face of omnipotent nature. In this sense, as Friedlaender observed, they embody Poussin's 'last fears and his last loves'.[4]

1. Friedlaender, 1962, pp. 249–50.
2. Hazlitt, 1844, II, p. 191.
3. Bonaventure d'Argonne (?) in *Actes*, 1960, II, p. 237.
4. Friedlaender, 1962, p. 262.

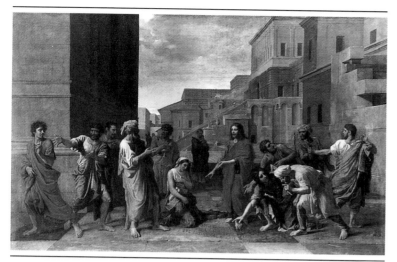

76

Christ and the Woman Taken in Adultery

1653

122 × 195 cm

Musée du Louvre, Département des Peintures, Paris

In the 1640s and '50s, Poussin's art appears haunted by that of Raphael – the Raphael of the Holy Families, the Vatican frescoes and, above all, the tapestry cartoons of the Acts of the Apostles for the Sistine Chapel. In 1641, the artist was commissioned by Louis XIII to design eight Old Testament scenes for a set of tapestries to complement Raphael's great series. Though nothing came of this idea, the achievement of the Renaissance master in these works subsequently set the standard for the majority of Poussin's history paintings of the next fifteen years, beginning with the Chantelou Sacraments (cat. 49–55) and continuing with such masterpieces as the *Judgement of Solomon* (cat. 62) and *Christ Healing the Blind Men* (fig. 72). The culmination of this style occurs in three pictures of the mid-1650s, all of which treat episodes from the New Testament against a severe architectural background. One of these – the *Death of Sapphira* (c. 1654; fig. 161) – was clearly conceived in open homage to Raphael, who had treated the related theme of the Death of Ananias (fig. 162), husband of Sapphira, in his set of tapestry cartoons. In Acts V, 3–10, Ananias and Sapphira are struck dead by the Lord within hours of one another for withholding from the poor a sum of money obtained from the sale of property.

Complementing the theme of divine retribution in the *Sapphira* is that of Christian charity and forgiveness in the present picture, which depicts the well-known subject recounted in John VIII, 2–11. The Pharisees present Christ with a woman taken in adultery and ask for his verdict on her sin:

But Jesus stooped down, and with his finger wrote on the ground, as though he heard them not.

So when they continued asking him, he lifted up himself, and said unto them, He that is without sin among you, let him first cast a stone at her.

Then the Pharisees 'being convicted by their own conscience, went out one by one . . . ' Left alone with the adulterous woman, Christ forgives her and begs her 'to sin no more'.

Poussin treats the climax of the action in the present work. Kneeling in the centre of the picture is the abject and humiliated figure of the adulteress, her ashen flesh-tones suggesting her shame. To the right, Christ points towards her and, with his left hand, questions the Pharisees on their own freedom from sin. Fearful, indignant or astonished by his temerity, they strike a sequence of dramatic poses that vividly evoke their discordant responses to Christ's challenge. Some skulk away, others accuse their companions or implore Christ, while, at the right, two figures attempt to decipher the mysterious words that Jesus has written on the ground. But the essence of the theme is reserved for the figure of a woman holding a child in the centre middle distance, who has paused to witness the scene. She is a familiar figure of charity and appears to symbolise Christ's later words to the Pharisees:

'I judge no man'.

The style of the picture is intensely Raphaelesque in its rigid symmetry, planimetric construction and idealised figures. As in Raphael's *Death of Ananias* or *Blinding of Elymas*, the theme of divine judgement is enacted in a consciously rhetorical manner, through a series of taut poses, stabbing gestures and exaggerated facial expressions. Further reinforcing the tensions of the drama is the strident sequence of primary colours spun out across the foreground of the picture. These endow the whole with an unnerving starkness that matches the severity of the theme. Though so explicit and uncompromising an approach may appear stilted and theatrical to modern tastes, it is intended to describe the narrative action with the maximum force and clarity. Poussin even resorts to a further means of achieving this in the present picture, and one not normally associated with Raphael. This is the starkly geometric architectural background, which includes a flight of steps in the centre middle distance to reinforce Christ's emphatic gesture.

The present picture was painted in 1653 for André le Nôtre,

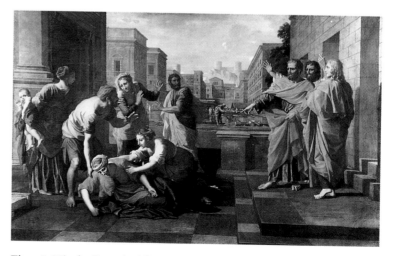

Fig. 161 Nicolas Poussin, *The Death of Sapphira*. Oil on canvas, 122 × 199 cm, c. 1654. Musée du Louvre, Département des Peintures, Paris

designer of the gardens at Versailles, and is probably the first of the three great cityscapes Poussin executed during these years. In the other two (fig. 161, cat. 78), the artist invites even more direct comparison with Raphael's set of tapestry cartoons by treating themes that are themselves derived from the Acts of the Apostles.

Bernini was unimpressed with this picture when he saw it in Paris in 1665, noting 'a man should know how to stop when he gets to a certain age'.[1] Poussin, however, believed his art to be improving as he entered the final phase of his career.[2] He was right, even in the case of the present picture, which is one of the most psychologically complex of all his works and posed one further challenge for the artist: that of applying his own 'mute' art to communicate the charge of the biblical dialogue – in short, to paint speech.

1. Chantelou (ed. 1985), p. 282.
2. *Correspondance*, p. 445.

PROVENANCE
Painted for André Le Nôtre in 1653 and given by him to Louis XIV in 1693

EXHIBITIONS
Paris, 1960, no. 103; Rouen, 1961, no. 88; Bologna, 1962, no. 82; Paris, 1994–5, no. 214

ŒUVRE CATALOGUES
Blunt, no. 76, Thuillier, no. 188, Wild, no. 177, Wright, no. 178, Mérot, no. 74

REFERENCES
Bellori, 1672, p. 452; Félibien (ed. 1725), IV, pp. 63–4

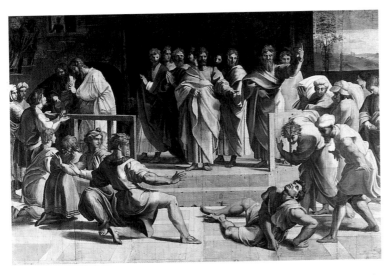

Fig. 162 Raphael, *The Death of Ananias.* Cartoon, 3.42 × 5.32 m, 1515–16. The Victoria and Albert Museum, London

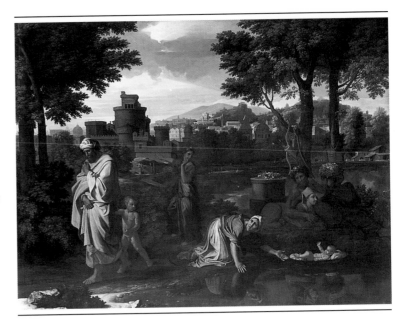

77
The Exposition of Moses

1654
150 × 204 cm

The Visitors of the Ashmolean Museum, Oxford

Although the Finding of Moses is one of the most frequently depicted Old Testament subjects, Poussin is the only major artist to have concerned himself with that perilous moment when the future leader of the Jews is exposed on the Nile. This forms the subject of one of his earliest works (c. 1627; fig. 5) and of the present picture, which was painted for the artist's friend and fellow painter, Jacques Stella, in 1654. If the rescue of Moses is a benevolent act of fate, indicating that he is predestined to greatness, the moment when he is set adrift on the Nile depicts him at his most human and vulnerable. As Poussin himself acknowledged, Fortune mixes the good with the bad, and all humanity can do is steel itself for her every blow.[1] Thus, in addition to painting three canvases of the Finding of Moses (cat. 35, 66; fig. 150) and a whole succession of works portraying the great events of Moses' life, Poussin devoted two pictures to depicting the lowest point of his existence.

The theme of the painting derives from Exodus II, 3–4, and is more fully recounted by Josephus (*Antiquities*, II, ix, 4). Pharoah has decreed that every male child born to the Israelites shall be destroyed by being cast into the river. When Moses is born, his parents hide him for three months. Fearing that he will be discovered, his mother eventually exposes him on the Nile in an ark of bulrushes, from which he is rescued by Pharoah's daughter.

In both of Poussin's canvases on this theme, the artist portrays Moses's family participating in the event. But whereas the early picture is primarily concerned with the physical action of releasing the child, the present work concentrates upon its psychological consequences. As the infant's mother exposes him, his sister Miriam – fearful for his safety – raises her finger

to her lips, bidding all to silence. With her right hand, she points to a group of figures approaching the distant riverbank. These may be intended to represent Pharoah's daughter and her handmaidens. At the left, Moses's father, accompanied by his young son Aaron, turns his back on the scene and exits, saddened and shamed. Reclining at the right is the river god of the Nile, embracing a sphinx and a cornucopia, a motif familiar from Poussin's *Finding of Moses* of 1651. Gazing impassively at the group, he appears to symbolise those purely earthly forces who hold no power over destiny. Most moving of all, however, is the anguished grimace of Moses's mother, who turns away as she commits the deed, as though unable to witness it.

The prominent still-life above the river god, consisting of pan-pipes, a shepherd's crook and a bow and arrow, has been variously interpreted.[2] Poussin's contemporaries identified Moses with any number of pagan deities, among them Pan, Priapus and Anubis;[3] and it is likely that these objects symbolise the dispensation of the ancients, which is here being superseded by the religion of the Old Testament.

The scene is set in a luxuriant landscape bounded by the outskirts of a city, which, unusually for Poussin, contains few references to Egypt. Instead, it is based on Pirro Ligorio's reconstructions of certain of the most celebrated buildings of ancient Rome.[4] But if Poussin appears unconcerned with archaeological accuracy in the present picture, he is deeply engaged with the world of nature, which forms a key element in the drama, both visually and symbolically.

This picture is one of a group of history paintings of the 1650s in which the figures are set against an elaborate landscape background. Also among these are the *Finding of Moses*, *Achilles among the Daughters of Lycomedes* (cat. 79), the *Holy Family in Egypt* (cat. 80) and the *Baptism of Christ* (cat. 85). With the exception of *The Finding of Moses*, all of these works date from the mid-1650s, a period when the artist had abandoned painting pure landscapes and redirected his interest in the natural world into the creation of such 'hybrid' compositions. In addition to the visual delights of these pictures, their spacious landscape settings serve as a reminder of the all-important role of nature in determining the course of human destiny. This is evident in the present work in the contrast between the rich and uncultivated landscape in the foreground of the picture, which appears shrouded in darkness, and the cityscape beyond, crowned by a spectacular sunburst – an obvious symbol of hope. If the latter represents the safety and security of civilisation under the rule of benevolent nature, the former alludes to those wild and mysterious forces that ultimately shape man's ends – and to which Moses is here being suddenly exposed.

This idea is reinforced by the centrifugal design of the present picture, which contains no central focus and in which all of the principal figures appear to be leading out of the composition. In this device alone Poussin conveys the uncertainty of the moment and the precarious nature of the infant's plight, which could go either way, depending upon fate.

1. *Correspondance*, pp. 239–40, 348–9.
2. Cf. Blunt, 1967, text vol., p. 335, and Colantuono, 1986, p. 319.
3. Loménie de Brienne in *Actes*, 1960, II, p. 213.
4. Howard Burns, 'Pirro Ligorio's Reconstruction of Ancient Rome', *Pirro Ligorio, Artist and Antiquarian*, ed. Robert W. Gaston, Milan, 1988, p. 42.

PROVENANCE
1654, painted for Jacques Stella; his descendants; bought by the Duc d'Orléans before 1727; 1792, sold to Walkuers; sold by him in the same year to Laborde de Méréville; 1798, bought by Bryan; bought in the same year by Richard, Earl Temple; 1848, sold by his son; bought A. Robinson; Francis Gibson; bequeathed to his son-in-law, Lewis Fry; by descent to Margery Fry; 1950, bought from her by the Museum

EXHIBITIONS
Paris, 1960, no. 105; Bologna, 1962, no. 83; Rome, 1977–8, no. 39; Düsseldorf, 1978, no. 41; Paris, 1994–5, no. 221

ŒUVRE CATALOGUES
Blunt, no. 11, Thuillier, no. 190a, Wild, no. 180, Wright, no. 182, Mérot, no. 8

REFERENCES
Bellori, 1672, p. 450; Félibien (ed. 1725), IV, p. 64; Blunt, 1950, pp. 39–40; Dempsey, 1963, pp. 117–18

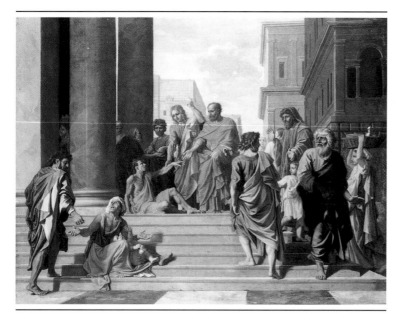

78

St Peter and St John Healing the Lame Man

1655

125.7 × 165.1 cm

Lent by The Metropolitan Museum of Art, New York
Purchase, Marquand Fund, 1924

This is the third and last of Poussin's great cityscapes of the
mid-1650s (cf. cat. 76, fig. 161) and the one most obviously
indebted to Raphael, who had treated the same subject in his
tapestry cartoons for the Sistine Chapel (fig. 163). Poussin
painted it in 1655 for a merchant and treasurer from Lyons
named Mercier who, as far as we know, commissioned nothing
else from the artist. Although one of the least appreciated of the
artist's late works, it can be seen as Poussin's swansong to the
Renaissance tradition of rhetorical history painting. In the years
that followed it, the artist explored a world that moved far
beyond the rationality of Raphael and his school and would
have been unthinkable to them.

The subject is from Acts III, 1–10, and portrays the first
miracle performed by the Apostles after Christ's death. A lame
man, begging for alms at the gates of the Temple of Jerusalem, is
miraculously cured by Saints Peter and John – an event that
arouses fear and wonderment in the Jews, who command the
Apostles 'not to speak at all nor teach in the name of Jesus'.

Poussin portrays the miracle taking place at the entrance to
the temple. As Peter gives the command for the lame man to
rise, John assists him and points to heaven, the true source of
the miracle. Though this group is clearly inspired by Raphael's
treatment of the same theme, the latter follows the Bible more
closely in showing Peter performing the miracle and raising the
lame man by his right hand. (The cartoon illustrated here would
be reversed in the tapestry.) Poussin curiously overlooks this
detail in favour of one that is reminiscent of another
Renaissance depiction of awakening life, Michelangelo's
Creation of Adam. But Poussin's greatest departure from

Raphael's design occurs in his treatment of the eye-witnesses to
the miracle, whose reactions are clearly intended to edify and
instruct the viewer.

In Raphael's tapestry design, two groups of figures frame the
main scene. On the left, women and children rush towards the
gate of the temple bearing sacrifices, oblivious to the miracle
being performed in their midst. At the opposite side, a mother
and child – a familiar Charity group – witness the event.
Flanking them are a standing man, who raises his hand in
amazement at the scene, and another cripple, who reminds us of
those awaiting their turn to be healed. Thus, as Raphael treats
the theme, the reactions of the figures are sharply divided
between those who register the meaning of the event and those
who do not.

In Poussin's canvas, however, a more diversified and
uncoordinated series of responses enriches the theme. The scene
is set on a flight of steps thronging with figures who go about
their daily ritual when suddenly, in their midst, a miracle
occurs. Entering the scene at the left – where we first look – is a
wealthy nobleman who distributes alms to a beggar-woman and
her child. As Poussin sees it, this act of charity is literally the
first step towards obtaining divine grace. Leaving the scene at
the right is an aged man, whose fearful expression indicates that
he has just registered the miracle and appears awestruck by the
Apostles' powers. Nearby, a youth turns to him and points
towards the alms-giving scene at the left, as if seeking to initiate
him to the new law of Christ. Above these figures, a man raises
his arms in astonishment at the charity and mercy he beholds;
while behind the lame man another figure gives alms to the
poor. Heedless of all this, two maidens bear gifts to the temple
at the extreme left and right of the composition. They remind
us of the 'unlearned and ignorant' few who refused to be drawn
by the teachings of Christ.

The importance of alms-giving in this picture represents
Poussin's greatest departure from Raphael's design and is
characteristic of his more reflective approach to such themes;
for, in his treatment of the subject, God's mercy itself inspires

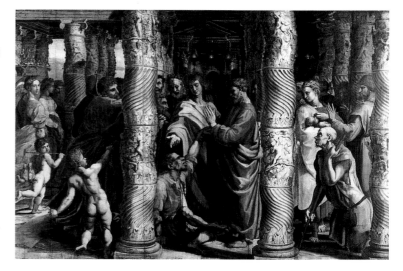

Fig. 163 Raphael, *The Healing of the Lame Man*. Cartoon, 3.42 × 5.36 m,
1515–16. The Victoria and Albert Museum, London

acts of charity in man. In addition to its edifying effect upon the viewer, this also reminds us of the result of the Apostles' miraculous acts and persuasive preaching. This was to convince the rich to sell their possessions and distribute the proceeds to the poor, the subject of another of Poussin's most Raphaelesque works of these years, the *Death of Sapphira* (fig. 161).

The motif of the steps and temple recalls that of the *Holy Family on the Steps* (1648; cat. 60) and may here too be intended to symbolise the path by which man ascends to God. In both pictures, these steps number seven, the same number as those of the temple revealed to Ezekiel by the Lord.[1]

The pale and chalky hues of the picture are characteristic of Poussin's late style, as are the large heads and hands of the figures. Both create an otherworldly impression that anticipates the even more remote and mysterious world of his late landscapes.

Close examination of the picture reveals that the woman facing forwards at the background right is painted over the architecture, which now shows through.

Though largely neglected in our own time, this picture was apparently much admired in its day. One year after it was painted, the design was copied in an altarpiece for the church of St Patrice, Rouen. A drawing by Géricault, made from an engraving of the composition, also exists in the sketchbook in the Louvre.[2]

1. The building at the extreme right of the present picture is closely comparable to the one from which Pope Leo IV delivers the papal blessing in Raphael's *Fire in the Borgo* (Stanza dell'Incendio, Vatican). Since both works are concerned with miracles performed by Christ's chief ministers, this quotation may be deliberate on Poussin's part. (I am grateful to David Hemsoll for this suggestion.)
2. Joanna Szczepinska-Tramer, 'Notes on Géricault's Early Chronology', *Master Drawings*, XX, 2, 1982, p. 140 and pl. 31.

PROVENANCE
Painted for Mercier in 1655; M. de Bordeaux; by 1679, Antoine Bouzonnet Stella; his descendants; Prince Eugene of Savoy; 1736, bought by the Prince of Liechtenstein; thence by descent until 1924, when acquired by the Museum

EXHIBITIONS
Paris, 1994–5, no. 222

ŒUVRE CATALOGUES
Blunt, no. 84, Thuillier, no. 197; Wild, no. 184, Wright, no. 186, Mérot, no. 96

REFERENCES
Félibien (ed. 1725), IV, p. 64

79
Achilles among the Daughters of Lycomedes
1656
100.5 × 135.5 cm

Virginia Museum of Fine Arts, Richmond
The Arthur and Margaret Glasgow Fund

Few late works by Poussin are as precisely documented as the present canvas. According to an inscription in the artist's own hand, he received payment for it on 15 November 1656. This is recorded on the back of a drawing for the *Holy Family in Egypt* (fig. 166),[1] where the patron of the Richmond picture is named as the Duc de Créqui, a fact corroborated by both Bellori and Félibien. Créqui, who owned two other paintings by Poussin, one of which was the *Holy Family with Six Putti* (fig. 18), became French Ambassador to Rome in the early 1660s.

The subject of the present painting is recounted by both Statius (*Achilleid*, I, 208–573) and Hyginus (*Fabulae*, XCVI). Achilles was the son of Peleus and Thetis. Attempting to save him from the Trojan War, Thetis disguised him as a woman and sent him to the court of King Lycomedes on the island of Skyros. There he was kept among the king's daughters until Ulysses and Diomedes discovered a means of revealing his true identity. On a visit to the king, they presented his daughters with a casket of jewels that also contained a sword and shield. Whereas the young women were attracted by the jewels, Achilles seized the weapons and, throwing off his disguise, joined the Greeks in the siege of Troy. There he was eventually killed by Paris with an arrow shot through his heel.

Poussin may have been prompted to treat this subject by the fact that it had been depicted twice in antiquity, by Polygnotus and Athenias of Maroneia.[2] As noted above,[3] however, the theme of the vocation and destiny of the future hero is a recurring one in his art and may explain his attraction to the present subject, which also forms the theme of an earlier canvas

by the artist of *c.* 1650 (fig. 7).

Though only five or six years separate Poussin's two versions of this theme, they are worlds apart in their treatment of the story. The earlier picture still shows Poussin's art at its most rhetorical and Raphaelesque. As Achilles unsheathes his sword at the right, one of the king's daughters registers startled recognition of his identity while Ulysses and Diomedes kneel at the left, their eyes fixed upon the hero, whose action reveals the success of their plot. In the present picture, this animated dialogue of gestures and gazes is forsaken in favour of a more undemonstrative approach to the theme. The figure group is now arranged centrally and symmetrically, facing the viewer, in the manner of the *Holy Family in Egypt* (cat. 80). Action is stilled, gestures restrained, and the drama rendered as psychological rather than physical. In the centre, the king's daughters finger the jewels, one of them coyly trying on an earring. At the left, Achilles, having donned his sword and shield, admires himself in a mirror – a motif that may relate to Statius's account of the tale, which notes that Achilles realises his identity when he confronts his reflection in a shield and beholds a warrior rather than a woman. Behind, Ulysses and Diomedes observe the outcome of their ruse in silence and stealth. Gazing on at the right is the aged figure of a nursemaid, whose air of gentle resignation evokes man's powerlessness in the face of destiny.

Further distinguishing the Richmond canvas from the earlier version of this subject is the setting of each scene. In keeping with his heroic style of history painting around 1650, Poussin accords a secondary role to nature in the Boston picture, which portrays the group against a landscape backdrop and appears to be set at the entrance to the king's palace. In the later version, however, nature assumes a more prominent role: the figures are set in a pristine landscape of craggy mountains and a tranquil lake which suggests that the hero is in hiding. At the upper right rises the castellated façade of the king's palace, a phantasmagoric structure that Poussin based on reconstructions of the Temple of Fortuna at Palestrina.[4] In contrast to the seclusion and isolation of this setting, with its lush undergrowth and protective trees, is the glimpse of the horizon at the left, which reminds us of the wider world that Achilles is about to enter – and conquer.

The colour of the picture also reveals a closer accord between figures and setting. Whereas the Boston version is confined almost entirely to the primary colours favoured by Poussin in his maturity, the Richmond canvas explores a range of more subtly nuanced hues – pale pinks, dull golds and soft yellows, greens and blues – which link the figures with the delicate colour harmonies of the natural world. In keeping with the visionary art of his final years, Poussin now sees both man and nature as manifestations of the same creative force.

A drawing (fig. 164) appears to mark a transitional stage between the Boston and Richmond paintings.[5] Executed in the tremulous style characteristic of Poussin's very last years, it shows Achilles unsheathing his sword at the left and the daughters of Lycomedes recoiling, as in the Boston canvas. In the poses of Ulysses and Diomedes and the motif of a figure admiring her reflection in a mirror, however, it anticipates the present painting.

X-ray examination of this picture, which has recently been cleaned, reveals that Poussin made a number of substantial changes to the composition. The casket of jewels was originally somewhat smaller and the pedestal at the left has been painted over the urn behind it, doubtless to balance this with the similar motif on the opposite side. In addition, the red and green drapery at the right was originally a single piece of fabric painted blue. Technical examination also revealed that the perspective lines of the composition converge upon a vanishing point on the far shore of the lake in the centre of the design and that the artist marked this point with an indentation in the paint surface – a procedure Poussin also adopted in the *Rape of the Sabines* (fig. 70) and the *Holy Family on the Steps* (cat. 60).

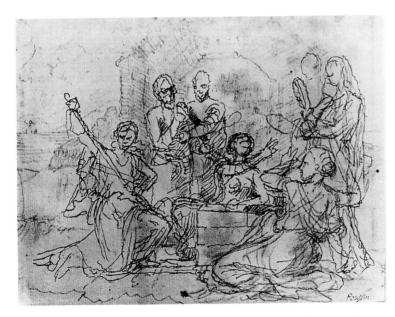

Fig. 164 Nicolas Poussin, *Achilles Among the Daughters of Lycomedes*. Pen and bistre wash over traces of black chalk, 16 × 20.2 cm. The Hermitage Museum, St Petersburg

1. CR I, pp. 30–1, no. 60
2. Pausanias, *Description of Greece*, Book I, *Attica*, xxii, 6 (for Polygnotus); Pliny, *History Naturalis*, xxxv, 34 (Athenias of Maroneia).
3. *Supra*, pp. 23–6.
4. Blunt, 1967, text vol., pp. 304–6 and fig. 245.
5. CR II, pp. 4–5, no. 106.

PROVENANCE
Painted for Charles III, Duc de Créqui, in 1656; 1806, W. Ellis Agar sale, London; bought with the entire Agar collection by Lord Grosvenor; 1807, his sale, London; 1811, sale of pictures from the Agar collection, London; 1957, bought by the Museum from Wildenstein

EXHIBITIONS
Paris, 1960 no. 111; Paris, 1994–5, no. 225

ŒUVRE CATALOGUES
Blunt, no. 127, Thuillier, no. 199, Wild, no. 191, Wright, no. A27, Mérot, no. 179

REFERENCES
Bellori, 1672, pp. 445–6; Félibien (ed. 1725), IV, p. 65; McLanathan, 1947; Wallace, 1962

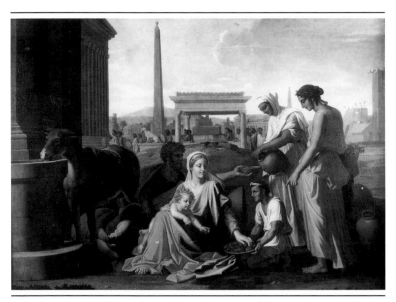

80

The Holy Family in Egypt

1655–7

105 × 143 cm

The Hermitage Museum, St Petersburg

The *Holy Family in Egypt* was painted in 1655–7 for Madame de Montmort, who married Poussin's close friend and patron, Chantelou, in 1656. Though the choice of theme is traditional, its treatment is highly unusual and cost the artist much deliberation. In a series of letters to Chantelou dating from 1655 to 1658, Poussin indicates that he was seeking a novel conception for this familiar subject, perhaps in response to the special nature of the commission; and this is immediately apparent in his depiction of the main figure group. The Holy Family is shown seated and resting upon their arrival in Egypt, accompanied by an ass. But rather than being attended by the putti traditionally included in such scenes (cf. fig. 75), they are fed dates by a youth and given water by two women whose costume and skin tones indicate that they are clearly intended to be Egyptian.

Though Poussin had often shown a desire to treat his subjects in an archaeologically accurate manner, the present picture is his most ambitious attempt at recreating the geographical setting of a given theme. This is evident not merely in the prominent obelisks visible in the distance, but in the figure group and certain of the minor architectural details included in the picture. Poussin himself provides a full explanation of these in a letter to Chantelou of 1658:

A procession of priests, with their heads shaved and crowned with leaves, dressed according to their fashion, carrying tambourines, flutes, trumpets, and a hawk on a stick. Those under the porch carry the box called Soro Apin which contains the bones and relics of their god Serapin, toward whose temple they are advancing. The rest, which appears behind the woman in yellow, is nothing more than a building made as a home for the Ibis bird which is shown there and a tower with a concave roof carrying a big vase to collect

dew – all this is not there just because I imagined it, but is drawn from the celebrated Temple of Fortuna at Palestrina, the pavement of which is made of fine mosaic, and on it is depicted to the life the natural history of Egypt and Ethiopia, and by a good hand. I put all these things into the painting in order to delight by their novelty and variety, and to show that the Virgin who is depicted there is in Egypt.[1]

The mosaic to which Poussin refers in this letter had been discovered around 1600 at Palestrina (ancient Praeneste) and, in the artist's day, was in the Palazzo Barberini in Rome. As Poussin indicates in his letter, it was then believed to be an accurate depiction of Egyptian life and customs, and for this reason aroused much curiosity. Cassiano dal Pozzo commissioned nineteen copies of it after its arrival in Rome (cf. fig. 165) – a fact that is unlikely to have gone unnoticed by Poussin.[2]

Charles Dempsey has shown that the artist transformed many details of this mosaic to suit his own purposes in the present picture.[3] Even more surprisingly, he has included a view of Rome in the far distance, complete with the Castel Sant'Angelo, a circular building reminiscent of the Pantheon, and at the far left a medieval tower surmounted by a cross. As Dempsey has convincingly argued, these anachronisms are intended to give the theme a deeper symbolic meaning:

The compelling group of the Holy Family served by three smiling Egyptian attendants is irresistibly reminiscent of traditional representations of the Adoration of the Magi. The true significance of the scene rises beyond a simple rationalised interpretation of the Rest on the Flight into Egypt, becoming as well an expression of Christ's reception and recognition by the pagan community . . . In the middle ground we see the worship of Serapis, the old god who, it will be remembered, is only a mortal; in the foreground Christ is seen received and venerated by the pagan community; in the distance, we see the future, the conquest of Rome by Christ's cross.

The quiescent poses and abstracted gazes of the figures are characteristic of Poussin's very late style – one in which action

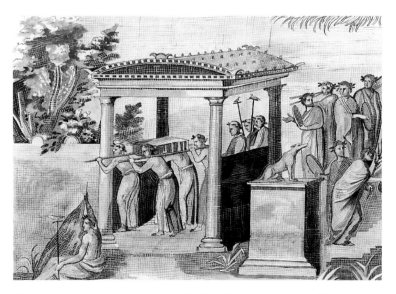

Fig. 165 Anonymous 17th-century Italian Artist, *Procession of Priests from the Palestrina Mosaic*. Watercolour, 33.2 × 48 cm. The Royal Collection

itself is rendered as a form of stillness. More unusual is the colour harmony of the painting, with its exotic tones of dull gold, salmon pink, vermilion and brown. When seen against the parched and arid hues of the background, these give the picture a terracotta colour harmony which in itself evokes the climate and landscape of Egypt.

A compositional study for the painting at Chantilly (fig. 166)[4] is executed in the trembling and tentative strokes typical of Poussin's drawing style of these years. It is close in design to the final canvas and among the most delicate of the artist's late drawings, its fine lines and intricate cross-hatchings appearing stitched into the paper.

Poussin returned to paint the Flight into Egypt itself in 1658, in a canvas for Cérisier. This was long believed to be lost, though its design is preserved in an engraving. However, in recent years, two painted versions of the composition have emerged, both of them claimed to be original.[5]

1. *Correspondance*, p. 448.
2. *The Paper Musem of Cassiano dal Pozzo*, Quaderni Puteani 4, British Museum, London, 1993, pp. 115–18, nos 70–2.
3. Dempsey, 1963, pp. 112–13.
4. CR I, pp. 30–1, no. 60.
5. Blunt, 1982, and Galerie Pardo, Paris, *Thèmes de l'âge classique*, 1989, pp. 50–1.

PROVENANCE
Painted for Madame de Montmort in 1655–7; Stroganoff collection, St Petersburg; 1931, entered the Hermitage from the Stroganoff Palace Museum

EXHIBITIONS
Paris, 1960, no. 109; Paris, 1994–5, no. 223

ŒUVRE CATALOGUES
Blunt, no. 65, Thuillier, no. 200, Wild, no. 195, Wright, no. 189, Mérot, no. 63

REFERENCES
Bellori, 1672, pp. 454–5; Félibien (ed. 1725), IV, pp. 148–9; Dempsey, 1963; NP/SM, pp. 202–4

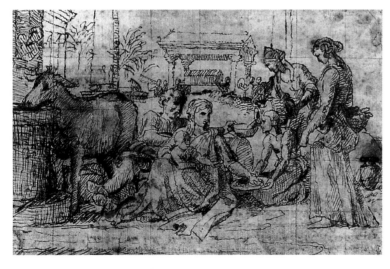

Fig. 166 Nicolas Poussin, *The Holy Family in Egypt*. Pen and bistre wash, 16.5 × 25.1 cm. Musée Condé, Chantilly

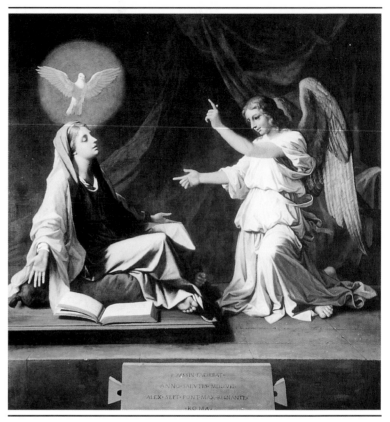

81

The Annunciation

1657
Inscribed: POVSSIN. FACIEBAT. ANNO SALVTIS. MDCLVII. ALEX. SEPT. PONT. MAX. REGNANTE. ROMA.
105 × 103 cm

The Trustees of the National Gallery, London

In Poussin's last figure paintings, he pares his art down to essentials. The figures are few, the poses petrified and the settings simplified. Nothing is allowed to disturb the silence. The subjects, too, are traditional and familiar, suggesting that the artist was seeking an even greater universality of expression in his final years. Included among them are the Lamentation over the Dead Christ (cat. 82), the Baptism of Christ (cat. 85) and the theme of the present picture, which derives from Luke I, 26–38. The Angel Gabriel announces to Mary at Nazareth that she will bear the Son of God. At first troubled by this salutation, Mary soon accepts God's will, saying: 'Behold the handmaid of the Lord; be it unto me according to thy word'.

This is the moment depicted here. The Virgin, with her arms outstretched, leans her head back in an attitude of submission. Above her is the dove of the Holy Spirit, a direct reference to the biblical words that 'the Highest shall overshadow thee'. At her side rests the book which, according to an early medieval tradition, she was reading when the angel appeared to her. At the right kneels Gabriel, pointing to heaven with one hand and to the Virgin with the other. The scene is bounded by a plain green drape and set on a simple tiled floor below which is a wooden tablet signed and dated 1657.

Though nothing is known of the early history of this picture, it has plausibly been suggested that it was painted for the tomb of Cassiano dal Pozzo, who died in 1657 and was buried in the church of Santa Maria sopra Minerva, Rome.[1] This attractive hypothesis finds support in the fact that Poussin informed Chantelou in December of that year that he was working on Cassiano's tomb.[2] It might also account for the many unusual features of the picture – above all, the elaborate inscription, square format and illusionistically painted tablet and floor. According to a 19th-century tradition, however, the picture

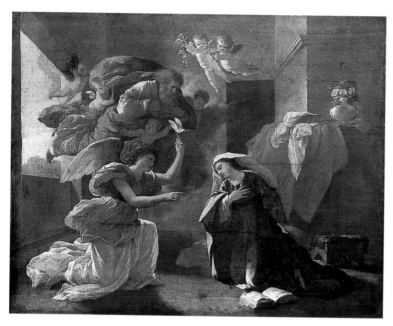

Fig. 167 Nicolas Poussin, *The Annunciation*. Oil on canvas, 75 × 95 cm, c. 1626–7. Musée Condé, Chantilly

came from 'the Pope's chapel'; and this would indicate that it was painted instead for Alexander VII.

In its stark simplicity and utter calm, the picture is often seen as Poussin's 'answer' to Bernini's *Ecstasy of St Theresa* (fig. 168) of 1644–7, the one classic and the other Baroque. Whether or not this comparison was conscious on Poussin's part, it reveals the degree to which his own art stood apart from the theatricality of mainstream Italian artists of the day. Whereas Bernini conveys mystical experience in a sensual and near-convulsive manner, the ecstasy of Poussin's Virgin is one of sublime tranquillity. Much closer to the ideals of the Baroque is Poussin's early *Annunciation* (c. 1626–7; fig. 167), with its conventionally animated poses, its detailed setting and still-life objects and its heavenly vision of God the Father surrounded by putti. In the thirty years that separate this picture from the London canvas, Poussin had discovered that the essence of a subject could often be conveyed by the simplest of means.

The deep spirituality of the present picture arises not only from its understated composition but from its unexpected colour harmonies. Unusually, the Virgin is clad in yellow, in addition to the traditional red and blue, and the angel in white, with wings of an iridescent combination of red, blue and grey.[3]

All these hues appear pale and chalky in quality; and, when seen against the deep greens of the Virgin's cushion and the background drape, they create an exotic and otherworldly impression appropriate to the miraculous nature of the theme. So, too, is the aureole of light surrounding the dove and the unearthly light illuminating the figures which, like the angel's message, emanates from above. This unusual feature also suggests that the picture may have been intended to decorate a tomb and be lit from a lantern above the altar, in the manner of Bernini's *St Theresa*.

A reduced version of the present picture, on wood, is in the Alte Pinakothek, Munich, and is regarded by some scholars as original. Whatever its status, it adds little to our understanding of Poussin's late career.

1. Costello, 1965.
2. *Correspondance*, pp. 445–6.
3. On the possible colour symbolism of the Virgin's draperies in this picture, see Copenhagen, 1992, p. 198.

PROVENANCE
Uncertain before 1845, when bought by Buchanan at the Thomas Wright sale; 1846, Buchanan sale; bought by Evans for Scarisbrick; 1861, his sale; bought by Part; c. 1877, Thomas Part collection; sold c. 1935 by his grandson, A. E. Part, to Christopher Norris, who presented it to the Gallery in 1944

EXHIBITIONS
Copenhagen, 1992, no. 22; Paris, 1994–5, no. 227

ŒUVRE CATALOGUES
Blunt, no. 39, Thuillier, no. 203; Wild, no. 192, Wright, no. 188, Mérot, no. 52

REFERENCES
Blunt, 1947[1]; Costello, 1965

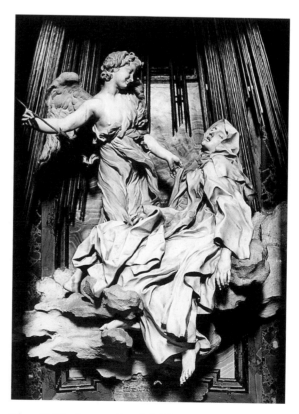

Fig. 168 Gianlorenzo Bernini, *The Ecstasy of St Theresa*. Marble, life-size, 1644–7. S. Maria della Vittoria, Rome

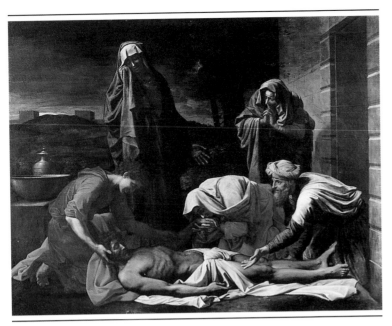

82

The Lamentation over the Dead Christ

c. 1656–8

94 × 130 cm

The National Gallery of Ireland, Dublin

Regarded by many as Poussin's greatest religious picture, the Dublin *Lamentation over the Dead Christ* was painted for an unknown patron around 1656–8 and, like the *Annunciation* (cat. 81) and *Baptism* (cat. 85) of these same years, treats one of the central themes of the Christian faith in a design of emblematic simplicity. But whereas Poussin had repeatedly depicted the birth and early life of Christ, scenes from the Passion are relatively rare in his career. By the artist's own admission, these aroused in him 'deep and distressing' thoughts which he found difficult to bear, and led him to avoid such themes.[1] The truth of these claims may be seen in the gravity and solemnity of the present picture, Poussin's final meditation on the death of Christ.

The body of Christ is laid out reverentially across the foreground of the picture like an offering upon an altar. Framing him are a group of mourners arranged in a sequence of monolithic poses that already assume the form of the tomb. These include the kneeling figures of the Magdalene and Evangelist, the former kissing Christ's hand and the latter supporting his head. Surrounding them are the Virgin, Mary Cleophas and Joseph of Arimathea. The scene is set against a bleak, nocturnal landscape devoid of any sign of life save that of a bare tree and two sprouting shrubs – traditional symbols of death and resurrection. At the left, an urn and basin are set ritualistically on a stone slab. Balancing them at the right is the gaping entrance to the tomb. In this simple equation, Poussin connects the instruments of the Passion with the promise of mankind's redemption through the sacrifice of Christ.

Silence, stillness and a stoical acceptance of death pervade the picture. Gestures are reduced to a mute dialogue of outstretched hands and lowered heads which speak of a deep, internalised grief, one that is beyond physical expression. As so often in Poussin's late art, the effect of such suppressed emotions is ultimately to redouble their force. This may be seen in the left hand of the Virgin, seeping out of her drapery in the exact centre of the picture. Silhouetted against the dark and distant hills, this motif conveys a sense of hopelessness and helplessness in the face of death that is devastating in its impact.

Like the *Annunciation* and *Baptism*, the composition has been divested of all inessentials and reduced to a handful of figures posed hieratically and in a frieze-like manner, like a monumental sculpted relief. As such, it recalls the art of antiquity or of the Italian Renaissance, from which Poussin borrowed two of the poses in the present picture. The figure of Christ derives from Sebastiano del Piombo's *Pietà* (*c.* 1515, fig. 169) and that of the Virgin from an engraving by Marcantonio Raimondi after Raphael.[2] In his reliance upon such 'archaic' sources, the artist reveals the extent to which he had repudiated the ideals of the Baroque by the late years of his career.

Those ideals are wholeheartedly embraced, however, in Poussin's earliest depiction of this subject, the canvas of *c.* 1628 now in Munich (fig. 170). In this, Christ's pose is more reminiscent of a hero fallen in battle than of the Son of God laid out for burial.[3] Mourning him are a group of figures whose impassioned poses and gestures convey grief, anguish and outrage, in a mood of heady emotionalism, such as one might expect from a young artist. The figures are arranged in a

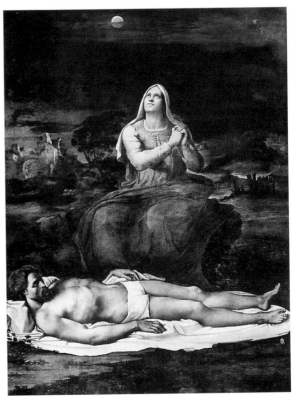

Fig. 169 Sebastiano del Piombo, *Pietà*. Oil on canvas, 269 × 225 cm, *c.* 1515. Museo Comunale, Viterbo

crescendo of curves which moves from the swooning Virgin to the distraught Magdalene and the workmanlike attitude of Joseph of Arimathea. All of these actions and emotions find their natural release in the figure of the Evangelist at the left, whose clenched fists and imploring gaze convey the depth of his sorrow as he wails into the night sky. Adding to the intensity of the picture are the weeping putti, the warm, rich colours and the atmospheric background, with its melting evening sky. Many of these devices also appear in the artist's early mythologies and bear witness to the romantic inspiration of his art during his first years in Rome.

By comparison with this youthful outburst, the Dublin canvas may appear cold, sober and unemotional. The rebellion of the early work here gives way to a mood of reverence and profound resignation which befits an aged master who already sensed himself close to death. But the pathos of the later picture finds its release in the jarring colour harmonies. Rather than the contrasting and compatible hues of the Munich canvas, these consist of a sequence of closely related and antagonistic colours – deep red, vermilion, orange, rose, violet and blue, set against acid greens, deathly whites and the slate greys and blues of the sky. The discordant impression they convey amounts to a visual cry of pain – one which reveals Poussin's deepened insight into the theme and into the resources of his own art. If the actions and expressions of the early picture still demand to be 'read' by the viewer, the shocking colouristic dissonances of the Dublin canvas appeal directly to the emotions, through the senses. Far from belonging to the devices of classical art, this may be seen as a late and personal form of expressionism on the artist's part.

1. *Supra.*, pp. 258.
2. *The Illustrated Bartsch*, 26 (formerly Vol. 14, Part 1), *The Works of Marcantonio Raimondi and of his School*, ed. Konrad Oberhuber, New York, 1978, pp. 49–52, nos. 34–35c.
3. As has often been remarked, the pose of Christ in this picture closely resembles that of the mortally wounded Adonis in the early *Venus with the Dead Adonis* (cat. 4).

PROVENANCE
Uncertain before 1837, when in the collection of Sir William Hamilton; by descent until 1882, when sold in the Hamilton Palace sale, London, and acquired by the Gallery

EXHIBITIONS
Paris, 1960, no. 96; Bologna, 1962, no. 84; Rome, 1977–8, no. 42; Düsseldorf, 1978, no. 44; Paris, 1994–5, no. 226

ŒUVRE CATALOGUES
Blunt, no. 83, Thuillier, no. 206, Wild, no. 190, Wright, no. 191, Mérot, no. 82

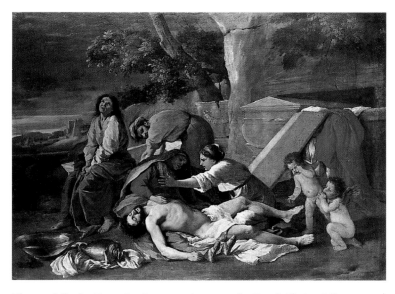

Fig. 170 Nicolas Poussin, *Lamentation over the Dead Christ.* Oil on canvas, 103 × 146 cm, *c.* 1628. Bayerische Staatsgemäldesammlungen, Munich

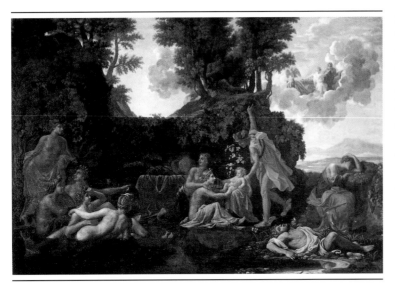

83
The Birth of Bacchus

1657
122 × 179 cm

Fogg Art Museum, Harvard University Art Museums, Cambridge, Gift of Mrs Samuel Sachs in memory of her husband

Painted for Jacques Stella in 1657, this mysterious canvas marks a new development in Poussin's late style. In a number of his history paintings of the 1650s – among them *Achilles among the Daughters of Lycomedes* (cat. 79) – the artist had set the scene in a rich and diversified landscape, which vies for attention with the figures. In the *Birth of Bacchus*, this tendency is carried one stage further. As in the *Landscape with Orion* (cat. 84) or *Apollo and Daphne* (fig. 19), landscape and figures are here accorded equal prominence and the theme is one of human destiny seen against a background of the cycles and balance of nature.

In Book III of the *Metamorphoses* (258–315), Ovid recounts the tale of the birth of Bacchus, who was born of the union of Jupiter and Semele. Jealous of the latter, Juno tricked Semele into requesting any wish of Jupiter. When she asked to see the god in his full glory, she was consumed by flames. The infant Bacchus was snatched from her womb and sewn up in his father's thigh, from where he was born. He was then entrusted by Mercury to the nymphs of Nysa, who hid him in their cave and nurtured him with milk. This is the moment depicted in the present picture, which shows Mercury delivering the infant Bacchus to the nymphs, who greet the future god with a wonderment and curiosity that calls to mind the parallel themes of the Finding of Moses or the Birth of Christ. Behind them stands the densely wooded entrance to their protective cave. In the sky at the right is Jupiter, who is revived after his labours with a cup of nectar offered by Hebe.

Though Poussin follows Ovid quite closely, certain details of the picture derive from Philostratus (*Imagines*, I, 14), who tells us that upon Bacchus's birth, the vines round the cave of the

nymphs burst into bloom – a motif prominently visible around the head of the young god. Philostratus also notes that the event was celebrated by Pan playing on his pipes. Poussin introduces this episode immediately above the group of Mercury and the nymphs. Unconnected with any early account of the tale, however, are the figures in the right foreground. They are readily identifiable as Echo mourning the dying Narcissus – the subject of one of Poussin's earliest mythologies (cat. 15) – and were presumably introduced by the artist to lend an allegorical interpretation to the myth. According to the 16th-century writer on mythology Natalis Comes (Natale Conti), the birth of Bacchus symbolised the fertility of nature – an idea already implied by Philostratus in his account of the flowering vines.[1] By this interpretation, the nymphs who tended him were seen as personifications of material fruitfulness, and the birth of the infant as a symbol of the infusion of life into matter. In contrast to this theme of the fecundity of nature, Poussin introduces the story of the unrequited love of Echo and Narcissus, which symbolises its opposite: sterility and death.

This theme appears more clearly delineated in a preparatory drawing for the painting (fig. 171),[2] which includes the figure of Apollo driving his chariot across the sky at the upper left, an allusion to the fertilising powers of the sun. In the final canvas, this motif is replaced by the rising rays of the sun which strike the cave and nurture the blossoming vines.

Poussin's use of two unrelated mythological tales to symbolise the harmony of nature is not unique to this picture. It also occurs in the *Rape of Europa* (1649–50; fig. 154) and the unfinished *Apollo and Daphne* of c. 1664.[3] In the latter, several episodes from the life of Apollo are combined to represent the opposing themes of fertility and sterility in nature. The seated figure of the sun god at the left is contrasted with that of Daphne at the far right. Behind, in the right middle distance, appears the dead Hyacinthus. Unrequitedly loved by Apollo, both Daphne and Hyacinthus met with tragic ends, their deaths symbolising the barrenness and sterility of nature, while Apollo himself alludes to its regenerative capacities. Though these ideas

Fig. 171 Nicolas Poussin, *The Birth of Bacchus*. Pen and bistre wash, squared, 23 × 37.5 cm. Fogg Art Museum, Harvard University Art Museums, Cambridge, Massachusetts.

are already implicit in the artist's early mythologies, among them the *Kingdom of Flora* (cat. 20), only in his very last years does Poussin portray them in a luxuriant landscape setting which serves as a symbolic counterpoint to the action.

The figure style and colouring of the present picture reinforce this idea and differ markedly from those of Poussin's early mythologies or his landscapes of 1648–51. Rather than being clearly outlined and modelled and placed in opposition to their surroundings, the figures in the *Birth of Bacchus* appear indistinguishable from them. With their soft and supple contours, labile poses and dank flesh tones, they seem at one with their natural setting, born of the very heat and moisture that surrounds them. Their fecundity is in turn mirrored in the landscape, which is lush and umbrageous at the left, behind the figures of Bacchus and the nymphs, and barren and rocky at the right, behind Echo and Narcissus. Indissolubly linked with the world of nature, the figures are also clad in the green and ochre hues of their organic surroundings, rather than in the sharply contrasting colours typical of Poussin's earlier landscapes. Through all of these devices, the artist creates the impression of a fragile and fluid world in which man and nature coexist, and both are subject to continuous change.

1. The allegorical meaning of this picture is fully discussed in Panofsky, 1949, pp. 116–20, and Blunt, 1967, text. vol., pp. 316–19.
2. CR V, p. 105, no. 433.
3. For which, see especially Blunt, 1967, text vol., pp. 319–20 and 336–51.

PROVENANCE
Painted for Jacques Stella in 1657; Philippe, Duc d'Orléans by 1727; 1790, sold to Walkuers; sold by him to Laborde de Méréville in the same year; 1798, bought Bryan; John Willett Willett; 1813, sold Coxe, London, but apparently bought in; 1819, Willett sale, London; bought Pinney; 1824, Chevalier Sebastian Erard, Paris; 1832, sold Henry, Paris; bought in; 1833, sold Christie's London; 1849, Montcalm sale, London; 1894, Adrian Hope sale, London; bought Sir A. Hayter; 1923, Anon sale, London; bought Durlacher; bought from him by Samuel Sachs and presented to the Fogg Art Museum by his wife in 1942

EXHIBITIONS
Paris, 1994–5, no. 228

ŒUVRE CATALOGUES
Blunt, no. 132, Thuillier, no. 204, Wild, no. 193, Wright, no. 190, Mérot, no. 122

REFERENCES
Bellori, 1672, p. 445; Félibien (ed. 1725), IV, pp. 65–6; Panofsky, 1949

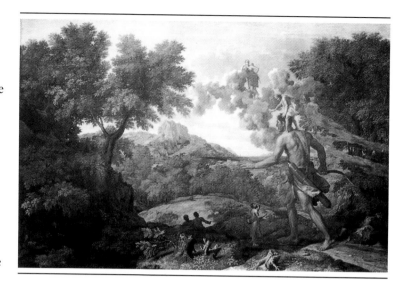

84
Landscape with Orion
1658
119 × 183 cm

Lent by The Metropolitan Museum of Art, New York
Purchase, Fletcher Fund, 1924

In an imaginary account of a noble hall, the Greek writer Lucian (*De domo*, 27–9) describes the frescoes that adorned its walls. One of these depicts the giant huntsman Orion who, for attempting to rape the princess Merope, was blinded by her father:

> On this there follows another prehistoric picture. Orion, who is blind, is carrying Cedalion, and the latter, riding on his back, is showing him the way to the sunlight. The rising sun is healing the blindness of Orion, and Hephaestos views the incident from Lemnos.

This description provided the immediate source for the present picture, which was painted for Michel Passart in 1658 and remains one of the most astonishing of Poussin's inventions. Nowhere else in his art does the supremely rational master of the *Manna* or the Chantelou Sacraments appear more wilfully anti-classical than in this extraordinary canvas.

Poussin does not follow Lucian's description exactly. Hephaestos is not depicted viewing the incident from Lemnos but standing at the giant's side and showing him the way. Instead, the role of spectator is taken by the goddess Diana, who plays no part in the story of Orion's blindness. She is shown standing on the top of a mysterious cloud that rises from behind the giant, veiling his sight. As Gombrich demonstrated,[1] these deviations from the story derive from later commentaries on the tale of Orion's blindness and are intended to provide an allegorical interpretation of the myth.

Poussin based his version of the legend on an account given by the 16th-century mythographer Natalis Comes, who in turn derived his version of the tale from the Greek poet Euphorion. The latter attributed to Orion three fathers – Neptune, Jupiter

and Apollo – who represent water, air and sun respectively. According to Comes, it was through the combined power of these elements that wind, rain and thunder arose in nature, an interpretation that explains the mysterious raincloud encircling Orion, which alludes at once to his blindness and his triple paternity. It also accounts for the presence of the moon goddess, Diana, who is included here for her meteorological significance. As Comes observes, it is the power of the moon that gathers up the earth's vapours and converts them into rain and storms. On this level, the picture may be read as an allegory of the circulation of water in nature, which begins with the rising cloud around Orion and returns to the earth in the form of rain once it has touched the moon.

Though so esoteric an interpretation of the myth may seem surprising, it explains Poussin's attraction to this bizarre story, which is rarely depicted in painting. It is also consistent with the allegorical figures often included in the artist's early mythologies and with the symbolic interpretations of Ovidian myth encountered in his very last works. As in the *Birth of Bacchus* (cat. 83) or *Apollo and Daphne* (fig. 19), the world of mythology is here seen to provide the key to one of the eternal mysteries of nature and, ultimately, to the order and harmony of the universe itself.

Poussin matches this theme with one of the most pantheistic landscapes of his entire career. With its dense undergrowth and umbrageous trees, the picture is pervaded by an intoxicating range of greens that evoke nature in its primordial state. Scarcely less visionary is the composition of the scene, which violates all the conventions of classical art in its abrupt and mysterious spatial elisions and dramatic distortions of size. These combine to conjure forth thoughts of the most wondrous and inexplicable forces in nature and reveal the aged Poussin immersed in the mystery of creation and awed by its elemental power.

The *Landscape with Orion* has a distinguished history, and from the time of the Romantics to that of the Surrealists, has exerted a profound impact upon painters, poets and writers. Once owned by Reynolds, it inspired two poems by Sacheverell Sitwell[2] and a phantasmagoric canvas by the Northern Irish artist, Stephen McKenna.[3] But its greatest champion was undoubtedly Hazlitt, who, in his memorable essay on the picture of 1821, matches Poussin's poetry with his own:

> He stalks along, a giant upon earth, and reels and falters in his gait, as if just awaked out of sleep, or uncertain of his way; you see his blindness, though his back is turned. Mists rise around him, and veil the sides of the green forests; earth is dank and fresh with dews, the 'grey dawn and the Pleiades before him dance', and in the distance are seen the blue hills and sullen ocean. Nothing was ever more finely conceived or done. It breathes the spirit of the morning; its moisture, its repose, its obscurity, waiting the miracle of light to kindle it into smiles; the whole is, like the principal figure in it, 'a forerunner of the dawn'. The same atmosphere tinges and imbues every object, the same dull light 'shadowy sets off' the face of nature: one feeling of vastness, of strangeness, and of primeval forms pervades the painter's canvas, and we are thrown back upon the first

integrity of things . . .

. . . Poussin was, of all painters, the most poetical. He was the painter of ideas. No one ever told a story half so well, nor so well knew what was capable of being told . . .[4]

1. Gombrich, 1944, pp. 37–41.
2. Sacheverell Sitwell, 'Landscape with the Giant Orion (1 & 2)', *Canons of Giant Art*, London, 1933, pp. 20–36.
3. The Orchard Gallery, Londonderry, and Arts Council Gallery, Belfast, *Stephen McKenna: Subjects, Scenes and Stories*, 1981, no. 2 (*The Blind Orion with Eos and Artemis*, 1981).
4. Hazlitt, 1844, II, pp. 190–202. Further to Hazlitt and Poussin, see Verdi, 1981².

PROVENANCE
1658, painted for Michel Passart; by 1687, Pierre de Beauchamp; 1745, Andrew Hay sale, London; bought Duke of Rutland; 1785, his sale, London; bought by Joshua Reynolds; bought Bryan; 1795, his sale; Desenfans; 1802, his sale, London; 1819, Philip Panné sale, London; bought Bonnemaison; probably sold by him to the Rev. John Sanford; bequeathed to his son-in-law, Lord Methuen; *c.* 1924, sold by his son; 1924, bought by Durlacher, London; purchased from them by the Museum in the same year

EXHIBITIONS
Paris, 1960, no. 113; Paris, New York, Chicago, 1982, no. 94; Paris, 1994–5, no. 234

ŒUVRE CATALOGUES
Blunt, no. 169, Thuillier, no. 205, Wild, no. 198, Wright, no. 165, Mérot, no. 216

REFERENCES
Bellori, 1672, p. 455; Félibien (ed. 1725), IV, p. 66; Borenius, 1931; Borenius, 1944; Gombrich, 1944

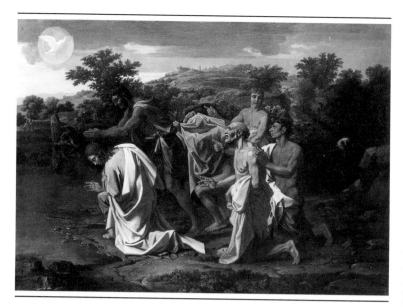

85
The Baptism of Christ

c. 1658

96 × 135.5 cm

The Philadelphia Museum of Art
The John G. Johnson Collection

With the exception of the Holy Family theme, Poussin portrayed the Baptism of Christ more often than any other subject in his career. In addition to the two canvases included in the sets of Seven Sacraments (cat. 44, 51), he devoted a small panel to this subject in 1648 (fig. 172). This was executed for Chantelou's brother, Jean, and is the artist's smallest surviving painting. About ten years later, he completed the present picture, his last and most mystical treatment of this theme. Nothing is known of the circumstances of this commission, which is not mentioned by any of the early sources. Even more surprisingly, the picture appears to be unrecorded before the present century.

The scene is one of almost unnerving starkness and solemnity. Six figures appear welded together into a single compact mass, like a monumental sculptural group. At the left, St John baptises Christ, who kneels at the edge of the River Jordan in an attitude of silent inner rapture. At the right, three men, representative of youth, maturity and old age, react to the miraculous appearance of the dove above Christ – a motif that recalls that of the late *Annunciation* (cat. 81). In the centre, a bending figure removes his garment in preparation for receiving the sacrament. Unlike the earlier versions of this theme for Pozzo or Chantelou, the picture includes no episodes or supernumeraries and scarcely any narrative action; all are banished from the scene in favour of an emphasis upon the deep spirituality of the moment.

Heightening the intensity of mood are the trance-like gazes and cataleptic gestures of the figures, whose ashen skin-tones and rigid stances endow them with an unearthly quality. In place of the discursive actions and expressions of his previous treatments of the theme, Poussin here explores only one abiding

emotion: awe. Nowhere is this better seen than in the man disrobing in the centre. A similar figure also performs this action at the left of the Pozzo *Baptism* (cat. 44). In the earlier work, however, he removes his clothes in a relaxed and workaday manner, much as one would undress for bathing. In contrast, the stooped and submissive figure in the Philadelphia picture fingers his garments with a reverence and deliberation such as one would reserve only for baptism.

The group is set before a wild and luxuriant landscape similar to that of Poussin's late landscapes with *Orion* (cat. 84) or *Hercules and Cacus* (cat. 86). In the distance, figures bathe or drink on the opposite bank of the river, as if to remind us of the more mundane uses to which water may also be put. Seen in the context of Poussin's art, such figures also recall another theme of ritual purification – namely, that of Diogenes (cat. 70) – and prompt one to wonder if this parallel between the ancient and Christian worlds was deliberate on the artist's part.

The colour of the picture is of an ethereal delicacy, with its mixture of coral pinks, powdery blues and saffron yellow. These pastel hues may be contrasted to the discordant colour harmonies of the Dublin *Lamentation* (cat. 82), which cannot be far from the present picture in date, as an example of Poussin's continuing concern in his later years to devise a colour harmony appropriate to his chosen theme.

Other features of the *Baptism* are characteristic of all the artist's late figure paintings. Among these are the heavily proportioned and somewhat ungainly figures, the tense and economical gestures and the prevailing mood of utter stillness. Like other late works, too, the Philadelphia picture accords a

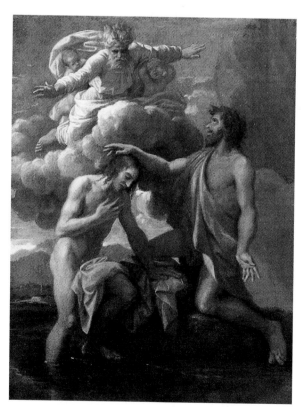

Fig. 172 Nicolas Poussin, *The Baptism of Christ.* Oil on cypress panel, 30.5 × 23 cm, 1648. Private Collection, New York

prominent role to landscape, which was to become the dominant concern of Poussin's final years. Even in the present instance, it serves as a key protagonist in the picture and possesses a pristine and primordial quality that casts the mind back to the earliest stages of human history. In the figure of the Baptist especially – clad in the hues of the natural world and silhouetted against a tree – Poussin announces the prevailing theme of his very last works: the coexistence of man and nature.

A drawing from Poussin's studio in the Albertina reproduces the figure group of the present picture with the addition of another standing man at the right.[1] It also omits the dove and contains a different landscape background. In all of these features, it agrees with a painted variant of the present canvas in a private collection,[2] the status of which would become clearer if the picture were cleaned.

1. CR V, p. 76, no. A 170.
2. Paris, 1994–5, no. 218.

PROVENANCE
Purchased by John G. Johnson before 1911 and bequeathed with his collection to the Philadelphia Museum of Art

EXHIBITIONS
Paris, 1960, no. 110; Paris, 1994–5, no. 219

ŒUVRE CATALOGUES
Blunt, no. 72, Thuillier, no. 192, Wild, no. 189, Wright, no. 184, Mérot, no. 71

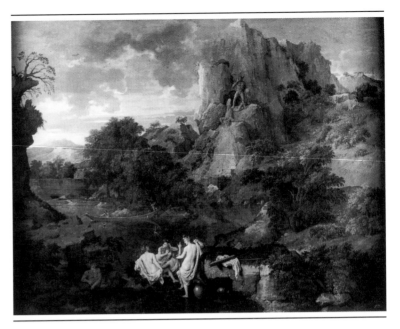

86
Landscape with Hercules and Cacus

c. 1660
156.5 × 202 cm

The Pushkin Museum of Fine Arts, Moscow

Although the concept of the 'sublime' was invented only in the 18th century, Poussin appears to anticipate it in such awe-inspiring landscapes as this, which surpasses even the *Orion* (cat. 84) in its portrayal of the power and grandeur of untamed nature. As in the *Orion*, the immensity and irrationality of the setting is reflected in the choice of theme, which derives from the *Aeneid* (VIII, 190–270) and depicts Hercules slaying the monster Cacus outside the lair in which the latter had hidden the cattle he stole from Hercules.

The scene is Mount Aventine, on the outskirts of the future city of Rome:

> Now look first at this rockface, with its overhanging crag, and see how beyond it there still remains a mountain lair, now abandoned, with its massive structure shattered asunder and a trail of mighty havoc left by falling rocks. Here there was a cavern, of a depth receding to a vast distance beyond the reach of any ray of sunlight. In this cavern Cacus, a man-monster of hideous aspect, had a home.

Poussin follows Virgil's description closely, showing a steep rockface at the top of which appears the cave of Cacus, entered by Hercules after a raging struggle. Virgil's account of this episode is so dramatic that it warrants quoting in full:

> Now there was a pinnacle of flint-rock which stood sheer, as if the stone had been cut away all round it, soaring to a dizzy height on the ridge above the cave; an impressive sight and a fit nesting-place for sinister birds of prey. It was inclined towards the downward slope, leaning towards the river on the left. Hercules now strained at it from the right side, pressing it forwards. He shook it, wrenched it from its roots, and then gave it a sudden thrust. At that thrust the

great sky thundered, the river-banks leapt apart, unlocking the deepest dwellings of the infernal world, and had flung wide open the pallid Empire hated of the gods, till the horrifying abyss comes into view from above and ghosts shudder at the inrush of light.

Hercules then slays Cacus, whom Poussin depicts in human form rather than as a 'man-monster', and drags his shapeless carcass from the cave by the feet.

The landscape in which Poussin has set Virgil's wondrous and grisly tale is one of untrammelled wildness. Loosely bounded by an outcrop of rock at the left, it is dominated by a vast mountain range containing the giant's lair. At the foot of this flows a river with boatmen; in the foreground, a group of nymphs and a reclining river god witness the drama. At the upper right appear the peaceable cattle liberated by Hercules. The scene is set against the 'thundered' sky stipulated by Virgil and coloured in a muted range of browns, greys and greens that

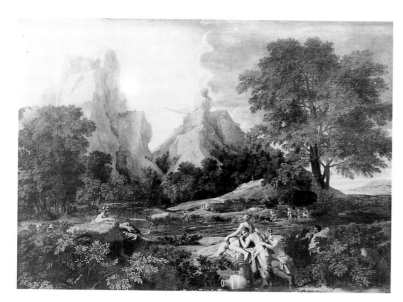

Fig. 173 Nicolas Poussin, *Landscape with Polyphemus*. Oil on canvas, 150 × 198 cm, 1649. The Hermitage Museum, St Petersburg

evoke nature at its most inchoate. Yet the proto-romantic character of the scene cannot disguise the fact that the victory of Hercules over Cacus had a moral significance as a symbol of the triumph of good over evil.

Nothing is known of the early history of the painting, which is unanimously dated to the years around 1660. In its freedom of handling, sombre colouring and primeval vision of nature it is comparable in style and audacity to the *Autumn* and *Winter* landscapes from the Four Seasons (cat. 90–1).

The present picture is often linked with the *Landscape with Polyphemus* (fig. 173) in the Hermitage, which depicts the monstrous Cyclops, seated on top of a mountain, serenading Galatea – the theme of one of Poussin's earliest mythologies (cat. 6). The two landscapes are nearly identical in size, share a comparably bizarre theme, and in the 18th century were in the same collection, where they were apparently regarded as pendants.[1] According to Félibien,[2] the *Polyphemus* was painted

for Pointel in 1649, a fact corroborated by the recent discovery of the latter's inventory, which makes no mention of the *Hercules and Cacus*. Moreover, whereas the former was engraved by Baudet in 1701, the present picture was not. Thus, the two works were certainly not conceived as a pair but must have been brought together and treated as such at some time after the publication of Baudet's engraving.

Poussin may have been drawn to the theme of Hercules and Cacus by Domenichino's landscape of the same subject of 1622–3 (fig. 174). This depicts Hercules dragging Cacus from his lair, accompanied by the startled onlookers and stolen cattle. Surrounding them is a tranquil and rustic landscape that bears little relation to the theme. But the same may not be said of Poussin's convulsive landscape, which evokes the violence and brutality of Cacus through a comparably terrifying image of nature.

1. Maurice Tourneux, 'Diderot et le Musée de l'Hermitage', *Gazette des Beaux-Arts*, XIX, 1898, p. 343.
2. Félibien (ed. 1725), IV, p. 59.

PROVENANCE
1772, bought by Diderot from the Marquis de Conflans for the Empress Catherine II of Russia; 1930, transferred from the Hermitage to the Pushkin Museum

EXHIBITIONS
Paris, 1960, no. 108; Paris, 1994–5, no. 235

ŒUVRE CATALOGUES
Blunt, no. 158, Thuillier, no. 215, Wild, no. 200, Wright, no. 198, Mérot, no. 217

REFERENCES
Alpatov, 1965; NP/SM, p. 173

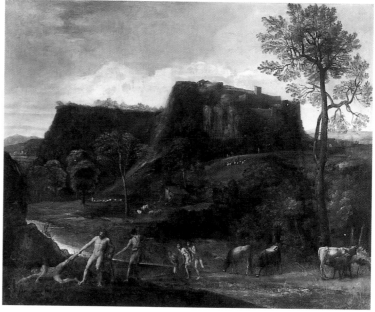

Fig. 174 Domenichino, *Landscape with Hercules and Cacus.* Oil on canvas, 121 × 149 cm, *c.* 1622–3. Musée du Louvre, Département des Peintures, Paris

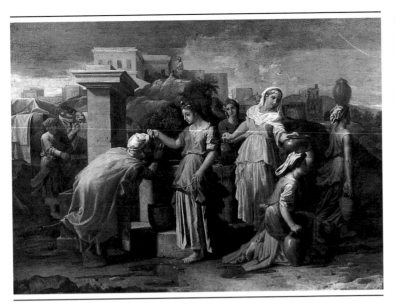

87

Eliezer and Rebecca

c. 1660–2

96.5 × 138 cm

Lent by the Syndics of the Fitzwilliam Museum, Cambridge

Poussin's third and final treatment of the theme of Eliezer and Rebecca (cf. cat. 5, 59) is one of his last figure paintings, datable to 1660–2. Though undocumented in any of the early sources, it is close in subject and design to the *Christ and the Woman of Samaria* he painted for Chantelou's wife in 1662, which is now lost and known only through engravings and a painted copy (fig. 175).[1] In both works, a small group of heavily proportioned figures are symmetrically arranged across the foreground of the picture and seen against a background of buildings and hills that abruptly encloses the scene, concentrating all the attention upon the dialogue between the figures.

This 'dialogue' is essentially similar in both paintings. In the *Woman of Samaria*, Christ reveals himself as the Messiah to an unknown woman drawing water from a well, saying: 'Whosoever drinketh of this water shall thirst again. But whosoever drinketh of the water that I shall give him shall never thirst.' (John IV, 4–30). In the present picture, Rebecca provides water for Abraham's servant, Eliezer, and his camels. In performing this act of charity, she reveals herself to be the future wife of Isaac, son of Abraham (Genesis XXIV, 22–7). Thus both works are concerned with the theme of divine selection around a well, symbol of purification. Poussin himself had painted the two subjects as pendants during his early years in Rome (cat. 5, fig. 35) and this general theme also appears elsewhere in his art.[2]

In the present painting, Eliezer drinks eagerly from a jug offered to him by Rebecca, while her companions draw water for themselves. Though their presence is not mentioned in the Bible, Poussin's inclusion of them here – and in the great canvas of 1648 in the Louvre – may derive from Josephus's account of

the tale (*Antiquities* I, xvi), which notes that all the other maidens at the well refused Eliezer's request for water 'on pretence that they wanted it all at home'. Rebecca alone obliged the stranger and, in so doing, revealed to him 'that God has thus plainly directed his journey'. Eliezer then rewards her with a gift of jewellery and announces that she has been chosen as Isaac's future wife.

Rather than emphasising the splendour and ceremony of the occasion, as he does in the Louvre picture, Poussin's last painting of this subject stresses its humility and humanity. The moment chosen is identical to that of his very early canvas of this theme of *c.* 1627. The heroine performs her charitable act while Eliezer's servant and camels await their turn. Yet a world of difference exists between Poussin's early and late canvases of this subject. The former treats the theme in a straightforward and lighthearted manner, with its scowling servant and smiling camel. In the present work, such details are avoided in favour of a more spiritual interpretation of the theme.

Like Poussin himself, Eliezer now appears considerably older than his counterpart in the early picture and bends down before Rebecca in an exaggerated and near-obsequious manner that conveys at once his infirmity and gratitude. Rebecca's kindness is in turn captured in her graceful and yielding pose. To the right her companions go about their routine unconcerned with the sudden elevation of the heroine. Unlike their counterparts in the canvas of 1648, they register neither envy nor amazement, only apparent indifference. In this distinction alone, Poussin reveals his altered spiritual outlook upon life. If the Louvre picture implies that man has the capacity to shape his own destiny through his actions, the present work suggests that these are instead governed by forces beyond his control.

The style of the present picture also introduces us to a more mutable world than that of the artist's two previous treatments of the theme. In place of the tentative and somewhat stilted

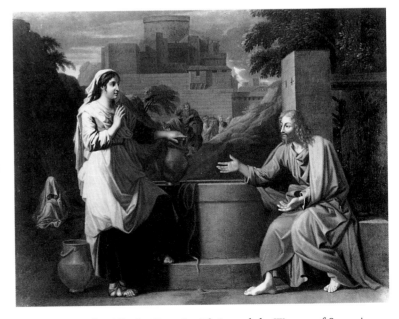

Fig 175 *Copy after* Nicolas Poussin, *Christ and the Woman of Samaria.* Oil on canvas, 94 × 121.2 cm. Original 1662. Private Collection, New York

poses of the first version, or the vigorous and authoritative attitudes of the Louvre canvas, Poussin's figures now strike a sequence of gentle and compliant poses, which suggest involuntary action. Reinforcing the poignant and elegiac mood are the pastel colour harmonies, which possess a matt and near-lifeless quality. Gone are the bold colour accents of the early picture and the confidence and mastery of the *Eliezer and Rebecca* of 1648. In their place appears a series of delicate and mixed hues – the fragile and uncertain colour harmonies of ever-changing nature.

A copy of a compositional drawing for the present picture is in the Louvre.[3]

1. Blunt, no. 73 and Mérot, no. 72 (with further bibliography).
2. *Supra.*, pp. 31, 36.
3. CR I, p. 4, no. A 1.

PROVENANCE
Hubert Galton; 1929, sold John D. Wood, Birmingham; 1933, bought from Duits, London, with an uncertain provenance, by Anthony Blunt; 1984, purchased by the Museum

EXHIBITIONS
Paris, 1960, no. 100; Rome, 1977–8, no. 46; Düsseldorf, 1978, no. 45; Paris, 1994–5, no. 236

ŒUVRE CATALOGUES
Blunt, no. 9, Thuillier, no. 217, Wild, no. 194, Wright, no. 196, Mérot, no. 6

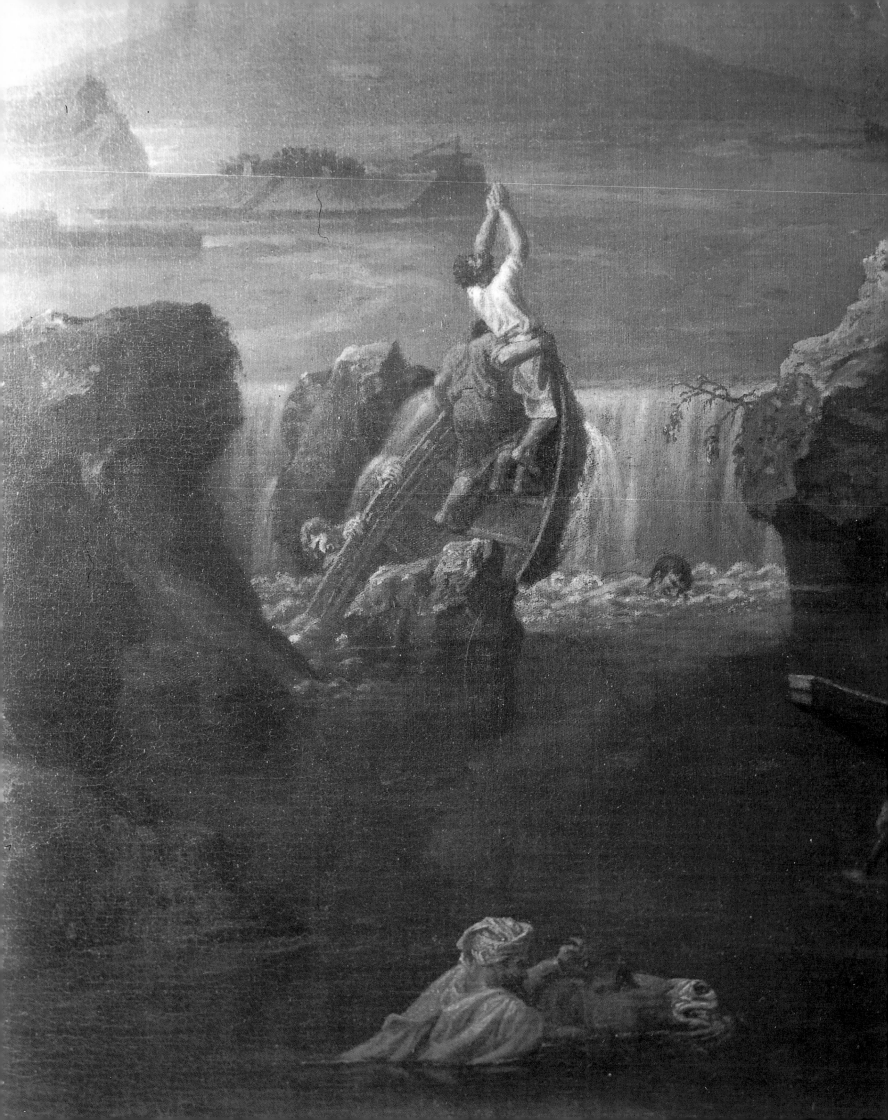

The Four Seasons

Poussin's last completed works were a set of landscapes depicting the Four Seasons, painted between 1660 and 1664 for the Duc de Richelieu, nephew of the famous statesman. Little is known of the history of this commission, which is not mentioned in the artist's letters nor in Bellori's early biography. Félibien provides a brief description of these pictures, noting the religious subject-matter of each and expressing a clear preference for *Winter*, which has always been the most celebrated of the set.[1] He concludes with a criticism of the Seasons that was to become commonplace: 'It is true that if one still sees in these four paintings the force and beauty of the painter's genius, one also observes in them the feebleness of his hand.' Whether or not one concurs with this judgement in front of the original canvases, which have all been recently cleaned, there can be no doubting their startling originality. The Four Seasons are unique not only in Poussin's oeuvre but in the entire history of art.

In his earlier landscapes with religious subjects (cat. 46–7, fig. 111), Poussin had confined himself to the conventional theme of a solitary saint in the wilderness – a surprisingly unadventurous approach from so iconographically innovative a master. Here, however, he portrays four unrelated biblical events that had never before been associated with the theme of the Four Seasons. Moreover, each of these episodes is introduced as part of a complex allegorical programme that unifies the cycle and finds its only true counterpart in certain of Poussin's late mythological landscapes, above all the *Birth of Bacchus* (cat. 83) and *Landscape with Orion* (cat. 84).

Representations of the Four Seasons took two opposed forms in the tradition inherited by Poussin. One of these was to personify each season using human figures bearing attributes of the different times of year, as in the painting from the studio of Guido Reni of 1615–20 (fig. 176). Often these figures were pagan deities associated with the season in question, such as Ceres for Summer and Bacchus for Autumn. The other and more widespread convention – especially in Northern art – was to depict each season in a landscape that included figures engaged in rural occupations appropriate to the time of year. This is the method adopted by Bruegel in his paintings of the Months and his drawings of the Seasons. Thus, Bruegel's *Summer* of 1568 (fig. 177) portrays figures gleaning wheat or resting in the fields. In Poussin's Four Seasons, however, the artist avoids both the emblematic and the domestic approach to this theme in favour of a solution he had adopted in the two sets of Sacraments. He employs a biblical theme appropriate to each season, which also lends a deeper meaning to the scene. These serve to contrast the changing cycles of nature with the changing course of human life – an idea that originates with the ancients and is a favourite theme of Poussin's art throughout his career.[2]

The subjects of the pictures are all drawn from the Old Testament. *Spring* depicts Adam and Eve in the Garden of Eden; *Summer*, the meeting of Ruth and Boaz; *Autumn*, the spies returning from the Promised Land; and *Winter*, the Deluge. Although these were clearly determined by the character of the

individual seasons, Sauerländer has demonstrated that all four subjects may also be read as a prefiguration of events in the New Testament[3] – an interpretation that converts the cycle into an allegory of the salvation of mankind through the Church. In the depiction of Spring, for instance, Paradise may be seen as symbolising the coming Church, and Adam, the coming Christ. Further enriching the meaning of these pictures is the fact that they may contain references to four pagan deities associated with the seasons and that they also depict four different times of day and four different stages of human life, which progress from courtship in spring to marriage in summer, and from fruition in autumn to death in winter. Though these varying levels of interpretation are discussed further in the entries on individual paintings in the series, it is worth stating that the complex symbolism of these pictures is so completely absorbed into the theme and design of each that they appear remarkably uncomplicated in meaning. As Alain Mérot has observed:[4]

> Never before, perhaps, in the history of Western painting, had so many different and often difficult things been stated with such simplicity. Never before had a painter had such a sense of the universe as a whole. Poussin was neither projecting a personal view of the world nor imbuing it with his own feelings, however: his sense of the universe was impersonal, and it is in this fact, seen by some as a defect, that his greatness lies.

Stylistically, the Seasons represent a synthesis of much that had preceded them in Poussin's landscape art. Two of the series – *Summer* and *Winter* – may be related to the artist's works in this vein of the years 1648–51, while the remaining canvases are closer in conception to Poussin's landscapes of 1658–60. However, all of them bear certain features of his very late style: above all, a soft, moist and fluid application of paint and a decided preference for natural settings that contain little or no architecture. Instead, Poussin sets his Old Testament themes in landscapes appropriate to an early moment in biblical history and depicts 'the world in its first naked glory'.[5]

The most striking stylistic feature of the four Seasons is their colouring. Each of these canvases is dominated by a single prevailing hue: green for *Spring*,

Fig. 176 *Studio of* Guido Reni, *The Four Seasons.* Oil on canvas, 170 × 221 cm, 1615–20. Kunsthistorisches Museum, Vienna

golden-yellow for *Summer*, greyish-brown for *Autumn* and blackish-grey for *Winter*. These colours evoke the character of each season and provide the supreme example in Poussin's landscape art of his application of the theory of the modes. In all four pictures, the artist sacrifices descriptive colour for expressive colour, and conveys through the abstract means of colour alone the emotional essence of his theme. This very 'modern' attitude towards colour, which anticipates later developments in painting from Whistler to Rothko, led the early 20th-century critic, Paul Desjardins, to characterise these pictures as 'four symphonies in four different tonalities' and to describe the artist himself as '*Poussin musicien*'.[6]

The Four Seasons met with a mixed reception when they arrived in Paris in the mid-1660s. According to Loménie de Brienne,[7] a gathering of French artists and critics of the day produced no general consensus on the relative merits of individual members of the series, two of which were subsequently made the focus of short *conférences* at the French Academy. Though *Winter* enjoyed widespread popularity from the 18th century onwards, the series as a whole remained little studied or appreciated until the 19th century, when it attracted the admiration of Turner and Hazlitt and, thereafter, of Corot and Cézanne. Such belated recognition testifies to the extent to which these supremely pantheistic landscapes stood in advance of their time.

1. Félibien (ed. 1725), IV, pp. 66–7.
2. *Supra.*, pp. 38–9.
3. Sauerländer, 1956, pp. 169–84.
4. Mérot, p. 243.
5. Hazlitt, 1844, II, p. 192.
6. Desjardins, 1903, p. 124.
7. Loménie de Brienne in *Actes*, 1960, II, p. 222.

PROVENANCE
Painted for the Duc de Richelieu between 1660 and 1664; 1665, purchased by Lous XIV

REFERENCES
Félibien (ed. 1725), IV, pp. 66–7; Sauerländer, 1956

Fig. 177 Pieter Bruegel, *Summer.* Pen and brown ink on yellowed paper, 22 × 28.5 cm, 1568. Kunsthalle, Hamburg

88

Spring, or The Earthly Paradise

1660–4

118 × 160 cm

Musée du Louvre, Département des Peintures, Paris

It is the first lovely dawn of creation, when nature played her virgin
fancies wild; when all was sweetness and freshness, and the heavens
dropped fatness. It is the very ideal of landscape-painting, and of the
scene it is intended to represent. It throws us back to the first ages
of the world, and to the only period of perfect human bliss, which
is, however, on the point of being soon disturbed.

William Hazlitt[1]

Spring depicts Adam and Eve in the Earthly Paradise (Genesis
II). God the Father departs at the upper right, while Adam and
Eve discourse on the Tree of Knowledge, visible in the centre
middle distance. At the left the dawning rays of the sun rise
between a cleft in the landscape, tingeing the tips of the trees
and revealing the new-born world. In the background, birds
swim peacefully on a tranquil lake framed by a distant
mountain range. Other than the human figures, they provide
the only sign of life in this scene of primeval nature. Unusually,
the serpent is absent from the Tree of Knowledge. In addition
to enhancing the serenity of the moment, this omission makes it
possible for the picture to be seen as an anticipation of events in
the New Testament, with Paradise prefiguring the coming
Church and Adam the future Christ.[2]

The landscape is one of overpowering richness, with dense
foliage and thick undergrowth carpeting the land and the trees
laden with fruit. Verdant greens pervade the scene and evoke the
vitality and freshness of nature at springtime. In keeping with
the idyllic mood of the theme, the landscape itself appears freely
composed. Bounded by an outcrop of rocks and a group of
trees, it opens out to two vistas surrounding the central grove of
trees. In the foreground lush vegetation encloses the scene and
recalls the power and splendour of burgeoning nature. Spatial

transitions appear fluid and continuous, and the landscape is
untouched by the hand of man. In Hazlitt's words, this is
nature 'playing her virgin fancies wild' – bursting with life and
growth.

As has often been noted, the composition of *Spring* is broadly
similar to that of the *Birth of Bacchus* (cat. 83). In both, the sun
rises at the left through a break in the landscape and a heavenly
figure appears at the upper right. Though this resemblance may
have been unconscious on Poussin's part, it has led some
commentators to relate the motif of the rising sun in the present
picture to the pagan god Apollo, who is certainly symbolically
present in the *Birth of Bacchus*. While it would be unwise to
push the parallel much further, it is worth noting that both
paintings are concerned with the fundamental theme of creation
in nature. In the mythological canvas, Jupiter, father of the
gods, gives birth to Bacchus, symbol of fertility, who is
nurtured by the nymphs and greeted by the rays of the rising
sun. In the present picture, God the Father creates both nature
and man, initiating the cycle of life and the course of the
seasons under the fertilising powers of the sun.

1. *The Complete Works of William Hazlitt*, ed. P. P. Howe, London and Toronto,
1934, XII, pp. 291–2.
2. Sauerländer, 1956, p. 174.

EXHIBITIONS
Paris, 1960, no. 115; Paris, 1994–5, no. 238

ŒUVRE CATALOGUES
Blunt, no. 3, Thuillier, no. 211, Wild, no. 204a, Wright, no. 200, Mérot, no. 206

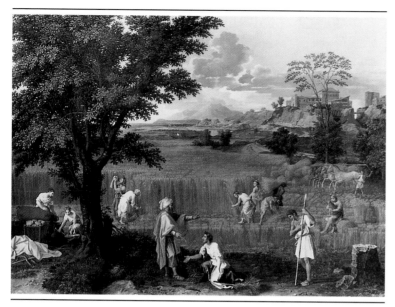

89

Summer, or Ruth and Boaz

1660–4

118 × 160 cm

Musée du Louvre, Département des Peintures, Paris

Like Bruegel before him (fig. 177), Poussin chose to illustrate
the season of Summer with a harvest scene. In keeping with the
programme of his own Four Seasons, however, the artist does
not portray a rural genre scene but one from the Old
Testament. The Moabite Ruth kneels before the Israelite Boaz
and begs to glean wheat in his fields (Ruth II, 1-17). Boaz grants
her this privilege and instructs his servants to 'reproach her
not'. In due course, the couple marry and from their union
springs the line of David and thereby of Christ. According to a
medieval interpretation of the story, the marriage of Ruth and
Boaz was itself symbolic of the union of Christ with the
Church.[1]

Poussin depicts the meeting of Ruth and Boaz in an
appropriately ceremonial manner. The couple are placed in the
centre foreground of the picture and seen in strict profile, as
Alain Mérot has observed, in contrasting attitudes 'of majesty
and humility'.[2] The germ of this motif may be found in an
engraving by Hendrick Goltzius of 1580 (fig. 178). With his left
hand, Boaz beckons a standing servant at the right to protect
the stranger. Behind this group, workers harvest in the fields.
Included among them is a group of five horses trampling the
wheat – a motif that calls to mind classical friezes, such as those
on the Arch of Titus. More unexpected is the seated bagpiper at
the right, serenading the main figures, who may be intended to
allude to their future marriage. At the extreme left, two women
are engaged in making bread: presumably a reference to the
Eucharist and another prefiguration of the New Testament.

Though references to pagan mythology are less explicit here
than in certain of the other Seasons, Sauerländer notes that
engravings of Ruth holding sheaves of wheat often recall images

of Ceres, traditional goddess of Summer and of the harvest.[3]

As befits the formality of the theme and the season of the
year, the landscape is the most rigorously designed of all the
Four Seasons. Carefully framed by isolated trees in the left
foreground and right middle distance, it is organised in a series
of stratified layers, all of them parallel with the foreground
figures and with the picture plane. These recede in an orderly
sequence to a distant view of mountains and buildings,
surmounted by clouds, which delimit the scene. This strictly
geometric method of construction reflects the theme of the
cultivation of nature. In contrast to *Spring*, which is set at early
morning, the scene takes place under a steady noonday light;
and the wealth of figures included in the picture permits
Poussin to introduce a wide variety of local colours, which
animate the landscape and mirror the festive nature of the
theme. In all these respects, the picture calls to mind Poussin's
heroic landscape style of 1648–51 rather than his more
naturalistic landscapes of the immediately preceding years.

Summer formed the subject of a brief *conférence* at the
French Academy in 1671, delivered by Jean-Baptiste de
Champaigne, nephew of the painter of the same name.[4]
Remarking on the freedom of handling and apparent lack of
finish of the painting – characteristic of Poussin's late style –
Champaigne observed that these enhanced the picture's overall
harmony and unity and prevented individual elements of the
composition from distracting attention from the whole.

The picture enjoyed great popularity with two central
European painters of the Neo-classical period, Joseph Anton
Koch (1768–1839) and his pupil Christian Gottlieb Schick
(1776–1812). The former painted and drew a series of
paraphrases of Poussin's *Summer* throughout his career, on
occasion combining with these motifs derived from the *Autumn*
landscape of the Seasons (fig. 179).[5]

An even greater admirer of the present picture was Cézanne,
who reputedly stood 'in ecstasy' before it in the Louvre and

Fig. 178 Hendrick Goltzius, *Ruth and Boaz*. Engraving, 19.6 × 27.3 cm,
1576.

later confessed to Joachim Gasquet: 'time and again I've wanted to rework the *Ruth and Boaz* motif'.[6] Further evidence of this is the existence of two harvesting scenes by Cézanne of *c.* 1877.[7]

1. Sauerländer, 1956, pp. 175–7.
2. Mérot, p. 248.
3. Sauerländer, 1956, p. 176.
4. *Conférences* (ed. Fontaine), pp. 119–23.
5. In addition to the drawing reproduced here, Koch painted three canvases of this theme: Schäfer collection, Schweinfurt, *c.* 1803; Thorvaldsen Museum, Copenhagen, *c.* 1803–5 (a collaboration with Schick); Tiroler Landesmuseum Ferdinandeum, Innsbruck, 1826–7.
6. *Joachim Gasquet's Cézanne, A Memoir with Conversations*, London, 1991 (orig. 1921), pp. 116, 211.
7. Lionello Venturi, *Cézanne, son art – son oeuvre*, Paris, 1936, 2 vols., nos. 249, 1517.

EXHIBITIONS
Paris, 1960, no. 116; Rouen, 1961, no. 91; Bologna, 1962, no. 86; Paris, 1994–5, no. 239

ŒUVRE CATALOGUES
Blunt, no. 4, Thuillier, no. 212, Wild, no. 204b, Wright, no. 201, Mérot, no. 207

REFERENCES
Conférences (ed. Fontaine), pp. 119–23

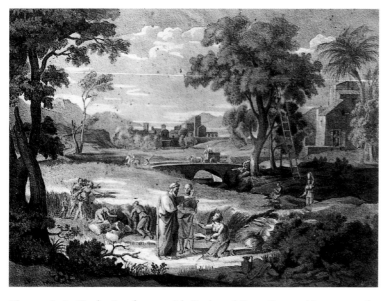

Fig. 179 J. A. Koch, *Landscape with Ruth and Boaz*. Pen and brown wash with pencil, heightened with white, on brown paper, 14.2 × 19.7 cm, *c.* 1799–1803. Kunstmuseum, Düsseldorf

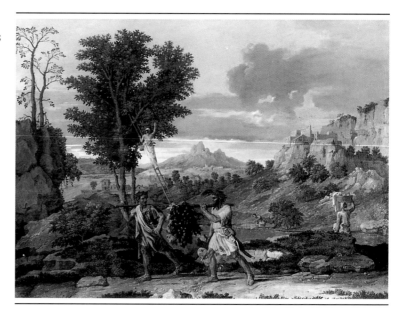

90

Autumn, or The Spies with the Grapes from the Promised Land

1660–4
118 × 160 cm

Musée du Louvre, Département des Peintures, Paris

The subject is from Numbers XIII. Moses has sent spies to the land of Canaan, promised to the Israelites by the Lord. They return after forty days bearing grapes, fruit of the 'land of milk and honey'. Poussin portrays two of the spies bearing a bunch of greatly enlarged grapes tied to a wooden beam in the centre of the picture. A comparison of this motif with an engraving by Hieronymus Wierix of 1607 (fig. 180), which Poussin clearly knew, reveals that this theme is intended as a prefiguration of Christ's Crucifixion and complements the Eucharistic symbolism of the bread in the *Summer* landscape (cat. 89).

Sauerländer has identified the woman gathering apples on the ladder at the left as a personification of the Church and the tree itself as the Tree of Knowledge, but this theory has not gained general acceptance.[1] The apples are more likely to be a reference to the theme of the fertility of nature in autumn. The same critic has also suggested, more convincingly, that the first three of Poussin's Seasons represent three different stages of human history: *Spring* depicts the state *ante legem*, before the giving of the law to Moses; *Autumn, sub lege*, under the old dispensation of Mosaic law; and *Summer, sub gratia*, under the new dispensation of Christ, direct descendant of the marriage of Ruth and Boaz.

The picture also continues the secular symbolism apparent in the first two Seasons. The prominence of the grapes may be seen as a reference to Bacchus, god of wine; and the time of day is evidently later than the previous paintings in the series and obviously intended to depict afternoon or early evening. Finally, if the figures of Adam and Eve represent innocence and those of Ruth and Boaz maturity, the action of the present

picture alludes to a later stage in man's life-cycle: the fruitfulness of middle age.

Poussin sets the theme in a harsh and craggy landscape which calls to mind the *Hercules and Cacus* (cat. 86) in its jagged rock formations and sparse vegetation. In the sky, thick clouds gather and appear to foretell the austerities of winter. Combined with the fruitfulness of autumn is the portrayal of a bleak and inhospitable time of year – one marked by a struggle for survival in nature. This is nowhere more apparent than in the contrast between the bare and leafy trees at the left and in the stony colours that pervade the picture. Rather than the glistening, rain-washed hues of *Spring* or the fully saturated ones of *Summer, Autumn* revolves around dusky greens, greys and browns – the dull and lifeless hues of waning nature.

Autumn has always attracted less praise than the other Seasons, doubtless because of its muted colouring, odd disproportions of scale, and rugged and somewhat undifferentiated landscape. The motif of the spies bearing grapes was imitated by artists of Poussin's circle,[2] but they invariably transposed it to a more appealing landscape. Only with the advent of naturalism in painting in the mid-19th century did *Autumn* win adherents. One of the greatest of these was Corot, who is reputed to have exclaimed in front of this picture: '*Voilà la nature*'.[3] Copies and variations on the design also exist by Paul Flandrin, Vuillard and Balthus.[4]

A drawing of the composition, which may be based on a lost original, is in the Pierpont Morgan Library, New York.[5]

1. Sauerländer, 1956, pp. 177–81.
2. Cf. Marie-Nicole Boisclair, *Gaspard Dughet, Sa vie et son oeuvre (1615–1675)*, Paris, 1986, pp. 303–4, no. R 14 (and the works and literature cited there).
3. Félix Bracquemond, *Du dessin et de la couleur*, Paris, 1885, p. 207.
4. Cf. Paris, 1993, pp. 167, 169 and 175.
5. CR IV, p. 53, no. A 143.

EXHIBITIONS
Paris, 1960, no. 117; Bologna, 1962, no. 87; Paris, 1994–5, no. 240

ŒUVRE CATALOGUES
Blunt, no. 5, Thuillier, no. 213, Wild, no. 204c, Wright, no. 202, Mérot, no. 208

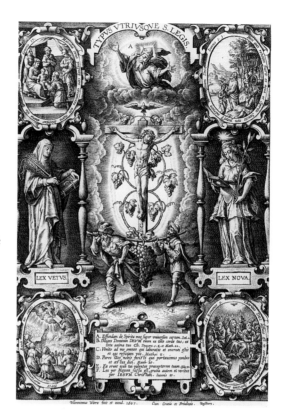

Fig. 180 Hieronymus Wierix, *Typus Utriusque S Legis.* Engraving, 1607

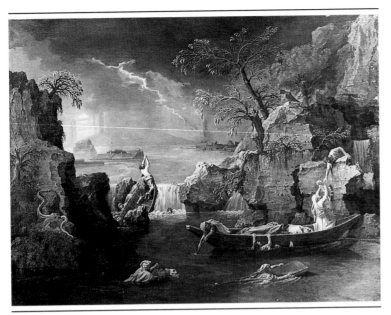

91
Winter, or The Deluge

1660–4

118 × 160 cm

Musée du Louvre, Département des Peintures, Paris

The end of the day and the end of the year, the demise of human life and of the world itself – all of these ideas are subsumed by Poussin in the *Winter* landscape from the Seasons, long regarded as one of the summits of the artist's achievement and a turning-point in the history of art. Though Poussin had painted two previous storm landscapes in 1651 (cat. 74-5), neither of these is so universal in theme as the present picture; nor were they so readily accessible to later generations. As a result, the *Deluge* (as it came to be known) enjoyed pride of place as the first great landscape in the classical tradition to depict the elemental fury of nature.

The subject is the biblical Flood (Genesis VII–VIII). At the

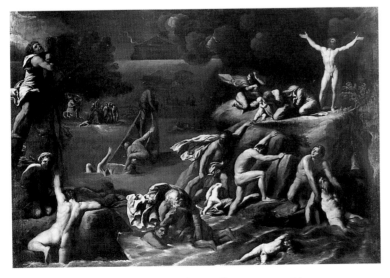

Fig. 181 Antonio Carracci, *The Deluge*. Oil on canvas, 166 × 247 cm. Musée du Louvre, Département des Peintures, Paris

background left, the ark of Noah floats under a pale moon. In the foreground, struggling against the rising waters of the Flood, is a cross-section of humanity, all of whom are destined to perish. At the far right, Poussin paints his last Charity group, a mother striving to lift her child to the safety of its father's arms. Further forward, figures cling to the edge of a boat or attempt to steer it to safety, while others swim. In the middle distance, a boat is thrashed against a cataract, throwing its occupants to the bow. One of these raises his hands in prayer, imploring the heavens for deliverance – a plea that is answered only by a streak of lightning across the darkened sky. Finally, at the left, a monstrous serpent slithers to safety. The author of the catastrophe we are witnessing – the bringer of sin and death into the world – has here returned to witness the world's demise.

The inclusion of the serpent introduces us to the deeper symbolism of the theme.[1] According to St Matthew's Gospel, the Deluge of the Old Testament was a prefiguration of the coming of Christ at the Day of Judgement: 'But as the days of Noe were, so shall also the coming of the Son of Man be.' (Matthew XXIV, 37). By this reading, Poussin's picture may be seen as a disguised Last Judgement, with the blessed in the ark

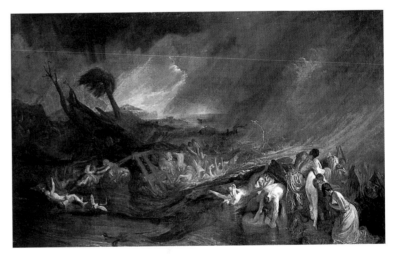

Fig. 182 J. M. W. Turner, *The Deluge*. Oil on canvas, 143 × 235 cm, 1804-5. The Trustees of the Tate Gallery, London

of Noah at the upper left and the damned in the lower right, exactly as they would appear in a traditional portrayal of this theme.

Several features account for the striking originality of Poussin's *Deluge*. The theme is a familiar one in Renaissance and Baroque art, with examples by Uccello, Raphael, Michelangelo, Antonio Carracci (fig. 181), Elsheimer and countless others. In all these works, the composition is dominated – if not confined – to a representation of the human figure. In contrast, the present painting is the first depiction of this theme that is truly a landscape, its figures being few and entirely subordinated to a vision of malevolent nature.

Though this aspect of the picture was often regarded as violating all the rules of classical painting, the composition is as carefully structured as that of *Summer* (cat. 89) and is organised

in a series of receding planes bounded by firm framing elements. Much more audacious is the pervasive grey colouring – one which immediately conveys the sombre and lugubrious nature of the theme. Although this approach to colour is anticipated in the *Landscape with a Storm* and *Pyramus and Thisbe*, the *Deluge* remains Poussin's most conspicuously monochromatic landscape, its unrelieved tones of leaden grey perfectly evoking the pallor and presence of death.

The painting enjoyed enormous popularity with later artists and critics and, during the Romantic period, came to be seen as Poussin's supreme contribution to the cult of the apocalyptic sublime.[2] Soon after its arrival in Paris, it formed the focus of a short *conférence* at the French Academy,[3] which included conventional praise for its harmony and economy of colour. Overshadowing this, however, was a criticism of the picture's subject, which was considered sterile because the portrayal of continuous rain prevented the figures from being seen to best advantage. Even more pedantically, Poussin was censured for depicting the season of winter showing a rainstorm rather than snow – a decision which was eventually explained away by the fact that his scene was set in the ancient Near East rather than in Paris!

For later admirers, however, the most awe-inspiring feature

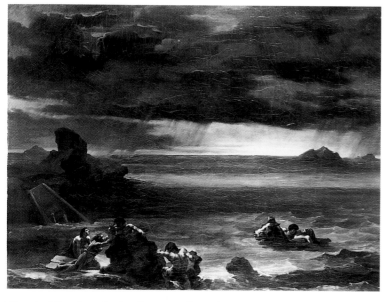

Fig. 183 Theodore Géricault, *Scène du Déluge*. Oil on canvas, 97 × 130 cm, 1815–16. Musée du Louvre, Département des Peintures, Paris

of Poussin's *Deluge* was the helplessness and insignificance of its figures in the face of wrathful nature. Seen in this way, it inspired numerous Romantic masters on both sides of the Channel, who often sought to outdo the effects they admired in Poussin's picture. Thus, in his *Deluge* of 1804–5 (fig. 182), Turner portrayed a natural disaster of even more cataclysmic proportions. Géricault (fig. 183), on the other hand, reduced the theme, rendering it barren and funereal. Adding to the poignancy of Poussin's *Deluge* for the Romantics was the fact that it was invariably regarded as the master's last painting – as the swansong of his art and of nature itself.

1. Blunt (1967, text vol., p. 334) has suggested that the inclusion of the serpent in the present picture may also be a reference to the underworld and, therefore, to the pagan god Pluto, thus completing the sequence of references to mythological deities that Poussin appears to allude to in his Seasons.
2. Cf. Verdi, 1981[1], and Morton D. Paley, *The Apocalyptic Sublime*, London, 1986, pp. 8–16.
3. *Conférences* (ed. Jouin), pp. 100–3.

EXHIBITIONS
Paris, 1960, no. 118; Paris, 1994–5, no. 241

ŒUVRE CATALOGUES
Blunt, no. 6, Thuillier, no. 214, Wild, no. 204d, Wright, no. 203, Mérot, no. 209

REFERENCES
Conférences (ed. Jouin), pp. 100–3; Verdi, 1981[1]

Bibliography

The sources listed below include only those works consulted in the preparation of the present catalogue. For a comprehensive bibliography on the artist up to 1965, consult Blunt, pp. 181–231; for a complete listing of writings on Poussin since 1965, see Paris 1994–5, pp. 539–56.

ACTES, 1960
Nicolas Poussin, (Centre national de la recherche scientifique, Colloques internationaux, Sciences humaines), ed. André Chastel, 2 vols, Paris, 1960.

ADELSON, 1975
Candace Adelson, 'Nicolas Poussin et les tableaux du Studiolo d'Isabelle d'Este', *La Revue du Louvre et des Musées de France*, 1975, pp. 237–41.

ALFASSA, 1933
Paul Alfassa, 'L'origine de la lettre de Poussin sur les modes d'après un travail récent', *Bulletin de la Société de l'Histoire de l'Art français*, 1933, I, pp. 125–43.

ALPATOV, 1965
Michael Alpatov, 'Poussins Landschaft mit Hercules und Cacus in Moskau (Zum Problem der heroischen Landschaft)', *Walter Friedlaender zum 90. Geburtstag*, Berlin, 1965, pp. 9–13.

BADT, 1969
Kurt Badt, *Die Kunst des Nicolas Poussin*, 2 vols, Cologne, 1969.

BARROERO, 1979
Liliana Barroero, 'Nuove Acquisizioni per la cronologia di Poussin', *Bollettino d'Arte*, 4, 1979, pp. 69–74.

BÄTSCHMANN, 1987
Oskar Bätschmann, *Nicolas Poussin, Landschaft mit Pyramus und Thisbe, Das Liebesunglück und die Grenzen der Malerei*, Frankfurt, 1987.

BÄTSCHMANN, 1990
Oskar Bätschmann, *Nicolas Poussin, Dialectics of Painting*, London, 1990.

BAYONNE, 1994–5
Nicolas Poussin, La collection du musée Bonnat à Bayonne, exhibition catalogue by Pierre Rosenberg and Louis-Antoine Prat, Paris, 1994.

BEAL, 1984
Mary Beal, 'Richard Symonds in Italy: his meeting with Nicolas Poussin', *The Burlington Magazine*, CXXVI, 1984, pp. 141–4.

BELLORI, 1672
Giovanni Pietro Bellori, *Le Vite de'pittori, scultori et architetti moderni...*, Rome, 1672.

BIALOSTOCKI, 1954
Jan Bialostocki, 'Une idée de Léonard réalisée par Poussin', *Revue des Arts*, IV, 1954, pp. 131–6.

BIRMINGHAM, 1992–3
Nicolas Poussin, Tancred and Erminia, exhibition catalogue by Richard Verdi, Museum and Art Gallery, Birmingham, 1992.

BLUNT, 1938
Anthony Blunt, 'Poussin's *Et in Arcadia Ego*', Art Bulletin, XX, 1938, pp. 96–100.

BLUNT, 1944
Anthony Blunt, 'The heroic and the ideal Landscape in the Work of Nicolas Poussin', *Journal of the Warburg and Courtauld Institutes*, VII, 1944, pp. 154–68.

BLUNT, 1947[1]
Anthony Blunt, 'The *Annunciation* by Nicolas Poussin', *Bulletin de la Société Poussin*, Premier Cahier, June 1947, pp. 18–25.

BLUNT, 1947[2]
Anthony Blunt, 'Poussin Studies I: Self-Portraits', *The Burlington Magazine*, LXXXIX, 1947, pp. 219–26.

BLUNT, 1947[3]
Anthony Blunt, 'Poussin Studies II: Three early works', *The Burlington Magazine*, LXXXIX, 1947, pp. 266–70.

BLUNT, 1950
Anthony Blunt, 'Poussin Studies IV: Two rediscovered late works', *The Burlington Magazine*, XCII, 1950, pp. 39–40.

BLUNT, 1959
Anthony Blunt, 'Poussin Studies VIII: A series of Anchorite subjects commissioned by Philip IV from Poussin, Claude, and others', *The Burlington Magazine*, CI, 1959, pp. 389–92.

BLUNT, 1964
Anthony Blunt, 'Poussin Studies XIV: Poussin's "Crucifixion"', *The Burlington Magazine*, CVI, 1964, pp. 450–4.

BLUNT, 1966
Anthony Blunt, *The Paintings of Nicolas Poussin, A Critical Catalogue*, London, 1966.

BLUNT, 1967
Anthony Blunt, *Nicolas Poussin*, The A.W. Mellon Lectures in the Fine Arts, 2 vols, London and New York, 1967.

BLUNT, 1974
Anthony Blunt, 'Newly Identified Drawings by Poussin and his followers', *Master Drawings*, XII, 3, 1974, pp. 239–48.

BLUNT, 1976
Anthony Blunt, 'Poussin's "Dance to the Music of Time" Revealed', *The Burlington Magazine*, CXVIII, 1976, pp. 844–8.

BLUNT, 1979[1]
Anthony Blunt, *The Drawings of Poussin*, New Haven and London, 1979.

BLUNT, 1979[2]
Anthony Blunt, 'Further Newly Identified Drawings by Poussin and his Followers', *Master Drawings*, XVII, 2, 1979, pp. 119–46.

BLUNT, 1981
Anthony Blunt, 'Poussin Reconsidered, A Second Autograph Version of Poussin's "Midas washing at the Source of the Pactolus"', *The Connoisseur*, CCVI, 1981, pp. 226–8.

BOLOGNA, 1962
L'ideale classico del seicento in Italia e la pittura di paesaggio, exhibition catalogue, Palazzo dell'Archiginnasio, Bologna, 1962.

BORENIUS, 1931
Tancred Borenius, 'A Great Poussin in the Metropolitan Museum', *The Burlington Magazine*, LIX, 1931, pp. 207–8.

BORENIUS, 1944
Tancred Borenius, 'The History of Poussin's *Orion*', *The Burlington Magazine*, LXXXIV, 1944, p. 51.

BREJON DE LAVERGNÉE, 1973
Arnauld Brejon de Lavergnée, 'Tableaux de Poussin et d'autres artistes français dans la collection Dal Pozzo: deux inventaires inédits', *Revue de l'Art*, 19, 1973, pp. 79–96.

BREJON DE LAVERGNÉE, 1987
Arnauld Brejon de Lavergnée, *L'inventaire Le Brun de 1683, La collection des tableaux de Louis XIV*, (Notes et documents des musées de France 17), Paris, 1987.

BRIGANTI, 1960
Giuliano Briganti, 'L'altare di Sant'Erasmo, Poussin e il Cortona', *Paragone*, XI, 123, 1960, pp. 16–20.

CR
Walter Friedlaender and Anthony Blunt, *The Drawings of Nicolas Poussin, Catalogue Raisonné*, 5 vols, London, 1939–74.

CHANTELOU, (ed. 1985)
Paul Fréart de Chantelou, *Diary of the Cavaliere Bernini's Visit to France*, ed. Anthony Blunt, Princeton, 1985.

CHANTILLY, 1994–5
Nicolas Poussin, La collection du musée Condé à Chantilly, exhibition catalogue by Pierre Rosenberg and Louis-Antoine Prat assisted by Véronique Damian, Paris, 1994.

COLANTUONO, 1986
Anthony Colantuono, *The tender Infant: invenzione and figura in the art of Poussin*, Ph. D. thesis, 2 vols, Johns Hopkins University, Baltimore, 1986.

COLTON, 1967
Judith Colton, 'The Endymion Myth and Poussin's Detroit Painting', *Journal of the Warburg and Courtauld Institutes*, XXX, 1967, pp. 426–31.

CONFÉRENCES, 1667
Conférences de l'Académie Royale de Peinture et de Sculpture pendant l'année 1667, Paris, 1667.

CONFÉRENCES, (ed. FONTAINE)
Conférences inédites de l'Académie Royale de Peinture et de Sculpture..., ed. André Fontaine, Paris, 1903.

CONFÉRENCES, (ed. JOUIN)
Conférences de l'Académie Royale de Peinture et de Sculpture, ed. Henry Jouin, Paris, 1883.

COPENHAGEN, 1992
Fransk Guldalder, Poussin og Claude og maleriet i det 17. arhundredes Frankrig, exhibition catalogue by Humphrey Wine and Olaf Koetser (in Danish and English), Statens Museum for Kunst, Copenhagen, 1992.

CORRESPONDANCE
Correspondance de Nicolas Poussin, (Archives de l'art français V), ed. C. Jouanny, Paris, 1911.

COSTELLO, 1950
Jane Costello, 'The twelve pictures "ordered by Velasquez" and the trial of Valguarnera', *Journal of the Warburg and Courtauld Institutes*, XIII, 1950, pp. 237–84.

COSTELLO, 1965
Jane Costello, 'Poussin's *Annunciation* in London', *Essays in Honor of Walter Friedlaender*, New York, 1965, pp. 16–22.

COSTELLO, 1975
Jane Costello, *Nicolas Poussin, The Martyrdom of Saint Erasmus*, Masterpieces of the National Gallery of Canada, 3, Ottawa, 1975.

CROPPER, 1980
Elizabeth Cropper, 'Poussin and Leonardo: Evidence from the Zaccolini MSS', *The Art Bulletin*, LXII, 1980, pp. 570–83.

CUNNINGHAM, 1940
Charles C. Cunningham, 'Poussin's *Mars and Venus*', *Bulletin of the Museum of Fine Arts, Boston*, XXXVIII, 1940, pp. 55–8.

DELACROIX, (ed. 1966)
Eugène Delacroix, *Essai sur Poussin*, Geneva, 1966; first published 1853.

DEMPSEY, 1963
Charles Dempsey, 'Poussin and Egypt', *The Art Bulletin*, XLV, 1963, pp. 109–19.

DEMPSEY, 1965
Charles Dempsey, 'Poussin's "Marine Venus" at Philadelphia: A Re-identification Accepted', *Journal of the Warburg and Courtauld Institutes*, XXVIII, 1965, pp. 338–43.

DEMPSEY, 1992
Charles Dempsey, 'Mavors armipotens: The Poetics of Self-Representation in Poussin's *Mars and Venus*', *Der Künstler über sich in seinem Werk*, ed. Matthias Winner, Weinheim, 1992, pp. 435–62.

DESJARDINS, 1903
Paul Desjardins, *Poussin*, Paris, 1903.

DORIVAL, 1947
Bernard Dorival, 'Les autoportraits de Poussin', *Bulletin de la Société Poussin*, Premier Cahier, June 1947, pp. 39–48.

DOWLEY, 1973
Francis H. Dowley, 'The Iconography of Poussin's Painting representing Diana and Endymion', *Journal of the Warburg and Courtauld Institutes*, XXXVI, 1973, pp. 305–18.

DUBLIN, 1985
Le Classicisme Français, Masterpieces of Seventeenth Century Painting, exhibition catalogue by Sylvain Laveissière and Jacques Thuillier, National Gallery of Ireland, Dublin, 1985.

DULWICH, 1986–7
Nicolas Poussin, 'Venus and Mercury', Paintings and their Context: I, exhibition catalogue, Dulwich Picture Gallery, London, 1986–7.

DÜSSELDORF, 1978
Nicolas Poussin (1594–1665), exhibition catalogue, Städtische Kunsthalle, Düsseldorf, 1978.

EDINBURGH, 1981
Poussin, Sacraments and Bacchanals, Paintings and drawings on sacred and profane themes by Nicolas Poussin 1594–1665, exhibition catalogue, National Gallery of Scotland, Edinburgh, 1981.

EDINBURGH, 1990
Cézanne and Poussin: the classical vision of landscape, exhibition catalogue by Richard Verdi, National Gallery of Scotland, Edinburgh, 1990.

FÉLIBIEN, (ed. 1725)
André Félibien, *Entretiens sur les vies et sur les ouvrages des plus excellens peintres anciens et modernes*, 6 vols, Trévoux, 1725.

FÉNELON, 1730
François Fénelon, *Dialogues sur la Peinture*, first published in Abbé de Monville, *La Vie de Pierre Mignard*, Paris, 1730, pp. 173–95.

FORT WORTH, 1988
Poussin. The Early Years in Rome. The Origins of French Classicism, exhibition catalogue by Konrad Oberhuber, Kimbell Art Museum, Fort Worth, 1988.

FRANKFURT, 1988
Nicolas Poussin, Claude Lorrain: Zu den Bildern im Städel, exhibition catalogue, Städelsches Kunstinstitut, Frankfurt, 1988.

FRIEDLAENDER, 1914
Walter Friedlaender, *Nicolas Poussin. Die Entwicklung seiner Kunst*, Munich, 1914.

FRIEDLAENDER, 1942
Walter Friedlaender, 'Iconographical studies of Poussin's works in American public collections – I: The Northampton *Venus and Adonis* and the Boston *Venus and Mars*', *Gazette des Beaux-Arts*, 1942, II, pp. 17–26.

FRIEDLAENDER, 1943
Walter Friedlaender, 'Iconographical studies of Poussin's works in American public collections – II: The Metropolitan Museum of Art's *King Midas washing his hands in the River Pactolus* and the Detroit Institute of Arts' *Endymion kneeling before Luna*' *Gazette des Beaux-Arts*, 1943, I, pp. 21–30.

FRIEDLAENDER, 1962
Walter Friedlaender, 'Poussin's Old Age', *Gazette des Beaux-Arts*, LX, 1962, pp. 249–64.

FRIEDLAENDER, 1966
Walter Friedlaender, *Nicolas Poussin, A new approach*, New York, 1966.

FRY, 1923
Roger Fry, '*Pyramus and Thisbe* by Nicholas Poussin', *The Burlington Magazine*, XLIII, 1923, p. 53.

GIDE, 1945
André Gide, *Poussin*, Paris, 1945.

GLEN, 1975
Thomas L. Glen, 'A Note on Nicolas Poussin's "Rebecca and Eliezer at the Well" of 1648', *The Art Bulletin*, LVII, 1975, pp. 221–4.

GOMBRICH, 1944
E.H. Gombrich, 'The Subject of Poussin's *Orion*', *The Burlington Magazine*, LXXXIV, 1944, pp. 37–41; reprinted in *Symbolic Images*, London, 1975, pp. 119–22.

GRAUTOFF, 1914
Otto Grautoff, *Nicolas Poussin, sein Werk und sein Leben*, 2 vols, Munich, 1914.

HAZLITT, 1844
William Hazlitt, *Criticisms on Art*, 2 vols, London, 1844.

HIBBARD, 1974
Howard Hibbard, *Poussin: The Holy Family on the Steps*, London, 1974.

HOURS, 1960
Madeleine Hours, 'Nicolas Poussin: Etude radiographique au Laboratoire du Musée du Louvre', *Bulletin du Laboratoire du Musée du Louvre*, 5, November 1960, pp. 3–39.

HOUSTON, PRINCETON, 1983
Nicolas Poussin 'The Rape of the Sabines' (The Louvre version), exhibition catalogue by Avigdor Arikha, The Museum of Fine Arts, Houston, The Art Museum, Princeton University, 1983.

HUNTER, 1959
Sam Hunter, 'Poussin's *Death of Germanicus*', *The Minneapolis Institute of Arts Bulletin*, XLVIII, I, 1959, pp. 1–13.

KAUFFMANN, 1960
Georg Kauffmann, *Poussin-Studien*, Berlin, 1960.

KIMURA, 1979
Saburo Kimura, 'Etudes sur Diogène jetant son ecuelle de Nicolas Poussin', I. *Bulletin de la Faculté des Arts de l'Université de Nihon*, 1979, 4, pp. 112–28.

KIMURA, 1982
Saburo Kimura, 'Etudes sur "Diogène jetant son ecuelle" de Nicolas Poussin', II. *Mediterraneus*, V, 1982, pp. 51–70.

KIMURA, 1983
Saburo Kimura, 'Autour de N. Poussin – Notes Iconographiques sur le thème de Diogène jetant son écuelle', *Bulletin de la Société Franco-Japonaise d'Art et d'Archeologie*, 3, December 1983, pp. 39–54.

KLEIN, 1937
Jerome Klein, 'An Analysis of Poussin's *Et in Arcadia ego*', *Art Bulletin*, XIX, 1937, pp. 314–17.

LAGERLÖF, 1990
R.M. Lagerlöf, *Ideal Landscape: Annibale Carracci, Nicolas Poussin and Claude Lorrain*, New Haven and London, 1990.

LEVEY, 1963
Michael Levey, 'Poussin's "Neptune and Amphitrite" at Philadelphia: A Re-identification Rejected', *Journal of the Warburg and Courtauld Institutes*, XXVI, 1963, pp. 359–60.

LICHT, 1954
Fred Stephen Licht, *Die Entwicklung der Landschaft in den Werken von Nicolas Poussin*, Basler Studien zür Kunstgeschichte XI, Basel and Stuttgart, 1954.

LURIE, 1982
Ann Tzeutschler Lurie, 'Poussin's "Holy Family on the steps" in The Cleveland Museum of Art: new evidence from radiography', *The Burlington Magazine*, CXXIV, 1982, pp. 664–71.

MCLANATHAN, 1947
Richard B.K. McLanathan, '"Achilles on Skyros" by Nicholas Poussin', *Bulletin of the Museum of Fine Arts*, Boston, XLV, 1947, pp. 2–7, 10–11.

MCTIGHE, 1989
Sheila McTighe, 'Nicolas Poussin's representations of storms and *Libertinage* in the mid-seventeenth century', *Word and Image*, Vol. 5, 4, October–December 1989, pp. 333–61.

MAGNE, 1914
Emile Magne, *Nicolas Poussin, premier peintre du roi (1594–1665), suivi d'un catalogue raisonné*, Paris and Brussels, 1914.

MAHON, 1960
Denis Mahon, 'Poussin's Early Development: an Alternative Hypothesis', *The Burlington Magazine*, CII, 1960, pp. 288–304.

MAHON, 1961
Denis Mahon, 'Réflexions sur les paysages de Poussin', *Art de France*, I, 1961, pp. 199–32.

MAHON, 1962
Denis Mahon, 'Poussiniana, Afterthoughts arising from the exhibition', *Gazette des Beaux-Arts*, 1962, II, pp. 1–138.

MAHON, 1965[1]
Denis Mahon, 'The dossier of a picture: Nicolas Poussin's *Rebecca al Pozzo*', *Apollo*, LXXXI, 1965, pp. 196–205.

MAHON, 1965[2]
Denis Mahon, 'A Plea for Poussin as a Painter', *Walter Friedlaender zum 90. Geburtstag*, Berlin, 1965, pp. 113–42.

MEROT, 1990
Alain Mérot, *Nicolas Poussin*, London, 1990.

NP/SM, 1990
Nicolas Poussin, Paintings and Drawings in Soviet Museums, Leningrad, 1990.

NEW YORK, CHICAGO, 1990
From Poussin to Matisse, The Russian Taste for French Painting, A Loan Exhibition from the U.S.S.R, exhibition catalogue, The Metropolitan Museum of Art, New York and the Art Institute of Chicago, 1990.

OBERHUBER, 1988
See Fort Worth, 1988.

OXFORD, 1990–1
A Loan Exhibition of Drawings by Nicolas Poussin from British Collections, exhibition catalogue by Hugh Brigstocke, Ashmolean Museum, Oxford, 1990.

PACE, 1981
Claire Pace, *Félibien's Life of Poussin*, London, 1981.

PANOFSKY, 1949
Dora Panofsky, 'Narcissus and Echo; Notes on Poussin's *Birth of Bacchus* in the Fogg Museum of Art', *The Art Bulletin*, XXXI, 1949, pp. 112–20.

PANOFSKY, 1938
Erwin Panofsky, '*Et in Arcadia Ego* et le tombeau parlant', *Gazette des Beaux-Arts*, I, 1938, pp. 305–6.

PANOFSKY, 1955
Erwin Panofsky, '*Et in Arcadia Ego*: Poussin and the Elegiac Tradition', *Meaning in the Visual Arts*, Garden City, New York, 1955, pp. 295–320, first published as '*Et in Arcadia ego*: On the Conception of Transience in Poussin and Watteau', in *Philosophy and History, Essays presented to Ernst Cassirer*, ed. R. Klibansky and H.J. Paton, Oxford, 1936, pp. 223–54.

PANOFSKY, 1960
Erwin Panofsky, *A Mythological Painting by Poussin in the National-museum, Stockholm*, Stockholm, 1960.

PARIS, 1960
Exposition Nicolas Poussin, exhibition catalogue, Musée du Louvre, Paris, 1960.

PARIS, 1973
La 'Mort de Germanicus' de Poussin du Musée de Minneapolis (Les dossiers du département des peintures, 7), exhibition catalogue by Pierre Rosenberg and Nathalie Butor, Musée du Louvre, Paris, 1973.

PARIS, NEW YORK AND CHICAGO, 1982
La peinture française du XVIIᵉ siècle dans les collections américaines (France in the Golden Age), exhibition catalogue, Galeries nationales du Grand Palais, Paris; The Metropolitan Museum of Art, New York; The Art Institute, Chicago, 1982.

PARIS, 1983–4
Hommage à Raphaël, Raphaël et l'art français, exhibition catalogue, Galeries nationales du Grand Palais, Paris, 1983–4.

PARIS, 1989
L'Inspiration du Poète de Poussin (Les dossiers du département des peintures, 36), exhibition catalogue by Marc Fumaroli, Musée du Louvre, Paris, 1989.

PARIS, 1993
Copier Créer, de Turner à Picasso: 300 oeuvres inspirées par les maîtres du Louvre, exhibition catalogue, Musée du Louvre, Paris, 1993.

PARIS, 1994–5
Nicolas Poussin 1594–1665, exhibition catalogue by Pierre Rosenberg and Louis-Antoine Prat, Galeries nationales du Grand Palais, Paris, 1994–5.

PASSERI, (ed. 1934)
Giovanni Battista Passeri, *Vite de' pittori, scultori ed architetti che anno lavorato in Roma, morti del 1641, fino al 1673*, Rome, 1772, (*Die Künstlerbiographien von Giovanni Battista Passeri*, ed. Jacob Hess, Leipzig and Vienna, 1934).

POSNER, 1967
Donald Posner, 'The Picture of Painting in Poussin's "Self-Portrait"', *Essays in the History of Art presented to Rudolf Wittkower*, ed. Douglas Fraser, London, 1967, pp. 200–3.

ROME, 1977–8
Nicolas Poussin 1594–1665, exhibition catalogue, Villa Medici, Rome, 1977–8.

ROUEN, 1961
Nicolas Poussin et son temps, exhibition catalogue, Musée des Beaux-Arts, Rouen, 1961.

SALERNO, 1977–8
Luigi Salerno, *Landscape Painters of the Seventeenth Century in Rome*, 2 vols, Rome, 1977–8.

SANDRART, (ed. 1925)
Joachim von Sandrart, *Teutsche Academie der edlen Bau-, Bild- und Mahlerey-Künste*, ed. A.R. Peltzer, Munich, 1925.

SANTUCCI, 1985
Paola Santucci, *Poussin, Tradizione Ermetica e Classicismo Gesuita*, Salerno, 1985.

SAUERLÄNDER, 1956
Willibald Sauerländer, 'Die Jahreszeiten. Ein Beitrag zur allegorischen Landschaft beim späten Poussin', *Münchner Jahrbuch der bildenden Kunst*, Dritte Folge, VII, 1956, pp. 169–84.

SAUSMAREZ, 1969
Painters on Painting (ed. Carel Weight RA), *Maurice de Sausmarez ARA on Poussin's "Orpheus and Eurydice"*, London, 1969.

SIMON, 1978
Robert B. Simon, 'Poussin, Marino, and the Interpretation of Mythology', *The Art Bulletin*, LX, 1978, pp. 56–68.

SOHM, 1986
P.L. Sohm, 'Ronsard's *Odes* as a Source for Poussin's *Aurora and Cephalus*', *Journal of the Warburg and Courtauld Institutes*, XLIX, 1986, pp. 259–61.

SOMMER, 1961
Frank H. Sommer, 'Poussin's "Triumph of Neptune and Amphitrite": A Re-identification', *Journal of the Warburg and Courtauld Institutes*, XXIV, 1961, pp. 323–7.

SOMMER, 1968
Frank H. Sommer, 'Questiones disputatae: Poussin's 'Venus' at Philadelphia', *Journal of the Warburg and Courtauld Institutes*, XXXI, 1968, pp. 440–4.

SPARTI, 1992
D.L. Sparti, *Le collezioni dal Pozzo. Storia di una famiglia e del suo museo nella Roma seicentesca*, Modena, 1992.

SPEAR, 1965
Richard Spear, 'The Literary Source of Poussin's *Realm of Flora*', *The Burlington Magazine*, CVII, 1965, pp. 563–9.

STANDRING, 1988
T.J. Standring, 'Some pictures by Poussin in the Dal Pozzo collection: three new inventories', *The Burlington Magazine*, CXXX, 1988, pp. 608–26.

STEEFEL, 1975
Lawrence D. Steefel, 'A Neglected Shadow in Poussin's "Et in Arcadia Ego"', *The Art Bulletin*, LVII, 1975, pp. 99–101.

STEIN, 1952
Meir Stein, 'Notes on the Italian Sources of Nicolas Poussin', *Konsthistorisk Tidskrift*, 1–2, 1952, pp. 5–12.

TERVARENT, 1952
Guy de Tervarent, 'Le véritable sujet du "Paysage au Serpent" de Poussin à la National Gallery de Londres', *Gazette des Beaux-Arts*, 1952, II, pp. 343–50.

THOMAS, 1986
Troy Thomas, ' "Un fior vano e fragile": The Symbolism of Poussin's *Realm of Flora*', *The Art Bulletin*, LXVIII, 1986, pp. 225–36.

THUILLIER, 1974
Jacques Thuillier, *Tout l'oeuvre peint de Poussin*, Paris, 1974.

THUILLIER, 1976
Jacques Thuillier, 'Poussin et le paysage tragique: "l'Orage Pointel" au musée des Beaux-Arts de Rouen', *Revue du Louvre*, 1976, pp. 345–55.

THUILLIER, 1988
Jacques Thuillier, *Nicolas Poussin*, Paris, 1988.

THUILLIER, 1994
Jacques Thuillier, *Nicolas Poussin*, Paris, 1994.

THUILLIER–MIGNOT, 1978
Jacques Thuillier and Claude Mignot, 'Collectionneur et Peintre au XVIIᵉ: Pointel et Poussin', *Revue de l'Art*, 39, 1978, pp. 39–58.

TOLNAY, 1952
Charles de Tolnay, 'Le portrait de Poussin par lui-même au Musée du Louvre, *Gazette des Beaux-Arts*, II, 1952, pp. 109–14.

VERDI, 1969
Richard Verdi, 'Poussin's Life in Nineteenth-Century Pictures', *The Burlington Magazine*, CXI, 1969, pp. 741–50.

VERDI, 1971
Richard Verdi, 'Poussin's "Eudamidas": eighteenth century criticism and copies', *The Burlington Magazine*, CXIII, 1971, pp. 513–24.

VERDI, 1976
Richard Verdi, *Poussin's Critical Fortunes: The study of the artist and the criticism of this works from c.1690 to c.1830 with particular reference to France and England*, Ph.D. thesis, University of London, 1976.

VERDI, 1979
Richard Verdi, 'On the Critical Fortunes – and Misfortunes – of Poussin's "Arcadia"', *The Burlington Magazine*, CXXI, 1979, pp. 95–107.

VERDI, 1981[1]
Richard Verdi, 'Poussin's *Deluge*: the Aftermath', *The Burlington Magazine*, CXXIII, 1981, pp. 389–400.

VERDI, 1981[2]
Richard Verdi, 'Hazlitt and Poussin', *Keats–Shelley Memorial Bulletin*, XXXII, 1981, pp. 1–18.

VERDI, 1982
Richard Verdi, 'Poussin and the "Tricks of Fortune"', *The Burlington Magazine*, CXXIV, 1982, pp. 681–5.

WALLACE, 1962
R.W. Wallace, 'The Later Version of Nicolas Poussin's *Achilles in Scyros*', *Studies in the Renaissance*, IX, New York, 1962, pp. 322–9.

WATERHOUSE, 1939
Ellis K. Waterhouse, 'Nicolas Poussin's "Landscape with the Snake"', *The Burlington Magazine*, LXXIV, 1939, pp. 102–3.

WATSON, 1949
Francis Watson, 'A new Poussin for the National Gallery', *The Burlington Magazine*, XCI, 1949, pp. 14–18.

WEISBACH, 1930
Werner Weisbach, 'Et in Arcadia ego, Ein Beitrag zur Interpretation antiker Vorstellungen in der Kunst des 17. Jahrhunderts', *Die Antike*, VI, 1930, pp. 127–45.

WEISBACH, 1937
Werner Weisbach, 'Et in Arcadia Ego', *Gazette des Beaux-Arts*, 1937, II, pp. 287–96.

WHITFIELD, 1977
Clovis Whitfield, 'Nicolas Poussin's *Orage* and *Temps Calme*', *The Burlington Magazine*, CXIX, 1977, pp. 4–12.

WILD, 1962
Doris Wild, 'L' "Adoration des Bergers" de Poussin à Munich et ses tableaux religieux des années cinquante', *Gazette des Beaux-Arts*, II, 1962, pp. 223–48.

WILD, 1980
Doris Wild, *Nicolas Poussin, Leben, Werk, Exkurse, Katalog der Werke*, 2 vols, Zürich, 1980.

WILDENSTEIN, 1957
Georges Wildenstein, *Les Graveurs de Poussin au XVIIᵉ siècle*, Paris, 1957.

WILDENSTEIN, 1962
Georges Wildenstein, 'Catalogue des graveurs de Poussin par Andresen', *Gazette des Beaux-Arts*, 1962, II, pp. 139-202.

WINNER, 1983
Matthias Winner, 'Poussins Selbstbildnis im Louvre als kunsttheoretische Allegorie', *Römisches Jahrbuch für Kunstgeschichte*, 20, 1983, pp. 417–49.

WINNER, 1987
Matthias Winner, 'Poussins Selbstbildnis von 1649', *'Il se rendit en Italie', Etudes offertes à Andre Chastel*, Paris, 1987, pp. 371–401.

WORTHEN, 1979
Thomas Worthen, 'Poussin's Paintings of Flora', *The Art Bulletin*, LXI, 1979, pp. 575–88.

WRIGHT, 1985
Christopher Wright, *Poussin, Paintings, A Catalogue Raisonné*, London, 1985.

ZIFF, 1963
Jerrold Ziff, 'Turner and Poussin' *The Burlington Magazine*, CV, 1963, pp. 315–21.

Photographic Credits

All works of art are reproduced by kind permission of the owners. Specific acknowledgements are as follows:

Aix-en-Provence, Jean Bernard Photographe, fig. 136
Basel, Oeffentliche Kunstsammlung, fig. 96
Berlin, Jörg P. Anders, cat. 46, 63, fig. 87
Boston © 1994, Museum of Fine Arts, Boston, All Rights Reserved, fig. 164
Brussels © A.C.L., fig. 156
Chicago © 1994, The Art Institute, All Rights Reserved, cat. 47
Denis Disconzi, cat. 6, 17, 31, 61, 74, 80, 86; black and white details: 17, 27, 43, 83, 91
Edinburgh, Antonia Reeve Photography, cat. 49, 50, 51, 52, 53, 54, 55
Florence, Fratelli Alinari I.D.E.A. S.p.A., All Rights Reserved, fig. 32, 42, 51, 52, 53, 55, 88, 112, 149, 168, 169
Photographie Giraudon, fig. 6, 15, 24, 38, 110, 166, 167
Hamburg, Elke Walford Fotowerkstatt Hamburger Kunsthalle, fig. 132, 177
Roy Jennings, cat. 79
Leipzig © 1994, Museum der bildenden Künste Leipzig, fig. 130
London, Prudence Cuming Associates Ltd., cat. 1, 13, 33, 39, 40, 41, 42, 56
Brian Merrett, MBAM/MMFA, fig. 152
John Mills (Photography) Ltd., cat. 68
Montpellier, Musée Fabre - Frédéric Jaulmes, fig. 125
Munich, Bayerisches Staatsgemäldesammlungen, Alte Pinakothek, fig. 170
José A. Naranjo, cat. 44
New York © 1995, The Museum of Modern Art, fig. 137
Paris © R.M.N., cat. 18, 32, 38, 59, 64, 65, 89, 90, fig. 12, 19, 21, 22, 26, 29, 39, 41, 54, 64, 71, 72, 104, 113, 119, 120, 122, 123, 124, 126, 129, 133, 135, 140, 146, 150, 151, 158, 161, 174, 181, 183
Paris © R.M.N. - D. Arnaudet, cat. 15, 35, 37, 71, 76
Paris © R.M.N. - P. Bernard, cat. 34, 70
Paris © R.M.N. - R.G. Ojeda, cat. 62, 88
Hans Petersen, cat. 58
Martine Seyve, cat. 4
Bernard Terlay, Aix-en-Provence, fig. 117
Wellard, cat. 11

Friends of the Royal Academy

SPONSORS

Mrs Denise Adeane
Mr P.F.J. Bennett
Mrs D. Berger
Mr Jeremy Brown
Mrs L. Cantor
The Carroll Foundation
Mr and Mrs Christopher Cates
Mrs Elizabeth Corob
Mr and Mrs S. Fein
Mr and Mrs R. Gapper
Mr and Mrs Michael Godbee
Lady Gosling
Mr Peter G. Goulandris
Lady Grant
Mr Harold Joels
Mr J. Kirkman
Dr Abraham Marcus
The Oakmoor Trust
Ocean Group p.l.c. (P.H. Holt Trust)
Mr J.P. Onions
Mr and Mrs R. Roberts
The Worshipful Company of Saddlers
Lady Samuel
Mrs M.C. Slawson
The Stanley Foundation
Mrs Paula Swift
Mr Robin Symes
Sir Brian Wolfson

ASSOCIATE SPONSORS

Mr Richard B. Allan
Mrs Meg Allen
Mr Richard Alston
Mr Ian F.C. Anstruther
Mrs Ann Appelbe
Mr John R. Asprey
Lady Attenborough
Mr J.M. Bartos
Mr N.S. Bergel
Mrs Susan Besser
Mrs Linda Blackstone
Mrs C.W.T. Blackwell
Mr Peter Boizot
C.T. Bowring (Charities Trust) Ltd
Mrs J.M. Bracegirdle
Mr Cornelius Broere
Lady Brown
Mr P.J. Brown Jr
Mrs Susan Burns
Mrs A. Cadbury
Mr and Mrs P.H.G. Cadbury
Mr and Mrs R. Cadbury
Mrs C.A. Cain
Miss E.M. Cassin
Mr R.A. Cernis
Mr. S. Chapman
Mr W.J. Chapman
Mr M. Chowen
Mrs J.V. Clarke
Mr John Cleese
Mrs D. Cohen
Mrs R. Cohen
Mrs N.S. Conrad
Mr C. Cotton
Mrs Saeda H. Dalloul
Mr and Mrs D. de Laszlo
Mr John Denham
Mr Richard Dobson
The Marquess of Douro
Mr D.P. Duncan
Mr J. Edwards
Mr Kenneth Edwards
Mrs K.W. Feesey MSc
Mrs B.D. Fenton
Mr J.G. Fogel
Mr Graham Gauld
Mr Robert Gavron
Mr Stephen A. Geiger
Mrs P. Goldsmith
Mr Gavin Graham
Mrs O. Grogan
Mr J.A. Hadjipateras
Mr and Mrs D. Hallam-Peel
Mr and Mrs Richard Harris
Miss Julia Hazandras
Mr M.Z. Hepker
Mr Malcolm Herring
Mrs P. Heseltine
Mr R.J. Hoare
Mr Reginald Hoe
Mr Charles Howard
Mrs A. Howitt
Mr Christopher Hull
Mr Norman J. Hyams

Mr David Hyman
Mrs Manya Igel
Mr C.J. Ingram
Mr S. Isern-Feliu
The Rt Hon. The Countess of Iveagh
Mrs I. Jackson
Lady Jacobs
Mrs G. Jungels-Winkler
Mr and Mrs S.D. Kahan
Mr Simon Karmel
Mr D.H. Killick
Mr P.W. Kininmonth
Mrs L. Kosta
Mrs. E. Landau
Mrs J.H. Lavender
Mr Morris Leigh
Mr and Mrs R. Leiman
Mr David Levinson
Mr Owen Luder
Mrs G.M.S. McIntosh
Mr Peter I. McMean
The Hon. Simon Marks
Mr and Mrs V.J. Marmion
Mr B.P. Marsh
Mr and Mrs J.B.H. Martin
Mr R.C. Martin
Mrs Catherine Martineau
Mr and Mrs G. Mathieson
Mr R. Matthews
Mr J. Menasakanian
Mr J. Moores
Mrs A. Morgan
Mrs A. Morrison
Mr A.H.J. Muir
Mr David H. Nelson
Mrs E.M. Oppenheim-Sandelson
Mr Brian R. Oury
Mrs J. Palmer
Mr J.H. Pattisson
Mrs M.C.S. Philip
Mrs Anne Phillips
Mr Ralph Picken
Mr G.B. Pincus
Mr W. Plapinger
Mrs J. Rich
Mr Clive and Mrs Sylvia Richards
Mr F.P. Robinson
Mr D. Rocklin
Mrs A. Rodman
Lady Rootes
Mr and Mrs O. Roux
The Hon. Sir Stephen Runciman CH
Sir Robert Sainsbury
Mr G. Salmanowitz
Mrs Bernice Sandelson
Mrs Bernard L. Schwartz
Mr and Mrs D.M. Shalit
Mr M. Sheldon
Shell UK Ltd
Mr Mark Shelmerdine
Mr R.J. Simmons
Mr John H.M. Sims
Mr and Mrs M.L. Slotover
Mr and Mrs R. Slotover
The Spencer Wills Trust
Mrs B. Stubbs

Mr J.A. Tackaberry
Mr and Mrs L. Tanner
Mr G.C.A. Thom
Mr H.R. Towning
Mrs Andrew Trollope
Mr E. Victor
Mr A.J. Vines
Mrs C.H. Walton
Mr D.R. Walton Masters
Mr Neil Warren
Miss J. Waterous
Mrs J.M. Weingarten
Mrs Edna S. Weiss
Mrs C. Weldon
Mr Frank S. Wenstrom
Mr J. Wickham
Mr Colin C. Williams
Mrs I. Wolstenholme
Mr W.M. Wood
Mr R.M. Woodhouse
Mr F.S. Worms

Royal Academy Trust

Sponsors of Past Exhibitions

The Council of the Royal Academy thanks sponsors of past exhibitions for their support. Sponsors of major exhibitions during the last ten years have included the following:

ALITALIA
Italian Art in the 20th Century 1989

AMERICAN EXPRESS FOUNDATION
Je suis le cahier: The Sketchbooks of Picasso 1986

ARTS COUNCIL OF GREAT BRITAIN
Peter Greenham 1985

THE BANQUE INDOSUEZ GROUP
Pissarro: The Impressionist and the City 1993

BANQUE INDOSUEZ AND W.I. CARR
Gauguin and The School of Pont-Aven: Prints and
 Paintings 1989

BBC RADIO ONE
The Pop Art Show 1991

BECK'S BIER
German Art in the 20th Century 1985

BMW 8 SERIES
Georges Rouault: The Early Years, 1903-1920 1993

ROBERT BOSCH LIMITED
German Art in the 20th Century 1985

BOVIS CONSTRUCTION LTD
New Architecture 1986

BRITISH ALCAN ALUMINIUM
Sir Alfred Gilbert 1986

BRITISH PETROLEUM PLC
British Art in the 20th Century 1987

BT
Hokusai 1991

CANARY WHARF DEVELOPMENT
New Architecture 1986

THE CAPITAL GROUP COMPANIES
Drawings from the J. Paul Getty Museum 1993

THE CHASE MANHATTAN BANK
Cézanne: the Early Years 1988

CLASSIC FM
Goya: Truth and Fantasy, The Small Paintings 1994
The Glory of Venice: Art in the Eighteenth Century
 1994

THE DAI-ICHI KANGYO BANK LIMITED
222nd Summer Exhibition 1990

THE DAILY TELEGRAPH
American Art in the 20th Century 1993

DEUTSCHE BANK AG
German Art in the 20th Century 1985

DIGITAL EQUIPMENT CORPORATION
Monet in the '90s: The Series Paintings 1990

THE DUPONT COMPANY
American Art in the 20th Century 1993

THE ECONOMIST
Inigo Jones Architect 1989

EDWARDIAN HOTELS
The Edwardians and After: Paintings and Sculpture
 from the Royal Academy's Collection, 1900-1950
 1990

ELECTRICITY COUNCIL
New Architecture 1986

ELF
Alfred Sisley 1992

ESSO PETROLEUM COMPANY LTD
220th Summer Exhibition 1988

FIAT
Italian Art in the 20th Century 1989

FINANCIAL TIMES
Inigo Jones Architect 1989

FIRST NATIONAL BANK OF CHICAGO
Chagall 1985

FONDATION ELF
Alfred Sisley 1992

FORD MOTOR COMPANY LIMITED
The Fauve Landscape: Matisse, Derain, Braque and
 their Circle 1991

FRIENDS OF THE ROYAL ACADEMY
Peter Greenham 1985
Sir Alfred Gilbert 1986

GAMLESTADEN
Royal Treasures of Sweden, 1550-1700 1989

JOSEPH GARTNER
New Architecture 1986

J. PAUL GETTY JR CHARITABLE TRUST
The Age of Chivalry 1987

GLAXO HOLDINGS PLC
From Byzantium to El Greco 1987
Great Impressionist and other Master Paintings from
 the Emil G. Bührle Collection, Zurich 1991
The Unknown Modigliani 1994

THE GUARDIAN
The Unknown Modigliani 1994

GUINNESS PLC
Twentieth-Century Modern Masters: The Jacques
 and Natasha Gelman Collection 1990
223rd Summer Exhibition 1991
224th Summer Exhibition 1992
225th Summer Exhibition 1993
226th Summer Exhibition 1994

GUINNESS PEAT AVIATION
Alexander Calder 1992

HARPERS & QUEEN
Georges Rouault: The Early Years, 1903-1920 1993
Sandra Blow 1994

THE HENRY MOORE FOUNDATION
Henry Moore 1988
Alexander Calder 1992

HOECHST (UK) LTD
German Art in the 20th Century 1985

THE INDEPENDENT
The Art of Photography 1839-1989 1989
The Pop Art Show 1991

THE INDUSTRIAL BANK OF JAPAN
Hokusai 1991

INTERCRAFT DESIGNS LIMITED
Inigo Jones Architect 1989

JOANNOU & PARASKE-VAIDES
(OVERSEAS) LTD
From Byzantium to El Greco 1987

THE KLEINWORT BENSON GROUP
Inigo Jones Architect 1989

LLOYDS BANK
The Age of Chivalry 1987

LOGICA
The Art of Photography, 1839-1989 1989

LUFTHANSA
German Art in the 20th Century 1985

THE MAIL ON SUNDAY
Royal Academy Summer Season 1992
Royal Academy Summer Season 1993

MARTINI & ROSSI LTD
The Great Age of British Watercolours, 1750-1880
 1993

MARKS & SPENCER PLC
Royal Academy Schools Premiums 1994
Royal Academy Schools Final Year Show 1994

MELITTA
German Art in the 20th Century 1985

PAUL MELLON KBE
The Great Age of British Watercolours, 1750-1880
 1993

MERCEDES-BENZ
German Art in the 20th Century 1985

MERCURY COMMUNICATIONS
The Pop Art Show 1991

MERRILL LYNCH
American Art in the 20th Century 1993

MIDLAND BANK PLC
The Art of Photography 1839-1989 1989
RA Outreach Programme 1992-1995
Lessons in Life 1994

MITSUBISHI ESTATE COMPANY UK
LIMITED
Sir Christopher Wren and the Making of St Paul's
 1991

MOBIL
From Byzantium to El Greco 1987

NATIONAL WESTMINSTER BANK
Reynolds 1986

OLIVETTI
Andrea Mantegna 1992

OTIS ELEVATORS
New Architecture 1986

PARK TOWER REALTY CORPORATION
Sir Christopher Wren and the Making of St Paul's
 1991

PEARSON PLC
Eduardo Paolozzi Underground 1986

PILKINGTON GLASS
New Architecture 1986

REDAB (UK) LTD
Wisdom and Compassion: The Sacred Art of Tibet
1992

REED INTERNATIONAL PLC
Toulouse-Lautrec: The Graphic Works 1988
Sir Christopher Wren and the Making of St Paul's
1991

REPUBLIC NATIONAL BANK OF NEW
YORK
Sickert: Paintings 1992

ARTHUR M. SACKLER FOUNDATION
Jewels of the Ancients 1987

SALOMON BROTHERS
Henry Moore 1988

SIEMENS
German Art in the 20th Century 1985

SEA CONTAINERS LTD
The Glory of Venice: Art in the Eighteenth Century
1994

SILHOUETTE EYEWEAR
Egon Schiele and His Contemporaries: From the
Leopold Collection, Vienna 1990
Wisdom and Compassion: The Sacred Art of Tibet
1992
Sandra Blow 1994

SOCIÉTÉ GÉNÉRALE DE BELGIQUE
Impressionism to Symbolism: The Belgian Avant-
Garde 1880-1900 1994

SPERO COMMUNICATIONS
The Schools Final Year Show 1992

SWAN HELLENIC
Edward Lear 1985

TEXACO
Selections from the Royal Academy's Private
Collection 1991

THE TIMES
Old Master Paintings from the Thyssen-Bornemisza
Collection 1988
Wisdom and Compassion: The Sacred Art of Tibet
1992
Drawings from the J. Paul Getty Museum 1993
Goya: Truth and Fantasy, The Small Paintings 1994

TRACTEBEL
Impressionism to Symbolism: The Belgian Avant-
Garde 1880-1900 1994

TRAFALGAR HOUSE
Elisabeth Frink 1985

TRUSTHOUSE FORTE
Edward Lear 1985

UNILEVER
Frans Hals 1990

UNION MINIÈRE
Impressionism to Symbolism: The Belgian Avant-
Garde 1880-1900 1994

VISTECH INTERNATIONAL LTD
Wisdom and Compassion: The Sacred Art of Tibet
1992

WALKER BOOKS LIMITED
Edward Lear 1985

OTHER SPONSORS

*Sponsors of events, publications and other items in the
past two years:*

Academy Group Limited
Air Namibia
Air Seychelles
Air UK
Alitalia
American Airlines
Arthur Andersen
Athenaeum Hotel and Apartments
Austrian Airlines
Berggruen & Zevi Limited
British Airways
British Midland
Bulgari Jewellery
Cable & Wireless
Christies International plc
Citibank N.A.
Columbus Communications
Condé Nast Publications
Brenda Evans
Fina Plc
Forte Plc
The Four Seasons Hotels
Häagen-Dazs
Tim Harvey Design
Hyundai Car (UK) Ltd
IBM United Kingdom Limited
Inter-Continental Hotels
Intercraft Designs Limited
Jaguar Cars Limited
John Lewis Partnership plc
A.T. Kearney Limited
KLM
The Leading Hotels of the World
Magic of Italy
Martini & Rossi Ltd
May Fair Inter-Continental Hotels
Mercury Communications Ltd
Merrill Lynch
Midland Bank Plc
Anton Mosimann
NK
Novell U.K. Ltd
Patagonia
Penshurst Press Ltd
Percy Fox and Co
Polaroid (UK) Ltd
The Regent Hotel
The Robina Group
Royal Mail International
Sears Plc
Swan Hellenic Ltd
Mr and Ms Daniel Unger
Kurt Unger
Venice Simplon-Orient-Express
Vista Bay Club Seychelles
Vorwerk Carpets Limited
Louis Vuitton Ltd
Warner Bros
White Dove Press
Winsor & Newton
Mrs George Zakhem